The International Lesson Annual
1989–90
September–August

THE INTERNATIONAL LESSON ANNUAL

1989–90

September–August

A Comprehensive Commentary on
the International Sunday School Lessons
Uniform Series

Edited by
HORACE R. WEAVER

Lesson Analysis by
PAT McGEACHY

ABINGDON PRESS
Nashville

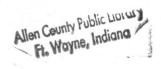

THE INTERNATIONAL LESSON ANNUAL—1989–90

ISBN 0-687-19153-X

Library of Congress ISSN 0074-6770

Manufactured by the Parthenon Press at
Nashville, Tennessee, United States of America

Editor's Preface

I wrote my first preface for *The International Lesson Annual* in March 1960, and it appeared in print in the spring of 1961. Now it is March 1988, and I am writing this preface for the *Annual* that will be ready for use for 1989–1990.

In reviewing several of the twenty-eight issues of *The International Lesson Annual*, I am amazed at how relevant the 112 quarters of study have been and are! It is very clear that the study of the Bible is always relevant in the pursuit of the meaning of life. For example, the second and third quarters of study for this issue of the *Annual* deal with the Gospel of John. John begins his Gospel with a clear statement about creation—who it was who created, and how creation took place. We read: "In the Beginning was the Word, and the Word was with God, and the Word was God. He was in the beginning with God; all things were made through him, and without him was not anything made that was made. In him was life, and the life was the light of men" (John 1:1-4).

This paragraph summarizes in beautiful language the belief that "in the beginning" there was an intelligent being who purposed and brought into being the universe. Through God's designing and timing, the elements (as seen in the atomic chart, with its 115 elements) and the creative Word that brought life (via the DNA molecule, the link between all flora and fauna), the heavenly deity "birthed" everything that exists. "All things were made through him . . ."

The fourth quarter deals with the wisdom of God. Such wisdom cannot be purchased. It can be grasped by those who seek the wisdom God so willingly offers.

How relevant the biblical record is for our time!

Each of the four quarters (with their thirteen lessons per quarter) is designed to help teachers in presenting the good news to their students. Each lesson has five sections. The first section, "The Main Question," raises the basic question with which each lesson is concerned. The second section, "As You Read the Scripture," exegetically explores the scripture passage being studied. The third section prints the passage from both the King James and the Revised Standard Versions. The fourth section, "The Scripture and the Main Question," contains expositions of the lesson's themes. The fifth section, "Helping Adults Become Involved," offers a step-by-step teaching plan. Topics under this latter heading include "Preparing to Teach," "Introducing the Main Question," "Developing the Lesson," "Helping Class Members Act," and "Planning for Next Sunday."

In addition to these five helpful teacher sections, special enrichment articles are offered. The interdenominational emphasis is continued, a fact that immeasurably broadens the insights of teacher-readers.

Horace R. Weaver, *Editor*

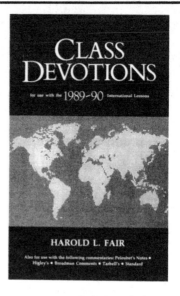

Contents

FIRST QUARTER

Visions of God's Rule

UNIT I: EZEKIEL: GOD'S CARE FOR JUDAH (SEPT. 3–24)

UNIT II: DANIEL: THROUGH OPPRESSION TO VICTORY
(OCT. 1–15)

UNIT III: I AND II THESSALONIANS: THE COMING OF THE LORD
(OCT. 22–29)

UNIT IV: REVELATION: A MESSAGE OF HOPE (NOV. 5–26)

SECOND QUARTER

John: The Gospel of Life and Light

UNIT I: JESUS COMES TO HIS OWN (DEC. 3–24)

UNIT II: JESUS REVEALS HIMSELF (DEC. 31–JAN. 28)

UNIT III: JESUS PREPARES HIS FOLLOWERS (FEB. 4–25)

THIRD QUARTER

The Gospel of Life and Light

UNIT IV: JESUS LAYS DOWN HIS LIFE (MAR. 4–APR. 15)

ABIDING IN LOVE (APR. 22–MAY 27)

(A Six-Lesson Course)

FOURTH QUARTER

Wisdom as a Way of Life

UNIT I: WISDOM IN THE PSALMS (JUNE 3–17)

UNIT II: PROVERBS OF THE WISE (JUNE 24–JULY 22)

UNIT III: THE LIMITS OF HUMAN WISDOM (JULY 29–AUG. 5)

UNIT IV: WISDOM IN THE NEW TESTAMENT (AUG. 12–26)

Visions of God's Rule

UNIT I: EZEKIEL: GOD'S CARE FOR JUDAH
Horace R. Weaver

FOUR LESSONS **SEPTEMBER 3–24**

This quarter's study focuses on two Old Testament and three New Testament books addressed to God's people during difficult times, with the intent of providing strength and encouragement. Many of the texts to be studied illustrate the type of literature we call apocalypse.

There are four units of study: Unit I, "Ezekiel: God's Care for Judah"; Unit II, "Daniel: Through Oppression to Victory"; Unit III, "I and II Thessalonians: The Coming of the Lord"; Unit IV, "Revelation: A Message of Hope."

Unit I consists of four lessons taken from the post-exilic prophet Ezekiel. Ezekiel's ministry was from 593–563 B.C. He was among the thousands who were captured by the Babylonians and taken to exile in Babylon. He was a priest who was called to be a prophet after being in exile. Our lessons are drawn from two periods of his writings: the oracles of warning written prior to the fall of Jerusalem, 587 B.C. (chapters 1–24), and the oracles of hope written after the fall of Jerusalem in 561 B.C. (chapters 33–48). Ezekiel's major interest is to help the exiles (and those still living in Jerusalem) to be aware that God is still with them (Immanuel). Though now in a foreign land, the Lord God is still with them and can be worshiped.

The lessons in Unit I begin with "God Is Present with Us," September 3, which is based on Ezekiel's vision of the living God who is no longer in Palestine but in a foreign country, Babylonia—who is ever-present and is worshiped even without a temple! "God Holds Us Accountable," September 10, contradicts Exodus 20:5 by saying that people are responsible for their own (not their ancestors') sins. "God Promises to Bless," September 17, applies the doctrine of individual responsibility to kings ("shepherds") and to those who hold various kinds of authority over the poor. "God Gives New Life," September 24, discusses Ezekiel's beautiful account of the Spirit's giving new life to the disheartened and hopeless.

Contributors to the first quarter:

Lynn Deming, Free-lance Editor and Writer; former Product Development Manager for Curriculum Resources Committee, Board of Discipleship, The United Methodist Church, Nashville, Tennessee.

Robert E. Luccock, Professor Emeritus of Worship and Preaching, Boston University School of Theology, Boston, Massachusetts.

Pat McGeachy, Pastor, Downtown Presbyterian Church, Nashville, Tennessee.

Horace R. Weaver, retired Professor of Religion and Philosophy, Union College, Barbourville, Kentucky; Executive Editor of Adult Curriculum Resources, The United Methodist Church, retired; Editor of *International Lesson Annual* for twenty-five years.

God Is Present with Us

Background Scripture: Ezekiel 1

The Main Question—Pat McGeachy

"Where there is no vision," says the old proverb, "the people perish" (Proverbs 29:18 KJV). This is true in all times but especially in history's darkest hours. And for the Hebrew people, no time seemed darker than the Babylonian captivity. Ezekiel is speaking of a vision seen in Babylon. (The date is a little uncertain, but the shape of the prophecy is such that we can take it to be during the beginnings of that dark period in which the Chaldeans ruled all of that world—perhaps just before the fall of Jerusalem in 587 B.C.) It was a time when everyone, even the optimist, was having a hard time finding something to cheer about.

Can you think of another time as dark? As we shall see from the similarities between this prophecy and those of the book of Revelation, it was not unlike the period of the terrible persecution of the early Christians by the Roman emperors. In our own day we might compare it to the United States during the Great Depression of the early thirties, or Europe during the fearsome expansion of Hitler's empire. In your own personal life you may have an even more discouraging time in mind.

The main question is, How can we see God when the world is dark? When times are dark, what light can we find? When the storm is at its worst, can we hope for a rainbow (Ezekiel 1:28; Genesis 9:14; Revelation 4:3; 10:1)? We all know about whistling in the dark and thinking positive, but can there be a genuine glow of hope for a discouraged individual or nation? Ezekiel's answer is a resounding "Yes!" He had the spiritual vision to see beyond the politically discouraging realities to the underlying eternal reality. What vision do you and I have? If we can answer this with a strong yes, like that of Ezekiel, then we have a gift to give a world troubled by the shadow of nuclear holocaust, of wars and terrorism, of hunger and poverty. It is an answer worth searching for.

As You Read the Scripture—Horace R. Weaver

Two very religious young men were born about the same time. Jeremiah was born in 626 B.C. while Ezekiel was born about 620 B.C. Jeremiah was called to be a prophet while still a lad, and Ezekiel (born a priest) was called to be a prophet in 593.

Both experienced the tragedy of war. Ezekiel was taken to Babylon; Jeremiah remained in Jerusalem. Prior to the exile Jeremiah had preached the inevitability of God's judgment on Judah if the people continued to abandon their faith in God and to live without justice and mercy. Ezekiel preached a similar message. He was born into the fortunate family of the Zadokite priests. All other priests had been denied the privilege of fulfilling their priestly functions, as outlined by the young king Josiah in 621 B.C. (the year that the book of Deuteronomy was found and became the law of Judah).

Military defeat was considered not only a physical disaster but an obvious

proof that the Lord had abandoned his people. Moreover, God had also abandoned the land. Where now was the Lord? Ezekiel's experience during a terrible storm assured him that the Lord was not limited to Jerusalem—God is not located in one place. God is mobile. The deity is also with his chosen people in Babylon. This conviction came to Ezekiel through one of the richest religious experiences in the Old Testament (Ezekiel 1–2:2a). The date for his call to prophecy was July 593. He was by the Chebar, a canal that flowed southeastward, passed through Nippur, and reentered the Euphrates near Erech.

Ezekiel 1:4. Undoubtedly Ezekiel, the Zadokite priest, was pondering the question as to where God was/is. As he questioned he became aware that he was facing a terrible windstorm (in a semi-desert area). He could feel the stormy wind, see a "great cloud (of dust) with brightness round about it," and lightning flashing. Out of the growing darkness he could see light.

Verses 5-6, 22. "From the midst of [the cloud] came the likeness of four living creatures." Each of the four cherubim had four wings and four faces (in the form of a lion, an ox, an eagle, and a man; compare Revelation 4:7). Above the four creatures was the firmament, shining like crystal.

Verses 15-20. The "wheels" are those of the royal chariots. We are reminded of King Josiah, who ordered the cleansing of the temple when he adopted Deuteronomy as the norm for Jewish life. Josiah ordered the destruction of a chariot and horses of a sun god (II Kings 23:11). Ezekiel, or at least his father, would have participated in that reform. The "wheels" of the divine chariot suggest God's mobility. God can be wherever needed! His Spirit determines the direction the chariot takes: "Wherever the spirit would go, they went . . . for the spirit of the living creatures was in the wheels " (verse 20).

"The rims were full of eyes" refers to the omniscient God. Ezekiel held an excellent view of God. Though he held to a faith that was rooted in the soil of Palestine, yet he was compelled (in exile!) to worship without a temple or priesthood, and to affirm the existence of a holy people without a land.

Verses 25-28b. The phrase "the likeness of" is used many times by Ezekiel in chapter 1. The prophet was careful not to use anthropomorphisms. There was a "voice from above the firmament over their [the four creature's] heads . . . and above the firmament over their heads there was the likeness of a throne" (yet not a throne, for God is Spirit—God does not "sit" on thrones).

"Seated above the likeness of a throne was a likeness as it were of a human form." God is not in human form, yet the deity is somewhat akin to human beings. Ezekiel wants it clearly understood he is not anthropomorphizing God! Compare this picture of the Lord with that in Habakkuk 3:4; Psalm 97:3; and Daniel 7:9-10. Ezekiel has an amazing sense of the *mysterium tremendum*. Little wonder he knelt with his face to the ground as he heard God address him.

Selected Scripture

King James Version	Revised Standard Version
*Ezekiel 1:4-6, 15-20, 26-28*b	*Ezekiel 1:4-6, 15-20, 26-28*b
4 And I looked, and, behold, a whirlwind came out of the north, a	4 As I looked, behold, a stormy wind came out of the north, and a

great cloud, and a fire infolding itself, and a brightness *was* about it, and out of the midst thereof as the colour of amber, out of the midst of the fire.

5 Also out of the midst thereof *came* the likeness of four living creatures. And this *was* their appearance; they had the likeness of a man.

6 And every one had four faces, and every one had four wings.

..

15 Now as I beheld the living creatures, behold one wheel upon the earth by the living creatures, with his four faces.

16 The appearance of the wheels and their work *was* like unto the colour of a beryl: and they four had one likeness: and their appearance and their work *was* as it were a wheel in the middle of a wheel.

17 When they went, they went upon their four sides: *and* they turned not when they went.

18 As for their rings, they were so high that they were dreadful; and their rings *were* full of eyes round about them four.

19 And when the living creatures went, the wheels went by them: and when the living creatures were lifted up from the earth, the wheels were lifted up.

20 Whithersoever the spirit was to go, they went, thither *was their* spirit to go; and the wheels were lifted up over against them: for the spirit of the living creature *was* in the wheels.

..

26 And above the firmament that was over their heads *was* the likeness of a throne, as the appearance of a sapphire stone: and upon the likeness of the throne *was* the likeness as the appearance of a man above upon it.

27 And I saw as the colour of amber, as the appearance of fire

great cloud, with brightness round about it, and fire flashing forth continually, and in the midst of the fire, as it were gleaming bronze. 5 And from the midst of it came the likeness of four living creatures. And this was their appearance: they had the form of men, 6 but each had four faces, and each of them had four wings.

..

15 Now as I looked at the living creatures, I saw a wheel upon the earth beside the living creatures, one for each of the four of them. 16 As for the appearance of the wheels and their construction: their appearance was like the gleaming of a chrysolite; and the four had the same likeness, their construction being as it were a wheel within a wheel. 17 When they went, they went in any of their four directions without turning as they went. 18 The four wheels had rims and they had spokes; and their rims were full of eyes round about. 19 And when the living creatures went, the wheels went beside them; and when the living creatures rose from the earth, the wheels rose. 20 Wherever the spirit would go, they went, and the wheels rose along with them: for the spirit of the living creatures was in the wheels.

..

26 And above the firmament over their heads there was the likeness of a throne, in appearance like sapphire; and seated above the likeness of a throne was a likeness as it were of a human form. 27 And upward from what had the appearance of his loins I saw as it were gleaming bronze, like the appear-

round about within it, from the appearance of his loins even upward, and from the appearance of his loins even downward, I saw as it were the appearance of fire, and it had brightness round about.

28 As the appearance of the bow that is in the cloud in the day of rain, so *was* the appearance of the brightness round about. This *was* the appearance of the likeness of the glory of the Lord.

ance of fire enclosed round about; and downward from what had the appearance of his loins I saw as it were the appearance of fire, and there was brightness round about him. 28 Like the appearance of the bow that is in the cloud on the day of rain, so was the appearance of the brightness round about.

Such was the appearance of the likeness of the glory of the Lord.

Key Verse: **As the appearance of the bow that is in the cloud in the day of rain, so was ... the appearance of the likeness of the glory of the lord. (Ezekiel 1:28)**

Key Verse: **Like the appearance of the bow that is in the cloud on the day of rain ... Such was the appearance of the likeness of the glory of the Lord. (Ezekiel 1:28)**

The Scripture and the Main Question — Pat McGeachy

A Revelation

A lot of Ezekiel's prophecy, like that of Daniel and the book of Revelation, is strange to the modern ear. So I'd like to begin this study by defining a much misused word: "apocalypse." Apocalyptic literature has a way of springing up during times of trouble. Its language is usually mysterious, filled with symbolic beasts and numbers and hard for our Western ears to understand. But we mustn't fall for popular misuses of the word. Thanks to some questionable definitions employed by Hollywood and a few fearmongering religious teachers, most people have come to think of "apocalypse" as a meaning fire and brimstone or some form of disaster.

But it doesn't. It is a very hopeful and basically simple word that means "revealing." Literally, its root meaning is "off [with] the cover." If you should come home at supper time, smell something delicious cooking, and, wondering what it could be, walk to the kitchen and lift the lid to find some Brunswick stew simmering there, that would be an "apocalypse"! What Ezekiel does, like other prophetic voices in troubled times, is make known the seemingly hidden presence of God. When things get dark, timid believers may believe that God has left us here. But voices of faith, like that of Ezekiel, make the glory of God known even in the winter of our discontent.

The Four Living Creatures (Ezekiel 1:4-14)

Clever "interpreters" of prophecy invent all sorts of explanations for the strange images in apocalyptic literature, but we must stick to the central truth: God has good news for captive people. The four living creatures depicted by Ezekiel symbolize the power and presence of God. They are quite similar to the four creatures depicted in Revelation 4:3-8, which are also related to the seraphim of Isaiah 6:1-9 who cry through the smoke, "Holy, holy, holy!" (Look up in your hymnal the song "Holy, Holy, Holy!")

15

The four creatures of Ezekiel are not exactly like those in Revelation 4; those in Ezekiel each have four faces—man, lion, ox, and eagle—while those in Revelation each have one of the same four faces. Since medieval times the four faces have stood for the four evangelists and their Gospels:

The man: Matthew, whose Gospel begins with the human lineage of Jesus
The lion: Mark, whose Gospel opens with the voice in the wilderness
The ox: Luke, who wrote the Gospel of sacrifice
The eagle: John, the soaring theologian

These creatures of course are *not* the four evangelists, but they do perform exactly the same function as the New Testament writers: to proclaim good news (gospel) to a dark world (John 1:5).

Wheels Within Wheels (1:15-21)

The old spiritual rightly affirms that the wheels turn "by faith" and "the grace of God." The vision is of an immense chariot, a mobile throne which, like Jacob's ladder, makes it clear that the power of God is not limited to the little land of Israel. Wherever God's people may find themselves dispersed, they must not suppose that they can run away from God (as Jonah did). Wherever we go and no matter how dark things get, we are to say, "Surely the Lord is in this place" (Genesis 28:16).

The Thunder of the Almighty (1:22-28)

Just when the world thinks it has got the upper hand, with a thunder of wings, with blazing fire, under shining crystal, bright as a rainbow, comes the glory of Almighty God. Again we have a vision similar to the one in Revelation 1:12-16 of the Christ. The might of Babylon may appear to have the stage. In our day there have been times when tyrants seemed to be winning. The little folk of the world—the poor, the very young, the old, the helpless—often feel that life is stacked against them. But standing in the shadows keeping watch over the faithful is the eternal God. And if you have the prophetic eyes of an Ezekiel, you can see that God is not merely standing passively. No, the Presence is moving on wings and wheels, forth into the fray, to do battle with the forces of darkness.

For some reason, I have always had a tendency to think defensively. They say that is what wins football games. But they also say that the best defense is a good offense, and that is what is happening here. Long ago, when the little church was coming into being at the confession of Simon Peter at Caesarea Philippi, Jesus said, "On this rock I will build my church, and the powers of death shall not prevail against it" (Matthew 16:18). The church is to take the offensive, to attack the very gates of hell!

The message of Ezekiel is clear: Whenever Babylon looms dark and powerful and seems to be invincible, eyes of faith can see in the sky of the Spirit God's winged evangelists, bearing good news. Behind them, on chariots of fire, huge and invincible, rolls the presence of the Almighty. How can we see this vision when our own world seems grey and bad? Well, there are Ezekiels in our own day: prophets, preachers, friends, and companions in the church. That is why we need one another and why every Lord's day we must return to the source of our spiritual encouragement, where we can renew our heavenly vision.

16

Moreover, we have Ezekiel himself! Your very act in studying this lesson is one way of seeing the vision. And the Bible is rich with others! There are those we have mentioned in Isaiah and Revelation, but there are also those of Daniel (such as 10:1-10), or Habakkuk (2:1-4), or Moses (Exodus 3:1-15), or Peter, James, and John (Luke 9:28-36). And, of course, there is the one great theophany (vision of the glory of God) that all Christians remember and love: the magnificent vision of angels in the Christmas sky (Luke 2:13-14). The Bible is rich with such promises of divine power.

But I would like to conclude this study of the question, How can we see God when the world is dark? By considering the person of the prophet himself. When the heavens were opened he "saw visions of God" (1:1) with such a brightness of glory that he fell upon his face (verse 28; compare Peter in Luke 5:8). Can you and I see such visions? In other words, can a contemporary Christian ever hope to have the spiritual insights of an Ezekiel?

Jesus promised us that we could expect to outdistance the gifts of the Bible, including his own powers (John 14:12-14). I take this to mean, among other things, that you and I, confronted with troubling times, are capable of perceiving the promises of God above and beyond the narrow vision of this world. A case in point: Two weeks before I wrote these words, there was a sad and apparently meaningless death in our community. A kindly elderly woman, going about her habitual deeds of kindness to the poor of this city, was brutally killed. The community reacted with immediate anger. But the family of the murdered woman, speaking through her son, a local pastor, urged the community to forgive the assailant, asserting that God's power rises above such cruel deeds and will ultimately triumph. Where did they get this insight? Could it be that they see God at work where the secular world cannot?

In a day like ours, when storms gather and the future seems bleak, there are Ezekiels among us—those who know that above the clouds are the seraphim, heralding the approach of wheels within wheels, the chariot of God. The rainbow shines through the rain, and tomorrow is in eternal hands. Skeptics may doubt (as well they should), but eyes of faith look beyond mere skepticism (note that the meaning of the word "skeptic" is at root "to look") to the assurance of things hoped for, the conviction of things "not seen" (Hebrews 11:1). Babylon does not have the last word (Revelation 14:8).

Helping Adults Become Involved—Robert E. Luccock

Preparing to Teach

The lessons in this quarter are all based on what is called *apocalyptic literature.* "Apocalypse" is a strange word, meaning literally, "a revelation." An apocalypse usually comes in the form of a vision given by God to a prophet or seer. Often the visions are frightening; at the same time they proclaim the good news of God's power and God's faithfulness.

The apocalyptic visions of Ezekiel are from an age vastly different from our own. Yet our contemporary films are apocalyptic: *Star Wars, The Empire Strikes Back, Apocalypse Now.* The class may want to consider what dif-

ferences there may be between biblical apocalypse and twentieth-century apocalypse.

Through apocalyptic visions God gives the covenant people the assurance of God's presence in both trial and rejoicing. So we move beyond the imagery of apocalypse. When we allow the literature to truly possess our imaginations, we may find ourselves more at home here than in many other parts of the Bible.

Here is one way to outline the lesson:

 I. Where we find the Jews
 II. Where we find ourselves
 III. The imagery of Ezekiel's vision
 IV. What images might we see today?

Introducing the Main Question

It was hard to be a faithful Jew in Babylon 580 years before Christ. Familiar landmarks were missing, guideposts were gone. The Jews had to survive without their temple and priesthood. "How can we see God when the world is dark?" they asked. Perhaps the class will suggest these two ways that people can see God when the world is dark:

1. We can trust the God who appeared with good news in Ezekiel's vision. What God could do for Israel, God will not overlook to do for faithful people here and now. Seeing can come from trust.

2. We can open our eyes to see how God has appeared in the darkest places around us. Dr. McGeachy gives an illustration of how God appeared in the family of the murdered woman. It is important in this lesson to move from ancient Babylon to the streets where we live. The visions are there for those who have eyes to see.

Developing the Lesson

I. Where we find the Jews

The Jews were forced to walk across the desert in 597 B.C. to exile in the pagan country of Babylon. Trace the journey on a large wall map, if available. The place was not conducive to singing the Lord's song. The people among whom they were forced to live worshiped strange gods.

The Israelites sat down and wept (Psalm 137:1). (Do not call them Israelis; that is a twentieth-century political term unknown in biblical times.) They needed assurance of God's presence, the security of being God's people, a way of holiness in an alien land.

II. Where we find ourselves

Whole populations of refugees and exiles still wander around the world. Our environments are often not conducive to fidelity and devotion. Sometimes we have to learn to do without familiar supports.

III. The imagery of Ezekiel's vision

As the scripture is read, have someone list these images on newsprint or a chalkboard:

> The stormy wind from the north
> A great cloud of brightness
> Fire flashing forth
> Lightning
> Four living creatures
> Wheels, with eyes on the rims
> A throne
> One in the likeness of a human form

Notice here that Ezekiel uses the words "in the likeness of." He is careful not to say that the Lord appeared as a human being. Compare Ezekiel's vision of the four creatures with Isaiah's visions in the temple (Isaiah 6:1-8). The class should also be aware that each of the four Gospels in the New Testament has become associated with one of the creatures in Ezekiel's vision.

IV. What images might we see today?

Ask the class members what visions they have seen.

Tolstoy's story "Where Love Is" describes how an old shoemaker saw Jesus "in the likeness of a peasant."

A preacher in Boston once began his sermon with "I saw Jesus last night on Massachusetts Avenue." People braced themselves for some hallucination. It turned out that Jesus, as the preacher described him, appeared "in the likeness of" a homeless man, a derelict in the city, hungry and cold. (Read Matthew 25:31-40.)

Helping Class Members Act

If you look ahead at the very first verse of Ezekiel 2, you see that God asks something of us in response to our visions. What are some of the ways we can respond faithfully to apocalyptic visions?

1. We can remember. Memory can often be a strong stay against drifting with a tide. Turn again to Psalm 137: "If I forget you, O Jerusalem, let my right hand wither!" (verse 5).

2. We can be part of the vision that others might see. It would be interesting to recall the people in our lives in whom we have seen a vision that made a difference between good and evil.

Planning for Next Sunday

Personal accountability before God is the subject of next week's lesson, which is based on Ezekiel 18. Encourage the class to read it carefully and to identify five groups to whom the prophet directs his words. Do we still see any of those groups in our common life?

God Holds Us Accountable

Background Scripture: Ezekiel 18

The Main Question—Pat McGeachy

The eighteenth chapter of Ezekiel is one long commentary on a very simple truth: We are each responsible for our own lives. As my mother (given to speaking in proverbs) used to say, "Every tub must stand on its own bottom." And I suppose you would agree with me that this is an obvious truth. But if it *is* so obvious, why did the Lord need a whole chapter to make it plain to the prophet? In fact, the history of the human race is made up of our refusal to take responsibility for our lives, or our claiming to be trapped by life so that we *have* no such responsibility.

Examine the following statements, which I occasionally overhear, and see if you do not see our question lurking in all of them to some extent:

"It was the devil made me do it!"
"This is not the real me."
"Something came over me."
"If my parents hadn't been such strict disciplinarians, perhaps I would not have grown up to be so sloppy about my appearance."
"There's nothing I can do about it; I'm programmed to be like this."
"I could never do something like that; our family never does."

This list could be continued indefinitely. It illustrates a kind of fatalism. Of course, there *are* ways in which the past determines who we are. We have certain physical and mental characteristics. "Which of you by being anxious can add one cubit to his span of life?" (Matthew 6:27). We have to live within the boundaries of the reality that we have been given. But within them there is plenty of room to shape our lives. I do not have to become a drunkard because my father was one, nor does the fact that he was sober all his life make me safe. I must live accountably before God.

The question then, for us as for Ezekiel's hearers, is, How can I take charge of my own life? God doesn't want to lose me (verse 32); why don't I repent and amount to something?

As You Read the Scripture—Horace R. Weaver

How easy it is to pass the buck when we are at fault. We seek to blame others for our bad circumstances and sins. My best friend, or my father's father, is the basic problem! This is precisely what Ezekiel 18 is about. Who or what is responsible for the evil things that happen?

There are two ways to approach this question. The first is to go with Exodus 20:5 and blame your unworthy ancestors: "I . . . am a jealous God, visiting the iniquity of the fathers upon the children to the third and fourth generation of those who hate me." The context of this statement is found in verses 4-5*a*, which state that no person of faith in Yahweh (the Lord) shall

make or worship or serve any man-made statues of animals or humans. Yahweh is an imageless deity. There can be no image that would reflect what God is like. To worship a statue is idolatry at its worst, and its consequences bring untold trouble to the worshiper.

God's statement about "visiting the iniquity of the fathers upon the children to the third and fourth generation" seeks to teach elders the importance of their decisions in the lives of the next generation. There is a sense of the significance of corporate sin.

The second way of dealing with this question is Ezekiel's statement of *individual* responsibility. It deals directly with the question of inherited guilt by denying the validity of that position, and argues persuasively for individual responsibility. The doctrine of individual responsibility is applied to five groups: (1) to a father, (2) to his son(s), (3) to his grandsons, (4) to a repentant unrighteous man, and (5) to a backsliding righteous man. This represents a new definition of moral and religious responsibilities.

Ezekiel 18:2-4. Ezekiel condemns the same proverb that Jeremiah condemned (31:27-32): "The fathers have eaten sour grapes, and the children's teeth are on edge [blunted]."

In the first generation, if the "father" is righteous, if he (and his wife) does not "lift up his eyes to . . . idols . . . does not defile his neighbor's wife . . . does not oppress any one, but restores to the debtor his pledge, commits no robbery, gives his bread to the hungry . . . executes true justice between man and man, walks in my statutes . . . he shall surely live, says the Lord God." The righteous man declares by his life-decisions for the good that he will live (be saved).

Verses 10-24. If a father's son "does none of these duties" (listed above), he shall not live! His blood shall be upon himself, not his father!

But if this evil son has a son (the third generation) who lives the moral and religious life of his grandfather, though not his father, he shall surely live. "The soul that sins shall die. The son shall not suffer for the iniquity of the father," nor the grandfather for the iniquity of his son.

Ezekiel then applies his doctrine of individual responsibility to a repentant backslider. The wicked man who repents will live. He is received in full measure, but it is clear such a repentant man still carries memories (including former temptations) within his mind and emotions. God will not "remember" his sins and hold them against him.

"But when a righteous man turns away from his righteousness and commits iniquity and does the same abominable things that the wicked man does, shall he live?" The answer is no!

Verses 30-32. People are judged according to their present commitment to moral and spiritual life. A has-been faces spiritual death. People choose their lifestyles; everyone may "get . . . a new heart and a new spirit." People choose whether they will be a curse or blessing to those who live around them.

Selected Scripture

King James Version	Revised Standard Version
Ezekiel 18:2-4, 19-24, 30-31	*Ezekiel 18:2-4, 19-24, 30-31*
2 What mean ye, that ye use this proverb concerning the land of	2 "What do you mean by repeating this proverb concerning the

Israel, saying, The fathers have eaten sour grapes, and the children's teeth are set on edge?

3 *As* I live, saith the Lord God, ye shall not have *occasion* any more to use this proverb in Israel.

4 Behold, all souls are mine; as the soul of the father, so also the soul of the son is mine: the soul that sinneth, it shall die.

...

19 Yet say ye, Why? doth not the son bear the iniquity of the father? When the son hath done that which is lawful and right, *and* hath kept all my statutes, and hath done them, he shall surely live.

20 The soul that sinneth, it shall die. The son shall not bear the iniquity of the father, neither shall the father bear the iniquity of the son: the righteousness of the righteous shall be upon him, and the wickedness of the wicked shall be upon him.

21 But if the wicked will turn from all his sins that he hath committed, and keep all my statutes, and do that which is lawful and right, he shall surely live, he shall not die.

22 All his transgressions that he hath committed, they shall not be mentioned unto him: in his righteousness that he hath done he shall live.

23 Have I any pleasure at all that the wicked should die? saith the Lord God: *and* not that he should return from his ways, and live?

24 But when the righteous turneth away from his righteousness, and committeth iniquity, *and* doeth according to all the abominations that the wicked *man* doeth, shall he live? All his righteousness that he hath done shall not be mentioned: in his trespass that he hath trespassed, and in his sin that he hath sinned, in them shall he die.

...

land of Israel, 'The fathers have eaten sour grapes, and the children's teeth are set on edge'? 3 As I live, says the Lord God, this proverb shall no more be used by you in Israel. 4 Behold, all souls are mine; the soul of the father as well as the soul of the son is mine: The soul that sins shall die."

...

19 "Yet you say, 'Why should not the son suffer for the iniquity of the father?' When the son has done what is lawful and right, and has been careful to observe all my statutes, he shall surely live. 20 The soul that sins shall die. The son shall not suffer for the iniquity of the father, nor the father suffer for the iniquity of the son; the righteousness of the righteous shall be upon himself, and the wickedness of the wicked shall be upon himself.

21 "But if a wicked man turns away from all his sins which he has committed and keeps all my statutes and does what is lawful and right, he shall surely live; he shall not die. 22 None of the transgressions which he has committed shall be remembered against him; for the righteousness which he has done he shall live. 23 Have I any pleasure in the death of the wicked, says the Lord God, and not rather that he should turn from his way and live? 24 But when a righteous man turns away from his righteousness and commits iniquity and does the same abominable things that the wicked man does, shall he live? None of the righteous deeds which he has done shall be remembered; for the treachery of which he is guilty and the sin he has committed, he shall die."

...

30 Therefore I will judge you, O house of Israel, every one according to his ways, saith the Lord God. Repent, and turn *yourselves* from all your transgressions; so iniquity shall not be your ruin.

31 Cast away from you all your transgressions, whereby ye have transgressed; and make you a new heart and a new spirit: for why will ye die, O house of Israel?

Key Verse: I will judge you . . . every one according to his ways, saith the Lord God. (Ezekiel 18:30)

30 "Therefore I will judge you, O house of Israel, every one according to his ways, says the Lord God. Repent and turn from all your transgressions lest iniquity be your ruin. 31 Cast away from you all the transgressions which you have committed against me, and get yourselves a new heart and a new spirit! Why will you die, O house of Israel?"

Key Verse: I will judge . . . every one according to his ways, says the Lord God. (Ezekiel 18:30)

The Scripture and the Main Question—Pat McGeachy

Sour Grapes (Ezekiel 18:1-4)

"The parents have eaten sour grapes, and the children's teeth hurt." This was evidently a common saying among ancient people. Jeremiah complained about it too (31:29-30). (He and Ezekiel were contemporaries, and one may have been quoting from the other. If you have a Bible with cross-references, you will notice a good many other similarities between the two prophets of the exile.) We have others: "Like father, like son." Proverbs, like all one-liners, rarely contain the whole truth. Of course, there *is* truth in the old saw; if there weren't, it wouldn't have become a popular saying. We do suffer for the sins of our ancestors. If you think about it, you can come up with some obvious examples: Does not one generation suffer when the previous generation allows soil to erode or pollutes the atmosphere? That is why we are told that God is jealous, "visiting the iniquity of the fathers upon the children to the third and fourth generation" (Exodus 20:5). The proverb does have truth in it. But the point here is that it does not contain the whole truth. We are to some extent conditioned by our heredity and our environment, but *it doesn't have to be that way.* Moreover, as long as we live that way we will never be spiritually free people.

In the nineteenth chapter of Acts, verses 11-20, there is a wonderful story about the seven sons of Sceva, who tried to exorcise a demon by ordering it out "in the name of the Jesus whom Paul preaches!" Of course, you remember that the disturbed man beat up all seven of them and ran them naked down the street. It's a bit of Bible slapstick, meant to drive home the same point that Ezekiel is getting at here: You can't cast out demons in the name of somebody else's Jesus! You can't accomplish the Christian life in the name of your mother's Jesus, or your pastor's Jesus, or the Jesus the church teaches. Victory comes only when I can speak of *my* Jesus. That is, I belong to God as an individual, and it is as myself (not with the church's skirts to hide me) that I must stand before God.

You Know the Rules (18:5-20)

Jesus told us that on the judgment day the sheep will be separated from the goats on the basis of how they have lived: Did they feed the hungry,

water the thirsty, welcome the stranger, clothe the naked, visit the sick and those in prison? (Matthew 25:31-46). When the rich young ruler (Mark 10:1-22) asked him, "What must I do to inherit eternal life?" Jesus said, "You know the commandments." And we do indeed. Ezekiel's account contains a few things that relate to ancient Jewish ritual, but for the most part the list is obvious to any ethical person:

Don't take part in an idolatrous meal (verse 6). (Canaanite worship places were often located in the heights.)
Don't make idols out of your own worship traditions (verse 6).
Don't sleep with somebody else's mate (verse 6).
Don't oppress anyone (verse 7), especially the poor and needy (verse 12).
Pay your debts (verse 7).
Don't steal (verse 7).
Feed the hungry (verse 7).
Clothe the naked (verse 7).
Don't charge interest (verse 8). (Any bankers in your class?)
Stay out of trouble (verse 8).
Treat people fairly (verse 8).
Keep the rules and regulations (verse 9).
Don't shed blood (verse 10).

If you keep these rules, isn't it obvious that you are a good person (no matter how wicked your parents may have been)? If you don't keep them, isn't it obvious that you are a wicked person (no matter how good your predecessors may have been)?

With just this sort of plain talk, Jesus astonished the people in the Sermon on the Mount (see Matthew 7:28-29). They were astonished because he taught with authority and "not like their scribes." The scribes had been burdening the people with technicalities and rituals, but Jesus broke through all that with common sense: "Every sound tree bears good fruit, but the bad tree bears evil fruit . . . You will know them by their fruits" (Matthew 7:17-20).

Every experienced pastor will know that people come to ministers with problems by which they feel trapped, somewhat like the following. (I don't wish to lift up sexual problems as being better or worse than other kinds; this just happens to be an incident that I remember.) A young woman said to her pastor, "I need your advice. My lover is cruel to me. He drinks and uses abusive language, and he beats me up. He has ordered me out, and he tells me that if I ever come back he will kill me."

"Then don't go back," said the minister.

"But I *have* to," she sobbed. "I love him!"

Now to you and me (as to her pastor) the answer is obvious, just as it should have been to the rich young man mentioned above. But like him, she felt trapped by something she did not want to give up (Matthew 19:22). She was caught in a monkey trap: They say you can catch a monkey if you fill a narrow-necked jar with peanuts, so that when he reaches in and grabs a fistful, he can't get his hand out. Then you run and grab him. Common sense, like Ezekiel, shouts a new proverb: "Eat sour grapes and *your* teeth will hurt." But we don't want to hear it.

Repent and Be Saved! (18:21-31)

Once it dawns on us that we *are* responsible before God and that we have no excuses, then we are burdened at once with a sense of our hopelessness. The knowledge of the law convicts us of sin and causes us to cry with Paul (Romans 7:24), "Who will deliver me from this body of death?" The young woman mentioned above and the rich young man who came to Jesus, like Ezekiel's hearers, believed that there was no escape for them. But there was, and it was a simple matter of turning loose, or better, *turning around,* for that is what repentance means.

I remember once climbing up with the big kids on the high dive, thinking that it would be fun to jump down. But when I got up there, it looked so far down, and the water looked so hard, that I couldn't jump, even though no athletic skill of any sort was required. (If I'd been a little clumsy I might have fallen off.) Instead, I did something much more difficult: I went back down the ladder amidst the jeers of all the other kids. And all I had to do was let go.

We are so afraid that God won't take us back! But listen to Ezekiel 18:32. God is yearning for our return (compare Matthew 18:14). As in Jesus' story of the waiting father (Luke 15:11-32), God is peering down the road, hoping that we, Israel, you, the rich young man, the love-struck young woman, all of us will come home. We try all sorts of tricks. We blame it on our ancestors. We blame it on God (Ezekiel 18:25). We blame it on the devil. But before God there is just one person who can repent of my sins, and that is me.

But one more word must be added. This is not in contradiction to Ezekiel 18, but in addition to it. I am not alone. I may stand alone before God, but One stands with me, all the same. There is an old spiritual that says, "You must walk that lonesome valley;/You have to walk it by yourself." And in Ezekiel's sense, that is true. But in another sense, made known in the Twenty-third Psalm, and in a hundred other places in the Scriptures, God is with us in the valley of the shadow. Because Jesus walked that lonesome valley, no one need ever walk it alone. He comforts us with his rod and staff, disciplining us with the law, yes, but offering us new life. (See Romans 8:1-4.) Why then do we insist upon death? God wills our repentance; in our heart of hearts we will it too. It is as easy as falling off a diving board, as turning loose of a fistful of peanuts, or a wicked lover, or a bank account full of CDs. Anyone can do it. But it's up to you.

Helping Adults Become Involved—Robert E. Luccock

Preparing to Teach

The second commandment (Exodus: 20:4-6) declares that God visits the iniquity of the fathers upon the children. Both Jeremiah (31:29-34) and Ezekiel dissent from that belief. Instead, Ezekiel confronts God's people with the painful truth: You cannot pass the buck for sins and suffering back to your ancestors. Is this scripture not also a word in season to us? We blame our ancestors, we blame society, we blame the rotten deal that we were given, and we blame bad luck for the evils that come to us—anything or anyone but ourselves. Ezekiel will have none of that. Ezekiel 18:5 and 9 allow no escape into excuses. In other words, "Knock off complaining and blaming; get yourself a new heart."

FIRST QUARTER

Here is an outline of the lesson:

 I. To appreciate Ezekiel's word, we must first look
at the second commandment (Exodus 20:5).

 II. It is never too late.

 III. How can a person turn and live?

Introducing the Main Question

A good place to get into the main question would be the recital of excuses
Dr. McGeachy regales us with in "The Main Question." The point this
chapter drives home is this: I am accountable for what I do with my life. A
familiar expression puts it, "The buck stops here—with me." This is hard
for disadvantaged persons to say when people with power have robbed
them of their advantages. It is hard for persons who fail to admit that they
are responsible for this loss, this accident, this embarrassment. Tell your
class how Dr. McGeachy climbed the ladder to make a high dive but was
afraid, so he climbed down that ladder and refused to dive into the pool. As
he says, it is often true that we have heavy odds to overcome. We tell
ourselves that if we were strong or rich or smart or beautiful, it might be
different.

Try putting it this way: We cannot always help what happens *to* us. We can
usually decide how we will *handle* what happens to us. God does not require
us to be brilliant or to be Number One. God will not save us from failure.
God asks us only to be faithful (Ezekiel 18:1-2). People who do these things
will live. We may not make the headlines or be salesperson of the month or
mother of the year. But in God's eyes the faithful person lives. To live is to
know and share the abundance of God's love.

Developing the Lesson

*I. To appreciate Ezekiel's word, we must first look at the second commandment
(Exodus 20:5).*

When we use the word "jealous," we usually imply grudging, envious
rivalry. We are far wide of the meaning to attribute such petty human
feelings to God. God is jealous in the sense that none can be first in our
loyalty and affections but God. When other persons, interests, or idols
usurp what must be fidelity to God alone, we are unfaithful and God is
"jealous."

"To the third and fourth generations" signifies the *corporate* character of
the covenant people. God made the covenant with the *whole* people, past,
present, and future. So what happens in one generation affects all the
generations to come.

Is this true in our own social history? Consider the consequences of
polluting the earth's air and water. What happens when a people allows the
moral fabric of a society to weaken?

II. It is never too late.

Even now, persons and nations can turn and live. What does it mean
to *live*? Horace Weaver points to one meaning: "to be saved." From what?
For what?

Another meaning would be to share God's purposes and will for us and

for our common life in the world. The passage from Ezekiel has a double purpose: to declare that every individual is accountable to God for his or her faithfulness or infidelity to God's commandments, and to call all to repent. Whatever the people had done, they could turn around. Accountability is often painful. That we can repent is good news.

Even in pagan Babylon, covenant-people could be faithful. Even in a polluted and degenerate world, Christian people can be loyal to the best God asks of us.

III. How can a person turn and live?

People addicted to drugs of any kind know that it is not enough to tell themselves, "I will be strong; I will not drink or do drugs any more." Paul Tillich once warned against saying to people struggling with weakness, "Be strong." Being strong is the one thing they cannot do. Something else needs to happen.

First, they need *a new spirit*. What is that new spirit, and where does one get it? See what the class will suggest in answer to this question. You may consider these components: (1) a new self-image that comes from understanding that God loves us and accepts us as we are; (2) a new awareness of how we stand at the juncture of past and future of our family, tradition, and history; (3) the discovery of new and challenging purposes to live for; (4) giving and receiving caring support to and from people who struggle with us.

Helping Class Members Act

If a chapter of Alcoholics Anonymous meets nearby, you might make arrangements for one or two to attend an open meeting. This should be sensitively done, not an invasion by a whole class at one time. You will hear testimony there of how men and women have turned and begun to live.

Perhaps some class members would like to try keeping a private journal (in most cases not to be shared with others) in which they note the times when they find themselves even *thinking* of how others are responsible for what has happened to them.

Consider how we can be accountable in church, family, community. Does some part of our church life and program seem disappointing? Instead of wringing our hands and looking for someone to blame, how could we make ourselves accountable for what happens? What of our attitudes in the family? Can we become more accountable for the quality of family life? How?

Planning for Next Sunday

Direct the students to read all of Ezekiel 34. Comparison with Isaiah 11:3b-9; Isaiah 61:1-3; and John 10:1-16 will be helpful. If you have anyone in your class who has had firsthand experience with sheep and shepherds, ask that person to be ready to share what shepherding is like.

God Promises to Bless

Background Scripture: Ezekiel 34:11-31

The Main Question—Pat McGeachy

It goes against the grain of some of us to be called sheep. This is particularly true of people in a country like the United States, where people pride themselves on their rugged individualism. From infancy we are taught by our culture (at least boys are) not to be sheep. And as the last lesson pointed out, Ezekiel too believed in individualism. But no one can read the Bible seriously without discovering that the shepherd and the sheep is an oft-used metaphor for God and the people of God. In some sense we need to learn sheep-hood.

In spite of all we had to say in the last lesson about our individual responsibility before God, there is another side to the matter: Under God we are called both to individual and corporate obedience. In human life there are differences: Some of us have gifts of leadership; others are followers. But before God we are a common herd. Let me use another metaphor. In the surface film of the waters of a cypress swamp live a lot of microorganisms, buzzing with their own importance, some looking down upon others. But to the pure snowy egret high in the cypress tree, they all look pretty much alike. As human beings we have much in common: We have all gone astray like lost sheep (Isaiah 53:6). We have basic needs: water, pasture, protection (Psalm 23), and God is our only provider. Moreover, God has made a divine promise, Ezekiel tells us, to be our good shepherd and to take care of us, if we will accept it. This means that we must give up lording it over one another (Ezekiel 34:20) and misusing the world as though it belonged to us alone (verses 18-19), and cease following false shepherds (Jeremiah 50:6; John 10:12). It may be an insult for me to treat you like a sheep, but before God that is what we are. The main question of our lesson is, Can we and will we follow the one Shepherd (John 10:16)? It is what God both wishes and promises.

As You Read the Scriptures—Horace R. Weaver

Ezekiel 34 continues the writer's concern for personal responsibility. However, in this case, the prophet applies the doctrine to the highest level of his society's structure—kings. Kings have moral, religious, and political responsibilities for all persons in their kingdoms. Ezekiel cries out against the actions of bad kings, whom he calls bad shepherds.

Good kings (shepherds) seek the welfare of their flocks, whereas bad kings think of their flocks as opportunities to manipulate and issue decrees that give them more opportunities for personal gain. It goes without saying that there must be leaders who wield power in every society. But such power needs to be tempered by a sense of responsibility.

A good shepherd, as Jesus described, is one who has deep concern for the sheep that has strayed from the flock, so much so that he leaves the ninety and nine to find the one that is lost (Luke 15:4-7). So should kings seek for

the lost, wounded, hungry, browbeaten members of their flocks. God too seeks to rescue the perishing! (Ezekiel 34:12-16).

Ezekiel 34:17, 20. God says, "I judge between sheep and sheep, rams and he-goats." That is, God distinguishes between the fat, overfed sheep, such as kings and those who hold special economic privileges, and the lean sheep, the kings' subjects, most of whom are in need of justice.

Verses 21-22. Ezekiel, who experienced the terrors of marching to exile from Jerusalem to Babylon, recalls being pushed and shoved (as with horns) by Babylonian soldiers. Bad leaders shove and push others around in similar fashion. Exploitation is always resented and is a major source of hate and unrest. Ezekiel, though a priest and a man with some special standing in captivity, understands the consequences of class distinctions—the differences between the haves and the have-nots. There are those who enrich themselves at the expense of their neighbors, robbing them of those things that make life worthwhile.

Verses 23-24. The statement "I will set up over them one shepherd, my servant David" reveals that Ezekiel still lives in the expectation of a return of the exiles to Jerusalem, there to be ruled over by an anointed king from the line of David. Note that all prophets during and after the exile were not of the same opinion about continuing the line of David.

Verses 25-30. The messianic hope is held high by Ezekiel. He looks forward to the day when God will intervene by raising up a man to restore justice and hence peace on earth. At such a time a renewal of the covenants previously made will take place and "my servant David will be prince among them" (verse 24). This does not mean David will be resurrected, but rather that a descendant of David will rule and bring justice.

The phrase "covenant of peace" rests on Hosea's faith: "I will make for you a covenant on that day with the beasts of the field, the birds of the air, and the creeping things of the ground; and I will abolish the bow, the sword, and war from the land . . . And I will betroth you to me . . . in righteousness and in justice, in steadfast love, and in mercy" (Hosea 2:18-19). Ezekiel's feet rest solidly on Hosea's shoulders!

One result of such a redemptive act by God will be "showers of blessing." By the thoughtful and caring acts of the rulers, peace shall permit the land to become fruitful, so that "no more [shall a person] be consumed with hunger in the land, and no longer suffer the reproach of the nations" (verse 29).

Ezekiel yearns for the good shepherd (ruler) whose concerns and decisions are based not on royal descent or the restoration of the Davidic throne and its power but on the fulfillment of his duties as a good shepherd—healing the sick, binding up the injured, leading home the wanderers (verse 4).

Verses 30-31. The religious consequences are religious certainty. Emmanuel: "I, the Lord their God, am with them, and . . . they . . . are my people, says the Lord God. And you are my sheep, the sheep of my pasture, and I am your God."

Selected Scripture

King James Version	Revised Standard Version

Ezekiel 34:17, 20-31

17 And *as for* you, O my flock, thus saith the Lord God; Behold, I judge between cattle and cattle, between the rams and the he goats.

...

20 Therefore thus saith the Lord God unto them; Behold, I *even* I, will judge between the fat cattle and between lean cattle.

21 Because ye have thrust with side and with shoulder, and pushed all the diseased with your horns, till ye have scattered them abroad;

22 Therefore will I save my flock, and they shall no more be a prey; and I will judge betwen cattle and cattle.

23 And I will set up one shepherd over them, and he shall feed them, *even* my servant Dā-vid; he shall feed them, and he shall be their shepherd.

24 And I the Lord will be their God, and my servant Dā-vid a prince among them; I the Lord have spoken *it.*

25 And I will make with them a covenant of peace, and will cause the evil beasts to cease out of the land: and they shall dwell safely in the wilderness, and sleep in the woods.

26 And I will make them and the places round about my hill a blessing; and I will cause the shower to come down in his season; there shall be showers of blessing.

27 And the tree of the field shall yield her fruit, and the earth shall yield her increase, and they shall be safe in their land, and shall know that I *am* the Lord, when I have broken the bands of their yoke, and delivered them out of the hand of those that served themselves of them.

Ezekiel 34:17, 20-31

17 "As for you, my flock, thus says the Lord God: Behold, I judge between sheep and sheep, rams and he-goats."

...

20 "Therefore, thus says the Lord God to them: Behold, I, I myself will judge between the fat sheep and the lean sheep. 21 Because you push with side and shoulder, and thrust at all the weak with your horns, till you have scattered them abroad, 22 I will save my flock, they shall no longer be a prey; and I will judge between sheep and sheep. 23 And I will set up over them one shepherd, my servant David, and he shall feed them: he shall feed them and be their shepherd. 24 And I, the Lord, will be their God, and my servant David shall be prince among them; I, the Lord, have spoken.

25 "I will make with them a covenant of peace and banish wild beasts from the land, so that they may dwell securely in the wilderness and sleep in the woods. 26 And I will make them and the places round about my hill a blessing; and I will send down the showers in their season; they shall be showers of blessing. 27 And the trees of the field shall yield their fruit, and the earth shall yield its increase, and they shall be secure in their land; and they shall know that I am the Lord, when I break the bars of their yoke, and deliver them from the hand of those who enslaved them. 28 They shall no more be a prey to the nations, nor shall the beasts of the land devour them; they shall

28 And they shall no more be a prey to the heathen, neither shall the beast of the land devour them; but they shall dwell safely, and none shall make *them* afraid.

29 And I will raise up for them a plant of renown, and they shall be no more consumed with hunger in the land, neither bear the shame of the heathen any more.

30 Thus shall they know that I the Lord their God *am* with them, and *that* they, *even* the house of Ĭs-rā-ĕl, *are* my pepole, saith the Lord God.

31 And ye my flock, the flock of my pasture, *are* men, *and* I *am* your God, saith the Lord God.

dwell securely, and none shall make them afraid. 29 And I will provide for them prosperous plantations so that they shall no more be consumed with hunger in the land, and no longer suffer the reproach of the nations. 30 And they shall know that I, the Lord their God, am with them, and that they, the house of Israel, are my people, says the Lord God. 31 And you are my sheep, the sheep of my pasture, and I am your God, says the Lord God."

Key Verse: **And ye my flock, the flock of my pasture, are men, and I am your God, saith the Lord God. (Ezekiel 34:31)**

Key Verse: **You are my sheep, the sheep of my pasture, and I am your God, says the Lord God. (Ezekiel 34:31)**

The Scripture and the Main Question—Pat McGeachy

There Is Only One Shepherd

I have sometimes wondered if we do not too casually use the title "pastor" to describe that office in the church. I suspect that we don't even think very often of its root meaning. I know it is biblical, but I can only find it used once (Ephesians 4:11), and there is plenty of solemn warning in the Bible about those who misuse the office. It isn't an assigned part of the background scripture for this lesson, but it is definitely part of the context, and you need to look carefully and thoughtfully at Ezekiel 34:1-10. God alone is Lord of the conscience, and no earthly leader, however spiritual and dedicated, can fill that role. Maybe we have to have pastors as long as we live in this sinful world, but God's promise is that ultimately we will all belong to one congregation and that there will be only one Shepherd (John 10:16). According to the book of Revelation, we won't have to go to church (Revelation 21:22) and our Shepherd will be a Lamb (7:17)!

God Our Shepherd (Ezekiel 34:11-16)

There is no better-loved metaphor in all of sacred Scripture than that of the Good Shepherd (Psalm 23; John 10:1-18). Although most of us are urban people today and may never have seen a shepherd, the Twenty-third Psalm is still our universal favorite. In his book *God Is for Real, Man*, written in the sixties when he was chaplain at the Erie County jail in Buffalo, Carl Burke described how his young offenders searched for another word to describe one who cares for them, seeks them out, and keeps them out of trouble. Would you believe they decided on "The Lord is like my probation

officer"! I have since tried to get other urban people to translate the first verse of Psalm 23 without using the word "shepherd." Try it for yourself. (Incidentally, the leading candidate so far has been "mother," with "scoutmaster" a distant second.)

Although Jesus quotes more from Psalms than from any other part of the Bible except Isaiah, he does not quote from our favorite psalm. Perhaps that is because he so thoroughly identified himself with the shepherd. Certainly he had it in mind when he described himself in John 10. But he may well have been thinking also of our Ezekiel passage. Here God is described as having just the same sort of personal concern for the sheep as Jesus. The principal task of the divine Shepherd, in addition to providing good pasture (verse 14), is to search for the lost and scattered sheep. And Jesus may have been thinking of this when he told the wonderful story recorded in Luke 15:4-7 and Matthew 18:10-14. It must have been a beautiful and hopeful word to Ezekiel's hearers, scattered as they were in their captivity and wondering if God had perhaps forgotten them.

You who are studying these lessons may not be captive in a political Babylon, but like all of us, you have your captors. You may be lost in the wasteland of television or the delusional world of substance abuse. Certainly you are led astray by many temptations, some of them (such as pride) so subtle that you may not even be conscious of them. But we need a shepherd as surely as did those displaced Israelites, and it is the promise of God to be just that for us.

The Pecking Order (34:17-24)

I haven't had a lot of close communion with sheep (most Americans have not), but I know something about chickens and cows. I have watched cattle line up to go into the barn at milking time, and observed that they always follow the same order. If one tries to usurp the "rightful" position of another, some butting and hooking may take place. Chickens too have fancy arrangements about who "rules the roost." My bet is that sheep are the same. At any rate, those described in verses 17-22 are clearly misusing each other, the strong abusing the weak and even spoiling the pasture for the rest (verses 18-19) and polluting the waters. Could this have something to say about our world where a fourth of the people control more than three-fourths of the world's resources? It is an optimistic oversimplification to say that one-third of the earth's population has plenty to eat, one-third has barely enough, and one-third is starving. God promises to set this right.

The solution will be not an earthly political one, but a heavenly political one (verse 23). God will raise up David, who we all remember was a shepherd par excellence (in addition to Psalm 23 see also I Samuel 17:34-37). It was customary among the prophets to invoke the name of David when the Messiah (Christ) was promised (see also Ezekiel 37:24). It conjured up not only shepherd images but remembrances of former glory, of victory over enemies, and of a rare period of peace in Israel's history. Thus it is no accident that Jesus was often addressed by that name (Matthew 21:9). It was important for the authentication of his messiahship that he be "of the house and lineage of David" (see, for example, Luke 2:4, 11, as well as the genealogies in Matthew 1 and Luke 3). Do you think that Ezekiel had Jesus in mind as he prophesied? Perhaps not in every detail as to how,

when, and where, but certainly we must call Ezekiel 34:24 a promise of the coming Christ.

And what does the Christ have to say about the pecking order in his kingdom? Servants will be leaders, the meek will inherit the earth, those who lose their lives will find them, and the bearers of crosses will be the true kings. The citations are too numerous to mention, so look at just one, Matthew 20:28: "The Son of man [this is a favorite phrase of Ezekiel's, by the way] came not to be served but to serve, and to give his life as a ransom." Be sure to note the context in which Matthew quotes this: an argument over who comes first in the Messiah's pecking order. In the true kingdom, under the true David, the sheep will be separated from the goats, and we will learn to live in right relationship with one another. Isn't it about time?

The Coming Peace (34:25-31)

This passage makes me think of the image of the peaceable kingdom in Isaiah 11:6-9 (see also 65:25). As the old gospel song has it, "Oh, that will be glory!" I can hardly wait. Not too long ago I heard a radio announcer interviewing a hundred-year-old man. The announcer asked the standard ridiculous question, "How long would you like to live?" But I have always loved the old man's answer: "I just want to live long enough to see how it all comes out." Well, here we have a periscope view around the corner of the future, and it looks good.

Some will say such a peaceable kingdom can never be. And Jesus warns that before the end there will be "wars and rumors of wars" (Matthew 24:6). But he also says mighty things will happen within our lifetimes (16:28). I am not very old, but I have seen some things take place in my own life that I would not have thought possible, for example, the wonderfully exciting new relationship between Protestants and Roman Catholics. When I was a boy we were desperately afraid of each other, and superstitions abounded. I could never have visualized that the day would come when I would stand side by side with a Roman priest, celebrating the Eucharist, but it has happened! I can promise you that greater things than the ecumenical movement are going on.

How can we achieve them? Only when we remember that we belong to another who is Shepherd over us all. We are the people of God (Ezekiel 34:30), the sheep of the Lord's pasture (verse 31). This is not original with Ezekiel; see also Psalms 100:3 and 95:7. If we follow some lesser leader, however noble, or (which is just as bad) if we follow our own noses, we will be led astray. But if we acknowledge the one Shepherd and live in utter obedience, then we can begin to experience the peaceable kingdom right now. Even that other driver, or that person in the twelve-item checkout line who has obviously got thirteen items, becomes a little less vicious in my eyes. Suddenly we are lost sheep together, and I know to whom we must turn.

Helping Adults Become Involved—Robert E. Luccock

Preparing to Teach

The prophet tells the exiled people that the shepherd (Jahweh, God) "will bring (the sheep) into their own land" (Verse 13). What good news for the

Israelites! They are going home! But it will not be "back to normalcy" or "business as usual." New expectations attach to old promises.

"Shepherd" was a familiar figure of speech for a ruler, in the biblical world of the Old Testament. Before Ezekiel's time, a shepherd was not primarily a kind, caring overseer of the flock. He was a ruler with absolute power over a flock of animals known to be comparatively stupid. One of the important things about chapter 34 is the image it gives of a new kind of shepherd (verses 11-16). As Horace Weaver points out, Ezekiel's metaphor of the shepherd is ancestor to the Good Shepherd passages of Matthew 18, Luke 15, and John 10.

One way to handle this lesson would be to consider the three central promises of chapter 34, using Dr. Weaver's "As You Read the Scripture" as a guide. Then go back to each of these promises and explore the situation to which they refer in Ezekiel's time and place. Finally, ask what meaning this scripture may have for us now.

Here is an outline of the lesson:

 I. God will judge the flock (verse 17).
 II. God will establish the rule of the royal servant,
 David (verses 23-24).
 III. God will make a covenant of peace with Israel
 (verse 25).

You will find newsprint and markers or a chalkboard useful today.

Introducing the Main Question

Pat McGeachy says, "We need to learn sheep-hood." Surely he puts us on. Who wants to be called a sheep? The point he makes, however, is that the shepherd and his sheep is a metaphor for God and the people of God. What need do we have for both the judgment and the blessings of chapter 34? Are we so unlike the people to whom the prophet addresses this chapter?

Try looking at your own situation in terms of the prophet's words. Think about parallels to these verses:

34:8—A judgment is rendered against shepherds. Sheep have become their prey, and shepherds have fed themselves.
34:18-19—A judgment is rendered against some of the sheep, who have fouled the pasture and the water.
34:21—Fat sheep shove and push the weak aside.
34:24—The monarchy of King David is proclaimed. Are there governments today whose inception comes from God? Is not our national motto "In God We Trust"? In what sense do we trust?
34:25—Are we now part of any covenants instituted by God? Look at Matthew 26:26-28. Is marriage a covenant?
34:26-31—Do we not find here an inspired picture of the kind of society where people enjoy the blessings of God?

Developing the Lesson

I. God will judge the flock (verse 17).

A wise person once remarked that any society can best be judged by how it treats the underdogs, that is, the weak, helpless ones at the bottom of the

social heap. Are nations and empires still on trial before this bar of judgment in the twentieth century after Christ?

II. God will establish the rule of the royal servant, David (verses 23-24).

We can scarcely imagine the impact this promise had on the Jewish exiles—to be told by the prophet that they were to return to Jerusalem and that a Davidic king would be restored to Israel! This revived the hopes of many years (for example, Isaiah 9).

We no longer look for a monarch who will establish God's reign on earth. Such a promise cannot be to us. We live in a secularized society. But all historical differences aside, reflect on the idea, "One shepherd who shall feed them and be their shepherd." Is that not still our hope? Lincoln voiced such hope in his address at Gettysburg: "This nation under God shall have a new birth of freedom." George Washington prayed after his first inauguration, "Almighty God, we make our earnest prayer . . . that the citizens entertain a brotherly affection and love for one another and for their fellow citizens."

Leaders today, no less than in Ezekiel's time, pursue their own interests at the expense of the people they have been chosen to lead. Fidelity to the tenets of justice, humanity, and integrity are needed today as much as ever.

III. God will make a covenant of peace with Israel (verse 25).

The list of favors promised in verses 25-30 contains some duplications. But by one count thirteen blessings are pledged by God in fulfillment of the covenant. It might be instructive to list these on newsprint or blackboard. You may wish to compare this list with what is promised in Isaiah 65:17-25. One way to bring this scripture into the present would be to have the class think about the human needs that lie beneath the promises of verses 25-30. Then measure our society at local, state, and national levels, both its public and private sectors, to see whether such blessings abound among us or are found wanting.

Helping Class Members Act

Using the list you have developed out of verses 25-30, the class could apply it to the church, the neighborhood, the workplace—wherever people stand in need. Would it not stimulate imagination to think of ways that individuals could become "undesignated shepherds"? That is, nonprofessional people can be agents of nurturance and leadership. For example, records are replete with stories of how neighbors have helped weaker people make their places a blessing (verse 26). We cannot make it rain, nor give anyone a "prosperous plantation." But a gift of faith made to someone living in fear and without hope might be the difference between life and death. Surely we ought to be able to communicate faith. Not that we make ourselves God; these are promises of *God,* not a social program. But as Paul put it, "God [is] making his appeal through us" (II Corinthians 5:20).

Planning for Next Sunday

Next week we shall study one of the most memorable Old Testament stories, the coming together of the dry bones in the valley (Ezekiel 37:1-4). One of the most celebrated black spirituals sings of the dry bones coming together. If you can find a recording of this spiritual, on either tape or disc, it might help enliven the study of Ezekiel's experience and words.

God Gives New Life

Background Scripture: Ezekiel 37:1-14

The Main Question—Pat McGeachy

We began our study of Ezekiel with a spiritual—"Ezekiel Saw the Wheel"—and we end with another: "Ezekiel Saw the Dry Bones." And this is appropriate because as those two songs were born in slavery, so also was the prophecy of Ezekiel, spoken to a captive people who believed that their hope was lost (Ezekiel 37:11). I think this must be my favorite passage in all the Bible. (I know, I say that about a lot of passages, but this time I really think I mean it.) It is a favorite because, as the Quakers say, "It speaks to my condition." I am a chronically depressed person (not a fatal disease, just a melancholy one), and it would do me good to read Ezekiel 37:1-14 every morning for my devotions, for I find it does two things for me: It gets right down there with me in the midst of my troubles and says, "No wonder you feel so bad!" In other words, it gives me permission to be depressed. But then it breathes on me the warm breath of hope and lifts me out of despair into life.

I hope that you are not depressed all the time; it isn't any fun. But everyone is depressed some of the time, and when you are, here is good medicine. Perhaps the main question of our time is, How can we regain our hope? The answer of Ezekiel 37 is not a worldly one—exercise, money, power, pleasure, pomp, diversion—but is rather from another country, a gift of the Spirit of God.

Jesus taught us that unless we are born of the water and the wind (John 3:5), we will continue in a state of spiritual drought. Christians captive to sin are like Israel in Babylon, and we need a word of hope. Ezekiel helps me answer the deep question: How can we be lifted out of darkness into light, out of despair into hope, out of a depression that prevents us from being able to function into a joy that gives life to muscle and sinew and sets us on the road to creative living?

As You Read the Scripture—Horace R. Weaver

Ezekiel is unique among Old Testament writers because he was willing to experiment with new images. Some examples are the prophet as a responsible watchman (3:16-21); the story of a waif in the woods (chapter 16); the story of the two sisters (chapter 23); the city of Jerusalem as a caldron (24:6-14); Tyre as a haughty, fallen mistress (chapter 26); Egypt as a monster (chapter 29); the useless vine (chapter 15); the good shepherd (chapter 34); and the beautiful life-giving river that flows under the throne of God (chapter 17).

We need also to be aware of the tremendous contributions Ezekiel made to the New Testament book of Revelation: The voice of Christ was "like the sound of many waters" (Revelation 1:15; 19:6); his feet were burnished bronze (1:15); the chariot-throne was like lapis lazuli, or jasper stone and

carnelian; there was a rainbow above the throne, like an emerald to look upon (4:3). And in the New Jerusalem was the presence of the living God, who no longer required a temple.

Ezekiel 37:1-14 relates the prophet's vision of the valley of dry bones. The dry bones symbolize the dark days when Babylonia conquered Israel and brought thousands of its best people to exile. After some twenty-two years of living with the exiles, the priest-prophet Ezekiel was still asking the question that many other exiles were asking: Can these bones (Israeli exiles) live? Will they ever become alive again as when in Jerusalem? The oracle promised the resurrection of the chosen people. When Ezekiel prophesied, the bones came together with a great clatter, and "wind" returned to the corpses, and they became a living host.

Ezekiel 37:1-6. "The hand of the Lord . . . brought me out by the Spirit . . . and set me down in the midst of the valley [plain]." Ezekiel is undergoing a tremendous spiritual/social/psychological experience. He is at a point where the purposes of God can break into history and give it a new direction.

Ezekiel, as one who was exiled by a horrible war, had witnessed the terrible consequences of losing the battle, leaving Jerusalem for the long trek to Babylon, he had seen the fallen bodies of thousands of his fellowmen. Now, in exile, after two decades, he returns via vivid memories and the Spirit to the red-stained battlefield.

Now Ezekiel sees the "very dry" bones and hears God ask him, "Son of man, can these bones live?" (verse 3). "Bones" refers not just to those Israelites who had died during the battle twenty years ago but to those who were exiled (and also to those still in Jerusalem). Ezekiel heard God say, "Behold, I will cause breath [or wind, spirit] to enter you, and you shall live" (verse 5). God's action made room for a tremendous change in their lives. But note also that God depended on a person who would be open to his purposes! Such a man was Ezekiel.

Verses 7-11. The chosen people (both exiles and those in Judah) were like the skeletons on the plain. They needed to experience the entrance of the Spirit into their lives. Those who have not experienced the coming of the Spirit into their lives are likened to the dead. Adam, though completely whole, did not come alive until he felt the Spirit (breath, wind) come into his life.

Verses 11-14. "Son of man, these bones are the whole house of Israel." "The whole house" includes both the northern kingdom (Israel) and the southern kingdom (Judah), who will ultimately be united.

Verses 12-13 suggest that God can do the impossible. How can God give new life? In this case the agent of new life is a prophet-priest named Ezekiel. God acts through persons who hold to hope.

Selected Scripture

King James Version	Revised Standard Version
Ezekiel 37:3-14	*Ezekiel 37:3-14*
3 And he said unto me, Son of man, can these bones live? And I answered, O Lord God, thou knowest.	3 And he said to me, "Son of man, can these bones live?" And I answered, "O Lord God, thou knowest." 4 Again he said to me,

4 Again he said unto me, Prophesy upon these bones, and say unto them, O ye dry bones, hear the word of the Lord.

5 Thus saith the Lord God unto these bones; Behold, I will cause breath to enter into you, and ye shall live:

6 And I will lay sinews upon you, and will bring up flesh upon you, and cover you with skin, and put breath in you, and ye shall live; and ye shall know that I *am* the Lord.

7 So I prophesied as I was commanded: and as I prophesied, there was a noise, and behold a shaking, and the bones came together, bone to his bone.

8 And when I beheld, lo, the sinews and the flesh came up upon them, and the skin covered them above: but *there* was no breath in them.

9 Then said he unto me, Prophesy unto the wind, prophesy, son of man, and say to the wind, Thus saith the Lord God; Come from the four winds, O breath, and breathe upon these slain, that they may live.

10 So I prophesied as he commanded me, and the breath came into them, and they lived, and stood upon their feet, an exceeding great army.

11 Then he said unto me, Son of man, these bones are the whole house of Ĭs-rā-ĕl: behold, they say, Our bones are dried, and our hope is lost: we are cut off for our parts.

12 Therefore prophesy and say unto them, Thus saith the Lord God; Behold, O my people, I will open your graves, and cause you to come up out of your graves, and bring you into the land of Ĭs-rā-ĕl.

13 And ye shall know that I *am* the Lord, when I have opened your graves, O my people, and brought you up out of your graves,

14 And shall put my spirit in you, and ye shall live, and I shall place you in your own land: then shall ye

"Prophesy to these bones, and say to them, O dry bones, hear the word of the Lord. 5 Thus says the Lord God to these bones: Behold, I will cause breath to enter you, and you shall live. 6 And I will lay sinews upon you, and will cause flesh to come upon you, and cover you with skin, and put breath in you, and you shall live; and you shall know that I am the Lord."

7 So I prophesied as I was commanded; and as I prophesied, there was a noise, and behold, a rattling; and the bones came together, bone to its bone. 8 And as I looked, there were sinews on them, and flesh had come upon them, and skin had covered them; but there was no breath in them. 9 Then he said to me, "Prophesy to the breath, prophesy, son of man, and say to the breath, Thus says the Lord God: Come from the four winds, O breath, and breathe upon these slain, that they may live." 10 So I prophesied as he commanded me, and the breath came into them, and they lived, and stood upon their feet, an exceedingly great host.

11 Then he said to me, "Son of man, these bones are the whole house of Israel. Behold, they say, 'Our bones are dried up, and our hope is lost; we are clean cut off.'" 12 Therefore prophesy, and say to them, Thus says the Lord God: "Behold, I will open your graves, and raise you from your graves, O my people; and I will bring you home into the land of Israel. 13 And you shall know that I am the Lord, when I open your graves, and raise you from your graves, O my people. 14 And I will put my Spirit within you, and you shall live, and I will place you in your own land; then you shall know that I, the Lord, have

know that I the Lord have spoken *it,* and performed *it,* saith the Lord.

spoken, and I have done it, says the Lord."

Key Verse: **[I] shall put my spirit in you, and ye shall live, and I shall place you in your own land. (Ezekiel 37:14)**

Key Verse: **I will put my Spirit within you, and you shall live, and I will place you in your own land. (Ezekiel 37:14)**

The Scripture and the Main Question—Pat McGeachy

Life's Deserts (Ezekiel 37:1-6)

The late Loren Eisley, a wonderful writer and a wise anthropologist, was not given to much optimism about life. But he said in one of his essays that if there is such a thing as a miracle, it has to do with water. And the opposite of that is, of course, dryness. Eisley spent much of his life picking through dry bones; it is the way of anthropologists. And it is also the way of honest psychologists, historians, and students of human nature. We learn the meaning of life by looking at dry places, much as a student of embryology learns how life normally develops by looking at abnormalities. And the gloomy vision of Ezekiel 37:1-6 is a sad picture indeed.

Note that the prophet is at pains to point out that the bones were *very* dry (verse 2). Nothing looks much more lifeless than dry bones. If you want to paint a picture of the dangers of the American West in the old pioneer days, be sure to draw in the skull of a dead longhorn. The skull is the sign of poisoned water and of death. So when the Lord asks Ezekiel, "Can these bones live?" the obvious answer of a practical scientific man is "Of course not!" How could there be life here in all this dehydrated calcium? If ever I saw death, this is it.

There are times when we all feel this way, such as when a loved one has died (especially in a tragic or seemingly meaningless way, such as being killed by a drunken driver), or when we have failed at something we really tried to accomplish. No doubt, even if you have not experienced pathological depression, you have known someone who has. You have seen an ordinarily jovial person with his or her face buried in hands, muttering that all is lost. When I think of gloom and despair, I think of a roomful of people I saw years ago. A wonderful young engaged couple had been courting and dreaming of the day when they could afford to get married. And the young man promised his bride to be that as soon as he finished building a house for them, they would be able to do it. But a week before the wedding, a carpenter's assistant on the job was overcome by carbon monoxide fumes from a running engine at the bottom of a well. The young man had himself lowered into the well, where he tied a rope around the unconscious man, who was pulled out and saved. But when they lowered the rope to the bridegroom, he had lapsed into unconsciousness, and he died before he could be pulled out. The whole community was transfixed with grief and anger, and I vividly remember the roomful of family members surrounding the weeping bride. Some well-meaning person attempted to cheer her by saying something like, "Well, we know it must have been God's will."

I wanted to shout in response, "No, no, never!" It is not the will of God that any of us should perish (Matthew 18:14; Ezekiel 18:32). And when we

are depressed, God hurts with us (Isaiah 53:4). God remembers that we are dried up (Psalm 103:14). Jesus weeps at our deaths (John 11:35). When someone is really down, like the young woman in my story, like Israel in Ezekiel's story, then at first we have to get down in the dry dust with them and say, as God says to us, "I know it hurts."

But then God asks the deeper question: "Is this the end?" "Son of man" (or as it might be rendered, "O human one"), "can these bones live?" "And Ezekiel seems about to say, "Of course not," but he remembers with whom he is talking, and so he hedges his answer, saying, "O Lord, you know." (Does this remind you of Peter?) And in response to this faltering faith, no larger than a grain of mustard seed (Matthew 17:20), God offers a promise of resurrection!

The Wind of God (37:7-10)

At this point we need to remember a curious thing about the words "wind," "breath," and "spirit." In both Hebrew (the language of the Old Testament) and Greek (the language of the New), the three words are identical! So, when Jesus said to Nicodemus (John 3:8), "the wind blows where it will . . . so it is with every one who is born of the Spirit of God," he was making a play on the words. This identity is apparent in a number of old uses. For instance, when a person died we used to say, "he gave up the ghost" (Matthew 27:50 KJV; the RSV says, "He breathed his last"). And all of us who have said the Apostles' Creed know that "Ghost" and "Spirit" are the same. When I was a boy, I remember how proud I was to be old enough to get rid of my velocipede, with its hard rubber tires, and get a bicycle, with what we use to call "pneumatic" tires. And you know about "pneumonia." Well, *pneumatos* is the Greek word that can be translated as "wind," "breath", or "spirit." (In some ways the Hebrew word *ru'ach* is even better, because it *sounds* like the wind. This word occurs in Genesis 1:2 and 2:7.)

And here in Ezekiel 37 the same word is used in all three senses. The God-given wind that blows from the north, south, east, and west (hence the four winds of verse 9) is also the God-given breath that provides new life for the slain host, and the God-given Spirit (verse 1) that brought Ezekiel to the valley and that will bring new hope to captive Israel (verse 14).

Now we can ask once more the question, How can we get this new breath of life? And the answer is that we cannot, any more than we can *get* the wind (John 3:8). The wind, even to a twentieth-century meteorologist, appears to know its own mind; it blows where it wills. And so it is with the Spirit of God. You can't conjure up God like Aladdin rubbing up his Arabian genie. There is no magical incantation that can *make* God move. But that does not mean that there is nothing we can do.

We can employ what our ancestors used to call the "means of grace." You can't, of course, get grace unless it is given; grace, by definition, is a gift. But prayer, Bible study, the sacraments, and the fellowship of the church are channels through which grace often comes, and by using them we put ourselves in the way most likely to find the holy wind blowing. As an old sailor, I like to think of the means of grace as setting my sails, so that when the wind does blow, as blow it will, I will be ready to catch it, or, better perhaps, for it to catch me and send my boat boiling on a reach close to the beam. If you have ever sailed, you will know how the boat, once "dead" in the water, seems to become a living thing when the wind at last rises.

The Promise of Life

We can set our sails with optimism because we have God's own promise, which cannot fail. Christians do not believe in the Greek notion of immortality, in which the soul, a sort of indestructible something, just goes on going on. We believe, rather, in resurrection. All souls die (Ezekiel 18:20) but the soul that is given to God "puts on immortality" (I Corinthians 15:54) and out of the buried seed (I Corinthians, 15:36; John 12:24) comes new life. God in Christ shares our death with us and invites us to share in Christ's resurrection (II Corinthians 4:14). So to my depressed self and to all who know what it means to feel hopeless and helpless, I offer the promise of Ezekiel: "I will put my Spirit within you, and you shall live."

I cannot conclude this look at the valley of the dry bones without inviting you to look, in closing, at the lovely vision of the never-ending waters that pour from the threshold of the temple in the mighty vision of Ezekiel 47:1-13. This same crystal river, which "flows from the throne of God," is depicted in the last chapter of the Bible, Revelation 22:1-2. Instead of an arid desert, we have here a vision of a tree-lined stream, a renewed Eden, where the tree of life grows (Genesis 2:9). That land too was once dry (Genesis 2:5), as are all lands and all hearts where the wind of God does not blow. But where faithful souls wait for the water and the wind (John 3:5), a stirring is felt, a wet warm breeze from a far country, bearing a delicious scent, whose name is hope.

Helping Adults Become Involved—Robert E. Luccock

Preparing to Teach

First, read Ezekiel 37:1-14 and Genesis 2:4-7 ("God breathed into his nostrils the breath of life"). Horace Weaver's "As You Read the Scripture" will help your understanding. The reading from Ezekiel marks one of the most important turning points for Old Testament Israel: the revival of the nation from apparent death. In its vivid recital of dry bones coming to life again through the breath of the Lord, the story never ceases to have meaning for the religious faith of Jews and Christians alike.

These fourteen verses divide naturally into a prelude, three scenes or themes, and a finale, a structure that may be used to outline the lesson:

 I. The question: "Can these bones live?" (verse 3)
 II. The bones come together (verses 7-10).
 III. The Lord raises Israel (verses 11-13).
 IV. "You shall live" (verse 14).

Introducing the Main Question

Dr. McGeachy introduces the main question by looking at the dry valley of our lives today. Let the class try to imagine some of the wasteplaces in which people pass their days. Consider: the Jews at Auschwitz, Indian-Americans plundered of their lands and culture, men and women no longer employable, people who suffer harassment, victims of lethal

disease—and all of us, when we become depressed! You will think of many more. Pat McGeachy points to Psalm 103:14: "God remembers that we are dried up."

We soon discover that neither Ezekiel nor the Lord "explains" the dry bones. What is offered is *breath* (the wind, God's Spirit), a way *out of the valley.* As Dr. McGeachy points out "wind" and "breath" are translations of the Hebrew word *ru'ach* and the Greek word *pneuma,* both meaning "spirit." The Lord responds to the main question in verse 14 with "I will put my spirit within you and you shall live."

One principal task of this lesson will be to stimulate the imagination of students to recognize where, when, and how people can receive the breath of God that gives life. Ask your students to discuss this.

Developing the Lesson

The drama of these fourteen verses will run from the bottom of a dry valley to one of the summits of biblical faith, from a question out of the heart of life (verse 3) to a proclamation of power to all people in the valleys of their existence (verse 14).

So that the lesson does not seem dry as the dust in that ancient valley, let us begin with the main question as it might be addressed to us. To that end, we will put out in front of us some of the valleys that dry up the bones of our lives. We all know some people who live in despair that life will never be any better. For many people unwelcome habits seem to have strangled their lives. It would be a strange place indeed whose population did not include more than one person forced into exile from home, for whatever reason. Let the class draw upon its own experiences and acquaintance with those whose lives are dried up. The dry bones of Israel represented the crushing of her national and religious hopes. The scene is now set, in Babylon and in our world.

I. The question: "Can these bones live?" (verse 3)

If we have been honest about dry bones, we will not find the question easy to answer. Ezekiel dared not give his own answer to the Lord. Have the class try this out for themselves. Is there anything more difficult to do than to talk with the person who is dried up? We can't say, "It's God's will." (Refer to Dr. McGeachy's story.) "Everything will surely work out for the best" somehow sticks in our throats. What would you say to the family of the young man who died in the well, or to the family of a victim of drunk driving? Perhaps the best we can reply to the main question will be words once spoken to Jesus, "I believe; help my unbelief" (Mark 9:24).

Now come the Lord's words to the prophet (verses 4-6). He is to speak words of hope; sinews, flesh, and skin are to gather on the bones once more, and breath will animate the restored flesh. In three words we perceive the heart of what the Lord says: flesh, breath, life. We need the flesh (the physical basis for life); we need animation from beyond our own flesh and social order (God's Spirit); we need confidence and hope nourished by faith ("with God all things are possible," Matthew 19:26).

II. The bones come together (verses 7-10).

The purpose of this story is to announce that the sinews and flesh of Israel's life as God's people are once again reanimated. The coming together of the bones is a token that God has not forsaken the covenant.

III. The Lord raises Israel (verses 11-13).

Israel has yet a life to live in obedience to God and in fulfillment of holy purpose. Even the devastation of the exile has not destroyed that promised life. God can breathe new hopes into life that seems abandoned.

IV. "You shall live" (verse 14).

Does Ezekiel here speak to us across the centuries? In our own dry valleys, do we yet have holy purposes to live for? Call to mind Joel's words (Joel 2:28-32), remembered by Peter at Pentecost (Acts 2:16-18).

What a glorious sweep these fourteen verses have, from a question the prophet dares not answer to the announcement of a promise that shall give hope to a defeated but resurrected nation for centuries to come. Are you surprised that anyone would call this his or her favorite passage in all the Bible?

Helping Class Members Act

The word "prophesy" sometimes means "to witness"—to declare the message we have received from God. The prophet did more than predict the future. He was one who spoke for God. Ask your students to discuss the opportunities we have to speak for God in our homes, in the workplace, in community life, and in the church. A good exercise with which to conclude this lesson might be for each class member to think of at least one place where he or she could speak for God, not in a pious vocabulary that might put people off but in hopeful words of encouragement, in sympathy, in supporting words of affirmation, in life-giving words of love.

Preparing for Next Sunday

Read Daniel 2. A historical atlas showing the empires of the Middle East from 600 B.C. on will be helpful. Read whatever you can find about dreams and how they can be explained.

UNIT II: DANIEL: THROUGH OPPRESSION TO VICTORY

Horace R. Weaver

THREE LESSONS OCTOBER 1–15

The unit "Daniel: Through Oppression to Victory" explores the apocalyptic hope of faithful Jews during the second century B.C. The writer of the book of Daniel seeks to help Jews in Judah to courageously maintain their faith and religious festivals regardless of what may happen to them. Facing the harsh demands of Antiochus Epiphanes, who outlawed the reading of the law (Torah), observances of all religious festivals (Day of Atonement, etc.), and the circumcision of sons, the writer of Daniel told six stories (chapters 1–6) and described several visions he had experienced (chapters 7–12).

Using the literary device of apocalyptic, the writer encouraged the Jews not only to be faithful and loyal but to accept a major conviction he espoused: that God is in full control of history. The writer of Daniel was convinced that he knew and could foretell the end-time, which he set at three and a half years from the date of the cessation of temple sacrifices. The "end" would actually be December 165 B.C., when the temple was freed of its "abomination of desolation."

The lessons in Unit II deal with the following: "Looking Toward the Future," October 1, assures the faithful that history is in the hands of God; "Deliverance of God's People," October 8, discusses Ezekiel's faith that God will deliver his people from the cruelty of Antiochus Epiphanes; "God Gives Victory," October 15, reviews Ezekiel's assurances to the faithful that the kingdom of God is at hand.

Prophetic and Apocalyptic Literature

LYNN DEMING

Most earlier scholarship focused on the differences between prophecy and apocalyptic. Current scholarship, however, emphasizes the similarities between these two types of Old Testament literature and the continuity of the two traditions.

In order to understand the relationship between prophecy and apocalyptic, we must first understand the meaning of each type of literature. In a general sense, prophecy can be defined as an outlook that interprets everything that happens in the historical realm in terms of divine will. In a more specific sense, prophecy is the work of the many prophets that appear in the Old Testament, from Moses to Malachi. Prophetic literature in the Old Testament is generally divided into two parts: pre-exilic prophecy (represented by Amos, Hosea, Isaiah, and others) and post-exilic prophecy (represented by such prophets as Haggai, Zechariah, Jeremiah, and Ezekiel).

When the Old Testament canon was collected, the historical books (Joshua through II Kings) were called the former prophets because of the

emphasis in those books on prophecy and the prophetic view that God controls the events of history. The books we think of as prophetic literature were called the latter prophets.

Apocalyptic is a system of thought that emphasizes various kinds of theological dualism, such as good and evil, or present and future. Apocalyptic literature is characterized by numerical symbols, the presence of angels and other supernatural beings, messianic allusions, and a focus on the future age when this current world will be replaced by a totally new order. Evidence of apocalypticism can be found in various places in the Old Testament, such as the book of Daniel and some of the later prophetic literature (Zechariah, for example). In the New Testament, apocalyptic traditions can be seen mainly in the book of Revelation.

Commentators who focus on the discontinuity between prophecy and apocalyptic usually make at least some of the following distinctions.

1. The end of time: Apocalyptic literature emphasizes a contest between the forces of good (God) and evil (Satan). Prophetic literature focuses on God and the extent to which God will judge the actions of human beings.

2. View of the future: Apocalyptic literature emphasizes that this world will be replaced by another. Events taking place in the present will be made insignificant by the coming of another age at some definite time in the future. Prophetic literature sees more importance in events now taking place, because they can influence the extent of judgment in the future.

3. Attitude toward the future: Apocalyptic literature is basically pessimistic about what will happen at the end of time. There is no escaping the destruction of the world that exists now. Prophetic literature holds some optimism for a hopeful future for the people, if they obey God's will in the present. For the most part, the prophets believed that God's judgment was not irrevocable.

Earlier scholarship maintained that apocalypticism was a late phenomenon in the history of Israel, a kind of intruder into the already established religious thought of the Hebrews. They saw apocalyptic as an outgrowth of Persian dualism, which was influential much later than the time when most prophetic literature originated. If Persian dualism was the major force behind the apocalyptic movement, that would place apocalypticism in the second century B.C.

More recently some scholars have seen that the apocalyptic movement probably had its roots not in Persian dualism but in pre-exilic prophecy itself. Several factors make this view plausible.

1. Both prophetic and apocalyptic literature often use the same older traditions in their material. The difference is that apocalyptic writers interpreted these earlier traditions more literally than did the prophetic writers. For example, traces of the apocalyptic world view can be found in the latter portions of the book of Isaiah. The prophet speaks of God as the first and the last, using the formula "I am He." This formula has its roots in earlier covenant theology, and its variations can be found in such historical traditions as the Ten Commandments (see Exodus 20:2). This formula is also used in the book of Revelation (see Revelation 1:17; 2:8). It is possible that both the prophet and the apocalyptic writer borrowed this formula from an earlier historical tradition.

2. Often the characters portrayed within apocalyptic literature see themselves as standing in the prophetic tradition. For example, Daniel introduces his vision in chapter 8 with words similar to those the prophets

used to introduce their visions (see Daniel 8:1-2). Also, in the tenth chapter of the book of Daniel, Daniel describes an event that is reminiscent of the prophet Isaiah's call (see Isaiah 6). An angel-like being touches Daniel's lips, allowing him to speak (see Daniel 10:15-17).

3. Apocalypticism emerged from the post-exilic community in Israel, which was struggling to find its identity. The tendency was to find identity in past traditions, such as the prophetic movement and the words of the prophets who were its main spokesmen.

Recent scholarship has emphasized that there is more continuity between apocalyptic and early prophetic traditions than there is between apocalyptic and foreign influences such as Persian dualism. In fact, the influence of the apocalyptic world view on Israelite theology and faith would seem to be considerable. In that case, it would make sense that such an important phenomenon would have its primary roots in earlier prophetic traditions that also profoundly affected Israelite life and faith.

LESSON 5 OCTOBER 1

Looking Toward the Future

Background Scripture: Daniel 2

The Main Question—Pat McGeachy

Do you keep track of your dreams? I once dreamed that I was running down a long dark tunnel, pursued by a strange and terrible beast. That was long ago, but I can still feel the terror when I think of that nightmare. Like Nebuchadnezzar, I wonder what it means.

The story of Daniel is set, like the prophecy of Ezekiel, in a time of Israel's nightmare. Indeed, it is hard to find a Bible passage that does *not* belong to such a period, for they were always, it seems, under the thumb of some captor: Egypt, Assyria, Babylon, Persia, Greece, or Rome. And for that very reason, the Bible speaks to us, for we too are captives. Current crises oppress us, as do today's moral and social conditions. The world seems out of control, and we long for relief from the tyranny and injustice around us and the evil within us. What will become of us?

In the midst of our nightmare comes Daniel, an interpreter of dreams. Like Nebuchadnezzar, we do not need to tell him about our dreams' contents, because he knows our hearts: Our dreams of grandeur have feet of clay, and our fears will come to naught. The name Daniel means, in Hebrew, "God is Judge." We can be certain that the Lord of history will do what is right. If we, like Nebuchadnezzar, lust for power, we can expect to fall. But if we, like Daniel and his furnace-famous friends Shadrach, Meshach, and Abednego, trust in and stand up for truth and justice, we can expect to survive.

The main question in this lesson for us is, For what do we dream? As I awoke in a great sweat from *my* nightmare, I saw clearly that the tunnel was my own viscera. The beast was within me; I had nothing to fear but my own self-destructive desires. We know that God's kingdom will triumph, no matter what happens. The question for us is, Do we choose greed or obedience, to lose with Nebuchadnezzar or to prevail with Daniel?

As You Read the Scripture—Horace R. Weaver

Behind Daniel 2 lies an ancient theory of world ages. One theory was cyclic: The world began with a golden age, and each succeeding age was worse than the preceding, until things were so bad the deity had to intervene and start the cycle all over again. There were four stages, according to Hindus, Buddhists, Zoroastrians, and the Greeks. Hesiod symbolized the four stages by referring to metals: gold, silver, brass, and iron. The four world powers of this chapter fit into this well-known scheme of world history.

The usual scheme for four stages included the Assyrians, the Medes, the Persians, and the Greeks. The writer of Daniel uses the following: the neo-Babylonians (replacing the Assyrians noted above), the Medes, the Persians, and the Greeks. The Greeks (under Alexander the Great) caused so much resentment that a fifth stage was considered inevitable—an Oriental empire. The writer of Daniel did not include the yearning of the Orientals. But he did include a fifth kingdom—the coming of the kingdom of God, and with it the end of all other (and future) kingdoms. The Lord God will be King of kings and Lord of lords. His kingdom will be everlasting.

Daniel 2:1-30. The writer of the story tells of Nebuchadnezzar the Babylonian king's dream of a huge statue ("image"). Quite in harmony with the times, the king seeks an interpretation of the dream. He orders the "corps of wise men" to not only interpret the dream but to tell him what his dream was. (Some have thought that he had forgotten his dream; others that he wanted to test his corps of wise men, which included magicians, enchanters, sorcerers, and Chaldeans. Note how the writer purposely omits reference to Daniel and his three friends, whose great wisdom had been demonstrated earlier.

The Chaldeans (representing the corps) state, "Not a man on earth . . . can show it to the king except the gods" (verses 10-12). Then Daniel and his three friends save the lives of the whole corps of wise men, including themselves! They pray to God, and God grants Daniel a vision in which he is given the interpretation. Daniel eventually faces the king and declares that only the "God in heaven" can reveal mysteries—and God has revealed "what will be in the latter days."

Verses 31-35. Daniel describes the image the king has seen, with "the head of . . . fine gold (symbolizing Nebuchadnezzar, the neo-Babylonian king); its breast and arms of silver (symbolizing Media); its belly and thighs of bronze, a mixture of copper and tin (symbolizing the Persians, led by Cyrus the Great); its legs of iron; its feet partly of iron and clay or tile (symbolizing Alexander the Great and the latter Greek rulers Ptolemy and the Selucids).

As Daniel describes the figure of the huge man (illustrating the philosophy of history of that day), he then refers to a stone quarried "not by

human hands," which smote the image on its feet of iron and clay. And immediately all the metals—the gold, the silver, the bronze, the iron—and the tile were "broken in pieces" and atomized, so that "not a trace of them could be found" (verse 35). The stone "became a great mountain" by enlarging itself until it became the whole earth. This mountain, though still encircled by the oceans and covered by the heavens above, symbolizes the universality of the kingdom of God.

Verses 36-44. Having told the king his dream, Daniel and his three friends say they "will tell the king its interpretation." This includes informing the king that he is "king of kings" because God has given him that position, "making him rule over all."

Note how the Gospel of Matthew picks up Daniel's words in the concluding phrase of the Lord's Prayer: "For thine is the kingdom, and the power, and the glory" (verse 37).

Daniel then tells the king that he is the head of gold (in the image) and that eventually all four kingdoms will be replaced by the kingdom of God. "A great God has made known to the king what shall be hereafter. The dream is certain, and its interpretation sure" (verse 45).

King Nebuchadnezzar then did homage to Daniel and honored him and his three friends with places of authority.

Selected Scripture

King James Version

Daniel 2:31-36, 39-44

31 Thou, O king, sawest, and beheld a great image. This great image, whose brightness *was* excellent, stood before thee; and the form thereof *was* terrible.

32 This image's head *was* of fine gold, his breast and his arms of silver, his belly and his thighs of brass,

33 His legs of iron, his feet part of iron and part of clay.

34 Thou sawest till that a stone was cut out without hands, which smote the image upon his feet *that were* of iron and clay, and brake them to pieces.

35 Then was the iron, the clay, the brass, the silver and the gold, broken to pieces together, and became like the chaff of the summer threshingfloors; and the wind carried them away, that no place was found for them: and the stone that smote the image became a great mountain, and filled the whole earth.

Revised Standard Version

Daniel 2:31-36, 39-44

31 "You saw, O king, and behold, a great image. This image, mighty and of exceeding brightness, stood before you, and its appearance was frightening. 32 The head of this image was of fine gold, its breast and arms of silver, its belly and thighs of bronze, 33 its legs of iron, its feet partly of iron and partly of clay. 34 As you looked, a stone was cut out by no human hand, and it smote the image on its feet of iron and clay, and broke them in pieces; 35 then the iron, the clay, the bronze, the silver, and the gold, all together were broken in pieces, and became like the chaff of the summer threshing floors; and the wind carried them away, so that not a trace of them could be found. But the stone that struck the image became a great mountain and filled the whole earth.

36 This *is* the dream; and we will tell the interpretation thereof before the king.

...

39 And after thee shall arise another kingdom inferior to thee, and another third kingdom of brass, which shall bear rule over all the earth.

40 And the fourth kingdom shall be strong as iron: forasmuch as iron breaketh in pieces and subdueth all *things:* and as iron that breaketh all these, shall it break in pieces and bruise.

41 And whereas thou sawest the feet and toes, part of potters' clay, and part of iron, the kingdom shall be divided; but there shall be in it of the strength of the iron, forasmuch as thou sawest the iron mixed with miry clay.

42 And *as* the toes of the feet *were* part of iron, and part of clay, *so* the kingdom shall be partly strong, and partly broken.

43 And whereas thou sawest iron mixed with miry clay, they shall mingle themselves with the seed of men: but they shall not cleave one to another, even as iron is not mixed with clay.

44 And in the days of these kings shall the God of heaven set up a kingdom, which shall never be destroyed; and the kingdom shall not be left to other people, but it shall break in pieces and consume all these kingdoms, and it shall stand for ever.

Key Verse: **The God of heaven [shall] set up a kingdom . . . which . . . shall stand for ever. (Daniel 2:44)**

36 "This was the dream; now we will tell the king its interpretation."

...

39 "After you shall arise another kingdom inferior to you, and yet a third kingdom of bronze, which shall rule over all the earth. 40 And there shall be a fourth kingdom, strong as iron, because iron breaks to pieces and shatters all things; and like iron which crushes, it shall break and crush all these. 41 And as you saw the feet and toes partly of potter's clay and partly of iron, it shall be a divided kingdom; but some of the firmness of iron shall be in it, just as you saw iron mixed with the miry clay. 42 And as the toes of the feet were partly iron and partly clay, so the kingdom shall be partly strong and partly brittle. 43 As you saw the iron mixed with miry clay, so they will mix with one another in marriage, but they will not hold together, just as iron does not mix with clay. 44 And in the days of those kings the God of heaven will set up a kingdom which shall never be destroyed, nor shall its sovereignty be left to another people. It shall break in pieces all these kingdoms and bring them to an end, and it shall stand for ever."

Key Verse: **The God of heaven will set up a kingdom which . . . shall stand for ever. (Daniel 2:44)**

The Scripture and the Main Question—Pat McGeachy

A Tyrant's Nightmare (Daniel 2:1-11)

Ancient peoples thought of their dreams as prophetic messages from God. So today, psychologists tell us that our dreams have messages for us. In

dreams we are free from all restraint and can get in touch with the dark dreads and deep longings that lie within our subconscious. To face up to the evil within us is to be able to do something about it. To be honest about our desires is the first step in being able to bring them to reality.

I don't know about you, but I have a lot of sympathy for Nebuchadnezzar. I think that if I were king of Babylon, I would have nightmares too. (In fact, I *am* king of my own private Babylon, and I do sometimes have them.) The king summoned his wizards (verse 2—"Chaldeans" simply means "Babylonians"; the priests of Babylon were famous for their astrology). He demanded that they help him understand his nightmares, but he refused to tell them what the dreams were about. He said that this was to test whether they were real magicians or false (verse 9). In this he was like everyone who goes to a psychiatrist: We want help, but we don't really want to reveal what is deepest within us. If a counselor is to help us (or if we are to help ourselves), we must come clean.

An Interpreter Is Found (2:12-14)

Belteshazzar (better known to us by his Hebrew name, Daniel; see 1:7) and his friends Hananiah, Mishael, and Azariah (better known as Shadrach, Meshach, and Abednego), had risen to positions of respect under their Babylonian captors. Their rise to power makes us think of another Hebrew slave, himself an interpreter of dreams, who rose to power in Egypt (see Genesis 39–41). Like Joseph, Daniel and his friends kept their faith, even though they were strangers in a strange land. Because of this, Daniel, unlike the false magicians of Chaldea, was in touch with God and understood, as one who knows God's will, the meaning of the human heart.

He too had a dream (verse 19), a genuine night vision, and for him, instead of being a nightmare full of terror, it was a vision of hope and confidence. His response was to sing a joyful prayer (verses 20-23), thanking God for the truth made known in the night. There are two possible reactions to dreams: to fear them and be filled with terror, or to welcome them as containing truth for us. When I have confidence in God, I can fearlessly face the voices that speak to me in the night, knowing that God will help me to understand them. God gives us wisdom and understanding (verse 21) and reveals deep and mysterious things (verse 22), for God knows what is in the darkness (see Psalm 139:12). Perfect love casts out fear (I John 4:18), and perfect trust in God enables us to look fully into the dark places of the human soul and emerge with understanding.

Courage, Compassion, and Humility (2:24-30)

Armed with his insight, Daniel courageously made known his willingness to confront the king. He requested that the king pardon his false wise men (verse 24) and be willing to confront the truth. This Daniel did not to enhance his own glory or to claim any special wisdom for himself (verse 30), but to glorify God and to make God known to this pagan ruler (verse 28).

The Dream Interpreted (2:31-44)

There are usually many explanations for dreams. Nebuchadnezzar's dream tells him something about himself and something about the future.

As for the future, it is clear that the king can expect to be succeeded by others, not as worthy as himself. Many attempts have been made to assign the various parts of the dream image to specific earthly kingdoms. One such interpretation would be this (Daniel 11:1-12; refer to *The Oxford Annotated Bible*, pp. 1084-86):

> The feet of clay: the breakup of Alexander's empire
> The golden head: Babylon
> The silver breast: Media
> The bronze midsection: Persia
> The iron legs: the Ptolemies and Seleucids
> The feet of clay: the breakup of Alexander's empire

The reader can divide up these kingdoms to fit the history that follows Nebuchadnezzar, but however they are spelled out, one central fact remains: Earthly empires have feet of clay. Another power (see verse 44), the kingdom of God, will have ultimate victory over the world. Any earthly emperor (or person of prominence and authority) had better learn not to take himself or herself too seriously.

It is worth remembering here the vision that the poet Shelley had of Ozymandius (Rameses II, the pharaoh who oppressed the children of Israel). The poem describes his broken statue in the desert, with its fallen pedestal that says:

> My name is Ozymandius, king of kings:
> Look on my works, ye Mighty, and despair!

But the poem concludes:

> Nothing beside remains. Round the decay
> Of that colossal wreck, boundless and bare
> The lone and level sands stretch far away.

No matter how important despots may seem, in the end they fall. Gandhi, the guru of India, took hope from this fact. Whenever he was discouraged, he would remember that not one tyrant in human history has ever survived.

So if you are a Daniel, or, like all of us, a person oppressed by life in some way, take comfort from the certainty that your particular Babylon will fall (see Revelation 19:2). But there is another King, one who will ultimately triumph, in whom we can put our trust. The vision of Daniel's interpretation reaches far into the future and presages the coming of the King of kings, Jesus Christ (see Revelation 19:6, 11-16). Over all earthly kings he is the victor, and in him is our hope.

If, on the other hand, you are a Nebuchadnezzar, I've got bad news for you! You are doomed, as are all tyrants. The only hope for you is to fall on your knees before God and in humility seek to serve the High King over all earthly rulers. Does this mean that no human being of importance will prevail? Well, in one sense, yes. See what Jesus says about earthly authority in Matthew 19:30; 20:16, 26. In another sense, what the dream of Nebuchadnezzar tells us is that the only greatness that can hope to survive is that which is devoted to the service of God and God's people (John 14:12).

We have, then, good news and bad. For the disturbed, this is a comforting dream. For the comfortable (if those in power can ever really be comfortable), it is a disturbing prophecy. It makes me think of the old hymn of Arthur Coxe:

> O where are kings and empires now
> Of old that went and came?
> But, Lord, thy Church is praying yet,
> A thousand years the same.
>
> Unshaken as eternal hills,
> Immovable she stands,
> A mountain that shall fill the earth,
> A house not made with hands.
> ("O Where Are Kings and Empires Now")

The King's Repentance (2:46-48)

You have to give old Nebuchadnezzar credit: He did try to shape up. He fell down on his face before Daniel, for he recognized the truth in the interpretation. And this is the first step. It is common for most of us, when the true meaning of our dreams is made known and the truth of our deep sin is brought to the light, to deny it. It is hard to face the fact that we have feet of clay. I don't want to admit that I am an alcoholic, or that I am really jealous of my wife or husband, or prejudiced, or prideful. But to look at such things, however nightmarish they may be, is to take the first step in overcoming them. It is dangerous to deny the tumor for fear of the surgeon's knife (see Matthew 5:29-30).

Nebuchadnezzar made good beginnings but did not go far enough. In the end his tyrannical ambitions drove him crazy, and he went out and ate grass (Daniel 4:33). But for those who truly fear God's name (see Malachi 4:2) there is hope. We can face the future with confidence. Our nightmares cannot overcome us, for God's eternal dream will come true.

Helping Adults Become Involved—Robert E. Luccock

Preparing to Teach

Today we shall talk about dreams, and we shall discover surprising parallels between the mood of many people today and that which Daniel faced.

Spend some time before the class meeting thinking about dreams—your own and others you have heard about. Write down one or two of your dreams; see if you can understand what they may have meant.

Looking at your Bible atlas or historical classroom maps, you will see how four great empires ruled the Middle East in succession from 605–167 B.C. This will help you understand Daniel's interpretation of Nebuchadnezzar's dream.

Try to imagine being a faithful Jew early in the second century B.C.—surrounded by a pagan culture, suppressed by cruel tyrants, even your language and religious life eroding away! But how many people today face situations not unlike those the Jews faced in Daniel's time. Consider the

enormous power of evil rampant in the world, the widespread social discouragement, the shattering moral chaos, and the mood of hopelessness about the future.

Here is an outline of the lesson:

 I. What do dreams tell us about ourselves?
 II. The mood that grips many people today
 III. The historical context of Daniel's story
 IV. Daniel interprets Nebuchadnezzar's dream.

Introducing the Main Question

The story in Daniel 2 hinges on the interpretation of a dream. Before we talk about that dream, let's look at our own dreams. What do your dreams tell you about yourself, your fears, your faith? It is hard to interpret our own dreams, as Nebuchadnezzar discovered. But upon reflection we may learn from our dreams some things about our fears and our ambitions.

You may find that a discussion of dreams will become the main topic on the agenda today—where they come from and what they mean. Try to guide the discussion so the class will not overlook that most dreams have a dark side, which seems to come from fears. We can acknowledge this dark side of ourselves, embrace it as being part of who we are, and understand God speaking a word of promise and reassurance even through dark events.

Developing the Lesson

I. What do dreams tell us about ourselves?
(Refer to "The Main Question.") People tend to dream about things that disturb their souls, even when the disturbance has been repressed. Your purpose in this lesson is not dream analysis for its own sake (few of us are competent to do that) but to feel as much as possible how Nebuchadnezzar felt and to see how dreams reflect our common fears, anger, disappointments, and ambitions. What did the king's dream reveal about himself?

II. The mood that grips many people today
To take a sample of how people feel, on the street, in the neighborhood, in the workplace, in church, or to sample dreams as we have done here, would turn up many happy people who are content with the way things are. But you would also come across discouraged people whose lives seem like one-way dead end streets. You would find frightened people worried about crime, drugs, and violence on every hand. Would you not discover people appalled at our descent into a kind of moral chaos, and the shadow of nuclear winter? Churches, synagogues, and religion in general are seemingly powerless to change any of it! Do any of these fears trouble *our* dreams? Remember, the fears will probably come disguised as images. We don't dream in intellectual or social generalities.

Many faithful Jews in Daniel's time must have been in despair too, over the depredations of Antiochus Epiphanes, who desecrated the holy temple in 167 B.C. by slaughtering a pig on the altar. It was to this despair that Daniel addressed his prophecy.

III. The historical context of Daniel's story

Daniel is both a *midrash*, a collection of stories told to express religious truth (as Jesus did with his parables), and apocalyptic, a work written to announce God's coming to inaugurate a new age. Daniel wrote the book to encourage the Jews passing through the time of troubles under Antiochus in the second century B.C. He set his stories back four hundred years to the time of the Babylonian exile when Nebuchadnezzar was king (605–562 B.C.). Daniel describes this king as the epitome of the harsh rulers who have tyrannized Israel.

IV. Daniel interprets Nebuchadnezzar's dream.

The Chaldeans, a priestly class of Babylonians who had studied mathematics, astrology, and magic, were unable to decipher the king's dream. At this point Daniel intervenes, offering to explain the dream himself. Present Dr. Weaver's analysis of this from his exegesis. Daniel had two things going for him: He trusted God to instruct him in what to say and do, and he had a keen intuition as to what the king feared and what would have naturally troubled his sleep. Daniel told the king how it would be with future empires. In the image he saw in his dream Nebuchadnezzar was symbolized by the head of gold (2:38). The shoulders of silver symbolized the Medes, who ruled for a brief time. The belly of bronze symbolized the Persian empire (2:39). In succession would come a fourth kingdom, as strong as iron (2:42). Daniel had the hindsight of four hundred years of history, knowing that Cyrus of Persia and Alexander the Great would succeed the Babylonian and Median empire.

Now comes Daniel's apocalyptic proclamation of a kingdom that shall never be destroyed (2:44). Nebuchadnezzar was satisfied because he heard himself called the "head of gold." The Jews were encouraged because they heard God promise them a kingdom upheld by God. Are we not to hear these stories as good news for us also? Else why should we bother to read Daniel at all?

Helping Class Members Act

What can we as men and women do in all of this? God alone delivers on apocalyptic promises! But there is something people can do besides wait in faith. Elie Wiesel, Nobel Prize winner and survivor of Auschwitz, once wrote about memory:

> When you're optimistic, you remember your less happy times and you become cautiously pessimistic. When you're pessimistic you remember the happy times and you become cautiously optimistic. Memory is life's great balancer. The choice we really have is between being a smiling pessimist or a weeping optimist. There are no absolutes in life. (*Boston Sunday Globe*, Feb. 7, 1981)

Faithful Christians in our times are called to be weeping optimists. We weep (with Jeremiah) for the "slain daughter of God's people." But we hope in the God who promises a kingdom that shall stand forever. Recall how Lowell finishes one stanza in his hymn "Once to Every Man and Nation": "standeth God within the shadow / keeping watch above his own."

Planning for Next Sunday

Reread chapter 2, then read Daniel 7, comparing the two. A historical atlas of the Bible will help you to visualize the history behind this chapter.

Deliverance of God's People

Background Scripture: Daniel 7

The Main Question—Pat McGeachy

It's one thing to remind ourselves, as we did in the last lesson, that all tyrants fall, but it's quite another to know how to deal with the frightening political realities around us. Those of us who have grown up in the United States during the last few decades have been a privileged people. We have been part of the most powerful country in the world. Unlike Israel under Babylon, or Afghanistan under the Soviet Union, we have been the top dog, not the underdog. But the majority of the world's people are powerless before the forces of history. And even here in this country, there are many who feel cut off from decision making.

On an individual basis, most of us have known times when we feel utterly helpless. Perhaps during a great grief, or the loss of a job, or a failure in school, or a personal moral or emotional problem, we have felt with Wordsworth that "the world is too much with us." And the world talks such a good game (see Daniel 7:8)! It is hard not to fall for its propaganda.

When such times come, we need a vision of hope. We need to behold God on the throne, the Ancient of Days (verse 9), restoring history to its rightful meaning and giving us hope. And we need to think that a human one (a son of man, verse 13) who understands our condition and yet has the power to overcome it is available for our help. The main question of Daniel 7 is, Is there any escape from the course of history? That course seems, to many of us, to be rolling like a juggernaut to doom and destruction. But the promise of this prophecy and of Daniel's dream is, for us Christians, a messianic one: A Savior is promised. Deliverance *is* possible. Can we believe that? Can we seize upon it for hope and strength? And, what is perhaps more important, can we act on that belief by living responsible, meaningful lives?

As You Read the Scripture—Horace R. Weaver

In Daniel 2, Daniel had interpreted dreams and visions. In chapter 7, Daniel, still in Babylonia, experiences the dreams and visions himself. He then must interpret his own dreams.

In the first six chapters, Daniel writes stories of pious Jews who are loyal, even unto possible death. In chapters 7–12 he writes of his visions, which declare that the end of persecution is near at hand—in fact, that in three and a half years ("time, two times and half a time") God will intervene in behalf of the Jews and destroy the Babylonian Empire.

The persecuted Jews are to take courage from Daniel's revelation. They are living now in the last age that precedes the coming of the kingdom of God. There the "saints" will reign and no longer suffer or be in subjection—in fact, their enemies will serve the Jews!

In his vision Daniel saw "four great beasts [come] up out of the sea, different from one another." Verses 7:3-7 describe the four animals: The

55

first was like a lion and had (two) eagles' wings; the second like a bear, holding three ribs in its mouth; the third like a leopard with four bird wings on its back and four heads. The fourth was a beast "terrible and dreadful and exceedingly strong; and it had great iron teeth."

Scholars call attention to the numerology: two wings, three ribs, four wings of a bird and four heads, ten horns.

Daniel 7:19-20. Daniel "desired to know the truth." The kings represent, as in Daniel 2, the four major empires: Babylonia, Media, Persia, and Greece (especially under the Seleucid [Greek] King Antiochus Epiphanes). The "ten horns" represent the ten political leaders that succeeded Alexander the Great. This "beast" with its ten horns had "teeth of iron and claws of bronze." It symbolized Antiochus Epiphanes, who sought to destroy all Jews who were loyal to their Hebrew faith. It is very helpful, if not essential, in understanding this passage to read I Maccabees 1:24-52 and 2:7-13, and II Maccabees 5:21-27. Review the last session from Daniel 2.

Verse 13. In Daniel's vision he saw the "Ancient of Days" (God), and was "presented" to the deity. Daniel witnessed the heavenly assize; the judgment of men and nations was in process. A million "served" (that is, attended to his legal and personal needs) while "ten thousand times ten thousand stood before him" to be judged. The "books were opened."

Verses 22-24. Antiochus Epiphanes, the Greek ruler over Palestine, ravaged the Jewish faithful.

Verse 24 refers to the ten-horned beast (Antiochus IV) who was different from (that is, the most despicable of) all other kings. He "shall put down three kings" probably refers to his defeat of Artaxias of Armenia and Ptolemy VI and VII of Egypt.

Verses 25-28. "He shall speak out against the Most High"; this refers to Antiochus Epiphanes' oppression of the Jews: He ridiculed their religious festivals and denied them the right to read the Torah, to put the mark of Abraham on their sons (circumcision), or to serve (worship) God in the traditional ways.

Daniel declares the end to be at hand and tells the Jews to hold to their faith. God will save and bless the faithful. This good news of the end came in 168 B.C. and was promised to be fulfilled in "a time, two times, and half a time"—three and a half years or 165 B.C. The loyal shall receive the kingdom of God! The "end" arrived in December 165 B.C. when Judas Maccabee, having won the wars against Antiochus Epiphanes, purified and dedicated the temple. The kingdom of God was not won by Judas Maccabee but was given by God to the deity's local servants. As Daniel wrote, "Here is the end of the matter."

Selected Scripture

King James Version	Revised Standard Version
Daniel 7:13, 21-27	*Daniel 7:13, 21-27*
13 I saw in the night visions, and, behold, *one* like the Son of man came with the clouds of heaven, and came to the Ancient of days, and they brought him near before him.	13 I saw in the night visions. and behold, with the clouds of heaven there came one like a son of man. and he came to the Ancient of Days and was presented before him.

21 I beheld, and the same horn made war with the saints, and prevailed against them;

22 Until the Ancient of days came, and judgment was given to the saints of the most High; and the time came that the saints possessed the kingdom.

23 Thus he said, The fourth beast shall be the fourth kingdom upon earth, which shall be diverse from all kingdoms, and shall devour the whole earth, and shall tread it down, and break it in pieces.

24 And the ten horns out of this kingdom *are* ten kings *that* shall arise: and another shall rise after them; and he shall be diverse from the first, and he shall subdue three kings.

25 And he shall speak *great* words against the most High, and shall wear out the saints of the most High, and think to change times and laws: and they shall be given into his hand until a time and times and the dividing of time.

26 But the judgment shall sit, and they shall take away his dominion, to consume and to destroy *it* unto the end.

27 And the kingdom and dominion, and the greatness of the kingdom under the whole heaven, shall be given to the people of the saints of the most High, whose kingdom *is* an everlasting kingdom, and all dominions shall serve and obey him.

21 As I looked, this horn made war with the saints, and prevailed over them, 22 until the Ancient of Days came, and judgment was given for the saints of the Most High, and the time came when the saints received the kingdom.

23 "Thus he said: 'As for the fourth beast,
there shall be a fourth kingdom on earth,
which shall be different from all the kingdoms,
and it shall devour the whole earth,
and trample it down, and break it to pieces.

24 As for the ten horns,
out of this kingdom
ten kings shall arise,
and another shall arise after them;
he shall be different from the former ones,
and shall put down three kings.

25 He shall speak words against the Most High,
and shall wear out the saints of the Most High,
and shall think to change the times and the law;
and they shall be given into his hand
for a time, two times, and half a time.

26 But the court shall sit in judgment,
and his dominion shall be taken away,
to be consumed and destroyed to the end.

27 And the kingdom and the dominion
and the greatness of the kingdoms under the whole heaven
shall be given to the people of the saints of the Most High;

> their kingdom shall be an ever-
> lasting kingdom,
> and all dominions shall serve
> and obey them.'"

Key Verse: **The Ancient of days came, and judgment was given to the saints of the most High. (Daniel 7:22)**

Key Verse: **The Ancient of days came, and judgment was given for the saints of the most high. (Daniel 7:22)**

The Scripture and the Main Question—Pat McGeachy

Monsters in a Dream (Daniel 7:1-8)

There are some dreams from which you wake with a wonderful sense of well-being, as did Daniel in 2:19. And then there are those that disturb us and leave us white-faced and shaken (7:15, 28). But, be it good or evil, the truth must be faced. To avoid bad news and to pretend that it doesn't exist is to court disaster. There was a wonderful science-fiction movie a few decades back called *The Forbidden Planet,* which depicted a civilization that had learned to increase the power of the brain so many times that people could bring things into reality just by thinking about them. But they forgot about the monsters from the id; in the end, their subconscious thoughts also became reality and destroyed them. There are monsters in our dreams, as in those of Daniel. And they can show us the truth about ourselves and our world, if we are willing to face it.

The monsters in Daniel's dream are four: (1) a lion with eagle's wings, that turned into a man; (2) a bear chewing on spareribs; (3) a four-headed leopard with four wings like a bird; (4) a strong, devouring beast with iron teeth and many horns (ten at first, then eleven, then eight—kind of a cross between a *Stegosaurus* and a *Tyrannosaurus rex!*) No wonder Daniel woke up in a cold sweat!

There has been much speculation as to what the four beasts in Daniel 7 stand for. One possible interpretation is as follows (it is similar to the one given to the vision in 2:31-35): (1) The lion was Babylon, the man that it turned into, Nebuchadnezzar. Most historians think that Belshazzar (verse 1) was never really king, but stood in for his disturbed father Nebuchadnezzar, who had the real clout. (2) The bear represented the Medes under Darius. (3) The leopard represented Persia under Cyrus. (4) The ten-horned devourer was the Greek empire, starting with Alexander the Great, the other horns being his lieutenants and their followers. The loud little horn was Antiochus Epiphanes, a rash and powerful ruler who tore down the Jews' temple in Jerusalem and desecrated it with statues of pagan gods. (If you have an Apocrypha, check I Maccabees 1.)

I have no idea if these are the only correct interpretations. Many others are possible. And you probably won't make up your own mind about it without checking the strikingly similar vision in Revelation 13. But we can be absolutely sure of one thing: The monsters represent the great fear of God's people, from the time of the Babylonian captivity down to the period just before Christ, relating to the continual oppression of the Jewish people. Like all oppressed people, they greatly needed encouragement. And this vision begins by sympathizing with them in their pain, and ends by offering hope for their deliverance.

The Old One and the Human One (7:9-14)

In contrast to the fearful vision of the four monsters, there now comes a fearful vision of God. But whereas the fear in the first case had been that of terror, the fear in the second case is that of reverence (see Psalm 111:7; Proverbs 1:7). The vision is not unlike that of Ezekiel 1; the throne has wheels of fire and seems to be portable, like the huge heavenly vehicle. It is also like the vision of Christ in Revelation 1:12-15. The Ancient of Days, older, wiser, and more powerful than the earthly kings, destroys them all, as surely as history will bring down the tyrants of earth.

Meanwhile a "son of man," or a "human one," approaches the throne and is given power by the Ancient of Days. This could be a figure representing the Messiah who is to come, or it could simply be a way of saying that God will give sufficient power into human hands to enable them to overthrow the tyrants that persecute them. In either case, it is comforting news to those held in captivity: "Help is on the way!"

Daniel's Reaction (7:15-28)

Daniel turned pale at this vision (verse 28); his spirit was troubled and anxious (verse 15). But he had the good sense to ask for advice (verse 16) and was told that ultimate victory would belong to the saints of God. The story is then retold (by the angel who is explaining things to Daniel?) in verses 19-27, and we are reassured that God's people will ultimately have victory over the enemies who now oppress them.

Of interest is the curious expression "a time, two times, and half a time" (see also Daniel 12:7; Revelation 12:14). The best explanation is that the total of these times is three and a half, exactly half of seven, the number of perfection, meaning that the reference is to a limited historical period. If you are interested in this numbers game, you may want to look at Revelation 12:6:

$$1260 \text{ days} = 42 \text{ thirty-day months} = 3\frac{1}{2} \text{ years}$$
(or 42 months—Revelation 11:2; 13:5)

While we're on the subject of numbers, if seven is the number of perfection, note that the number of the monster in Revelation 13:18 is 666, a number that triply falls short of seven. And remember that the New Testament word for "sin" is a term from archery that means "to fall short of the mark." Even the dark forces are "trying." Their greedy ends are, in a way, the same as those of God, namely, that all the nations should belong to them. But in the end, because they put their trust in their own might, they are doomed to fall. Truly, "all have sinned and fall short of the glory of God" (Romans 3:23).

This whole business is frightening. Even though the meaning of the nightmare is plain to us—that God will triumph—still, just to look at monsters like these is a disturbing experience. And you and I don't want to have to take part in battles with dragons. But that is how things are. And, though looking at them turns us pale, as it did brave Daniel, still we must face the truth.

It doesn't help to disguise them by giving them cover-up names (euphemisms) so that we can pretend that they are not really dragons: "Sin"

can become "sickness" (it *is* a sickness, of course, but more than that); "immorality" can become "changing cultural patterns"; "lack of faith" can be called "healthy intellectual inquiry"; "cowardice" can become "sensible precautions."

And there are some worse ones: "Government lies" hide under the cloak of "national security"; "murder" becomes "necessary termination"; "genocide" becomes "preserving the purity of the race."

This sort of thinking can breed Hitlers, Stalins, Jonestowns.

But it is the promise of our lesson that such monstrous uprisings are only temporary. If we dare to see them for what they are, we can take comfort from the certainty that God will bring them down. There is an Ancient of Days who will work the evil spells back upon themselves until they are destroyed. The Old One (God) will give power into the hands of the Human One (Christ), and he will establish a kingdom that cannot be destroyed. The government will be upon his shoulders (Isaiah 9:6), and he shall reign forever and ever (Revelation 11:15) as King of kings and Lord of lords (Revelation 19:16).

If I were a captive in Israel long ago, or a person today, afraid for the future, and I dreamed such a dream, I might awaken in a cold sweat, but I think I would feel a lot better in the morning.

Helping Adults Become Involved—Robert E. Luccock

Preparing to Teach

Some knowledge of the history reflected in this chapter is essential if you would help students get behind the imagery of Daniel's apocalyptic vision. Refresh your mind first on Daniel 2. Notice the parallel between the dreams of Daniel and Nebuchadnezzar. Horace Weaver's "As You Read the Scriptures" and Pat McGeachy's "The Main Question" are particularly helpful in their summaries of Middle East history leading down to 167 B.C.

Both Dr. Weaver and Dr. McGeachy write about the importance of names. They are the key to the meaning of the dream. If you have access to a Bible dictionary you may want to look up the two entries "Ancient of Days" and "Son of Man."

Here is an outline of the lesson:

> I. Daniel's dream
> A. The monsters
> B. Ancient of Days and son of man
> C. Judgment
> II. Promises for the future
> III. Promises to us?

Introducing the Main Question

The word "hostage" has acquired new and frightful meaning in our time. Who has not wondered what it would be like to be a hostage to terrorists? "Will I ever be rescued? When will deliverance come?" These are the main questions asked by individuals and by whole populations being held hostage

in prisons, in exile, or by apartheid. After more than 2500 years, the
questions will not go away.

We know even better what it is to be hostage to hopelessness, evil, fear, or
sin. The message of Daniel is "Hold on! Help is on the way!" But we still ask,
When, and how?

Developing the Lesson

This lesson exposes us to the tension of being held hostage to some kind
of tyranny and of rejoicing in the hope of deliverance. That's where the
Jews found themselves in Daniel's time (about 168–165 B.C.), and where
many people find themselves today. Our mood swings between despair and
hope.

Chapter 7 centers around a vision or dream. Whereas in chapter 2
Nebuchadnezzar had a dream that Daniel explained, this time the dream is
Daniel's.

I. Daniel's dream
A. The monsters

In his nightmare Daniel sees four hideous beasts rising out of the sea.
They represent the four empires that ruled the Middle East for nearly five
hundred years: Babylon, Media, Persia, and Greece. Some of the rulers
were more benevolent than others. Under Antiochus Epiphanes, the Jews
were humiliated and oppressed by an alien people and culture. Under
Cyrus the Great of Persia they were released from Babylonian captivity in
538 B.C. But during all this time Israel was never far from being hostage to
some tyranny. Dr. Weaver and Dr. McGeachy give good summaries of
Daniel's dream. It required no stretch of the imagination for the Jews to
recognize the fourth horrifying beast that rose out of the sea in Daniel's
dream.

Then into their terror came words of hope: To one like a son of man was
given dominion, glory, and kingdom (7:13-14). The fourth beast did not
mean the end of the line for Israel!

B. Ancient of Days and son of man

Suddenly receiving a signal that deliverance for the oppressed may be
imminent has been a human experience under many circumstances. In
Beethoven's opera *Fidelio*, Florestan, an incorruptible, high-minded citizen,
has been thrown into a dungeon by a cruel, tyrannical governor. He does
not know if he will ever see the sky again. Suddenly from offstage a trumpet
call is heard, a signal that rescuers are coming. The moment in the opera
house is electric with emotion. Beethoven has included this musical
sequence in his acclaimed Leonora Overture no. 3.

In the final days of World War II, Allied prisoners of war in Germany and
death camp prisoners reported that when they heard great fleets of Allied
bombers flying overhead on their way to Berlin, their emotions were
indescribable. Only the oppressed can fully know what it means to hear
signals of their release.

C. Judgment

Apocalyptic promises are always accompanied by judgment. In colloquial
speech we might say, "The promise is 'No give-away,'" or, "There is no free
lunch." In one sense, of course, it *is* a give-away; God *gives* the kingdom to
the "saints of the Most High" (7:27). We don't bargain for it, or "earn it the

old fashioned way," by working. But the kingdom only comes following judgment; the books will be opened (7:10). Such an end-of-the-age judgment everywhere marks Israel's apocalyptic expectation. The "nations" are called to the bar of God's justice, Israel included! (Amos 2:6-7).

II. Promises for the future

Three promises are given: (1) The kingdom will be forever; (2) it will be given to the saints; (3) it will be given to them in three and a half years.

Daniel was nearly on target as to the time of deliverance. In 165 B.C. Judas Maccabeus defeated Antiochus, and the temple was rededicated almost three years from the date of Daniel's prophecy. Apparently the victory and rededication happened *after* this book was finished. As we know, two thousand years later, this was not the kingdom of God for Israel. It was deliverance of the oppressed of *that* generation.

III. Promises to us?

We hear virtually the same promises in the Gospels: "It is your Father's good pleasure to give you the kingdom" (Luke 12:32). Everywhere Jesus talks about the kingdom to come. Are these more "Promises, Promises"? Are we doomed to an endless cycle of frustration and denial?

Many people have given up hope altogether. Others trust God's promise, even when they cannot see (walking by faith, not by sight), remembering Jesus' warning not to seek signs: "An evil . . . generation seeks for a sign" (Matthew 12:39). It is not given to soothsayers or latter-day prophets to tell us "when." Maybe it will not be until the close of the age.

"In the meantime"—a wonderful phrase for Christians to remember! We are living in the "meantime," in between the times. One thing is asked of us: to be faithful in whatever we are given to do, or wherever we are given to live.

Helping Class Members Act

In these matters most of us need to act "within ourselves." *Judgment* and *trust* may be the spiritual disciplines we most need. A healthy exercise would be for each one to examine his or her own life to find at least one matter that stands under judgment of the Most High, and to do the same for the *church* and the *community*.

Can we not also practice *trust* far more than we do? When we are unsure of outcomes, can we walk in trust if not in full sight? The practice of such trust comes only by stoicism or prayer (perhaps some of both).

Planning for Next Sunday

In preparation for next Sunday, compare Daniel 12 to Mark 13 (the Gospel apocalypse). Do they differ in any important ways? If so, how?

God Gives Victory

Background Scripture: Daniel 12

The Main Question—Pat McGeachy

Not long ago, a fine Christian farmer whom I know lost his sixteen-year-old son. He had other, older sons who were successful in business, but this one was the apple of his eye, the one who loved to farm with his daddy, and who, they all understood, would one day assume his place in managing the family farm. But now he was dead, killed in a freak accident while driving a tractor, and the old man was utterly overcome with grief. He could not function. He spent his days with his head buried in his hands, saying over and over to himself, "What's the point of life now?"

How would you attempt to minister to that farmer? Surely you can understand how broken and disappointed he must be, believing that God had utterly deserted him. I know how he feels, for even the drowning of a baby duck makes me wonder about the purpose of things, let alone the death of a cherished son. But if you can put yourself in his shoes, you may begin to feel something of the anguish of the ancient Jew whose temple had been profaned with the "abomination of desolation" (Daniel 12:11), and for whom all hope seemed lost.

What *is* the meaning of history? Is it all going to end in a nuclear holocaust? Where are the good old patriotic promises of our young nation? Where are the sweet expectations that we felt about life when we were young? Shall we too bury our faces in our hands and bemoan the loss of our dreams? Or is there promise of life even in the midst of death? Not much is said in the Old Testament about resurrection, but here in Daniel 12 is a clear indication of it. Daniel, perhaps one of the latest of the Old Testament books to be written, assures us that all is not lost. In and through and above all of life's pain and tragedy, faith shines. Our question is this: Can you and I, and my farmer friend, and, indeed, our world grasp and believe that hope?

As You Read the Scripture—Horace R. Weaver

The writer of the book of Daniel portrays Antiochus Epiphanes as a despicable man who assumes he is God manifest. He gives "no heed to the gods of his fathers . . . [nor] to any other god, for he shall magnify himself above all" (Daniel 11:37). His pride, arrogance, and constant warfare will soon end, for "he shall come to his end, with none to help him" (Daniel 11:45).

Daniel 12:1-4. The end of the tribulation fast approaches, and the resurrection is near. "At that time shall arise Michael [the patron angel of the Jews], the great prince who has charge of [stands for] your people." Michael will participate in the overthrow and death of Antiochus IV and thus help in bringing in the final consummation. But first there will be the time of tribulation: "There shall be a time of trouble, such as never has been since there was a nation." Michael, as he sees the end of time (the death of

Antiochus IV and the tribulation he brought), will prepare for ushering in the reign of the saints.

Those who are to "be delivered" will be a smaller group than many expect. Those to be delivered are "every one whose name shall be found written in the book." Those who have been faithful, obedient to the law (the Torah) and the prophetic style of life (justice, love of kindness, and a humble walk with God), will be acknowledged as saints.

In the resurrection of the dead, the saints will "awake" to "everlasting life," and the rest (the disloyal in thought, word, and deed) "to everlasting shame [abhorrence] and contempt [aversion]." Verse 12:2 is the first time the word "resurrection" is applied to both the righteous and the unrighteous. Hosea and Ezekiel refer to a national, not a personal resurrection.

As in Jesus' parable (Matthew 25:32-33), there is a separation of the good ("the wise") and the evil. The writer of Daniel presupposes an actual judgment as each person faces the record of their deeds (Daniel 7:10). After separation they receive their reward. The "wise shall shine like the brightness of the firmament," which suggests that the spiritually knowledgeable saints will be luminaries for lesser folk. They will shine forever!

In this closing vision of Daniel (verse 4), he is told by the angel to "shut up [close] the words and seal the book." To "seal the book" means to conceal its words until the time is ripe.

Arthur Jeffery, the exegete for Daniel in *The Interpreter's Bible*, comments that "the writer's literary framework is the court at Babylon, and there must be an explanation somewhere why these matters revealed there were not known to earlier generations. The explanation is that they were written down and sealed up until the time of the end drew near, when they were to be made available to the faithful that they might understand the significance of the events amid which they were living" (vol. 6, pg. 544).

Verses 5-13. Daniel saw two angels. One angel said to the other angel (who was clothed in linen), "How long shall it be till the end of these wonders?" The other angel raised his hands toward heaven and in the presence of both Daniel and the other angel swore that the end would come at the end of three and a half years. The oath was witnessed by both Daniel and the angel. The date is calculated from 167 B.C., "from the time that the continual burnt offering is taken away [by Antiochus Epiphanes], and the abomination that makes desolate is set up" (the sacrifice of a pig on the holy altar and the installment of Zeus in the Holy of Holies in the temple).

The numbers of days (1,335 and 1,290) are not accurate. Probably they represent fresh estimates of the beginning of the end of persecution. Truly, no one (except God) knows when the end will come.

Selected Scripture

King James Version

Revised Standard Version

Daniel 12:1-3, 5-13

1 And at that time shall Mī-chā-ĕl stand up, the great prince which standeth for the children of thy people: and there shall be a time of

Daniel 12:1-3, 5-13

1 "At that time shall arise Michael, the great prince who has charge of your people. And there shall be a time of trouble, such as

trouble, such as never was since there was a nation *even* to that same time: and at that time thy people shall be delivered, every one that shall be found written in the book.

2 And many of them that sleep in the dust of the earth shall awake, some to everlasting life, and some to shame *and* everlasting contempt.

3 And they that be wise shall shine as the brightness of the firmament; and they that turn many to righteousness as the stars for ever and ever.

...

5 Then I Daniel looked, and, behold, there stood other two, the one on this side of the bank of the river, and the other on that side of the bank of the river.

6 And *one* said to the man clothed in linen, which *was* upon the waters of the river, How long *shall it be to* the end of these wonders?

7 And I heard the man clothed in linen, which *was* upon the waters of the river, when he held up his right hand and his left hand unto heaven, and sware by him that liveth for ever that *it shall be* for a time, times, and an half; and when he shall have accomplished to scatter the power of the holy people, all these *things* shall be finished.

8 And I heard, but I understood not: then said I, O my Lord, what *shall be* the end of these *things*?

9 And he said, Go thy way, Daniel: for the words *are* closed up and sealed till the time of the end.

10 Many shall be purified, and made white, and tried; but the wicked shall do wickedly: and none of the wicked shall understand; but the wise shall understand.

11 And from the time *that* the daily *sacrifice* shall be taken away, and the abomination that maketh desolate set up, *there shall be* a thousand two hundred and ninety days.

never has been since there was a nation till that time; but at that time your people shall be delivered, every one whose name shall be found written in the book. 2 And many of those who sleep in the dust of the earth shall awake, some to everlasting life, and some to shame and everlasting contempt. 3 And those who are wise shall shine like the brightness of the firmament; and those who turn many to righteousness, like the stars for ever and ever."

...

5 Then I Daniel looked, and behold, two others stood, one on this bank of the stream and one on that bank of the stream. 6 And I said to the man clothed in linen, who was above the waters of the stream, "How long shall it be till the end of these wonders?" 7 The man clothed in linen, who was above the waters of the stream, raised his right hand and his left hand toward heaven; and I heard him swear by him who lives for ever that it would be for a time, two times, and half a time; and that when the shattering of the power of the holy people comes to an end all these things would be accomplished. 8 I heard, but I did not understand. Then I said, "O my lord, what shall be the issue of these things?" 9 He said, "Go your way, Daniel, for the words are shut up and sealed until the time of the end. 10 Many shall purify themselves, and make themselves white, and be refined; but the wicked shall do wickedly; and none of the wicked shall understand; but those who are wise shall understand. 11 And from the time that the continual burnt offering is taken away, and the abomination that makes desolate is set up, there shall be a thousand two hundred and ninety days. 12 Blessed is he who waits and comes to the thousand three hundred and

12 Blessed *is* he that waiteth, and cometh to the thousand three hundred and five and thirty days.

13 But go thou thy way till the end *be:* for thou shalt rest, and stand in thy lot at the end of the days.

thirty-five days. 13 But go your way till the end; and you shall rest, and shall stand in your allotted place at the end of the days."

Key Verse: **At that time thy people shall be delivered, every one that shall be found written in the book. (Daniel 12:1)**

Key Verse: **At that time your people shall be delivered, every one whose name shall be found written in the book. (Daniel 12:1)**

The Scripture and the Main Question—Pat McGeachy

Phoenix from the Ashes (Daniel 12:1-4)

The phoenix was a bird in ancient Egyptian mythology who, dying in fire, rose renewed from the ashes to a new life. It has long been a pagan symbol for immortality. As is so often true, the primitive myth has a kernel of truth in it: New life comes when you least expect it. The glad news of Easter comes only after the brutal tragedy of Good Friday. And the hope that Daniel offers us will not come before there shall be "a time of trouble, such has never been seen" (verse 1; see Matthew 24:6-7). It seems that things must get worse before they can get better.

But even in these tough times, there is a note of hope, for Michael will arise to lead us. Michael belongs to that mysterious class of beings known as "archangels" or "chief angels." Their numbers vary in later Jewish mythology, but the most common is four:

> *Michael:* the patron angel of the Jews
> *Gabriel:* the messenger of God
> *Raphael:* the angel of healing
> *Uriel:* the angel of light

Only two of them are mentioned in our Bible: For Michael, in addition to Daniel see Jude 9 and Revelation 12:7; for Gabriel, see Daniel 8:16 and 9:21, and Luke 1:19, 26. But Raphael and Uriel (and others) are found in the Apocrypha (especially Enoch and Tobit) and in many later Jewish writings. An archangel is one who is very close to God (Psalm 8:5), and the naming of one of them here is to give comfort to the persecuted Jews. It says, in effect, "You may feel desolate and alone, but God's right-hand forces are fighting along with you." Indeed, Daniel himself is so encouraged, because apparently it is an angel of a major sort that is speaking the words of this chapter to him (Daniel 10:18).

So powerful will these forces be that the dead will be raised. Although the resurrection of the dead is today a principal belief of both Jews and Christians, this is the only place in the Old Testament where it is specifically described. (There were Jews in Jesus' day who did not believe in it—Matthew 22:23.) There are traditional places where, from our Christian perspective, we can see promises of resurrection: Job 19:25-27; Isaiah 26:19; Psalm 17:15; and perhaps others. But in Daniel 12 it is unequivocal. (Note, however, that the promise is not universal: Only *some* of those who

66

sleep will awake (verse 2), and only some will be lifted up to heaven like the stars (verse 3). And as to just how this all will be, Daniel is instructed to seal up in the book (see Revelation 5:1-5; 22:10). Time will tell.

What of the Time? (12:5-13)

Like all of us, Daniel is full of curiosity about the time of these things (see Matthew 24:3). We want to know *when*. But we are given no answer. Jesus says (Matthew 24:4) that even he does not know the exact date of the last things; it is a secret in the heart of God. And Daniel's teacher gives him a cryptic reply: "A time, two times, and half a time" (verse 7). As we saw in the last lesson (7:25), this adds up to three and a half (half of seven, the perfect number) and apparently means "an indeterminate period of human history."

We are then to set about the business of doing what is right: Let the pure be pure and the wicked do wickedly (compare Revelation 22:11). The times are uncertain, but what is certain is that we must be about our Father's business. Having confidence in the ultimate outcome, we can spend and be spent in the cause of righteousness. There will be others who do not understand, but "What is that to you? Follow me!" (John 21:22).

We are told one thing: to watch for "the abomination that makes desolate" (verse 11), something unspeakable. This may specifically refer to the actions of Antiochus Epiphanes, who set up pagan statues in the Hebrew temple, but it stands as well for every utter sacrilege (see also 11:31). Like my farmer friend who lost his son, most of us know what it is like to experience utter disaster, times when the very best seems suddenly turned into the very worst. I can think of some examples; you will know of better ones:

—A beloved pastor is discovered to have a sexual problem, and the church just seems to fall apart in shame and disbelief.

—Just when we think we have saved enough money for a peaceful retirement, a medical emergency strikes and wipes out our savings.

—A bright, promising teenager suddenly turns to drugs and other antisocial behavior.

All sorts of guilt-laden questions engulf us: Why me, Lord? Where did we go wrong? What have I done to deserve this? But Daniel's prophecy counsels us not to fall into such grievous anguish. Healthy sorrow, guilt, and pain we must of course experience. But because we, like Daniel, have been raised as people of faith, we are not to "grieve as others do who have no hope" (I Thessalonians 4:13). Instead, we are to endure with patience our tragedy and pain, "knowing that suffering produces endurance, and endurance produces character, and character produces hope, and hope does not disappoint us" (Romans 5:3-4). As the heavenly messenger said to Daniel (verse 12), "Blessed is he who waits and comes to the thousand three hundred and thirty-five days." This figure, like the figure of 1,290 days mentioned in verse 11, extends the period a little beyond the 1,260 days (or forty-two months, or three and a half years) implied in "a time, two times, and half a time." It may refer to a specific historic period, but it also means that our patience must always be willing to wait for God's good time. (See Habakkuk 2:1-4 and 3:17-19, as well as Psalm 90:4 and II Peter 3:8-9.) There may not be any visible evidence of life beyond this life, but there is

plenty of glorious religious tradition that gives evidence that pious patience pays off. Remember the words of Isaiah (40:31):

> They who wait for the Lord shall renew their strength,
> they shall mount up with wings like eagles,
> they shall run and not be weary,
> they shall walk and not faint.

I remember reading long ago a corny children's story about a boy and his dog, which involved the young man's falling into an icy pond. He couldn't climb to safety up the slippery muddy bank; he could only hang onto a root with freezing fingers and wait for the dog to go for help. I don't remember the story's details as to how the lad was rescued, but I do remember that he sustained himself during his long ordeal by repeating over and over to himself a sentence he had heard his father use, "Courage consists of hanging on one minute longer." It is not in the great and noble deeds that most of us find satisfaction but in the faithful, daily "hanging on" while the world around us seems full of "abominations of desolation." I am not a good enough man to tell my farmer friend who has lost his son that he ought to "cheer up." If I were in his shoes, there is no telling what my grief would be like. But it is still true that he ought to cheer up. And God is continually telling us to do so. Jesus said, "In the world you have tribulation; but be of good cheer, I have overcome the world" (John 16:33).

Among some of the ancient Greeks there was a rather optimistic philosophy called "the immortality of the soul." That doctrine taught that the pains and sufferings of this life are "unreal," and that the soul (a kind of indestructible, invisible thing) will continue after death into eternity, the world of reality. Some people hold to such a belief today. But the Christian faith holds not to the immortality of the soul, but, as the Creed has it, "the resurrection of the body." Our faith is that we must experience the tragedy and the suffering of death, but that out of that abomination new life will emerge. (See what Paul says in I Corinthians 15:42-50, and Jesus in John 12:24.) Rest in that belief (Daniel 12:13), and wait for the promise.

Helping Adults Become Involved—Robert E. Luccock

Preparing to Teach

This chapter makes two central affirmations: God will deliver the saints of the Most High, and the dead will be raised.

The first is familiar, found everywhere in the Old Testament. Recall the promises given in Daniel 2 and 7. The second affirmation is something new, and unique in the Old Testament. Daniel was one of the last books to be written in the Old Testament (167–166 B.C.). Faith in a resurrection thus appears late in Jewish history before Christ.

You should compare Daniel 12 with earlier affirmations about resurrection. Recall Ezekiel 37; the emphasis there is more on the nation, the whole people who will be raised, as it is in the other books of the prophets. But see also Isaiah 26:19 and Job 19:25-27, both intimations of resurrection. Both Dr. Weaver in "As You Read the Scripture" and Dr. McGeachy in "The Main Question" offer excellent preparations for teaching.

Compare this apocalypse with the apocalypse in the Gospels (Mark 13 or Matthew 24, parallel chapters) and that in I Corinthians 15.

Here is an outline of the lesson:

> I. God speaks to an open grave.
> II. Michael announces the end-time.
> III. What of the time?

Introducing the Main Question

Can we grasp and believe the hope, that many shall awake to everlasting life? Many things are different today from what they were in Daniel's time. Transportation is different, communication is different, knowledge of the heavens and the earth is different. Customs, clothing, and communities are all different. But broken hearts standing beside an open grave—these are the same. Dr. McGeachy's farmer friend, you, and I feel the same ache that filled the hearts of Jews in the second century before Christ.

Daniel offers an answer to that ache and that longing: Many will awake. Great faith is born in times of great trouble. This first clear affirmation of a resurrection came at "a time of trouble, such as never has been." Goodness out of evil, light out of darkness, life out of death—these have always been the fruit of tribulation (see John 16:33).

Developing the Lesson

I. God speaks to an open grave.

The best place to understand the import of this lesson is beside an open grave. We have all been there; we understand something of what it feels like. Start with your own feelings: loss of a person, loss of life's meaning, and the main question—what has happened, what will happen, to the one who died? What do *we* do now?

The Jews must have asked the same questions long ago. Michael speaks to them (12:2).

II. Michael announces the end-time.

Michael was the major angel of the Jews (see "The Main Question"). He spoke for God to Daniel. What he had to say was both good news and bad news. Every apocalypse in the Bible announces the same paradox. The promised deliverance as well as the faith to receive it always and *only* comes out of great tribulation (see Revelation 7:14, a scripture we shall study closely in four weeks).

Fred Craddock in *Proclamation 3—Series B* reminds us: "In the second century B.C. the Syrian oppressors of Israel reached their worst. Jews were hanged for keeping the Sabbath or being true to their kosher diet. Some were forcefed pork and others were executed at the time of prayer." We may regard it as paradoxical that out of a time like that a belief in resurrection would arise. But as Dr. Craddock points out, "a doctrine of resurrection arises not as a faint hope but an inescapable necessity." Not because death is so intolerable that we must try to swallow it with a

69

resurrection, but because in the crucible of our tribulation and grief the God of promises speaks of love that transcends the grave.

We need to look closely at the idea of resurrection here and compare it with what preceded it in the Old Testament and what followed it in the New. Here you will want to look at Isaiah 26:19; Job 19:25-27; Psalm 17:15; and once again at Ezekiel 37:11. There are intimations of resurrection here. But the dominant idea of the Old Testament was a national resurrection. *Israel* would inhabit a restored kingdom. Individual life was more or less submerged in the nation.

Following Jesus' resurrection, personal rebirth to new life with the risen Christ had changed the face of death, and of life! A landmark in preparation for that change is here in Daniel.

Notice that Michael announces a "limited" resurrection: those whose names are "in the book," the "many [who] . . . shall awake," "those who are wise," "those who turn many to righteousness." When we read in Daniel 12:2 that some shall awake to shame and everlasting contempt, our minds naturally turn to the familiar parable in Matthew 25:31-46.

This lesson is not the occasion to fully explore the Christian doctrine of resurrection. Resurrection in Daniel 12 is not the same as in John 15–16 or I Corinthians 15. But they share this in common: Neither one comes out of philosophical assurance; both come as a response of trust in the power and love of God.

III. What of the time?

Michael does not answer Daniel's question, and ours, about *when*. One of the angels says three and a half years (remember Daniel 7). But to Daniel's persistent query he says, "Go your way" (12:9, 13). The book is sealed. The names of the faithful are inscribed here. The book cannot be opened "until the time of the end." The main emphasis of the passage is not on time but on what Daniel is to do "in the meantime." "Go your way" is a command to live faithfully to the end. Do you hear and see a foregleam in Daniel 12:13 of Matthew 28:20?

Helping Class Members Act

Act? Who are *we* to act in matters of the apocalypse? *God* will act in God's own way and time. But does this mean that we can do nothing but sit and wait?

See what the class may suggest. Two quotations from Daniel regarding our obligations come to mind, which should not be left out of any discussion.

1. "Those who turn many to righteousness" (13:3): Apparently, precept and example are part of what faithfulness requires. What are some appropriate methods we might use to turn others to righteousness (to trusting God, to being right with God)? Our own faith through tribulation, standing by someone having a hard time, speaking of that power greater than ourselves who can hold life up and turn it around? You will think of others.

2. "Go your way" (12:9, 13): This means to go on the way you have been going, *in faith.*

Planning for Next Sunday

In the course of the next lesson you may ask class members how they would live their lives differently if they knew their "last days" had come (illness, catastrophe, etc.). Think about it; gather your own thoughts so you can guide the class. One year to live—how would it change your values and priorities?

UNIT III: I AND II THESSALONIANS: THE COMING OF THE LORD

Horace R. Weaver

TWO LESSONS **OCTOBER 22–29**

In I Thessalonians Paul teaches his fellow Christians that the *parousia* (the second coming of Jesus Christ) is coming soon and encourages them to be ready for that event. In II Thessalonians, Paul, Silvanus, and Timothy face the confusion of the Thessalonian claim that Jesus had already come. Paul states clearly that this is impossible, because a rebellion must come first and "the man of lawlessness" must be revealed.

The two lessons of this unit speak to the above-mentioned concerns. "Encourage One Another," October 22, has a twofold message: When the Lord comes again, all saints who have died will be raised from the dead to be with the living saints, and no one knows when that day will come, so continue to "build one another up" in the faith. "Stand Firm," October 29, reminds us that the day of the Lord Jesus Christ has not yet come, and that therefore we must "continue to love the truth and so be saved."

LESSON 8 **OCTOBER 22**

Encourage One Another

Background Scripture: I Thessalonians 4–5

The Main Question: Pat McGeachy

There are two things that bother most of us: the possibility that things won't change, and the possibility that things won't stay the same. When things are constantly changing, we feel disturbed and uneasy, often miserable. But when things are always the same, we feel bored and uneasy, often miserable. In a way, life is both of these; you remember the adage: The more things change, the more they stay the same.

Life for the early Christians brought this uncertainty into sharp focus.

Living as they did in the expectation of an early return of Christ, they were tempted to say, "Oh well, nothing is permanent," and to neglect their daily responsibilities, such as family loyalty, charity, and love for one another. On the other hand, as the years began to pass and Christ did *not* show up as expected, they were tempted to be discouraged, overcome with grief, and unable to function as joyful Christians should.

Our own day seems far removed from that of the Thessalonians, and yet we have the same needs as they: We too suffer from the daily grind, the presence of grief, and the fear of death. When we are discouraged by these old enemies, we need a renewed sense of excitement and expectation. At the same time, we must not become so preoccupied with the other world as to neglect our faithful carrying out of the ordinary duties of the Christian life.

We need, in short, a healthy Christlike tension between time and eternity. We need to learn to live with "one foot in heaven" and one foot solidly planted in the daily round. We must be secure in the belief that Christ will soon come and at the same time be faithful to the task of holding fast to that which is good. First Thessalonians 4–5 is an excellent formula for Christian living, in their age and in ours.

As You Read the Scripture—Horace R. Weaver

Cassander, brother-in-law of Alexander the Great, named one of the major cities of the east Mediterranean for his wife Thessalonica. The city boasted of a Roman naval station and docks, and of its location on the overland military highway.

Paul was aware that this city also boasted of its two mystery religions—the cults of Dionysus (the dying and rising god) and Orpheus (a fertility cult). Paul, with his friends Silvanus and Timothy, chose to bring the message of Jesus Christ to this pagan and sensuous city. They would seek to replace its phallic symbols with the cross.

I Thessalonians 4:1-12. It is against the above background that we find Paul proudly urging the faithful to continue to live lives of purity and love.

Paul urges his converts to "abstain from immorality" (*pornia,* which refers to any kind of illicit sexual indulgence). Paul makes his appeal inasmuch as he knows their past experiences included promiscuous sexual indulgence. The three missionaries (who together wrote Thessalonians) call for men to respect and honor their wives. They are to sanctify, not desecrate, their marriages (verses 3-7). The converts are to live quietly, to mind their own affairs, and to work with their hands (verse 11).

Verses 13-18. Questions had been sent to Paul, Silvanus, and Timothy showing concern for those Christians who had "fallen asleep" (died) before the parousia—the second coming of Jesus Christ. Paul states that "since" (note, not "if," as in the King James Version) "we believe that Jesus died and rose again . . . God will bring with him those who have fallen asleep [died]" (verse 14). Any who have faith in the resurrected Christ—whether they are alive or dead—will be blessed with life everlasting.

These promises are made sure by "the word of the Lord" (verse 15). Indeed, the "Lord himself will descend from heaven with a cry of command" (a summons given by some high official; verse 16). It is a call to the dead: Arise, even as Jesus was raised from the dead in Jerusalem. The trumpet that will be blown is the straight (as distinguished from the curved)

ram's horn, blown only at the time of Jubilee. Michael, the patron angel of Judaism, gives the call by blowing the sacred trumpet. All persons will appear before the angel Michael and the heavenly assize for judgment (for good or bad). The "sound of the trumpet" was a feature of the events of "the day of the Lord" in the centuries-old traditions of Judaism.

I Thessalonians 5:1-7. The phrase "the day of the Lord" has a double meaning, which can easily lead to theological confusion. Several Old Testament passages refer to the day of Yahweh. Examples are Isaiah 2:12; 13:6ff.; Amos 5:18; Zechariah 14:1; Malachi 4:5. This was to be a terrible day of divine retribution, vengeance, judgment. "The day of God" appears twice in the New Testament: II Peter 3:12 and Revelation 16:14. When the Septuagint translation of the Hebrew Old Testament was made, the Hebrew word for Yahweh was not transliterated; instead, the Greek word for "Lord" *(kurios)* was substituted. So, in the Septuagint "the day of Yahweh" becomes "the day of the Lord." Early Christians called both Jesus and God *"Kurios."* Hence we have two meanings when we say "the day of the Lord." Paul spoke of the day of the Lord as the second coming of Jesus Christ from heaven, with vengeance and destructive power (I Thessalonians 5:2-3; II Thessalonians 2:1-2; II Peter 3:1-10). But the day of God and the day of our Lord Jesus Christ are not properly equated. Paul notes the difference when he refers to the day when God will judge the secrets of men through the agency of Jesus Christ (Romans 2:16; see Martin Rist's article, "The Day of Christ," in *The Interpreter's Dictionary of the Bible,* vol. A–D, p. 783).

Verses 8-11. Paul urges the Thessalonian Christians to have sober minds and to prepare for warfare by putting on the "breastplate of faith and love." Christians are to "build one another up."

Selected Scripture

King James Version	Revised Standard Version
I Thessalonians 4:13-18	*I Thessalonians 4:13-18*
13 But I would not have you to be ignorant, brethren, concerning them which are asleep, that ye sorrow not, even as others which have no hope.	13 But we would not have you ignorant, brethren, concerning those who are asleep, that you may not grieve as others do who have no hope. 14 For since we believe that Jesus died and rose again, even so, through Jesus, God will bring with him those who have fallen asleep. 15 For this we declare to you by the word of the Lord, that we who are alive, who are left until the coming of the Lord, shall not precede those who have fallen asleep. 16 For the Lord himself will descend from heaven with a cry of command, with the archangels' call, and with the sound of the trumpet of God. And the dead in Christ will rise first; 17 then we who are alive, who are left,
14 For if we believe that Jesus died and rose again, even so them also which sleep in Jesus will God bring with him.	
15 For this we say unto you by the word of the Lord, that we which are alive *and* remain unto the coming of the Lord shall not prevent them which are asleep.	
16 For the Lord himself shall descend from heaven with a shout, with the voice of the archangel, and with the trump of God: and the dead in Christ shall rise first:	

17 Then we which are alive *and* remain shall be caught up together with them in the clouds, to meet the Lord in the air: and so shall we ever be with the Lord.

18 Wherefore comfort one another with these words.

I Thessalonians 5:1-11

1 But of the times and the seasons, brethren, ye have no need that I write unto you.

2 For yourselves know perfectly that the day of the Lord so cometh as a thief in the night.

3 For when they shall say, Peace and safety; then sudden destruction cometh upon them, as travail upon a woman with child; and they shall not escape.

4 But ye, brethren, are not in darkness, that that day should overtake you as a thief.

5 Ye are all the children of light, and the children of the day: we are not of the night, nor of darkness.

6 Therefore let us not sleep, as *do* others; but let us watch and be sober.

7 For they that sleep sleep in the night; and they that be drunken are drunken in the night.

8 But let us, who are of the day, be sober, putting on the breastplate of faith and love; and for an helmet, the hope of salvation.

9 For God hath not appointed us to wrath, but to obtain salvation by our Lord Jesus Christ,

10 Who died for us, that, whether we wake or sleep, we should live together with him.

11 Wherefore comfort yourselves together, and edify one another, even as also ye do.

Key Verse: **Therefore let us not sleep, as do others; but let us watch and be sober. (I Thessalonians 5:6)**

shall be caught up together with them in the clouds to meet the Lord in the air; and so we shall always be with the Lord. 18 Therefore comfort one another with these words.

I Thessalonians 5:1-11

1 But as to the times and the seasons, brethren, you have no need to have anything written to you. 2 For you yourselves know well that the day of the Lord will come like a thief in the night. 3 When people say, "There is peace and security," then sudden destruction will come upon them as travail comes upon a woman with child, and there will be no escape. 4 But you are not in darkness, brethren, for that day to surprise you like a thief. 5 For you are all sons of light and sons of the day; we are not of the night or of darkness. 6 So then let us not sleep, as others do, but let us keep awake and be sober. 7 For those who sleep sleep at night, and those who get drunk are drunk at night. 8 But, since we belong to the day, let us be sober, and put on the breastplate of faith and love, and for a helmet the hope of salvation. 9 For God has not destined us for wrath, but to obtain salvation through our Lord Jesus Christ, 10 who died for us so that whether we wake or sleep we might live with him. 11 Therefore encourage one another and build one another up, just as you are doing.

Key Verse: **So then let us not sleep, as others do, but let us keep awake and be sober. (I Thessalonians 5:6)**

The Scripture and the Main Question—Pat McGeachy

Respect Personhood (I Thessalonians 4:1-8)

The sexual question always seems to leap out at us, not because sexual sins are more important than others but because of all our appetites this one seems to be the most intense. I don't know that Paul was much of an authority on sex (he was apparently a bachelor), but he knew enough about it to know that it is a stumbling block for many of us (see I Corinthians 7:8-9). So strong is the desire in us, especially when we are young, that we do foolish things in the name of "this may be my only chance." The poets have long encouraged us to "gather rosebuds" while we may.

But in a world in which Christ may come at any moment, or in which tensions may cause the world to self-destruct (those may be two ways of talking about the same thing), it becomes even more important that we not lose our perspective. In sexual matters, as in eating and drinking, we mustn't forget that our physical bodies are the dwelling place of the Spirit (I Corinthians 6:19). Another way to say this is, Both I and my sexual partner are first of all persons, and only second the piece of apparatus that we use to satisfy our physical needs. We must treat ourselves and our partners as individuals of worth. This means that we will be faithful in our commitments to each other, tender and respectful in our relationships, and keep our passions under control. "For God has not called us for uncleanness, but in holiness" (I Thessalonians 4:7).

Love One Another (4:9-12)

Just as it is important to keep sexual love (*eros*) in its proper perspective, it is necessary that friendship (*philia*) be given its due. Paul's counsel to the Thessalonians in these verses has a kind of humble quietness to it that flies in the face of the busy world of today. Listen to the advice:

I know you love each other (verse 9),
but do so all the more (verse 10).
Live quietly (verse 11),
keep to your own affairs (verse 11),
do quality handwork (verse 11),
command the respect of others (verse 12),
be self-sufficient (verse 12).

It doesn't sound much like the frenzied activity of those who are awaiting the second coming just around the corner, does it? Rather, it sounds like the steady, obedient activity of a people who are settled in for good.

And this is the way we should live, no matter what the future may promise. Look at the advice of Jeremiah to the captives in Babylon (Jeremiah 29:7): "Seek the welfare of the city where I have sent you." This has been a special text for me as pastor of several churches during the past years. I have never known real permanence in any of the communities I have lived in; at any moment orders might come to move on. But I have found that I do better when I ignore the question of "when we might be leaving." To live with your suitcase packed is not really to live at all. For me, at least, it has been important to put down roots, to become a part of the

community, to let my children establish relationships. When the time comes to move, there may be grief, but the only way to live anywhere is to live as if you belong there.

So, I firmly believe, is the Christian to live in this world. We are always to be conscious of the imminent return of our Lord. We are to live always in the awareness of our own mortality. You and I will not live forever (thank God). But God has placed us here as exiles in the world (John 17:11-19), and we are to devote ourselves to living the good life, loving our neighbors, turning out good things with our hands, and spreading the gospel of God's presence among our neighbors. We will be happier for it.

The opposite side is worth mentioning. Those who live their lives concentrated entirely on the expectations of tomorrow are doomed to frustration. They are like my children on the occasion of our grand trip to the coast. After days of packing and planning we finally set out down the driveway on the beginning of an eight-day journey. About a hundred yards into the highway, a small voice piped up from the end of the station wagon (in what we called the "way-back"). "Are we there yet?" he asked. That's no way to live.

Believe in Life, Not Death (4:13-18)

We are the people of the Resurrection, not the Funeral. You might not believe this if you looked at us from day to day, for we are so preoccupied with dying. Our preachers seem to wear black all the time, and there is not a lot of warmth in our liturgy. Newspapers delight in gloomy news. We are, if I may borrow a phrase from the psychologists, chronically depressed.

But that is not the way Paul thought the Thessalonians should live, "as others do who have no hope." We are to live as those who believe that life has a happy ending, that ultimately it is a comedy, not a tragedy. I don't mean that we should pour molasses over all the hurt of the world, pretending that it is not real. *Resurrection* does not mean *immortality*. It means experiencing death, with all its pain and tragedy, but overcoming it with victory (I Corinthians 15:57). There is plenty of suffering in every comedy. "In the world you have tribulation," said Jesus (John 16:33), "but be of good cheer, I have overcome the world."

Keep Awake (5:1-11)

There is a third rule for the mutual living of these days, and that is that we maintain a sober expectancy about the times. We are not to be prophets of doom (verse 9), nor are we to pretend that there will be no problems (verse 3). Instead, we are to live as those who expect something exciting and good to be just around the corner. Life, if you will, should be a perpetual Advent season in which we behave toward one another as those who are on a great adventure. Have you ever noticed how much nicer people are to one another when they are on a camping trip? Even the laziest seem willing to help chop wood or do the dishes. (I know there are some people whom this sort of adventure turns into grumps, but they don't usually go camping in the first place.) In times of tension people become either very bad or very good. Do you remember how during the electric power failure in New York City some years ago some people resorted to looting, but most were truly helpful to each other? It is this last sort of person whom the people of God

must be: living as those who expect Christ to be coming soon, so that we give to one another the very best companionship along the way.

Behave Yourself (5:12-28)

We have, then, three good rules for the living of the Christian adventure: (1) Respect persons; (2) love one another; (3) keep awake. In the light of these, Paul concludes with a charge to all of us. In one form or another you hear many of these words at the conclusion of worship services. Here let me paraphrase them, giving the verse references as I go but pretty much letting Paul's own words speak for themselves. You might try your own hand at turning these verses into a charge for your congregation at worship, or advice to your children as they go out into the world, or just plain good advice for yourself.

> Live in peace (verses 13, 23).
> Be whole [body, mind, and spirit] (verse 23).
> Give everybody a valentine (verse 26).
> Respect your leaders (verses 12-13).
> Work hard (verse 14).
> Help the weak (verse 14).
> Encourage each other (verse 14).
> Be patient (verse 14).
> Do good, not evil (verses 15, 21).
> Rejoice and pray (verses 16-17).
> Trust the Spirit (verse 19).

When the Lord *does* come, I hope he finds me behaving like that.

Helping Adults Become Involved—Robert E. Luccock

Preparing to Teach

Preparing to teach this lesson calls for a combination of reading and imagination. Read Matthew 24:29-35 to help create in yourself the mood of expectation and awe that held many Jews and Christians in its grip in the first century A.D. First Thessalonians 4–5 introduces us to the kinds of questions people were asking in Thessalonica. By going back to review Daniel 12; Isaiah 26:10; Ezekiel 37:1-14; and Job 19:25-27, we gain a sense of continuity with Israel's past.

"As You Read the Scripture" and "The Main Question" examine both the background and the implications of these scriptures. They will help you generate your own thoughts about the lesson. A companion approach to lesson preparation involves imagination. Try to *feel* your way into the "last days" or the "end-time." That should not be difficult in this present age. You will think about the meaning of your own death and the end of the whole present age. These are terrifying thoughts, but these scriptures were written for people asking fearful questions. How will you live in a time when the end may be drawing near?

Here is an outline of the lesson:

FIRST QUARTER

 I. Introduce the main question.
 II. The day of the Lord
 III. Are we also living "the last days"?
 IV. In the meantime
 V. Each day: the last day and the first

Introducing the Main Question

Pat McGeachy puts the main question for us: How do we live in healthy, Christlike tension between time and eternity? This was the main question for first-century Christians; it remains a main question for troubled twentieth-century Christians.

One way to introduce this question would be to ask class members how they might live their lives differently if they knew their "last days" had come. Might we do things we have neglected? Might we not want to do certain things any more?

In the meantime, what? We cannot live always in the urgency of "the last days." But we also know we do not have an eternity before us. So?

Paul counsels the Thessalonians (4:3, 8-11). What meaning do these words have for us in our present age?

Developing the Lesson

I. Introduce the main question.

This lesson may seem an excursion into ancient history unless we can feel within ourselves the fears, unanswered questions, and hopes of the Christians to whom Paul wrote in the years 50–51 A.D. One way to crawl into their skins is to imagine ourselves living in "the last days" of time.

Do we wonder about the same things? If we no longer await the signs promised in Matthew 24:29-35, we surely wonder about nuclear holocaust, nuclear winter, the sweeping epidemic of AIDS, devastating earthquakes, toxic wastes, and all the other world-wide traumas that scientists predict. And as we grow older we all wonder about death, the deaths of those we have known and loved and who have gone before us, and the meaning of our own deaths.

II. The day of the Lord

This lesson is a biblical word about time, the last days, and resurrection. It will be well at this time to review some of the scripture we have studied in this unit on visions of God's rule (especially Daniel 12; Ezekiel 37, and Isaiah 26). Jews and Christians alike have almost from the beginning expected a day of the Lord. Recall the early prophecy of Amos: "The Day of the Lord . . . is darkness and not light" (Amos 5:18). (Refer to "As You Read the Scripture" on the day of God.)

Two streams run through Israel's apocalyptic tradition: judgment and blessing. We have encountered both of these in Ezekiel and Daniel. The emphasis in Paul is less on judgment than it is on comfort and preparation for the day.

III. Are we also living "the last days"?

Hopefully the opening exercise of this lesson will bring some awareness that we live under the same promises. In a secular age we are less likely to

attribute any apocalypse to God. The vivid imagery of Matthew 24 or Mark 13 is not persuasive to us. But whether the apocalypse comes from God or "nature" or human agency, we do live under the threat of an end-time. And for each of us there is a certain end-time, with the recurring questions of Scripture still to be asked.

A child came to her grandmother, saying, "Billy said the world is coming to an end. Is that true?" Her grandmother gave a wise answer: "Each day is the end of the world for someone, and each day is a new day for us to live."

IV. In the meantime

The emphasis in Paul's letter is on how to live "in the meantime," in the tension between time and eternity. Consider Paul's prescription to the Thessalonians. Is it outdated in 1989? The morality of sex and marriage (4:1-8)? Love for each other, minding your own business, working with your hands (4:9-12)? Being sober (5:8)? Would we change any of that? How?

Paul's words were a great comfort to the Christians whose loved ones had died before "the great day." God has not forgotten them!

V. Each day: the last day and the first

The question of how to live in the tension between time and eternity has been well expressed in the rule: Live each day as if it were both the last and the first day of the rest of your life. Paul gives this formula to the Thessalonians, a rule that sees us through the unknowns of time: "Encourage one another and build one another up" (5:11).

Helping Class Members Act

As we pointed out in lesson 7, there is discouragingly little one can do in the way of action when it comes to apocalypse. We could walk around with placards saying "repent." But who looks at or listens to such displays?

We *can* act inwardly, however. We can think about how we would like to live both in *eternity* (as if this were the last day of our lives), and in *time* (as if this were the first day of a life that will continue). You might ask members of the class to bring their lives under thoughtful scrutiny, to see what they are honestly satisfied with and to try to imagine what God would want them to change. Paul's words to the Thessalonians might be a helpful instrument of evaluation. Pat McGeachy in "The Main Question" gives a helpful specific suggestion in the form of a checklist.

Planning for Next Sunday

In preparation for next week, you might have a number of class members volunteer to ask one other person, not necessarily a class member, this question: What resources have you drawn your strength from over the years? What has given you strength to "stand firm"? You should plan to make this sharing an important part of next week's lesson.

Stand Firm

Background Scripture: II Thessalonians 2–3

The Main Question—Pat McGeachy

And that's when she put her book down. And looked at me. And said it: "Life isn't fair, Bill. We tell our children that it is, but it's a terrible thing to do. It's not only a lie, it's a cruel lie. Life is not fair, and it never has been, and it's never going to be."

Would you believe that for me right then it was like one of those comic books where the light bulb goes on over Mandrake the Magician's head? "It isn't!" I said, so loud I really startled her. "You're right. It's not fair." I was so happy if I'd known how to dance, I'd have started dancing. (William Goldman, *The Princess Bride* [N.Y.: Ballantine, 1974], pp. 187-88)

I know how William Goldman felt. As long as you think life is supposed to be fair, you are always blaming yourself for the bad things that happen or taking the credit for the good stuff. But when you know that bad things happen to good people and that troubles can be expected, a great load is lifted. Ours is not to reason why, but to get on with the business of living.

I disagree with Edith Neisser on one point: The promise of the Bible is that one day things *will* be fair. One day God will set things right. But she's right, they aren't fair now, and we are in for more troubling times to come; you can count on it. So the main question for us is this: How shall we live victorious lives in a world where the cause of righteousness seems continually to be bested by the forces of darkness?

Look around you. Do you not see the presence of "the son of perdition" (2:3) in lots of places? Whatever you want to call it—the antichrist (I John 2:18), the devil (I Peter 5:8), lawlessness, the beast (Revelation 13:18), the principalities and powers (Ephesians 6:12)—there is no denying the presence of evil in our world. And sometimes we are almost overcome by it. It is then that we most of all need to "stand firm." In our last lesson we saw what manner of life we ought to be living in these latter days; in this one we look for the strength and comfort that will enable us to "hang in there" and to live, even in apocalyptic times, as Christians should.

As You Read the Scripture—Horace R. Weaver

Paul, Timothy, and Sylvanus heard the rumor that the day of the Lord had arrived. Paul writes to remind them that the "day" would not come "unless the rebellion comes first, and the man of lawlessness is revealed." The apostles also heard that some idlers and busybodies were creating problems. This letter was written to deal with these two major problems.

II Thessalonians 2:1-2. Verse 1 deals with two problems: the claim that the day of our Lord Jesus Christ has come, and "our assembling to meet him." Paul urged his fellow Christians "not to be quickly shaken in mind or excited, either by spirit [possibly words of prophecy by a member of their group] or by word [an oral message by a teacher], or by letter purporting to be from us [Paul, Timothy, and Sylvanus—perhaps a lost or maybe a forged

letter]." The phrase "assembling to meet him" refers to the usual Jewish apocalyptic final gathering together of Israel out of the dispersion. Here it refers to Christians.

Early Christianity held two theological points of view in tension: (1) Salvation is already accessible through Jesus' resurrection and the gift of the Spirit, and (2) there will be full (complete) salvation when all history and all the cosmos is redeemed and the kingdom of God is fulfilled. Gnostics taught the necessity of point one above and overlooked (or saw no need for) point two. Jesus thus would not be Lord of the cosmos or of history but only the savior of saved souls (see Leander Keck's article in *The Interpreter's One-Volume Commentary*, pp. 878-79).

Verses 3-12. Paul states clearly that the day of the Lord Jesus has not come, for it must be preceded by "the rebellion" and "the man of lawlessness." The word "rebellion" probably refers to a religious falling away within the church, which will affect the entire world. The "man of lawlessness" is a "son of perdition," who "exalts himself against every so-called god or object of worship. . . . He takes his seat in the temple of God, proclaiming himself to be God." This same attitude was held by Antiochus Epiphanes in 167 B.C. and by the mad Roman emperor Caligula. Emperor Domitian held the same exalted view of himself in the days when John wrote the book of Revelation, about 95 A.D.

Verse 6 refers to the "restrainer," using a neuter gender word. This non-male, non-female force restrains the lawless one. In verse 7 it is masculine gender. The writer(s) do not identify the restraining force, or power or authority. But "the mystery of lawlessness" is at work—invisible, intangible, unheard. This is very much like most forces of evil: intelligent, determined, dedicated, deadly, opposing everything good and godly in life. Lawlessness! But "the Lord Jesus will slay him with [nothing more than the] breath of his lips." The son of perdition cannot withstand the person of Jesus. Note that Satan does not come to war against God or Jesus; rather, the lawless one comes "by the activity of Satan," as the agent of Satan.

Verses 9-10 refer to the great tragedy to befall those "who are to perish"; they have seen satanic power, "pretended signs and wonders," because they "refused to love the truth and so be saved." The tragedy of their dedicated hatred of the true and beautiful is that they will be judged by the fruits of that style of life.

"Therefore God sends upon them a strong delusion, to make them believe what is false." Evil costs a person his life.

Verses 13-15. Gratitude is expressed to the Thessalonians "because God chose you from the beginning [as the first converts] to be saved, through sanctification by the Spirit and belief in the truth."

Selected Scripture

King James Version	Revised Standard Version
II Thessalonians 2:1-15	*II Thessalonians 2:1-15*
1 Now we beseech you, brethren, by the coming of our Lord Jesus Christ, and *by* our gathering together unto him,	1 Now concerning the coming of our Lord Jesus Christ and our assembling to meet him, we beg you, brethren, 2 not to be quickly shaken in mind or excited, either by spirit
2 That ye be not soon shaken in	

mind, or be troubled, neither by spirit, nor by word, nor by letter as from us, as that the day of Chrīst is at hand.

3 Let no man deceive you by any means: for *that day shall not come,* except there come a falling away first, and that man of sin be revealed, the son of perdition;

4 Who opposeth and exalteth himself above all that is called God, or that is worshipped; so that he as God sitteth in the temple of God, shewing himself that he is God.

5 Remember ye not, that, when I was yet with you, I told you these things?

6 And now ye know what withholdeth that he might be revealed in his time.

7 For the mystery of iniquity doth already work: only he who now letteth *will let,* until he be taken out of the way.

8 And then shall that Wicked be revealed, whom the Lord shall consume with the spirit of his mouth, and shall destroy with the brightness of his coming:

9 *Even him,* whose coming is after the working of Satan with all power and signs and lying wonders,

10 And with all deceivableness of unrighteousness in them that perish; because they received not the love of the truth, that they might be saved.

11 And for this cause God shall send them strong delusion, that they should believe a lie:

12 That they all might be damned who believed not the truth, but had pleasure in unrighteousness.

13 But we are bound to give thanks alway to God for you, brethren beloved of the Lord, because God hath from the beginning chosen you to salvation through sanctification of the Spirit and belief of the truth:

14 Whereunto he called you by

or by word, or by letter purporting to be from us, to the effect that the day of the Lord has come. 3 Let no one deceive you in any way; for that day will not come, unless the rebellion comes first, and the man of lawlessness is revealed, the son of perdition, 4 who opposes and exalts himself against every so-called god or object of worship, so that he takes his seat in the temple of God, proclaiming himself to be God. 5 Do you not remember that when I was still with you I told you this? 6 And you know what is restraining him now so that he may be revealed in his time. 7 For the mystery of lawlessness is already at work; only he who now restrains it will do so until he is out of the way. 8 And then the lawless one will be revealed, and the Lord Jesus will slay him with the breath of his mouth and destroy him by his appearing and his coming. 9 The coming of the lawless one by the activity of Satan will be with all power and with pretended signs and wonders, 10 and with all wicked deception for those who are to perish, because they refused to love the truth and so be saved. 11 Therefore God sends upon them a strong delusion, to make them believe what is false, 12 so that all may be condemned who did not believe the truth but had pleasure in unrighteousness.

13 But we are bound to give thanks to God always for you, brethren beloved by the Lord, because God chose you from the beginning to be saved, through sanctification by the Spirit and belief in the truth. 14 To this he called you through our gospel, so that you

our gospel, to the obtaining of the glory of our Lord Jē-sŭs Christ.

15 Therefore, brethren, stand fast, and hold the traditions which ye have been taught, whether by word, or our epistle.

Key Verse: **Stand fast, and hold the traditions which ye have been taught. (II Thessalonians 2:15)**

may obtain the glory of our Lord Jesus Christ. 15 So then, brethren, stand firm and hold to the traditions which you were taught by us, either by word of mouth or by letter.

Key Verse: **Stand firm and hold to the traditions which you were taught. (II Thessalonians 2:15)**

The Scripture and the Main Question—Pat McGeachy

Satan at Work (II Thessalonians 2:1-12)

To the list of the devilish names given above we need to add "the satan." I like to spell it with lowercase letters because I think that to personify the devil is to put it up as a kind of god over against God and to thereby give the devil more than his due than is right. But however you write it, or whatever you think about demons, don't fail to see that there is clearly a *demonic* presence in our world. Life is not fair. Ugly things happen, and, what is worse, they seem to happen often to those who deserve better.

Even more frightening, many men and women seem to be in league with the dark powers. There are lots of us who refuse "to love the truth and so be saved" (verse 10). As I write these words I am thinking of a man (I will call him Saul) who is in a mental hospital. He wants (he says) to be an artist and a priest, and begs me to send him to a monastery where he can paint and be holy. But every time anybody buys him a bus ticket, he ends up in a sleazy apartment somewhere, surrounded by filth, empty beer bottles, tubes of paint, and weird paintings of a hollow-eyed Jesus staring in demonic agony from the paper. The doctors say that he is schizophrenic. But just giving his disease a name does not keep it from being demonic.

I see this evil not only in troubled individuals like Saul but in high places as well: in the greed of some businesses, in the hunger for power in parts of every government, and in the wanton disregard that the whole human race has for our lovely planet, which our children will one day inherit. We are trashing it just as surely as Saul trashes his apartments, and we want to cry with Paul, "Who will deliver me from this body of death?" (Romans 7:24).

The second letter to the Thessalonians helps me to deal with demonic forces by making it clear that God permits them to have their day (verse 11) and that they are to be expected (verse 3). We are not to give up just because the false gods (verse 4) seem to be winning. Paul says, in effect, "What did you expect? This is just how things are." Why God permits this, I do not know. Perhaps it is because of a Divine patience, seventy-seven times more forgiving than you and I would be, which is letting the judgment day be put off until everyone has a chance to turn to the truth (verse 10). Perhaps it is just the way things are: that in a world where freedom and goodness are possible, it is necessary that badness and slavery be a real possibility too, and God is willing to take that risk.

As I say, I don't know. But I *do* know which side I'm on, and you do too. Let us then stand firm, do battle against the beast wherever we meet it, and trust that God, in that day whose time none of us knows (Matthew 24:36), will set things right.

FIRST QUARTER

Hang On! (2:13-17)

When I was a boy I used to delight in the fictional exploits of Frank Meriwell, the famous Yale pitcher who could throw a curve ball that broke first in and then out. What I liked best about Merry was how cool he was under stress. He never panicked, even when the train was bearing down upon him or he was about to be tethered to the runaway wild horse. Once, when he found himself trapped on a narrow Rocky Mountain road with a runaway stage coach thundering towards him, he calmly rode his bicycle over the edge of a precipice, laughing as he did so. I always wanted to be able to laugh like that in the presence of evil, but I thought it was only possible for superheroes like Frank Meriwell.

But here is hope for us ordinary mortals! Paul, who has suffered as much or more than any of us, says that he gives thanks to God always, and calls us to stand firm. How can he be rejoicing with the world thundering to doom all around him? (Paul didn't have the nuclear age, of course, but he had the wicked and cruel Roman Empire to contend with.) Is it really possible for feeble Christians like you and me to have such a joyful attitude in the presence of all the dark things that are going on around us?

Yes, it is, and Paul prays for us that this will happen. And he gives us the words of his benediction (2:16-17). Let me suggest that you make it your own prayer for your fellow Christians, just as it is given to the Thessalonians, or for you and yours, changing the pronouns to the first person, or even for yourself, changing the pronouns to the first person singular. I now give it to you in that form and invite you to pray it aloud:

> O Jesus Christ my Lord, O God my Father, you loved me and gave me eternal comfort and good hope through grace. Comfort my heart and establish me in every good work and word.

It is a good prayer for times of trouble. Note that it is addressed both to God and to Jesus, almost as though they were the same. Which of the two do you customarily visualize when you pray? Here we have a convincing argument that it doesn't really matter; that we are supposed to confuse the two. After all, if we have seen one, we have seen the other (John 14:9). I believe that if you will make this prayer your own, you will have strength in those times when the Jordan swells.

We Need Each Other (3:1-17)

But it is not enough for me to pray to God for comfort for myself. I need to pray for Paul as Paul is praying for me; we need each other. Even the negative things that Paul has to say in this passage about lazy bums who won't pull their fair share of the load (verse 6) or who refuse to obey the traditions (verse 14) are the backside of the positive truth that we all need each other. Notice that Paul doesn't want us to consider these weaker members as evil in themselves (verses 15) but as sisters and brothers who are in trouble.

That brings me back to my poor disturbed friend, Saul. The enemy is not flesh and blood (Ephesians 6:12), not my fellow human beings, but the dark forces of evil to which we humans fall prey. I will seek with all my power to rescue Saul from the schizophrenic devil that possesses him. But when I

have done my best, I will have to withdraw from him (verse 14), as hard as that is, that he may be forced to face the truth about himself. I pray that the Lord will give him peace (verse 16), but I cannot let him destroy the peace of God's people. We need to strengthen each other, for these are evil times.

But let's not give up too easily. As Paul says, "Do not be weary in well-doing" (verse 13), or again, "May the Lord direct your hearts to the . . . steadfastness of Christ" (verse 5). I don't know how you picture Jesus' virtues. He is variously seen as gentle, peaceful, tender, loving, and kind, with children on his knee. Quite so. But sometimes it helps me to remember that of all the qualities that Jesus possessed the one I admire the most was his faithful endurance. When all others forsook him, he kept on, always with his face set for Jerusalem, to the agony of the cross. And I do not have to be a Frank Meriwell to partake of that same endurance. His rod and staff can comfort me in the valley of thick darkness, and I can keep on keeping on, even when my own strength fails.

In this, Jesus is most like God, for God is the great Keeper of promises. The Guardian of Israel is awake while you and I are asleep, keeping watch over us wayward children. Even in our dark times God is with us, as with the people of the little church in Thessalonica, long ago. It isn't easy, standing firm when the world around us is in flames. But we can, and we will, because the faithful, steady Jesus is our companion of the way.

Helping Adults Become Involved—Robert E. Luccock

Preparing to Teach

Teaching this lesson can be tough because it brings us smack up against the most baffling question we ever have to face: Why is there so much evil ("lawlessness") in the world? It is for that reason one of the most important lessons in the unit.

Your preparation will include a good share of time recognizing what the main issues are and developing a plan by which the class may come to grips with the problem. You may want the class to work its way into this mystery through three stages: (1) acknowledge the presence and extent of evil in the world, (2) consider attempts to rationalize or explain why evil is here, and (3) determine how to live with it in faith.

First, of course, read II Thessalonians 2–3. Horace Weaver's "As You Read the Scripture" will help you grasp the meaning of this not always easy to understand passage. Matthew 24:15-28 vividly pictures evil rampant in the world. On living with such evil you will find comfort in such passages as Isaiah 43:1-7; John 16:31-33; and Matthew 10:24-39.

Here is an outline of the lesson:

> I. Introduce the main question.
> II. Lawlessness is at work (2:7).
> III. "Stand firm" (2:15).
> IV. "The Lord . . . will strengthen you" (3:3).

Introducing the Main Question

Here is the main question: How shall we live victorious lives in a world where the cause of righteousness seems continually to be bested by the forces of darkness?

FIRST QUARTER

To introduce this question and follow through on it compels us first to take full account of the evil (principalities and powers, Ephesians 6:12) against which we must contend. Do some brainstorming on this. You will list evils and lawlessness in high places of government, the marketplace, your own community. You will not overlook demonic evil within families or the evil within ourselves—our hidden, often unacknowledged feelings of anger, lust, jealousy, racism, and our cowardly cop-outs.

Why is there so much of this in the world? How can we ever stand firm against it? We will move on to these questions as we develop the lesson.

Developing the Lesson

I. Introduce the main question.

(See above, "Introducing the Main Question"; add ideas that come to you from Pat McGeachy's "The Main Question.")

When you have the broad picture of the extent and intensity of evil that the class recognizes, you will neither be able nor want to avoid the question, Why? Why does God allow such lawlessness to continue unchecked? Why do good people not get what they "deserve"? Why are so many good causes defeated or allowed to fail? Neither Paul nor the Thessalonian Christians asked these questions as such. We cannot avoid them.

Three kinds of explanations are most commonly offered:

1. We suffer on account of our sins. This is what the friends of Job in the Old Testament tried to tell him, but he would have none of it. (Of course, there is a difference between "natural evil" such as sickness and lawless evil such as Paul talks about, but people have tried to rationalize them in the same way.) Many people think that the perpetrators of evil carry out God's justice. If I am the victim of evil, I must have done something to deserve it. A variant of this theory has it that I suffer on account of the sins of my ancestors. None of this thinking can square with the teachings of Jesus, or with his own death at the hands of lawless men (Acts 2:23).

2. Others have said that lawlessness comes from our God-given human freedom (Joshua 24:14-15). Men and women are free to choose evil as well as good. Lawlessness comes into the world through the abuse of freedom. This seems to be true, but why?

3. People have also dealt with evil by saying, "It will be made right in the life to come," or, "When the kingdom comes, accounts will be settled." This is one way to deal with the problem. It is not an explanation. In the meantime . . .

II. Lawlessness is at work (2:7).

Consider the evils Paul mentions to the Thessalonians: deceit (2:3, 10), rebellion against God (2:3), blasphemy (2:4), pretension (2:9), untruthfulness (2:12). Recall some of the evils Paul identified in his first letter to the Thessalonians (I Thessalonians 4:1-8; 5:14-22).

III. "Stand firm" (2:15).

Paul offers no explanation as to why such lawlessness continues, only the promise that the Lord Jesus will slay the "man of lawlessness" (2:8). The time of that settlement has not yet come (2:1-2). In the meantime the Thessalonians are to stand firm. In what? Presumably the whole Christian gospel. As Paul says, "Hold to the traditions which you were taught" (2:15).

This is a word also to us. For the "time of troubles" has not yet ended two thousand years later. Lawlessness is still rampant, and it looks as though it may be until the end of time. Early Christians believed the end-time would come soon. Indeed, Paul says, "We shall not all sleep [die]" (I Corinthians 15:51) before the kingdom appears. We have had to revise that timetable repeatedly. We expect to be at it a long time, beyond our generations. How do we cope?

IV. "The Lord . . . will strengthen you" (3:3).

Without this assurance, telling someone to "stand firm" is like shouting to a person caught in a riptide, "Swim harder." But who can swim against the tide of lawlessness in the world, evil piled up by strong men and women who put themselves above the moral law? Paul promises a resource *greater than ourselves!* Read Ephesians 6:10-20 and consider the metaphors the writer of that letter uses. Of what resources do they speak?

Helping Class Members Act

You could continue the activity that was suggested in the last lesson's "Preparing for Next Sunday" section for another week. Class members who did not volunteer for this week might, on the basis of sharing today, offer to ask friends about their sources of spiritual strength. Certainly class members can search their own memories about what has sustained them, given them strength to "stand firm." From such reflection may come a feeling of surprise at how many resources they have. And introspection for this purpose may become a powerful catalyst for thanksgiving.

Planning for Next Sunday

An important question will emerge out of next week's lesson: How does Jesus help people find their true destinies in life? Be thinking about this during the week, because what people see Jesus doing with human lives is a step toward the apocalyptic faith of the New Testament.

UNIT IV: REVELATION: A MESSAGE OF HOPE
Horace R. Weaver

FOUR LESSONS **NOVEMBER 5-26**

As we read the book of Revelation, we must be aware of the historical period in which it was written and realize that the book is addressed to terribly persecuted Christians. The Roman emperor Domitian acclaimed himself God and demanded that all nations in the empire worship him. A new statue of Domitian was built in Ephesus, and priests demanded that it be worshiped. Christians were forced to decide who they would worship: the god Caesar, or God as seen in Jesus Christ. John, a bishop of Ephesus who was enduring terrible hardships on the island of Patmos, wrote Revelation to help his people maintain loyalty to Christ and God even unto death.

If we think of the Jewish Holocaust, with its horrors and fears of torment, we can begin to understand John's message. John's writing has nothing of the Sermon on the Mount in it. Jesus Christ has become a divine warrior who overcomes all who oppose his military might. Christ is said to be seated on a white horse, wearing a white robe dipped in blood, leading his heavenly armies—made up mostly of martyrs and angels. John notes that Jesus was descended from David, was of the Jewish race, and was crucified and raised from the dead, but these few facts barely scratch the surface of the Synoptic Gospels with their gospel of love and concern for hungry, lost, unredeemed sinners. So we must keep in mind that John is not writing a message to us directly but rather indirectly. That is, John's message is directed to those Christians living in his time (around A.D. 90–96). We join him in his claim that God is the God of history, that God is concerned about the unjust suffering of his followers. God loves them. Evil will eventually be destroyed. The kingdom will come.

Unit IV offers four lessons. "Christ Redeems," November 5, portrays the glory of the Creator and the wonders of the Lamb (Jesus Christ). "Provision for the Redeemed," November 12, affirms God's desire to grant life after death to the 144,000 who are "sealed," plus millions more who are faithful and loyal in worshiping God rather than Caesar. "The Victorious Christ," November 19, discusses Christ's defeat of the anti-God forces and thus grants the ultimate gift of life to the faithful. "New Heaven and New Earth," November 26, denies that there will be a renovation of heaven and earth (which will be destroyed by fire); rather, there will be a truly new heaven and earth.

LESSON 10 NOVEMBER 5

Christ Redeems

Background Scripture: Revelation 4–5

The Main Question—Pat McGeachy

Like Ezekiel and Daniel, much of the book of Revelation is strange and hard to understand. But in these two chapters we have a beautiful and simple image with a meaning that is crystal clear. And this passage gives us a way of answering what may be the toughest question of all: How can death and guilt be overcome? Or, to put it another way: Is there any hope for our troubled world, so full of suffering and inhuman behavior?

The answer of Revelation is, of course, a resounding yes. But there is more to it than simple optimism. We are given a vision into the throne room of God, into the heart of eternity, and there we learn something about the Divine nature. And as we learn, there rises in the background an ever-increasing chorus of celestial voices, growing in volume and number until at last it overwhelms us with splendor. What we have here is almost like

the final scenes of a great musical or grand opera, one that ends happily with great rejoicing.

The word "revelation" (please note that it is *not* in the plural) means "an uncovering," as when the lid is lifted on a stewpot, revealing the contents. In this weird and wonderful book, with which the New Testament ends, we catch a glimpse (nothing more) of eternity. The book was written during a time of great persecution, when the church seemed to be meeting defeat on every hand. It was given to them as a word of comfort in a dark hour. And such a word it should be for us. Let us turn to these two chapters, with their vision of the throne room of God, and seek an answer to the question that is asked in 5:2: "Who is worthy to open the scroll and break its seal?" The scroll is the book of our destinies, and the Lamb, who is Christ, has the power to bring it to fulfillment. That is good news indeed, and worth a song—and what a choir sings it! But let us look through this knothole in eternity and see for ourselves.

As You Read the Scripture—Horace R. Weaver

In the introduction to unit 4 the position of chapters 4–5 is located between the seven letters to seven individual churches (Revelation 1–3) and the main body of Revelation with its group of seven visions (Revelation 6–21:8).

Revelation 4–5 contain two introductory visions of eternal realities in heaven. The first vision describes the glory of the Creator; the second describes the glory of the Lord (Jesus, the Lamb). Our background scripture (4–5) includes both visions.

Revelation 4:1-11. A variety of prophetic and apocalyptic threads are interwoven to produce a magnificent view of God. John looks heavenward and finds an "open door" through which he enters: "At once I was in the Spirit, and lo, a throne stood in heaven" (verse 1). Prophetic strands from Isaiah 6, Ezekiel 1, and Jeremiah (17:12) colorfully portray the divine scene, with God on his bejeweled and artistically designed throne, surrounded by twenty-four thrones, each occupied by an elder—probably twelve for the tribes of Israel and twelve for the apostles. The famous four creatures perpetually sing: "Holy, holy, holy, is the Lord God Almighty, who was and is and is to come" (verse 4:8).

The deity is categorized:

> Worthy art thou, our Lord and God,
> to receive glory and honor and power,
> for thou didst create all things,
> and by thy will they existed. . . .
> (4:11)

"All things" include such things as the particles that form matter (quarks and leptons), DNA, and the magnetic "compass" located behind the eyes of migratory indigo bunting birds and monarch butterflies, who fly thousands of miles with unerring skill. The earth is full of the glory of God (Isaiah 6).

Revelation 5:1-14. The vision of the Lamb is not about a meek and mild Messiah. The Lamb, another title for Jesus Christ, is symbolic of the Paschal Lamb of John's Gospel.

John sees "in the right hand of him [God] who is seated on the throne a

scroll written within and on the back, sealed" (verse 1). John borrows this figure of speech from Ezekiel (2:9-10). John sees the scroll, "sealed with seven seals," which needs to be opened to release the seven plagues contained within it. The seven seals will be removed one at a time as the scroll is unrolled, so that the plagues will not be released simultaneously, but separated by time.

John "wept much that no one was found worthy to open the scroll or to look into it" (verse 4). But one of the twenty-four elders seated on thrones told John not to weep, for "lo, the Lion of the tribe of Judah, the Root of David . . . can open the scroll and its seals" (verse 5). The lion of Judah refers to Genesis 49:9-12, where Jacob states that

> Judah is a lion's whelp
>
> ..
>
> The scepter shall not depart from Judah
>
> ..
>
> He washes his garments in wine,
> and his vesture in the blood of grapes.

Descent from David is not as important as the fact that Christ "has conquered, so that he can open the scroll and its seven seals" (verse 5).

"Between the throne and the four living creatures and among the elders," John sees a Lamb, "as though it had been slain" (i.e., it is spattered with blood and sweat) (verse 6). The Lamb has seven horns (symbolizing its power) and seven eyes (symbolizing the omniscience of Christ).

When the Lamb takes the scroll, the four living creatures (compare Ezekiel 1) and the twenty-four elders prostrate themselves before him. And they sing a new song about how the lamb "hast made them [the new Israel] a kingdom and priests to our God, and they shall reign on earth."

Having heard millions of heavenly voices singing (5:11-12), John now hears "every creature in heaven and on earth and under the earth and in the sea, and all therein, saying, 'To him [God] who sits upon the throne and to the Lamb be blessing and honor and glory and might for ever and ever.' And the four living creatures [cherubim/seraphim] said, 'Amen!' and the [twenty-four] elders fell down and worshiped" (verses 13-14).

Selected Scripture

King James Version	Revised Standard Version
Revelation 5:1-12	*Revelation 5:1-12*
1 And I saw in the right hand of him that sat on the throne a book written within and on the backside, sealed with seven seals.	1 And I saw in the right hand of him who was seated on the throne a scroll written within and on the back, sealed with seven seals; 2 and I
2 And I saw a strong angel proclaiming with a loud voice, Who is worthy to open the book, and to loose the seals thereof?	saw a strong angel proclaiming with a loud voice, "Who is worthy to open the scroll and break its seals?" 3 And
3 And no man in heaven, nor in earth, neither under the earth, was	no one in heaven or on earth or under the earth was able to open the scroll or to look into it, 4 and I wept

able to open the book, neither to look thereon.

4 And I wept much, because no man was found worthy to open and to read the book, neither to look thereon.

5 And one of the elders saith unto me, Weep not: behold, the Lion of the tribe of Juda, the Root of David, hath prevailed to open the book, and to loose the seven seals thereof.

6 And I beheld, and, lo, in the midst of the throne and of the four beasts, and in the midst of the elders, stood a Lamb as it had been slain, having seven horns and seven eyes, which are the seven Spirits of God sent forth into all the earth.

7 And he came and took the book out of the right hand of him that sat upon the throne.

8 And when he had taken the book, the four beasts and four *and* twenty elders fell down before the Lamb, having every one of them harps, and golden vials full of odours, which are the prayers of saints.

9 And they sung a new song, saying, Thou art worthy to take the book, and to open the seals thereof: for thou wast slain, and hast redeemed us to God by thy blood out of every kindred, and tongue, and people, and nation;

10 And hast made us unto our God kings and priests: and we shall reign on the earth.

11 And I beheld, and I heard the voice of many angels round about the throne and the beasts and the elders: and the number of them was ten thousand times ten thousand, and thousands of thousands;

12 Saying with a loud voice, Worthy is the Lamb that was slain to receive power, and riches, and wisdom, and strength, and honour, and glory, and blessing.

much that no one was found worthy to open the scroll or to look into it. 5 Then one of the elders said to me, "Weep not; lo, the Lion of the tribe of Judah, the Root of David, has conquered, so that he can open the scroll and its seven seals."

6 And between the throne and the four living creatures and among the elders, I saw a Lamb standing, as though it had been slain, with seven horns and with seven eyes, which are the seven spirits of God sent out into all the earth; 7 and he went and took the scroll from the right hand of him who was seated on the throne. 8 And when he had taken the scroll, the four living creatures and the twenty-four elders fell down before the Lamb, each holding a harp, and with golden bowls full of incense, which are the prayers of the saints; 9 and they sang a new song, saying,

"Worthy art thou to take the scroll
 and to open its seals.
for thou wast slain and by thy
 blood didst ransom men for
 God
from every tribe and tongue and
 people and nation,
10 and hast made them a kingdom
 and priests to our God,
and they shall reign on earth."
11 Then I looked, and I heard around the throne and the living creatures and the elders the voice of many angels, numbering myriads of myriads and thousands of thousands, 12 saying with a loud voice, "Worthy is the Lamb who was slain, to receive power and wealth and wisdom and might and honor and glory and blessing!"

Key Verse: **Worthy is the Lamb that was slain to receive power, and riches, and wisdom, and strength, and honour, and glory, and blessing. (Revelation 5:12)**

Key Verse: **Worthy is the Lamb who was slain, to receive power and wealth and wisdom and might and honor and glory and blessing! (Revelation 5:12)**

The Scripture and the Main Question—Pat McGeachy

Twelve and Seven (Revelation 4:1-5)

If you are going to study Revelation, you will have to come to terms with its numbers. The book itself is divided into seven parts, and most of those sections are further subdivided into parts of seven (seven seals, seven bowls, seven trumpets, seven angels, etc.). The number seven fascinated the ancients (seven known planets, seven days in the week named after those same planets). Seven seemed to be the number of perfection, so that six (or 666) is the number of evil, that which falls short of the perfect (see Revelation 13:18).

Twelve is the number for the church, and in this passage (verse 4) we have twice twelve or twenty-four. Surely we have here the church of the Old Testament (twelve tribes) and the church of the New Testament (twelve apostles), united at last. It is the promise that Paul made in Romans 11:26, that all Israel would be saved. The scene around the throne is one of rejoicing. It is as though the story has finally come to its glad and happy climax; all God's people are gathered together at last; the circle is unbroken, so the whole crowd has burst spontaneously into "Hail, Hail, the Gang's All Here." What a celebration!

The Four Creatures (4:6-10)

In the King James Bible these are called "the four beasts." But the word "beast" (perhaps due to the story "Beauty and the Beast") conjures up visions of a horrible creature (*The Beast That Ate Pittsburgh*). But then so does the word "creature" (*The Creature from the Black Lagoon*). In fact, both words simply mean "a created being."

The "living creatures" are to be identified with the seraphim of Isaiah 6:2 as well as the cherubim of Ezekiel 10:20. Note that the Hebrew suffix "im" makes a word plural. In the singular, we would call the creatures "seraph" and "cherub," the latter mistakenly associated by painters in the Middle Ages with fat little babies; not so—they were fearsome creatures. Notice the similarity of the images of lion, ox, and eagle with the pictures given in Ezekiel 1:10.

The important thing about this scene is not so much the nature of the beasts as the observation that they never stop singing (verse 8). In the great musical in the sky, all the angels and archangels know the words and the music, and the entire heavenly entourage joins in the glad rejoicing. The doxology sung by the four beasts is the same song sung by the seraphim of Isaiah 6, joined in many times over by United Methodists, Presbyterians, Disciples, and others in the well-known hymn, "Holy, Holy, Holy!"

The Casting of Crowns (4:9-11)

As the cameras close in on the central figures in the throne room, the twenty-four elders are heard continuing the anthem with a song giving honor to the One who sits on the throne, "who was and is and is to come."

The Lion and the Lamb (5:1-10)

The One who is worthy of opening the book that contains the destiny of the human race is described both as a Lion and a Lamb, in other words, both as the triumphant Messiah and the Suffering Servant. For all of those who are wondering about the nature of forgiveness, we are clearly told by this sequence of things that the Divine purpose does not depend on us for the fulfillment of the letter of the law but on the triumph of the Lamb, the conquering Messiah.

In the King James Version of the Bible, this scroll is simply called a "book." The Revised Standard Version correctly calls it a "scroll," for that in fact is what it is. Perhaps it will help us if we describe it simply as a rolled-up book, *The Lamb's Book of Life* (see 21:27). The Lamb's book is the book of destiny, our passport to heaven, the secret of our fortune. We might ask the question like this: "Who can solve the riddle of life and give us hope?" Or perhaps, "How can I ever get out of this mess that my guilt and sin have got me into?" (Paul says it very much like that in Romans 7:24.)

How is this Lion/Lamb able to solve the riddle of life? Note from the description in verse 6 the curious nature of the creature:

—it stood as though it had been slain (a very difficult way to stand!)
—it had seven horns
—it had seven eyes

Because of the perfect nature of the number seven as it is used in this book, we can assume for the Lamb (Christ) purity of life. So, God has provided a perfect sacrifice, a pure and holy Lamb to be slain in our place.

It is impossible for me to read this passage without thinking of the words of Abraham in Genesis 22:8, "God will provide himself the lamb." If you remember that story, it was Abraham's son who was to be the lamb; in our story it is God's Son who fills that role. I must confess to you that the idea that God would ask Abraham to do such a thing is difficult for me to stomach. But as far as that goes, the whole Hebrew sacrificial system kind of seems a bloody, pagan mess. (You will notice that the Jews haven't practiced it since the destruction of the temple, although one of my rabbi friends tells me that visitors continually ask him, "Where do you sacrifice the animals?") It is hard for people of our day to put ourselves in the position of those who were accustomed to think of the sacrifice of innocent beasts as a way of atoning for our sins, or "appeasing" God.

Of course, enlightened people have always known that such sacrifices are, like our sacrament of the Lord's Supper, outward signs of a deeper truth. See, for example, Psalm 50:12-15; Amos 5:21-24; or Hosea 6:6, where it is clearly stated that justice and righteousness are far more important than the symbols of worship. But the atoning death of Jesus the Lamb is not "merely" a sacramental sign. It is a real death, a real sacrifice,

and a real turning of reality upside down. As has often been said, Jesus was not crucified on a brass cross between two candlesticks, but on a rude wooden frame between two thieves. It was a bloody, horrid business, with all the stench of death. But it is the mystery of God, that is, the nature of reality, that pure innocence suffers to redeem the guilty, and that the love of God for the world is such that the ultimate sacrifice is willingly given (John 3:16).

God did not send Jesus into the world to condemn the world (John 3:17) but to *save* the world! And it has been done! Whether you think of it as substitution (Christ substituted for me in the prisoner's dock), conflict (Christ doing battle against the forces of darkness), example (Christ showing us the way of humble obedience unto death), or moral influence (Christ giving us the inspiration to follow in his footsteps), the fact remains the Lamb has done it, with the strength of a lion. I think the atonement must be something of all of those things and a lot more that I am not capable of understanding, but in this vision of eternity, seen through a wrinkle in time, I can see just enough to know that *it has been done!*

The World's Greatest Choir (5:11-14)

And so, I want to join with the jillions of angels (that's about the best translation I can give to verse 11) and every creature in heaven and on earth and under the earth (does this mean that even Satan will finally give up and join the chorus?) and the humpback whales and the mermaids in the sea, in singing the glad and glorious hallelujah. What a choir that will be! I can sing as loud as I want to.

Helping Adults Become Involved—Robert E. Luccock

Preparing to Teach

The first thing we must do in preparing to teach these lessons from Revelation is to put aside any notions that this writing is literally true. It is symbolically true. This distinction is important. John, who wrote Revelation on the island of Patmos in the late first century, put his visions of God and the Christ in symbolic pictures. No one has ever seen God, but John wanted to encourage Christians who in many places were under severe siege. Through his visions he affirmed the power of God, declaring God to be worthy of glory and honor. And he gave assurance that the Lamb (Christ) was given power to redeem the world.

John's visions are filled with first-century imagery well understood by his readers. Those details are no longer relevant to us. The truths those visions proclaimed are eternal, as important today as they were in John's day. In preparing to teach it will be important to reflect on what questions must have come to the minds of Christians living in a world of threat and persecution.

Here is an outline of the lesson:

I. Introducing the main question
II. Visions of Revelation—God
III. Visions of Revelation—the Lamb

Introducing the Main Question

This is the main question: Who can solve the riddle of life and give us hope? Life is still a riddle nearly two thousand years after Revelation was written. And even for Christians not directly threatened with persecution for following the Christ, ours is hardly a time of soaring hope. A promising way to introduce the main question would be to have students share what they believe to be the questions that most disturb people today. Your teaching task will be to bring those questions up against the visions of Revelation and discover what Revelation has to say to troubled Christians today.

Developing the Lesson

I. Introducing the main question

Who can solve the riddle of life and give us hope? The usual procedure in teaching is to work *from questions to answers*. In this lesson we will be working *from answers back to questions*. Revelation 4–5 give us the answers that John gave to the Christians of his day. From these visions (answers) we can find our way back to what the questions must have been. "Who can solve the riddle. . . ?" Why do such things happen to us (persecution, martyrdom)? Is there any hope, now or hereafter?

What questions do people ask *today*? List the ones that seem most disturbing to the class: What about the future? Does life have any ultimate meaning? Is there any hope? Although couched in a different language, are these not the same questions Christians asked in the first century? What about the visions seen by John? Do they have meaning or comfort for us?

II. Visions of Revelation—God

Look closely at Pat McGeachy's "The Main Question." He helps us understand the importance of numbers in Revelation and the way in which numbers became a secret code to Christians who knew the key. It is interesting to recall at this point how spirituals served the same purpose for slaves in America. The spirituals were coded symbols through which people gave encouragement, comfort, and messages about freedom to each other. What we see in John's visions is a picture of power and glory far transcending the earthly grandeur of Rome.

In John's vision, the church of the New Testament (the twelve apostles) comes together with the twelve tribes of the Old Testament. There is *continuity* from the beginning, and *consummation* in the vision of heaven at the end. (Again, refer to Dr. McGeachy.) As we read 4:10, the lines from Charles Wesley's hymns come to mind: "Till we cast our crowns before thee,/Lost in wonder, love, and praise" ("Love Divine, All Loves Excelling"). To move from some of the fantastic imagery of Revelation to a great congregation singing Wesley's hymn (which is also filled with symbolic pictures) is to realize that the certainty of God found in Revelation has come down the centuries so that we see it and hear it today.

III. Visions of Revelation—the Lamb

But such visions of the glory, majesty, and power of God are only part of the answer. Who can put *us* in that scene? We still need a Savior who can lead us into the Divine presence. Without that power from beyond ourselves, we

are like waifs looking through the windows of a great mansion at a wonderful party to which we have no invitation, and where we do not belong.

John says the Lamb, Jesus the Christ ("Lamb of God who takes away the sin of the world"—John 1:29), is worthy and able to do that. The Lamb can open the scroll (the book of life) and read. It is essential at this point to talk about *how* Jesus Christ does this. We can't see into the realm of heaven, but Christ begins to unroll the scroll even here where we can see and hear. How does Jesus help people find their true destinies in life? What about those who have found a new purpose in him? And those who received God's forgiveness through him and were able to begin again? To catch something of that vision here and now is to appreciate even more the glorious songs that the myriads sing in John's vision.

A stirring vision, but will it ever come to be? Two thousand years have brought in their train apartheid, oppression of people on every continent of the earth, innocent lives snuffed out by preventable hunger, disease, and abuse. Can we really believe in the vision? We have only our faith that we belong to the Lamb and the "evidence of things not seen": God's mercy, love, and forgiveness. That can be our apocalyptic vision.

Helping Class Members Act

It often happens that our best actions are things that we do deep inside ourselves, not seen by anyone else. In the Lamentations of Jeremiah we are given the promise, "The Lord is good to those who wait for him, to the soul that seeks him" (Lamentations 3:25). Have the students read on through verse 28. Quiet times when we focus all of our memory and awareness on God's power and love are times when new visions may come to us.

But we can act toward others as well. Take time this week to think of someone who needs encouragement, comfort, fresh hope. A visit, a letter, a phone call, a gift, an invitation, a word of faith when vision is dim—to do such things you do not have to presume to be an apocalyptic messenger. But you may restore vision for someone in the time of waiting.

Planning for Next Sunday

Next week we shall think about how to survive the woes of the world. Faith seems to be indispensable in the lives of survivors. Reading some of the great faith passages of Scripture will be good preparation. Suggestions: Psalm 121; Isaiah 11:6-9; 43:1-3; 55:1-11; Micah 4:1-4; Jeremiah 31:31-34; John 16:29-33; Revelation 21:1-4.

Provision for the Redeemed

Background Scripture: Revelation 7

The Main Question—Pat McGeachy

In order to understand the question raised by this chapter, we must look briefly at chapter 6. (Note that chapter 7 begins with the words "After this.") Using the vivid image of the four horsemen of the apocalypse and a scene of celestial catastrophe, chapter 6 describes the troubles that the world can expect: war, famine, death, and disaster. And anybody who has lived for more than a few years knows that this vision is accurate. As Jesus put it, "In the world you have tribulation" (John 16:33).

The question is, How can we survive the woes of the world, both those we have now and the ones we can confidently expect in the future? And to complicate the question a little further, Is it fair for those who have really been faithful to suffer like the bad guys? Revelation 7, which comes in the midst of the opening of the seals of the Lamb's book of life (see our last lesson) to reveal a destiny of troubles upon troubles, depicts an idyllic scene in which the redeemed of God are protected from the cataclysm by the Lamb himself.

There is another seal involved. Unlike the seven seals that bind the book, this seal is a mark made by the living God on the foreheads of the redeemed. The image that comes to my mind when I ponder this scripture is the invisible seal that they stamp on your hand at some theme parks when you have to go out. It shows up when held under an ultraviolet lamp at the gateway, and gives you permission to come back in again. You have permission to "go in and out and find pasture" (John 10:9). If God marked Cain the murderer (Genesis 4:15) to protect him in the world, surely there will be protection for the saints and martyrs. Is this really so?

As You Read the Scripture—Horace R. Weaver

In Revelation, John wrote of things that were (chapter 1), things that are (chapters 2–5), and things that shall be hereafter (chapters 6–22). John wrote of seven visions. The first was the vision of the seven seals (chapter 6); the second, the vision of the seven trumpets (chapters 8–9). Between chapters 6 and 8–9 is the first of three interludes, which deals with the vision of the redeemed from which today's lesson is drawn. This vision has two parts: (a) the sealed of the house of Israel (7:1-8), numbering 144,000, and (b) a proleptic tableau of the glorified martyrs—innumerable!

Revelation 6 describes horrible events that are at hand: conquest (war), disaster, famine, and death.

Revelation 7:1. Before parts *a* and *b* (above) can be fulfilled, a great persecution will bring the required number of martyrs to a specified total. John says, "After this [the vision of war and its disasters] I saw four angels standing at the four corners of the earth." They were restraining the "four winds" of destruction, causing a temporary pause in the affliction of plagues on earth. The exiles in Babylon apparently brought this cosmology

back with them to Judah. The earth was considered a square, with angelic watchers stationed at each corner of the square earth. These watchers could restrain or permit the four winds to wreak havoc. In this vision the angels were "holding back" the winds.

Verses 2-3. The question of the faithful was, Would they become extinct? The answer is "I saw another angel ascend from the rising of the sun, with the seal of the living God." This angel said, "Do not harm the earth or the sea or the trees, till we have sealed the [Christian and Jewish] servants of our God upon their foreheads." The "seal" is the stamp made by the signet ring of authority. This stamp guarantees protection to the servants of God. Ezekiel 9:4 refers to an angel placing an ink mark on the foreheads of the righteous so they will not be killed when sinful citizens of Jerusalem are destroyed.

Verses 4-7. The number of the faithful to be sealed (and thus protected) was to be 144,000 of the new Israel. Symbolically, the names of the tribes of Israel are called and sealed.

Verses 9-12. In this proleptic tableau of the glorified martyrs, victory of all martyrs (beyond the 144,000) is anticipated in advance of the event. Their number is incalculable—"which no man could number"—and they are from "every nation, from all tribes and people and tongues" (i.e., from every national, racial, and linguistic group in the Church Triumphant). They stand before the throne "clothed in white robes" (symbols of immortality), with palm branches (symbols of victory) in their hands.

The heavenly choirs sing antiphonally. The uncountable group sings, "Salvation belongs to our God who sits upon the throne, and to the Lamb!" Then "all the angels . . . round the throne and round the elders and the four living creatures . . . worshiped God, saying: 'Amen!' " (a word that signifies agreement, if not a repetition of what was heard of the first choir). They add the sevenfold doxology: "Blessing and glory and wisdom and thanksgiving and honor and power and might be to our God for ever and ever! Amen."

John is an ecstatic celebrant of God. Like Spinoza, he was a "God-intoxicated man."

Verses 13-17. One of the twenty-four elders, hearing the affirmations of millions, asks John, "Who are these?" John responds: Those "who come out of the great tribulation; they [the martyrs] have washed their robes and made them white in the blood of the Lamb." The scene closes with a vocal tapestry of prophetic utterances, borrowed from Daniel 12:1; Isaiah 49:10; Psalm 121:6; Ezekiel 34:23; Psalm 23:2; and Isaiah 25:8. John loved his Old Testament!

Selected Scripture

King James Version

Revised Standard Version

Revelation 7:1-4, 9-10, 13-17

1 And after these things I saw four angels standing on the four corners of the earth, holding the four winds of the earth, that the wind should not blow on the earth, nor on the sea, nor on any tree.

Revelation 7:1-4, 9-10, 13-17

1 After this I saw four angels standing at the four corners of the earth, holding back the four winds of the earth, that no wind might blow on earth or sea or against any tree. 2 Then I saw another angel

2 And I saw another angel ascending from the east, having the seal of the living God; and he cried with a loud voice to the four angels, to whom it was given to hurt the earth and the sea,

3 Saying, Hurt not the earth, neither the sea, nor the trees, till we have sealed the servants of our God in their foreheads.

4 And I heard the number of them which were sealed: *and there were* sealed an hundred *and* forty *and* four thousand of all the tribes of the children of Israel.

...

9 After this I beheld, and lo, a great multitude, which no man could number, of all nations, and kindreds, and people, and tongues, stood before the throne, and before the Lamb, clothed with white robes, and palms in their hands;

10 And cried with a loud voice, saying, Salvation to our God which sitteth upon the throne, and unto the Lamb.

...

13 And one of the elders answered, saying unto me, What are these which are arrayed in white robes? and whence came they?

14 And I said unto him, Sir, thou knowest. And he said to me, These are they which came out of great tribulation, and have washed their robes, and made them white in the blood of the Lamb.

15 Therefore are they before the throne of God, and serve him day and night in his temple: and he that sitteth on the throne shall dwell among them.

16 They shall hunger no more, neither thirst any more; neither shall the sun light on them, nor any heat.

17 For the Lamb which is in the midst of the throne shall feed them,

ascend from the rising of the sun, with the seal of the living God, and he called with a loud voice to the four angels who had been given power to harm earth and sea, 3 saying, "Do not harm the earth or the sea or the trees, till we have sealed the servants of our God upon their foreheads." 4 And I heard the number of the sealed, a hundred and forty-four thousand sealed, out of every tribe of the sons of Israel.

...

9 After this I looked, and behold, a great multitude which no man could number, from every nation, from all tribes and peoples and tongues, standing before the throne and before the Lamb, clothed in white robes, with palm branches in their hands, 10 and crying out with a loud voice, "Salvation belongs to our God who sits upon the throne, and to the Lamb!"

...

13 Then one of the elders addressed me, saying, "Who are these, clothed in white robes, and whence have they come?" 14 I said to him, "Sir, you know." And he said to me, "These are they who have come out of the great tribulation; they have washed their robes and made them white in the blood of the Lamb.

15 Therefore are they before the
 throne of God,
 and serve him day and night
 within his temple
 and he who sits upon the
 throne will shelter them
 with his presence.

16 They shall hunger no more,
 neither thirst any more;
 the sun shall not strike them,
 nor any scorching heat.

17 For the Lamb in the midst of the
 throne will be their shepherd,

and shall lead them unto living fountains of waters: and God shall wipe away all tears from their eyes.

and he will guide them to springs of living water; and God will wipe away every tear from their eyes."

Key Verse: **For the Lamb which is in the midst of the throne shall feed them, and shall lead them unto living fountains of waters; and God shall wipe away all tears from their eyes. (Revelation 7:17)**

Key Verse: **For the Lamb in the midst of the throne will be their shepherd, and he will guide them to springs of living water; and God will wipe away every tear from their eyes. (Revelation 7:17)**

The Scripture and the Main Question—Pat McGeachy

The Troubles of the World (Revelation 6)

We won't spend much time on this because it is not a part of the assigned scripture for this lesson, but it is part of the context in which our lesson must be seen to be understood. If you want to take a look at it, there are several ways it can be interpreted:

1. The four horsemen (6:1-8): I think the rider on the white horse is Christ (see 19:11-16), doing battle against the other three: war (red), famine (black), and death (pale). As long as the world remains there will always be a battle to be fought against these evils.

2. The martyrs (6:9-11): In these battles there will inevitably be some casualties, but God will provide special safe-keeping for them. The Greek word for "witness" or "testimony" in verse 9 is *marturia,* from which we get our word "martyr."

3. The holocaust (6:12-17): I suppose that in all generations people have worried about calamity, but ever since July 16, 1945, there has been a special nuclear cloud hanging over us all. Whatever you think about that, you can be assured that the universe will not last forever. We have a choice of catastrophes to look forward to, from entropy to an exploding sun. It will come (verse 15) to the great as well as the small, and there will be no place to hide.

In the midst of all this, Revelation 7 is given as a great promise that the faithful can trust God to care for them, whatever lies ahead.

The Gross Thousand (7:1-8)

We're back to the numbers game again. 144,000 is $12 \times 12 \times 1,000$. And as we saw in the last chapter, the two twelves are the church of the Old Testament (Israel) and the church of the New. The figure 1,000 means a very large number (the ancients rarely counted much beyond a thousand). It also implies the fullness of time, or an extended period of history (see 20:2), sometimes called "the Millennium." We are not to worry overmuch about the exact number, partly because it is clearly a symbolic figure meaning "the total number of the redeemed out of all God's people," but also because of the numberless nature of the crowd to be found in the very next paragraph.

The Uncountable Multitude (7:9-12)

As a child I used to puzzle over how big a crowd would be which "no one could number." Did that mean, I would ask myself, that no one could count it exactly, that is, by numbering everybody off "one . . . two . . . three . . . "? If you could count like that—I estimate at about two persons per second, over a lifetime, working twelve hours a day and taking Sundays off—you could number about two billion people, which is a little less than half of the population of the world at this writing, although it is going up rather faster than we can count. I don't know whether one would be allowed to use calculus in measuring that crowd, say, counting the number of persons in a given area and then figuring the total area, or whether using computers would be acceptable. But however you figure it, you'll have to agree that it is a heaven of a lot of people.

All that absurdity is to drive home the point than an attempt to pin these mysterious visions down to human measure is to miss this message. What we have here is the promise that God plans a redemption beyond our wildest dreams. When you see a crowd like that, there is nothing to do but cheer, or break into song as the multitude did (verse 12). It may be hard to sing while you're flat on your face (verse 11), but sometimes I wonder if we more staid Christians wouldn't have a better feeling for heaven if we loosened up a bit. Charles Wesley set the tune and the model for us:

> "Salvation to God, who sits on the throne!"
> Let all cry aloud and honor the Son:
> The praises of Jesus the angels proclaim,
> Fall down on their faces and worship the Lamb.
> ("Ye Servants of God")

The Lamb Shepherd (7:13-17)

"Who are these?" one of the Elders asks. "You know," says John, submissively. And the glad answer comes, "These are the ones who have survived the troubles of the world because they have been purified by the blood of the lamb." That washing in blood should make things white is a little hard to believe, but no more difficult than the notion that a lamb can be shepherd. We are asked to believe that one who has died has conquered death. And we too will have to go through it. Christ has never promised us a rose garden. But he has made us a promise all the same: "In the world you have tribulation; but be of good cheer, I have overcome the world" (John 16:33).

The lovely image in verses 15-17 is one of a number to be found throughout the Bible that ought to be committed to memory, so that they could be said over and over by every soldier slogging in the trenches, every parent patiently dealing with a rebellious child, every woman married to a man with a substance-abuse problem, and every person who works at a thankless job for an unfair employer. I don't know which I like best, but here are some of them for you to sample:

> Psalm 121
> Isaiah 11:6-9
> Isaiah 55:1-13

FIRST QUARTER

Micah 4:1-4
Jeremiah 31:31-34
Malachi 4:1-2
Revelation 21:1-4
Revelation 22:1-5

Of course I have left a very important one out: Psalm 23, from which this image borrows. Jesus, as many a stained-glass window will attest, is clearly identified by Christians with the Shepherd of that psalm (see John 10:1-18). But here in this image we have both the Lion and the Lamb sides of Jesus, both the conquering Messiah and the Suffering Servant. This Shepherd is capable of warding off the sun, so that it shall not "smite us," but also able to stoop down and wipe the tears from our eyes. It makes me start to cry with gladness just to think about it.

But is it fair to claim all this? What good does it do to read such beautiful passages in the presence of an infant deformed from birth and doomed to life on a respirator? What's the value of talking about living water to one whose body is covered with radiation burns? Who will comfort the paranoid lady with her shopping bag full of all her possessions, by proclaiming, "Behold, the days are coming"? You are right, that is a good question. But don't forget chapter 6, with the clashing lances of the horsemen and the hiss of stars falling into the ocean. There's judgment coming as well as sweet grass and still waters. If you asked me to pick my favorite out of the visionary texts listed above, I think I would choose the Malachi passage. I would choose it because it seems to me to combine both Revelation 6 and Revelation 7. It describes the day of the Lord as an oven, a hot desert sun that burns up all that is evil. (Perhaps some sort of *nova* is indeed predicted by the Bible.) But note that *the very same sun that burns up the evil brings healing to the redeemed.* And who are the redeemed? Those who fear God, that is, who love goodness, who hunger and thirst for righteousness, and who, when they look at last into the face of Jesus of Nazareth, will know him and love him.

The church building in which I worship is a curious one. Its interior is modeled after the temple to Ammon Ra at Karnak on the upper Nile, where monotheism had its beginnings. Sometimes, when I am blue with the pain of the world, I like to go and sit in that church and think about Malachi. You see, the old Egyptian symbol for God was a sun with wings, and that is what the scripture promises: "For you who fear my name the sun of righteousness will rise, with healing in his wings" (Malachi 4:2). With that promise the Old Testament ends, and in the last book of the New Testament it is renewed: You will be protected from the heat of the judgment (7:16) and the Lion/Lamb/Shepherd will wipe all your tears away.

Helping Adults Become Involved—Robert E. Luccock

Preparing to Teach

One could easily get lost in this lesson and wander aimlessly amid the imagery and symbols of John's visions. These guidelines may be helpful.

First, read through chapter 6, noting its symbols of the sword, famine, pestilence, and death. These four horsemen of the apocalypse still stalk the earth. Frightening images from our own time come to mind.

Second, let the main question take firm hold on your attention: How can we survive the woes of the world? How do *you* survive? How have Christians survived across the centuries? Do John's visions help? If so, how?

Third, read through chapter 7, trying to see the truth behind each verse to which John bears witness through his symbols.

Finally, reflect on the scripture passages listed by Pat McGeachy and suggested in last week's lesson. Out of this reflection and prayer you may recognize two pillars of faith on which the Christian gospel stands and on which *Christian* survival depends: trust in God's word to protect and strengthen the faithful in this life, and trust in God's promise of life beyond the apocalypse.

Here is an outline of the lesson:

 I. Briefly review chapter 6, about the four horsemen who still ride the earth.
 II. Introduce the main question: How can we survive the woes of the world, past, present, and future?
 A. How do class members survive?
 B. How have Christians survived?
 C. How do John's visions help?
 III. The faith behind John's visions
 A. Angel with the seal (7:2)
 B. $12 \times 12 \times 1,000$ (7:4)
 C. A multitude none can number (7:9)
 D. Promises of the Lamb (7:15-17)

Introducing the Main Question

The main question can best be introduced against the backdrop of chapter 6, the vision of the four horsemen. Where are these horsemen riding in the world today? Where do they cast their shadows on the future? (Consider epidemics of incurable disease, nuclear holocaust, toxic pollution, etc.) Now ask the main question: How can we survive such woes? Survival is compounded of may things: human imagination, resistance to evil, patience, trust, and practice of the presence of God. You and the class will discuss together how John's visions may help us survive. You will do this as you develop the lesson.

Developing the Lesson

I. Briefly review chapter 6, about the four horsemen who still ride the earth.
These are terrible visions. They come out of the violence, persecutions, and martyrdoms John saw in his world. It was a time of severe testing for Christians. But what about 1,900 years later? Thomas Hardy wrote at the time of the First World War: "After two thousand years of Mass,/We've got as far as poison gas." Has the gospel made no difference? The persecutions under Nero and Domitian seem almost benign compared with the slaughter under Hitler and Stalin. People die of preventable disease and unnecessary starvation. Why do these horsemen still ride, spreading terror across the world? It is almost as hard to live with that question as it is to survive the woes themselves. We met this question squarely in lesson 9. As we said then,

beyond the question of *why*, we do much better asking *how*—how can we cope with apocalpytic times?

II. Introduce the main question: How can we survive the woes of the world, past, present, and future?

The main question for us, as it was for Christians in the first century, is, How can we survive the woes of the world, past, present, and future? If we confine our attention here only to the images in John's vision, the whole exercise may remain abstract and historically remote. One way to prevent this would be to ask the class how *they* survive in this kind of world.

A. How do class members survive?

Let it be clear that we're talking here about more than physical survival. *Christian* survival means being whole persons, loyal to the best that we know, faithful to Christ even to the point of death. Is it not a *Christian paradox* that survival may sometimes mean death? Jesus said, "What will it profit a man, if he gains the whole world and forfeits his life?" (Matthew 16:26). One might say, "If he survives but doesn't survive—if he lives but does not have life."

B. How have Christians survived?

Some class members may want to share what they know of how Christians have survived in the past—not just stories of heroism in the Roman arena or the Nazi death camps, but the heroism of nursing homes residents, of people living with handicaps or working under extreme conditions, of little children brave beyond their years.

C. How do John's visions help?

Ask the class if *they* think the visions of John can help a Christian survive. Perhaps they will mention that the visions can give us hope. The visions declare that we are not alone but are surrounded by a great crowd of witnesses (Hebrews 11:1). The visions promise freedom from fear and healing of grief. Above all, they tell us that God is with us.

III. The faith behind John's visions

A. Angel with the seal (7:2)

Angels were thought to be messengers from God. This angel rises with the assurance that we are all in the hands of the living God.

B. 12 × 12 × 1,000 (7:4)

12 × 12 × 1,000 means the total number of the redeemed. 144,000 is a *symbolic sum* meaning a great many.

C. A multitude none can number (7:9)

An "uncountable multitude" means that not even the least shall be lost or overlooked. Those who have come out of the great tribulation have heard the gracious invitation, "Come, O blessed of my Father, inherit the kingdom prepared for you from the foundation of the world" (Matthew 25:34).

D. Promises of the Lamb (7:15-17)

What does God promise? The shelter of God's presence, an end to hunger and thirst, Jesus Christ to guide us to living water (meaning the resources with which to find the life God intends us to have), an end to weeping, and healing for broken hearts.

How can all this help us to survive? Are we just to sit and wait for it to happen? No, it makes a difference to work for peace, to struggle for justice, to care for the hungry, the homeless, the fearful, and the brokenhearted—*if we know that God also cares*. It makes a difference to realize that our lives, our

communities, our world matter to God, that *we are not lost in the stars, nor spending our years in a vain cause.* In a world and in a time that make people feel like nothing at all, visions like those of John restore to us the divine image in which we were created.

Helping Class Members Act

Role models—people who have really survived some of the world's most ruinous woes—can be both instructive and inspiring. You could have students find such a role model—someone they have known, a public figure, a historical character—and put down as much as possible about how that person "hung in there" and not only survived but transfigured suffering and pain into strength and glory. Role models shape character.

Planning for Next Sunday

You may wish to hear portions of Handel's *Messiah* sung next Sunday, as you consider Revelation 19–20. The music is available on both tape and records. Try to find a way to play it for your class. You should be thinking about how wonderful, and how difficult, the faith that is sung in *The Messiah* really is.

―――――――――――――

The Victorious Christ

Background Scripture: Revelation 19–20

―――――――――――――

The Main Question—Pat McGeachy

The book of Revelation is not easy to outline. A good exercise would be to read through it and see where you would place the climax of the story. I think that if that were my task, I would be torn between two points. One would be the mighty doxology at the end of chapter 11, after Christ among the seven lamps (chapter 1), the seven churches (chapters 2–3), the throne room anthems (chapters 4–5), the seven seals (chapters 6–8), and the seven trumpets (chapters 8–11): "The kingdom of this world has become the kingdom of our Lord and of his Christ, and he shall reign forever and ever" (verse 15).

The other point would be the hymn in chapter 19, after we have had the Woman, the Dragon, and the Beast (chapters 12–14), the seven bowls (chapters 15–16), and the overthrow of Rome (Babylon—chapters 17–18): "Hallelujah! For the Lord our God the Almighty reigns. . . . King of kings and Lord of lords" (19:6, 16).

Of course, if you are accustomed, as I am, to singing Handel's *Messiah* every Christmas, you will have noticed that the great composer agrees with me (or else I got the idea from him), because he chose these verses for the

grand climax, the famous "Hallelujah Chorus." Indeed, you might sum up the book of Revelation in the three-word sentence (see I Corinthians 12:3), "Jesus is Lord."

The book was written during a time of terrible persecution and discouragement for the church, and affirms that Christ conquers all foes: the devil within and the evil empire without. And ours too is a terrible and discouraging time. From AIDS to nuclear bombs, we are surrounded by the fear of personal death or corporate destruction. The forces of darkness appear to be winning in many places, polluting and using up the earth. Can we affirm that Jesus is "King of kings and Lord of lords" in such a world? There are secular claims to the contrary, but if we listen to the message of Revelation, we will hear in it a strong word of hope.

As You Read the Scripture—Horace R. Weaver

The background scripture for today's lesson is Revelation 19–20. Handel's *Messiah*, with its famous "Hallelujah Chorus," is based on 19:16. John "heard what seemed to be the mighty voice of a great multitude in heaven crying, 'Hallelujah! Salvation and glory and power belong to our God. . . .'" The setting for this "mighty voice" is the heavenly joy over the destruction of Rome, a city unexcelled for its wickedness. In the great drama of Revelation, the curtain is down on the city of destruction, and is raised on a panoramic view of heavenly glory.

Domitian, the demonic emperor of Rome when John wrote, declared himself to be God. The Roman Senate approved his claim. Domitian demanded he be called "Our Lord and God." John surely is aware of that title as he hears the heavenly choir sing, "Hallelujah! For the Lord our God the Almighty reigns" (19:6).

Revelation 19:11-16. John, having described the six series of seven visions each and the horrible consequences to Rome and the deified emperors, now describes the glorious and eternal rewards God will give for the steadfast loyalty of Christians. The time has come for God's entrance on the stage of history to fulfill his promises of punishment and rewards.

The seventh series, with its seven visions each, climaxes the apocalyptic drama. Satan, with his diabolical forces, is soon to be overthrown. Then a new earth, which comes down from heaven, will replace the old earth; God will create a new age for his righteous followers. Martin Rist summarizes the eschatological pattern:

> The conquering Christ will come from heaven with his heavenly army and will defeat the Antichrist, who with the false prophet will be cast into the lake of fire, thus ending his rule forever; and Christ will also annihilate the Antichrist forces composed of the peoples of the earth. Following this defeat of his demonic agents, Satan himself will be bound by an angel and locked in the bottomless pit for a thousand years. . . . The martyrs will be restored to life, and they, and they alone, will reign with Christ for a thousand years. (*The Interpreter's Bible*, vol. 12, p. 511)

This is the Millennium.

John, as did Ezekiel, saw the heavens open to reveal a white horse, and "[Jesus] who sat upon it is called 'Faithful and True' " (verse 11). Like the Messiah of Isaiah 11:3-4, the conquering Christ will judge and make war.

Verse 12 states that Christ's "eyes are like a flame of fire," as he views the depredations of Hitler-like leaders who torment and destroy his loyal and innocent followers.

Verse 13 is a rewriting of Isaiah 63:1-6, with its scene of the treading of the wine press: "He [Christ] is clad in a robe dipped in [sprinkled with] blood" of foes trodden on like grapes in a winepress. His name is "Word of God" which reminds us of the Gospel of John: "In the beginning was the Word."

In verse 14, the "armies of heaven" are not angels but the martyrs who are "arrayed in fine linen." Jesus Christ is likened to Christian soldiers marching as to war! Matthew 26:53 states that Jesus had "more than twelve legions of angels" at his command. Here, "martyrs" replaces "angels." The martyrs are to have authority over nations. Their leader is Christ, "King of kings and Lord of lords."

Revelation 20:10-15. The devil is thrown into the lake of fire, joining the beast and the false prophet, where they will be "tormented day and night for ever and ever" (verse 10). Up to this point in time, Satan has been conceived as being in charge of planet earth. Now he is in hell—the lake of fire. John took only one verse to declare the downfall of Satan (verse 10).

Verses 7-13 describe how God on the "great white throne" judges the dead by referring to their deeds ("what they had done"), recorded in the book of the dead. Jesus Christ judges the living by referring to their deeds as recorded in the "book of life."

Verses 14-15. Now that judgment has taken place, there is no need for Hades and Death. So they are "thrown into the lake of fire." They are joined by anyone whose "name [is] not found written in the book of life."

Selected Scripture

King James Version

Revelation 19:11-16

11 And I saw heaven opened, and behold a white horse; and he that sat upon him *was* called Faithful and True, and in righteousness he doth judge and make war.

12 His eyes *were* as a flame of fire, and on his head *were* many crowns; and he had a name written, that no man knew, but he himself.

13 And he *was* clothed with a vesture dipped in blood: and his name is called The Word of God.

14 And the armies *which were* in heaven followed him upon white horses, clothed in fine linen, white and clean.

15 And out of his mouth goeth a sharp sword, that with it he should smite the nations: and he shall rule them with a rod of iron: and he

Revised Standard Version

Revelation 19:11-16

11 Then I saw heaven opened, and behold, a white horse! He who sat upon it is called Faithful and True, and in righteousness he judges and makes war. 12 His eyes are like a flame of fire, and on his head are many diadems; and he has a name inscribed which no one knows but himself. 13 He is clad in a robe dipped in blood, and the name by which he is called is The Word of God. 14 And the armies of heaven, arrayed in fine linen, white and pure, followed him on white horses. 15 From his mouth issues a sharp sword with which to smite the nations, and he will rule them with a rod of iron; he will tread the wine press of the fury of the wrath of God the Almighty. 16 On his robe and on

treadeth the winepress of the fierceness and wrath of Almighty God.

16 And he hath on *his* vesture and on his thigh a name written, KING OF KINGS, AND LORD OF LORDS.

his thigh he has a name inscribed, King of kings and Lord of lords.

Revelation 20:11-15

11 And I saw a great white throne, and him that sat on it, from whose face the earth and the heaven fled away; and there was found no place for them.

12 And I saw the dead, small and great, stand before God; and the books were opened: and another book was opened, which is *the book* of life: and the dead were judged out of those things which were written in the books, according to their works.

13 And the sea gave up the dead which were in it; and death and hell delivered up the dead which were in them: and they were judged every man according to their works.

14 And death and hell were cast into the lake of fire. This is the second death.

15 And whosoever was not found written in the book of life was cast into the lake of fire.

Revelation 20:11-15

11 Then I saw a great white throne and him who sat upon it: from his presence earth and sky fled away, and no place was found for them. 12 And I saw the dead, great and small, standing before the throne, and books were opened. Also another book was opened, which is the book of life. And the dead were judged by what was written in the books, by what they had done. 13 And the sea gave up the dead in it, Death and Hades gave up the dead in them, and all were judged by what they had done. 14 Then Death and Hades were thrown into the lake of fire. This is the second death, the lake of fire; 15 and if any one's name was not found written in the book of life, he was thrown into the lake of fire.

Key Verse: The kingdoms of this world are become the kingdoms of our Lord, and of his Christ; and he shall reign for ever and ever. (Revelation 11:15)

Key Verse: **The kingdom of the world has become the kingdom of our Lord and of his Christ, and he shall reign for ever and ever. (Revelation 11:15)**

The Scripture and the Main Question—Pat McGeachy

The Destruction of the Harlot (Revelation 19:1-4)

In his brief passage there is reference to "Babylon," the great harlot of chapters 17–18. Of course the city of Babylon had lain in ruins long before Revelation was written. When John penned these words, Rome was the empire in power. The emperor Domitian was a cruel tyrant who was persecuting the church and putting its faithful leaders to death. The destruction of Babylon is meant to assure the people of God that the wicked empire is doomed.

When we apply the scripture to our own day, we must think of existing power structures. It is tempting to read into the prophecy a criticism of

other nations than our own, but when we look at the corruptions that threaten our own land and compare them to the symptoms described in Gibbon's *The Decline and Fall of the Roman Empire*, it is hard not to be worried about ourselves. Who *is* the wicked woman in our day?

Contrasted as she is with the pure bride of Christ (in the next verses), she reminds me of another biblical contrast: Dame Folly and Lady Wisdom, in Proverbs 7–9. If you turn to that passage, note that in chapter 7 a seductive woman who tempts men to folly is described, and her threat is repeated in 9:13-18. But in between we are told of Wisdom, the master architect who worked with God in shaping the world. We are called, dramatically, to reject Folly, the seductress whose ways seem so delightful, and to follow Lady Wisdom.

Just so, Revelation 19 warns us not to fall for the seductive calling of the secular empires of the world, whoever they may be, but to turn to the true Church, the Bride of Christ, and to follow our Lord faithfully, for in the long run it is he, and not the pagan kingdoms, who will triumph.

The Marriage of the Lamb (19:5-10)

This is not the only place in the Bible where marriage is a metaphor for the relationship between God and the people of God. (Just to refer to a few examples, see Hosea 1–3; Jeremiah 31:31-32; Matthew 25:1-12; Mark 2:18-20; and Revelation 21:2.) In Matthew 22:1-13, the kingdom of heaven is described as nothing other than a marriage feast. It has been suggested that the Bible is truly a love story with the traditional plot:

Boy gets girl: God creates the human race.
Boy loses girl: The fall.
Boy gets girl back: The restoration of the broken relationship by Christ.

We can safely say that the story ends here in Revelation with the traditional formula: So they got married and lived happily ever after. (Dedicated feminists may object that in this metaphor God is depicted as male and the church as female. I suppose it could be told the other way around, but this is the way Bible puts it.)

The Conquering Christ (19:11-16)

There may also be some pacifists who are disturbed by the metaphor in these verses: Christ as a military conqueror. But it also is a common one in the Bible, and we must remember that it *is* a metaphor (his sword is sticking out of his mouth!) An actual military battle is not intended. When Paul tells us to "put on the whole armor of God" in Ephesians 6:10-17, he makes it clear that we are not to slay people: "For we are not contending against flesh and blood, but against the principalities, against the powers . . . against the spiritual hosts of wickedness" (6:12). But fighting against sin is nonetheless, a very real battle, and it is comforting to have a strong image of a leader brave and bold. We will need all the help we can get in the dread conflict to come.

The Last Battle (19:17-21)

This too is a spiritual conflict, the same battle of Armageddon spoken of in 16:16. It is given a geographical name ("plain of Megiddo") because of

past battles fought there. The message to us is that ultimately all that is ugly and vicious in the world will be overthrown, including powerful secular empires (the beast) and corrupt religious structures (the false prophet). Again, John uses some pretty bloody images, but if you stop to think about it, even spiritual conflicts are rather messy. There is nothing lovely about any form of death.

The Millennium (20:1-15)

I have said that the previous battle was the last, but in a sense it isn't quite over yet (the fat lady hasn't sung). John is a realist, and he knows that history must go on until the last convert has been made and ultimate justice is done. There will be an indeterminate time of peace, with the devil in chains. (Remember that one thousand is an idealized number and mustn't be applied to an exact period of human history. We are forbidden to know such details of history; see Matthew 24:36 and Acts 1:7.)

But there are important things we *are* to know:

1. Satan, the old serpent who has plagued the human race since the garden of Eden, will finally be whipped (verses 1-3).

2. Those who have died for their faith will be given positions of power in heaven, but they need never fear dying again (verses 4-6). The second death, which is the ultimate destruction of evil, can never bother them anymore. Once you have died in the Lord, nothing can harm you. This refers not merely to physical death but to spiritual death: losing your life for Christ's sake (see Colossians 3:3).

3. Satan will make one last attempt, but it will be a failure, and this time he will be obliterated (verses 7-10).

4. The ultimate judgment will come, and those who are not in the Lamb's book of life will die, but those who are won't be hurt (verses 11-14).

I suppose that all of this is pretty frightening, if you look at it in one way. All that business about beasts and brimstone, bottomless pits and lakes of fire, is the stuff of which nightmares are made. I don't recommend that you read these chapters to very small children. But it was never intended as bad news; rather, it was written as a word of the greatest comfort to those who were being killed "all the day long" (Romans 8:36). Let me put it this way: If you are a little kid with a hand in the cookie jar, I can see why these chapters might sound like bad news. But this was not written to frighten Sunday school children out of their sins; it was written by a man in prison to terrified men and women who did not know from one minute to the next when the dread knock would come on the door and they would be led away to a fate more horrible than that described in Revelation. The real world was no cookie jar to them; it was a nightmare. Now to such persons the assurance that the devil is going to get what's coming to him and that the people who long for God and goodness will be protected by Christ from destruction was joyful tidings indeed.

We can go a step further. Deep down, even those of us who have been fortunate enough to grow up in a world free from persecutors like Nero and Domitian live in a nightmare world. It doesn't take a Freud to tell me that there are vicious dragons grunting around inside of me. All it takes is one impolite driver cutting in front of me during rush-hour traffic, and the monsters will come charging out. And I don't like those dragons. I *want* them to be cast into the lake of fire. I want the day to come when I won't have

to be afraid of the beast within me. That is why I pray our Lord's words regularly, "lead us not into temptation" and "thy kingdom come." It will suit me fine for the battle of Armageddon to take place and the devil be thrown down. And while it does scare me in one sense, just like standing on the edge of the grand Canyon scares me, in another sense it fills me with holy awe and hope, and I want to say, "Let the battle begin, and let me be faithful to do my part."

Helping Adults Become Involved—Robert E. Luccock

Preparing to Teach

Listen, if you can, to Handel's *Messiah,* and ponder the glorious words, especially of the "Hallelujah Chorus." The lesson today centers around the question, Can we really believe Revelation's affirmations of faith? Some class members may have an untroubled faith that all will be exactly as Revelation declares. Blessed are they! Let us try to learn from them. The lesson must not be taught in any way that questions their faith.

Others, however may have difficulty believing what Revelation promises. You as a teacher must take their difficulties seriously; sometimes doubts may linger within a person's fragile faith. The plan of this lesson will be to measure the *forces that assail our faith* and the *ground on which we can stand with confidence.*

Here is an outline of the lesson:

I. Visions of John
 A. 19:11-16
 B. 20:11-15
II. The main question: Can we affirm that Jesus is "King of kings and Lord of lords" in this kind of world?
III. Barriers to such faith
 A. Science gives little reason to believe in such life beyond death.
 B. The forces of evil seem everywhere stronger than the power of good.
IV. Grounds for our faith
 A. Christ's victory over death and the power of evil
 B. Personal experience of the transforming power of love
 C. Inner assurance strengthened by the arts and Christian witness
V. Listening to the "Hallelujah Chorus"

Introducing the Main Question

For most of us the main question is not about white horses, a lake of fire, or the clash between the armies of Satan and of the Faithful and True. These we understand to be symbols of the ultimate showdown between good and evil. Our main question probably has to do with the faith that John's symbols represent: Can we affirm that Jesus *is* truly "King of kings and Lord of lords"? Our struggle is an inward one fought on the battle-ground of faith. The same contending forces that we read about in Revelation are drawn up within ourselves. In the struggle to believe, we need to

reckon with the forces on the side of faith, and the powers against which faith must contend.

You and the class draw up your own balance sheet. In the outline and in the development that follows, you will find evidence to consider.

Developing the Lesson

I. Visions of John
 A. 19:11-16

One way to probe the meaning of these visions would be to read the text verse by verse, or in pairs of verses at one time, using Horace Weaver's "As You Read the Scripture" as an interpretive key. The purpose here is to recognize the faith out of which these visions came. When you finish 19:11-16, try translating the images in the text into an affirmation of faith that develops in the same sequence as the verses. The following is only an example; you should not take it as a complete exposition of the faith. The class might do this as a group exercise.

Jesus the Christ lives! He is faithful and true to all that he said. *First,* he comes as righteous Judge (Matthew 25:31-46), weighing all persons as to whether they have been faithful to what they heard and saw in Christ at his first appearing. The light of Christ's judgment can penetrate any sham behind which we may try to hide.

Second, his name is *Savior, Messiah, Emmanuel,* all of which come together in the name *Jesus*—"he will save his people from their sins" (Matthew 1:21).

Again, he demonstrates power over his foes (his robe is stained with their blood). His Word and the armies of martyrs will judge all the earth, and Jesus will be called Lord of *all* lords.

 B. 20:11-15

Satan, lord of the kingdom of evil, has been overthrown. Now all who ever lived come before the bar of God's judgment. *They are evaluated for what they have done.* If any have not loved the Lord or done what he asked, they will have no part in the kingdom of the Christ.

II. The main question: Can we affirm that Jesus is "King of kings and Lord of lords" in this kind of world?

Scripture affirms what is to come. But as Martin Luther once asked, when he had done all the works of penance prescribed by the church and been absolved of sin, "Who knows if it be true?" If your minds (or your doubts) find no stumbling block here, blessed are you! But many people *are* nagged by doubt. What are some of the difficulties?

III. Barriers to such faith
 A. Science gives little reason to believe in such life beyond death.

We live in a secular age. We test any "truth" by reason and by whatever evidence can be found. Science gives little evidence to believe in such life after death. Some people maintain that they have been in touch with persons who have died. Many believe that they have been reincarnated from former lives. But neither of these ideas are found anywhere in Scripture. And such testimony is not widely convincing to a lot of people.

 B. The forces of evil seem everywhere stronger than the power of good.

History, from the time of the Pharaohs in Egypt to twentieth-century tyrants, gives little support to the hope that evil will be conquered by

goodness. "Right forever on the scaffold, wrong forever on the throne" as James Russell Lowell described it in "Once to Every Man and Nation."

IV. Grounds for our faith
A. Christ's victory over death and the power of evil
We begin with the resurrection! However it may have occurred, Christ's Spirit has been alive in the world from the first Easter on, as evidenced by the continued life of the church and by the way people have continued to find in Christ light in their darkness, hope beyond their despair, forgiveness for their sin. Science does not give us the only pathway to truth. Great mystery surrounds these things, but unnumbered hosts of people cannot dismiss all this as some kind of illusion.
B. Personal experience of the transforming power of love
We have probably all experienced the transforming power of love somewhere in our lives. If we have found it real here and now, we have a ground of hope as we imagine the final consummation.
C. Inner assurance strengthened by the arts and Christian witness
Great artists like George F. Handel—and a company of witnesses across the centuries—bear us tidings of great joy. It may be difficult sometimes to believe as John did in Revelation. But it seems even more unlikely that the faith of so many has been based on nothing at all.

V. Listening to the "Hallelujah Chorus"
Let us listen with our minds and our hearts to the faith of Revelation, as Handel set it to music. (Now present portions of Handel's oratorio, perhaps the "Hallelujah Chorus.")

Helping Class Members Act

As with other lessons in this study of visions of God's Rule, we find opportunity to act both inwardly and beyond ourselves. First, inwardly: We strengthen our faith when we can give clear reasons *why* we believe as we do. This is a good time to encourage class members to think things through carefully, with the heart as well as the mind, so that they can state clearly what their faith is and why they affirm it.

Second, outwardly: Taking our cue from 12:20, "they were judged by what they had done," we need to audit our lives from time to time to see how much we have really done, and are doing, in terms of Matthew 25:31-46; Luke 10:25-37; and Romans 12:6-21. Have students draw up checklists based on these passages to measure "what they have done."

Planning for Next Sunday

There may be time and opportunity next week (the last meeting on visions) to look back in review. It should be helpful for you to have gathered the principal affirmations found in Daniel, Ezekiel, I and II Thessalonians, and Revelation. Compare their common denominator with Matthew 5–7, 13; Luke 10:25-37; and Romans 12:6-21.

New Heaven and New Earth

Background Scripture: Revelation 21:1–22:5

The Main Question—Pat McGeachy

When I conduct a funeral, I almost always want to hear one or more verses from these two chapters. I know there are other precious passages, such as Psalm 23 and John 14. But I do not feel satisfied, not at the deepest level of my being, if I do not go beyond the matter of personal salvation (the Lord is *my* shepherd) and beyond the hope of mansions in my Father's house, to some sense of the whole universe set right.

You see, I happen to think that the world is out of joint. Well, think about it. Our cars are always breaking down. Our children are always getting into trouble. Just when you think you've got your retirement nest egg all figured, inflation wipes out your plans. The Third World tries to rise but is beaten back by the entrenched forces of the establishment. The ozone layer is being destroyed by methane gas from all the termites that are chewing up the Amazon rainforests. What chances have tomorrow's children? Only entropy? Murphy's law prevails.

You remember Murphy don't you? His law, simply stated, is "If anything can go wrong, it will." But there are many corollaries:

The other line always moves faster.
The chances of a dropped slice of bread landing butter-and-jelly-side down are directly proportional to the cost of the carpet.
If you are in the bathtub, the phone will ring.
If you can, you can't (e.g., if there is no yellow line in your lane, there will be a car coming).
Hofstadter's Law: It will take you fifteen minutes longer than you think, even if you take into account Hofstadter's law.
The ultimate corollary: Murphy was an optimist.

All this light talk is to underscore the deep question: Will the center hold? Is there hope for history? Is the world worth living in?

As You Read the Scripture—Horace R. Weaver

John has a seventh vision: the end of Satan's evil age and the beginning of God's righteous age. Within this great vision are seven smaller visions, the seventh one being "the new creation and God's eternal age" (21:1-8).

Revelation 21:1-7. "Then I saw a new heaven and a new earth." The emphasis is on "new"—not a renovated or purified heaven and earth, but an entirely new one. Second Peter 3:10, 13 makes it clear: The first heavens and earth will be annihilated by fire, and, as promised, a new heaven and a new earth will be created. John perceives this promise fulfilled. Even the crystal sea no longer exists.

Verse 2. John "saw the holy city, New Jerusalem, coming down out of

heaven from God," which negates the idea of a restoration of an old "holy city."

Verse 2b states that the New Jerusalem is "prepared as a bride adorned for her husband." Later it will be said that the church is prepared as a bride for her husband.

Verse 3. John remembers Ezekiel: "My tabernacle also shall be with them: Yea, I will be their God, and they shall be my people" (37:27 KJV). John wants it to be clear: God is not transcendent in heaven, far removed from his people. In this new age, God is immanent; his divine presence *(Shekinah)* will be eternally with the faithful.

Verse 4. Now that death has been removed, eliminated, God's presence with the martyrs brings in new experiences: "God will wipe away every tear from their eyes," for death will be no more! The martyrs are free from mourning and pain.

Verse 5. God, now seated on his "throne" in the New Jerusalem, says, "Behold, I make all things new." The terrible days under the rule of Satan are gone forever; both Satan and those who lived his lifestyle are gone. They are receiving their due punishment, whereas the faithful and righteous are enjoying an eternity of blessedness in the New Jerusalem with God.

Verse 6. "And he said to me [John], 'It is done!'" meaning, God approves his many acts toward both sinners and saints. Each deserves what their deeds have proven to be—good or evil. "I am the Alpha and the Omega, the beginning and the end. To the thirsty I will give from the fountain of the water of life without payment."

Verse 7. Martyrs are again reminded that their rewards (verse 6b) are to be the *heritage* of those who *conquer*.

Verses 22-23. There will be no physical temple—there will be no need for one! Hebrews 9:23-28 expresses the theology that the sacrifice of Christ has done away with all other sacrifices. John claims, "I saw no temple in the city, for its temple is the Lord God the Almighty and the Lamb." Likewise, there will be no need of sun or moon, "for the glory of God is its light, and its lamp is the Lamb." A prayer in the Apocalypse of Abraham (chapter 17) beautifully suggests that no light is needed in the heavenly dwelling places other than "the unspeakable splendor from the light of Thy countenance."

Verses 24-27. Both Jewish Messianism and apocalypticism believed that Gentiles would eventually convert to Judaism and worship the Lord Yahweh. But in Revelation the nations were viewed as enemies of God. Here the "nations" will "walk" in the "light" of the New Jerusalem, and "kings of the earth" will bring their "glory" and "honor" into it. The excluded are those whose names are not written in the Lamb's book of life.

Selected Scripture

King James Version	Revised Standard Version
Revelation 21:1-7, 22-27	*Revelation 21:1-7, 22-27*
1 And I saw a new heaven and a new earth: for the first heaven and the first earth were passed away; and there was no more sea.	1 Then I saw a new heaven and a new earth; for the first heaven and the first earth had passed away, and the sea was no more. 2 And I saw the
2 And I John saw the holy city,	holy city, new Jerusalem, coming

new Jerusalem, coming down from God out of heaven, prepared as a bride adorned for her husband.

3 And I heard a great voice out of heaven saying, Behold, the tabernacle of God *is* with men, and he will dwell with them, and they shall be his people, and God himself shall be with them, *and be* their God.

4 And God shall wipe away all tears from their eyes; and there shall be no more death, neither sorrow, nor crying, neither shall there be any more pain: for the former things are passed away.

5 And he that sat upon the throne said, Behold, I make all things new. And he said unto me, Write: for these words are true and faithful.

6 And he said unto me, It is done. I am Alpha and Omega, the beginning and the end. I will give unto him that is athirst of the fountain of the water of life freely.

7 He that overcometh shall inherit all things; and I will be his God, and he shall be my son.

...

22 And I saw no temple therein: for the Lord God Almighty and the Lamb are the temple of it.

23 And the city had no need of the sun, neither of the moon, to shine in it: for the glory of God did lighten it, and the Lamb *is* the light thereof.

24 And the nations of them which are saved shall walk in the light of it; and the kings of the earth do bring their glory and honour into it.

25 And the gates of it shall not be shut at all by day: for there shall be no night there.

26 And they shall bring the glory and honour of the nations into it.

27 And there shall in no wise enter into it any thing that defileth, neither *whatsoever* worketh abomination, or *maketh* a lie: but they

down out of heaven from God, prepared as a bride adorned for her husband; 3 and I heard a great voice from the throne saying, "Behold, the dwelling of God is with men. He will dwell with them, and they shall be his people, and God himself will be with them; 4 he will wipe away every tear from their eyes, and death shall be no more, neither shall there be mourning nor crying nor pain any more, for the former things have passed away."

5 And he who sat upon the throne said, "Behold, I make all things new." Also he said, "Write this, for these words are trustworthy and true." 6 And he said to me, "It is done! I am the Alpha and the Omega, the beginning and the end. To the thirsty I will give water without price from the fountain of the water of life. 7 He who conquers shall have this heritage, and I will be his God and he shall be my son."

...

22 And I saw no temple in the city, for its temple is the Lord God the Almighty and the Lamb. 23 And the city has no need of sun or moon to shine upon it, for the glory of God is its light, and its lamp is the Lamb. 24 By its light shall the nations walk; and the kings of the earth shall bring their glory into it, 25 and its gates shall never be shut by day— and there shall be no night there; 26 they shall bring into it the glory and the honor of the nations. 27 But nothing unclean shall enter it, nor any one who practices abomination or falsehood, but only those who are written in the Lamb's book of life.

which are written in the Lamb's
book of life.

Key Verse: **Behold, the tabernacle
of God is with men, and he will
dwell with them, and they shall be
his people. (Revelation 21:3)**

Key Verse: **Behold, the dwelling
of God is with men. He will dwell
with them, and they shall be his
people, and God himself will be
with them. (Revelation 21:3)**

The Scripture and the Main Question—Pat McGeachy

God's Camping Trip (Revelation 21:1-4)

It is the conviction of God that the world is worth saving (John 3:16-17).
Moreover, God intends to demonstrate that by "pitching a tent" (that is what
"tabernacle"—"dwelling," in the Revised Standard Version—means) in the
world with us. Thus, the Eternal speaks to a basic longing in the heart of
humanity, voiced by the secular poet W. B. Yeats in "He Tells of the Rose in
His Heart":

For my dreams of your image that blossoms a rose in the deeps of my heart.
All things uncomely and broken, all things worn out and old,
The cry of a child by the roadway, the creak of a lumbering cart,
The heavy steps of the ploughman, splashing the wintry mould,
Are wronging your image that blossoms a rose in the deeps of my heart.

The wrong of unshapely things is a wrong too great to be told;
I hunger to build them anew and sit on a green knoll apart,
With the earth and the sky and the water, remade, like a casket of gold
For my dreams of your image that blossoms a rose in the deeps of my heart.

If the secular poet wishes for things to be built anew (Yeats is not the only
one; consider Omar Khayyam, who longs to remold things "nearer to the
heart's desire"), how much more the Christian. Did not Jesus speak of "a
new commandment" and "new wine"? And are we not commanded in
Psalms (33:3 and 98:1) to sing a "new song" (see also Revelation 5:9)? We are
promised a new name (Revelation 3:12) in the New Jerusalem. We even
have a new promise (or covenant, I Corinthians 11:25). In short, if anyone is
in Christ, that one is a "new creation" (II Corinthians 5:17).

God knows that we aren't satisfied with the way things are and so enters
into human history through Jesus Christ to change things. History is ever
thereafter altered; we call the years from then on *anno Domini,* and the years
before then "Before Christ." To those who are willing to accept this
truth—Emmanuel (Isaiah 7:14), "God with us"—there is a new and fresh
assurance. The New Jerusalem is just around the corner; the happy ending
is about to begin. God has camped out in our world.

The Alpha and the Omega (21:5-8)

I once saw an ad in a magazine that said, "Your Ford dealer knows your
car from alpha to zeta." It sounded impressive, but to an old fraternity man
and New Testament student it rang a little hollow. For zeta is only the sixth
letter in the Greek alphabet. The last letter is omega. Surely you have seen
this old symbol somewhere around your church:

It means that God transcends human history, that the Eternal overarches time, enters into it at will (as in the life of Christ), and bears it up under the everlasting arms. It means that all history is in God's control (see Revelation 1:8, 17). It means that God cannot be pinned down (see Exodus 3:14) and that Jesus Christ is larger than time (John 8:58).

The one who is Lord over time (and space; see Romans 8:38-39: "neither . . . things present, nor things to come . . . nor height, nor depth") can make outrageous promises: free life-giving water (verse 6; see Isaiah 55:1); the inheritance of God's own royal family (verse 7; see John 1:12-12); the assurance that all that is ugly will be done away with (verse 8).

> No more let sins and sorrow grow,
> Nor thorns infest the ground;
> He comes to make his blessings flow
> Far as the curse is found.
> ("Joy to the World")

The Bride's Jewelry (21:9-21)

You will have to excuse me from making much of this section, because I am a man and not much into jewelry. I recognize this as a fault in me, like color blindness. Some people find jewels very beautiful and satisfying. And many people's vision of heaven picks up on these verses. In moving evangelical sermons and in old gospel songs, I have heard many mentions of streets of gold (verse 21), gates of pearl (verse 21), and walls of jasper (verse 11). That is all right, I think, because it represents one of the ways we can talk about that which is more beautiful than we can imagine. Jesus once described the kingdom as a pearl of great price (Matthew 13:45-46). But we must remember that such metaphors can only hint at what God has prepared for us (see I Corinthians 2:9). For me, some of the talk in the following verses about clear water and beautiful trees is more comforting. But each of us must choose the metaphor most pleasing. (Another one that I like is the great choir that we met in chapters 5–7, but for a tone-deaf person that wouldn't be very useful.) We can only conclude that it will be better than we can imagine. Some wedding!

No Temple There (21:22-27)

You don't have to go to church in heaven! This will be great news to all the restless children I know. But I need to warn you that it can be read the other way around; God is always present there, so it will be like one continuous church service! The good thing is that there will be nothing evil there (verse 27)—no shushing parents, no boring sermons, no dull anthems.

Best of all is the radical, mind-blowing news that those gates are never closed. (They *would* be closed after dark, but it never gets dark there—verse 25.) How many jokes have you heard about the person who arrived at the pearly gates and had to argue with Saint Peter about admission? Well, they are all lies: Those gates are never shut. If you ever get to heaven (that is, if you are one who loves God and goodness), you can walk right in.

The Beautiful River (22:1-5)

As background for these verses, read the description of the same river (from the same temple) in Ezekiel 47:1-12. This is the image that I love, those beautiful trees on the banks of that crystal river. As a long-time lover of the forests (I live on a sixty-acre woodlot), I see this vision as a restoration of the original garden of Genesis 2:8-9. Note that the same tree of life is growing there. It is not an accident that the word "paradise" comes from a Persian word, *pardes,* meaning "a garden."

What is the image here? That God plants life where evil sows death:

> Instead of the thorn shall come up the cypress;
> instead of the brier shall come up the myrtle;
> and it shall be to the Lord for a memorial,
> for an everlasting sign which shall not be cut off.
> (Isaiah 55:12)

All things shall be made new; the old garden, deserted by Adam and Eve, who failed to cultivate it as they should, is at last restored. To every amateur ecologist who has grieved over the destruction of the rainforests or the pouring of concrete in the city streets of the world, this is good news. It is no accident that the risen Christ should have been mistaken for a gardener (John 20:15). He is the great Gardener, the true Vine, the Pruner, the Planter, the Sower of seed (I will leave it to you to find these many references in the Gospels).

All of this can be summarized in the phrase, "Behold, I make all things new." Murphy's law is not the last word. It is, rather, the word of a fallen world, a world before the triumph, before the Millennium, before the conquering Christ comes riding in on the great white charger with the sword of the Word protruding from his mouth. He will surely come. And when he does, what will he do? Plant a new garden, in the new earth, in the shadow of the New Jerusalem, where you and I, ourselves made new, may walk on streets of gold and (better still, for my money) past the river of the water of life, under the trees of healing.

Helping Adults Become Involved—Robert E. Luccock

Preparing to Teach

A proverb of some American Indians has it, "I can never know another man until I have walked for a whole day in his shoes." To feel the greatest possible impact of today's lesson, we must walk in the shoes of those most in need of Revelation's promises. We must sit where they sit. So your preparation will be to read with all possible imagination Revelation 21 and

22:1-5. Then try to enter vicariously into the lives of those for whom such pledges offer the needed new life.

Many lives are under siege: Hope tries to hold out against despair; fear shadows the steps of faith; perseverance is exhausted by the dark forces of life; joy is held hostage to bereavement; remorse excludes forgiveness; compulsions shackle inner freedom. Multitudes of people's lives are devoid of any significant meaning and purpose. You need to try to imagine what faith requires of people so besieged. Then look at the ground of biblical faith. We reach out to trust the promises even though that sometimes means hanging on by the "skin of our teeth" (Job 19:20) and almost always saying in prayer, "I believe; help my unbelief" (Mark 9:24).

Here is an outline of the lesson:

 I. People under siege
 II. The main question: Will the center hold? Is there hope for history? Is the world worth living in?
 III. The basis of hope
 A. Faith finds solid ground in Scripture.
 B. Faith finds solid ground in human experience.
 C. Faith finds solid ground in inward experience.

Introducing the Main Question

You may introduce the main question by having class members try to imagine themselves as living one of the besieged lives suggested above. Where in those lives is the critical center that must hold against the siege? What trustworthy evidence do we see that offers hope for human history? We must never conclude that because one or more *individuals* may be unable to hold out against the dark powers that have life under siege, that therefore the world is without hope. The consummation of human hope often lies beyond *our* sight and beyond our *present personal experience*. But present personal experience is the ground upon which we take our first steps toward faith.

Developing the Lesson

I. People under siege

John gave his visions to the followers of Jesus in his time, who were under siege by tyrants against whose cruelties they had to hold out and stand firm. The visions of Revelation were a resource and a comfort (strength) for Christians wanting to be faithful. Not many of us are under the same kind of attack (although in some places in the world it is dangerous to be Christian). But our lives are under siege from different adversaries. Seven deadly powers come immediately to mind: despair, fear, surrender, sorrow, remorse, compulsions, and emptiness. In one way or another, we may call these sins. (Sorrow is natural; Jesus wept. But sorrow that we do not allow to be healed by love in a way is unfaithful.) Your class may add others to the list. What special needs do such persons have?

Examples: Many people feel that the roads of life wind uphill all the way. They despair of ever reaching the top, and feel they are destined for a life of poverty, ill health, and one disappointment after another.

> What has been is what will be,
>> and what has been done is what will be done;
>> and there is nothing new under the sun
>>> (Ecclesiastes 1:9)

Does Revelation 21–22 offer these people any hope? Any rebuttal to the preacher of Ecclesiastes?

Most of us are repeatedly tempted to despair over the future of the human race. Can *the world* ever be free of poverty, exploitation, pollution, and the catastrophes of war? What promises do John's visions hold out for the world?

How many in our world have become slaves to addictions of every sort? (Alcohol, drugs, food, sex, compulsive spending, stealing, etc.) If only some power could release them from their bondage!

Persons under siege from all quarters of life's compass face a towering question: Will the center of their lives hold? Is there any hope in history, or beyond history, that all people could be liberated from the powers of darkness?

II. The main question: Will the center hold? Is there hope for history? Is the world worth living in?

The familiar line of W. B. Yeats describes life as many find it in our age: "Things fall apart; the center cannot hold." In a time when the world has seemingly lost the Divine center, and when even the human center no longer holds, so much has been lost. The age of consumer acquisition fails to fill the empty places of the human heart. Guilt and remorse accumulate, for there is none to take them away. Even the circuits of communication with a God of grace seem somehow to be jammed. What hope have we?

III. The basis of hope

Revelation promises a new earth; a new heaven of which we have not even imagined; an end to crying, pain, and death, living water for thirsty souls; our adoption as sons and daughters of God; a world delivered from falsehood; and healing for the nations. *If we could believe all these pledges, the center would surely hold!* We do have hope!

A. Faith finds solid ground in Scripture.

From the psalms of David (especially 23, 121, 139, and 145), through Isaiah 11:1-9; Jeremiah 31:31-34; Ezekiel 37:3-14; Matthew 25:31-46; Romans 8:28-39; and II Corinthians 4, we find promises and assurance for times like these. Difficult as some of these may be, is it easier to dismiss all of this faith as groundless?

B. Faith finds solid ground in human experience.

From the time of the first martyrs all the way to Martin Luther King, Jr., and Mother Teresa, people have found it even as Jesus said it would be. As an endless line of splendor passes in review, some of us say in prayer, "I want to be in their number, when the saints go marching in." Life has here and now in many places been made new. People have felt an energy in this that can make *all* things new.

C. Faith finds solid ground in inward experience.

Faith finds solid ground in the inward experience of every person who rises from prayer forgiven, comforted, and trusting the intuition and assurance that God so loves *the world* that he gave his only Son. Because

Christ has walked the pages of world history, history does have meaning. Life is worth living.

Class Members Act

Today we complete thirteen lessons on "Visions of God's Rule." From Ezekiel and Daniel through Paul and Revelation, the focus has been on the Apocalypse—the end-time of history—and God's inauguration of the new heaven and new earth. This vision is an important dimension of the Christian faith. But if this were the whole gospel, we could be accused of believing in "pie in the sky when we die."

If we are to be true to the *whole* faith, we will always keep in view the witness of Jesus that "the kingdom of God is in the midst of you" (Luke 17:21). In the Sermon on the Mount and in the parables, Jesus left his followers with imperatives for participation in the kingdom *now*.

As a closing exercise of this study, students may be encouraged to say what kind of "life together" we should seek to live in order to be worthy of Jesus the Christ (Matthew 10:38).

Planning for Next Sunday

Next week we begin a study of the Gospel of John. The title of this quarter is "John: The Gospel of Life and Light." You will benefit by noting the titles of each of the thirteen lessons, noting also the various units of study. The specific title for December 3 is "Pointing to Jesus." Read the background scriptures: John 1:6-8, 19-37; 3:22-30.

John: The Gospel of Life and Light

UNIT I: JESUS COMES TO HIS OWN
Horace R. Weaver

FOUR LESSONS **DECEMBER 3–24**

This quarter and the first seven sessions of the next quarter are devoted to the Gospel of John. This Gospel is treasured by Christians for its literary beauty and its theological subtlety. The Fourth Gospel seeks to show the church that Jesus is neither a passing figure receding in memory nor a spiritual ideal removed from history. Instead, John affirms that Jesus Christ, who once walked on this earth, is still present in the events of human experience as living Lord. John gives special attention to images and symbols of Jesus, such as the Word, Living Water, Bread of Life, Light of the World, and Servant. These provide insights into Christ's ongoing significance. John invites contemporary persons to believe in and follow Christ.

The twenty total lessons on John are divided into four units. The first three units make up the second quarter (December–February). The fourth unit is the initial study of the third quarter (March–April). In the second quarter, Unit I, "Jesus Comes to His Own," introduces Jesus' person and purpose for coming to the world and concludes with a Christmas lesson. Unit II, "Jesus Reveals Himself," emphasizes Jesus' revealing God in words and deeds. Unit III, "Jesus Prepares His Followers," signals the arrival of the fateful hour (John 12:23) and introduces Jesus' instructions to his disciples in anticipation of his leaving them.

Unit IV, "Jesus Lays Down His Life," deals with John's treatment of Jesus' Passion and concludes with an Easter lesson. This unit becomes the first unit in the third quarter.

Unit I has four lessons, which deal with the following: "Pointing to Jesus," December 3, challenges us to learn from John the Baptist to point the way to Jesus Christ and to live a life of service to others. "Life Can Begin Anew," December 10, responds to the question, What must we do to be saved? "Never to Thirst Again," December 17, leads us to ask ourselves what we want, deep down, more than anything else in the world. "The Meaning of Christ's Coming," December 24, probes the question, Do we believe the universe is rational?

Contributors to the first quarter:
Ralph W. Decker, former Professor, Boston University School of Theology; retired Dean and Professor, Scarritt College; former Director of Department of Educational Institutions, United Methodist Church.
Pat McGeachy.
Gail R. O'Day, Ordained Minister in the United Church of Christ; Professor at Candler School of Theology, Emory University, Atlanta, Georgia.
Douglas E. Wingeier, Professor of Practical Theology; Director of Field Education; Dean of the Summer School; Garrett Evangelical Theological Seminary, Evanston, Illinois.

The Distinctiveness of the Gospel of John

Gail R. O'Day

The distinctiveness of the Gospel of John is apparent first of all in its *formal differences* from the Synoptic Gospels. In Matthew, Mark, and Luke, Jesus' ministry opens and is conducted in Galilee. Jesus moves out of Galilee to Judea and Jerusalem only once, in the final journey that culminates in his death. In the Gospel of John, however, Jesus' ministry alternates between Galilee and Jerusalem. He makes three trips from Galilee to Jerusalem in the course of his ministry (2:31; 5:1; 7:10), as opposed to the one trip of the Synoptics.

In Matthew, Mark, and Luke, Jesus' ministry lasts for one year. The chronological framework of John is quite distinct from this. The references to the feast of Passover in John provide chronological markers against which to measure Jesus' ministry. John reports that three different Passovers are celebrated in the course of Jesus' ministry (2:13; 6:4; 11:55), as opposed to the one Passover celebrated during Jesus' final days in the Synoptics. The Gospel of John thus does not confine Jesus' ministry to a one-year span but recounts a three-year ministry.

In the Synoptic Gospels, Jesus' one and life-ending visit to Jerusalem lasts for one week. In John the visit to Jerusalem that culminates in Jesus' death is of considerably longer duration. Jesus is in and around Jerusalem from 7:10 onwards, a stay of approximately six months.

The second area in which the distinctiveness of the Fourth Gospel is apparent is in its *literary style*. The Johannine literary style is marked by the use of both narrative and discourse. At times the discourse grows out of the narrative (chapters 5–6). At others, the narrative and discourse are completely interwoven, creating drama-like scenes (e.g., chapter 9).

The distinctiveness of the Gospel of John is finally apparent in its *portrait of Jesus*.

Jesus is characterized in the Gospel of John by the "I am" sayings. Jesus says, "I am" the bread of life (6:35); the light of the world (8:12); the door of the sheep (10:7); the good shepherd (10:11); the resurrection and the life (11:25); the way, the truth, and the life (14:6); and the true vine (15:1). Jesus also says "I am" without supplying any predicate (e.g., 6:20; 8:24, 28). In these instances, the "I am" statements function to identify Jesus with God (compare Exodus 4:14). The function of all the "I am" sayings is to proclaim Jesus' identity.

In John the emphasis shifts from teaching about the kingdom of God, as is the case in the Synoptic Gospels, to teaching about Jesus himself and his relationship to God. A different theological vocabulary is used to convey these new themes. The recurring vocabulary in John includes light, life, glory, witness, truth, Son, and Father.

The distinctiveness of the Johannine portrait of Jesus is most obvious in the prologue (1:1-18) with which the Gospel opens. Before the story of Jesus gets underway, the Fourth Evangelist provides the readers of the Fourth Gospel with a poetic proclamation of Jesus' identity. From the opening verses of this Gospel, there is no secrecy or hiddenness about who Jesus is. Jesus is the incarnate Word of God, the only begotten Son of God.

Pointing to Jesus

Background Scripture: John 1:6-8, 19-37; 3:22-30

The Main Question—Pat McGeachy

Adult: What do you want to be when you grow up?
Child: I want to be vice-president of the United States.

I never heard a conversation like that one, and I don't expect to. Nobody sets a goal in life of playing second fiddle. And yet every orchestra has them. Indeed, most people play secondary roles: We are needed to run interference in football games, carry water to the players, and sell peanuts in the stands. Very rarely do we get to be the starting quarterback, let alone the first violinist or the president. Are we then settling, somehow, for being second rate?

John the Baptist was not a "big-steeple" preacher. Indeed, he was outside the establishment altogether. In the sixties we called people like that "hippies." He was a scruffy desert man, clothed in wild clothing, and living on a peculiar diet of high protein and natural sweet (see the description of him in Mark 1:6). And he did not assume the role of first importance (Mark 1:7-8). "He was not the light, but came to bear witness to the light" (John 1:8). Of Jesus he said, "He must increase, but I must decrease" (John 3:30).

John is thus an excellent model for everyone who is cast as a "second banana" in life. But more than that, he is a model for all of us. Next to Jesus, no matter how spiritually mature we may be, we are always imperfect. And still more, even if you or I *could* somehow achieve spiritual perfection, that too must take the form of subservience to others. Jesus said, "Whoever would be first among you must be slave of all" (Mark 10:44). We need, then, to look carefully at this strange priest, John the Baptist. In him we may find help in carrying out the task of every Christian: to point the way to Jesus and to live, as every Christian should, a life of service to others in which we give *them* the credit.

As You Read the Scripture—Ralph W. Decker

All four Gospels report that John the Baptist was related to the mission of Jesus. In the first three his role is that of a herald proclaiming the approach of the kingdom of God. John is the first to recognize and proclaim Jesus as the Messiah.

John 1:6-8. These two verses are a bit of prose that interrupts the poem-like presentation of Jesus as the Word (1:1-18). It is the first of a number of passages that makes it clear that John was subordinate to Jesus. This probably reflects the existence of a sizable John the Baptist sect. Several New Testament passages indicate that the Baptist formed a company of disciples around himself (John 1:35; 3:25; Luke 7:19) and that this movement continued after his death (Acts 18:24-52; 19:1-4). References outside the New Testament show that the movement lasted well into the third century. It seems to have regarded John the Baptist as the Messiah and Jesus as one of his disciples.

Verse 6. In this Gospel the name John never carries with it the title "the Baptist," as it does in the other three. The emphasis here is on his witness, not his baptism. The Greek word translated "sent" carries the idea of being commissioned for a special duty.

Verse 7. John's commission was to testify that Jesus was the word, the light of humankind (1:4). The ultimate purpose of John's testimony was to lead persons to faith in Jesus Christ.

Verse 8. John emphasizes the Baptist's inferior position, probably to offset the claims of his followers. A second prose interruption of the poem appears in verse 15. There John himself declares that he is subordinate to the coming one.

Verses 19-23. The prologue poem or hymn being ended, the author presents John as vigorously denying that he is the Messiah. His denial was in answer to the questions of official delegations from the authorities in Jerusalem.

Verse 19. The author uses the term "Jews" in several ways. Here it seems to refer to the religious party called Sadducees, since they were the party of the priests and Levites. Verse 24 may refer to another delegation sent by the Pharisees, the other major religious party in Judaism. The Sadducees were strong in Jerusalem and in control of the temple. The first question, "Who are you?" had to do with authority rather than identity. It might be paraphrased to read, "Who are you to speak thus about the kingdom of God?"

Verse 20. Under questioning, John quickly denied that he was the Messiah.

Verse 21. He also denied that he was Elijah, the ninth century B.C. prophet whom the final verses of the Old Testament predicted would return and preach at the end of the age (Malachi 4:5-6).

Verse 22. Further, he rejected identification as the unnamed prophet who was expected to announce the new age (Deuteronomy 18:15).

Verse 23. After this step-by-step downgrading, John described himself as a lonely voice, without name or title or position, calling for repentance.

Verses 29-34. These verses are a second part of John's testimony that Jesus is the Messiah. The first part (verses 19-28) took the negative approach by excluding John. These verses carry the positive declaration that Jesus is the Messiah, the Son of God.

Verse 29. Two ideas from Hebrew Scripture seem to have been combined in the concept of "the Lamb of God, who takes away the sin of the world": (1) the Passover lamb, the blood of which provided exemption from death for the Israelites in Egypt (Exodus 12:1-13) and (2) the Servant who suffers for others and is "like a lamb led to the slaughter" (Isaiah 53). John clearly meant that Jesus would free people from sin by sacrifice.

Verses 32-33. All four Gospels tell of the Spirit descending upon Jesus at the time of his baptism. Only John adds that "it remained on him," identifying him as the Messiah.

Selected Scripture

King James Version	Revised Standard Version
John 1:6-8, 19-23, 29-34	*John 1:6-8, 19-23, 29-34*
6 There was a man sent from God, whose name *was* John.	6 There was a man sent from God, whose name was John. 7 He

7 The same came for a witness, to bear witness of the Light, that all *men* through him might believe.

8 He was not that Light, but *was sent* to bear witness of that Light.

..

19 And this is the record of John, when the Jews sent priests and Levites from Jerusalem to ask him, Who art thou?

20 And he confessed, and denied not; but confessed, I am not the Christ.

21 And they asked him, What then? Art thou Elias? And he saith, I am not. Art thou that prophet? And he answered, No.

22 Then said they unto him, Who art thou? that we may give an answer to them that sent us. What sayest thou of thyself?

23 He said, I *am* the voice of one crying in the wilderness, Make straight the way of the Lord, as said the prophet Esaias.

..

29 The next day John seeth Jesus coming unto him, and saith, Behold the Lamb of God, which taketh away the sin of the world.

30 This is he of whom I said, After me cometh a man which is preferred before me: for he was before me.

31 And I knew him not: but that he should be made manifest to Israel, therefore am I come baptizing with water.

32 And John bare record, saying, I saw the Spirit descending from heaven like a dove, and it abode upon him.

33 And I knew him not: but he that sent me to baptize with water, the same said unto me, Upon whom thou shalt see the Spirit descending, and remaining on him, the same is he which baptizeth with the Holy Ghost.

34 And I saw, and bare record that this is the son of God.

came for testimony, to bear witness to the light, that all might believe through him. 8 He was not the light, but came to bear witness to the light.

..

19 And this is the testimony of John, when the Jews sent priests and Levites from Jerusalem to ask him, "Who are you?" 20 He confessed, he did not deny, but confessed, "I am not the Christ." 21 And they asked him, "What then? Are you Elijah?" He said, "I am not." "Are you the prophet?" And he answered, "No." 22 They said to him then, "Who are you? Let us have an answer for those who sent us. What do you say about yourself?" 23 He said, "I am the voice of one crying in the wilderness, 'Make straight the way of the Lord,' as the prophet Isaiah said."

..

29 The next day he saw Jesus coming toward him, and said, "Behold, the Lamb of God, who takes away the sin of the world! 30 This is he of whom I said, 'After me comes a man who ranks before me, for he was before me.' 31 I myself did not know him; but for this I came baptizing with water, that he might be revealed to Israel." 32 And John bore witness, "I saw the Spirit descend as a dove from heaven, and it remained on him. 33 I myself did not know him; but he who sent me to baptize with water said to me, 'He on whom you see the Spirit descend and remain, this is he who baptizes with the Holy Spirit.' 34 And I have seen and have borne witness that this is the Son of God."

Key Verse: **The next day John seeth Jesus coming unto him, and saith, Behold the Lamb of God, which taketh away the sin of the world. (John 1:29)**

Key Verse: **The next day [John] saw Jesus coming toward him, and said, "Behold, the Lamb of God, who takes away the sin of the world!" (John 1:29)**

The Scripture and the Main Question—Pat McGeachy

It is perhaps too bad that the word "minister" has come to mean for many people "a preacher," or "the pastor." This is too bad because it is a rich word, and one that should be part of the vocabulary of every one of us. When we find it in the New Testament, it always translates the Greek word that we call in English "deacon." And it literally means "servant." Jesus applied the word to himself (Matthew 20:28): "The Son of Man came not to be served but to serve, and to give his life as a ransom for many." (If you have a King James Version of the Bible, you will see that "to serve" is rendered as "to minister.")

But ministry is not restricted to Jesus, or to the apostles, or to the clergy. It is the task of us all. See, for instance, Ephesians 4:11-13, where we are told that the task of all gifted people is to help equip the saints (that is, the members of the church) for "the work of ministry," until we are all grown up as mature disciples. Every one of us is called to ministry. When we were baptized we were ordained to serve Christ by serving others, and by pointing to Jesus in word and in deed.

Perhaps this bothers you somewhat, as it does me. We say (like Moses in Exodus 4:10), "Why me, Lord? I'm not equipped for such a great task." Well, if you feel that way, you can take great comfort from Jesus' cousin John. See what that other John (the writer of the Fourth Gospel) has to say about him.

Bearing Witness (John 1:6-8)

There is something very moving about the simple statement, "There was a man sent from God, whose name was John." You may remember that it was used in the funeral service for President John F. Kennedy. Do you think that is a proper use of the text? Was John Kennedy sent from God? Whether he fulfilled the mission for which he was sent, only history will tell, but it is our faith that he, and I, and you, and every other Christian is so called and so sent.

The name John is the short form of a Hebrew name that means "God has been gracious." Everything that John had (and that we have) is a gift. We can train our gifts, sharpen them and fine-tune them, and put them to work however we see fit, but we do not originate them. I'm afraid that I sometimes forget this when I do something particularly well and proceed to give myself all the credit for it, or when I do something particularly stupid and try to take all the blame. The truth is that, like Popeye, "I am who I am," and that means that I can do no more, and should do no less, than what God has made me capable of doing.

Well, what can you and I do? We can bear witness to the light. If you keep your eyes open on any clear night, you can almost always see a few patches of bright sunlight, even after midnight. I'm speaking of the moon and the planets; remember that they have no light of their own. They do not

originate light but reflect it. In a similar fashion you and I, like John, although we are *not* the light, can bear witness to the light.

Behold the Lamb! (1:19-37)

Everybody had ideas about who this strange baptist preacher might be (remember how they wondered about Jesus [Matthew 16:14]), but he rejected all their names for him. Instead (verse 23) he quoted Scripture to them, Isaiah 40:3. In effect he was saying, "I'm nobody in particular; I'm just a voice saying what God has told me to say."

We must not confuse the message with the messenger. Billy Graham, I am told, likes to say, "I'm just the delivery boy; I didn't write the telegram." There is a sense in which all Christian witnessing is a form of plagiarism. We don't originate the Gospel, we pass it on. Note how similar the preaching of John is to the preaching of Jesus. Compare, for example, Matthew 3:2 with Mark 1:15. You and I can, and should, say the same thing to the world in which God has placed us, sometimes in words but always in the way we live and how we behave toward others. As has been said, "You may be the only Bible that someone else will read."

And how do we witness? The simplest form of it is to do just what John did: He said, "Look!" He pointed to Jesus and called him God's Lamb, to be sacrificed for the sins of the world. In speaking to his Jewish hearers, John would expect them to understand what this meant, because they had all been raised under the sacrificial system of the priests. (Remember how, when Jesus was a baby, his parents took him to the temple to offer a sacrifice [Luke 2:22-24].) Perhaps it is not so easy for people nowadays to comprehend the meaning of a sacrificial lamb. But everybody you and I know understands the meaning of guilt and longs for forgiveness. In that sense we can always point people to Christ.

It is important to add that we are not to magnify ourselves but to lift up Christ. This is particularly helpful when we are relating to persons of other faiths. If we approach them in a kind of "top-down" manner, as though we thought of ourselves as superior to them, they will certainly be offended. An evangelist, it has been said, is not one who stands on the stage and says to the world below, "If you want to be saved, come up here on the stage with me." Rather, an evangelist is one beggar who says to another, "Friend, I have found some bread I would like to share with you." In just such a manner John points to Christ. He identifies with us. "I," he says, "can only baptize with water, but Jesus can pour out the Holy Spirit upon you."

When a minister (representing the church) baptizes a new Christian, the minister uses water, but the promise is that the Spirit is given by God. In like manner when as a minister you witness to Christ, you can only use human words and deeds, but the promise is that God can use your human words and deeds for mighty acts. As Paul once wrote (I Corinthians 3:6), "I planted, Apollos watered, but God gave the growth."

I Must Decrease (3:22-30)

It is very hard to be free from jealousy, in any walk of life. You would think that Christians would be free from it, but sometimes we get the feeling that the church has more of it than anybody else. All of us seem to have a lot of "turf-guarding" instincts. We are jealous if another church has more members than ours, or a more powerful organ, or a taller steeple. And we

attach a lot of superiority to that which is familiar and comfortable to us. I once heard this conversation:

First Methodist: "You know, I think if I weren't a Methodist, I'd be a Presbyterian."

Second Methodist: "Well, if I weren't a Methodist, I'd be ashamed of myself!"

Maybe so, but while we are deciding between the Methodists and the Presbyterians, let's not forget that Jesus was baptized by a Baptist (that is, a baptizer).

And that Baptist did not count his own baptism to be better than others. Indeed, though he was doing it in the place where the water was deepest (verse 23), he carefully pointed out to his disciples that Jesus is the bridegroom. In a sense he is saying, "I'm only a groomsman." You are familiar with the old adage, "Always a bridesmaid, but never a bride." But John has turned this phrase into one with special meaning. He says, in effect, "You shouldn't refuse to go to the wedding just because you're not the bride or the bridegroom. Your joy should be full because you are a member of the wedding party!" (verse 29).

You and I are called to play second fiddle (and third and fourth and so on). But what an orchestra! And what an honor to be included! "No one," Bishop Pike said, "has authority who does not stand under authority." Because you and I stand under Christ and, like John, point to him, we are included as Christ's own special friends (15:14). In all the world there is no greater honor.

Helping Adults Become Involved—Douglas E. Wingeier

Preparing to Teach

Pray for your class members, your church, and yourself as an instrument for transmitting God's message. Read over the entire unit to get a quick overview. Also read the introductory articles on the Gospel of John in Barclay's *Daily Study Bible, The Interpreter's One-Volume Commentary on the Bible,* volume 8 of *The Interpreter's Bible,* and *Harper's Bible Dictionary.* For this lesson, study the background scripture and the exposition of it in the commentaries. Also read Ephesians 4:11-13.

Recall an instance in which you felt ministered to. Reflect on three questions about that experience: How did you feel? What made this ministry? How was God present and active?

Your aim is to help persons understand, accept, and act on the call to ministry in their baptism, interpreted as bearing witness to Jesus as Lord, as John the Baptist did. Organize the lesson as follows:

I. Ministry is for everyone.
 A. What does ministry mean?
 B. Who is called to ministry?
II. Ministry is bearing witness.
 A. John was sent from God.
 B. John pointed to the light.
 C. John introduced Jesus.
III. Ministry is accepting authority.
 A. John subordinated himself to Jesus.
 B. John acted on his own authority.

Introducing the Main Question

"The Main Question" section is helpful in identifying your key theme, which is to see John the Baptist as a model for our ministry.

Ask members to recall a time when they felt ministered to. Write the above three questions on the board. Give the group time to think and write some notes. Then ask persons to share their experiences and responses to the questions. Write their comments on the board in three columns: Feelings, Qualities of Ministry, and Activity of God. Lead the group in drawing some conclusions about ministry in light of their experiences, such as: People are changed through ministry; any Christian can do ministry; one feels more whole/affirmed/forgiven/uplifted/challenged when being ministered to; God works through people.

Explain that we are taking John the Baptist as our model of ministry because he (1) knew he was sent from God to perform a task, (2) pointed to Jesus rather than himself, and (3) witnessed to Jesus as Lord by putting himself under the authority of Jesus. Make connections between these three emphases and the lists on the board.

Developing the Lesson

I. Ministry is for everyone.
 A. What does ministry mean?

Explain the meaning of the word "minister," using the material in "The Scripture and the Main Question." The Greek word *diakonia* means "service" or "ministry" and is the origin of our word "deacon." John the Baptist and Jesus both came to serve, and all we who follow after them are likewise called to serve both God and the human family.

 B. Who is called to ministry?

Have someone read aloud Ephesians 4:11-13. Comment that God has given gifts to all Christians (the saints) to be used in ministries that serve the well-being of the whole church (Body of Christ). Ask the class to name the ministries being performed and the gifts being used in their church. Observe that the persons carrying out these ministries are not pastors but mostly laypersons.

When we talk in terms of a call to ministry, like Moses we may think we are not qualified. But when we look at the ministries (forms of service) actually being carried out by our church members in both church and community, we realize that in actuality we have responded to the call and are busily engaged in ministry whether we know it or not.

Mention that many churches now print on their bulletins and letterheads, "Ministers: all members of the congregation; Pastor: Rev. X." This makes visible the biblical understanding that all Christians are ministers; the pastor performs one specialized form of ministry—training and motivating (equipping) the other members for their ministries.

II. Ministry is bearing witness.
 A. John was sent from God.

We are sent into ministry. It is not something we just decide to do. We feel an inner urgency; it is something we must do. The Spirit of God impresses on our hearts that we are needed to perform a particular task. If we don't do it, it won't get done. John knew that God was calling him to prepare the way

for Jesus the Messiah. We know that God has something specific for us to do also.

B. John pointed to the light.

John's particular form of ministry was bearing witness that Jesus was the Messiah. He did not seek to attract followers to himself but rather led them to "he who comes after me, the thong of whose sandal I am not worthy to untie" (1:27). He wanted people to believe his words, but also to believe in Jesus.

C. John introduced Jesus.

We may find it difficult to talk about Jesus to our friends and neighbors. The hard-sell manipulative tactics used by some have given Christian witnessing a bad name and built up resistance to it in both hearer and witness. We need to find effective ways of introducing Jesus to others. Ask the class to share forms of witness that have been meaningful to them.

Suggest four ways of witness: ethical decision making, practical help, sharing what one's faith has meant, and working for social justice. Ask them to give examples of each. Show how each type can be a way of introducing Jesus to others.

III. Ministry is accepting authority.

A. John subordinated himself to Jesus.

As mentioned in "As You Read the Scripture," John the Baptist denied that he was either the Messiah, Elijah, or an unnamed prophet (1:25), but instead asserted that "after me comes a man who ranks before me" (1:30). He baptized only with water, but Jesus would baptize with the Holy Spirit (1:33). Jesus was the bridegroom, John only the groom's friend (3:29). "He must increase, but I must decrease" (3:30). Rather than setting out to make a name for himself, John the Baptist subordinated himself to the authority of Jesus.

Refer to comments under "The Main Question" about being willing to play secondary roles. Note that this does not mean being mediocre or second rate, but rather submitting ourselves to the authority of Jesus, to seek to do his will rather than our own.

B. John acted on his own authority.

Paradoxically, by accepting the authority of Jesus, John gained the inner authority to act with conviction in defiance of popular convention and the political and military authorities. He paid for this with his life, but his brave witness succeeded in calling attention to Jesus and paving the way for "the Lamb of God" to "take away the sin of the world" (1:29) and for many "to believe through him" (1:7).

Likewise, by acknowledging the authority of Jesus over our lives, we can gain an inner sense of authority that empowers us to act with courage. By accepting Christ we gain confidence to speak and act for him in situations of crisis or temptation.

Helping Class Members Act

In closing, help group members identify ways in which they can point to Jesus through their words and acts during the coming week. Close by singing "A Charge to Keep I Have" and praying for strength to empower our witness during the coming week.

Planning for Next Sunday

Ask the class to prepare by reading John 3:1-21 and to be ready to share instances of their being in ministry to others during the week.

LESSON 2 DECEMBER 10

Life Can Begin Anew

Background Scripture: John 3:1-21

The Main Question—Pat McGeachy

These days we are accustomed to hearing the phrase "born-again Christian" spoken almost as though it were one word. When I hear it, it often seems to be used as a catch phrase to describe true Christians as opposed to false. Some of us claim to be born again as though that distinguished us from those who are merely nominal Christians, those who are just "going through the motions" but haven't really understood what their faith means. Such persons, we imply, "cannot see the kingdom of God" (John 3:3).

Is this true? Are there really two kinds of Christians, the *ins* and the *outs*? And if it is true, how does one get to be born again? Surely we would all want to do it if we could, because we don't want to miss out on the kingdom. We feel very much like Nicodemus: It's hard to understand.

First of all, lets be careful that we do not use "born again" or any other Bible statement as a catch phrase by which to judge others. We have been specifically *forbidden* to judge (see Matthew 7:1). Just because someone has not had exactly the same religious emotional experience as mine does not mean that person does not belong to God. I dare not condemn another for not being just like me. But having said that, it remains obvious that some people, like Nicodemus, feel "unsaved," left out, and uncertain. Like Nicodemus we are searching for answers to our faith questions, and we turn, as he did, to Jesus. We want to know, "Is it possible for my life to begin all over, new and fresh? And if so, what must I do to help that happen?" At one time or another most of us have felt this way. Like the jailor at Philippi (Acts 15:30), we each want to know, "What must I do to be saved?"

If that is the main question of this lesson, it is certainly a big one. Indeed, it is the main question of life itself, and one that we need to answer.

As You Read the Scripture—Ralph W. Decker

John 3:1. Nicodemus appears three times in this Gospel and nowhere else in the New Testament. He was a member of the leading religious party (a Pharisee) and of the Sanhedrin, the supreme council of the nation ("a ruler of the Jews"). In 7:50-52 it is reported that he challenged the legality of judging Jesus without a trial and was rebuked. In 19:39 it is said that he

joined Joseph of Arimathea, another Sanhedrin member, in burying the body of Jesus. He may have been, like Joseph, a secret disciple (19:38).

Verse 2. The writer emphasizes that it was by night that Nicodemus visited Jesus. He repeats that statement in 19:39. It is often suggested that Nicodemus was reluctant to be seen with Jesus, who his colleagues regarded as of questionable standing. Another interpretation is that he sought a long evening talk when Jesus was free of the crowds. In calling Jesus "Rabbi" he showed that he respected him as a teacher and came to him as a learner. In John the miracles are referred to as signs (2:11, 23; 4:54; 6:2; 7:31; 9:16). The author, like Nicodemus, regarded them as showing the power and presence of God.

Verse 3. That we have only a small part of a conversation is indicated by Jesus' giving an answer although no question is reported. There may have been one about how one enters the kingdom that John the Baptist was proclaiming. Jesus said one enters it in the same way one enters earthly life—by being born into it. The Greek words translated "born anew" may mean either "born a second time" or "born from above." Jesus may have used them deliberately since the kingdom birth, a spiritual experience, is both a new beginning and a gift from God. This verse contains the first example of a dialogue pattern that occurs a number of times in this Gospel. Jesus makes a statement that may be understood literally or as referring to a spiritual truth. He is taken literally and thus is misunderstood. He then explains the spiritual meaning of his words.

Verse 4. Nicodemus thinks Jesus is referring to a physical experience.

Verse 5. This verse reflects the Christian belief in double baptism—with water by the church and with the Holy Spirit by God.

Verses 7-8. The Greek word translated "wind" is another double-meaning word. It is *pneuma,* exactly the same word that is translated "Spirit" in this verse. This is also the translation of the Hebrew and Aramaic word *ruach.* The point is that neither wind or Spirit can be seen, but both are real and their effects are apparent.

Verses 9-10. In the Greek, Nicodemus is called "the teacher of Israel," indicating that he was an intelligent person even though he had trouble understanding Jesus.

Verses 11-13. This section seems to be directed not toward Nicodemus but toward those he represented, the leaders who had not accepted Jesus.

Verse 13. Only the one who came from God fully understands God.

Verse 14. Numbers 21:4-9 tells that when the Israelites were plagued by snakes in the wilderness, healing came to those who looked at a bronze serpent hanging on a pole. This is taken as symbolizing the healing of the cross.

Verse 15. "Eternal life" is a favorite term of John. He uses it of a quality of living rather than of an everlasting existence. It does not come with death; it can be entered here and now.

Verses 16-17. It is not clear whether these are the words of Jesus or of the author of the Gospel. Ancient manuscripts have no quotation marks, and without them it is difficult to tell where direct speech ends and comment begins. The King James Version left the verse without quotation marks. The New King James Version added quotation marks to make them the words of Jesus. The Revised Standard Version, following the King James, makes the verses a statement by John.

Verse 16. Martin Luther called this verse "the Gospel in miniature."

Selected Scripture

King James Version

John 3:1-17

1 There was a man of the Pharisees, named Nicodemus, a ruler of the Jews:

2 The same came to Jesus by night, and said unto him, Rabbi, we know that thou art a teacher come from God: for no man can do these miracles that thou doest, except God be with him.

3 Jesus answered and said unto him, Verily, verily, I say unto thee, Except a man be born again, he cannot see the kingdom of God.

4 Nicodemus saith unto him, How can a man be born when he is old? can he enter the second time into his mother's womb, and be born?

5 Jesus answered, Verily, Verily, I say unto thee, Except a man be born of water and *of* the Spirit, he cannot enter into the kingdom of God.

6 That which is born of the flesh is flesh; and that which is born of the Spirit is spirit.

7 Marvel not that I said unto thee, Ye must be born again.

8 The wind bloweth where it listeth, and thou hearest the sound thereof, but can'st not tell whence it cometh, and whither it goeth: so is every one that is born of the Spirit.

9 Nicodemus answered and said unto him, How can these things be?

10 Jesus answered and said unto him, Art thou a master of Israel, and knowest not these things?

11 Verily, verily, I say unto thee, We speak that we do know, and testify that we have seen: and ye receive not our witness.

12 If I have told you earthly things, and ye believe not, how shall ye believe, if I tell you *of* heavenly things?

13 And no man hath ascended

Revised Standard Version

John 3:1-17

1 Now there was a man of the Pharisees, named Nicodemus, a ruler of the Jews. 2 This man came to Jesus by night and said to him, "Rabbi, we know that you are a teacher come from God; for no one can do these signs that you do, unless God is with him." 3 Jesus answered him, "Truly, truly, I say to you, unless one is born anew, he cannot see the kingdom of God." 4 Nicodemus said to him, "How can a man be born when he is old? Can he enter a second time into his mother's womb and be born?" 5 Jesus answered, "Truly, truly, I say to you, unless one is born of water and the Spirit, he cannot enter the kingdom of God. 6 That which is born of the flesh is flesh, and that which is born of the Spirit is spirit. 7 Do not marvel that I said to you, 'You must be born anew.' 8 The wind blows where it wills, and you hear the sound of it, but you do not know whence it comes or whither it goes; so it is with every one who is born of the Spirit." 9 Nicodemus said to him, "How can this be?" 10 Jesus answered him, "Are you a teacher of Israel, and yet you do not understand this? 11 Truly, truly, I say to you, we speak of what we know, and bear witness to what we have seen; but you do not receive our testimony. 12 If I have told you earthly things and you do not believe, how can you believe if I tell you heavenly things? 13 No one has ascended into heaven but he who descended from heaven, the Son of man. 14 And as Moses lifted up the serpent in the wilderness, so must the Son of man be lifted up, 15 that whoever believes in him may have eternal life."

up to heaven, but he that came down from heaven, *even* the Son of man which is in heaven.

14 And as Moses lifted up the serpent in the wilderness, even so must the Son of man be lifted up;

15 That whosoever believeth in him should not perish, but have eternal life.

16 For God so loved the world, that he gave his only begotten Son, that whosoever believeth in him should not perish, but have everlasting life.

17 For God sent not his Son into the world to condemn the world: but that the world through him might be saved.

Key Verse: **Verily, verily, I say unto thee, Except a man be born again, he cannot see the kingdom of God. (John 3:3)**

16 For God so loved the world that he gave his only Son, that whoever believes in him should not perish but have eternal life. 17 For God sent the Son into the world, not to condemn the world, but that the world might be saved through him.

Key Verse: **Truly, Truly, I say to you, unless one is born anew, he cannot see the kingdom of God. (John 3:3)**

The Scripture and the Main Question—Pat McGeachy

Dissatisfaction (John 3:1-3)

Nicodemus, a prominent person in his faith community, sneaked out at night to see Jesus. We can assume that he didn't want his fellow Pharisees to know that he was dissatisfied with his spiritual life and was turning to this new prophet for answers. Can we translate this into our own space? What if a prominent United Methodist minister or layperson, someone who has always been "a good Christian" and comes from a good family, should seek out a modern-day guru and admit to dissatisfaction with the journey of faith? What if you or I did it?

Notice that Nicodemus did not come right out with his worries. He began the conversation with words that may have been a kind of flattery: "You must be God's person because of what you do." But Jesus has a way of seeing past what we say aloud, right into our hearts. He knew that Nicodemus had come because there was something missing, for all his position, in his religious life. And he told him that he needed to experience a new birth. Surely that is what you and I need to hear if we are experiencing problems with our faith. We too need to start over. But how can we do it?

Waiting on the Wind (3:4-8)

The startling answer that Jesus gives us is that we cannot do it! We must wait on it, as one waits for the wind to blow. Let me interrupt here to remind us that in the Bible (both in Hebrew and in Greek) the words for "wind," "breath," and "spirit" are the same word. Here are a couple of other places where you can spot this. In Luke 23:46, the Revised Standard Version says

of Jesus' death, "he breathed his last"; note that the King James Version translates it, "he gave up the ghost [spirit]." And look also at Ezekiel 37, where all three words are used. In a way Jesus is making a play on words here, but in a deeper way he is making a profound point. He has told Nicodemus that he must be born of "water and the wind."

When I think of the Spirit as the wind of God, I immediately think of my younger days when I did a good bit of saltwater sailing. My brother and I always wanted a motor boat, but our dad would argue us out of it, saying, "They're noisy and smelly and they run out of gas." "Sometimes you run out of wind, too," we would argue. "Yes," he would say, "but the wind always comes back." And so it does. A good sailor cannot make the wind blow, nor determine its direction (3:8). But there is something the sailor can do: set the sails properly and use the rudder wisely so that whenever and however the wind comes, the boat will move in the right direction.

There are ways that we can wait on the wind of God. We can't merit God's grace in any way, by good works or by incantations. But through what some call the "means of grace"—prayer, Bible study, the sacraments, and the Christian life—we can so set our spiritual sails as to catch the Spirit when God chooses to breathe on us. Nicodemus is right. You can't make yourself be born again, but Jesus knows something else: You can make yourself available to the new birth that comes from God as a gift.

The Best News in the World (3:9-17)

The new birth in the Spirit is a matter of belief. "Whoever believes in [Jesus] may have eternal life" (verse 15). It is hard to believe, but even a teacher of Israel (verse 10) or a prominent church leader of today can miss this point. We are so conditioned by the world to believe that we stand under judgment because of our behavior—the bad things we have done, the good things we have failed to do—that we simply miss the point that God loves us (verse 16) not because we are so lovable (I John 4:10), but because God is love (I John 4:8).

When this good, glad news dawns on us, it is like what some psychologists call an "Aha!" experience. It is as though we went all the way through the sixth grade believing that we were in danger of flunking out, only to discover the incredible truth that in this school, everybody is assured of a diploma if he or she only asks for one. In God's school you have already been given an A. If you believe this, you are in no danger of flunking whatever. Do you not think that the next six years of school will be more fun? You might say that the point when you realized that your diploma is a gift was the time of your "rebirth." Before that time you lived under the constant fear of flunking; every homework assignment was a grievous burden and every test terrifying. But now, at last, you can enjoy going to school, enjoy learning for its own sake, not out of fear of flunking but out of the love of knowledge.

In just such a way the knowledge of God's approval comes to us with the fresh wind of the Spirit, filling us with new life and hope. To know that God loves me is to be born again. And if you know this, then you are a "born-again" Christian. The new birth is not some mysterious religious experience that some folks have and others can't get; it is nothing other than belief in John 3:16. It may be that you came to believe that long ago, when you were so very young that you cannot remember the experience. Or it

may be that it hit you like a bolt of lightning as a grown person, like it did the apostle Paul. Or it may be that, like me, you have to be reminded about it regularly. (This is one reason that I need to go to church every week, to hear the minister [even if it is me] say once again the old familiar words, "In Jesus Christ we are forgiven.") When you and I hear these words and believe them, we are born again, and our lives are made new. We are a part of the kingdom of God.

If, like Nicodemus, you do not feel a part of that kingdom but left out, then you must set your sails to catch the Spirit by returning to the old places where you have felt the wind before: your prayers, the reading of the Scriptures, the fellowship and communion of the church. Remember that you were once baptized with water; now wait for the wind. As sure as God is the great Keeper of Promises, you can be certain that it will happen. We know this, because we know that God has our salvation at heart. Just as the principal of that school we were talking about has no intention of flunking anybody who faithfully attends, so God has no intention of destroying those who long for salvation. It is not God's will that a single one of us should perish (Matthew 18:14). God did not send Jesus into the world to condemn the world, but that the world might be saved through him (John 3:17).

Good Works (3:18-21)

When we have been born again, that is, when we have come to realize anew that God truly loves us and wants us to be saved, it changes us. Just as the student who knows that an A is coming can relax and be a better student, so we, knowing that God really loves us, begin to grow in the way we live. We actually begin to do those things we have been neglecting, and we have the power to begin quitting those things that are destructive to ourselves and others. Newborn Christians are sometimes a little clumsy at our new life; as long as we are in the body we will keep on making mistakes. But when we know God loves us, we begin to bear fruit in the form of good works.

In my Revised Standard Version Bible there are quotation marks after 3:15 indicating that the translators believed that this is the end of Jesus' words to Nicodemus and that the rest of the passage (verses 16-17) is the words of the writer. But it could be Jesus continuing to talk. (There are no quotation marks in the ancient manuscripts.) Whether it was John or Jesus, the last words (verses 19-21) tell us that if we love the light our deeds will begin to show it. To be born again is to decide to love light, not darkness. I once knew a mean, nasty, cruel man, who, on encountering Jesus, said to himself, "I'm not going to live like this any more." And he changed. So can you and I.

Helping Adults Become Involved—Douglas E. Wingeier

Preparing to Teach

Reflect on new birth experiences you have had. Consider religious conversion experiences, but also life crises and transitions when God's Spirit has given you new insight, confidence, or direction, and you have gained a new lease on life. In your prayer of preparation thank God for these new births, and also ask for wisdom and sensitivity to help your class discover and claim these experiences as well. Read John 3:1-21 and its exposition in

the *The Interpreter's Bible,* and Barclay's commentary on John. Also read John 7:45-52 and 19:38-42, the other two New Testament passages that mention Nicodemus.

Your purpose is to enable persons to recall, claim, and share previous new birth experiences and to remain open to future ones, in light of their study of Jesus' conversation with Nicodemus about the new birth.

Employ the following outline:

> I. The incentive for change
> A. For Nicodemus
> B. For us
> II. The power to change
> A. For Nicodemus
> B. For us
> III. The outcome of change
> A. For Nicodemus
> B. For us

Introducing the Main Question

Ask class members to share instances of their ministry or witness during the previous week. Prime the pump by telling one of your own. Remind them that Christian witness can take the form of either deeds of service, moral choices, acts to effect humanizing change, or words that share our faith—as long as they are done in the name of Jesus.

Next, give a word-association test. Ask persons to write down the first word or phrase that comes to mind when they hear each of the following: change, transition, conversion, born again, being saved. Call for their responses to these when they come up later in the lesson.

Share Pat McGeachy's discussion of born-again Christians, the *ins* and the *outs,* and "What must I do to be saved?" under "The Main Question." Introduce today's story by explaining who Nicodemus was, as described in "As You Read the Scripture."

Developing the Lesson

I. The incentive to change

A. For Nicodemus

As a wealthy Pharisee, member of the Jewish Supreme Court, and prominent religious and political leader, Nicodemus would seem to have no need for Jesus the Galilean rabble-rouser. But apparently Nicodemus was dissatisfied with his life. Riches, learning, status, and recognition had not met his inner spiritual hunger, and so at a deeper level he had a great need for Jesus the Savior. His incentive for change (here ask the group for responses to the word "change" and discuss them in relation to Nicodemus's need for change) was a profound, heartfelt recognition that human effort and achievement could not bring peace to his soul. And so, discreetly and under cover of darkness, he sought Jesus out to learn from him the mystery of being born again. (Here discuss the group's responses to "born again.")

B. For us

Like Nicodemus, our incentive for change can also come from an inner

dissatisfaction with our lives. Our hopes may have been dashed; our achievements may have gone sour; relationships may be troubled; earlier choices may not have worked out; people may have let us down; the beliefs we thought were certain may now seem doubtful. In short, we are in transition (here call for sharing of members' responses to the word "transition") from one set of plans/decisions/values/relationships/goals to another.

God is working in our lives through these transitions, whether we are aware of it or not. The Spirit of God is nudging/driving/calling/blowing us into change. God wants to convert us (here discuss the group's written associations with "conversion") from one level of living to a deeper one.

II. The power to change
A. For Nicodemus

Seeking the meaning and purpose that his life apparently lacks, Nicodemus pays Jesus a compliment in the hope that he will reveal a religious formula for salvation. (Here discuss the group's responses to the phrase "being saved.") Jesus does so, but not in the way Nicodemus expects. Being a Pharisee, a "keeper of the law," Nicodemus likely is looking for a set of steps he could follow, some "spiritual laws" to memorize and obey, or some prayers to recite. Instead, Jesus answers him in images—the new birth, the blowing wind. Nicodemus wants specific answers, but Jesus points him to a mystery. Life in the Spirit is like the wind—you can't see it, you don't know where it comes from, you can't control it. You can only surrender yourself to it and set your sail and rudder to let it blow you in the right direction, as Pat McGeachy puts it.

Nicodemus has come on a serious and urgent quest, but he has to be content with a vague and intangible response from Jesus. The power to change comes in the Spirit. If you want to change, be born of the Spirit; open your life to the mysterious blowing wind of God.

B. For us

And so it is with us. When we face transition, disillusionment, inconsistency between previous beliefs and present circumstances, or disappointment with trusted people, we can be born again into new awareness by opening our lives to the mysterious blowing wind of God's Spirit, which will give us the power to change.

III. The outcome of change
A. For Nicodemus

We do not know just how much Nicodemus was changed by this encounter with Jesus. In the other two passages in which he appears in John, we see him taking some risks on Jesus' behalf. (Ask two persons to read aloud John 7:45-52 and 19:38-42.) It could well be that a new openness to God's Spirit empowered him with the courage to oppose his fellow Sanhedrin members and to join with Joseph of Arimathea, a secret disciple, to prepare Jesus' body for burial.

B. For us

The outcome of change for us is equally mysterious. What is certain is that the new birth brings with it the inner assurance that we belong to God. What is unpredictable is what the wind of the Spirit will lead us into as a result of this knowledge. We may continue in our present circumstances but with a transformed attitude and new vision of what we can become. On the other

hand, we may decide to alter our situation radically—changing jobs, moving to a new location, adopting new disciplines, making new covenants.

God works through transition to bring new birth. New births occasion further changes. Our God is a God of change.

> Remember not the former things,
> nor consider the things of old.
> Behold, I am doing a new thing;
> now it springs forth, do you not perceive it?
> (Isaiah 43:18-19)

Helping Class Members Act

Ask members to cite instances of the Spirit "doing a new thing" in their lives. Begin by sharing a new birth experience of your own. Point out that new births occasioned by God's Spirit are not limited to religious conversions but also include new insights, discoveries, and life transitions that liberate, transform, and point to new directions. Offer a prayer asking the Spirit to open us to the blowing wind that we may be born again and again into God's transforming vision, freedom, and power. Close by singing the hymn "Amazing Grace."

Planning for Next Sunday

In addition to reading John 4:1-42, ask class members to complete the sentence "I want . . ." ten times and bring their lists to class next week.

Never to Thirst Again

Background Scripture: John 4:1-42

The Main Question—Pat McGeachy

I think that thirst is the strongest of all desires. It is true that we need air more than we need food and water, but without air we suffocate in a few seconds. So we don't often dwell for long on the need for it; we take it for granted. And a person can go for many days without food. (Some of us probably ought to.) Sex, power, security, and prestige we can postpone. But thirst—when it hits us it is ravenous.

Have you ever been *really* thirsty? I don't just mean wishing for a drink; I mean the image of the old prospector in the desert, crawling toward the water hole. Once, in the company of other pilgrims, I came down off of the high tops after a journey of some days in the mountains. Like tenderfeet we had let our canteens run dry, and the berries we ate only added to our misery. Down a ravine, at last, we heard the precious trickle of water—a

pencil-thin drop from a spring. We drew straws for the first sip, and I drew the short one. I remember waiting in utter torment for my turn, watching the other fellows drink. What desire! And what ultimate satisfaction!

But what is the real thirst of life? (Read Psalm 42:1-3 or Psalm 63:1-4.) More than the need for water is our need for ultimate meaning and hope. It is what C. S. Lewis called "sweet desire," that longing in the heart of everyone for God. The Samaritan woman in John 4 understood thirst, as we all do. But she ravenously longed for something deeper than her earthly desires. Jesus, who knew her need, answered it with painful honesty, and so he will answer us.

Stop and think: What do you want, deep down, more than anything else in the whole world? If you are like me and the woman of our story, you probably have been seeking it in all the wrong places. It is hard to talk even to our best friends about such desires. But it is life's main question, and Jesus comes to us with a wonderful answer.

As You Read the Scripture—Ralph W. Decker

John 4. Most of the events reported in this chapter took place in Samaria. Palestine was about 120 miles long from north to south. In Jesus' day it was divided into three districts: Galilee to the north, Samaria in the middle, and Judea to the south. The population of Samaria was an ethnic mixture that according to the Jewish view resulted from the intermarriage of local Jews with pagan colonists brought in when the area was overrun by the Assyrians about 720 B.C. The Samaritans shared many of the religious beliefs of the Jews. They worshiped the one God, accepted the five books of Moses as the law, and observed the same holy days. When Jews returned from the Babylonian captivity about 520 B.C., the Samaritans offered to help rebuild Jerusalem and the temple. Their offer was refused by the Jewish leaders because of the Samaritans' mixed blood and mixed beliefs. The Samaritans then tried unsuccessfully to prevent the rebuilding. From that time on there was deep antagonism between the Jews and the Samaritans. Jews traveling between Judea and Galilee usually crossed the Jordan River, traveled through Perea (which was largely Jewish), and recrossed the river, thus avoiding Samaria. John does not give the reason for Jesus' taking the shorter way.

Verse 7. The previous paragraph placed Jesus at Jacob's Well near the village of Sychar in Samaria at about noon. As he rested while his disciples went into Sychar to buy food, a Samaritan woman came to draw water. The ensuing conversation follows John's usual pattern for retelling an event. A physical circumstance (thirst) leads Jesus to speak of a spiritual matter (satisfaction of the thirst of the soul). He is misunderstood and taken literally. The misunderstanding provides an opportunity for significant teaching. Some interpreters make a great deal of the fact that the woman came alone and at midday. They see her as avoiding the rebuffs of other women because of her shady reputation. Jesus reached across a number of barriers in speaking to her. Jewish men did not talk with women in public. Jews did not talk with Samaritans. If the woman was of questionable character, Jesus was extremely unconventional.

Verse 8. John explains why Jesus was alone with the woman.

Verse 9. It was not the request for a drink that surprised the woman. A traveler would be without equipment to draw from the well. It was the fact

that he was a Jew, as she may have recognized from his dress or speech. The statement about no dealings is either John's comment or the addition of a later editor to explain the circumstances to non-Jewish readers. In some translations, such as the New English Bible and the Good News Bible, this added comment is put in terms of the Jews' refusal to share dishes with Samaritans; these translations also use parentheses to show that it is an editorial comment.

Verses 10-11. "Living water" refers to a flowing spring, in contrast to a cistern-type well into which water seeps from the surrounding soil.

Verses 12-15. Jesus explains his figure of speech, but the woman persists in taking him literally.

Verse 27. The returning disciples were surprised by Jesus' violation of custom but did not question it.

Verses 28-29. The woman to whom Jesus, after discussing with her aspects of her private life (verses 16-18) and the meaning of true worship (verses 19-24), had revealed himself to be the Messiah (verses 25-26) hurried to share the revelation with the other villagers. The abandoned water jar is evidence of her excitement and haste.

Verses 39-42. These verses report two ways in which the Christian faith has been spread: by the testimony of believers and by personal experience.

Selected Scripture

King James Version

Revised Standard Version

John 4:7-15, 27-29, 39-42

7 There cometh a woman of Samaria to draw water: Jesus saith unto her, Give me to drink.

8 (For his disciples were gone away unto the city to buy meat.)

9 Then saith the woman of Samaria unto him, How is it that thou, being a Jew, askest drink of me, which am a woman of Samaria? for the Jews have no dealings with the Samaritans.

10 Jesus answered and said unto her, If thou knewest the gift of God, and who it is that saith to thee, Give me to drink; thou wouldest have asked of him, and he would have given thee living water.

11 The woman saith unto him, Sir, thou hast nothing to draw with, and the well is deep: from whence then hast thou that living water?

12 Art thou greater than our father Jacob, which gave us the well, and drank thereof himself, and his children, and his cattle?

13 Jesus answered and said unto

John 4:7-15, 27-29, 39-42

7 There came a woman of Samaria to draw water. Jesus said to her, "Give me a drink." 8 For his disciples had gone away into the city to buy food. 9 The Samaritan woman said to him, "How is it that you, a Jew, ask a drink of me, a woman of Samaria?" For Jews have no dealings with Samaritans. 10 Jesus answered her, "If you knew the gift of God, and who it is that is saying to you, 'Give me a drink,' you would have asked him, and he would have given you living water." 11 The woman said to him, "Sir, you have nothing to draw with, and the well is deep; where do you get that living water? 12 Are you greater than our father Jacob, who gave us the well, and drank from it himself, and his sons, and his cattle?" 13 Jesus said to her, "Every one who drinks of this water will thirst again, 14 but whoever drinks of the water that I shall give him will never thirst; the water that I shall give him will

her, Whosoever drinketh of this water shall thirst again:

14 But whosoever drinketh of the water that I shall give him shall never thirst; but the water that I shall give him shall be in him a well of water springing up into everlasting life.

15 The woman saith unto him, Sir, give me this water, that I thirst not, neither come hither to draw.

..

27 And upon this came his disciples, and marvelled that he talked with the woman: yet no man said, What seekest thou? or, Why talkest thou with her?

28 The woman then left her waterpot, and went her way into the city, and saith to the men,

29 Come, see a man, which told me all things that ever I did: is not this the Christ?

..

39 And many of the Samaritans of that city believed on him for the saying of the woman, which testified, He told me all that ever I did.

40 So when the Samaritans were come unto him, they besought him that he would tarry with them: and he abode there two days.

41 And many more believed because of his own word:

42 And said unto the woman, Now we believe, not because of thy saying: for we have heard *him* ourselves, and know that this is indeed the Christ, the Saviour of the world.

Key Verse: **Whosoever drinketh of this water shall thirst again: But whosoever drinketh of the water that I shall give him shall never thirst. (John 4:13-14)**

become in him a spring of water welling up to eternal life." 15 The woman said to him, "Sir, give me this water, that I may not thirst, nor come here to draw."

..

27 Just then his disciples came. They marveled that he was talking with a woman, but none said, "What do you wish?" or, "Why are you talking with her?" 28 So the woman left her water jar, and went away into the city, and said to the people. 29 "Come, see a man who told me all that I ever did. Can this be the Christ?"

..

39 Many Samaritans from that city believed in him because of the woman's testimony, "He told me all that I ever did." 40 So when the Samaritans came to him, they asked him to stay with them; and he stayed there two days. 41 And many more believed because of his word. 42 They said to the woman, "It is no longer because of your words that we believe, for we have heard for ourselves, and we know that this is indeed the Savior of the world."

Key Verse: **Every one who drinks of this water will thirst again, but whoever drinks of the water that I shall give him will never thirst. (John 4:13-14)**

The Scripture and the Main Question—Pat McGeachy

Natural Thirst (John 4:1-8)

Jesus knew what it was to be tired (verse 6). (Do you suppose he got short-tempered as you and I do when we are very weary?) Lonely and

exhausted, he sat by Jacob's Well (it is still there and still called by that name) while his disciples went into town for food (verse 8). It is hard for us to think of our Lord as suffering thus; we like to picture him as something like Superman, invulnerable to the ordinary pains of life. But he was "in every respect . . . tempted as we are" (Hebrews 4:15) and thus understands all our weaknesses (Psalm 103:14). No doubt he *could* have turned stones into bread (Matthew 4:3-4), but he chose to relate to the world of hunger and thirst as you and I do.

Then there came (verse 7) a woman of Samaria, herself thirsty. In spite of our wish to think that others don't have our desires, don't hurt like we do, we must admit that even Samaritans thirst. They were a despised group, cousins of the people of Israel, but by virtue of their traditions, different and therefore suspect. Nonetheless, as the old cliché has it, they put on their pants the same way we do—that is, their needs and hopes are as ours. It would be nice to think that poor and humble folk lack our "sophisticated" needs, but the truth is they are, like us, longing after true meaning in life.

Jesus defied two cultural traditions, those of the Samaritans and those of his own people, by speaking to this woman. But it is the natural response of the lifeguard. When someone is drowning, you leap into action, defying the pull of gravity and the turbulent waters for the sake of a life. And here was a person whose life was at stake. She thought of it as an ordinary thirst for water; Jesus knew it to be thirst for the water of life.

The Water of Life (4:9-15)

There is a lot of misunderstanding going on here: the woman doesn't know whom she is talking to (verse 10), and she doesn't know what she is asking. But Jesus knows who *she* is, and understands far more about her than she knows about herself (verses 17-18). He accepts her on her own primitive level of thirst and answers her in terms of her deepest needs. At another time (in the Sermon on the Mount, Matthew 7:7-11) Jesus has made it clear that God's generosity exceeds that of ours. If one of your children asked for a serpent, would you not instead offer a fish? And if your child asked for a rock to eat, would you not actually give bread? God answers the question we are really asking, and just as Jesus replied to the heart of Nicodemus when the Pharisee himself may not have fully formulated his question, so now he answers the deepest question of the Samaritan woman's heart.

It is also, of course, the question of my heart and yours: Where is the water of life? It is one of the last cries in the Bible (Revelation 22:17), and it goes far back into the Old Testament (Isaiah 55:1-2). Its basic meaning is this: Can anything satisfy this burning thirst that is in me for things to be set right? The answer is yes (see Matthew 5:6). But in order to believe this answer, one must come to know and trust Jesus.

The Whole Truth (4:16-19)

Jesus has a funny way of making people know and trust him. Instead of making nice, polite social noises ("Nice to see you; thanks for the drink; how's your job?"), he stuck his nose right into her most intimate and embarrassing realities (verse 18). How do you suppose he knew all of this?

Is he not the Son of the Author who wrote the story? And does he not know all about you and me too?

I have a secret, quiet lie that I have long been pretending, that God doesn't really know what I am up to. But I will never know happiness until, like the writer of Psalm 139, I can cry, "Search me and know me, O God!" Jesus is not only the Way and the Life (John 14:6); he is also the Truth that sets us free (John 8:32). The cure for my sin can only come when I learn to look it full in the face and repent. When I try to cover it, it festers until it destroys.

With this Samaritan woman, the sin was her failure to take seriously the responsibilities of marriage and its commitments. With you and me it may be others. I may need to face up to the fact that I really *am* an alcoholic, or that I have not *truly* forgiven one who has wronged me, or that my children are right when they claim that I nag them to death. To look my faults straight in the face is to be able to do something about them.

I am not a good enough person to be able to confront an overprotective mother or a stubbornly chauvinistic husband or an angry child as honestly as I should. But I can do my best to speak the truth in love (Ephesians 4:15), and best of all, I can help them met Jesus in the Bible, in the church, and in my attempts at living the Christian life. If Christ be lifted up, he has promised that he will draw everyone unto him (John 12:32).

True Worship (4:19-30)

We Christians spend a lot of energy arguing over how, where, and when to worship. It has been suggested that the ecumenical movement founders not on theological differences but on differences in practice: baptism, the Lord's Supper, choice of music. You have surely noticed that when you go to a different church the thing that makes you feel the most like a stranger is the hymns they sing. Maybe the secret to Christians getting together would be to produce a common hymnbook, which would make us all feel at home. But then we have enough trouble agreeing just among ourselves how our hymns ought to be sung!

What does it mean to worship God "in spirit and in truth" (verse 23)? There is a sense in which we already have the capability to do this ("the hour . . . now is"). When we get together with others who are "soul mates," we have a feeling that we are with them, even if their practices are different from our own. It has been suggested that the denominations are like the spokes of a wheel, with God at the hub. The closer you get to the center, the closer together the spokes become. Indeed, a really committed United Methodist may feel closer to a really committed Baptist than either of them would feel to a person on the fringes of their own communion.

The point is this: Jews and Samaritans alike have need for the water of life, as do Methodists and Baptists. Our energies should be devoted not to arguing with one another as to the ways of doing things but to providing that water for each other.

Getting on with the Task (4:31-42)

Jesus now changes the metaphor from that of water to that of the harvest fields (verse 35). If the church devotes its energy to its own preservation, it will die, but if it seeks to serve others it will bear much fruit (Luke 9:24). I

once visited a prison industry in Texas where minimum security federal prisoners make canvas mailbags for the postal service. There are several rooms in which the cloth is cut and sewn, grommets are attached, and drawcords run through them. Finally they are stamped "U. S. Mail" and stored in a large holding space. Naturally one doesn't send out for something to put the bags in; they simply fill one bag with several others. The room consists of bags full of bags. It seems to me that the church at its worst is a bag full of bags. We go out in the harvest fields to get more laborers to go out into the fields. . . But the bags are intended to hold not bags but letters! And the church is intended not to contain itself but to attack the gates of hell (Matthew 16:18 KJV). We have letters to carry—a message to Jerusalem, and Judea, and Samaria, and to the uttermost parts of the earth (Acts 1:8).

Helping Adults Become Involved—Douglas E. Wingeier

Preparing to Teach

Pray that members may have their thirst for God quickened by their prayer and preparation. Study John 4:1-42 and the discussion of it in *The Interpreter's Bible* and/or Barclay's commentary on John. Read the article entitled "Water" in *Harper's Bible Dictionary*. Find a tape or record of the song, "Jesus Met the Woman," or someone to sing or lead it. Bring a pitcher and bowl to class.

Your aim is to point up the contrast between our ordinary desires and the thirst to know Jesus as Savior and Lord. In pursuing this aim, organize the lesson as follows:

 I. What is the real thirst of life?
 A. Ordinary wants do not satisfy.
 B. Life's main question is the search
 for meaning and hope.
 II. What is the living water?
 A. Water has life-giving traits.
 B. But we always thirst again.
 C. Jesus is the water of life.
 III. What is the truth about me?
 A. We hide the real truth about ourselves.
 B. Jesus knows us as we are.
 C. It is freeing to be known.
 IV. What is our real worship and work?
 A. We worship in spirit and truth.
 B. Our work is in the harvest.
 C. Others believe and the faith is spread.

Introducing the Main Question

Divide the class into groups of three. Ask each group to select three "I wants" from their lists that are basic to human happiness. Write these on the board. Discuss: (1) What would happen if everyone had these wishes granted? (2) How are these desires consistent or in conflict with each other?

(3) If these were fulfilled, what would still be lacking to make life complete? Share the ideas in Pat McGeachy's "The Main Question."

Developing the Lesson

I. What is the real thirst of life?
 A. Ordinary wants do not satisfy.

Conclude from the previous discussion that most of the things we want are material, transient, or unsatisfying. Have members share experiences in which the goal they sought, when achieved, left them feeling unfulfilled. Ask what efforts they think the Samaritan woman made to find happiness that led her to the point of need she exhibited to Jesus (verses 16-18). Why did her endeavors (and ours) fail to satisfy? Perhaps because they are self-centered, aiming to gain security by gathering things, honors, status, or people around us. These are represented by the woman's request of Jesus in verse 15.

 B. Life's main question is the search for meaning and hope.

Select from the lists of wants those that express spiritual thirsts. What makes these different from the other wants? What evidence do we find that the woman had this kind of need too? The search for meaning and hope is universal, but we try to cover it up by seeking more immediate and material goals. The way the woman kept taking Jesus' comments about living water literally is evidence of this tendency in her (verses 10-11).

II. What is the living water?
 A. Water has life-giving traits.

Pour water from the pitcher into the bowl. Ask the class to list the uses and qualities of water—such things as cleansing, nurturing growth, cooking, quenching thirst, irrigating. Write these on the board.

 B. But we always thirst again.

The benefits of water are temporary and limited. As Jesus said to the woman, "Every one who drinks of this water will thirst again" (verse 13). Water is good and useful but does not provide lasting satisfaction of our spiritual thirst for meaning and hope.

 C. Jesus is the water of life.

Have Isaiah 35:6b-7a and 55:1-2; Revelation 22:17; Matthew 5:6; and John 4:13-14 read aloud to emphasize the biblical theme of God's satisfying our spiritual thirst. Give a personal witness of how Jesus meets your need for meaning and purpose. Invite others to do the same. If you are not comfortable with personal sharing, tell about someone else's finding Jesus as a source of saving hope. The book *Conversions*, edited by Hugh Kerr and John Mulder (Grand Rapids, Mich.: Eerdmans, 1985), contains fifty such stories. Play the record or sing the song "Jesus Met the Woman."

III. What is the truth about me?
 A. We hide the real truth about ourselves.

Ask each member to tell something about themselves that no one else knows. This can be something insignificant, like a scar on the knee, a grade-school achievement, or a middle name. This will illustrate how reluctant we are to let others know us. Ask them how they would feel if Jesus began probing their private lives as he did the Samaritan woman's. Present the ideas in the section of "As You Read the Scripture" headed "The Whole

Truth." Ask: why don't we want others to know our secrets? What would our church be like if we opened our lives more to each other?

B. Jesus knows us as we are.

Describe what happened in the life of the woman when she met Jesus (verses 16-19, 39-42). Because Jesus knew her and revealed to her the inner state of her soul, she believed, and through her testimony others believed as well. When we open our hearts to Jesus, he holds up a mirror to us and we are empowered to change.

C. It is freeing to be known.

It takes real effort to keep up our defenses so others will not know us. Once we realize that Jesus already accepts us as we are, we can let down our guard and begin to let others see us, warts and all. It is easier for others to accept us when we allow them to know us, and then we are able to accept ourselves more readily. It is liberating not to have to hide anymore. Jesus frees us from the fear of being known as we really are.

IV. What is our real worship and work?

A. We worship in spirit and truth.

Ask those who have worshiped in churches of other denominations or nations how they felt. Discuss what it means to worship "in spirit and in truth." How does one distinguish true worship from false? What can we learn from those who worship differently? Present the ideas in the section "True Worship" in "The Scripture and the Main Question." Emphasize that it is God, the object of worship, that makes worship true, not the form that we take.

B. Our work is in the harvest.

What does Jesus mean by "fields white for harvest"? What does it mean to "reap"? (verses 35-38). The freedom of being known leads us to worship in spirit and truth, which in turn creates the desire to share our new relationship with God. In telling the good news of salvation, others are led to find Christ too. This is reaping the harvest—telling thirsty persons of Christ's love so they will come to know Jesus and be liberated and transformed by his accepting love.

C. Others believe and the faith is spread.

As with the woman, those we tell will believe in him because of our testimony (verse 39). Share Pat McGeachy's illustration of the "bag full of bags" and discuss ways of preventing your church from becoming like that.

Helping Class Members Act

Ask members each to think of someone with whom they might share their faith as "laborers in the harvest" this week, and to report to each other next Sunday how the conversations went. Close with prayer asking God to empower us for sharing our faith during the coming week.

Planning for Next Sunday

Besides reading Luke 2:8-12 and John 1:1-5, 9-18, assign members each to bring a Christian decoration next Sunday that reminds them of the true meaning of Christmas.

The Meaning of Christ's Coming

Background Scripture: Luke 2:8-12; John 1:1-5, 9-18

The Main Question—Pat McGeachy

One week before Christmas, in the city where I live, a seventy-four-year-old woman disappeared. She was a quiet, generous, loving person, who spent all of her free time working with the poor and homeless of the city—a sort of local Mother Teresa. Her family and friends searched for her frantically. Three days later the police found her body, strangled, her throat cut, stuffed in the trunk of her car parked near the rescue mission where she had been on one of her errands of mercy. Our town was plunged into a sad and lonely Christmas, wondering what to make of all this. "You know," said one man, "if you were at all inclined to believe that the universe has no meaning, this would be evidence to support that."

But that is not what emerged from the tragedy. Her son, pastor of a church, speaking for her family offered forgiveness to the unknown assailant. "We know," he said during her funeral service, "the answers are not easy and clear, but we still believe in the miracle of forgiveness, and we extend our arms in that embrace." He urged the mourners to remember her life of ministry and to continue her work of compassion. Out of the darkness of her death a light began to shine.

Some scientists believe that the world began with a great burst of primal energy that they call "the Big Bang." But there would have been no bang, for there was then no air to carry the sound, and no ears to hear it. Instead, as though a Voice had called for it in the darkness, there was a great Light (Genesis 1:3). It came into a darkness that could not comprehend it (John 1:5 KJV). And there are still those who do not believe in the Light (1:10). But to those who believe (verse 12) power came. The main question for us is, Do we believe that the universe is rational? And the answer is a resounding "Yes!" for the Light, the Word, has come to live among us.

As You Read the Scripture—Ralph W. Decker

It is sometimes said that only Matthew and Luke have nativity stories. While it is true that John has no report of a babe in a manger, he does give his version of the incarnation. In the hymn-like language of the prologue to his Gospel (1:1-18), he tells how "the Word became flesh." Combining Luke's story of the announcement to the shepherds with John's presentation of the entry of God into the lives of humans enables us to see that the babe in swaddling clothes is also the source of grace and truth.

Luke 2:8-12. Only Luke tells of the angels' announcement to the shepherds.

Verse 8. Shepherds were very low on the social and economic scales of the day. The fact that Luke reports that the first disclosure of the Messiah was to such persons shows his strong interest in the poor and the alienated. The report that the sheep were in the open fields suggest a season warmer than

December. It was not until the fourth century that the church fixed the date for celebrating the birth of Jesus.

Verse 9. The Greek word translated "angel" can also be rendered "messenger."

Verse 10. Luke's belief that the Gospel was universal—for Gentile as well as Jew—is reflected in the statement that the good news was for all people.

Verse 11. Bethlehem was the city of David, his birthplace. It was a village about six miles southwest of Jerusalem. Three important titles are given to the newborn Jesus: Savior, Christ (which is the Greek-English form of "Messiah"), and Lord (a title used primarily for God).

John 1:1-5. This passage is highly philosophical in comparison with Luke's simple narrative of the nativity.

Verse 1. The Greek term translated "Word" is *logos*, which means more than a spoken sound. It also means "reason." It was in widespread use when the Gospel of John was written. Greek philosophers used it to designate the divine force which creates and regulates all things. A philosopher named Philo, a Jew by birth and a Greek by culture, set out to harmonize ideas found in Hebrew Scripture with those prevailing in the Greek world. He saw *logos* as the perfect bridge between Hebrew theology and Greek philosophy. He held that wherever the Scriptures spoke of the Word of God, it meant the divine power the Greeks called Reason. John's prologue (1:1-18) relates his Gospel to both the Greek and Hebrew ideas of the Logos as an intermediary between God and the world. It goes beyond Philo and the Greeks to say "the Logos became flesh" in Christ. Verse 1 describes the Word as eternal, in fellowship with God, and divine.

Verse 3. Creative activity is added to the characteristics of the Word.

Verse 4. Another characteristic is his life-giving power. "The light of men" is that which enables them to comprehend and understand God's will.

Verse 5. The present tense of the verb can mean "is shining" or "keeps on shining" despite the darkness. *The Good News Bible* offers the translation "the darkness has never put it out."

Verses 9-18. These verses move the Word from the realm of philosophy and theology into everyday human living.

Verse 9. The Greek has no punctuation. That supplied by the King James editors ties "coming into the world" with "every man"; that in the Revised Standard Version links it with "the light." The difference reflects editorial preferences.

Verses 10-13. Although Jesus has not yet been identified as the incarnate Word, it is clear that the author is describing the experience of Jesus.

Verse 14. This, with verse 18, gives the essential message of John's Gospel—the doctrine of the incarnation, the presence of God in the human life of Jesus.

Verse 16. John and others can testify to experiencing God's grace through Jesus.

Verses 17-18. The author now identifies Jesus as the incarnate Word, the true and complete revelation of God.

Selected Scripture

King James Version

Luke 2:8-12

8 And there were in the same country shepherds abiding in the field, keeping watch over their flock by night.

9 And, lo, the angel of the Lord came upon them, and the glory of the Lord shone round about them: and they were sore afraid.

10 And the angel said unto them, Fear not: for, behold, I bring you good tidings of great joy, which shall be to all people.

11 For unto you is born this day in the city of David a Saviour, which is Christ the Lord.

12 And this *shall be* a sign unto you; Ye shall find the babe wrapped in swaddling clothes, lying in a manger.

John 1:1-5, 9-18

1 In the beginning was the Word, and the Word was with God, and the Word was God.

2 The same was in the beginning with God.

3 All things were made by him; and without him was not any thing made that was made.

4 In him was life; and the life was the light of men.

5 And the light shineth in darkness; and the darkness comprehended it not.

..

9 *That* was the true Light, which lighteth every man that cometh into the world.

10 He was in the world, and the world was made by him, and the world knew him not.

11 He came unto his own, and his own received him not.

12 But as many as received him, to them gave he power to become

Revised Standard Version

Luke 2:8-12

8 And in that region there were shepherds out in the field, keeping watch over their flock by night. 9 And an angel of the Lord appeared to them, and the glory of the Lord shone around them, and they were filled with fear. 10 And the angel said to them, "Be not afraid: for behold, I bring you good news of a great joy which will come to all the people; 11 for to you is born this day in the city of David a Savior, who is Christ the Lord. 12 And this will be a sign for you: you will find a babe wrapped in swaddling cloths and lying in a manger."

John 1:1-5, 9-18

1 In the beginning was the Word, and the Word was with God, and the Word was God. 2 He was in the beginning with God: 3 all things were made through him, and without him was not anything made that was made. 4 In him was life and the life was the light of men. 5 The light shines in the darkness, and the darkness has not overcome it.

..

9 The true light that enlightens every man was coming into the world. 10 He was in the world, and the world was made through him, yet the world knew him not. 11 He came to his own home, and his own people received him not. 12 But to all who received him, who believed in his name, he gave power to become children of God: 13 who

the sons of God, *even* to them that believe on his name:

13 Which were born, not of blood, nor of the will of the flesh, nor of the will of man, but of God.

14 And the Word was made flesh, and dwelt among us, (and we beheld his glory, the glory as of the only begotten of the Father,) full of grace and truth.

15 John bare witness of him, and cried, saying, This was he of whom I spake, He that cometh after me is preferred before me: for he was before me.

16 And of his fulness have all we received, and grace for grace.

17 For the law was given by Moses, *but* grace and truth came by Jesus Christ.

18 No man hath seen God at any time; the only begotten Son, which is in the bosom of the Father, he hath declared *him*.

were born, not of blood nor of the will of the flesh nor of the will of man, but of God.

14 And the Word became flesh and dwelt among us, full of grace and truth; we have beheld his glory, glory as of the only Son from the Father. (15 John bore witness to him, and cried, "This was he of whom I said. 'He who comes after me ranks before me, for he was before me.'") 16 And from his fulness have we all received grace upon grace. 17 For the law was given through Moses; grace and truth came through Jesus Christ. 18 No one has ever seen God; the only Son, who is in the bosom of the Father, he has made him known.

Key Verse: **And the Word was made flesh, and dwelt among us. (John 1:14)**

Key Verse: **The Word became flesh and dwelt among us. (John 1:14)**

The Scripture and the Main Question—Pat McGeachy

Meaning and Reality (John 1:1-5)

There are many creation stories in the Bible. There is the familiar one in Genesis 1 that follows very closely the order of the scientific theory: from chaos to form, from life in the sea to the land, and at last, man and woman. And there is the familiar one in Genesis 2 that follows the creationist's order, beginning with a dry earth, then a mist, a man, the creatures, and finally a woman. But these are not the only ones. There is the remarkable account in John 1, which deals less with the way in which things came into being and more with the meaning that lies at the heart of reality.

John's creation story begins with the very same words as the book of Genesis: "In the beginning." (Indeed, the word "genesis" means "beginning.") And as Genesis describes the Spirit (wind) of God brooding over the formless world, John tells us that in the beginning with God was the divine principle of rationality, the Word. In this respect John's account is like still another creation story, the one in Proverbs 8:22-31, in which wisdom, personified as a woman, is depicted as the architect who worked beside God in the making of the world.

But John goes further. The Word, he tells us, is eternal and divine; more than that, the Word is personal. John uses the masculine pronoun because

he is shortly going to identify that eternal Word with a historic person, the man Jesus.

We are dealing here with the most profound mysteries. I hope you will understand me when I say that I do not understand this. It, like the mysterious "big bang" of the astronomers, is beyond our power to comprehend. Perhaps that is one reason that there are several creation stories in the Bible; no single one could contain the truth of the origin of all things. But I believe we *can* understand the central truth that this powerful scripture reveals: It is the faith of the evangelist that at the heart of reality lies reason. It is an affirmation of faith in the face of chaos, of light in the heart of darkness: The universe makes sense. No evil, not even the murder of a good woman going about her works of mercy, can take that truth away from us.

The Word Made Flesh (1:9-14)

But the Christian Gospel goes further still. Christmas is an even more astonishing miracle: the Word, the eternal principle of light and rationality, became a human being. There is much that troubles the thoughtful Christian about Christmas. The holiday as we know it has been often badly treated. It began, as you know, as a secular feast: the celebration of the winter solstice, a time when the days began to grow longer once again, and hope warmed the hearts of the people of the north. With blazing Yule logs, decorations of evergreen, and lighted trees, people symbolized their hope. When Christian missionaries moved into northern Europe, they saw that this pagan festival was a natural setting for the celebration of the Word becoming flesh. So, just as God blessed our secularity by being made known in the world of flesh and blood, the winter solstice feast was baptized into Christ's feast—Christ's mass, or Christmas.

And on our end, Christmas has often been further secularized by our overemphasis on merchandising and partying. But even here we must not fail to remember that Christmas really does mean that God enters fully into our lives, even our shopping and our Christmas cards and our parties. If we could enter into all of that with sobriety and with faith, we might better understand the meaning of the feast. Sometimes you hear it said that we must "keep Christ in Christmas." Of course we should, but we should also keep "mas" in Christmas! Mass is the feast: the turkey or the boar's head. The Word really did become flesh in very respect, and those who believe (verse 12) have the power to become children of the Eternal God.

This does not mean that all the earthly things we do are good. But it does mean that we, born anew of the Spirit (see John 3:5), are able to see all the things of this world through divine eyes. Our birth, our childhood, our family life, our schoolwork, our vocations, our sexuality, even the feast we call Christmas, are blessed with the presence of Eternity.

Grace upon Grace (1:15-18)

The creation story in John 1 casts new light on the creation stories of the Old Testament. The Hebrew people knew that God was eternal and rational. Through Moses and the law (verse 17) they came to respect God's moral authority as no others have. And now through Christ we have come

to know what God is like (1:18)—no less ethical and moral but also a loving and forgiving parent who, by the gift of Christ, has taken our sins away.

Tidings of Great Joy (Luke 2:8-12)

I am glad that the first people to learn of the birth of Jesus were shepherds, for the occupation is one that is close to the earth. The role of the shepherd is a dear one to Christians, because of the Twenty-third Psalm and Jesus' use of the metaphor (John 10:1-18, etc.). It is true that there are many urban people today who have never seen a shepherd. (Carl Burke, in his book, *God Is for Real, Man,* found this true of his young charges in the Buffalo jail, and helped them to choose other metaphors for the Lord's comforting presence. They decided on "probation officer"! What would you suggest? Mother? Scoutmaster?) But we need to hang on to the old image too, especially at Christmastime. The Shepherd is of the earth, earthy. Our familiar friends were spending the night out under the stars, there on the ground. (There are still, in the fields of Boaz on the outskirts of Bethlehem, shepherds plying their trade with virtually no difference in their dress or activities from those of old.) And there, to earthy men lying close to the ground, there came light from heaven.

Their first reaction was fear (verse 9). It is always this way with angelic appearances. We who are used to chubby cherubs from medieval paintings, or girlish winged figures on old Sunday school leaflets, have forgotten that angels are terrible creatures, in the literal sense of that word: "inspiring terror." When the "glory of the Lord" shines round about you, you are certain to be, as one little boy said, "shore afraid." This ancient story is so familiar that I have to shut all the manger scenes I have ever seen out of my mind and try to picture it as it might have been. Like the mystery of the light shining in the darkness in John 1, the picture of the glory shining in the Bethlehem night is too wonderful to comprehend.

But, as in the case of the Word made flesh, we have here one element in the story that we can understand: a baby, "wrapped in swaddling cloths and lying in a manger." Just today, before I wrote these words, I was looking through the glass window of a hospital nursery at a tiny girl, wrapped in swaddling clothes (they make them out of paper nowadays), and wondering at her bright eyes, looking for all the world as though she knew a strange man was watching her. (I suppose all people are strange to a newborn.) But there came over me, as I looked at that baby, the thought: Here lies the hope of the world. In our town, where an elderly woman was murdered by one whom she tried to help, there is the promise of love and light, in the form of a brand new life. Just so, once in royal David's city, long ago, the Hope of all the world came among us. "And we beheld his glory, glory as of the only begotten of the Father, full of grace and truth."

Helping Adults Become Involved—Douglas E. Wingeier

Preparing to Teach

Pray for yourself and your class that during the bustle of the Christmas season you will be able to keep Christ, the Word made flesh, at the center of your Christmas celebration.

In addition to this week's assigned scriptures, read the creation stories in

SECOND QUARTER

Genesis 1–2 and Proverbs 8:22-23. Also study the exposition of these passages in the commentaries mentioned previously, and the articles entitled "Logos," "Shepherd," and "Angel" in *Harper's Bible Dictionary*. Have hymnals available.

The aim for this lesson is to enable class members to rediscover the joy and hope in the Christmas story and to rededicate themselves to letting the Word become flesh in them.

Use the following outline:

I. The universe makes sense.
 A. The Logos creates.
 B. The light shines.
II. The secular becomes sacred.
 A. Keep the "mas" in Christmas.
 B. Let the Word become flesh in us.
III. The baby brings hope.
 A. The shepherds are afraid.
 B. The angels announce good news.
 C. The baby is born.

Introducing the Main Question

Open the class by telling Pat McGeachy's story about the woman who was murdered and the forgiving response of her son. Ask: How would you have responded had this happened in your family? Can you think of other examples of the light shining in the darkness? (verse 5). Where do people get the resources to respond to seemingly senseless tragedy with courage, hope, and goodwill? Is the universe rational? Ask someone to read aloud John 1:1-5, 9-18.

Developing the Lesson

I. The universe makes sense.
A. The Logos creates.
Present the ideas in the section titled "Meaning and Reality" in "The Scripture and the Main Question" and in Ralph Decker's comments on verse 1. Ask persons to look up and read aloud the three other creation stories and then discuss how they are alike and different from each other and the one in John 1. Explain that the Greek word translated "Word" in John 1 is *logos*, meaning the divine energy or principle responsible for creating the cosmos. John for the first time identified this being with Jesus the Christ. Because the universe was created by Jesus the Son/Word of God, it *did* make sense for the early Christians, in spite of all the persecution and suffering they were undergoing.
B. The light shines.
Help the group imagine what it must have been like for people without artificial means of illumination to be offered a light that "the darkness has never put out." When nighttime is pitch black, the promise of a light that cannot be extinguished gives great hope! Jesus, the Word/Logos become flesh, offers this hope to all humankind! The universe now makes sense again because we are assured that the darkness of sin, injustice, and evil cannot put out the light of love.

II. The secular becomes sacred.

A. Keep the "mas" in Christmas.

Remind the class of the pagan origins of Christmas in the Roman festival of Saturnalia and the medieval feast celebrating the winter solstice, as described under "The Word Made Flesh" in "The Scripture and the Main Question." Explain that this is appropriate inasmuch as Jesus, the Word made flesh, bridged the gap between the spiritual and the material, the sacred and the secular. Because he chose to adopt human form and enter the earthly sphere, all of creation is once again sanctified in God's sight. Hence, Christ and "mas" (feast/celebration) belong together, and the Christmas parties, gifts, and decorations are holy when done in Christ's name and for his glory. Ask the class to show the Christmas decorations they have brought and to tell how they give expression to the true meaning of Christmas.

B. Let the Word become flesh in us.

Paul uses the phrase "Body of Christ" to refer to the church or to the people of God who seek to embody the Spirit of Christ in their lives and relationships as an ongoing testimony that "He lives." The incarnation of God's presence and love that was first made known in Jesus continues to shine forth, imperfectly to be sure, in the living witness of those called by his name. When we embody and express the qualities of love, forgiveness, justice, reconciliation, and care of the creation, we are "keeping Christmas"—not only on December 25 but on the other 364 days of the year as well. If the universe is to continue to make sense and the light to continue to shine, Christ needs us to continue to let the Word become flesh in our lives.

III. The baby brings hope.

A. The shepherds are afraid.

Remind the class of the familiar story of the shepherds, angels, and babe in the manger, as told in Luke 2:8-12. Share the information about the shepherds in the section "Tidings of Great Joy" in "The Scripture and the Main Question." Ask: What do we as humans have to be afraid of in this Christmas season? List class members' responses on the board. Ask: What makes each one fearful? How does it affect us—our behavior, our plans, our relationships?

B. The angels announce good news.

Continue discussing the list of fears on the board. Ask about each: What could give us hope in that situation? What are the "good tidings of great joy" that speak to that condition? Who are the "angels" (messengers) who can announce good news to our world? Help the class come to the realization that this responsibility falls to us. Then ask: How can we incarnate the Word in ways that might help overcome these fears?

Now ask for reports on last week's witnessing experiences. Try to strike a balance between holding members accountable to their covenant to share their faith and supporting them in what may have been feeble or ineffective efforts. Remind them that Christ is counting on us to be the Word made flesh, the light in the darkness, and the messengers with good news for our time, even as he filled these roles for his.

C. The baby is born.

Tell Pat McGeachy's story of viewing a tiny baby in the hospital and thinking, "Here lies the hope of the world." Ask class members to share

similar experiences. Ask: In view of all the fears we listed, why do persons continue to bring children into the world? Does this help us understand why God chose to send a message of love and hope in the form of a tiny baby? Close by singing "While Shepherds Watched Their Flocks" and offering a prayer of thanks for God's gift of the Christchild who has become the hope of the world.

Helping Class Members Act

Ask the class to covenant again to seek opportunities during the coming week to share the "good news of great joy" with at least one other person and to report next week how it went.

Planning for Next Sunday

Remind all to read John 4:46–5:18. Ask them also to think about what it means to be whole, what it means to be healthy, and what it means to be holy, and to come with a list of the qualities of each.

———————————

UNIT II: JESUS REVEALS HIMSELF
Horace R. Weaver

FIVE LESSONS **DECEMBER 31–JANUARY 28**

The theme of this quarter is "The Gospel of Life and Light." In Unit I, entitled "Jesus Comes to His Own," we noted how John the Baptist bore witness to Jesus, how life can begin anew, that our thirst for the highest can be satisfied, and that the Word (through which all things were created) became flesh and dwelt with us.

Now, in Unit II, we shall study the various ways Jesus reveals himself to us. "Becoming Whole," December 31, asks how we can become wholly holy. "Accepting the Evidence," January 7, considers whether we are to construct our own private theology or accept the Bible's evidence for *God's* truth in Jesus. "Satisfying Hunger," January 14, challenges us: How can we put our resources at God's disposal? "Being Set Free," January 21, means Jesus gives us the spiritual and moral power to run our own lives. "Following the Light," January 28, leads us not to identify sinners but to where the light is, and tells how to find it.

Becoming Whole

Background Scripture: John 4:46–5:18

The Main Question—Pat McGeachy

Sometimes important clues to the meaning of life can be found in the ordinary words we speak. For instance, notice that hiding in the word "salvation" is "salve," a healing ointment. And the word "holy" comes from an old English word that is also the root of "whole" and "heal." Somewhere at the heart of my being there is a relationship between my faith, my actions, and my health. Thus Psalm 103:3 tells in parallel that God "forgives all your iniquity, . . . heals all your diseases."

You can get into trouble over this. I mean, if every time you come down with a bad cold you ask, "What have I done to deserve this?" you are probably making too much over it. And some people seem to live mighty sinful lives without ever seeming to come down with anything. But why do we say, "I caught a cold," rather than "A cold caught me"? And why is it that so often when I misuse my body and soul by worrying too much or working overtime, I seem to come down with something that forces me to go to bed for a day or two?

In today's lesson we encounter the healing Jesus. Mixed in with his acts of healing are some insights into faith and forgiveness, as well as into Jesus' own character and courage. Apparently we can't divide ourselves up into compartments called "body," "mind," and "spirit." Somehow we must discover what it means to be a *whole* person. In a rural congregation I once quoted the aphorism, "One who sings prays twice," and an old farmer instantly replied, "Yep. And one who taps his foot prays three times." He understood that one's spiritual life is an act of the entire person. Nowadays there is much talk among the caring professions about what is called "holistic" medicine, the belief that we cannot compartmentalize our lives. Surely the same term can be applied to our faith journey, so that the main question becomes for me, "How can I be wholly holy?"

As You Read the Scripture—Ralph W. Decker

John 5:1. The phrase "a feast of the Jews" shows that the material was written for non-Jewish readers. The feast is not identified. It was probably one of the three annual feasts that every adult male Jew wished to celebrate in Jerusalem: Passover, Pentecost, Tabernacles. Many scholars think it was Pentecost, an agricultural festival sometimes called the Feast of Weeks. Pentecost, which means "fifty," came fifty days after Passover and marked the beginning of the harvest of early crops.

Verse 2. The Sheep Gate was in the city wall on the north side of Jerusalem (Nehemiah 3:1). There are no other references to the location of the pool, either in the Bible or other writings. John's description of five porticos has led to the ruins of a pool a little northwest of the temple area. This pool, in addition to porches on its four sides, had a porch built across its middle, dividing it in half. Ancient manuscripts give three different names

for the place, each of which is followed by some important English translation. Some call it Bethzatha, which means "house of the olive" and is the choice of the Revised Standard Version. Others call it Bethesda, which means "house of mercy" and is the King James reading. Still others name it Bethsaida, which means "house of the fisherman" and is followed by the Douay Version.

Verse 4. The Revised Standard Version and almost all other recent translations omit the last few words of verse 3 and all of verse 4 as they appear in the King James Version. This is because this material does not appear in the older manuscripts. It is generally regarded as a later addition, explaining the man's statement in verse 7.

Verse 5. The one feature of the affliction that John emphasized was its duration. In an earlier healing of an official's son Jesus had shown his power over distance (4:46-54). Here his power over time is demonstrated.

Verse 6. Most healings in John, unlike those in the other Gospels, do not involve either touching or mention of faith. They result directly from the will and word of Jesus. Jesus' question, to which no direct answer is given, suggests that the man had grown so accustomed to his condition that he had lost his desire to have it changed.

Verse 7. It is sometimes suggested that the pool was fed by a spring which bubbled up periodically, giving rise to the story about the angel and healing.

Verse 8. Pallets, light mats, were the beds of the poor. They were easy to roll and carry.

Verse 9. According to all four Gospels, healing on the sabbath was one of the major conflicts between Jesus and the Pharisees (Matthew 12:9-14; Mark 3:1-6; Luke 6:6-11).

Verse 10. Here the discussion starts not from the healing but from the action of the healed man. Carrying a sleeping mat on the sabbath was one of the actions specifically forbidden by the religious authorities.

Verse 11. The man's reply was a natural one. As we would put it, he was following doctor's orders.

Verse 12. The questioners wanted to know who was advising sabbath-breaking.

Verse 13. As in other instances in this Gospel, recognition of the true nature of Jesus comes gradually.

Verse 14. Jesus' words raise the question of whether he shared the belief of many in his day that all disease was due to sin. The later healing of a blind man shows that he did not (9:1-7). The present word applies only to the present case. John may have intended to show that Jesus had divine knowledge of the man's character.

Verse 15. The man's report was not a betrayal of Jesus. It was a normal step in answering a charge of sabbath-breaking. It did, however, shift the criticism from the man and his pallet to Jesus and his act of healing.

Selected Scripture

King James Version

Revised Standard Version

John 5:1-15

1 After this there was a feast of the Jews; and Jesus went up to Jerusalem.

John 5:1-15

1 After this there was a feast of the Jews, and Jesus went up to Jerusalem.

2 Now there is at Jerusalem by the sheep *market* a pool, which is called in the Hebrew tongue Bethesda, having five porches.

3 In these lay a great multitude of impotent folk, of blind, halt, withered, waiting for the moving of the water.

4 For an angel went down at a certain season into the pool, and troubled the water: whosoever then first after the troubling of the water stepped in was made whole of whatsoever disease he had.

5 And a certain man was there, which had an infirmity thirty and eight years.

6 When Jesus saw him lie, and knew that he had been now a long time *in that case,* he saith unto him, Wilt thou be made whole?

7 The impotent man answered him, Sir, I have no man, when the water is troubled, to put me into the pool: but while I am coming, another steppeth down before me.

8 Jesus saith unto him, Rise, take up thy bed, and walk.

9 And immediately the man was made whole, and took up his bed, and walked: and on the same day was the sabbath.

10 The Jews therefore said unto him that was cured, It is the sabbath day: it is not lawful for thee to carry *thy* bed.

11 He answered them, He that made me whole, the same said unto me, Take up thy bed, and walk.

12 Then asked they him, what man is that which said unto thee, Take up thy bed, and walk?

13 And he that was healed wist not who it was: for Jesus had conveyed himself away, a multitude being in *that* place.

14 Afterward Jesus findeth him in the temple, and said unto him, Behold, thou art made whole: sin no more, lest a worse thing come unto thee.

15 The man departed, and told

2 Now there is in Jerusalem by the sheep gate a pool, in Hebrew called Bethzatha, which has five porticoes. 3 In these lay a multitude of invalids, blind, lame, paralyzed. 5 One man was there, who had been ill for thirty-eight years. 6 When Jesus saw him and knew that he had been lying there a long time, he said to him, "Do you want to be healed?" 7 The sick man answered him, "Sir, I have no man to put me into the pool when the water is troubled, and while I am going another steps down before me." 8 Jesus said to him, "Rise, take up your pallet, and walk." 9 And at once the man was healed, and he took up his pallet and walked.

Now that day was the sabbath. 10 So the Jews said to the man who was cured, "It is the sabbath, it is not lawful for you to carry your pallet." 11 But he answered them, "The man who healed me said to me, 'Take up your pallet, and walk.'" 12 They asked him, "Who is the man who said to you, 'Take up your pallet, and walk'?" 13 Now the man who had been healed did not know who it was, for Jesus had withdrawn, as there was a crowd in the place. 14 Afterward, Jesus found him in the temple and said to him, "See, you are well! Sin no more, that nothing worse befall you." 15 The man went away and told the Jews that it was Jesus who had healed him.

the Jews that it was Jesus, which had
made him whole.

Key Verse: Jesus saith unto him,
Rise, take up thy bed, and walk.
And immediately the man was
made whole, and took up his bed,
and walked. (John 5:8-9)

Key Verse: Jesus said to him,
"Rise, take up your pallet, and
walk." And at once the man was
healed, and he took up his pallet
and walked. (John 5:8-9)

The Scripture and the Main Question—Pat McGeachy

Belief and Belief (John 4:46-54)

The story of the centurion ("commander of a hundred") stationed in
Capernaum is also found in Matthew (8:5-10) and Luke (7:2-10). He was a
man who knew how to give and to follow orders, and in one sense he
"believed" that Jesus could give orders that his sick son be healed (verse 50).
But after the fact he and his whole household believed (verse 53), perhaps
in a deeper way.

Yet I wonder which was the more profound act of belief. There is the
story of the man who "believed" that the daredevil could push a
wheelbarrow over a tightrope because he had seen it done, but he did not
"believe" enough to be willing to take a ride! Here we have "intellectual"
belief that accepts the facts but not "existential" belief that is willing to make
a commitment. Some of us "believe" in Jesus in our heads, but don't seem to
"believe" in our daily lives. And yet our friend the centurion was a man who
acted first and *then* came to a reasoned faith.

I think many of us come to faith by this route. Think of the person who
becomes active in a church, fixing meals, singing in the choir, or visiting the
lonely, and only later begins to develop a reasoned understanding and to
validate practice with theology. Do we first come to do and then believe, or
should it happen the other way around?

Perhaps it can best be understood as "holistic." I have heard of a
missionary who was attempting to translate the New Testament into the
rather limited language of a South Sea island. Its people had simple words
like "coconut" and "fish," but few learned words, like "belief." As the
missionary pondered how to translate the phrase "Believe on the Lord Jesus
Christ," the sound of running feet came from without. A native messenger
burst into the translator's hut, having run the whole length of the island. In
exhaustion the runner collapsed on a couch, saying in the island tongue, "I
lean-my-whole-weight on this bed." And the missionary chose that verb:
"Lean-your-whole-weight on the Lord Jesus Christ, and you will be saved."
Saving belief is an act of the whole person, and it doesn't really matter which
you put first, the understanding or the action.

Permission for Healing (5:1-9)

The traditional site of the pool of Bethzatha (it has several names) has
been excavated in Jerusalem. It is deep in the earth now, but even in Jesus'
day the portico of the sick must have been a couple of feet above the water's
surface. It would be very hard for a crippled person to get down to the water
when it was troubled. (The business about the healing in the troubling of the

water raises some questions about another kind of belief of an almost superstitious kind, but there is some psychological evidence that even this sort can sometimes bring healing. If you really believe that washing warts with water from a silver bowl by the light of a full moon will cause them to disappear, they sometimes do. Warts are like that.) The lame man in this story, though, had about given up.

"Do you want to be healed?" asked Jesus (verse 6). Of course he did! He had been lying there for years. But he was utterly discouraged, having no help. We often cannot do it on our own. We need the bedside manner of a beloved physician, or the word of a friend. A friend of mine became terribly depressed. He had given his only nephew, his namesake, a bicycle for Christmas. And the boy had ridden it into traffic and been killed. My friend lay on his bed for days, staring at the ceiling, blaming himself, unable to work or act at all. After an appropriate time (you have to give yourself permission to be depressed for a while; knowing how long is an art), his wife came into the bedroom, looked down at him with her hands on her hips and said, "All right, get up." So he got up.

So Jesus said to the man, "Get up, pick up your bed, and walk." And he did. It is worth noting that the man had no idea who Jesus was (verse 13). This could hardly be a healing based on theological insight or faith in a particular person. It was simply a man who longed to be healed encountering at last one who could give him permission to get well! Can you and I give such permission to others? After all, Jesus told us that he would give us keys to unlock hope in others' lives. He said, "Whatever you bind on earth shall be bound in heaven, and whatever you loose on earth shall be loosed in heaven" (Matthew 16:19). There are times (and knowing when they have come takes insight and understanding, like that of my friend's wife) when we may be able to say to those around us, "Get up." Sometimes it can be done with nothing more (or less) than a prayer and the laying on of a hand (James 5:13-16). We can help each other by the pool.

What is perhaps even harder is accepting that help. Either because we feel unworthy, or we have given up like the lame man in this story, or our pride won't let us take favors, we don't tell others when we hurt, and we won't accept favors from them. But we are not alone in this world, and we need each other. Even a strange unknown figure, like Jesus in this story, may possess the power to help me with my alcohol problem or my depression or even my paralyzed limbs.

Priorities (5:9b-18)

We religious people can be pretty good at missing the point. If we become so wrapped up in keeping the rules, like that of sabbath-keeping, we may miss the point of life: wholeness. The sabbath was given to us for our wholeness (Mark 2:27), to give us rest and provide a healthy rhythm to our lives. The notion that it is unlawful to carry a pallet on the sabbath is a nitpicking approach to morality. (There is even a tradition that for a tailor to leave a needle stuck in a sleeve is to be guilty of carrying the tools of one's trade on the Sabbath, and that to drag a chair across a dirt floor is plowing!) Sabbath observance is an important commandment, and one I suspect our generation is neglecting to its peril (just take a look at your shopping centers this Sunday). But wholeness, healing, and holiness are more important than ritual, and life is more important than the restrictions that preserve ritual.

Note that Jesus warns the healed man (verse 14) lest sin make him sick again in an even worse way. We began by suggesting that it's hard to blame a particular illness on a particular sin. But it is certainly true that we can practically guarantee that certain sins will produce certain sicknesses. Relationships between things like gluttony and heart trouble, or between drunkenness and liver disorders, are pretty obvious. The whole book of Job was written to make it clear that not all suffering comes from specific acts of evil; Job was a righteous man. Sometimes innocent people suffer from others' sins. You have known babies born with congenital diseases due to parental shortcomings. But that is the subject for another study. For now let us clearly see that the message of today's lesson is that God desires for us to be whole, in body, mind, and spirit.

Some wag has pointed out that our wholeness is rarely complete, and that if we are honest, we should sing, "Wholely, holey holy!" Maybe so, but that is not what we were intended to be. Listen to the commandment in I Peter 1:15-16: "As he who called you is holy, be holy yourselves in all your conduct; since it is written, 'You shall be holy, for I am holy.' " We are called of God to be saints (the holy ones; those set apart). Our bodies are God's temples. And one of the ways we know that Jesus is truly the Word made flesh is his amazing ability to make broken lives whole.

Helping Adults Become Involved—Douglas E. Wingeier

Preparing to Teach

Ask God for guidance as you prepare. Pray for particular needs of members as they enter a new year.

Read John 4:46–5:18 and its exposition in *The Interpreter's Bible*, Barclay's commentary on John, and the article entitled "Sabbath" in *Harper's Bible Dictionary*. Look up definitions of the words "whole," "heal," and "holy."

Your purpose is to help persons discover and reflect on the relationship of their faith, actions, and health, and to risk taking healthy action for what they believe. The lesson may be organized as follows:

 I. To act is to believe is to act.
 A. Acting leads to believing.
 B. Believing leads to healing.
 II. Helping is healing.
 A. Healing requires a helper.
 B. Healing requires accepting help.
 C. Healing requires taking a risk.
 III. The point of life is wholeness.
 A. Keeping the rules may cause us to miss the point.
 B. God wants us to be whole/holy/healed.

Introducing the Main Question

Ask the group for its thoughts on the meaning of "whole," "holy," and "healthy." Draw a line down the center of the board, and write their ideas on one side and the definitions on the other. Ask the group to identify differences and similarities. Explain that all three words come from the old English word *hal,* which is akin to the German *heil.* Contemporary holistic

medicine brings the three together as originally intended. Have Psalm 103:3 read aloud, and show the relationship between having one's sins forgiven and one's diseases healed. Ask the class to share experiences that have brought home the connection between health and faith.

Developing the Lesson

I. *To act is to believe is to act.*
 A. *Acting leads to believing.*
"It is easier to act one's way into a new way of thinking than to think one's way into a new way of acting." This is what happened with the centurion at Cana. He had no faith in God but wanted his child to get well and heard that Jesus might be able to help. So he acted! He went to Jesus, asked for healing, and then believed Jesus' word. Ask class members for examples of when they or others have acted on what they thought was right, with the result that their faith was strengthened, such as in playing a hunch, trusting a stranger, speaking to someone on an impulse, or risking on the spur of the moment.
 B. *Believing leads to healing.*
The official's son *was* healed. His act of faith resulted in an act of healing. And so it can be with us. As psychologist Erik Erikson points out, basic trust is the foundation upon which all healthy human development depends. Faith in God, others, and the universe is closely intertwined with moral action, physical health, and mental stability.

II. *Helping is healing.*
 A. *Healing requires a helper.*
Turn now to the healing of the paralytic at the pool. Share the background information found in "As You Read the Scripture" and your commentary and dictionary reading.
Tell Pat McGeachy's story about the wife who told her depressed husband to "get up." Invite other examples from the class. Emphasize that one way Christians can help one another is to challenge each other to take responsibility for our lives. Like the man at the pool, we need someone to tell us it's time to stop feeling sorry for ourselves and "Rise, take up your pallet, and walk" (verse 8).
 B. *Healing requires accepting help.*
Pat McGeachy also emphasizes that the helper can't do it without our cooperation. We must be humble enough to accept the offer of help. We must realize that we are not self-sufficient, that others have gifts from which we can benefit. In the Christian community we are interdependent. To be dependent is to lack initiative. To be independent is to lack appreciation. To be interdependent is to recognize that we need each other and to accept help when it comes. This is what Paul means by "so we . . . are one body in Christ, and individually members one of another" (Romans 12:5). We can only be whole individually when we acknowledge that we are part of a larger whole—the community of faith.
Now ask for reports on ways members have shared the good news of Christ's healing love during the past week. Then invite them to name other ways they can help persons in the congregation, community, and world to become more whole. Write these on the board, and discuss means of implementation during the new year.

C. Healing requires taking a risk.

The paralytic did not know whether he could stand, lift, and walk, or not. But he had to take the risk. Jesus offers the invitation to become healed/whole/holy, but we must act in response. When we do so, the strength is somehow provided to do what we did not think was possible. In the risking/responding/acting, the healing and wholeness come. Ask the class to tell of times when their risk has been rewarded. Sharing what Christ has done for them when they thought they lacked the words or the courage is one such example.

III. The point of life is wholeness.

A. Keeping the rules may cause us to miss the point.

Jesus broke the law about working on the sabbath by healing the paralytic. For him, the wholeness of a human being was more important than the formal requirements of religion. Give information on sabbath-keeping from the section headed "Priorities" in "The Scripture and the Main Question" and the article "Sabbath" in *Harper's Bible Dictionary*.

Rather than pointing a finger at the legalism of first-century Judaism, however, ask the class for illustrations of ways we may miss life's larger purpose by sticking too closely to the rules. Such instances as staying within the speed limit while taking someone to the hospital, refusing admission to a worship service to someone who is dirty and unkempt, withholding love from underachieving children, and insisting on conformity as a condition for acceptance, could be cited. Each is a situation of misplaced priorities. We emphasize a piece of the whole rather than the wholeness God offers us. In doing so we miss out on the fullness of health and holiness that is available in the gospel of grace.

B. God wants us to be whole/holy/healed.

The ministry of Jesus was—and is—a ministry of healing. The centurion and his son and the paralytic at the pool were restored to wholeness by the power of God's love—a power also available to us.

Close by singing (or reading) "Pass Me Not, O Gentle Savior," followed by a time of silence and then a New Year's prayer, asking God for the healing and wholeness that comes through taking the risk to act on what one believes.

Helping Class Members Act

From the list on the board of ways we can help others become more whole, help the group agree on one they would like to take on together. This could be a class covenant to risk sharing their inner pair as "wounded healers" with one another. Or it could be a church project, such as creating a fund to assist members at times of crisis. A social witness effort, like working for low-income housing or hunger alleviation, is another possibility. Ask a committee to work out plans and report at a later session.

Planning for Next Sunday

Besides reading John 5:19-47, ask each member to interview someone from another denomination, asking: How do you know that Jesus is the Son of God? How do Christians in your tradition live out this belief? Have them be ready to share their findings and also to discuss these questions from their own viewpoints.

Accepting the Evidence

Background Scripture: John 5:19-47

The Main Question—Pat McGeachy

There is a tendency these days for people to decide things pretty much by feel. The do-it-yourself happiness books seem devoted to self-gratification and trusting one's inner integrity. I will grant that for many of us cerebral people, who have been deciding life's issues on dry intellectual reasoning, there is probably some need to try listening to the right hemisphere of our brains for a while, to move from head knowledge to heart knowledge. But that is not what I am talking about. I'm talking about a trend toward individualistic religion, a denial of authority, and a glorifying of the private conscience.

Let me illustrate this in two ways: One is a liquor ad that sometimes runs in national magazines. It is simply a page, blank except for a small photo of a bottle of very expensive whiskey and the words "Honor Thyself." I know that we cannot love our neighbor unless we first love ourselves (Mark 12:31), but I see this ad saying, in effect, "Fulfill your own desires, and nuts to everybody else."

The other illustration is on the opposite side of the coin. A certain holiness minister accosted an Episcopal priest of my acquaintance during a temperance drive. The priest argued for tolerance, reminding the minister that Jesus had turned water into wine. "I know that," said the preacher, "and I'd of thought a lot better of him if he hadn't done it." In other words, "I don't care what the evidence is, or what the Bible says, I will stand by my own opinion."

Both of these stances are essentially self-directed. They make me think of a pupil saying, "Phooey on grades and homework; I must do my own thing." Of course some grades are arbitrary and unfair, and some homework is busy-work, but that is not the point. The main question is, Are we to construct our own private theology, or will we accept the Bible's evidence for *God's* truth in Jesus?

As You Read the Scripture—Ralph W. Decker

John 5:19-47. These verses form the first of several speeches of Jesus reported in John's Gospel. This one is a discourse on sonship and contains some important claims by and about Jesus. The language and ideas are different from those of Jesus' speeches in the other Gospels, for example in the Sermon on the Mount. The difference has raised the question as to whether these are the actual words of Jesus or doctrinal statements about him. One widely-held view is that they are something of both—the words of Jesus as they had passed through the thought and faith of John. John wrote about seventy years after the resurrection. During those years the experiences of the early Christians had been added to the words of Jesus. So rather than the actual words of Jesus we may have the statement of what those words meant to John and his fellow-believers.

167

Verse 30. In answering the charge of having broken the sabbath in healing the invalid at the pool (5:16-17), Jesus said that he was doing the work of God (5:17). He was then accused of claiming to be equal to God (15:18). He now explains his relationship to God more fully. His position is clearly subordinate. He is able to act as he does only because he acts on God's authority. The judgments he makes are just because they are always in accord with the will of God.

Verse 31. This verse introduces the key word "witness." The rabbis taught that self-witness is inadequate; there must be supporting witnesses. The same rule is voiced in 8:13. Here Jesus recognizes the rule and presents his witnesses.

Verse 32. The first is the Father. This idea is present in verses 34 and 37 also.

Verse 33. The next testimony is that of John the Baptist given to the delegation that questioned him (1:19-29).

Verse 34. Jesus' knowledge of his nature and mission did not come from John or any other human. It was from God. He called attention to John's testimony because the questioners respected him.

Verse 35. Jesus reminds them that they had respected John and his message.

Verse 36. Jesus next offers the testimony of his works. They are evidence of God's power working through him. This had been recognized by Nicodemus (3:2). Jesus submits that his works are stronger evidence than the words of the Baptist. Throughout this Gospel Jesus offers his works as evidence that his mission is God-empowered (10:25, 38; 14:11; 15:24).

Verses 37-38. Jesus again presents God as his chief supporting witness. He recognizes that his critics have never seen God but rebukes them for neglecting God's word sent to them through the prophets. Their failure to heed those prophets has made them unready to accept Jesus. (See 1:11.)

Verses 39-40. The critics had studied the Scriptures in detail, hoping to find the key to eternal life. Yet they failed to recognize that those Scriptures had predicted Jesus' coming.

Verses 41-47. In these verses "honor" replaces "witness." The critics were asking that Jesus produce testimony from some human source. Jesus saw that as praise rather than testimony.

Verse 41. Jesus does not rely upon human accreditation of his work.

Verses 42-44. His critics are more sensitive to the praise of humans than to the favor of God.

Verses 45-47. There is no need for Jesus to condemn them. Their failure to heed Moses has already done so. Moses is said to have written passages of Scripture that referred to Jesus (Deuteronomy 18:15 might be so regarded). Although the Jews based their hopes of God's favor on obedience to the laws of Moses, they did not heed Moses' word about the future. They were therefore unprepared for the mission and message of Jesus.

Selected Scripture

King James Version

Revised Standard Version

John 5:30-47

30 I can of mine own self do nothing: as I hear, I judge: and my

John 5:30-47

30 "I can do nothing on my own authority; as I hear, I judge; and my

judgment is just; because I seek not mine own will, but the will of the Father which hath sent me.

31 If I bear witness of myself, my witness is not true.

32 There is another that beareth witness of me; and I know that the witness which he witnesseth of me is true.

33 Ye sent unto John, and he bare witness unto the truth.

34 But I receive not testimony from man: but these things I say, that ye might be saved.

35 He was a burning and a shining light: and ye were willing for a season to rejoice in his light.

36 But I have greater witness than *that* of John: for the works which the Father hath given me to finish, the same works that I do, bear witness of me, that the Father hath sent me.

37 And the Father himself, which hath sent me, hath borne witness of me. Ye have neither heard his voice at any time, nor seen his shape.

38 And ye have not his word abiding in you: for whom he hath sent, him ye believe not.

39 Search the scriptures; for in them ye think ye have eternal life: and they are they which testify of me.

40 And ye will not come to me, that ye might have life.

41 I receive not honour from men.

42 But I know you, that ye have not the love of God in you.

43 I am come in my Father's name, and ye receive me not: if another shall come in his own name, him ye will receive.

44 How can ye believe, which receive honour one of another, and seek not the honour that *cometh* from God only?

45 Do not think that I will accuse you to the Father: there is *one* that accuseth you, *even* Moses, in whom ye trust.

judgment is just, because I seek not my own will but the will of him who sent me. 31 If I bear witness to myself, my testimony is not true; 32 there is another who bears witness to me, and I know that the testimony which he bears to me is true. 33 You sent to John, and he has borne witness to the truth. 34 Not that the testimony which I receive is from man; but I say this that you may be saved. 35 He was a burning and shining lamp, and you were willing to rejoice for a while in his light. 36 But the testimony which I have is greater than that of John; for the works which the Father has granted me to accomplish, these very works which I am doing, bear me witness that the Father has sent me. 37 And the Father who sent me has himself borne witness to me. His voice you have never heard, his form you have never seen; 38 and you do not have his word abiding in you, for you do not believe him whom he has sent. 39 You search the scriptures, because you think that in them you have eternal life; and it is they that bear witness to me; 40 yet you refuse to come to me that you may have life. 41 I do not receive glory from men. 42 But I know that you have not the love of God within you. 43 I have come in my Father's name, and you do not receive me; if another comes in his own name, him you will receive. 44 How can you believe, who receive glory from one another and do not seek the glory that comes from the only God? 45 Do not think that I shall accuse you to the Father; it is Moses who accuses you, on whom you set your hope. 46 If you believed Moses, you would believe me, for he wrote of me. 47 But if you do not believe his writings, how will you believe my words?"

46 For had ye believed Moses, ye would have believed me: for he wrote of me.

47 But if ye believe not his writings, how shall ye believe my words?

Key Verse: **Search the scriptures: for in them ye think ye have eternal life: and they are they which testify of me. (John 5:39)**

Key Verse: **You search the scriptures, because you think that in them you have eternal life; and it is they that bear witness to me. (John 5:39)**

The Scripture and the Main Question—Pat McGeachy

Consistency (John 5:19-24)

The first question we would ask of a candidate for Messiahship might be whether that candidate's ministry is consistent with what we already know of God's way of working. If Jesus had appeared espousing things that stood in direct violation of what we already knew of God, we would be right to be suspicious. Suppose he had opposed what we knew of fundamental morality, proposing a new set of commandments including things like: Reject your parents; celebrate promiscuity; kill or be killed. Then we would have known immediately that he was a fake.

Some people thought Jesus *did* reject the old commandments. They accused him of sabbath-breaking, gluttony, and drunkenness (John 5:18; Matthew 11:19). But he did not come to violate the old rules; he came to speak to their inner truth, saying, "I have not come to abolish [the law and the prophets] but to fulfil them" (Matthew 5:17). Or, as he puts it here (John 5:19), "The Son can do . . . only what he sees the Father doing."

Jesus does do unexpected things; he performs miracles like the one in John 2:1-11, turning water into wine. But that is consistent with what God has been doing in the natural world since the beginning of time. If you have the patience and can wait by a grapevine long enough, it will draw up water through its roots and into its branches and make grapes. In time the grapes will fall ripe to the ground and ferment in the sun. In a sense Jesus was only speeding up the process. If, like a medieval alchemist, Jesus had turned lead into gold, or if he had stood for cruelty and bestiality rather than compassion and justice, we might have been suspicious. A tree that bears bad fruit cannot be a good tree (Matthew 7:18). But Jesus does what God would surely do: heal the sick, cast out demons, bring good news to the poor. And if we do not honor him (5:23), then we are dishonoring God. One of the reasons we should accept Jesus' authority is that he operates under the authority of God.

The God of the Living (5:25-29)

"I came," Jesus said (John 10:10), "that they may have life, and have it abundantly." When a prophet arises who stands for death, not life, as happened a few years ago in the horrible example of Jonestown in Guyana, then no right-thinking person should honor him. God is not the God of the dead but of the living (Mark 12:27). Regardless of the mysteries that surround Jesus—things like his inexplicable birth, his extraordinary

miracles, and his amazing resurrection—we must not stumble over the one clear fact: to follow him is to find life.

I confess that as a young man I did not fully realize this. I tried, as many young people do, to find life in my own strength. I thought that the secret of happiness was to be popular, to have athletic ability, or money and cars, or, at the very least, to be clever and cute. My parents tried to tell me that happiness is to be found not in seeking to attract friends but in being a friend. But I would not listen. Only after a series of shattering social embarrassments and adolescent indiscretions did I fall back in desperation on Jesus' promise, "Whoever loses his life for my sake . . . will save it" (Luke 9:24). I began to learn to listen, to care for others, and to reach out to them in love. And lo and behold, Jesus was right! People who live that way *do* have friends. As long as I sought happiness, it eluded me (in spite of what the Declaration of Independence tells me about my right to pursue it). But when I quit looking for it and began to live for others, my cup became full and running over.

Jesus is the Lord of goodness, not evil (5:29), and those who stand for goodness will find resurrection. Not even death can stop goodness from triumphing. Evil may laugh, like the mad scientists on Saturday morning cartoons, but evil does not have the last laugh. Jesus can be trusted because the evidence is clear: Those who follow his way of love find life. But those who follow the way of selfishness come in the end to death. Mahatma Gandhi took great comfort in remembering that not a single tyrant has lasted; in the long run every single one of them has fallen. Yes, and on the other hand everyone who has lived a life devoted to goodness has been vindicated. Try it; you'll see!

The Bible Bears Witness (5:30-47)

There is a notion among Bible-thumping folks that we ought to take the Bible more literally. Well, I will agree with that, only I would suggest that many people who shout and pound on the Bible need to follow their own advice. The trouble with very conservative Christians is not that they take the Bible too seriously, but that they don't take it seriously enough. Most of us have our own private "red letter" edition of the Bible. That is, those parts that comfort our prejudices seem to stand out in red, while those parts that disturb us fade into the background where we can overlook them.

Let me illustrate. This past Christmas, you and I will have heard over and over again the words of Isaiah 40 comforting God's people, or Isaiah 9 about the light shining in the darkness, or Isaiah 11 about the peaceable kingdom. Great stuff! But how often do we read for devotional purposes the solemn warnings of Amos 5:23: "Take away from me the noise of your songs"? Do we turn, in our troubles to Malachi 3:2: "Who can endure the day of his coming, and who can stand when he appears? For he is like a refiner's fire"? We need to stand under Scripture, and not only the lovely words but also the plain talk: not only the assurance that God loves us but also the demands of the social gospel that the prophets lay upon us.

In Jesus day the religious leaders claimed to believe in the Law of Moses (John 5:45), but they would not accept Jesus when he came in fulfillment of that law (Matthew 5:17). This means, Jesus says, that they didn't really believe Moses in the first place. Let me try to put this in contemporary terms by retelling an old parable.

There was, according to this tale, a life-saving station on the dangerous coast of North Carolina, where hundreds of ships foundered each year on the reefs. Brave rescuers launched boats, rowed out to save the seamen from the ships that were breaking up, and brought them dripping and exhausted into the life-saving station. They became famous for their rescue work, and soon other stations sprang up along the coast, and many lives were saved.

But after a time the life-saving station became so famous that it began to prosper economically. They built a new station with carpeting and a fancy lobby and a little statue of a gold lifeboat in the center of it. Gradually they spent more and more time keeping up the station and less and less time rowing out to save drowning sailors. Eventually they began to hire others to do this dirty work, and when their employees brought wet and bedraggled survivors in from the sea they didn't like them dripping on the new carpets, so they sent them to the mission barracks down the street. "There is no room for that sort in our station," they said.

This story *could* be about Israel, and her refusal to recognize the continuation of her mission in Jesus, who went to publicans, sinners, and Gentiles with the good news. Or it could be about you and me, who claim to be Bible-believing Christians and yet are made very uncomfortable when Jesus lays on us the very commands that we have known he called us to long ago. As long as we receive glory from one another (verse 44), we will not recognize the glory of God when it shines right in our eyes. We may faithfully search the Scriptures (verse 39), but when they call us to radical obedience, we find them very very uncomfortable.

Helping Adults Become Involved—Douglas E. Wingeier

Preparing to Teach

Pray for wisdom for yourself and receptivity for your class, that the idea of the authority of God's word may be clearly communicated.

Read John 5:19-47 and an exposition in a commentary. Barclay's treatment is especially helpful. Interview a person of another denomination, and think about your response to the two questions.

The aim is to help members compare the authority on which they base their beliefs with the Bible, and to live by Jesus' teachings as a witness to his Sonship. You might want to follow this outline:

I. Jesus does God's work and will.
 A. The Son gives life.
 B. The Son passes judgment.
 C. Belief leads from death to life.
II. Jesus acts on God's authority.
III. The Bible bears witness.
 A. People in Jesus' time did not believe the words of Moses.
 B. People in our time do not obey the words of Jesus.

Introducing the Main Question

Daniel Yankelovich in his book *New Rules* says that the older generation lived by the "old rules" based on self-denial, while younger folk follow the "new rules" centered in self-fulfillment. Both are faulty because they are

focused on self. In place of the divisive conflict between these two value systems, our society needs a new approach founded on commitment.

Present the material in Pat McGeachy's "The Main Question" on individualistic religion—"Do your own thing" and "Honor thyself." Invite other examples. Ask: What has caused this trend? What is the corrective? How should Christians respond? How can we help young people deal with it? Then raise Dr. McGeachy's basic question: Are we to construct our own private theology, or will we accept the Bible's evidence for *God's* truth in Jesus?

Developing the Lesson

I. Jesus does God's work and will.

John 5:19-24 describes what the Son of God does and promises that if we believe in him we will pass from death to life. Begin discussion by asking for responses to the first interview question, How do you know that Jesus is the Son of God? Hear the answers from other denominations first; then invite members' views. Write all responses on the board. Look for differences and similarities. Group the answers in categories: biblical testimony, miracles, life and ministry, crucifixion and resurrection, personal experience, the church's authority. Then turn to answers in today's text.

A. The Son gives life.

Jesus is the Son of God because God not only resurrected him but also empowered him to give life to others (verses 19-21). The infant born by Caesarian, the couple beginning married life, the man recovering from a triple bypass, the woman in remission after chemotherapy, the refugee starting over in a new land, the sinner saved by grace, the newly baptized, the person returning to the church after a long lapse—all receive the gift of life from Jesus.

B. The Son passes judgment.

Jesus is the Son of God because God has given him the authority to judge. The driver with a speeding ticket, the marriage broken up by spouse neglect, the job lost due to absenteeism, the grandparent whose children never call because of childhood memories of abuse, the nation facing resentment abroad and crime and drug abuse at home in response to longtime racism and greed, the church facing membership apathy and decline due to self-centeredness and absence of mission, the goats on the left who have ignored the needs of "the least of these" (Matthew 25:41-46)—all encounter the judgment of Jesus.

C. Belief leads from death to life.

Jesus is the Son of God because through his death and resurrection he has redeemed us (verse 24). "There is therefore now no condemnation for those who are in Christ Jesus. For the law of the Spirit of life in Christ Jesus has set me free from the law of sin and death" (Romans 8:1-2). The son enables us to pass from death to life. Family members reconciled after a quarrel, the recovered alcoholic, the prodigal who "arose and came to his father" (Luke 15:11-24), the divorcee who finds happiness in a new marriage, the street person who receives a bed and warm meal, the sinner who accepts Christ's saving grace, the nation that recommits to values of justice and human rights, the earth that is stewarded into beauty and productivity, the church that gives its energies to discipleship and mission—all are experiencing redemption, passing from death to life.

As each of these signs of Jesus' Sonship is discussed, ask: Do you see Jesus at work in these instances of life, judgment, and redemption? If not, what is the power behind them? If so, how can you help these works of his to be accomplished?

II. Jesus acts on God's authority.

John 5:30-40 grounds Jesus' claim to Sonship in the divine authority, as verified by the valid testimony of *God* (verses 32, 37-38), *John the Baptist* (verse 33), and *Jesus' own works* (verse 36). Share the insights on these verses from Ralph Decker's "As you Read the Scripture." Discuss: How can we be sure that an idea is based in God's authority, and not in human opinion? Jesus knew that his own say-so was not sufficient to convince people of his Sonship (verse 31), he so appealed to other sources of authority. Introduce the Wesley Quadrilateral—Scripture, tradition, reason, and experience—as criteria by which we can test truth-claims.

III. The Bible bears witness.

Now ask for reports on the second interview question, How do Christians live out their belief in Jesus as the Son of God? Write the answers on the board, both those from other traditions and those from class members. Group them into categories such as worship, lifestyle, service, witness, and moral choices. Compare this discussion with the treatment of verses 41-47 by Dr. Decker, the material under "The Bible Bears Witness" in "The Scripture and the Main Question," and the ideas below.

A. People in Jesus' time did not believe the words of Moses.

John's Gospel contends that Jesus was the fulfillment of Messianic prophecies (verses 45-46). They should have recognized him on the basis of their own authority, but they did not. They stood accused, because they ignored the guidance of their Bible.

B. People in our time do not obey the words of Jesus.

We likewise ignore the guidance of Jesus' words (verses, 42, 44, 46). The way to demonstrate our faith in Jesus as the Son of God is to live by his words. Ask the class to mention teachings of Jesus that provide direction for a life that would bear witness to his Sonship. Such ideas as loving one's neighbor, forgiving seventy times seven, bearing one another's burdens, doing unto others, giving a cup of cold water, and peacemaking could be listed on the board.

Helping Class Members Act

Ask each person to select from the list on the board one guideline that they intend to try living by during the coming week as a witness to Jesus' Sonship. Have them write their names beside the ones they plan to follow. Save the list to look at next week. Close with the hymn "Jesus Calls Us" and a prayer asking for guidance and strength for faithful living in the week ahead.

Planning for Next Sunday

Next week's lesson is on Jesus, the bread of life. Ask someone to bring a loaf of homemade bread. Ask five individuals to read and report on these sections of John 6: verses 1-15; 15-25, 26-40, 41-65, and 66-71.

Satisfying Hunger

Background Scripture: John 6

The Main Question—Pat McGeachy

This lesson is similar to that of December 17, in which we spoke of thirst after the water of life. There we suggested that thirst is the strongest of human desires. And it is true that though one could live for many days without food, three or four without water is all life can stand. But there is a sense in which bread is more important than water. Water may make life possible, but bread makes life rich and satisfying. Thirst, like the need for air, is easily satisfied unless you are in the desert. But water, like air, is cheap and plentiful; it falls from the sky. Bread, however, must be earned by the sweat of the brow, and it is utterly delicious. Of all the wonderful smells of the world, baking bread is the best. You can walk past a bakery and go through all sorts of *déjà vu*, reliving ancient delights.

Jesus, on the night of his arrest, took bread and gave it eternal significance. But his other uses of bread have deep meaning too. And in this story we have to do with all the resources of God and ourselves. If, like me, you sometimes get discouraged with the world and our ability to achieve any real justice, peace, or happiness, remember Andrew's lad (6:9), the boy with five loaves and two fishes. With the help of God your resources, however limited they may seem, can accomplish wonders. The main question for us, then, is, How can we put our resources at God's disposal? How can we draw on the strength of Christ without trying to use him as a source of cheap bread? (verse 34). It is not easy; Jesus calls us to eat of his own flesh and drink his blood, and this is a hard saying (verse 60). But where else can we go (verse 68); with Jesus the way may be hard, but it is the way to eternal life. There are so many hungers: We hunger for justice, for peace, for health and hope, for the wisdom to get from breakfast to bedtime. Can it really be true that if we come to Jesus we will never hunger again (verse 35)?

As You Read the Scripture—Ralph W. Decker

John 6:35-51. This passage is the first of seven sections of John's Gospel usually referred to as the "I am" passages: 6:35; 8:12; 10:7; 10:11; 11:25; 14:6; 15:1. Nothing like them is found in the other Gospels. These self-characterizations present the many-sided nature of Jesus as they use ordinary things to illustrate his extraordinary being.

Here, the usual dialogue pattern of this Gospel leads into Jesus' revelation of himself as the bread of life. On the day following the feeding of the five thousand, the crowds came seeking him. He told them they had come hoping to be fed again and urged them to "labor for the food . . . that endures to eternal life." They took him literally and asked to be given that bread. Their request opened the way for Jesus to reveal himself as the life-giving bread.

Verse 35. This is an important verse. It makes it clear that Jesus is speaking figuratively and prevents any interpretation of his later words

175

about eating his flesh and drinking his blood (verse 56) as an invitation to cannibalism. Jesus used the figures of both hunger and thirst, implying that he is the water of life as well as the bread of life. As food and water sustain physical life, so "coming" and "believing" sustain the spiritual life.

Verse 36. The slowness of the Jews to respond to Jesus is one of the themes of this Gospel (1:10–11; 3:10-12; 5:40).

Verse 37. Some interpreters find hints of predestination in this verse and verse 44. They need not be read as though God decides which individuals will believe in Jesus and which will not. They can mean that God offers the opportunity and provides the influences that lead to belief.

Verses 38-39. God acts through Christ to bring persons into the life that is eternal. It is his grace that sent Jesus and his will that all should respond. Since Christ's will is one with God's, he strives to bring all to salvation.

Verse 40. If there is predestination in this passage, it is not the predestination of individuals but the predestination of a way of salvation. It is predestined that all who respond to Christ in faith shall be saved.

Verse 41. "The Jews" is John's usual designation for those who opposed Jesus. This suggests that the author wrote for persons of non-Jewish background. These opponents object to Jesus' statement that he came from heaven.

Verse 42. Failing to look beyond his physical origin, they call him the son of Joseph.

Verses 43-44. Jesus returns to the theme that it is God working through him that leads persons into eternal life.

Verse 45. Isaiah was the prophet who wrote that all would be taught by the Lord (Isaiah 54:13). Persons who have found God's word in the Scriptures have been prepared to accept Christ.

Verse 46. This repeats 1:18. God's instruction has not been direct. It has been through the prophets.

Verse 47. The present tense of both "believes" and "has" indicates that both belief and eternal life are present realities. This same concept was presented in 3:15. It is one of the major teachings of this Gospel that eternal life is a state into which one can enter here and now. It is a quality of life that is not subject to the limits of time. This concept of eternal life does not rule out resurrection and life after death. Jesus says, "I will raise him up in the last day" four times in chapter 6.

Verse 48. Jesus sustains the quality of life that is eternal.

Verse 49. Earlier (verse 31) the critics had referred to the manna in the wilderness as bread from heaven. Jesus points out that it did not prevent death.

Verses 50-51. It is the bread from heaven, which feeds the spirit not the body, that gives eternal life. Jesus will give his life to provide it.

Selected Scripture

King James Version	Revised Standard Version
John 6:35-51	*John 6:35-51*
35 And Jesus said unto them, I am the bread of life: he that cometh to me shall never hunger; and he that believeth on me shall never thirst.	35 Jesus said to them, "I am the bread of life; he who comes to me shall not hunger, and he who believes in me shall never thirst.

36 But I said unto you, That ye also have seen me, and believe not.

37 All that the Father giveth me shall come to me; and him that cometh to me I will in no wise cast out.

38 For I came down from heaven, not to do mine own will, but the will of him that sent me.

39 And this is the Father's will which hath sent me, that of all which he hath given me I should lose nothing, but should raise it up again at the last day.

40 And this is the will of him that sent me, that every one which seeth the Son, and believeth on him, may have everlasting life: and I will raise him up at the last day.

41 The Jews then murmured at him, because he said, I am the bread which came down from heaven.

42 And they said, Is not this Jesus, the son of Joseph, whose father and mother we know? how is it then that he saith, I came down from heaven?

43 Jesus therefore answered and said unto them, Murmur not among yourselves.

44 No man can come to me, except the Father which hath sent me draw him: and I will raise him up at the last day.

45 It is written in the prophets, And they shall be all taught of God. Every man therefore that hath heard, and hath learned of the Father, cometh unto me.

46 Not that any man hath seen the Father, save he which is of God, he hath seen the Father.

47 Verily, verily, I say unto you, He that believeth on me hath everlasting life.

48 I am that bread of life.

49 Your fathers did eat manna in the wilderness, and are dead.

50 This is the bread which cometh down from heaven, that a man may eat thereof, and not die.

51 I am the living bread which

36 But I said to you that you have seen me and yet do not believe. 37 All that the Father gives me will come to me; and him who comes to me I will not cast out. 38 For I have come down from heaven, not to do my own will, but the will of him who sent me; 39 and this is the will of him who sent me, that I should lose nothing of all that he has given me, but raise it up at the last day. 40 For this is the will of my Father, that every one who sees the Son and believes in him should have eternal life: and I will raise him up at the last day."

41 The Jews then murmured at him, because he said, "I am the bread which came down from heaven." 42 They said, "Is not this Jesus, the son of Joseph, whose father and mother we know? How does he now say, 'I have come down from heaven'?" 43 Jesus answered them, "Do not murmur among yourselves. 44 No one can come to me unless the Father who sent me draws him; and I will raise him up at the last day. 45 It is written in the prophets, 'And they shall all be taught by God.' Every one who has heard and learned from the Father comes to me. 46 Not that any one has seen the Father except him who is from God: he has seen the Father. 47 Truly, truly, I say to you, he who believes has eternal life. 48 I am the bread of life. 49 Your fathers ate the manna in the wilderness, and they died. 50 This is the bread which comes down from heaven, that a man may eat of it and not die. 51 I am the living bread which came down from heaven; if any one eats of this bread, he will live for ever; and the bread which I shall give for the life of the world is my flesh."

came down from heaven: if any man eat of this bread, he shall live for ever: and the bread that I will give is my flesh, which I will give for the life of the world.

Key Verse: **And Jesus said unto them, I am the bread of life: he that cometh to me shall never hunger; and he that believeth on me shall never thirst. (John 6:35)**

Key Verse: **Jesus said to them, "I am the bread of life; he who comes to me shall not hunger, and he who believes in me shall never thirst." (John 6:35)**

The Scripture and the Main Question—Pat McGeachy

Limited Resources (John 6:1-15)

The story of the feeding of the five thousand is the one miracle of Jesus' that appears in all four of the Gospels. In addition to John it is found in Matthew 14:13-21; Mark 6:32-33; and Luke 9:10-17. (Indeed, if you count the story of the *four* thousand, you can find it also in Matthew 15 and Mark 8.) It is clearly the most important of Jesus' acts apart from the events of Holy Week. What sets it apart? It could be that it has eucharistic significance, that is, that it is related to the Last Supper. (In that case, so must be the meal stories in Luke 23:13-35; John 21:4-14; and others.) Breaking bread with Jesus is part and parcel of what being a Christian means.

In addition, the story helps us deal with our limited resources by pointing out how, together with the power of God, our few loaves and fishes can accomplish miracles. There is great hunger in the world, and left to ourselves we human beings don't seem to be doing a very good job of dealing with it. But with Christ's help perhaps we can.

We can misuse this miracle. The multitude tried to turn it into a permanent feast by forcing Jesus to be their king (verse 15). But as someone said during the last election, "You can't elect Jesus; Jesus is *already* king!" We err if we try to turn Jesus into a deliverer of free bread. Rather than say, "I believe in Jesus because he gives me bread," I should say, "Because I believe in Jesus, I have bread enough and to spare." That belief can also help me to have confidence in those around me. Even Andrew's lad can make a significant contribution. We must not underestimate the power of God to take any human resources, even yours and mine, and change the face of things.

Walking on the Water (6:16-25)

If John wanted to argue Jesus' deity on the strength of his magic, you would think he would have made more of this incident, but he throws it in almost in passing. Miraculously they crossed the lake in spite of the storm, and when the crowd, who had to cross the next day in the more natural manner, found Jesus there too, they were curious about how and when he had arrived (verse 25). Jesus is always turning up, like Candid Camera, in unexpected places. He will come, we are told, like a thief in the night (Luke 12:39-40). Often when we set out to do ministry in a new area or a foreign

land, we are surprised to discover that Jesus has been there before us. He is not a follower but a pioneer (Hebrews 12:2). Like the wind of the Spirit (3:8), he comes and goes as he will.

The Bread of Life (6:26-40)

The multitude was following Jesus for the wrong reason (verse 26); they wanted the bread, but they did not want the tough road that Jesus was to walk. In I Corinthians Paul tells us that the church is Christ's body (12:27), but exactly one chapter earlier (11:24) he has reminded his readers that the body of Christ is to be broken for the world. To eat of Christ's body is far more than to be well fed; it is to radically alter one's life. He invites us to freedom from hunger and thirst (verse 35), but not to the sort of fatness the crowd was seeking. Those who follow Christ may have many things to suffer, but their hearts' desire will be filled; they will feed on the delicacies of the soul, on heavenly bread (verses 33, 38). Manna can satisfy the body, but only this bread can satisfy the soul.

A Hard Saying (6:41-65)

There were two negative reactions to Jesus' words. The religious authorities were angry at him for blaspheming; they heard him claiming to be God. But the disciples were upset too, because of the difficulty of the symbolism of the bread. To speak of eating Christ's body and drinking his blood is a frightful thing! It has offended pious Jews and philosophical Greeks since the beginning (see I Corinthians 1:22-25). But children can understand it. (In fact, James White once said that he found children could understand the mystery of the bread being the body of Christ more readily than they could believe that that funny tasting water was really bread!) And faithful Christians have learned that it is a blessed mystery.

However, it *is* a hard saying. And Jesus did not appear too surprised (verse 61) that some doubted. When you stop to think about it, the surprising thing is the number of those who believe. Think of the many kinds of secular bread that the world offers. When we can turn to food and alcohol for escape or to money to take our minds off of our troubles (note that some people call money "bread") or put our trust in all manner of earthly gods (sleep, security, sex, sensationalism), then it is a wonder that more people do not walk away from the hard sayings of Jesus. Most of the seed seems to fall on the path or in shallow soil or among the thorns, and only a little on the good ground (Mark 4:1-20). It seems that many are called, but few are chosen (Matthew 22:14).

And yet Jesus promises that whoever eats of his own bread will live forever (verse 58). It is characteristic of false gods that though they cannot save us, they do have the capacity to destroy. A person can become a slave to one of the lesser breads, such as drugs, and it can (and ultimate will) be fatal. But it only offers a pretend solution. Jesus' bread, on the other hand, while it never promises to take away the pain of life (whether that involves breaking away from families, taking up crosses, or drinking bitter cups) does promise ultimately to save. Which would you rather have: a temporary salvation that frees you from pain, or a permanent salvation for which you must hurt for a while. Omar advises us to "take the cash and let the credit go,/nor heed the rumble of a distant drum" ("The Rubaiyat"). Who, after

all, has been to heaven? Who has seen God? The answer to that is Jesus (verse 46). And to believe in him is to have eternal life. And Omar notwithstanding, there is more here than just a distant drum. We do not have to wait till we get to heaven to taste the true bread. There are foretastes of it in this life, and satisfactions that this world cannot afford. It may be a cross, but it carries with it sublime pleasure. Surely you remember the old hymn:

> In the cross of Christ I glory,
> Towering o'er the wrecks of time;
> All the light of sacred story
> Gathers 'round its head sublime.
>
> When the woes of life o'ertake me,
> Hopes deceive, and fears annoy,
> Never shall the cross forsake me;
> Lo! it glows with peace and joy.
>
> When the sun of bliss is beaming
> Light and love upon my way,
> From the cross the radiance streaming
> Adds more lustre to the day.
>
> Bane and blessing, pain and pleasure,
> By the cross are sanctified;
> Peace is there, that knows no measure,
> Joys that through all time abide.
> ("In the Cross of Christ I Glory")

Where Else Can We Go? (6:66-71)

Although the authorities criticized Jesus and some of his disciples deserted him, this moment became a time of faith decision for Simon Peter and the Twelve, similar to the great confession at Caesarea Philippi (Matthew 16:16). His statement is worth memorizing, for though it is couched strangely in the negative, it is a powerful affirmation of what their young faith is blossoming into: "Lord, to whom shall we go? You have the words of eternal life; and we have believed, and have come to know, that you are the Holy One of God" (verses 68-69). They have been with Jesus for a good while now, and though he has not specifically told them (see Matthew 16:17), it has begun to dawn on them. This is no ordinary man! He serves no ordinary bread! This is one who comes from heaven, bringing manna like our ancestors never saw! It is better to have fed on this bread than to have eaten at the greatest banquet in the world. It is a foretaste of a supper yet to come (Revelation 3:20; 19:9).

Helping Adults Become Involved—Douglas E. Wingeier

Preparing to Teach

This lesson uses a material symbol (bread) to make a spiritual point (Christ fills our need and calls us to offer our resources to him). Ask him to

use you as a means of meeting the inner need of your class members and challenging them to dedicate their energies and gifts to Christ.

Read John 6 and the commentaries about it, plus the article entitled "Bread" in *Harper's Bible Dictionary*. Have Bibles and hymnals available. Remind the volunteers to prepare their reports and bring the bread.

Your aim is to help persons take Christ into their lives and dedicate themselves and their resources to him for the meeting of human need. Organize the session as follows:

I. Jesus feeds the multitudes.
 A. The people are hungry.
 B. The resources are limited.
 C. A little boy shares.
 D. The people eat their fill.
II. Jesus walks on water.
 A. He appears in unexpected places.
 B. He goes before us.
III. Jesus is the bread of life.

Introducing the Main Question

Hold the loaf of homemade bread in both hands as you stand before the class. Say, "Bread is the staff of life. This bread has been baked by (name) and given to us for feasting this day. It represents for us our Lord Jesus, the bread of life. He gives himself to us to satisfy our needs and calls upon us to share our gifts and resources with him and with all people." Then offer a prayer, asking for guidance and understanding as you open your hearts and minds to be fed with the bread of life. Present the basic ideas under Pat McGeachy's "The Main Question," which are essential to identifying the central purpose of the lesson. Lift up the parallel between this lesson and the earlier one on water, the availability of Christ's resources to us, and the need for us to offer ours to him.

Developing the Lesson

I. Jesus feeds the multitudes.
Ask the person reporting on John 6:1-15 to tell this version of the feeding of the five thousand. Share the ideas in the section on "Limited Resources" in "The Scripture and the Main Question." Build on the person's report by emphasizing:
A. The people are hungry.
They (and we) need the bread of life. Bread satisfies our physical need for the moment, but we get hungry again. The aroma of freshly baked bread only whets our appetite. We need to find the meaning and purpose of life in order to be satisfied. We try various approaches—food, drink, sex, work, money and things, exercise and fitness, education, travel and adventure—but we are still hungry.
B. The resources are limited.
The people had not come prepared. There was very little to eat. There was consternation as to what to do. Only one little boy offered his lunch. In our satiated society of fast-food chains, conspicuous consumption, and disposable everything, it is hard to understand what limited resources

means. Remind the class of places like the African Sahel, Palestinian refugee camps, and Central America, where drought, war, and economic exploitation have blocked the meeting of basic human needs. But perhaps in our society more than any other, the preoccupation with things, achievement, and upward mobility has created deep spiritual hunger. When material resources abound, spiritual resources are obscured.

C. *A little boy shares.*

Some say that the lad's generosity shamed the others into sheepishly pulling their lunches out of their cloaks. Such overcoming of selfishness would be a miracle, all right. But however it happened, Jesus helped the boy's loaves and fishes become enough to feed the crowd, with plenty left over.

D. *The people eat their fill.*

When we dedicate our resources to Christ, he causes marvelous things to happen with them. Our stewardship and generosity can contribute to meeting others' needs. Invite the class to think of examples of how this has or could happen in their lives, church, community, and world.

II. *Jesus walks on water.*

Call for the report on verses 16-25. Share the ideas from Pat McGeachy on this story.

A. *He appears in unexpected places.*

In talking about how Jesus appears in unexpected places, ask the group to think of instances of this. Examples might include Rosa Parks on the Montgomery bus, a passing motorist stopping to help change a flat tire, a caring teacher helping a struggling student, a blood donor, a word of encouragement when one is down, and a reminder to a workaholic to slow down and smell the roses.

B. *He goes before us.*

The affirmation that he goes before us is often more evident by hindsight than at the moment. Ask members to recall occasions when in retrospect they can see God's guiding hand, while at the time they felt bewildered and confused. These are the times when we must move out in faith, believing that Christ is with us and directing us even when we cannot feel his presence and have no clear idea of what to do.

III. *Jesus is the bread of life.*

Ask for the reports on verses 26-40, 41-65, and 66-71 in order, and supplement each with material from sections of Pat McGeachy's "The Scripture and the Main Question." Emphasize that Jesus is the only food that really *satisfies* (verse 35); that communion is not cannibalism but symbolic of Christ *abiding in us* and we in him (verse 56); and that like Simon Peter we are *called to decide* what we think about Jesus and to base our lives on this belief (verses 67-68).

Drawing on the material in Ralph Decker's "As You Read the Scripture," explain three possibly controversial points. First, the frequent references to "the Jews" (e.g., verse 41) in the Gospel of John must not be allowed to contribute to anti-Semitism. It was Jesus' contemporaries who opposed him, but there have been many of every race and nationality who have opposed him since. These are often good people, sincere in their beliefs, who just don't see things the way we do. Respectful dialogue and efforts at

understanding opposing viewpoints will get us farther than biased condemnation or rejection.

Second, the hints at predestination in verses 37 and 40 may be interpreted, as Dr. Decker puts it, as predestination that "all who respond to Christ in faith shall be saved."

Finally, the eternal life referred to in verses 47 and 68 is not just "pie in the sky by and by" but a quality of life in Christ that begins now and continues after death for the faithful.

Helping Class Members Act

To close the session, have the group stand and form a circle. Sing "In the Cross of Christ I Glory." Then break the loaf and, passing half in either direction around the circle, have persons offer bread to one another with the words, "Abide in Christ, the bread of life." When all have partaken, ask: What loaves and fishes will you offer for the feeding of the multitudes? Listen as members identify the gifts and resources they have to give to Christ for use in church and world. Everything from dollars to talents to acts of caring and thoughtfulness may be mentioned. After each person's statement, have the group respond with "Multiply our gifts, O Christ." Send them forth with the words, "Go, abiding in Christ, to share the bread of life with others."

Planning for Next Sunday

In addition to reading John 8:12-59, ask class members to complete the sentence "I am . . . " four times and bring their lists next week.

Being Set Free

Background Scripture: John 8:12-59

The Main Question—Pat McGeachy

There is a sea creature called the hermit crab. This soft-shelled animal lives in the discarded shells of sea snails and whelks and moves to a new one whenever one is outgrown. But there are brief times when the hermit crab is on the loose, free from attachment to a shell. At these times it is most vulnerable and, one suspects, very nervous until it finds a new home.

Some of us are like that. We dream of freedom; we celebrate liberty; but when it is offered us we shrink from it. We seem to prefer the security of a dictatorship to the responsibility of a democracy. We say, "Trust the government and let them take care of it; they know more than we do." Or we run to the pages of a simplistic Bible or to the skirts of an authoritarian

church where something or someone else will do our thinking for us. Freedom is hard to take.

And yet Christ promises something radical to his followers: a true freedom. In Christ we are delivered from an absolute law. You simply can't look in the Bible under *T* for troubles or *P* for problems and find there the answers. We are given guidelines and grace to follow them, but in Christ we are free indeed. How old must my daughter be when I let her go out with boys? The Bible doesn't say. Where do I draw the line? There may not be a clear answer. For whom shall I vote? God leaves it up to me.

It's a frightening business, but it's wonderful. Jesus gives us what seems to be the power to run our own lives. He treats us as though we were only a little less than God. He says, "Before Abraham was, I am," (verse 58), as though he identified with the timeless deity who called himself, "I AM WHO I AM" (Exodus 3:14). When Jesus said this, the authorities tried to kill him (verse 59). What do we do when he makes this audacious claim to us, with its equally audacious promise? That is the question.

As You Read the Scripture—Ralph W. Decker

John 8:31-47. This passage deals with three major concepts of John's Gospel: truth, freedom, and Sonship. The discussion is so involved that it cannot be readily separated. The arguments and answers overlap and blend into each other. Truth, freedom, and Sonship are all interwoven.

Verse 31. Verse 30 reported that many had believed in Jesus as he explained his relationship with God (verses 21-30). Jesus tells those persons that discipleship means more than agreeing with his words. It means continuing to learn and grow under his guidance.

Verse 32. Continued learning leads to knowledge of the truth and to freedom from ignorance and falsehood. This verse must be read in relation to verse 31. Many have used it wrongly to support their ideas of truth. Together the two verses make it clear that truth is that which is learned from Jesus.

Verse 33. This verse introduces another example of the usual pattern of dialogue between Jesus and his critics. Jesus makes a pronouncement. The critics misinterpret it. Jesus makes a fuller statement showing the spiritual meaning of the original one. The critics still misunderstand. Jesus then speaks at length on the spiritual matter. The claim of Jesus' opponents cannot be taken literally. The Scriptures contain many references to how the descendants of Abraham were enslaved in Egypt, carried into captivity by Assyria and Babylonia, and ruled by several foreign powers, including Rome at the time of this dialogue. Their statement was one of pride rather than historical fact. Even though they had been oppressed many times, the Jews considered themselves free in spirit.

Verses 35-36. Slaves are contrasted with sons. A son is free and can give freedom. A similar idea appears in the contrast of Jesus and Moses in Hebrews 3:5.

Verse 37. Jesus acknowledges his opponents' claim to physical descent from Abraham and argues that they should therefore be receptive to him.

Verse 38. "My Father . . . your father," another of the many contrasts found in John, introduces a discussion of the nature of true Sonship. Jesus implies that it is seen not in physical descent but in family resemblance in matters of character, attitudes, purpose, and conduct.

`Verses 39-40.` The opponents repeat their claim to descent from Abraham. Jesus responds that they do not act like Abraham. He says that they show that someone else is their father.

Verse 41. They take this as a charge that they are illegitimate, but catching the drift of Jesus' thought they shift to the claim that their father is God—not by a physical but by a spiritual relationship.

Verse 42. Jesus again raises the question of family resemblance. If they were related to God, as they claim, they would recognize that he also is related to God and would accept him.

Verse 44. Jesus says they must be children of the devil because they believe and act like him. He is a murderer, and they are ready to kill Jesus. He is a liar, and they resist the truth. Jesus suggests that the family resemblance is obvious.

Verse 45. Being children of falsehood, they do not heed the truth.

Verse 46. Jesus challenges them to either prove that he has been false or accept the truth he has brought. Apparently his challenge went unheeded. Although no one undertook to convict him of sin, a number of accusations had been leveled against him in chapters 5 through 8. Those accusations had been becoming increasingly severe.

Verse 47. Jesus concludes this part of the argument by repeating the charge that his critics are not God's children because they fail to respond to the ideas and purposes of the Father. They do not pass the test of true sonship: family likeness in character and conduct.

Selected Scripture

King James Version

John 8:31-47

31 Then said Jesus to those Jews which believed on him, If ye continue in my word, *then* are ye my disciples indeed;

32 And ye shall know the truth, and the truth shall make you free.

33 They answered him, We be Abraham's seed, and were never in bondage to any man: how sayest thou, Ye shall be made free?

34 Jesus answered them, Verily, verily, I say unto you, Whosoever committeth sin is the servant of sin.

35 And the servant abideth not in the house for ever: *but* the Son abideth ever.

36 If the Son therefore shall make you free, ye shall be free indeed.

37 I know that ye are Abraham's seed: but ye seek to kill me, because my word hath no place in you.

38 I speak that which I have seen

Revised Standard Version

John 8:31-47

31 Jesus then said to the Jews who had believed in him, "If you continue in my word, you are truly my disciples, 32 and you will know the truth, and the truth will make you free." 33 They answered him, "We are descendants of Abraham, and have never been in bondage to anyone. How is it that you say, 'You will be made free'?"

34 Jesus answered them, "Truly, truly, I say to you, every one who commits sin is a slave to sin. 35 The slave does not continue in the house for ever; the son continues for ever. 36 So if the Son makes you free, you will be free indeed. 37 I know that you are descendants of Abraham; yet you seek to kill me, because my word finds no place in you. 38 I speak of what I have seen with my Father, and you do what you have heard from your father."

with my Father: and ye do that which ye have seen with your father.

39 They answered and said unto him, Abraham, is our father. Jesus saith unto them, If ye were Abraham's children, ye would do the works of Abraham.

40 But now ye seek to kill me, a man that hath told you the truth, which I have heard of God: this did not Abraham.

41 Ye do the deeds of your father. Then said they to him, We be not born of fornication; we have one Father, *even* God.

42 Jesus said unto them, If God were your Father, ye would love me: for I proceeded forth and came from God; neither came I of myself, but he sent me.

43 Why do ye not understand my speech? *even* because ye cannot hear my word.

44 Ye are of *your* father the devil, and the lusts of your father ye will do. He was a murderer from the beginning, and abode not in the truth, because there is no truth in him. When he speaketh a lie, he speaketh of his own: for he is a liar, and the father of it.

45 And because I tell *you* the truth, ye believe me not.

46 Which of you convinceth me of sin? And if I say the truth, why do ye not believe me?

47 He that is of God heareth God's words: ye therefore hear *them* not, because ye are not of God.

39 They answered him, "Abraham is our father." Jesus said to them, "If you were Abraham's children, you would do what Abraham did, 40 but now you seek to kill me, a man who has told you the truth which I heard from God; this is not what Abraham did. 41 You do what your father did." They said to him, "We were not born of fornication; we have one Father, even God." 42 Jesus said to them, "If God were your Father, you would love me, for I proceeded and came forth from God; I came not of my own accord, but he sent me. 43 Why do you not understand what I say? It is because you cannot bear to hear my word. 44 You are of your father the devil, and your will is to do your father's desires. He was a murderer from the beginning, and has nothing to do with the truth, because there is no truth in him. When he lies, he speaks according to his own nature, for he is a liar and the father of lies. 45 But, because I tell the truth, you do not believe me. 46 Which of you convicts me of sin? If I tell the truth, why do you not believe me? 47 He who is of God hears the words of God; the reason why you do not hear them is that you are not of God."

Key Verse: **Ye shall know the truth, and the truth shall make you free. (John 8:32)**

Key Verse: **You will know the truth, and the truth will make you free. (John 8:32)**

The Scripture and the Main Question—Pat McGeachy

The Daring Assertion (John 8:12-20)

The only person I ever knew who claimed to be God was a patient in a mental hospital. What would happen to you, do you think, if you made such a claim? The only reason they didn't arrest Jesus that day at the temple treasury (verse 20) was that his hour had not yet come. For Jesus made the

audacious assertion, "If you knew me, you would know my Father also." Seen from the point of view of the religious establishment, this is blasphemy; it sounds like he is making himself equal to God. But try turning it around. He is also saying, "I have no authority of my own." In that sense the audacious assertion is really a humble statement.

Suppose you should say, "I am here to do God's work in the world." Does that mean that you think you are really God in disguise, or that God has no hands but your hands? Or does it mean, on the other hand, that you intend to be obedient, not to your own personal desires but to a higher calling. Arrogance is always the back side of humility. What *is* your purpose in life, and how do you decide it? C. S. Lewis once described a man who said on his death bed, "I now see that I spent most of my life in doing *neither* what I ought *nor* what I liked" (*The Screwtape Letters* [N.Y.: Macmillan, 1948], p. 64). If you were a perfect person, those two things would be exactly the same. So Jesus said, "My food is to do the will of him who sent me" (John 4:34).

A truly humble person may not be at all quiet and passive (that is not what "meek" means). If I am truly humble I do not spend any time thinking about myself and wondering what other people are thinking of me. Instead, set free from the burden of covering my own exits, I am at liberty to do whatever I choose. And for one who loves God, there can be no greater joy than doing what God wants done. This in no way means that my freedom under God is undisciplined, any more than a great running back in football is free from the rules of the game. Rather, it means that the game and its rules are a source of rejoicing, not grumbling, and that discipline itself is a joy.

The Freeing Truth (8:21-31)

In this passage Jesus makes it clear that even his death will be in obedience to the Father. "When you have lifted up the Son of man" (verse 28) means "When you have crucified me." And that death will reveal to all the world how much God loves us, and how Jesus had been totally and completely obedient to a will greater than his own. Then Jesus tells those who have begun to understand what he is saying (verse 31) that their own obedience unto death will give them freedom.

But (verse 33), they *do not know that they are not free*! It is a subtle trick of false gods that when we are enslaved to them they give us the illusion of freedom. So at first, at any rate, alcohol makes us think that we have been liberated, and so do all other secondary forms of commitment. And what was the slavery of these children of Abraham? It was pride in their inheritance and in the illusion that they were keeping the law.

Unfortunately, if you are honest at all (see Romans 7:14-20) you know that the keeping of the law is an illusion. Even if by the most wonderful religious sweat and toil you were able to keep every "jot and tittle" (dotting of i's and crossing of t's) of the law, you would still be trapped by the monster god that lurks behind all righteousness: Pride. The most subtle of all the false gods, Pride fools me into believing not in God but in myself. "I am a child of Abraham," I announce proudly. Or in contemporary terms, "I've been a good Methodist all my life, with Sunday school attendance pins that hang down to my belt." Or, "My family has lived here in Central City since before the Revolution; surely I am a free citizen."

What makes Pride such a subtle deity is that of all the gods it is the best.

Pride is the virtue that makes law-abiding citizens; that makes me clean up my room, do my homework, succeed in business, behave myself. And the better I behave the harder it becomes for me to admit that I am a sinner. Instead I pray, "Thank God that I am not like those others" (Luke 18:11). I believe that I am utterly free, when in fact I am a slave to self.

The Great I AM (8:34-59)

Jesus' critics believe that they are the children of Abraham, but really they are the children of the devil (verse 44). It is an insult to tell them this because they really are, by the world's standards, the best people on earth. But God calls for a higher righteousness, a circumcision of the heart (Romans 2:29). The true child of Abraham is thus not the one who follows the ritual but the one whose utter loyalty is to the God who made the rules. And who is that? Incredibly, it is Jesus, who claims, "Before Abraham was, I am" (verse 58). At this point the Jews are about to kill Jesus because he has come very close to pronouncing the unspeakable name. The strange shift of tense, from "was" to "am," is a reflection of Exodus 3:14-15, where God answers Moses' question, "What is your name?" God said, "I AM WHO I AM. . . . Say this to the people . . . 'The Lord . . . has sent . . . you.' " Notice in your Bible that whenever the word "Lord" is spelled with four capital letters, it stands for the Hebrew word YHWH (or sometimes JHVH), which means "He Is." To this day a pious Jew praying in Hebrew, coming to the word YHWH, will say instead, "Adonai," which is the Hebrew word for Lord, for fear of violating the solemn commandment against taking God's name in vain. So when Jesus said, "I am," he was treading very close to sacred ground for his hearers.

And Jesus does tread on sacred ground. His great gift to us is his willingness to make friends with the distant, holy YHWH, to touch the untouchable mountain (Exodus 19:12-13 and Hebrews 12:18-24), to look into the face of eternity (Psalm 90) and call it Father. Jesus has taught us that God, the righteous God of Mount Sinai on whom no one can look and live, loves us with an everlasting love and wants to have us in holy communion with the Divine Self. It *is* blasphemous! But it is also the best and holiest step ever taken.

We have said that the back side of humility is arrogance. So the back side of arrogance is humility. When Jesus says, "I and the Father are one" (John 10:30), he is telling us that he has submerged his own will into the will of God. Is it possible for you and me to make such an arrogant/humble statement? The apostle Paul once said (Philippians 1:21), "For me to live is Christ." Perhaps it is dangerous for a brand new Christian, flushed with the first joys of discovering God's grace, to speak as though God were speaking. And maybe even more so for one who has spent many years trying to live as God would have us. And yet I have known one or two saints, persons who have spent a lifetime immersed in the life of faith, who have begun to develop God-like characters, so that when they speak you could almost believe that God is speaking.

And what is the difference between those persons' confident faith and the false confidence of those who claimed to Jesus that they were the children of Abraham? I don't know. That is why we believe that salvation is through faith, not works. That is why we must be very careful not to "play God" with other people's lives or assume that we can change the rules to suit ourselves.

But at the same time, following the example of our Lord, it is possible when we are at our spiritual best (most humble) to feel that we are close to the heart of God. God IS who God IS, and when I am who I am, or who I ought to have been all along, then I am, like God, truly free. At those times, I am not like the hermit crab, searching for a shell to hide in; I am like the chambered nautilus, building more stately mansions until Christ sets me free indeed.

Helping Adults Become Involved—Douglas E. Wingeier

Preparing to Teach

Pray for class members by name, asking God to nurture their faith, strengthen them for any struggles they are facing, and give them an open mind and a readiness to risk sharing their thoughts in discussion.

Study John 8:12-59, the treatment of it in *The Interpreter's Bible* or Barclay's commentary on John, and the article entitled "Truth" in *Harper's Bible Dictionary*. Complete your list of the six "I ams." Type "I represent Jesus" on enough calling cards to give one to each class member.

Your aim is to assist persons to compare the sources of their identities with those of Jesus, and to ground their identities in a relationship with God and the faith community. Use this outline:

> I. To know Jesus is to know God.
> A. Jesus represents God.
> B. We represent Jesus.
> II. The truth will make you free.
> A. Jesus' death reveals his truth.
> B. True discipleship means freedom.
> III. Jesus knew his origins.
> A. "I am a child of Abraham."
> B. "I am a child of God."
> C. "I AM WHO I AM."

Introducing the Main Question

Divide the class into groups of three and have them discuss these multiple-choice questions, explaining their answers. Write the choices on the board as you read them.

1. Which would you least like to be: a boss, a servant, unemployed?
2. Which would you be most likely to respond to: do what you're told; do what you please; do what's right?
3. Which would you most like to have: certainty, freedom, security?
4. Which has contributed most to shaping your identity: your parents, your education, your faith?
5. Which do you best represent: your family, your alma mater, your firm, your church?

Reassemble the group and ask for observations on this exercise. Where do they place their trust? How much do they value freedom? What is most central to their identity? Present the ideas in Pat McGeachy's "The Main

Question." Emphasize that Jesus was a free person who knew who and whose he was and who died to help us be like him.

Developing the Lesson

I. To know Jesus is to know God.

Ask class members to share their responses to question four about influences shaping our identities. Which have been most important to their development? Are there others beyond this list? Are there some they should seek out?

A. Jesus represents God.

Now discuss John 8, another discourse between Jesus and the Pharisees, which begins with a declaration that he is the light of the world. The Pharisees contest this claim, and Jesus responds with the startling assertion that he *represents God* on earth. If they know Jesus, they will know God also (verse 19). The strongest influence shaping Jesus' identity was his relationship with God.

B. We represent Jesus.

Ask for responses to question 5—who we best represent. Explore how we represent these groups—by words, behavior, dress, associations, calling cards, and so forth. Would these groups be proud of the way we represent them? Are there other agencies that we would rather represent? How does our awareness of who we are representing affect the way we come across?

Just as Jesus represents God, so we *represent Jesus*. We usually identify ourselves and others in terms of what we do for a living. What would it be like to hand someone a calling card identifying yourself as representing Jesus? Can it be said of you as it was of him that those who have seen you have seen God?

II. The truth will make you free.

Discuss members' responses to questions two and three on their views of freedom. What do their choices indicate about their understanding of freedom? Present Jesus' view of freedom from verses 21-33. Draw on ideas from Dr. Decker's "As You Read the Scripture" and the section "The Freeing Truth" in "The Scripture and the Main Question."

A. Jesus' death reveals his truth.

It is only when Jesus is lifted up on the cross that we know him as Savior and Lord (verse 28). It is his suffering love that finally authenticates his ministry and teachings. It is this truth—that God loves us enough to send the Son to die for us (John 3:16)—that truly frees us. What we are freed from by this truth is the fear of death—the fear that keeps us from living the way we know God wants us to. Compare this understanding of Christian freedom with the views on freedom expressed by the group thus far.

B. True discipleship means freedom.

Verses 31-32 make clear that the truth that makes us free is based on a life of discipleship rooted in Jesus' word. Only if we observe Jesus' teachings can we claim to be genuine disciples, and only as his disciples can we gain true freedom.

With reference to question two and the section on "The Freeing Truth," explain the differences between individual freedom (do your own thing), political freedom (absence of coercion), the illusion of freedom (slavery to false gods like alcohol and pride), and Christian freedom (joyful discipleship).

Looking at class members' responses to question one, comment on the differences between being unemployed (nothing to do), being a boss (telling others what to do), and being a servant (freely choosing to obey the Master).

III. Jesus knew his origins.

Discuss the "I am . . ." statements. Ask: Are your statements primarily adjectives (shy, industrious, stubborn), nouns (a mother, a Christian, a farmer), or verb forms (outgoing, forgiving, exciting)? What do they say about the kind of person you are? Now look at how Jesus identified himself in verses 34-59.

A. "I am a child of Abraham."

Jesus identified himself with his people through Abraham, as did the Pharisees (verses 39-41). He claimed the tradition from which he came and shared the faith of his people. Ask the group if their "I am . . ." statements reflect this kind of firm belonging to a people—whether family, ethnic group, or faith community.

B. "I am a child of God."

The Pharisees accused Jesus of being a Samaritan and having a demon, but he retorts that he comes from God and that it is they who are liars and children of the devil (verses 42-55). His identity is grounded in his relationship with God. Ask members if their identity statements reflect this source.

C. "I AM WHO I AM."

In an obvious allusion to Exodus 3:14, where Moses at the burning bush encountered a God who said, "I AM WHO I AM," Jesus nearly provokes a stoning by boldly claiming that he is who he is in his own right (verses 56-59). Because he existed before Abraham he must be the Son of God, the Messiah. This is blasphemy to the Pharisees, and they cannot tolerate it. Present ideas from "The Great I AM" section in Pat McGeachy's "The Scripture and the Main Question" to further interpret this statement. Ask members whether their faith gives them the self-confidence to stand for their convictions in the face of strong opposition, as Jesus did.

Helping Class Members Act

Hand out the "I represent Jesus" calling cards. Ask members to write their names on the backs, and to think of a person or situation to which they could present this card during the coming week. Close by singing "Take up Thy Cross" and offering a prayer asking God to give us confidence in our identity and freedom to represent Christ boldly this week.

Planning for Next Sunday

Assign all to read John 9. Call for three volunteers to tell the story of the healing of the blind man from the perspective of the man himself, of his parents, and of the Pharisees. Finally, ask members as they read and view the news during the week to make a list of signs of light and darkness revealed in these events.

Following the Light

Background Scripture: John 9

The Main Question—Pat McGeachy

Whenever a newsworthy event takes place, the question of blame seems to jump to the foreground. "Who's at fault?" the press inquires. "What did the higher-ups know? Who's covering up?" It appears that if we can place the blame we can then forget about it, as though it were all settled. And everyone looks around guiltily as if to say, "It wasn't my fault." Indeed, this tendency is so universal that once a few years back when I slipped on the ice and fell head over teakettle, before I had even examined myself for injuries I sprang to my feet and, looking around to see if anybody had observed my awkward behavior, said aloud to nobody in particular, "I didn't do that on purpose."

Well, of course not. Nobody does anything foolish on purpose. I'm sure the prodigal (Luke 15:11-24) didn't set out to waste his money on riotous living; he probably thought he was "discovering the real meaning of life" or something like that. But calamity befalls us like a famine (Luke 15:14), and if we want to we can lay blame all about us, but there is really only one way to go, and that is home. In our lesson for today, when Jesus met the blind man the question was not, Who has sinned? but, Where is the light? And that is the main question for you and me. We can waste our energy blaming the blind man or his parents or God (verse 2). Or we can criticize the way Jesus kept the Sabbath (verse 16). Or we can accuse everybody except ourselves of ignorance (verse 34). But when all the blaming has been done, the plain fact remains, as the blind man saw with amazing grace: "I once was lost but now am found,/Was blind, but now I see." Jesus, the light of the world, turns his bright radiance on us all, and we see that there is none righteous, no, not one. And by that same light the way out is illuminated. The question is, Will we open our eyes, both to bear its brightness and to behold its promise?

As You Read the Scripture—Ralph W. Decker

John 9 develops a theme that has already appeared several times in this Gospel, namely, that Jesus is the light of the world (1:9; 8:1). It is closely tied with chapter 8, since it continues the discussion of Jesus' work of freeing persons from bondage. The passage begins with a miracle that is soon called a sign (9:16). It moves through controversy over a physical event to a statement of spiritual truth. The chapter offers the lesson that Jesus frees persons from spiritual darkness.

John 9:1. No indication is given as to time or place. It may be assumed that this event, like those immediately preceding, took place in Jerusalem during a festival observance. It is a characteristic of this Gospel that when a miracle is reported it involves an affliction of long standing. (Compare the man at the pool who had been ill thirty-eight years with Lazarus who had been dead four days—5:5; 11:17.)

Verse 2. The disciples' question reflects two concerns: (1) the widely held

belief that all suffering is punishment for sin and (2) the debate then taking place as to the relation of sin to birth defects. If all affliction is a result of sin, then a birth defect must be the result of a sin committed before the birth of the afflicted. While popular opinion placed the blame on the parents, some rabbis taught that a soul might sin before it entered a human child. The wording of the question indicates that the disciples may have shared those beliefs.

Verse 3. Jesus' reply shows that he did not share either. He described the man's blindness, whatever its cause, as an opportunity for him to demonstrate the compassion and goodness of God.

Verse 4. The pronoun "we" indicates that Jesus included his followers, who were to continue God's work after his death and resurrection.

Verse 5. The proclamation here is another "I am" passage. It is the theme of this section of the Gospel.

Verse 6. John gives more detail than usual about the actual procedure in the healing. Saliva has often been regarded as having healing properties. Mixed with dust, it was made into a salve that was applied to the eyes or other parts of the body. Jesus used spittle without dust in healing a blind man at Bethsaida, according to Mark (8:22-26).

Verse 7. John calls attention to a play on words in Jesus instructions. Perhaps he saw the name of the pool as symbolic of Jesus, whom he frequently calls the one who was sent (8:16, 18, 29, 42; 9:4). Healing comes through Siloam, the "sent" pool, and through Jesus, the sent Son.

Verses 8-11. Curiosity opens the way for the man's witness to Jesus, but only as "a man named Jesus."

Verses 13-14. Under examination he raises his witness to "a prophet" (verse 17). Under further examination he calls Jesus "a man from God." This is too much for the authorities. They excommunicate him.

Verses 35-39. The chapter closes with the concept of judgment that runs through the Gospel: The choices and decisions one makes determine one's fate.

Verse 35. Jesus' question concerned belief in the Messiah.

Verse 36. The man asks for a personal experience—a messiah he can see.

Verse 37. Jesus reveals himself as he did to the woman at the well (4:26).

Verse 39. Jesus' presence and message compel persons to make choices, and choices become judgments. The blind man chose light and was freed to live in the light. The Pharisees rejected the light and condemned themselves to live in darkness.

Verses 40-41. Some of the Pharisees saw the trend of Jesus' words and asked Jesus if he considered them blind. He answered that rejection of truth is the worst kind of spiritual blindness.

Selected Scripture

King James Version	Revised Standard Version
John 9:1-11, 35-41	*John 9:1-11, 35-41*
1 And as *Jesus* passed by, he saw a man which was blind from *his* birth.	1 As he passed by, he saw a man blind from his birth. 2 And his
2 And his disciples asked him, saying, Master, who did sin, this	disciples asked him, "Rabbi, who sinned, this man or his parents, that

man, or his parents, that he was born blind?

3 Jesus answered, Neither hath this man sinned, nor his parents: but that the works of God should be made manifest in him.

4 I must work the works of him that sent me, while it is day: the night cometh, when no man can work.

5 As long as I am in the world, I am the light of the world.

6 When he had thus spoken, he spat on the ground, and made clay of the spittle, and he anointed the eyes of the blind man with the clay.

7 And said unto him, Go, wash in the pool of Siloam, (which is by interpretation, Sent.) He went his way therefore, and washed, and came seeing.

8 The neighbours therefore, and they which before had seen him that he was blind, said, Is not this he that sat and begged?

9 Some said, This is he: others *said*, He is like him: *but* he said, I am *he*.

10 Therefore said they unto him, How were thine eyes opened?

11 He answered and said, A man that is called Jesus made clay, and anointed mine eyes, and said unto me, Go to the pool of Siloam, and wash: and I went and washed, and I received sight.

...

35 Jesus heard that they had cast him out; and when he had found him, he said unto him, Dost thou believe on the Son of God?

36 He answered and said, Who is he, Lord, that I might believe on him?

37 And Jesus said unto him, Thou hast both seen him, and it is he that talketh with thee.

38 And he said, Lord, I believe. And he worshipped him.

39 And Jesus said, For judgment I am come into this world, that they

he was born blind?" 3 Jesus answered, "It was not that this man sinned, or his parents, but that the works of God might be made manifest in him. 4 We must work the works of him who sent me, while it is day; night comes, when no one can work. 5 As long as I am in the world, I am the light of the world." 6 As he said this, he spat on the ground and made clay of the spittle and anointed the man's eyes with the clay, 7 saying to him, "Go, wash in the pool of Siloam" (which means Sent). So he went and washed and came back seeing. 8 The neighbors and those who had seen him before as a beggar, said, "Is not this the man who used to sit and beg?" 9 Some said, "It is he"; others said, "No, but he is like him." He said, "I am the man." 10 They said to him, "Then how were your eyes opened?" 11 He answered, "The man called Jesus made clay and anointed my eyes and said to me, 'Go to Siloam and wash'; so I went and washed and received my sight."

...

35 Jesus heard that they had cast him out, and having found him he said, "Do you believe in the Son of man?" 36 He answered, "And who is he, sir, that I may believe in him?" 37 Jesus said to him, "You have seen him, and it is he who speaks to you." 38 He said, "Lord, I believe"; and he worshiped him. 39 Jesus said, "For judgment I came into this world, that those who do not see may see, and that those who see may become blind." 40 Some of the Pharisees near him heard this, and they said to

which see not might see; and that they which see might be made blind.

40 And *some* of the Pharisees which were with him heard these words, and said unto him, Are we blind also?

41 Jesus said unto them, If ye were blind, ye should have no sin: but now ye say, We see; therefore your sin remaineth.

him, "Are we also blind?" 41 Jesus said to them, "If you were blind, you would have no guilt; but now that you say, 'We see,' your guilt remains."

Key Verse: **I am the light of the world. (John 9:5)**

Key Verse: **I am the light of the world. (John 9:5)**

The Scripture and the Main Question—Pat McGeachy

Who's to Blame (John 9:1-12)

Most diseases, even simple ones like the common cold, cause us to ask, "What have I done to deserve this?" Some of them, like certain sexually transmitted diseases, have ready answers. Other like congenital blindness are not so easy to explain. (Job agonized over the question for 42 chapters.) It is clear from Scripture that some illness comes as the consequence of sin (John 5:14), but not all. God sends rain and sunshine on both the good and the evil (Matthew 5:45). And some things appear to be just plain unfair. (Read what Jesus said about those whom Pilate killed and those on whom the tower of Siloam fell, in Luke 13:1-5. That tower, by the way, must have been very near the pool mentioned in this story.)

In fact, laying blame is a waste of time. The question is not, Who done it? but, What is to be done? In the case of this story it almost seems that the poor man had been waiting in his blindness all of these years so that God's power could be made known (verse 3), and perhaps so that the man himself might ultimately be led to faith. "Why?" may sometimes be a useful question, but it is better to get on with the main question: How shall the blind see?

It is interesting that we have here one case in which Jesus used a form of medication to heal the man's eyes. I wouldn't make too much of it, but there have been actual cases of people, blind from birth because of non-functioning tear ducts, who have had their sight given to them by the transplanting of salivary glands into the corner of the eye. (Believe it or not, one who has had such an operation tends to cry a lot when sitting down to eat because the saliva is conditioned to run at meal times!) At any rate, saliva is very much like tears, and Jesus did use it in making the clay poultice for this man's eyes. He then sent him to the aqueduct of Siloam, which means in Hebrew "where the waters are sent." The pool stands at the lower end of the tunnel of Hezekiah, an underground aqueduct that is still in use today.

Good Out of Evil? (9:13-17)

The simple blind man could see clearly that which the Pharisees could not: that one who does good must be good. Once when the scribes accused Jesus of being of the devil because he cast out a demon, Jesus accused them of committing an unforgivable sin, because they called a good an evil (Mark

195

3:20-30). The unforgivable sin is thus the sin that will not be confessed because the sinner is convinced of his own righteousness. Not even God can forgive one who will not repent.

But the blind man, ignorant of theology, saw the point at once. I have been told that often when blind children are taught to draw in perspective (such as a picture of a road receding in the distance, which looks very much like an isosceles triangle) that they first say, "But it doesn't come together like that, does it?" "No," the teacher will reply, "but if you could see, you would see that it *looks* as though it did." After much practice at such drawing, the concept of the vanishing point dawns on the child, who quite often says, just as you and I might, "Oh! Now I see!"

It is also reported by some that when blind persons first have their sight restored they cannot at first identify what they see because they are not accustomed to picturing shapes. Things must look much like a mass of meaningless color to them. One man whose sight Jesus restored saw "men as walking trees" (Mark 8:24). But whether this newly sighted man could see people and things clearly or not, he could certainly see the truth!

Deliberate Blindness (9:18-34)

The argument went on for some time, with the formerly blind man growing in faith and stubbornly sticking to his guns. The authorities at first decided that he must not really have been blind (verse 18). His parents hedged on the question for fear of them (verse 22). And they insisted that Jesus must have been a sinner (verse 25). Only the man himself, full of his restored sight, clearly saw the truth and marveled at their stupidity (verse 30).

When one has decided in advance what to believe, sometimes no evidence can convince. I remember reading in my college psychology book about a mental patient who believed that he was dead. The attending physician used all sorts of arguments to get him to admit that he was really alive, but he remained unconvinced. Finally the doctor asked him, "Do dead people bleed?" "Of course not," said the patient. So the doctor took a bodkin and pricked the man's arm; blood spurted forth. But the patient only shook his head and said, "How about that! Dead people *do* bleed!"

I suspect you have known some folks who have refused to face the truth, in spite of all the evidence shown them. You probably won't admit it (I wouldn't either, because by my own argument I couldn't), but I suspect that you too have your blind spots. There are parents who are cruel to their children but do not know they are brutal. There are drunkards who do not know they have a problem with alcohol. And there are plenty of highly opinionated people who have no idea how prejudiced they are. For some of them it may take a very blinding light to force them to see the truth. (Check again the story of Paul's conversion in Acts 9:1-22.) And sad to say, there are some of us, so stubborn in our sin, who will never admit the truth, so that we remain in our guilt (verse 41).

The Light of the World (8:12; 9:5, 35-41)

Perhaps the real reason for this man's blindness is contained in verse 38. All his life he had remained in darkness, but that darkness, as it sometimes forces blind people to sharpen their other senses, turned him into a man

who stubbornly persisted in seeing the truth. Confronted with the light, he was converted.

It doesn't always work this way. Sometimes, for some, the light is too much. Look at the last chapter in the Old Testament, Malachi 4:1-2. There we learn that when Messiah comes it will be as a bright day, burning like an oven, which will burn up all the evildoers. "But," says the Lord, "for you who fear my name the sun of righteousness shall rise, with healing" (Malachi 4:2). The same light that blinds some gives sight to others.

What is the difference? Again, as in the question of who to blame, it is not easy to answer. But I wonder if it does not have something to do with whether we really *want* the light. There are some creatures who, when their stump is turned over, go scurrying away from the fearful blaze. But others, like moths, are attracted to the flame. The way to salvation is to look for, long for, search for the light. You may remember how in Bunyan's *The Pilgrim's Progress,* Evangelist began the conversion of Christian by saying to him, "Do you see yonder wicket gate?" "No," said the other. "Then, do you see that distant shining light?" "I think so," said Christian. "Then walk toward it," said Evangelist, "and you will come to the gate through which you must enter."

In the little letter of I John we are told that "God is light and in him is no darkness at all. If we say we have fellowship with him while we walk in darkness, we lie and do not live according to the truth; but if we walk in the light, as he is in the light, we have fellowship with one another, and the blood of Jesus his Son cleanses us from all sin" (1:5-7). There is darkness in each of us, to be sure, but the promise is that if we go like moths to that eternal flame, it will not destroy us. It may hurt; but like a refiner's fire it will purify (Malachi 3:2-3). There can be nothing between us and God but utter honesty. If we lie to God, like the Pharisees who only pretended to see, we remain in our guilt. But whoever truly seeks the light will find it (Matthew 7:8), and then, by the miracle of God, they can be the light of the world (Matthew 5:15).

Helping Adults Become Involved—Douglas E. Wingeier

Preparing to Teach

Pray for members during the week as they try to represent Jesus faithfully. Ask for guidance in planning a lesson that will nurture their growth in faith and discipleship.

Study the story in John 9 and commentaries on it. The articles entitled "Blindness," "Light," "Pharisees," and "Siloam" in *Harper's Bible Dictionary* give helpful information. Bring Sunday's newspaper to class.

The aim is to help members learn the effect of the transformation from blindness to sight in terms of growing appreciation for Jesus, overcoming prejudice, discerning signs of light from signs of darkness, and becoming lights in the world.

Organize the session as follows:

 I. The blind man saw the light (1).
 A. He did not deserve it.
 B. He received his sight.

II. The blind man saw the light (2).
 A. He called Jesus a man.
 B. He called Jesus a prophet.
 C. He called Jesus "from God."
 D. He called Jesus "Lord."
III. The real blind were the Pharisees.
 A. They had prejudged the situation.
 B. This is prejudice.
IV. Jesus is the light of the world.
 A. The light reveals who sees and who is blind.
 B. We can see the light.

Introducing the Main Question

We humans tend to place blame. Rather than just accepting events, taking responsibility ourselves, or acting to change a situation, we look for a scapegoat. Develop this idea with thoughts from Pat McGeachy's "The Main Question." Ask members for examples from their experience—arguments with a spouse, covering one's tracks with a boss, giving lame excuses to a police officer, or explaining a mistake.

Developing the Lesson

I. The blind man saw the light (1).
A. He did not deserve it.
This leads into today's story. When the disciples tried to assign blame for the man's blindness, Jesus replied that blame was not the issue. In Pat McGeachy's words, the question is not, Who done it? but, What is to be done? Jesus explained that he did not deserve it, nor did his parents' sin cause it, and then went right to the task of healing the man.
B. He received his sight.
Ask the member who read the story from the blind man's viewpoint to tell how he received his sight. Add background from Ralph Decker's "As You Read the Scripture" and other reading on the first-century view of the relation of sin to birth defects, the pool of Siloam, and the use of spittle.

II. The blind man saw the light (2).
A. He called Jesus a man.
Not only did the man recover his sight, but he also grew in his appreciation for Jesus. When he first described the healing to his neighbors, he called Jesus a man (verse 11).
B. He called Jesus a prophet.
When the Pharisees challenged the validity of his cure, he called him a prophet (verse 17).
C. He called Jesus "from God."
After seeing how his parents tried to avoid controversy out of fear of the authorities (here ask a member to tell the story from the parents' perspective, in verses 18-23), he was emboldened to identify the one who had healed him as being "from God" (verse 33).
D. He called Jesus "Lord."
Finally, after he had been excommunicated for sticking to his story, he fell down and worshiped him, saying, "Lord, I believe" (verse 38). The more

significant miracle was the insight gained and the commitment made to the Lord of all life!

III. The real blind were the Pharisees.
A. They had prejudged the situation.
Ask the same class member to tell the story from the standpoint of the Pharisees. From your background reading explain that the Pharisees were schooled in the law and deeply offended by Jesus' breaking the sabbath in this and other healings. From their perspective no one who violated the Holy Law could possibly be godly, let alone the Messiah. They had prejudged the situation from their theological viewpoint, and so were blinded to new revelation.
B. This is prejudice.
Deciding how to interpret and react to a situation on the basis of presuppositions and without considering all the evidence is the nature of prejudice. Ask the class for examples of prejudice in current situations, such as disliking people who are different from us, assuming our way is best, refusing to accept new interpretations, or being unwilling to cooperate with new people in fresh ventures.

Ask members to share their lists of the signs of light and darkness in the week's news. Pass out sections of the Sunday paper so they can add to the lists from today's events. Write up the signs in two columns on the board. Point out that whether we view these as light or darkness depend on our points of view. Because no one sees the whole picture, we all have a bias. The important thing is which bias we choose. To look at life through Jesus' eyes is to have a bias toward the signs of light—seeing the presence of God in events that lead to the healing, well-being, and liberation of all people.

IV. Jesus is the light of the world.
The healing provides occasion for "the works of God to be made manifest" and for Jesus to be recognized by those with eyes to see (see Matthew 13:16) as the Son of God, the light of the world. Identify which signs on the board make manifest the works of God and reveal Jesus as the light of the world. Ask about each: How is Jesus present and active? How might we cooperate with him to overcome darkness and bring light? How can we work for healing in these situations?
A. The light reveals who sees and who is blind.
One way Jesus is present is in revealing who sees and who is blind. Identify who sees and who is blind in the news stories on the board. How does the light of Jesus help us discern this? What does this suggest about the attitudes and actions we should take in these situations?
B. We can see the light.
Use the examples of *Pilgrim's Progress* and the gypsy moth from the section "The Light of the World" in "The Scripture and the Main Question" to emphasize that we can see the light. The blind man not only recovered his sight but also discovered that he who had healed him was the Messiah and Lord of his life. We also must open our eyes and let in the light of Christ. We can let him heal our blindness, expose our sin, correct our prejudices, convert our souls, and illumine our path into the future.

Helping Class Members Act

Have someone read I John 1:5-7. Emphasize that walking in the light of Christ overcomes the darkness, enables us to have fellowship with one

another, and makes it possible for us to be cleansed of sin. Ask someone else to read Matthew 7:8, which promises that those who seek the light will find it. Have another read Matthew 5:15, which challenges us to be lights in the world.

Ask the class to study the list of signs of light and darkness and decide on one issue they want to tackle as a group. Put a small committee in charge of planning a project or strategy for attacking that problem, and ask them to report next Sunday. Possibilities include contributing food to a soup kitchen, staffing a homeless shelter, sponsoring a refugee, writing letters to Congress about South Africa or Central America, or starting a nuclear freeze campaign.

Close by singing either "I Am the Light of the World" or "Walk in the Light!" followed by a prayer asking God to make us open to receive the light of Christ and willing to be a light to others.

Planning for Next Sunday

Assign members to read John 12. Ask for volunteers to read and report on Mark 12:41-44 (the poor widow); Mark 10:17-22 (the rich young ruler); Mark 14:3-9 (the anointing of Jesus); Mark 11:1-11 (Palm Sunday); and Mark 14:32-52 (the Garden of Gethsemane). For the latter three, ask them to note the differences between the accounts in Mark and in John.

UNIT III: JESUS PREPARES HIS FOLLOWERS
Horace R. Weaver

FOUR LESSONS **FEBRUARY 4–25**

In Unit III, "Jesus Prepares His Followers," we study the arrival of Jesus' fateful hour (John 12:23) and Jesus' instructions to his disciples in anticipation of his leaving them. This unit builds directly on the foundations laid in the preceding two units.

The four lessons for Unit III have the following emphases: "Choosing the Light," February 4, challenges us with the question of our commitment to the Light (Jesus): Will we head for it, learn to love it, and walk in it? "Choosing to Serve," February 11, challenges us to grasp, adopt, and live out the role of "the suffering servant" in our own lives. "Choosing the Way," February 18, illustrates the "way" Jesus calls us to follow him, namely, his teaching, lifestyle, and promises. "Empowered by the Spirit," February 25, offers keen insights into the meaning and purposes of the Holy Spirit.

Choosing the Light

Background Scripture: John 12

The Main Question—Pat McGeachy

This lesson properly follows the one for last week, in which Jesus proclaimed himself the light of the world. Now we have to do with the question of our own commitment. It is not enough for the light to be shining; we must, like Bunyan's Christian, head for it, learn to love it, and walk in it (I John 1:7).

In John 12 we encounter many people who make this choice, some for and some against the light. Some deliberately choose blindness; others offer themselves unreservedly in commitment to Christ. In the same chapter we encounter Jesus himself, praying deeply and intensely as he sorts out the shape of his own ministry and commits himself without reserve to following the light that God has given him.

You who read these words may be one who has never made such a choice. Or you may be one who feels that you have already made it, long ago. In either case it is important for you to consider your calling. Paul said in II Corinthians 6:2, "Behold, now is the acceptable time . . . now is the day of salvation." Each of us, in every moment, should re-commit ourselves. Each day we should remember Joshua's call (Joshua 24:15), "Choose this day whom you will serve."

In one sense every Bible lesson we study is a renewed call to commitment. Every sermon we hear is an "evangelistic" sermon, announcing the good news to that portion of each one of us that still has not fully believed. From the wasteful Mary with her jar of expensive ointment to the searching Greeks who demanded to see Jesus, we are given examples of those who sought to renew their faith. But it must be genuine; we must not be like the Palm Sunday crowd who shouted "Hosanna!" that day and four days later cried, "Crucify him!" Now, in this moment, in studying the twelfth chapter of John, we have a fresh opportunity to choose the light. Will we?

As You Read the Scripture—Ralph W. Decker

John's twelfth chapter reports events of the week preceding the Crucifixion. It starts with the anointing of Jesus at Bethany and the entry into Jerusalem. Verses 20 to 36 give a brief account of the four days between the entry and the Last Supper.

John 12:20. John had closed the account of the entry with the complaint of the Pharisees that the world had gone after Jesus (12:19). He now reports an incident that shows that they were correct. Many Greeks and other Gentiles were attracted to the Jewish religion's belief in one God and strict moral codes. Some fully adopted Judaism and participated in all its rites and ceremonies. These were called proselytes. Others accepted the theology and morality of the Jews but not their rituals. These Gentiles were called God-fearers. The Greeks of this verse could have been either. They probably were full converts who had traveled to Jerusalem to participate in

the approaching Passover. The incident is reported by John only. It may have been of special interest to him since he was writing for non-Jews. It is his report of the first of many Gentiles who would follow Jesus.

Verse 21. The Greeks may have come to Philip because he had a Greek name. Both Philip and Andrew were among the twelve chosen by Jesus to be apostles. They both had Greek names and lived in Bethsaida, a Greek city outside the borders of Galilee. Both appeared earlier in this Gospel (1:43-45; 6:5-8).

Verse 22. It seems to have been characteristic of Philip to involve others. Earlier he had brought Nathanael to Jesus (1:43-46).

Verse 23. Earlier Jesus had said that his hour had not come (2:4; 7:6). Now he says that it has come. The glorification of the Son means more than the attention of a few Gentiles. As verses 27-28 indicate, it means the crucifixion and resurrection.

Verse 24. The paradox of life through death is illustrated by the mystery of the life of a grain of wheat continuing through years of wheat harvests after the grain of wheat is gone.

Verse 25. The paradox in this verse appears five times in the first three Gospels (Matthew 10:39; 16:25; Mark 8:35; Luke 9:24; 17:33).

Verse 26. Following Jesus means sharing his suffering (Mark 8:34), but it also means sharing in the honor that the Father bestows upon him.

Verses 27-36. This paragraph is John's parallel to the account of Jesus' agony in the garden of Gethsemane on the night before the crucifixion (Matthew 26:36-46; Mark 14:32-42; Luke 22:40-46). Although briefer and less vivid, it presents the same struggle within the soul of Jesus and the same outcome—the conviction that even a death upon a cross can work for the glory of God and the fulfillment of his purpose.

Verse 28. The word "name" means more than identification. "Glorify thy name" may be paraphrased "fulfill thy purpose." It is like the Gethsemane prayer, "Not my will but thine be done."

Verse 30. The voice came to convince the hearers that Jesus was the Son of God.

Verses 31-36. One of John's favorite terms is "judgment" and one of his favorite ideas is that persons execute judgment upon themselves by their choices.

Verse 31. According to popular Jewish belief, God had granted Satan temporary rule over the world.

Verses 32-33. John saw the cross not as suffering and shame but as glory. "Lifted up" has a double meaning: being raised on a cross and being exalted as Son of God.

Verse 34. Jesus' words did not fit the crowd's idea of the Messiah.

Verse 35. Jesus warned that the time for responding to him was growing short.

Verse 36. Those who trust themselves to the guidance of Jesus, the light of the world (8:12), become like him.

Selected Scripture

King James Version

John 12:20-36a

20 And there were certain Greeks among them that came up to worship at the feast:

21 The same came therefore to Philip, which was of Bethsaida of Galilee, and desired him, saying, Sir, we would see Jesus.

22 Philip cometh and telleth Andrew: and again Andrew and Philip tell Jesus.

23 And Jesus answered them, saying, The hour is come, that the Son of man should be glorified.

24 Verily, verily, I say unto you, Except a corn of wheat fall into the ground and die, it abideth alone: but if it die, it bringeth forth much fruit.

25 He that loveth his life shall lose it; and he that hateth his life in this world shall keep it unto life eternal.

26 If any man serve me, let him follow me; and where I am, there shall also my servant be: if any man serve me, him will *my* Father honour.

27 Now is my soul troubled; and what shall I say? Father, save me from this hour: but for this cause came I unto this hour.

28 Father, glorify thy name. Then came there a voice from heaven, *saying*, I have both glorified *it*, and will glorify *it* again.

29 The people therefore, that stood by, and heard *it*, said that it thundered: others said, An angel spake to him.

30 Jesus answered and said, This voice came not because of me, but for your sakes.

31 Now is the judgment of this world: now shall the prince of this world be cast out.

32 And I, if I be lifted up from the earth, will draw all *men* unto me.

Revised Standard Version

John 12:20-36a

20 Now among those who went up to worship at the feast were some Greeks. 21 So these came to Philip, who was from Bethsaida in Galilee, and said to him, "Sir, we wish to see Jesus." 22 Philip went and told Andrew; Andrew went with Philip and they told Jesus. 23 And Jesus answered them, "The hour has come for the Son of man to be glorified. 24 Truly, truly, I say to you, unless a grain of wheat falls into the earth and dies, it remains alone; but if it dies, it bears much fruit. 25 He who loves his life loses it, and he who hates his life in this world will keep it for eternal life. 26 If any one serves me, he must follow me; and where I am, there shall my servant be also; if any one serves me, the Father will honor him.

27 "Now is my soul troubled. And what shall I say, 'Father, save me from this hour'? No, for this purpose I have come to this hour. 28 Father, glorify thy name." Then a voice came from heaven, "I have glorified it, and I will glorify it again." 29 The crowd standing by heard it and said that it had thundered. Others said, "An angel has spoken to him." 30 Jesus answered, "This voice has come for your sake, not for mine. 31 Now is the judgment of this world, now shall the ruler of this world be cast out; 32 and I, when I am lifted up from the earth, will draw all men to myself." 33 He said this to show by what death he was to die. 34 The crowd answered him, "We have heard

33 This he said, signifying what death he should die.

34 The people answered him, We have heard out of the law that Christ abideth for ever; and how sayest thou, The Son of man must be lifted up? who is this Son of man?

35 Then Jesus said unto them, Yet a little while is the light with you. Walk while ye have the light, lest darkness come upon you: for he that walketh in darkness knoweth not whither he goeth.

36 While ye have light, believe in the light, that ye may be the children of light.

from the law that the Christ remains for ever. How can you say that the Son of man must be lifted up? Who is this Son of man?" 35 Jesus said to them, "The light is with you for a little longer. Walk while you have the light, lest the darkness overtake you; he who walks in the darkness does not know where he goes. 36 While you have the light, believe in the light."

Key Verse: If any man serve me, let him follow me; and where I am, there shall also my servant be: if any man serve me, him will *my* Father honour. (John 12:26)

Key Verse: If any one serves me, he must follow me; and where I am, there shall my servant be also; if any one serves me, the Father will honor him. (John 12:26)

The Scripture and the Main Question—Pat McGeachy

Holy Waste (John 12:1-8)

There is plenty of time for slogging in the trenches and doing our daily duty. The poor are always with us (verse 8), and we have our duty to them (Matthew 25:34-36). But sometimes the Christian thing to do is to give God everything we have. (Remember the little lady [Mark 12:41-44] who put into the treasury her whole living. And don't forget the rich young man [Mark 10:17-22] who was unable to give up all that he had to follow Jesus.) Judas, giving some sign here of the cynicism that drove him to betray Jesus, acted like a practical treasurer. But there are times when bookkeepers are not needed, when we need to blow the whole thing.

Would that we could capture something of Mary's enthusiasm! The closest thing I ever saw to it was the reaction of a mentally retarded young man who on the day of his confirmation let his feelings unabashedly out. Each of the other young people in his confirmation class, when their name was called, went in dignity to the chancel, as was certainly proper. But when this lad's name was announced, he leaped joyfully into the aisle, shouting at the top of his lungs, "Oh boy, oh boy! I'm joining the church!" His understanding of membership may have been faulty, but his loving heart knew more than the minds of his sedate classmates. (If I knew how to do it, I'd like to rewrite the liturgy for confirmation so that it would contain something like this: "The minister shall call the name of the confirmee, who shall then leap into the aisle, shouting, 'Oh boy! I'm joining the church!'" But I suppose you can't program that sort of thing.)

Mary's heart, too, was right, and Jesus commended her for her unabashed love.

A Death Plot (12:9-11)

Inserted between the fervent Mary and the exuberant crowds is this little aside about the plot of the authorities not only against Jesus but against Lazarus. You will have to give them credit: They too were passionate in their cause. It is not enough to choose with enthusiasm; one must choose life, not death (Deuteronomy 30:19).

A Joyful Parade (12:12-19)

It wasn't really much of a parade—only one entry: a man on a donkey. But like most spontaneous celebrations, it was a good one. To this day we cut palm branches and shout, "Hosanna!" in remembrance of the crowd's enthusiasm. Nobody could stop them from their demonstration (Luke 19:40). Even the Pharisees shrugged their shoulders in frustration (verse 19). But like Judas reacting to Mary's spikenard, they only became more angry.

As there is a place for holy waste, there is also a place for holy enthusiasm. But the fickle nature of this crowd, who soon will turn to cries of "Crucify him!" reminds us that outward cheering is often superficial. What Christ wants from us, more than our cheers, is deep commitment from the heart.

A Strange Reaction (12:20-26)

On the preacher's side of a pulpit that I know about, one that is often filled by visiting clergy, there is a brass plate that stares back at the minister with the words, "Sir, we would see Jesus." Each time I have stepped into that pulpit I have been brought up short by that challenge and made an extra effort to see that the wish is fulfilled. I have always admired those searching Gentiles who argued their way into the presence of Jesus. Andrew, with his characteristic evangelistic concern, went directly to Jesus with the news. But Jesus' response seems somewhat strange to us.

Instead of saying, as we do when strangers come to our church door, "Welcome, glad to have you!" Jesus almost seems to be saying, "Wait a minute, you don't know what you're getting into." Did he suspect them of having only a superficial interest in him? Or was he simply trying to warn them about the seriousness of the step they were about to take? At any rate, one thing is clear: We are not to come casually into the presence of Christ. He is not calling us to a pep rally but to go with him to Calvary. Before we can bloom and bear fruit, we must, like a seed, fall into the ground and die. (There is a passage very much like this in I Corinthians 15:36.) Think not that this is a popular cause you are joining. Jesus is calling you to lose your life. Of course, you will find it, eternally and forever, but do not let the enthusiastic crowds fool you. You cannot go directly to Easter; you must first pass through Good Friday. You must follow Jesus up the long lonely hill, and it won't be easy (Matthew 8:20).

Jesus' Own Struggle (12:27-36)

Most of us, on leading the way on a dangerous mission, would probably assume a kind of John Wayne look, hoping to inspire confidence in our followers. No matter how uneasy we felt inside, we would not want to show

it. But Jesus was completely open with people. He unabashedly admitted that his soul was troubled. Perhaps if we would be more open with each other, we could help each other more effectively; certainly speaking our feelings would help us to be in touch with them.

In Jesus' case the help came not from the crowds but through a voice from heaven. With the sound of thunder God answered the troubled prayer. In the other three Gospels this prayer takes place apart from the disciples, with only Peter, James, and John, and the three of them asleep. But in John's account his agony is public. And the crowd didn't like what they heard. They don't like to think of a Christ who will be crucified (verse 34); they don't even like to think of a Christ who is a Son of man, a human one. They want an unreal Christ, an invulnerable Superman, who will take all their troubles away. But Jesus promises them no such easy out; he only promises them the light that will show them the way.

Jesus Alone (12:36b-50)

And now Jesus *does* withdraw into seclusion. He has been willing to share his feelings with the crowds, but he knows that he must do his struggling all alone. As the old spiritual has it:

> Jesus walked that lonesome valley,
> had to walk it by himself.
> Nobody else could walk it for him.
> He had to walk it by himself.

John tells us that the multitudes who were left behind were troubled too. Many of them (verse 42) had by now become convinced of Jesus' Messiahship but were afraid to follow him. Well they might be. Even Peter, the Rock, will soon quail before the possibility of arrest and punishment, and all the disciples will forsake Jesus and flee. But it is especially sad that some of the religious authorities wanted to follow him and didn't have the nerve. A few of them did, of course—people like Joseph of Arimathea, who provided the tomb for his burial. But think what mighty things might have happened had a great number of the leaders become genuine converts.

Perhaps it is just as well. We know that when Constantine became a Christian and it got to be the thing to do, the early church's zeal began to diminish. But that is only speculation. We can only be very sad that they did not come and be sure that we ourselves do not fall away.

Jesus' final cry makes it clear what they have missed. He did not come to judge us (John 3:17); he came to help us. But we judge ourselves in rejecting him. God does not come to us as the petty judge in a police court, deciding to send some to prison and setting others free. No, God comes to us as the great liberating judge, who would turn all us prisoners loose from the sin that binds us. But when we refuse that offer of eternal life and remain in our sin, we judge ourselves. Why do we not choose the light?

Helping Adults Become Involved—Douglas E. Wingeier

Preparing to Teach

Think of each class member—their families, work, problems, and faith. Ask God to help you make this lesson relevant to their needs as you challenge them to deeper commitment.

Study John 12 and its exposition in the *Interpreter's Bible* and Barclay's commentary on John. Read the Mark passages and compare the details of the three events in the Mark and John accounts.

Your purpose is to help members recover a sense of what really happened in some events in Jesus' last week and discover how that relates to their lives today—specifically their commitment, generosity, attitudes toward Jesus, searching, and struggle to know life's purpose. Using the following outline will contribute to that aim:

> I. Mary anoints Jesus' feet.
> II. The crowd welcomes Jesus.
> III. Some Greeks seek Jesus.
> IV. Jesus struggles with his destiny.

Introducing the Main Question

Today's session looks at the people who came to Jesus as he entered his final week. Give a brief overview of who these people were—Mary of Bethany (who bathed his feet in costly ointment), the Palm Sunday crowd (who welcomed him with palm branches), some Greeks (who just wanted to see him), and the chief priests (who wanted to kill him). Just as they each had to choose what attitude to take toward Jesus, so do we. Today we consider our commitment to Jesus.

Developing the Lesson

Conduct this session like a television interview. Hold a "mike" in your hand as you talk with the persons who have read the Mark passages and the events in John 12.

I. Mary anoints Jesus' feet.

First, call on the person reporting on Mark 14:3-9 to tell what happened. Then ask another member for an account of John 12:1-8. Ask the class to identify the differences, and then try to explain why the two accounts vary. Suggest that human memories are always selective and that these two writers were addressing different audiences with different purposes in mind. The important thing is not agreement in detail but rather the reasons behind remembering and transmitting the story in the first place. Ask the group what they think is the reason behind this story. Suggest that it may have to do with the fact that Mary is both *enthusiastic* and *generous*.

Interview the persons who have read the stories of the poor widow (Mark 12:41-44) and the rich young ruler (Mark 10:17-22). Ask each in turn: What happened? Why did they do what they did? What was each's attitude toward things? Toward God? Then ask the same questions of the persons who reported on Mary's anointing of Jesus. Emphasize her enthusiastic tribute to a friend and her lavish generosity in spending her resources to honor him—in contrast to the frugality and lack of vision of Judas. Point out that there are times to save and times to give, and we must discern which are which. Invite members to examine their own attitudes toward possessions and use of resources in light of Mary's enthusiasm and generosity.

II. The crowd celebrates Jesus' arrival.

Now interview persons who have read the Palm Sunday accounts in Mark and John. Ask each what happened and what attitudes toward Jesus were expressed. Discuss the discrepancies and explain that eyewitnesses to such a complex event are bound to report it differently.

Point out the differences in attitude between the chief priests, who were hostile to Jesus and sought to destroy both him and his friend Lazarus; the crowd, who hailed him with hosannas but later deserted him; and the disciples, who were puzzled by all the hoopla, not understanding at first that this triumphal entry into Jerusalem was a messianic statement by their Master.

Ask the group to consider what their attitude to Jesus will be.

III. Some Greeks seek Jesus.

Share Ralph Decker's explanation of who these Greeks might have been. Highlight that Philip and Andrew, both of whom had Greek names and came from a Gentile part of Palestine, were the natural disciples to be sought by Greeks wanting an introduction to Jesus. Also point out that these disciples had a strong evangelistic impulse (see John 1:43-46).

Use the ideas in "A Strange Reaction" to explain Jesus' unexpected response. Emphasize that the attitude of curiosity is too casual; Jesus is looking for commitment, for he is facing the cross and needs followers who will "take up their cross and follow him" (Mark 8:34). Ask class members to consider why they are interested in Christ and the church. Is it casual curiosity, cautious conventionality, or clear commitment? Encourage them to continue their search to know Jesus and to deepen their commitment to him.

IV. Jesus struggles with his destiny.

Now interview persons who have read the Mark and John accounts of Jesus in the garden. Ask each to describe what happened and then to surmise how both Jesus and the disciples must have felt. Ask members to guess what they might have felt and done had they been there. Explain that the addition of a crowd and an angelic voice in the John account makes this both a more public and a more assuring experience for Jesus.

Jesus' struggle in the Garden resulted in three convictions that sustained him in his coming ordeal: (1) *He will glorify God* (verse 28). While death by crucifixion is painful and undignified, Jesus is convinced that his faithfulness unto death will bring honor, not disgrace, to the God he serves. (2) *He will draw people to him* (verse 32). People could be repulsed by a bloody crucifixion, but instead Jesus is assured that people will be attracted to him and want to follow him. (3) *He will save the world* (verse 47). Far from dying a useless death, Jesus is convinced through this time of agonizing prayer that his suffering will be redemptive.

Invite class members to reflect on (1) how their lives glorify God, (2) whether they are drawing people to Christ, and (3) how they are working with Jesus toward the redemption of the world.

Helping Class Members Act

This lesson has raised some big questions. Write them on the board so folks can take them away for further consideration: (1) Will you commit (or

recommit) your life to Jesus Christ? (2) Will you offer your resources for use in his service? (3) What attitude will you take toward Jesus—casual curiosity, cautious conventionality, or clear commitment? (4) Will you continue your quest to know Jesus more fully? (5) To what purpose will you give your life? Will you seek to glorify God, lead people to Jesus, and work for the redemption of the world?

Close by singing "Have Thine Own Way, Lord," followed by silent meditation on the five big questions.

Planning for Next Sunday

Announce that since next week's lesson is on the story of Jesus' washing the disciples' feet, the session will include a foot-washing ceremony, if the members of the class approve. Ask them to read John 13:1-30 and pray for receptive hearts as they consider the experience.

Choosing to Serve

Background Scripture: John 13:1-30

The Main Question—Pat McGeachy

Jesus, I think you will agree, was a master teacher. There has never been a more dramatic and effective audio-visual illustration than his use of the towel and the basin in the upper room. Some churches have chosen to make this a sacrament, like Baptism and the Lord's Supper. Did not Jesus clearly say, "You ought to wash one another's feet"? (verse 14). Yes, he did. And some of his followers (Lebanese Christians, Primitive Baptists, and others) continue the practice as a part of their regular worship. Why do we not?

Part of the answer is that although Jesus *did* give specific orders to his twelve apostles to wash each other's feet, there is no other mention of the practice in the Bible. Apparently it was not practiced by the New Testament church on a regular basis. Perhaps Jesus meant it as a one-time act for the twelve in the upper room.

However we decide that question, one thing is clear: The servant role so clearly depicted by the dramatic act of washing the feet of the twelve apostles *is* a universal command to the church. Jesus' own life as a servant is proof enough of this (see Matthew 20:28). He chose as the model for his own ministry the suffering servant described by the prophet Isaiah (see Isaiah 42:1-4; 49:1-6; 50:4-9; 52:13–53:12; 61:1-4). Note where these prophecies enter into the formation of Jesus' own service (see Matthew 12:18-21; Luke 4:16-21).

Most community groups offer their members honor and prestige, and their requirements for admission are that you come with good recommen-

SECOND QUARTER

dations. But the church calls its members to lowly duties, and its membership requirement is that we be confessed sinners. We Christians are a strange fraternity—the foot washers of the world. Like Churchill, we offer our people blood, toil, sweat, and tears. But the honors that come to one who serves with Jesus cannot be measured (see Mark 9:33-37). Dare we risk following his example? Dare we do otherwise?

As You Read the Scripture—Ralph W. Decker

John 13:1-17. These verses open John's account of the Last Supper. It differs from the accounts in the other Gospels in that it makes no mention of the bread and wine or of the institution of the sacrament. This may be because John had already dealt at length with Jesus as the bread of life (6:25-51). Instead, it reports the foot washing, which the others do not mention, as a lesson in servanthood.

Verse 1. It is clear that John did not regard the supper as the Passover meal. It may have been a simple fellowship meal of a teacher and his disciples. John's account of the meal opens with a solemn statement concerning Jesus' love for his disciples. The words "to the end" may mean either "to the end of his life" or "to the utmost degree."

Verse 2. John gives the name of Judas' father, a bit of information not given elsewhere. The question of why Judas betrayed Jesus has been a troublesome one for many persons, but not for John. He saw the devil using Judas. Having suggested betrayal to Judas (verse 2), he then took over his personality and directed his actions (13:27).

Verse 3. Jesus had accepted the fact that his hour had come and that all would be in accord with God's will.

Verses 4-5. The Revised Standard Version places Jesus' action during the meal, not after it as does the King James Version (verse 2). That position has better manuscript support and fits better with what took place. John gives no hint as to why Jesus acted as he did. In his account of the supper Luke says that the disciples fell to arguing "which of them was to be regarded as greatest" (Luke 22:24). Such a situation could have triggered the object lesson in humility and service. In a time when the usual foot covering was open sandals and there were no paved roads or walkways, it was customary for a host to provide water to wash the feet of his guests. It was also customary for a slave or servant to do the washing. Apparently, no slave or servant was present at the supper. None of the disciples volunteered to perform the menial task. Jesus, although the host, assumed the role of a slave. Fully aware of the authority and power God had given him, he did the lowly work none of the others would do. It was a powerful demonstration of humility and service.

Verses 6-10. The conversation with Peter is highly symbolical. Taking it as dealing only with bodily cleansing will miss the point. It plainly deals with the cleansing of the inner life.

Verse 6. Peter's reaction is in keeping with his tendency to be impulsive and outspoken, as shown in the other Gospels (Matthew 16:16, 22; Mark 13:26-31).

Verses 7-8. Jesus suggests that Peter is missing the lesson and discloses the symbolic nature of his words.

Verse 9. Peter, perceiving the symbolism, again reacts vigorously and asks for total cleansing.

Verse 10. Some scholars see a reference to baptism and suggest that Jesus meant that those who had been baptized had been purified of sin and needed only removal of the stains of everyday living. The phrase "not all of you" indicates that Judas was included in the foot washing, yet his heart was not cleansed of its evil purpose.

Verses 12-15. The purpose of the foot washing is plainly stated. It was to give the disciples a lesson in humility and mutual concern and to demonstrate that unselfish service was to be their mission.

Verse 16. The phrase "he who is sent" is the translation of a word that can also be translated "messenger." The servant is not better than the master, nor the messenger than the one who sent him. The disciples cannot claim to be too good to perform the kind of loving, unselfish service Jesus performed.

Verse 17. This verse echoes the Sermon on the Mount parable of the wise and foolish builders (Matthew 7:24-27).

Selected Scripture

King James Version

John 13:1-17

1 Now before the feast of the passover, when Jesus knew that his hour was come that he should depart out of this world unto the Father, having loved his own which were in the world, he loved them unto the end.

2 And supper being ended, the devil having now put into the heart of Judas Iscariot, Simon's *son,* to betray him;

3 Jesus knowing that the Father had given all things into his hands, and that he was come from God, and went to God;

4 He riseth from supper, and laid aside his garments; and took a towel, and girded himself.

5 After that he poureth water into a bason, and began to wash the disciples' feet, and to wipe *them* with the towel wherewith he was girded.

6 Then cometh he to Simon Peter: and Peter saith unto him, Lord, dost thou wash my feet?

7 Jesus answered and said unto him, What I do thou knowest not now; but thou shalt know hereafter.

8 Peter saith unto him, Thou shalt never wash my feet. Jesus

Revised Standard Version

John 13:1-17

1 Now before the feast of the Passover, when Jesus knew that his hour had come to depart out of this world to the Father, having loved his own who were in the world, he loved them to the end. 2 And during supper, when the devil had already put it into the heart of Judas Iscariot, Simon's son, to betray him. 3 Jesus, knowing that the Father had given all things into his hands, and that he had come from God and was going to God, 4 rose from supper, laid aside his garments, and girded himself with a towel. 5 Then he poured water into a basin, and began to wash the disciples' feet, and to wipe them with the towel with which he was girded. 6 He came to Simon Peter; and Peter said to him, "Lord, do you wash my feet?" 7 Jesus answered him, "What I am doing you do not know now, but afterward you will understand." 8 Peter said to him, "You shall never wash my feet." Jesus answered him, "If I do not wash you, you have no part in me." 9 Simon Peter said to him, "Lord, not my feet only but also my hands and my head!" 10 Jesus said to him, "He who has

answered him, If I wash thee not, thou hast no part with me.

9 Simon Peter saith unto him, Lord, not my feet only but also *my* hands and *my* head.

10 Jesus saith to him, He that is washed needeth not save to wash *his* feet, but is clean every whit: and ye are clean, but not all.

11 For he knew who should betray him; therefore said he, Ye are not all clean.

12 So after he had washed their feet, and had taken his garments, and was set down again, he said unto them, Know ye what I have done to you?

13 Ye call me Master and Lord: and ye say well; for *so* I am.

14 If I then, *your* Lord and Master, have washed your feet; ye also ought to wash one another's feet.

15 For I have given you an example, that ye should do as I have done to you.

16 Verily, verily, I say unto you, The servant is not greater than his lord; neither he that is sent greater than he that sent him.

17 If ye know these things, happy are ye if ye do them.

bathed does not need to wash, except for his feet, but he is clean all over; and you are clean, but not all of you." 11 For he knew who was to betray him; that was why he said, "You are not all clean."

12 When he had washed their feet, and taken his garments, and resumed his place, he said to them, "Do you know what I have done to you? 13 You call me Teacher and Lord; and you are right, for so I am. 14 If I then, your Lord and Teacher, have washed your feet, you also ought to wash one another's feet. 15 For I have given you an example, that you also should do as I have done to you. 16 Truly, truly, I say to you, a servant is not greater than his master; nor is he who is sent greater than he who sent him. 17 If you know these things, blessed are you if you do them."

Key Verse: **Verily, verily, I say unto you, The servant is not greater than his lord; neither he that is sent greater than he that sent him. (John 13:16)**

Key Verse: **Truly, truly, I say to you, a servant is not greater than his master; nor is he who is sent greater than he who sent him. (John 13:16)**

The Scripture and the Main Question—Pat McGeachy

The Towel and the Basin (John 13:1-11)

This paragraph begins with one of the world's longest list of modifying phrases. Listen to them:

> Before the feast of the Passover,
> when Jesus knew that his hour had come
> to depart out of the world to the Father,
> having loved his own who were in the world,
> he loved them to the end.
> And during supper,

> when the devil had already put it
> into the heart of Judas Iscariot,
> Simon's son, to betray him,
> knowing that the Father had given
> all things into his hands,
> and that he had come from God
> and was going to God,
> Jesus rose from supper.

Musically, this would call for a great cadenza. Clearly everything has been building up to this moment. It is time for a dramatic chord.

But the dramatic moment brings forth a most humble act: the washing of feet. If you and your class have never experienced a foot washing, I would strongly suggest that you have one, there with each other. If you do, you will find some interesting things. The first time I ever took part in one, I was expecting it to be embarrassing. I thought to myself, "It must be very humiliating to wash the feet of another." But I was in for a surprise! The hard part was not washing another's feet but sitting there trying not to look foolish while *someone else washed my feet.* Ever since that moment, I have understood how Peter felt. I was raised among "self-made" people. I was taught by my parents that "every tub must stand on its own bottom." I am one of those people who never likes to ask for directions, even in a strange town. (With that sort of pride I have gotten very lost several times.) My cry is, "Mother, please, I would rather do it myself." So I don't like to have my feet washed.

But Jesus says to you and me, as he said to Simon, "If I do not wash your feet, you have no part in me." So we reply with the same exaggerated humor, "In that case, Lord, give me a complete bath!" (verse 9). We must let the Lord help us; that is, we must be willing to accept the grace of God, not to attempt to achieve salvation by our own righteousness.

The Role of the Servant (13:12-20)

Then Jesus, having enacted the powerful symbol, gives us our marching orders. Like a good teacher he asks, "Do you understand what I have just done? Do you know what it means?" (verse 12). And lest we miss the point altogether, he explains it in no uncertain terms: "If I, your Lord and Teacher, have acted thus, how should you act? You must behave in exactly the same way. You don't think you are better than I am, do you?"

How hard it is for us to follow this example! All the images that call to us from the pages of the newspaper, the programs on television, the songs on the radio, and the pronouncements of the politicians cry out the opposite. Jesus says, "Be a foot washer." But the world cries, "Be a winner!" Jesus says, "Give up your life." But the world calls, "Keep up with the Joneses!" Jesus says, "Happy are those who mourn!" But the world entices us to get our kicks. Jesus says, "Take up your cross," and the world says, "Be sure that you have plenty salted away in your IRA!"

It may be, however, that Jesus' servant model will one day be vindicated. Consider this theory: For the first fifty thousand years of the human race on earth, we were hunters and gatherers. Then, about ten thousand years ago, we learned how to be agrarian people. But farmers still like to hunt for pleasure. Then, about five hundred years ago, the Industrial Revolution

started, and we began to become manufacturers. But factory workers still like to farm and hunt for pleasure. In the last one hundred years we have become a service-oriented economy (there are more people in service jobs today than in manufacturing or farming). And bankers, preachers, teachers, doctors, lawyers, and clerks like to make things for pleasure (as well as farm and hunt.) Now, say the economists, we are about to enter into a leisure world, in which computers and robots will take over all the jobs and we won't have anything to do. Do you think we could learn to be servants for our avocations? (Of course, we would still want to work in our shops and gardens; I doubt if we will do much hunting, for we have endangered about all the species in the world, and we may finally learn to let them be.)

I wish I thought that optimistic picture was going to be true any time soon. But whether it comes true or not, we still have our orders: We are to serve one another. We are to take care of the poor and the hungry in our midst. We are to look out for the mentally ill who wander aimlessly and frightened on our streets. We are to teach and train the unemployed and the unemployable and help them to feel a sense of worth about themselves. We are to teach people to fish so that they can sustain themselves. We are to heal the sick, cast out demons, and preach the gospel of love. Do we dare take these orders seriously? Do we dare not?

The Traitor (13:21-30)

"So . . . he . . . went out; and it was night." What a sad thing to happen at the end of Jesus' beautiful illustration of how the kingdom ought to be. He had just told them they ought to be servants, foot washers. He had even washed Judas's feet. But in this case, it did not take. You know, it may have been the servant message itself that drove Judas to his betrayal.

There is no reason to doubt that Judas loved Jesus and that he wanted him to be proclaimed king of the Jews and indeed emperor of the world. But that, you will remember, was the very thing that the devil had tempted Jesus with in the first place (Luke 4:5). Instead, Jesus chose the role of the vulnerable servant, the one who would lay down his life for the sheep. The best explanation of Judas's behavior is that he could not stand this passive role for his Lord. He wanted Jesus to be recognized *now,* not in some dim and distant future. Surely it wasn't a measly thirty pieces of silver that tempted him. It must have been that he thought he could push Jesus into action by delivering him into the hands of the authorities. Then, surely, at last he would call on the legions of heaven to come rescue him and set him on his rightful throne. And of course he could have (Matthew 26:53), but the point is, he didn't. He chose to follow his servant role all the way to his death.

When this became apparent to Judas, he repented of his deed and hanged himself. But what shall you and I do? Are we not daily tempted to use Jesus as Judas wanted to, to deliver us from troubles, to find us parking places, to defend us from criticism by our enemies, and above all to make us respectable church goers?

Let us then go with him, outside the camp, bearing abuse for him (Hebrews 13:13). Let us choose to be servants, in large ways and small. Not too long ago, I got in one of those lanes in the supermarket that has a sign over it saying, "Twelve items or less." In front of me there was a woman with a good two dozen things in her basket. In righteousness I pointed this out to

her. Before the scene had ended, she had moved into another line, cursing me at the top of her lungs. She even followed me into the parking lot, shouting, "If I were married to you, I would divorce you!" No doubt. But I will always wonder, what would have happened if I had acted like a servant to her? And what if we all acted that way? Do you think the kingdom would come?

Helping Adults Become Involved—Douglas E. Wingeier

Preparing to Teach

The main point of this lesson might be conveyed more powerfully by the foot washing act than by any words you speak. Ask God to prepare members' hearts, that they may be open to humbly accept the message of servanthood as it is portrayed.

Study John 13:1-30 and the commentaries about it. Barclay is especially eloquent about the foot washing. Read the articles entitled "Servant" and "Service" in *Harper's Bible Dictionary* to get an idea of how much an emphasis on service contrasted with the values and lifestyle of Jesus' time. If the members of your class agreed last week to a foot washing, then be sure to bring a pitcher, basin, and towel to class. If they disagree, do not force it on them. But describe the event using the pitcher and basin. Perhaps one or two class members would volunteer to allow you to wash their feet as a demonstration for the class. Also have Bibles, hymnals, and pencils and slips of paper available.

The purpose of this lesson is to lead persons to grasp, accept, and live out the role of servant as the core of their lifestyles. This outline will contribute to that end:

> I. Jesus takes the towel and basin.
> II. Jesus teaches about servanthood.
> III. Judas betrays Jesus.

Introducing the Main Question

The ideas in "The Main Question" are essential in identifying the central theme of this lesson: The foot washing is a symbol of the Christian lifestyle of servanthood. It should be made clear that this service of foot washing was never used in New Testament times for disciples, only by Jesus for his twelve apostles.

Place the pitcher of water, basin, and towel on the front table. Ask the member(s) who agreed to it last week to remove their shoes and socks. Invoke a prayerful atmosphere. Have someone read aloud John 13:1-10. Pour water from pitcher into basin. Have one member carry the basin from person to person, asking each to dip his or her feet in the water, after which you wipe them with the towel. When you are through, offer a brief prayer asking for the gifts of humility, receptivity, and dedication so that we may become the kind of servants Jesus calls us to be. (Remember, do not force everyone to participate. The basin should be taken only to those who agree to it.) Conclude by giving members opportunity to share their thoughts and feelings about the experience. Present Pat McGeachy's ideas about

embarrassment, pride, and self-made people in the section of "The Scripture and the Main Question" entitled "The Towel and Basin."

Developing the Lesson

I. Jesus takes the towel and basin.

Briefly retell the story of the footwashing at the Last Supper. Give the background from "As You Read the Scripture." Assign class members to look up and read Matthew 20:28; Isaiah 42:1-4; 49:1-6; 50:4-9; 52:13–53:12; 61:1-4; Matthew 12:18-21; and Luke 4:16-21, to demonstrate Jesus' preoccupation with the servant role. Explain that the footwashing was an object lesson in the centrality of service to Jesus' purpose and to his challenge to his followers. Follow Ralph Decker's explanation of how Jesus washes the twelve apostles feet, Peter protests then accepts, and Judas is washed but not cleansed. The latter point illustrates that we can go through worship experiences without being touched if our hearts are not receptive.

II. Jesus teaches about servanthood.

Make two columns on the chalkboard, one headed "Jesus says" and the other "We say." Ask the class to think of contrasts between what Jesus teaches and our usual response. Start by writing up the four pairs of opposites mentioned in the second paragraph of the section entitled "The Role of the Servant" in "The Scripture and The Main Question." Others might include love one another versus get the best of one another; forgive versus get even; go the second mile versus suspect the other's motives; and do unto others versus do others in.

In a recent and significant book, *Habits of the Heart*, Robert Bellah and others contend that America's preoccupation with individualism is tearing the social fabric apart. Persons are so concerned with doing their own thing, getting their needs met, protecting their rights, and finding self-fulfillment, that they have lost interest in their neighbor's welfare and the well-being of the community as a whole. The service motive has been overwhelmed by the profit motive. Everyone is asking, "What's in it for me?" Ask the class if they agree with this analysis of the predicament of American society? Ask: What examples can you cite from current events? Do you see the tendencies? Can a society in which citizens lack commitment to the well-being of the whole survive long? What can be done to turn the situation around? Remind them of President Kennedy's famous dictum, "Ask not what your country can do for you, ask what you can do for your country." Compare this with Jesus' statements about service in the passages read earlier. Explain that when he said, "You also ought to wash one another's feet," he was not instituting another sacrament but rather speaking symbolically about the need for his followers to adopt a lifestyle of humble service to each other and all humankind.

It is not enough just to give lip service to this concept by wearing stoles (the stylized version of the towel) or calling ourselves ministers (the Greek word *diakonia* can be translated either "ministry" or "service"). But if you know these things, blessed are you if you do them. Cite the examples of active service given in the last paragraph of the section "The Role of the Servant" in "The Scripture and the Main Question," and ask the class for more examples—assisting farmers who have had mortgages foreclosed, providing shelter for the homeless, establishing a supervised drop-in

center for latchkey children, offering a listening ear to a person in a troubled marriage.

III. Judas betrays Jesus.

Verses 21-30 give John's version of *Jesus' identification of his betrayer* at the Last Supper. Ask members to look up and read Matthew 26:20-25 and Mark 14:17-21, to contrast the accounts. *Harmony of the Gospels* or *Gospel Parallels* will display the stories of Matthew, Mark, and Luke (but not of John) side by side on the same page for purposes of comparison.

Various interpretations have been given as to why Judas betrayed Jesus. The one in "The Traitor" in "The Scripture and the Main Question" seems plausible. But John simply says that Judas is motivated by Satan (verse 27). The power of evil got into him and caused him to send his own best friend to his death. Ask the class for instances from their own lives when "something got into them" that led them into perverse and unexplainable acts. Telling a lie when they knew they were guilty, not following through on a responsibility when they knew others were depending on them, playing hooky from school or job, and cheating on a spouse could be examples they might mention. Whether we attribute these to the motivation of Satan or not, we know we are guilty and need God's forgiveness for them.

Helping Class Members Act

Ask each member to think of one need in their community or situation that calls for a servant response. Have them write it on a slip of paper and place it in the bowl (emptied of water). Keep the bowl on the front table through the week as a reminder that these needs are awaiting a servant of Christ to address them. Tell them that reports of action taken will be called for next Sunday. Close with the hymn "The Voice of God Is Calling" and a prayer asking for vision and strength to serve the needs of a hurting world.

Planning for Next Sunday

Assign members to read John 13:31–14:14. Also ask them to make a list of the ways others in the community know that members of your church are disciples of Jesus.

LESSON 12 FEBRUARY 18

Choosing the Way

Background Scripture: John 13:31–14:14

The Main Question—Pat McGeachy

In the book of the Acts, before the church began to be called the church, it was called the Way (see Acts 9:2; 19:9; 19:23; 22:4; 24:22). It was not a

formal, organized institution, but simply a group of Jews who believed they had found the Messiah, together with their Gentile friends. They believed that, at long last, their sense of purpose in life had found its fruition, that at last they knew where they were going and how to get there. They were on the Way, and they wanted others to go with them.

There is no more beautiful conversation in the world than this between Jesus and his eleven friends (Judas Iscariot has now left them) in the upper room. Only John makes much of the dialogue there, but he gives us what may be the favorite passage in the New Testament. What makes it very special is that it offers hope; it helps us believe that we too are on the Way. Let us now, in this and the lesson to follow, join in that conversation, for in spite of our modern sophistication we too are often lost and uncertain. We do not know what tomorrow will bring. We are like the sad little cocker spaniel in the airport baggage lot, looking mournfully out of his cage. "What do you suppose makes that dog so sad?" said a passerby. "You'd be sad too," replied the skycap. "You don't know where he's going, I don't know where he's going, and *he* don't know where he's going. He's chewed up his tag."

So men and women find themselves today. Sometimes our family life is uprooted. Sometimes we are uncertain as to our vocation. Sometimes we do not know where to put our shoulders to the wheel of life. We are, to use an old-fashioned word, lost. But there comes to us from John 14 a word of hope. Jesus says to us, "I am the Way." His teaching, his lifestyle, and his promises point us in a direction. It is up to us to walk that way.

As You Read the Scripture—Ralph W. Decker

John 14:1. The opening words of this verse reflect the distress and anxiety of the disciples at the announcement that Jesus was about to leave them. They must have been dismayed by the prospect of being left without his leadership and guidance. Because punctuation is not clear in the old Greek manuscripts, the two phrases in the second part of this verse may be read four different ways. Each phrase is either a statement of fact or a command. Each of the four possible readings has significant values: (1) "You believe in God (statement), you believe also in me (statement)"; (2) "believe in God (command), believe also in me (command)"; (3) "you believe in God (statement), believe also in me (command)"; (4) "believe in God (command), you believe also in me (statement)." The King James Version follows number 3. The Revised Standard follows number 2. The message of all four readings is the same: The disciples are to be sustained by their trust in God and in Christ.

Verse 2. The terms Jesus uses, "Father's house" and "to prepare a place," carry the idea of going home to a place of rest and security. While the phrase "many rooms" has sometimes been taken to refer to degrees of blessedness or to stages on the way to perfect bliss, it is generally regarded as simply a symbol for roominess. God's dwelling place has room for all. The second half of this verse presents another problem of punctuation. The Revised Standard Version treats it as a question, while the King James treats it as a statement. The main difference is that the Revised Standard Version implies that Jesus had already discussed the hereafter with his disciples and had assured them of a heavenly home.

Verse 3. This is the first reference in this Gospel to the return of Jesus. It contains John's only use of the phrase "come again." Elsewhere Jesus says simply that he will "go" and "come." No hint is given as to the time of return.

Verse 4. Jesus assumed that during the time they were with him the disciples had learned that he would return to the Father.

Verse 5. Philip puts forth the practical argument that no one can know the road to follow until the destination is known.

Verse 6. In another "I am" passage Jesus tells Philip that the goal is fellowship with the Father and that the way to reach it is through him (Jesus). He is the way to the Father, the truth about the Father, and the incarnation of the will of the Father.

Verse 7. Therefore, to know him is to know the Father.

Verse 8. Philip makes a very human request. He wants a God he can see. Like most, he handles physical sight better than spiritual insight.

Verse 9. Jesus had been revealing the Father to Philip and the others since he first called them to follow him. They had been slow to see that.

Verse 10. All of Jesus' words and works have had their authority and power from the Father. They have been revealing his nature and purpose.

Verse 11. Difficulty in accepting Jesus' claims can be overcome by accepting his works as evidence that God is working through him.

Verse 12. The followers of Jesus will continue his work. They will do greater works because they will be many in number, they will not be confined to a few years in Palestine, they will multiply his works of compassion and grace, and he will be working through them to reveal the Father to many.

Verse 13. Their power will come from prayer "in the name of Jesus." In five statements that they are to pray (14:13-14; 15:7; 16:23-24, 16:26), "in my name" appears in all but one (15:7). Praying as he prayed will put them in touch with his power.

Verse 14. Prayers in Jesus' spirit cannot be selfish or centered on material things. They are prayers for the will of God.

Selected Scripture

King James Version

John 14:1-14

1 Let not your heart be troubled: ye believe in God, believe also in me.

2 In my Father's house are many mansions: if *it were* not *so,* I would have told you. I go to prepare a place for you.

3 And if I go and prepare a place for you, I will come again, and receive you unto myself; that where I am, *there* ye may be also.

4 And whither I go ye know, and the way ye know.

5 Thomas saith unto him, Lord, we know not whither thou goest; and how can we know the way?

Revised Standard Version

John 14:1-14

1 "Let not your hearts be troubled; believe in God, believe also in me. 2 In my Father's house are many rooms; if it were not so, would I have told you that I go to prepare a place for you? 3 And when I go and prepare a place for you, I will come again and will take you to myself, that where I am you may be also. 4 And you know the way where I am going." 5 Thomas said to him, "Lord, we do not know where you are going; how can we know the way?" 6 Jesus said to him, "I am the way, and the truth, and the life; no

6 Jesus saith unto him, I am the way, the truth, and the life: no man cometh unto the Father, but by me.

7 If ye had known me, ye should have known my Father also: and from henceforth ye know him, and have seen him.

8 Philip saith unto him, Lord, shew us the Father, and it sufficeth us.

9 Jesus saith unto him, Have I been so long time with you, and yet hast thou not known me, Philip? he that hath seen me hath seen the Father; and how sayest thou *then,* Shew us the Father?

10 Believest thou not that I am in the Father, and the Father in me? the words that I speak unto you I speak not of myself: but the Father that dwelleth in me, he doeth the works.

11 Believe me that I *am* in the Father, and the Father in me: or else believe me for the very works' sake.

12 Verily, verily, I say unto you, He that believeth on me, the works that I do shall he do also; and greater *works* than these shall he do; because I go unto my Father.

13 And whatsoever ye shall ask in my name, that will I do, that the Father may be glorified in the Son.

14 If ye shall ask any thing in my name, I will do *it.*

Key Verse: **I am the way, the truth, and the life: no man cometh unto the Father, but by me. (John 14:6)**

one comes to the Father, but by me.

7 If you had known me, you would have known my Father also; henceforth you know him and have seen him."

8 Philip said to him, "Lord, show us the Father, and we shall be satisfied." 9 Jesus said to him, "Have I been with you so long, and yet you do not know me, Philip? He who has seen me has seen the Father; how can you say, 'Show us the Father'? 10 Do you not believe that I am in the Father and the Father in me? The words that I say to you I do not speak on my own authority; but the Father who dwells in me does his works. 11 Believe me that I am in the Father and the Father in me; or else believe me for the sake of the works themselves.

12 "Truly, truly, I say to you, he who believes in me will also do the works that I do; and greater works than these will he do, because I go to the Father. 13 Whatever you ask in my name, I will do it, that the Father may be glorified in the Son; 14 if you ask anything in my name, I will do it."

Key Verse: **I am the way, and the truth, and the life; no one comes to the Father, but by me. (John 14:6)**

The Scripture and the Main Question—Pat McGeachy

The Rule of the Road (John 13:31-35)

It is not a new rule (I John 2:7); it was given long ago in Leviticus 19:18. And yet in and through the life of Jesus it becomes new. We sometimes call the day of the upper room "Maundy Thursday," from the Latin word *mandatum,* meaning "commandment." For on that day, Jesus summed up all the rules for his people, saying, "Love one another, even as I have loved you." This contains all the other rules (Romans 13:8-10). And when we look at the life, teachings, death, and resurrection of Jesus, we are given a new

understanding of what it means. "So *that's* what he meant by love one another!" (Ephesians 4:32).

The love of which Jesus speaks here is not passion, appetite, or *need* love. It is not friendship, cooperation, or *shared* love. It is charity, *gift* love. It is the free giving of one's self for others. It is not pouring out molasses on the world's problem. No, sometimes it is tough love, hard, intellectual and disciplined, not to be confused with sentimentality. It is nothing other than the love that God has shown for us (Romans 5:8; I John 4:10). It is the love through which the universe was created, and with which God so loved the world that the Son was sent (John 3:16).

Moreover, it is the proof of our faith and our way of evangelism. "By this all . . . will know . . . if you have love" (verse 35). This love is the *motive* that inspires us to walk in the Way, the *means* that empowers us to keep at it, the *method* by which we carry out the task, and the *measure* of our success. It is all we need to know of theology ("God is love") and ethics ("Love one another").

The Way Himself (13:36–14:6)

Both Simon and Thomas have questions: "Where are you going?" asks Peter. "How can we know the way?" asks Thomas. To Peter Jesus replies, "You, although you are a rock, are not capable of going with me; you will deny me." To Thomas he answers, "I am the Way."

Of course he says also that he is the Truth and the Life. But they are really only two other "ways" of saying the same thing. As for the truth, Jesus had long before said it would set us free (8:32); as for life, he had promised that we would have it abundantly (10:10). I wonder why he did not answer, when Pilate asked him, "What is truth?" (18:38), for there stood the truth before him. Such a direct statement he apparently reserved for the chosen few, who recorded it for us.

Jesus is the Way, the Truth, and the Life, and, he adds, "No one comes to the Father, but by me." I do not believe that he intended this as an exclusivistic statement, meaning "Buddhists, Jews, and agnostics cannot get to heaven," though sometimes Christians use it to put down persons of other faiths. Rather, I believe it means, "If Buddhists, Jews, agnostics, or anybody else get to heaven, it will be by me." He does not mean it as a magic word that can get us there; he had long ago said, "Not everyone who says to me 'Lord, Lord' shall enter the kingdom" (Matthew 7:21). He means it for its plain, unvarnished meaning: "Follow me."

And so we must. We must follow him in his life of service, in his healing of the sick, in his compassion for the poor, in his zeal to seek out the lost. And we must follow him in his courageous journey before the high priest, before Pilate, and up the hill of death. But even there we are to have great hope. "In my Father's house," he said, "are many rooms." The King James Version says "mansions." I suspect the Revised Standard Version is a better translation, but there is something about that lovely old word that gives heaven a taste of grand and wonderful majesty. Of course, we do not really know what it will be like. The descriptions in the Revelation are only hints. Some like the pearly gates and golden street that are mentioned; I personally prefer that crystal river bordered by the trees of healing—I like forests better than jewelry. But take your pick; they are metaphors. "No eye has seen, nor ear heard, nor the heart of man conceived, what God has

prepared for those who love him" (I Corinthians 2:9). And surely the cartoon images of harpers flitting about on clouds are not to be taken very seriously. But because we know Jesus is the way, we do know something very certain and sure about heaven: Love, relationship, companionship, truth, and joy will be there. Who cares how the streets are paved?

The Son and the Father (14:8-11)

Again Jesus identifies himself with God. As we have said, this is not necessarily an arrogant statement: It can mean nothing more or less than "My will is completely subservient to the will of God." And Jesus makes it clear that he does not necessarily mean this as a theological statement. He says, in effect (verse 11), trust me when I say that God and I are one, but if you want to, just believe that it works. The older I get, the more this last statement has come to mean to me. I have long sought to understand theology: how God could be in Christ, how Christ could be both divine and human, how the death of Christ could save me from my sins. But my mind boggles at such concepts. However, there is one thing that I do understand: Whenever I have faithfully tried to follow Christ, it has worked for me. When I have lived as a servant for others, I have been richly blessed by service from others. When I have lost my life, I have found it. When I have asked for nothing I have been given much. When I have died, I have been more alive than ever.

What I am trying to say is that for all of the great theologians of the church, and praise God for them, the heart of the matter is that walking in the Way doesn't require a theology, it requires obedience. To be a member of the church you are not required to explain the substitutionary theory of the atonement (or, if you'd like a bigger phrase, the teleological suspension of the ethical); no, you're just asked if you believe in Jesus as Lord and Savior. Of course, that *is* theology, but it is not a matter of book learning, it is a matter of loyalty. After all the arguments are said and done, there is a clear word from Jesus: "What is that to you? Follow me" (John 21:22).

Even Greater Works (14:12-14)

And the passage ends with an amazing promise: We will be able to do even more amazing things than Jesus did. I don't know if this means things like heart transplants and space flight. Maybe it refers to Christian martyrs and saints who have endured even more pain and suffering than Jesus of Nazareth. Or possibly it has reference to some modern evangelists who have spoken to more people in one radio broadcast than Jesus did in his whole lifetime. Come to think of it, even I have done that.

What I do know that it means is that the power of God was not confined to the historical man, Jesus. The Christ is still alive and at work in the world, in and through you and me. It means that the work of your Sunday school class, your church, you yourself, is just as important, or perhaps even more so than what the disciples did in the Holy Land two thousand years ago. How do you feel about your daily life? If you believe what Jesus has taught us here, then you should realize that when you walk in the Way your works are a part of the mighty act of God.

When I remember that, it puts a spring in my step and hope in my heart. I am no longer the confused "What do I do now" Christian. I am working

with Jesus, and he is at work in and through me. I can answer the great question of life's vocation with the profound words spoken long ago by a twelve-year-old boy, "Didn't you know that I must be about my Father's business?" That, my friends, is the Way.

Helping Adults Become Involved—Douglas E. Wingeier

Preparing to Teach

Pray daily for members during the week, asking God to strengthen them for the tasks of service they have pledged to perform. Also ask for wisdom and guidance that the lesson you are planning may speak meaningfully to their hearts and lives.

Read John 13:31–14:14 and commentaries on it. Make your own list of ways the community knows your church members are followers of Jesus. Such evidence as regular worship attendance, high moral standards, faithful community service, outreach to the poor and oppressed, and a church climate of genuine caring and concern might be included.

Your purpose in this lesson is to lead members to appreciate and affirm that Jesus is the way of love, and to open themselves to living by this standard. With that end in view, the material may be organized as follows:

I. Jesus gives a new commandment.
II. Jesus points the way.
 A. Peter asks the way.
 B. Jesus prepares a place.
 C. Thomas asks to know.
 D. Jesus is the way.
III. Jesus promises greater works.
 A. Philip asks to see God.
 B. We must ask in Jesus' name.

Introducing the Main Question

The basic ideas in "The Main Question" clarify the central point of this lesson. Jesus is the Way that gives direction to our lives; he calls us to walk in it.

Begin by asking for reports from both the committee planning a service project (see lesson 9) and individuals who carried out acts of service last week. Spend time getting the entire group on board with the class action project. Be sure assignments are agreed to, timelines specific, and lines of accountability clear.

When the reports are completed, ask: What characterizes these actions? Why do we do them? What makes them Christian? Suggest that similar acts might well be done by non-Christians but that what makes the difference is the motivation of Christian love. "We love, because he first loved us" (I John 4:19). The love of God in our hearts empowers us to love and serve our neighbors.

Tell Pat McGeachy's story in "The Main Question" about the dog that had chewed up his tag. Ask if they think this well describes people in our time—not knowing were we are going. Jesus said, "I am the way, the truth, and the life" (John 14:6). He is the way of love. To all lost people he says,

223

"Love me, love God, love your neighbor, love yourselves—and you will know the way!"

Developing the Lesson

I. Jesus gives a new commandment.

As Pat McGeachy observes in "The Rule of the Road" (in "The Scripture and the Main Question") the commandment to love is not new (see Leviticus 19:18). What made it so compelling in Jesus, however, is that he not only taught it but lived it! He was the incarnation of love. He accepted, healed, forgave, transformed—all the power of love. And now he is commanding his followers to live that way too. "Love one another; even as I have loved you," he tells them (13:34).

At this point call for the lists of ways others will now that we are disciples of Christ. Write them on the board. If people are slow to respond, suggest your own ideas as pump-primers. After discussing this ask people to complete this multiple choice question: Jesus said, "By this shall all people know that you are my disciples, that you": (1) baptize by immersion; (2) have a growing church; (3) believe the Apostle's Creed; (4) pray every day. After discussion ask someone to read John 13:35 for the correct answer—"that you love another." Have them look at the list of signs of discipleship to see which are characterized by Christian love.

II. Jesus points the way.

The next part of today's passage (13:36–14:6) contains a dialogue about the way between Jesus and his disciples.

A. Peter asks the way.

Jesus tells him he cannot go with him now, and when Peter asks why, Jesus predicts his denial before the cock crows. Ask the group to cite instances of how we deny Jesus' way of love—by holding grudges, rejecting those different from us, ignoring human need around us, and taking advantage of others from a power position.

B. Jesus prepares a place.

The way of love leads to eternal life with God. Even though Jesus' way of love led him to the cross and put the disciples in jeopardy, they need not have troubled hearts, for the ultimate outcome is sure. Where Jesus is going they will follow. The life of love is blessed by God—eternally! This promise should offer encouragement to your class struggling with group and individual projects of loving witness and service.

C. Thomas asks to know.

Thomas the doubter still doesn't understand. He wants it to be perfectly clear. Sometimes feigning ignorance or confusion is a dodge. Whether or not this was the case with Thomas, press the class to be sure they understand clearly what Jesus is talking about. We are called to live the way of love, regardless of the cost!

D. Jesus is the way.

There can be no doubt any longer. They have seen the way, truth, and life with their own eyes. The way Jesus has lived before them is the way they (and we) are called to live. It (he) is the way to healthy community, the way to nurturing relationships, the way to just social systems, the way to eternal blessing, the way to know God.

III. Jesus promises greater works.

But the greatest surprise in the conversation is still to come.

A. Philip asks to see God.

Jesus tells him that to have been with him is to have been with God. Asserting his Sonship once again, Jesus claims to be the expression of God by which God's loving nature is made plain to the human race. We know what God is like because we have seen Jesus. The implications of this are both clear and staggering. As John puts it in another place: "By this we know love, that he laid down his life for us; and we ought to lay down our lives for the brethren [and sisters]. . . . Let us not love in word or speech but in deed and truth. . . . let us love one another; for love is of God, and he who loves is born of God and knows God. . . . if God so loved us, we also ought to love one another" (I John 3:16–4:11).

B. We must ask in Jesus' name.

Such love seems humanly impossible, and so it may be. But you "who believe in me will also do the works that I do; and greater works than these will [you] do" (14:12). The promise is here that great as was the love of Jesus, the works of love of his followers can be even greater—not in our own strength but by the power of God. "Whatever you ask in my name, I will do it" (14:13). The context of this amazing promise makes it clear that Jesus is not referring to trivial or magical requests, but rather asking for the wisdom and power to live the way of love.

Helping Class Members Act

Sing the hymn, "Lord, Whose Love Through Humble Service." Invite members to offer brief prayers asking God for whatever they need that fits the way of Jesus, the way of love. The group response after each request is "We pray in Jesus name." For example, a member prays, "For the healing and comforting of my sick mother," and the group responds, "We pray in Jesus name."

Planning for Next Sunday

As next week is the final one in this quarter, ask the class, in addition to reading the background scripture for that lesson, John 14:15-31, to also review the scriptures and themes of the past twelve Sundays.

LESSON 13 FEBRUARY 25

Empowered by the Spirit

Background Scripture: John 14:15-31

The Main Question—Pat McGeachy

The Holy Spirit is the most neglected member of the Trinity. This must we because we have a hard time understanding what the doctrine of the

Spirit means. I remember hearing a struggling young divine in my class in seminary questioning the theology professor. "I understand about God," he said, "and I believe in Jesus, but I just don't know if I believe in the Holy Spirit." "Oh," said the professor, "then you believe in a Binity." "I don't know what that is," said the student, "but if you say so, I guess I do."

I don't think that teacher was very helpful to the young man. If I were teaching in seminary today and a student raised that question, I think I would suggest a way of looking at it like this: The Spirit is God (or Jesus) in your heart and life. That isn't very theological, but then Jesus doesn't raise the theological question here. He simply says, "The Father will send the Spirit in my name" (verse 26). That sounds as if the Spirit comes from both of them, as the Nicene Creed says: "who proceedeth from the Father and the Son." Whatever the Spirit means, he is surely personal. I could just as well have said "she" in that last sentence because the Spirit is not limited to either sex; I chose to use the masculine pronoun because that is what most people are used to, and it is important, I think, not to speak of the Spirit as "it," a kind of impersonal Force (Luke Skywalker notwithstanding). From what John tells us in this lesson, it is clear that the Spirit is very personal: a Counselor (the King James Version says "Comforter," which always made me think of the delicious down-filled cover on my grandmother's bed, magically warm in winter and cool in summer), one who cares about me very much and empowers me to care about you. I think my young seminary friend needs the Spirit of God, and so do you and I. What will we make of the Spirit?

As You Read the Scripture—Ralph W. Decker

John 14:15. One of the qualities of love is the desire to do what the loved one wants. Love is concern for doing the will of the beloved.

Verses 16-17. In these verses is the first of five promises of Jesus that his disciples will have the presence and support of the Holy Spirit. The first four (14:16-17; 14:25-26; 15:26-27; 16:3-11) promise a Counselor. The fifth (16:12-15) promises the Spirit of truth, a title used to define the Counselor in 14:17 and 15:26. The Greek word translated "Counselor" is *parakletos*. Literally, it means "one called to the side of" or "one called to help." The word is practically untranslatable and some versions leave it as "paraclete" (Douay Version). Other translations have been intended to tell how the paraclete works. They include "Helper" (New King James Version, Goodspeed, Moffatt, Good News); "Advocate," a legal term similar to "lawyer" (New English Bible, Confraternity Version); "Counselor," in the sense of legal counsel (Revised Standard Version); "comforter," in the sense of "strengthener" (King James Version). Each translation has value for understanding the work of the Spirit.

Verse 16. The Counselor will be sent, as Jesus was, by God. He will be different from Jesus ("another") and one whose presence will be permanent. Surrounding passages, however, indicate that Jesus and the Counselor are both part of the same reality. This verse is used to give support to the doctrine of the Trinity, which teaches that there are three separate and distinct aspects of God. It says that the *Son* will ask the *Father* to send the *Spirit*.

Verse 17. The same human resistance that led to the rejection of Jesus will lead to the rejection of the Holy Spirit. But for those who are open to

light and truth, the Holy Spirit will be *with* them (collectively) and *in* them (individually).

Verses 18-21. Verse 16 seems to say that Jesus will no longer be with his disciples. These verses correct that idea with an assurance of Jesus' early return and continuing presence after his death and resurrection. The rest of the paragraph makes it clear that the relationship will be a spiritual one. This raises the question of the relationship of the spiritual presence of Jesus to the presence of the Holy Spirit. The answer lies in the Trinity. If Father, Son, and Holy Spirit are indeed one, all are present when one is present.

Verse 18. This is a straightforward promise to return.

Verse 19. The brief period of separation will end with the resurrection. Then Jesus will show himself to the faithful but not to the unbelieving world. The experience will impart new life to his disciples.

Verse 20. In that experience will come the knowledge of a threefold union of Father, Son, and believer. The believer will be united with God and Christ in will and action.

Verse 21. The union will be based on love and obedience.

Verse 22. This Judas is called "Judas the son of James" in the lists of the apostles found in Luke (6:16) and Acts (1:13). There are no other references to him anywhere in the New Testament. His question reflects the widely held view that the coming of the Messiah would be a spectacular world event.

Verse 23. Jesus' reply limits the experience of his return to those who love him and show their love by their obedience. They are the ones prepared for it.

Verse 26. The second mention of the Counselor definitely identifies him as the Holy Spirit. He will be sent by God to remind them of Jesus' teachings and to instruct them further. He will bring new revelations and deeper understanding if the truth.

Verse 27. This returns to the thought of 14:1. The quickening of the disciples' minds and the remembrance of Jesus' words will bring peace.

Selected Scripture

King James Version	Revised Standard Version
John 14:15-27	*John 14:15-27*
15 If ye love me, keep my commandments.	15 "If you love me, you will keep my commandments. 16 And I will pray the Father, and he will give you another Counselor, to be with you for ever, 17 even the Spirit of truth, whom the world cannot receive, because it neither sees him nor knows him; you know him, for he dwells with you, and will be in you.
16 And I will pray the Father, and he shall give you another Comforter, that he may abide with you for ever;	
17 *Even* the Spirit of truth; whom the world cannot receive, because it seeth him not, neither knoweth him: but ye know him; for he dwelleth with you, and shall be in you.	
18 I will not leave you comfortless: I will come to you.	18 "I will not leave you desolate; I will come to you. 19 Yet a little while, and the world will see me no more,
19 Yet a little while, and the	

world seeth me no more; but ye see me: because I live, ye shall live also.

20 At that day ye shall know that I *am* in my Father, and ye in me, and I in you.

21 He that hath my commandments, and keepeth them, he it is that loveth me: and he that loveth me shall be loved of my Father, and I will love him, and will manifest myself to him.

22 Judas saith unto him, not Iscariot, Lord, how is it that thou wilt manifest thyself unto us, and not unto the world?

23 Jesus answered and said unto him, If a man love me, he will keep my words: and my Father will love him, and we will come unto him, and make our abode with him.

24 He that loveth me not keepeth not my sayings: and the word which ye hear is not mine, but the Father's which sent me.

25 These things have I spoken unto you, being *yet* present with you.

26 But the Comforter, *which is* the Holy Ghost, whom the Father will send in my name, he shall teach you all things, and bring all things to your remembrance, whatsoever I have said unto you.

27 Peace I leave with you, my peace I give unto you: not as the world giveth, give I unto you. Let not your heart be troubled, neither let it be afraid.

Key Verse: **But the Comforter, which is the Holy Ghost, whom the Father will send in my name, he shall teach you all things, and bring all things to your remembrance, whatsoever I have said unto you. (John 14:26)**

but you will see me; because I live, you will live also. 20 In that day you will know that I am in my Father, and you in me, and I in you. 21 He who has my commandments and keeps them, he it is who loves me; and he who loves me will be loved by my Father, and I will love him and manifest myself to him." 22 Judas (not Iscariot) said to him, "Lord, how is it that you will manifest yourself to us, and not to the world?" 23 Jesus answered him, "If a man loves me, he will keep my word, and my Father will love him, and we will come to him and make our home with him. 24 He who does not love me does not keep my words; and the word which you hear is not mine but the Father's who sent me.

25 "These things I have spoken to you, while I am still with you. 26 But the Counselor, the Holy Spirit, whom the Father will send in my name, he will teach you all things, and bring to your remembrance all that I have said to you. 27 Peace I leave with you; my peace I give to you; not as the world gives do I give to you. Let not your hearts be troubled, neither let them be afraid."

Key Verse: **The Counselor, the Holy Spirit, whom the Father will send in my name, he will teach you all things, and bring to your remembrance all that I have said to you. (John 14:26)**

The Scripture and the Main Question—Pat McGeachy

Love = Obedience (John 14:15-24)

It is the first duty of the Spirit to convince us of our obligation to the law and to empower us to keep it. "If you love me," Jesus said, "you will keep my

commandments." This is not so much an order as a statement of fact. To love God *is* to keep the commandments (see I John 4:20-21). So the Spirit is with us in our loving. We don't do it very well by ourselves. But the Spirit helps us in our weakness (see Romans 8:26). The life of love, or the spiritual life, is not simply the keeping of certain rules, it is a matter that operates below the threshold of consciousness, "with sighs too deep for words."

Perhaps I can illustrate this best by speaking of marriage. (Those of you who are single will understand that there are other relationships that would do just as well, but this is one that I am familiar with, so I have to stick with it.) When two people get married in the blush of romantic love, they may very well find that the "little nameless acts of kindness and of love" come naturally. Love has a way of making this happen. But married couples had best beware, because as time goes on, loving words and actions get taken for granted and sometimes forgotten. (The same sort of thing can happen to other disciplines like saying family prayers at the table.) When this happens, you have to start remembering that it is your *duty* to be kind and loving to your mate. But that's not very romantic; I don't want to think of my wife's being nice to me as her *duty*. (Actually I'm not sure what's so wrong with that, but it is a feeling I have.) Now here is where the Spirit comes in. A bride and groom of thirty years or so can find a spirit in their marriage—not the spirit of the honeymoon (which corresponds to the time when Jesus walked among us, or to the first glad days of being a new Christian), but the spirit that comes to abide with the old couple when the blush is gone. Now I don't want to say anything pejorative about young love, but I must tell you that the latter state is better than the first. The spirit of a marriage of years is a wonderful counselor, a comforter in the dark days of life when your children are all gone and the arthritis gets in your joints.

Those who have not experienced such a marriage cannot know what I am talking about ("the world cannot receive"), but those who know what it is to be in the Spirit will understand my metaphor. It has little to do with the obvious visible gifts of the Spirit, like speaking in tongues, and more to do with the deep places of the heart. It's not magic, just fundamental reality. And it's there for the asking.

Peace Not of the World (14:25-31)

Then Jesus ties in the promise of the Spirit with the promise of peace. But note that he calls it *my* peace, peace that the world cannot give, any more than it can understand the Spirit: This is the peace that "passes understanding" (Philippians 4:7). It is "peace with God through our Lord Jesus Christ" (Romans 5:1).

During the days of World War II President Franklin Roosevelt was searching for something to serve as a motive for our fighting. He conceived of what he called the "Four Freedoms." Norman Rockwell was commissioned to paint them: freedom from fear, freedom from want, freedom of speech, and freedom of religion. Before introducing them he called together a number of leaders, including some clergy, to get their reactions to them. According to one story, a minister who was in the room and heard the four freedoms proposed said softly, "Nero had them all." But the president and the others did not understand what he meant.

In fact, it was true: Nero feared no one; he had the power of life and death over his subjects. He had no wants; he could have an orgy every day.

He certainly had freedom of speech; the emperor can say whatever he wishes. And as for freedom of religion, he had himself proclaimed a deity. But those four freedoms are the peace that *this* world offers. They are not the peace that Christ offers in the Spirit, his own peace that he gives to us, not as the world gives. The peace of Christ is a deep sense of well-being, but it is not necessarily freedom from the pains of this world. The early Christians lived under constant fear; they were often poor; they were not free to speak their minds or to practice their faith. And yet they had a peace far greater than that of Nero, who eventually committed suicide.

All this is summed up for me in what may be Jesus' most gracious words: "Let not your hearts be troubled, neither let them be afraid." I say those words over to myself in all sorts of crises. They speak to me like the opening lines of Psalm 27,

> The Lord is my light and my salvation;
> whom shall I fear?
> The Lord is the stronghold of my life;
> of whom shall I be afraid?

Thus the Spirit of God comforts me in whatever troubles I find myself. It is not a comfort that says, "You will have no troubles"; rather, it is a comfort that says, "no trouble can destroy you."

A story came to me some years ago out of Uganda, in the days of Idi Amin. The churches were under persecution, forbidden to operate. But one pastor had been outspoken against the government. One day, when he was meeting with his officers, an armed squad of government troops burst into the room and aimed their rifles at the pastor. "Prepare to die!" shouted their leader. And the minister replied, with incredible calm, "Go ahead and shoot. You cannot kill me. I have already died, and my life is hid with Christ in God" (Colossians 3:3). There was a long pause, and the leader of the death squad lowered his gun, and bade his men march away. "I used to be a Christian," he said, "but out of fear I have followed the emperor. I cannot kill you; go in peace."

I don't know that I could have made so bold a stand. I have the good fortune to live in a land where my faith is not likely to be so tested any time soon. But I know that that is the sort of peace I am speaking of. I hope and pray that my courage will stand up if I am ever caught in such a bind. But whether it does or not, the fact remains true: My heart need never be troubled or afraid. Perplexed, yes. Discouraged, often. Frustrated, sure. Broken, maybe, and cast down (II Corinthians 8:9-11). But never destroyed.

And then Jesus says something that we hardly notice but that is charged with moment: "Rise, let us go hence." He is saying, in effect, "Come on, let's go. Let's get at it." And he is speaking of the cross. How dared he speak so casually about it, as though he were casually saying, "Well, time to go now"? He dared because he possessed that same peace that he has promised to us. He does not order us to do what he has not already done. Because he has "walked that lonesome valley," it is not true that we have to walk it by ourselves. No, his rod and staff comfort us, even in the thickest darkness.

Strange as it may seem, I have discovered on those few times that I have been lonely and somewhat frightened that even the presence of a kitten in the room, or a little child, can make me feel much more secure. If that is so,

then how much more will the certainty of the presence of the Spirit of the Eternal God keep my spirits up in life's darkest hour! There is no cross we cannot bear, no temptation we cannot meet, no obstacle we cannot overcome, when we are walking with the Maker of the universe. Nothing can separate us from the love of God—neither life nor death, neither time nor space, no power, in heaven or in earth, because the Spirit is with us, the Spirit of God. And what does that mean? The Spirit of Jesus of Nazareth, our eternal Friend.

Helping Adults Become Involved—Douglas E. Wingeier

Preparing to Teach

Seek the guidance of the Holy Spirit as you prepare. Pray that the Spirit may open the minds of class members to the meaning of the scripture, that they may grow in faith, understanding, and commitment to live in response to the Spirit of God.

Read John 14:15-31 and its exposition in *The Interpreter's Bible* or Barclay's commentary on John. Also read the articles on "Holy Spirit," "Paraclete," and "Trinity" in *Harper's Bible Dictionary*. Write a paraphrase of this week's passage. Have Bibles, hymnals, paper, and pencils available.

Your purpose is to help persons understand the relationship of the Holy Spirit within the Trinity, to appreciate the action of the Holy Spirit in their lives, and to respond in loving obedience to God's word. A subsidiary aim is to review the major themes and challenges of the past thirteen weeks. Use the following outline:

 I. To love is to keep Jesus' word.
 A. The Holy Spirit is our Counselor.
 B. The Holy Spirit dwells with us.
 C. The Holy Spirit helps us love God and
 keep Jesus' words.
 II. God will send the Holy Spirit in Jesus' name.
 III. Jesus is leaving.
 IV. We, too, move on.
 A. Where we have been
 B. Where we are going

Introducing the Main Question

Begin by reading the Apostles' or the Nicene Creed. Point out that these historic affirmations of faith are divided into three paragraphs, one each dealing with God the Father (Creator), Son (Redeemer), and Holy Spirit (Sustainer). Thus was the doctrine of the Trinity formulated in the early church. Ask the class for their understanding of the Trinity. Introduce ideas from "The Main Question" and the dictionary articles.

Explain that the Latin word *persona* means "role" and is used to describe the cast of a drama. Hence the three "persons" really refer to three roles in the Godhead, not three individuals. Just as I am at the same time husband, father, and son, so the same God plays the roles of Creator, Redeemer, and "God present with us for guidance, comfort, and strength" (the classical definition of the Holy Spirit).

Developing the Lesson

Form groups of four to six persons. Divide today's scripture as follows: verses 15-17, 18-21, 22-24, 25-27, 28-31. Ask each group to paraphrase one section in words that are (a) faithful to the original intent and (b) meaningful to them. Then have them discuss: How would our lives and church be different if we took these words seriously? Ask someone in each group to be prepared to share their paraphrase and ideas as the lesson proceeds.

I. To love is to keep Jesus' word.

The theme of love is closely tied in with the Holy Spirit in today's passage. Ask the class why they think this is. The Holy Spirit is the Spirit of Jesus, which is the spirit of love. Share Dr. Pat McGeachy's illustration of marriage from the section on "Love-Obedience" in "The Scripture and the Main Question."

A. The Holy Spirit is our Counselor.

Call for the paraphrase of verses 15-17. Ask for the class's understanding of the Holy Spirit. Share information from Ralph Decker's "As You Read the Scripture" and the dictionary articles on "Holy Spirit" and "Paraclete." Discuss the differences that serious belief in an indwelling Counselor/Spirit of truth would make—more patience, empathy, and respect in our relationships, for instance.

B. The Holy Spirit dwells with us.

Hear the paraphrase of verses 18-21. Explain that Jesus promised to send the Holy Spirit after he left—one who would dwell in the hearts of believers, representing Christ in them and us. They/we know that the living Christ continues with us because of the presence of the Holy Spirit. The impact this belief could make on our lives and church might include receiving courage to live by our convictions, comfort when lonely or despairing, and a sense of unity and harmony in the church.

C. The Holy Spirit helps us love God and keep Jesus' words.

Ask for the paraphrase of verses 22-24. Show how the Holy Spirit enables us to love Christ, live by Jesus' teachings, and have a sense of God's love dwelling in our hearts. Invite members to give testimony of the Holy Spirit's presence in their hearts and lives in these ways. Let them describe the difference this makes in their lives, such as inner peace, going out of their way to help others, forgiving one who has wronged them, and speaking out on a social issue.

II. God will send the Holy Spirit in Jesus' name.

Explain that the Holy Spirit is with us because God is faithful to this promise. When we pray "in Jesus' name," we are praying in the power of the Holy Spirit. Hear the paraphrase of verses 22-24; add comments from "As You Read the Scripture" and your commentary study.

John here tells us that the Holy Spirit performs two functions among us. The Spirit will teach us and will give us peace. Call for the paraphrase of verses 25-27. Write "teaching" and "peace-giving" at the top of two columns on the board, and ask members for instances of ways they have been taught or given peace by the Spirit.

Examples of learning from the Spirit might include coming to accept a life transition, being challenged to take a new step, being led to a deeper

understanding of Scripture, or being encouraged to risk taking an unpopular stand or making a costly ethical decision. The Spirit brings the peace of Jesus into our lives through enabling reconciliation in relationships, social justice for the poor and oppressed, and inner tranquility in the midst of uncertainty or struggle. Introduce ideas from the "Peace Not of the World" section in "The Scripture and The Main Question." Explain that whether we are aware of it or not, instances of learning, growth, peace, and love in our lives and world are the work of the Holy Spirit. There is a quality to this learning and peace that the world cannot give; it can come only from the Spirit of God.

III. Jesus is leaving.

Ask for the paraphrase of verses 28-31. Point out that this is the farewell discourse of Jesus with the disciples. He is telling them goodbye, but also promising that he will come again (verse 28). Discuss how belief in Jesus' return—whether we interpret that physically or spiritually—can make a difference in our lives. It can give us courage or the example to say and do what we know is right.

Finally, Jesus says, "Rise, let us go hence." Introduce Pat McGeachy's observations about this matter-of-fact statement. It is time for Jesus to face the cross.

IV. We, too, move on.

You are completing one unit and moving on to another, though still in the Gospel of John. With help from the class, review and write on the board (or make photocopies) the themes and challenges of the past thirteen weeks' studies, along these lines:

A. Where we have been

We have learned that: We are called to ministry in our baptism (lesson 1); in the Spirit we can be born again and again (lesson 2); we must distinguish between our ordinary desires and the thirst to know Jesus (lesson 3); there is joy and hope in the Christmas story (lesson 4); our faith, actions, and health are closely related (lesson 5); the Bible is our authority for faith and life (lesson 6); Christ is the bread of life (lesson 7); the truth will make us free (lesson 8); we can be transformed from blindness to sight (lesson 9); events in Jesus' life are relevant to ours (lesson 10); Jesus took the role of a servant (lesson 11); Jesus is the way of love (lesson 12); and the Holy Spirit is active in our lives (lesson 13).

B. Where we are going

As disciples of Christ we are called to bear witness to Jesus as Lord (lesson 1); remain open to future new birth experiences (lesson 2); become laborers in the harvest by sharing our faith (lesson 3); let the Word become flesh in us (lesson 4); act for what we believe (lesson 5); live by Jesus' teachings as a witness to his Sonship (lesson 6); dedicate our resources to Christ for meeting human need (lesson 7); base our identities in a relationship with God and church (lesson 8); be lights in the world (lesson 9); grow in commitment and generosity, and search to know life's purpose (lesson 10); adopt the servant's role (lesson 11); live the loving way of Jesus regardless of the cost (lesson 12); and respond in loving obedience to the Holy Spirit and God's word (lesson 13).

Helping Class Members Act

Close with a litany. Read from the board (or photocopies) the items in which we can learn from and gain peace from the Holy Spirit. After each is read, have the group respond with "Guide us, Spirit of God" or "Grant us your peace, O Holy Spirit." Then read the themes and challenges of this unit, and have the group respond with "Thank you for teaching us, Spirit of God" or "Empower us to respond to this challenge, O Holy Spirit." When this is done, say "Amen" and sing either "Spirit of God, Descend upon My Heart," or the chorus, "Spirit of the Living God, Fall Afresh on Me."

Planning for Next Sunday

Ask the group to read next week's background scripture (John 15:1-17) and to pray for the Spirit's guidance and strength in responding to the challenges of this study with courage and faithfulness.

THIRD QUARTER

The Gospel of Life and Light

UNIT IV: JESUS LAYS DOWN HIS LIFE
Horace R. Weaver

SEVEN LESSONS **MARCH 4–APRIL 15**

During the second quarter of "The Gospel of Life and Light" we studied three units based on the Gospel of John, namely: "Jesus Comes to His Own," "Jesus Reveals Himself," and "Jesus Prepares His Followers." The third quarter completes the study of the Gospel of John in seven lessons under the theme of "Jesus Lays Down His Life." After this study of seven lessons, we then move to a six-week study of the letters of John (I, II, III John) under the theme "Abiding in Love."

Unit IV deals with John's treatment of Jesus' Passion and concludes with an Easter lesson. Unit IV's seven lessons deal with the following: "When Love Abides," March 4, explores the meaning of (1) Jesus' rich imagery of the vine and its branches, with reference to the ways in which we as twentieth-century Christians are grafted onto that perfect vine, and (2) the way in which abiding love fulfills the requirements that Jesus placed before his apostles and us. "Guided by the Spirit of Truth," March 11, helps persons attain a new sense of Christ's presence, in a variety of forms and ways. We are not alone! "Facing Crucial Choices," March 18, asks, How can we make sure we do not betray Jesus, and how will we manage when others betray us? "Denying Jesus," March 25, helps persons relive in their own lives the experience of Peter, and to feel, as he did, both guilt and forgiveness. "Standing for the Truth," April 1, challenges us: Knowing the truth, how shall we find the courage and the will to act on it? "Facing Death," April 8, seeks to help adults gain a fresh understanding of the events of the crucifixion and to internalize them in such a way that Jesus' and our deaths take on renewed meaning and significance. "Resurrection and Faith," April 15, proclaims how the resurrection and faith bring hope in these dark days.

Contributors to the third quarter:

Harry B. Adams, Associate Dean, Yale Divinity School, New Haven, Connecticut.

John Gilbert, Associate Executive Editor, Department of Youth and Adult Publications, Church School Publications, The United Methodist Church.

Pat McGeachy.

Gail R. O'Day.

When Love Abides

Background Scripture: John 15:1-17

The Main Question—Pat McGeachy

We live in what might be called the "age of the self." Self-help books teach us how to feel okay about ourselves, and advertisements call us to pamper ourselves. Not too long ago I saw an ad in a national magazine consisting of a full page containing only two things: a small bottle of very expensive liquor and two words: "Honor Thyself." But the teachings of Jesus call us to a way of life that is exactly the opposite of that phrase. We are to honor and love God and neighbor. In fact, Jesus tells us that to honor yourself is to lose yourself, but to give yourself up for God and others is to discover what true selfhood means. (In addition to this week's passage, you may want to recall Matthew 10:39; 16:24-26; Luke 9:23-25; and John 12:24-26.)

Much of the appeal of the culture of self-worship is based on a mistaken notion that the world has about Christian sacrifice. (Perhaps this is partly our own fault for being such long-faced saints.) Somehow, the world seems to have gotten the idea that faithfulness to Christ is rather painful and joyless. But Jesus has much to tell us here about what real joy means (verse 11). To pick up on the Lord's own metaphor, we might say that the faithful are not offered a tasteless and unpleasant diet but a bowl of delicious fruit.

In short, the advice that says "Honor thyself" leads eventually to self-destruction, but Christ's call, "Abide in me," leads ultimately to joy and the bearing of fruit. But it is very hard to turn loose of my "self." I am a lot like the monkey with his hand trapped in the narrow-necked jar because he cannot bring himself to let go of his fistfull of peanuts. I cling to the things that do not make for my own best interest. But if, forgetting myself, I abide in the true Vine (verse 4), it becomes possible for me to live a fruitful life.

As You Read the Scripture—Harry B. Adams

Chapters 14 through 17 of the Gospel of John contain the farewell statement of Jesus to his disciples, so that these words in chapter 15 are part of his final sharing with his followers. The thought here is compact, and ideas interweave so that they disappear and then reappear.

John 15:1-11. A key notion in these verses is found in the word "abide." The word itself appears nine times and points to the quality of a relationship that is close, sustained, and nurturing. Several times Jesus says that the disciples are to abide in him, and twice he talks of the disciples abiding in his love. In describing the relationship this way Jesus indicates that he and his followers are more intimately involved than teacher and student, master and slave, or leader and follower. The disciples are to abide in him and he in them.

To indicate how close and essential this relationship is, Jesus uses an organic metaphor as he talks of the branch that must abide in the vine.

236

A branch cut off from the vine is dead; a branch organically connected to the vine can live. And so Jesus says to the disciples, "Apart from me you can do nothing."

Jesus offers other insights related to this notion of abiding, as illustrated by the figure of the vine. He talks about the fruit that can and must be borne. On the one hand, he says that the branch that bears no fruit will be cut off. On the other hand, he says that the branch can bear fruit only if it abides in the vine. As followers of Christ, we must bear fruit, but we can bear fruit only if we abide in him.

He talks of other results that are possible for those who abide in him. They can ask whatever they will in prayer, and it shall be done for them. They give glory to God by the fruit they bear as people of Christ. They abide in Christ when they keep the commandments he has given them. And by abiding in the love Christ has for them, the disciples enter into a relationship with him that is like the one he has with God.

Verses 12-17. In verse 10 Jesus declares that those who keep his commandments will abide in his love. This section begins and ends with the affirmation of what Jesus in fact commands: "This is my commandment, that you love one another." When we love one another, we abide in the love Christ has for us. When we abide in the love Christ has for us, we are able to love one another.

Jesus indicates something of the character of that love when he talks of a person giving up life for another, meaning how his own love will be illuminated by his death on behalf of others.

Jesus then moves to another way of talking about the closeness of his relationship with the disciples when he says that they are not his servants but his friends, friends to whom he has made known all that God is doing.

Selected Scripture

King James Version

John 15:1-17

1 I am the true vine, and my Father is the husbandman.

2 Every branch in me that beareth not fruit he taketh away: and every *branch* that beareth fruit, he purgeth it, that it may bring forth more fruit.

3 Now ye are clean through the word which I have spoken unto you.

4 Abide in me, and I in you. As the branch cannot bear fruit of itself, except it abide in the vine; no more can ye, except ye abide in me.

5 I am the vine, ye *are* the branches: He that abideth in me, and I in him, the same bringeth forth much fruit: for without me ye can do nothing.

6 If a man abide not in me, he is

Revised Standard Version

John 15:1-17

1 "I am the true vine, and my Father is the vinedresser. 2 Every branch of mine that bears no fruit, he takes away, and every branch that does bear fruit he prunes, that it may bear more fruit. 3 You are already made clean by the word which I have spoken to you. 4 Abide in me, and I in you. As the branch cannot bear fruit by itself, unless it abides in the vine, neither can you, unless you abide in me. 5 I am the vine, you are the branches. He who abides in me, and I in him, he it is that bears much fruit, for apart from me you can do nothing. 6 If a man does not abide in me, he is cast forth as a branch and withers; and the branches are gathered, thrown

cast forth as a branch, and is withered; and men gather them, and cast *them* into the fire, and they are burned.

7 If ye abide in me, and my words abide in you, ye shall ask what ye will, and it shall be done unto you.

8 Herein is my Father glorified, that ye bear much fruit; so shall ye be my disciples.

9 As the Father hath loved me, so have I loved you: continue ye in my love.

10 If ye keep my commandments, ye shall abide in my love; even as I have kept my Father's commandments, and abide in his love.

11 These things have I spoken unto you, that my joy might remain in you, and *that* your joy might be full.

12 This is my commandment, That ye love one another, as I have loved you.

13 Greater love hath no man than this, that a man lay down his life for his friends.

14 Ye are my friends, if ye do whatsoever I command you.

15 Henceforth I call you not servants; for the servant knoweth not what his lord doeth: but I have called you friends; for all things that I have heard of my Father I have made known unto you.

16 Ye have not chosen me, but I have chosen you, and ordained you, that ye should go and bring forth fruit, and *that* your fruit should remain: that whatsoever ye shall ask of the Father in my name, he may give it you.

17 These things I command you, that ye love one another.

Key Verse: **This is my commandment, That ye love one another, as I have loved you. (John 15:12)**

into the fire and burned. 7 If you abide in me, and my words abide in you, ask whatever you will, and it shall be done for you. 8 By this my Father is glorified, that you bear much fruit, and so prove to be my disciples. 9 As the Father has loved me, so have I loved you; abide in my love. 10 If you keep my commandments, you will abide in my love, just as I have kept my Father's commandments and abide in his love. 11 These things I have spoken to you, that my joy may be in you, and that your joy may be full.

12 "This is my commandment, that you love one another as I have loved you. 13 Greater love has no man than this, that a man lay down his life for his friends. 14 You are my friends if you do what I command you. 15 No longer do I call you servants, for the servant does not know what his master is doing; but I have called you friends, for all that I have heard from my Father I have made known to you. 16 You did not choose me, but I chose you and appointed you that you should go and bear fruit and that your fruit should abide; so that whatever you ask the Father in my name, he may give it to you. 17 This I command, you, to love one another."

Key Verse: **This is my commandment, that you love one another as I have loved you. (John 15:12)**

The Scripture and the Main Question—Pat McGeachy

The True Vine (John 15:1-4)

The Jesus we meet in the Fourth Gospel is fond of saying, "I am . . ." He said it so much that the Jews felt he was being blasphemous (see John 8:58-9) because, of course, God's name in Hebrew is "I Am" (see Exodus 3:14). In a way, his critics have a point, because *most* people who begin a sentence with "I am" are getting ready to brag. But there is one person who can say "I am" without being egotistical, and that is a truly humble person who is not thinking of self at all. In other words, Jesus is living out his very own teaching about losing one's self. He is so selfless that he is not the least bit self-conscious. Whenever I (and I suspect you also) try that, I end up being unable to escape from bragging. But Jesus is so ego free that he can unabashedly make remarkable claims about himself: "I am," he says, the Bread of life (6:35), the Light of the world (8:12), the Door of the sheep (10:7), the Good Shepherd (10:11), the Resurrection and the Life (11:25), the Way, the Truth, and the Life (14:6).

There are others, but none more meaningful to the loneliness that is in us all than "I am the vine." It is a lovely thought anywhere, but especially in the dry land where Jesus lived, where the vine was a symbol of life and security. Every pious Hebrew longed for the day when it would be possible to say, "I have my own vine and fig tree, and nothing can make me afraid" (Micah 4:4). A vine means life, growth, productivity, and even more: family (Psalm 128:3) and celebration (Psalm 104:15).

The vine with which Jesus identifies himself is no ordinary plant. It is owned and cared for by the One who planted the first garden, who both nurtures and judges Israel. Unlike the murderous flesh-eating plant of *The Little Shop of Horrors*, this is a tender vine that gives up its own juices so that its branches may bear fruit. Thus in the spirit of "to lose your life is to find it," Jesus, the vine, freely nourishes us on his own strength. Can we do the same for one another?

Joy and Discipline (15:6-11)

We rarely celebrate the Lord's Supper in my congregation without someone speaking Jesus' words about the vine. And this is appropriate, for communion is the most vivid example we have of Christ nurturing us with the gift of his own self, body and blood. And the invitation to the Eucharist, like John 15, is at once both a call to joy and a solemn warning. (See I Corinthians 11:23-32. When Paul tells us that it is dangerous to take the Supper without "discerning the body," he does not mean that we must comprehend the holy mystery of the sacrament but rather that we must remember the nature of the church: that we are united as one body just as branches are grafted into a vine. You can find Paul using a similar metaphor about our being grafted into a fig tree in Romans 11:17-24.)

The discipline involves pruning (verse 2) and in extreme cases casting away (verse 6). The joy involves bearing fruit (verse 8) and so experiencing the same joy (verse 11) that Christ himself has. And what form does that fruit take? The answer, of course, is love (verses 9-10). Does this mean that God will cast us out like so much trash for burning if we don't love each other? Well, that is one way of talking about it, because there is no question

that without love we do suffer the hell of separation. But said that way, it sounds as though God is a mean truant officer, just hoping to find someone without love so as to be able to say, "Aha! I caught you not loving; into the fire you go!" (verse 6). But that is not the way it is at all; God, in Christ, is searching diligently for us, as one searches for a lost sheep or a coin or a child (Luke 15). Perhaps a better image would be that of a *loving* truant officer who wants us to know the joy of an education. Such a public servant would know that if we do not finish school we will miss the joys of a rich, full life and experience the hell of poverty, both of body and mind. In just such a way Jesus wants us to experience the full joy of love. It's not, "If you don't love, God will get you!" Rather, it's "If you don't love, you won't get God."

So how does a Christian bear fruit? The metaphor of the vine helps us again. We don't squeeze up our energy and say over and over, "I've got to bear more fruit," as though by anxious thought we could make it happen (Matthew 6:27). Vines don't grit their teeth, and love doesn't fuss and fume (I Corinthians 13:4-7). How do we bear fruit? By abiding in Christ. "Abide" is a lovely word, involving almost no effort at all. In the King James Version of the Bible this same word is variously translated: abide, continue, dwell, endure, be present, remain, stand, tarry. "Abide" is a call to relaxation, to letting go, to trust and calm commitment. If we really want to be loving, we must start by accepting the wonderful news that God loves us. If we really want to bear fruit, we must start by nurturing ourselves on the sweet sap of the vine. We are called to discipline, yes, but that discipline begins with the joy.

Love and Grace (15:12-17)

Some Christians like to call the Thursday before Easter "Maundy" Thursday. That strange name comes (rather deviously) from the Latin word *mandatum,* meaning "commandment," because for centuries people heard John 13:34 read over and over in Latin: "A new commandment I give to you, that you love one another, even as I have loved you." Now Jesus repeats it, in the context of the vine image: Bearing fruit (verse 16) means loving one another (verse 17).

What's new about this commandment? Of course, in one sense it isn't new at all (see I John 2:7-8). We have known since long before Jesus that we ought to love each other. Look at Leviticus 19:18, or read Confucius. But Jesus adds the radical new phrase "as I have loved you"! Now it comes to us not merely as marching orders but as instructions that have already been fulfilled by the Commander who gives them. You are not *enlisting* in this fight (verse 16), you have been drafted! Your job is not to go out and invent ways of loving; those ways have already been demonstrated for you.

In other words, Christ is our motive, Christ is our means, and Christ is our method. Because we abide in the vine, we are moved to want to love. Because we abide in the vine, we are empowered by Christ for love beyond our own strength. And because we abide in the vine, we are shown the way to do it: the way Christ did it.

This is supported in many other New Testament places, notably Ephesians 4:32: "Be kind to one another [how?] . . . forgiving one another, as God in Christ forgave you." There is no better example. No greater act of love ever took place than when Christ laid down his life for his friends, especially since his friends were pretty sorry excuses for friends (see

Romans 5:6-8, and also I John 4:10-12). We are sinners and helpless. It is not we who loved, but God who loved first.

But now that we have come to know the love of God in Jesus, he adopts us into his family and treats us not as servants but as his own children. He trusts us and sends us forth into the world, believing that we will go on to do the thing he called us to do, namely, to find joy in loving as we have first been loved. Probably you know Saint Augustine's one-liner, "Love God and do as you please." In a way this is merely a remake of Jesus lovely statement recorded in John 15: "Abide in me, and bear fruit." You see, if we love God, we will want to do God's will. And if we abide in Christ, we cannot help bringing forth good fruit (Matthew 7:18).

Helping Adults Become Involved—John Gilbert

Preparing to Teach

Begin your preparation by going to God in prayer. Seek God's guidance for each class member by name. Pray for yourself as the teacher of your class, that all that you do may bring glory to God.

This session continues Jesus' discourse in the upper room the very night he was betrayed. Read the words aloud; notice that these are calm words, full of reassurance. But as you read them aloud, especially from the Revised Standard Version, you will feel yourself pulled along by a sense of urgency, by a recognition that Jesus knew that his hour had come and that he must say in a few short sentences those final things he wanted to leave with his apostles and with us.

Your main aim or goal in this session is twofold: (1) to explore with group members the meaning of Jesus' rich imagery of the vine and its branches, especially with reference to the ways in which we as twentieth-century Christians are grafted onto that perfect vine, and (2) to consider the ways in which love, abiding love, fulfills the requirements that Jesus placed before his apostles and before us that evening in the upper room.

You might use this outline as the structure for your session, but remember, every lesson plan must be adapted to the needs of your own group members:

 I. Explore the meaning of Jesus as the vine.
 A. Cite contemporary images of the vine.
 B. Explore the meaning of being grafted onto the vine.
 II. Discuss the concept of "abiding."
 A. Identify contemporary lifestyles in which persons abide, intentionally or unintentionally.
 B. Probe the changes in lifestyle brought about by a commitment to abide in Jesus.
 III. Discover ways that self-giving love fulfills the commandment to abide in Jesus as the vine.
 A. Discuss the nature of the love to which Jesus calls us.
 B. Describe and discuss the changes that must be made in order to love as Jesus requires.

You will want to have on hand a chalkboard and chalk or large sheets of paper with suitable markers. If possible arrange chairs for class members in

a circle, to facilitate discussion. Place the chalkboard or newsprint where all can see it easily.

You will want to read John 15:1-17 several times before you begin to teach. Can you explore this chapter in several translations? Do you have access to commentaries that might help you understand this rich passage.

Introducing the Main Question

As Pat McGeachy points out, we live in a confusing time. On the one hand, we are taught from every side that we are persons of worth, that we have vast potential, that we should exercise our gifts and skills to the very limits of our abilities, and that we should affirm who and what we are. "God made you, and God doesn't make junk!" is a popular teenage expression. Psychologists tell us that one of the major problems of today is that many persons don't like themselves, and this leads to neuroses and psychoses and all the rest of the emotional imbalances that plague persons.

But on the other hand, Jesus tells us to deny ourselves and follow him, to humble and abase ourselves, to put others first.

How can we do this? Jesus gives us the answer in this magnificent fifteenth chapter, if we will probe it carefully. The answer is "Abide in me." In abiding in him, in abiding in love, we can affirm ourselves as children of God and perceive our proper relationship to God and to one another. In so doing, we put ourselves in proper perspective. The solution lies not in choosing to deny self or boost self; the solution lies in fulfilling self by abiding in Jesus and the love that Jesus prescribes.

Developing the Lesson

I. Explore the meaning of Jesus as the Vine.
 A. Cite contemporary images of the vine.
Invite group members to think together about Jesus' image of the vine. Ask them to call out images that Jesus might use in our time to communicate the same concept. Pose this question this way: Jesus used the image of the vine because it spoke directly to persons who lived in an agricultural society where grapevines were very important. If Jesus were speaking to us today and wanted to make the same point, what images might he use? As persons call out suggestions, jot these down on the newsprint or chalkboard. Do not reject any ideas, but press group members to understand Jesus' image of the vine thoroughly, then to "translate" it into modern terms. If group members are slow in calling out images, you might share with them that a young adult class asked to do this exercise mentioned the vine being somewhat like the central electrical power line that comes into a home where it is divided into circuits, each of which carries out special functions. Or that it is like the main railroad track running cross-country but intersected at times by spurs that serve smaller cities and towns. This does not suggest that you should reject agricultural images; a rose fancier in your group would know all about pruning branches from the main stem, or an African violet grower in the class could speak of plucking certain buds from the plants to insure bigger buds elsewhere.
 B. Explore the meaning of being grafted onto the vine.
As you ponder these images, explore in depth what Jesus was saying. What is the fruit that Jesus calls us to bear? How do we know if we are

bearing good fruit? That is, what criteria can we as humans use to evaluate the fruit of our lives? Do we use the same criteria God uses in evaluating the fruit of our lives, the adequacy of our branch on the true vine of Christ?

II. Discuss the concept of "abiding."
 A. Identify contemporary lifestyles in which persons abide, intentionally or unintentionally.
Pat McGeachy holds that a key to understanding the fifteenth chapter of John is the word "abide." He claims that to abide involves almost no effort at all; then he lists several synonyms for the word. Share these synonyms with the class, then ask them to list some more. Help them see that "abide" is, as Dr. McGeachy points out, a word of relaxation rather than effort; it is a word of trust rather than merit; it is a word of peace rather than struggle.
 B. Probe the changes in lifestyle brought about by a commitment to abide in Jesus.
Shortly after I first read Dr. McGeachy's ideas on the subject, my family and I went to a lake near our home. I usually swim vigorously in order to get physical exercise, but this day I decided to be lazy. I took two lifejackets with me out into the lake, then simply laid back, allowing the jackets to support me while I felt the warmth of the sun and the water. I drifted easily, rocking gently in the slight breeze. I didn't need to kick or paddle; the jackets supported me. This is what abiding is like, I thought—trusting, fully confident that I will be held up, supported, sustained. That's what Jesus assures us in Matthew 11:28; that's what accepting the grace of God through faith (not by obedience to the law) means for Paul.

III. Discover ways that self-giving love fulfils the commandment to abide in Jesus as the vine.
 A. Discuss the nature of the love to which Jesus calls us.
Pose this question for general discussion: "How can we love as Christ first loved us? What would such love look like and be like?" List answers and responses on the chalkboard or newsprint.
 B. Describe and discuss the changes that must be made in order to love as Jesus requires.
Help group members perceive that such love is a response, not a requirement, and that the lifestyle such love stimulates is a life lived in response to what God has already done, not a life lived in fear of what God will do. You might present this idea this way: When the Christian begins to abide in Jesus as the true vine, when the Christian makes a total commitment of trust in Jesus, that Christian begins to live in response to the love she or he feels from Jesus. It is a response to Jesus that stimulates such love; it is giving back in part the love one feels that is the hallmark of such love. A lifestyle or a love lived out of fear of what God will do if we don't love is no love at all; it is self-centered, self-saving love; it is doomed to failure. But the love about which Jesus spoke is a self-giving love lived in response to the love of God in Christ.

Helping Class Members Act

Invite class members to examine their own lives during the coming week and to keep a very personal journal listing examples each day of the times they have acted out of self-interest and the times they have consciously acted

in response to Christ's love for them. Invite class members to read Matthew 6:25-33 at the beginning of each day and to commit themselves wholly to abiding in Christ for that day.

Planning for Next Sunday

Direct class members to read John 16 before your next session and to ponder the nature of the Counselor Jesus promises. Can class members bring to the next session evidences of the presence of the Counselor in our world today?

LESSON 2 MARCH 11

Guided by the Spirit of Truth

Background Scripture: John 16

The Main Question—Pat McGeachy

Most of the time I feel pretty much alone, even when there are a lot of other people around. If you are not like that, you are a very fortunate person. But everybody is absolutely alone some of the time. When you are in your mother's womb, you are surrounded by love, and yet (unless you happen to be a twin) you are all by yourself there. And when you die, you have to do that all by yourself. There is a country music song that says, "You have to go to sleep alone." And it is especially lonely for us when we lose someone we really care about. That can happen in lots of ways—death, divorce, going off to college, moving away, changing jobs, to name a few.

Now the disciples are about to lose their dearest friend, the person who has given new meaning and hope to their lives. Worse than that, they are going to undergo really tough times—criticism, punishment, even death. And Jesus, aware that all this will come upon them, is preparing them to face it with hope and courage. He does not try to cover up the pain that they can expect. Ever the perfect realist, he knows that no amount of "positive thinking" can prevent his own loneliness (verse 32) and the inevitable discouragement of his followers. So he gives them a promise and a reminder.

The promise is that the Spirit of truth will come. Even though they cannot now understand or deal with the things that are to happen (verse 12), the time will come (verse 13) when the Spirit will open their eyes to understand the truth; then they will be able to look back and say, "So *that's* what it all meant!"

The reminder is that no matter what difficulties they may encounter, Jesus has already won the ultimate victory. "In the world you have tribulation, but be of good cheer, I have overcome the world" (verse 33).

244

The main question, then, is, Do we have the resources to face life's aloneness, and if not, how can we get them?

As You Read the Scripture—Harry B. Adams

John 16:12-15. As John interprets the relationship between Jesus and his disciples, there are matters that the disciples will not be able to grasp while Jesus is with them in the flesh. They will come to fuller understanding only after the death and resurrection of Jesus and when the Spirit returns to guide them.

When the Spirit does return, significant possibilities will be opened to them. Jesus indicates several things that will happen. First, they will have new expression to them of the truth, for "when the Spirit of truth comes, he will guide you into all the truth." Jesus has declared that he is the truth, but the disciples are simply incapable of grasping some of the dimensions of the truth that he manifests. But the Spirit will be active in the lives of the followers of Christ, to enable them to grow in their understanding of the truth.

Second, the Spirit will not come with some new authority or new word but will make known what God speaks through the Spirit. The Spirit that is at work in the Christian community is always a new expression of the power and truth of God made known in Jesus Christ.

Third, the Spirit "will declare the things that are to come." Jesus was not in the business of predicting details about the future, and neither is the Spirit in the Christian community. But the Spirit brings the assurance of the future, that whatever the future holds it will be within the presence and the purpose of God.

Fourth, the Spirit will glorify Jesus. The Spirit brings new expressions of the truth and new power into the faithful community, but it is truth and power in accord with those exhibited by Christ, and thus they give glory to him.

Verses 16-24. This section is built around the words "a little while." Jesus talks about two periods of time in verse 16, both of them short. A little while and the disciples will not see him any more; a little while and they will see him again. The first period is the short time that remains for Jesus to be with his disciples before he is crucified; the second period is the short time that will elapse before they know him as the risen Lord.

As often happens in John, the disciples do not understand, and again as often happens in John, Jesus knows what they are puzzled about before they even ask him.

Jesus tells them that they will grieve because of what will happen to him. But even as a woman's pain in childbirth turns into joy, so the disciples will rejoice when Jesus returns to them.

For on that day whatever they ask *in the Lord's name* will be given to them.

Selected Scripture

King James Version	Revised Standard Version
John 16:12-14	*John 16:12-14*
12 I have yet many things to say unto you, but ye cannot bear them now.	12 "I have yet many things to say to you, but you cannot bear them now. 13 When the Spirit of truth

13 Howbeit when he, the Spirit of truth, is come, he will guide you into all truth: for he shall not speak of himself; but whatsoever he shall hear, *that* shall he speak: and he will shew you things to come.

14 He shall glorify me: for he shall receive of mine, and shall shew *it* unto you.

15 All things that the Father hath are mine: therefore said I, that he shall take of mine, and shall shew *it* unto you.

16 A little while, and ye shall not see me: and again, a little while, and ye shall see me, because I go to the Father.

17 Then said *some* of his disciples among themselves, What is this that he saith unto us, A little while, and ye shall not see me: and again, a little while, and ye shall see me: and, Because I go to the Father?

18 They said therefore, What is this that he saith, A little while? we cannot tell what he saith.

19 Now Jesus knew that they were desirous to ask him, and said unto them, Do ye enquire among yourselves of that I said, A little while, and ye shall not see me: and again, a little while, and ye shall see me?

20 Verily, verily, I say unto you, That ye shall weep and lament, but the world shall rejoice: and ye shall be sorrowful, but your sorrow shall be turned into joy.

21 A woman when she is in travail hath sorrow, because her hour is come: but as soon as she is delivered of the child, she remembereth no more the anguish, for joy that a man is born into the world.

22 And ye now therefore have sorrow: but I will see you again, and your heart shall rejoice, and your joy no man taketh from you.

23 And in that day ye shall ask me nothing. Verily, verily, I say unto you, Whatsoever ye shall ask the Father in my name, he will give *it* you.

comes, he will guide you into all the truth; for he will not speak on his own authority, but whatever he hears he will speak, and he will declare to you the things that are to come. 14 He will glorify me, for he will take what is mine and declare it to you. 15 All that the Father has is mine; therefore I said that he will take what is mine and declare it to you.

16 "A little while, and you will see me no more; again a little while, and you will see me." 17 Some of his disciples said to one another, "What is this that he says to us, 'A little while, and you will not see me, and again a little while, and you will see me'; and, 'because I go to the Father'?" 18 They said, "What does he mean by 'a little while'? We do not know what he means." 19 Jesus knew that they wanted to ask him; so he said to them, "Is this what you are asking yourselves, what I meant by saying, 'A little while, and you will not see me, and again a little while, and you will see me'? 20 Truly, truly, I say to you, you will weep and lament, but the world will rejoice; you will be sorrowful, but your sorrow will turn into joy. 21 When a woman is in travail she has sorrow, because her hour has come; but when she is delivered of the child, she no longer remembers the anguish, for joy that a child is born into the world. 22 So you have sorrow now, but I will see you again and your hearts will rejoice, and no one will take your joy from you. 23 In that day you will ask me no questions. Truly, truly, I say to you, if you ask anything of the Father, he will give it to you in my name. 24 Hitherto you have asked nothing in my name; ask, and you will receive, that your joy may be full."

24 Hitherto have ye asked noth-
ing in my name: ask, and ye shall
receive, that your joy may be full.

Key Verse: **When he, the Spirit of
truth, is come, he will guide you
into all truth. (John 16:13)**

Key Verse: **When the Spirit of
truth comes, he will guide you into
all the truth. (John 16:13)**

The Scripture and the Main Question—Pat McGeachy

When the Establishment Won't Listen (John 16:1-4a)

Jesus was a Jew, and so were most of his early disciples. He did not come to
do away with the religion of his mothers and fathers, but to help it become
what it was meant to be all along (see Matthew 5:17). When Paul and the first
Christian missionaries began their journeys, they started with the
synagogues, where they expected to be heard (see Acts 17:1-2, for example,
as well as Romans 1:16). But it was not to be, as Jesus foresaw. Paul himself
was to be one of those whose zeal led him to persecute the early disciples.

In the same way the reformers (Luther, Calvin, etc.) sought not to break
away from the medieval Catholic church but to remake it nearer to the
Bible's teaching. And of course, John Wesley remained in the Church of
England for all of his ministry; he would have been pleased to see that great
institution reshaped according to his fresh understanding of the gospel. But
it is hard to change institutions. This is true of secular traditions (like
governments and universities), but it is especially true of religious bodies. In
addition to their natural inertia, we have a way of making idols out of our
"sacred" traditions. We say, "We've never done it that way before!"
Churches don't look like churches unless they have colonial columns in
front of them; the order of worship doesn't seem right if the "Old
Hundredth" doxology isn't sung at time of the offering.

Of course, we should be loyal to our institutions as long as we can, for if we
always went off on our own over every issue that came up, there would be a
different denomination for each one of us. It would be chaos. But there do
come times when each individual has to stand alone against the traditions.
Knowing when that time has come is one of the great questions of life. I
would suggest the time has not come unless all of the following are in
agreement:

> The Bible
> Your conscience
> Your common sense
> The testimony of some other people you trust
> The testimony of the Spirit

And that last one brings us to the next section.

The Counselor (16:4b-15)

Jesus knows that he has to "cut the apron strings" from his disciples so
that they can grow up. The Zen Buddhists like to say, "Kill the Buddha."
This is their rather dramatic way of reminding themselves that they must

not remain dependent on a guru if they expect to achieve spiritual maturity. In one sense, of course, Christians will always be dependent on Jesus; we cannot hope to achieve our salvation by our own strength; it is always the gift of God (see Ephesians 2:8). But in another sense we must learn to move from "spiritual milk" to the solid food of the faith (I Corinthians 3:21; 13:4).

It is a little like a fledgling being kicked out of the nest or a child going off to school on his or her own. It's a little like a person making a solo flight in an airplane without the instructor or a subordinate officer beginning to show signs of reaching upward for more responsibility. However you look at it, Jesus knew that we need to make the step and that having made it, we will be able to do even greater things (John 14:12). I don't know exactly what he meant by that, but I know of a retired missionary who in his lifetime restored sight to more than ninety thousand (that's correct!) persons through improved technique in cataract removal. That is many more blind persons than Jesus healed.

To have the Counselor or the Spirit, then, is to have grown spiritually (note the word "spirit" hiding there) to the point that you can now discern for yourself your deepest needs and those of the people around you. The Spirit helps the spiritually mature to

—Be convinced and to convince others of sin (verse 8). Without that insight I may foolishly continue in my own misguided way.
—Point the way to righteousness (verse 10). We can't always be turning to Jesus (or mother or dad or the church) to ask what's right and wrong. We need to know, both in matters of personal morality and social justice.
—Perceive what we could not have seen while we were children in the faith (verses 12-13). The Spirit teaches us what we could never have known about truth.

All of this must be seen over against the arrogant claim for spiritual independence of Adam and Eve, who thought they were achieving spiritual maturity in eating the fruit of the tree of knowledge. We will never become "independent" of God or become gods ourselves, but we can grow up to work as "partners" with God in the great task. Just as now that we are grown, we can be much closer to our parents than we ever could when we were children, so having grown in Christ, we no longer need to be his slaves, but his "friends" (John 15:15).

Sorrow into Joy (16:16-24)

Growing up is painful; ask any adolescent. I know that I do not wish to be a teenager again. But like labor pains (verse 21), it is a hurt worth bearing. We may be weeping now (verse 20), but joy comes in the morning (Psalm 30:5). Jesus physically left those early disciples, that they might learn to cope without him, or better, with his Spirit in his absence. He also leaves us from time to time. Sometimes prayers seem to go unanswered. Perhaps when I cry, "God, help me!" and no help seems to come, it may be that God is saying in effect, "I will not help you now, for I trust you to make your own decision in this matter." If we need it, God may strike us down on some Damascus road, to force us in the right direction. But it is a compliment to our faith when we are left to struggle on down the road alone. It is as the old stag said to Bambi, "Your mother has no time for you now." The time has

come for me to walk the valley of the shadow by myself. But I am never *truly* alone. The Spirit, which is the Shepherd's rod and staff, is with me. Even in that dark night, goodness and mercy follow after, and I will dwell in the house of the Lord forever.

I Have Overcome (16:25-33)

The reason that we can confidently sing "We Shall Overcome" is that Christ has already overcome (verse 33). This does not mean that we will have no tribulation; while the earth remains, there will always be that. But it does mean that God is surely with us. There is no question of Jesus standing between us and God, like the high priest of ancient sacrifices. That may have been his role in the act of the cross (see Hebrews 8–9), but now the veil in the temple has been torn in two from top to bottom (Mark 15:38; Hebrews 10:20), and we have direct access to God.

In a way, we can understand the atonement only by thinking of God demanding righteousness, and Jesus supplying it in his perfect life and death. But in another way, we must never think that while Jesus is our friend, God is our enemy. It was God in Christ who was reconciling us (II Corinthians 5:19) at Calvary. And it is not simply Jesus but God the Father who loves us and will answer our prayers (John 16:27).

The world *has* been overcome. Sure, there will be tribulation, but what of it? The outcome is sure. Yes, there are birth pains, but the new life is already born. True, sparrows fall, but God has them counted (Matthew 10:29-31), and no death of God's servants will go unnoticed or unrewarded. Nobody said it would be painless, but the pain will be worth it. The day may come, burning like an oven (Malachi 4:1-2), but for those who belong to Jesus, the sun of justice will rise on wings of healing.

Helping Adults Become Involved—John Gilbert

Preparing to Teach

Commence your preparation by praying that God may illuminate your understanding of this passage from the Gospel of John. Seek to open your heart and mind to God as you read and reread these words of Jesus. Then pray for each of your group members by name, lifting up before God the needs of each individual.

To "get inside" this passage, especially in light of the concerns raised by Pat McGeachy, recall those times when you have felt most completely and entirely alone. Do not reflect only on moments of physical isolation; bring to mind those moments of emotional and social isolation, those moments when you felt completely alone and experienced the sense of helplessness that accompanies feelings of extreme aloneness.

Now reflect on those moments in your life when you have felt the presence of God in very powerful and unexpected ways. Can you bring to mind what you were doing and what was happening that made these occasions especially significant in terms of a sense of God's presence? Would you be willing to share some of each of these kinds of experiences with group members?

The purpose of this session is to comprehend the ways in which Christ is very present with us here and now in our lives, even though he is not present

to our external senses of touch, taste, smell, sight, or hearing. Persons should emerge from this session with a new sense of Christ's constant presence in a variety of forms and ways. We are not alone.

You may want to outline your session like this:

I. Jesus promises the Counselor.
 A. The nature of the Counselor
 B. The individual experience of the Counselor
II. Jesus is present in Spirit though absent in body.
 A. The necessity of Jesus' departure from the physical body

Can you arrange your classroom with chairs in a circle to facilitate discussion? Also, have on hand a chalkboard and chalk or large sheets of paper and suitable markers. Many teachers have on hand a supply of extra Bibles, paper, and pencils for the use of students during the session.

Be aware that this particular session may arouse some strong feelings in class members. Loneliness is a difficult subject for many persons to face. Do not be afraid of expressions of strong feelings, but attempt to resolve these feelings in and through the session. Make the group as supportive as possible. Can group members provide emotional support for the new widow and thereby be the presence of Christ for her? Can the group undergird in the name of Christ the middle-aged man who has never married and is completely alone except for a routine job? These are dimensions of being the church alive, the church in action.

Introducing the Main Question

One of the most universal human experiences is the feeling of aloneness. Note that aloneness is different from loneliness. Loneliness is a passing feeling that is often the creation of the situation. Aloneness is a constant, nagging sense of isolation no matter what the outward circumstances. Jesus had appeared to and called a group of loyal followers. And in walking with them for three wonderful years he had overcome both their feelings of loneliness and aloneness. He had broken down the walls of isolation between them and one another and between them and God. The apostles were no longer alone; they were no longer encysted in their own worlds. Their worlds had been opened up, and their lives were full.

But now Jesus, the cause and the reason for their sense of fulfillment, was preparing them for his departure. But at the same time he was promising them that they would not be alone, that they would not return to their former condition of isolation and separateness. He promised them a Counselor, the Spirit of truth, the very presence of God with them.

And in making this promise to the disciples, Jesus was making this promise to you and to me. He has broken down our aloneness, he has overcome our isolation. The question is, Do we live in that reality?

Developing the Lesson

I. Jesus promises the Counselor.
 A. The nature of the Counselor
Explore the nature of the Counselor with the group members. Help them discuss the meaning of Jesus' statement that the Counselor would convince

the world of sin and righteousness. Help group members see that one of the distinct functions of the Holy Spirit in our lives is to be for us the presence of God within us, the presence of God helping us to determine the ways we are called by his grace to live. The Holy Spirit has been described as that part of us which is God. While this may be an oversimplification, it does help us see that as Jesus gave us of his body and blood in the sacrament of the Lord's Supper, so did he this same night, promise to reside within us in the form of the Holy Spirit, as the divine presence in our lives. Thus the Counselor is not one who is to come; the Counselor is one who is already here, strengthening and sustaining us in every way.

A caution: Christian theology has raged for centuries over the nature of the Holy Spirit, some arguing that the Spirit proceeds from the Father and is thereby co-existent with him, others arguing that the Holy Spirit was "created" later and proceeds from the Father and Son. This latter position was declared a heresy almost sixteen hundred years ago, but it still emerges from time to time. Do not get involved in a tangential discussion of this; merely be aware of it in case it arises from within the group.

B. The individual experience of the Counselor

But how can one know if the Holy Spirit is directing him or her? Dr. McGeachy answers this thorny question by posing five judgment criteria: the Bible, the conscience, common sense, the testimony of others you trust, and the testimony of the Spirit. One major Protestant denomination goes a bit further in listing as the criteria Scripture, tradition (what the church has always believed), experience (what has happened in the life of the individual), and reason (our common sense and our ability to think things through). You might discuss as a group how these interact to provide answers for life's questions.

II. Jesus is present in Spirit though absent in body.

A. The necessity of Jesus' departure from the physical body

Pose this question: Why could Jesus not remain with the disciples in the body? Entertain a number of answers and responses, all of which probably have some truth to them. Then help the group members recognize some central ideas:

a. Jesus' departure was part of God's plan.

b. Jesus' departure ensured that the disciples would carry on his message.

c. Jesus' departure demonstrated that Jesus is not bound by time and space.

d. Jesus' departure transformed Christianity from a cult built around a historical figure to a life-sustaining faith based in the constant and eternal presence of Christ here and now.

e. Jesus' departure was a vivid demonstration to the disciples of Jesus' Sonship, forcing those disciples—and us—to abandon traditional categories and ways of understanding in order to see all things new (Revelation 21:5).

Helping Class Members Act

Of vital importance is moving the disciples' experience in the upper room into the contemporary world. Jesus' words were not addressed to the disciples only but to us here and now. Ask each group member to reflect in

silence, then to keep careful notes during the coming week on the ways her or his life is different because of the presence of Christ. Persons might ask themselves in everyday experiences: "How would I respond differently if the presence of Christ were not within and around me?" The Counselor was given to us; are we fully aware of the Counselor in our midst?

Planning for Next Sunday

Ask class members to carefully study John 11:47-53 and John 18:1-14 prior to your next session.

LESSON 3 MARCH 18

Facing Crucial Choices

Background Scripture: John 11:47-53; 18:1-14

The Main Question—Pat McGeachy

How could anybody betray Jesus? Maybe I could imagine somebody letting down the president of the United States, or even being a traitor to friends and family, but who could stoop so low as to deliver into the hands of his enemies the one perfect person who ever lived?

But as strange as it seems, it is most often innocence that is betrayed. It seems that we are jealous of such innocence and want to see it besmirched. It makes us feel better to think that the righteous one can be brought down to our level. Or perhaps it is not so much jealousy as frustration. It anger us that the innocent party is being so patient with our enemies, not clobbering them as we think they deserve. It's the sort of feeling you get when you are driving in a hurry in traffic, and the car in front of you takes a long time to let the person in front of *it* into the line. Sometimes goodness is just plain irritating.

So, one part of the main question is, How can we make sure that *we* do not betray Jesus? For apparently many of us do. But the other side of the question must be asked from Jesus' point of view: How will we manage when other people betray us? It is hard not to give up when this happens.

Sometimes when a wife or husband is unfaithful, the one who has been hurt will use this as an excuse to give up on the marriage, saying something like, "What's sauce for the goose is sauce for the gander." But that is just when the marriage needs your loyalty most. "Everybody's doing it" is never an excuse for dropping your moral standards. Jesus, deserted by his friends, betrayed by one of his own, and condemned by his enemies, continued to put his trust in the faithful God whom he served.

Frankly, I don't like to think about betrayal. It's like a disease; I don't want to have anything to do with it. But it might happen, by me or to me, so I'd better be prepared to do battle.

As You Read the Scripture—Harry B. Adams

The long discourse Jesus had with his disciples, recorded in chapters 14–17, is at an end, and the Gospel of John now begins the story of the arrest, trial, and crucifixion of Jesus. The account here is similar in basic outline to the accounts in the other three Gospels; but as is true throughout this Gospel, John is more interested in asserting theological convictions than in an accurate depiction of what actually happened.

Several significant assertions about Jesus are made as John tells the story: Jesus is in absolute control of the situation; Jesus lays down his life in behalf of his followers; Jesus gives freedom to his followers by his sacrifice; Jesus acts in obedience to the commandment of God.

John 18:1-2. The Kidron valley is just to the east of Jerusalem. John does not name the garden identified as Gethsemane by Matthew and Mark. Judas was able to find Jesus there because the disciples and the Lord had often gathered there.

Verse 3. Judas had last been with Jesus and the disciples as they ate together what was to be their last supper. Jesus had warned that one of them would betray him, and when Jesus identified Judas as the one, Judas left the group. John particularly noted that it was night when Judas went out (13:30). It was still night when they came to find Jesus to do their evil deed, for they carried lanterns and torches.

Verses 4-5. John makes explicit that Jesus knew exactly what was happening. When he saw Judas and the soldiers and officers approaching, he initiated the contact with them by asking who they were seeking. When they told Jesus who it was they were after, he replied, "I am he," a reflection of the several times in this Gospel when Jesus has asserted "I am": "I am the bread of life"; "I am the good shepherd."

Verses 6-9. John makes clear that those who came to get Jesus really had no power over him, for when he told them who he was "they drew back and fell to the ground."

Again Jesus initiates the contact with them as he asks who they are seeking. When he says again that he is the one they are looking for, he makes clear why he wants them to take him: so that those who are with him can be let go and set free. The word referred to in verse 9 was spoken by Jesus in John 17:12.

Verses 10-11. Peter tries to defend Jesus, but his effort is futile and he is so inept that he cuts off the ear of Malchus, the high priest's slave. No human effort will change anything in this scene, for Jesus is doing what God has given him to do.

Verses 12-14. Jesus is seized and bound and led to Annas, who was high priest from A.D. 6 to 15; Annas still controlled the Sanhedrin through his son-in-law, Caiaphas. The reference to the counsel that Caiaphas had given recalls the incident recorded in John 11:49-51.

Selected Scripture

King James Version

John 18:1-14

1 When Jesus had spoken these words, he went forth with his disci-

Revised Standard Version

John 18:1-14

1 When Jesus had spoken these words, he went forth with his disci-

ples over the brook Cedron, where was a garden, into the which he entered, and his disciples.

2 And Judas also, which betrayed him, knew the place: for Jesus ofttimes resorted thither with his disciples.

3 Judas then, having received a band *of men* and officers from the chief priests and Pharisees, cometh thither with lanterns and torches and weapons.

4 Jesus therefore, knowing all things that should come upon him, went forth, and said unto them, Whom seek ye?

5 They answered him, Jesus of Nazareth. Jesus saith unto them, I am *he*. And Judas also, which betrayed him, stood with them.

6 As soon then as he had said unto them, I am *he,* they went backward, and fell to the ground.

7 Then asked he them again, Whom seek ye? And they said, Jesus of Nazareth.

8 Jesus answered, I have told you that I am *he*: if therefore ye seek me, let these go their way:

9 That the saying might be fulfilled, which he spake, Of them which thou gavest me have I lost none.

10 Then Simon Peter having a sword drew it, and smote the high priest's servant, and cut off his right ear. The servant's name was Malchus.

11 Then said Jesus unto Peter, Put up thy sword into the sheath: the cup which my Father hath given me, shall I not drink it?

12 Then the band and the captain and officers of the Jews took Jesus, and bound him,

13 And led him away to Annas first; for he was father in law to Caiaphas, which was the high priest that same year.

14 Now Caiaphas was he, which gave counsel to the Jews, that it was expedient that one man should die for the people.

ples across the Kidron valley, where there was a garden, which he and his disciples entered. 2 Now Judas, who betrayed him, also knew the place; for Jesus often met there with his disciples. 3 So Judas, procuring a band of soldiers and some officers from the chief priests and the Pharisees, went there with lanterns and torches and weapons. 4 Then Jesus, knowing all that was to befall him, came forward and said to them, "Whom do you seek?" 5 They answered him, "Jesus of Nazareth." Jesus said to them, "I am he." Judas, who betrayed him, was standing with them. 6 When he said to them, "I am he," they drew back and fell to the ground. 7 Again he asked them, "Whom do you seek?" And they said, "Jesus of Nazareth." 8 Jesus answered, "I told you that I am he; so, if you seek me, let these men go." 9 This was to fulfil the word which he had spoken, "Of those whom thou gavest me I lost not one." 10 Then Simon Peter, having a sword, drew it and struck the high priest's slave and cut off his right ear. The slave's name was Malchus. 11 Jesus said to Peter, "Put your sword into its sheath; shall I not drink the cup which the Father has given me?"

12 So the band of soldiers and their captain and the officers of the Jews seized Jesus and bound him. 13 First they led him to Annas; for he was the father-in-law of Caiaphas, who was high priest that year. 14 It was Caiaphas who had given counsel to the Jews that it was expedient that one man should die for the people.

Key Verse: No man taketh [my life] from me, but I lay it down of myself. (John 10:18)

Key Verse: No one takes [my life] from me, but I lay it down of my own accord. (John 10:18)

The Scripture and the Main Question—Pat McGeachy

A Strange Prediction (John 11:47-53)

The eleventh chapter of John is, of course, the famous story of the raising of Lazarus from the dead, with its ringing declaration, "I am the resurrection and the life." Perhaps because of this dramatic event, it is easy to overlook the curious announcement, recorded in the last few verses, of Caiaphas the high priest. He too was aware (verse 46) of Jesus' remarkable accomplishment and prophesied (verse 50) that Jesus "should die for the people, and that the whole nation should not perish."

We needn't suppose that Caiaphas meant any sort of messianic prediction by this announcement. Very soon now it will be in the house of Caiaphas (Matthew 26:57; John 18:28) that Jesus will be first examined and then locked up. If you go to Jerusalem today you will find the church of "St. Peter of the Cock-Crow" built over the traditional site of that house, and beneath it a lonely cell into which the prisoner must be lowered by ropes. Legend has it that Jesus spent the night in that jail, but none of the Gospels record what he might have felt or prayed there. Lonely as the vigil in the garden was (Matthew 26:36-46), at least a few disciples slept nearby, but here he was utterly deserted by his friends. No, Caiaphas was evidently thinking that Jesus could be used as a convenient scapegoat (Leviticus 16:20-22) to divert the attention of the Romans away from the official government of Israel. The curious thing about his remark is that it turned out to be true in a way he could never have dreamed. Thus, verses 51-52 are a prefiguring of I John 2:2: "He is the expiation for our sins, and not for ours only but also for the sins of the whole world." In support of his idea (verse 53), Caiaphas and his friends began to plot ways to execute Jesus as a troublemaker.

The Willing Sacrifice (John 18:1-11)

They needn't have bothered. Jesus had long before steadfastly set his face to go to Jerusalem, where he was to die (Luke 9:51; Isaiah 50:7). He was not simply the victim of plots by the power structure; it was his own choice. "No one takes my life from me," he had announced (10:18), "but I lay it down of my own accord." Again and again he has tried to warn his friends that this is the way things are to be, but they have not been able to bear it (see, as a prime example, Matthew 16:21-23).

In this incident Simon is still playing the role of Satan, drawing his sword and attempting to thwart the inevitable course of history. It almost seems that in this story, *Judas* is closer to his master's will than Peter! At least his treachery brought about the necessary fulfillment of prophecy, whereas the clumsy fisherman was trying to stop it by drawing his sword and putting up a fight (verses 10-11). But Jesus will have none of it; if the kingdom could be brought about by swords, Judas Maccabeus would have done it long before. Another more subtle sword is at work here, the sword of the Spirit, which is the Word (Ephesians 6:17; Hebrews 4:12; Revelation 1:16).

Then is Judas merely a pawn in the larger plan of God? Are we not

responsible for our own actions? Let's be careful not to get very far into the great debate about determinism and free will. Let us simply conclude that two wills were operating here: the will of God (with which Jesus was totally in accord) and the will of Judas. When two such wills collide, which will prevail? That of the Sovereign of the Universe, certainly. God permitted Judas to do his wicked deed. Perhaps the unfortunate disciple really believed he was helping precipitate the revolution by forcing Jesus into action; or maybe he was merely greedy for the thirty pieces of silver. But whatever his motives, the prevailing motive was that of God in Jesus. Neither Peter's rashness nor Judas's treachery could stop Jesus from the cause for which he had come into the world. He was to lay down his life, and lay it down he would, in spite of foe or friend.

Just behind the house of Caiaphas, in the old city of Jerusalem, there is a set of centuries-old steps leading down to the brook Kidron (verse 1), across from which there is a garden on the slopes of the Mount of Olives. When you go to the Holy Land, you will be disappointed to discover that it is untrue that "those little lanes, they have not changed." In fact, most of the Jerusalem of Jesus' day is buried many feet below street level. But those steps may be one of the few visible places where Jesus' own feet walked. Past the house of the priest he went, the one who would be his accuser in a few hours. In a strange way Caiaphas had already passed sentence, before the trial. And like the betrayal of Judas, the sentence of the high priest would serve not to thwart the will of the Christ but to bring it to fulfillment.

Before Annas (18:12-14)

From here on out, the events in the last days of Jesus' life move swiftly, inexorably, through a series of mock trials to his ultimate death. It makes me think of the top of Stone Mountain, in Georgia. When I was a small boy, my grandmother walked with me to the top, where my incipient acrophobia began to tell on me. The stone gradually sloped in all directions, until the great monolith fell away in a steep precipice. The signs warned *Do Not Go Beyond This Point,* for it had been proven by bitter experience that one who ventured thus far might be unable to stop his deadly momentum. When did Jesus get to this point of no return? You might say it was when he overturned the tables in the temple and incurred the wrath of the authorities (Mark 11:18). Or you might say it was when he set his face to Jerusalem (Luke 9:51). But I say that the answer was brooding in the heart of God when the Spirit brooded over the waters of chaos (Genesis 1:2), for the death of the Lamb been written in the Book from before the foundation of the world (Revelation 13:8).

The die has been cast, and with Peter sneaking behind, Jesus is taken to the house of Annas. It was a brief stop on the way. This Annas was the father-in-law of Caiaphas, and formerly high priest, but no longer in office. However, he apparently still bore the title (like ex-presidents and governors) and must have still been thought of as having a good bit of influence, for that is where they went first. Part of the proof of his importance is to be found in the fact that both he and Caiaphas were prominent in the examination of Peter and John when the two of them were subsequently arrested (Acts 4:6).

Jesus has almost nothing else to say; in the courts he remains virtually silent; on the cross he speaks only to God and a few disciples. He has made

his presentation; from now on it is up to God. When we come up before the Annases and the Caiaphases of this world, when we are saddled with enemies like Judas and well-meaning friends like Peter, when we are alone and lost, how shall we endure? There is a line in a nineteenth-century Gethsemane hymn that comes to my mind. After reminding us of the Man of Sorrows weeping in blood, wrestling alone with fears in that dark garden, the poet concludes:

> 'Tis midnight, and from heavenly plains
> Is borne the song that angels know;
> Unheard by mortals are the strains
> That sweetly soothe the Saviour's woe.
> ("'Tis Midnight, and on Olive's Brow")

And yet, Jesus having walked that lonesome valley for us, we too can hear those strains. No priestly hierarchy, no treacherous comrade, no rash friend can take away the one friendship that abides forever. As God promised long ago to that earlier Jesus (Joshua and Jesus are the same name in Hebrew), "Be strong and of good courage; be not frightened, neither be dismayed; for the Lord your God is with you wherever you go" (Joshua 1:9). Nothing can separate us from the love of Christ (Romans 8:38-39), and when the time comes that we are brought before Annas or Caiaphas, we do not need to be afraid (Matthew 10:19).

Helping Adults Become Involved—John Gilbert

Preparing to Teach

According to Pat McGeachy, the main question for today's lesson has two parts: (1) How can we make sure we do not betray Jesus? (2) How will we manage when other people betray us?

As you commence your preparations for teaching this session, take time to go to God in prayer. Pray for yourself, for your skills as a teacher, for your sensitivity to each of your students, for an open mind and an open heart. Pray for the awareness of God's presence in your midst as you and your class members study God's word. Seek God's guidance. Then pray for each member of your group by name.

Study the biblical passages for this session carefully. They include the plot on the part of some of the Jews to arrest and try Jesus, and they include the actual arrest of Jesus in the garden. You will want to read these accounts in several translations and paraphrases; get the story straight in your mind so that you can focus on the meaning of the incredible story and on its theological insights and intentions. One suggestion: Read the parallel stories in the three Synoptic Gospels, but do not worry about minor inconsistencies among the accounts. Bear in mind that John may have been writing as much as sixty-five years after the actual events he describes. His concern is not simply with accuracy of reporting but with the deeper meanings and theological implications of these events. Much can be said for the other three Gospel writers; each wrote from a distinctive theological perspective and for slightly different purposes. Thus, their accounts do not agree on every detail any more than the three major network news shows agree on every detail of a major story they are covering. In short, do not

allow your class to simply become a time of comparing and contrasting these accounts, or a time of trying to determine which is the most accurate. Such efforts miss the main point of the story.

You will need to plan your session around the needs and interests of the members of the group, but you may wish to adapt this outline:

I. The story of Jesus' arrest and trial
II. Were the events of John 18 foreordained?
III. Jesus is still being betrayed.

As always, arrange your chairs for optimum discussion. Have the chalkboard where all can see it easily, or use large sheets of paper fastened to a wall or door. Use visual images to enliven your class sessions.

Introducing the Main Question

Post in your meeting room a large sign that simply reads, "How do you betray Jesus?" Do not call attention to it or use it as a subject for discussion. Simply let the sign speak for itself, reminding all that each of us betrays Jesus day in and day out in scores of ways we recognize and many ways we fail to recognize. Dr. McGeachy also raises the question of how we handle our betrayal by others. This is a very common experience, one that all members of your group have endured. While this is an important question, try to keep most of the session focused on the ways in which we betray Jesus and the responses Jesus makes to that betrayal, as well as the response he made to the betrayal in the garden that night two thousand years ago.

Developing the Lesson

I. The story of Jesus' arrest and trial

Work with the whole group in developing the sequence of events leading up to the trial of Jesus. Start with the raising of Lazarus from the tomb. Write this on the newsprint or chalkboard. Now, ask group members to scan John 11:47-53 and call out what happens next in sequence. Jot down these events in their order on the chalkboard or newsprint. Next, move to chapter 18 of John, and ask group members to call out the events that happened in this passage in order.

When this task is completed, review the steps, pointing out the unfolding of this drama. Point out its inevitability, the way in which Jesus knew every step of the way just what he was going to do and the awful cost of each step. For example, pose these questions for brief discussion: Did Jesus know what would happen if he raised Lazarus from the dead? Or, to back the events up even further, did Jesus know what would happen if he returned to Judea (John 11:8)? Bringing the question to the fore, did Jesus know what would happen if he remained in Jerusalem after Judas had left the table? Did he know what would happen if he went with his apostles to one of their favorite spots, the garden of Gethsemane?

Point out that the central emphasis of John throughout his Gospel is the Word becoming flesh—God coming to earth to share our lives with us, to feel and to know and to experience fully as we do. You might point out Hebrews 4:15 as an example of this. Jesus is the high priest, but a high priest who knew the very worst of human life and experience as well as the elation of oneness with God.

II. Were the events of John 18 foreordained?

If your group is accustomed to working in teams, divide it into three small teams, and ask each team to consider one of these questions. Team one: What would have happened to us if Jesus had run from Jerusalem the night of Passover and hidden in the desert? Team two: What would have happened to us if Jesus had denied that he was Jesus in the garden and made good his escape? Team three: What would have happened to us if Jesus had called for legions of angels to slay his accusers and those who had come to arrest him? Hear brief reports from each team. Then pose this question: Do you believe (as does Dr. McGeachy) that the arrest, trial, crucifixion, and resurrection of Jesus Christ were ordained from the beginning of the world?

III. Jesus is still being betrayed.

Review quickly, using the newsprint or chalkboard notes that you made, the various ways Jesus was betrayed—by Judas, by the apostles, by some of the Jews, by some of the high priest's people, and so on. Pose this question for discussion: How do persons betray Jesus Christ today? In what ways do our actions, our words, even our thoughts betray Jesus Christ from time to time? Press for examples and illustrations. Help group members perceive that all persons betray Jesus in many ways every day. Then pose this question: What is the response of Jesus Christ to our repeated betrayal of him? Be sure that persons recognize both the forgiveness and the judgment of Jesus Christ in and through their responses.

Helping Class Members Act

Ask each class member to jot down on a small piece of paper the most obvious ways she or he betrays Jesus Christ. Ask class members to pray silently about what they have written on those slips of paper, then to fold and tuck them into purse or wallet as a way of reminding themselves of their commitment to try to overcome at least one behavior that betrays Jesus Christ.

Planning for Next Sunday

Invite group members to read and ponder John 18:15-27 before your next session.

Denying Jesus

Background Scripture: John 18:15-27

The Main Question—Pat McGeachy

Charlie was at a ward meeting at last. He had been invited by some of the politicians whom he most admired to attend a party in the basement of the lodge, to meet the mayor. He was only sorry that his friend Freddy was not there. They had often talked about how much it would mean to break into the fraternity of those whose decisions made a real difference to the city. And now Charlie had it made; after this, nobody would be able to call him a nobody! He was a friend of the mayor himself!

Then the mayor and his friends came in, and Charlie was introduced to him. "Glad to know you," said the politician. "We've been hoping to find someone like you from this precinct who could carry the ball for us. Good thing you're not one of the usual wimps like Freddy. You haven't been hanging around with him lately, have you?"

Charlie gulped and swallowed. "No, not lately," he stammered. He had been with Freddy that afternoon, but this didn't seem the appropriate time to say so. He wanted so much to win the approval of the mayor and his friends. "Not lately" . . . was that a lie? It hadn't been within the last couple of hours, that was true enough. But a lump stuck in Charlie's throat. Freddy was his best friend, and he had denied him.

I like to think that I wouldn't deny my friends, certainly not my Lord. But you never know what pressure will do to you. Simon had been renamed Peter, the "Rock" (Matthew 16:18). But the rock moved. The foundation stone of the church shifted its ground. Of course you or I wouldn't do such a thing! But that is what Charlie believed. Who knows what pressure might do to us? Would we stand firm?

The heart (main question) of this lesson is to help persons relive in their own lives the experience of Peter, and to feel as he did both guilt and forgiveness.

As You Read the Scripture—Harry B. Adams

This session and the session next week are both devoted to the trial of Jesus. First Jesus is brought before the Jewish authority, the high priest. Then he is brought before the Roman authority, Pilate.

In both confrontations between Jesus and the authorities, the Gospel of John makes clear that it is really not Jesus who is on trial but those who have seized him. And as this session makes clear, those who would be his disciples are also put on trial when the life and ministry of Jesus are threatened.

John 18:15-18. These verses focus on Peter, the most vocal and aggressive of the disciples. As Jesus had sat at the table with the disciples during their final meal together, he had told them that they could not come with him now. Peter had protested and wanted to know why he couldn't go with Jesus (John 13:31-38).

In this scene he does follow Jesus, as the Lord is taken before Annas. The

260

other disciple who gets Peter into the courtyard is not identified, but it could well be the disciple identified elsewhere as "the one whom Jesus loved" (John 13:23; 20:2; 21:7, 20). John's Gospel always places this disciple and Peter together.

Peter does follow Jesus into the courtyard, but when the maid asked if he was not one of Jesus' disciples, Peter promptly replied, "I am not." This denial stands in sharp contrast to Jesus' acceptance of his role and identity earlier in the chapter. When those who come to get him say they are seeking Jesus of Nazareth, he immediately responds, "I am he" (John 18:5-6, 8).

Verses 19-24. Jesus now stands before the religious authority and is asked about two things—his disciples and his teachings. It is surely ironic that he is questioned about his disciples just as the chief disciple, Peter, is denying that he is one. As far as his teaching is concerned, no specific issue is raised, and Jesus defends himself by saying that he has always taught publicly, so that people in the world and in the temple and the synagogue could hear.

As often happens when people know what they want to do but have a weak case to make, there was a resort to violence. An officer strikes Jesus and accuses him of being discourteous. When Jesus wants to know what he has done that is wrong, there is no answer. Annas doesn't look very good in this encounter with Jesus; he sends Jesus on to Caiaphas, the high priest.

Verses 25-27. The story now returns to focus on Simon Peter, who has been standing in the courtyard, trying to keep warm by the fire. Once again, when they ask Peter if he is not one of Jesus' disciples, he utters the emphatic denial, "I am not."

Peter's inept action in cutting off the ear of the high priest's slave when they came to get Jesus in the garden now comes back to threaten him, for a kinsman of the one whom Peter attacked asks if Peter wasn't there with Jesus. Again, Peter denies any relationship with Jesus. And then the cock crows, fulfilling the warning Jesus had given Peter at the Last Supper (John 13:38).

Selected Scripture

King James Version

Revised Standard Version

John 18:15-27

15 And Simon Peter followed Jesus, and *so did* another disciple: that disciple was known unto the high priest, and went in with Jesus into the palace of the high priest.

16 But Peter stood at the door without. Then went out that other disciple, which was known unto the high priest, and spake unto her that kept the door, and brought in Peter.

17 Then saith the damsel that kept the door unto Peter, Art not thou also *one* of this man's disciples? He saith, I am not.

18 And the servants and officers stood there, who had made a fire of

John 18:15-27

15 Simon Peter followed Jesus, and so did another disciple. As this disciple was known to the high priest, he entered the court of the high priest along with Jesus, 16 while Peter stood outside at the door. So the other disciple, who was known to the high priest, went out and spoke to the maid who kept the door, and brought Peter in. 17 The maid who kept the door said to Peter, "Are not you also one of this man's disciples?" He said, "I am not." 18 Now the servants and officers had made a charcoal fire, because it was cold, and they were

coals; for it was cold: and they warmed themselves: and Peter stood with them, and warmed himself.

19 The high priest then asked Jesus of his disciples, and of his doctrine.

20 Jesus answered him, I spake openly to the world; I ever taught in the synagogue, and in the temple, whither the Jews always resort, and in secret have I said nothing.

21 Why askest thou me? ask them which heard me, what I have said unto them: behold, they know what I said.

22 And when he had thus spoken, one of the officers which stood by struck Jesus with the palm of his hand, saying, Answerest thou the high priest so?

23 Jesus answered him, If I have spoken evil, bear witness of the evil: but if well, why smitest thou me?

24 Now Annas had sent him bound unto Caiaphas the high priest.

25 And Simon Peter stood and warmed himself. They said therefore unto him, Art not thou also one of his disciples? He denied it, and said, I am not.

26 One of the servants of the high priest, being his kinsman whose ear Peter cut off, saith, Did not I see thee in the garden with him?

27 Peter then denied again: and immediately the cock crew.

standing and warming themselves; Peter also was with them, standing and warming himself.

19 The high priest then questioned Jesus about his disciples and his teaching. 20 Jesus answered him, "I have spoken openly to the world; I have always taught in synagogues and in the temple, where all Jews come together; I have said nothing secretly. 21 Why do you ask me? Ask those who have heard me, what I said to them; they know what I said." 22 When he had said this, one of the officers standing by struck Jesus with his hand, saying, "Is that how you answer the high priest?" 23 Jesus answered him, "If I have spoken wrongly, bear witness to the wrong; but if I have spoken rightly, why do you strike me?" 24 Annas then sent him bound to Caiaphas the high priest.

25 Now Simon Peter was standing and warming himself. They said to him, "Are not you also one of his disciples?" He denied it and said, "I am not." 26 One of the servants of the high priest, a kinsman of the man whose ear Peter had cut off, asked, "Did I not see you in the garden with him?" 27 Peter again denied it; and at once the cock crowed.

Key Verse: **Then saith the damsel that kept the door unto Peter, Art not thou also one of this man's disciples? He saith, I am not. (John 18:17)**

Key Verse: **The maid who kept the door said to Peter, "Are not you also one of this man's disciples?" He said, "I am not." (John 18:17)**

The Scripture and the Main Question—Pat McGeachy

The First Denial (John 18:15-18)

It was a cold night. Not often are we given a temperature reading for a Gospel event (I'm thinking, for instance, of John 10:23; what sort of garments do you think Jesus would have worn in the winter?) The presence

of the fire adds a touch of reality to this stark scene. The central figures have moved into the interior of the house, but around the periphery the bit players are standing: the maid at the door, the slaves, and the non-commissioned officers. And among them is Peter, warming himself at the fire (verse 18).

The other disciple (verses 15-16; tradition says it was the disciple John—see also 13:28) has managed to make it into the house, because the high priest knew him. Either this gives him enough political "pull" to enable him to slip inside, or, figuring that he would be recognized anyway, he made bold to enter. The point is that Peter is alone. So was Jesus, as we saw in the last lesson. But it can come upon you with enormity. (I remember once when I was a very young man that my mother and father took a trip on a rather rickety airline into the heart of Brazil; it dawned on me that for the first time in my life I had no one to turn to, to lean on for help in making a decision.) John and Peter usually went together (Matthew 17:1; Mark 9:2; 14:33; Luke 8:51; 9:28, etc.) and they would do so again (Acts 3:11). But now Peter is very much on his own, surrounded by suspicious folk whom he must be anxious to please. He is an ignorant country boy, a Galilean in Jerusalem (see Mark 14:70), awkward and uncertain. And when the question is put directly to him (verse 17), he falters and fails. "Not me!" he says. Are you sure you would have done better?

Annas and Jesus (18:19-24)

We are indebted to John for having slipped inside, for otherwise we would know nothing of the interchange between Annas and Jesus. Only the Fourth Gospel makes much of Jesus' verbal sparring with his accusers, and there was not a lot of that. This conversation, and the give and take between Jesus and Pilate (18:33-38; 19:9-11), are about it. In the accounts in Matthew, Mark, and Luke, Jesus has variations on only three responses:

1. No answer (Matthew 26:63; Mark 14:61; also John 19:9).
2. You said it (Matthew 26:64; Luke 22:70; 23:3).
3. You will see the Human One ("the Son of Man") come in power (Matthew 26:64; Mark 14:62; Luke 22:69).

For the most part, the Lord prefers to remain silent before his accusers. Unlike insecure Peter, who is ready to blab a denial at the least question, Jesus, firm in his faith, knows that his defense is in the hands of God.

Here his reply to Annas is directly to the point: "You know what I have been teaching, or you would if you had been willing to listen," (verses 20-21) and, "Either charge me with a crime or leave me be" (verse 23). This simple honesty is too much for Annas, who has him bound and carried away to his son-in-law (who succeeded him as the chief priest). And John, if that is who it really was, stands quietly by, taking it all in. Is his silence less a denial than Peter's? Yet he is the only apostle who stood near the cross!

The Second Denial (18:25)

Back to Peter, who is still warming himself by that fire. There are slight variations among the four Gospels about the way the three denials happen:

THIRD QUARTER

The three tempters:	1	2	3
John: 18:15-27:	A maid	"they"	a kinsman of Malchus
Matthew 26:66-79:	A maid	another maid	bystanders
Mark 14:66-72:	A maid	the same maid	bystanders
Luke 22:54-62:	A maid	someone else	still another

The truth is, this story is more exactly preserved than almost any other event in Jesus' life. The slight variations do not alter the story at all, the central plot of which has been preserved by the church since its beginnings. If Peter was indeed the head of the church in those early days, we must commend him for his honesty. The story of his failure is told faithfully by the disciples, just as Israel fondly remembers David and Bathsheba. It helps to remember that the giants have their failings too.

The Third Denial (18:26-27)

O crumbling Rock! Once terror has gripped you in its teeth, it is hard to break free. For the third time Peter angrily denounces his Lord. And Luke adds the poignant words (verse 61), "And the Lord turned and looked at Peter." There is a familiar painting based on this text, by H. Becroft, which a cousin of mine kept on the wall by a chair in her house. She called it "The Jesus Chair" and used it to psychoanalyze her guests when she observed their reaction to the Lord's gaze. "I can always tell what they are thinking," she would say.

But what *could* Peter have been thinking? His despair was not suicidal like that of Judas (Matthew 27:5), but his weeping may have been even more bitter (Matthew 26:75). And it is not to reach its climax until the post-resurrection experience (John 21:15-22). There Jesus forces Peter to face the truth about his triple failure, which begins the process of hardening that will one day lead Peter to face his accusers with courage (Acts 4:13ff.) and to die for his Lord (John 21:19).

The fearful denial is transcended and replaced by the gracious command, "Feed my lambs." This story gives hope to me, for the many times that I have denied Jesus, perhaps not in so many words, but often in silence, and sometimes by engaging in behavior that the Lord would plainly reject. I like to think that it is often in ignorance, but every time I make that claim, the truth rises up to denounce me: "You know you're not ignorant. You're afraid, and you don't want to face the truth."

Sometimes I think that things are going very unfairly for me. We never get to choose our own martyrdom. I would rather die for some great heroic cause, with a Walter Mitty smile on my lips, but more often than not it sneaks up on me in a less than dignified way. It doesn't happen on the march to Selma; it happens in a barbershop in your home town when the barber begins to make racial slurs in the presence of the black man who shines shoes—do you speak up? It doesn't happen on a Crusade with Richard the Lion-Hearted; it happens when the person in the seat beside you on an airplane holds up a copy of the Good News New Testament and says, "I don't understand this, could you explain it to me?" It doesn't happen in the

jungles of the mission fields, it happens in the jungles of the schoolyard where you wearily toil each day as a teacher, and you encounter a child with a drug problem. All three of those events happened once to me, and I am not sure to this day that I responded boldly enough, or with the compassion of a true disciple. But that is not the end of the story, for I now that it will happen again, like "Candid Camera," when I least expect it. I will be warming myself at a fire, and a maid or a servant or a bystander will ask me about Jesus.

Knowing me, I expect I will try to hedge. "It's not fair, Lord," I will argue. "You didn't give me time to look up the Bible references so I could make my reply succinct and to the point. You could have had this person come to hear one of my sermons or read one of my Sunday school lessons. Why do you catch me off guard in the barbershop or the airplane or the schoolyard?" Or, when I am feeling especially put upon, "How come you don't put other people in this same embarrassing position?" But the Lord, as he looked upon Peter, looks on me (and you) and says, as he said long ago beside the lake, calling Simon to a life of witnessing (John 21:22), "What is that to you? You follow me." There is nothing then but to get up and go.

Helping Adults Become Involved—John Gilbert

Preparing to Teach

This Sunday's study is based on a comparatively brief passage of Scripture. Also, the story this passage describes is so familiar that many persons may be tempted to dismiss it with an "I know that." But take time to read and reread the story several times. Use different translations and paraphrases if you have access to them. Then try to jot down the story in your own words, creating your own paraphrase. We do not really know a story until we can retell it ourselves in our own words.

Now spend some time in prayer. Honestly talk with God about your own life and the times you have betrayed both the will and the person of Jesus Christ your Lord. Talk with God about how you felt at those moments of betrayal, and how you felt in the days that followed. Then earnestly thank God for the forgiveness and the reconciliation that has been extended to you through Jesus Christ. You will not know of the ways the members of your group have betrayed Jesus Christ as Peter did, but you can be sure each of them has. So pray for each of them by name. Pray that they might know the forgiveness Christ offers even after he has been betrayed by those he is forgiving. Pray that that same spirit of forgiveness might fill each of your group members—and you.

You will notice as you study Pat McGeachy's material in this session that he compares and contrasts the several biblical accounts of Peter's denial. Again, do not become entangled in extensive examinations of these, or argue about which may be the most accurate. Remember that the Gospel of John may have been written as many as sixty-five years after the events it describes and that the other Gospels were probably written at least a full generation after these events. The meaning of the stories, not the fine detail, is significant.

The main goal in this session is to help persons relive in their own lives the experience of Peter and to feel as he did both guilt and forgiveness. In a way, this is a different kind of learning goal. The purpose here is not simply to *know* something (educators call this a cognitive goal) but also to *feel* or

experience something. Such goals are known as affective goals, and they are very important in Christian education. Be prepared for some minor discomfort on the part of group members; affective learning experiences may be somewhat new and different for them. But unless we get the gospel inside ourselves—the feelings and emotions as well as the facts—it has little meaning for us. That is one of the reasons why Jesus repeated the classic words of Deuteronomy 6:4, reminding us that we must love God with our hearts, that is, our feelings, as well as with our minds.

Plan your session around a simple outline, such as this:

I. Identify the major events in the story of Peter's denial.
II. Explore the feelings and emotions within Peter.
III. Identify and examine parallels of Peter's denial in contemporary life.

Arrange the chairs in your classroom for optimum discussion, if possible. If you are planning to use some role-play during this session, you might choose to place the chairs in a horseshoe shape so that the role-plays can be enacted in the open end of the horseshoe.

Introducing the Main Question

Post a large sign in your classroom that reads simply, "When were you last a Peter?" Do not draw attention to it; simply let it speak to class members as they arrive and as they glance at it during the session.

When all class members have arrived, invite them to a moment of silent prayer. After a few seconds, say very softly, "Lord, forgive us our denials and rejections of you. Forgive us those moments when we, like Peter, have turned our backs on you. Forgive each of us those occasions when we have failed to stand for you and for you only. Amen."

Developing the Lesson

I. Identify the major events in the story of Peter's denial.

Invite the class members to join in outlining on the chalkboard or newsprint the events and facts in the story of Peter's denial. This is simply a "this came first, then that happened" sequence.

Now, encourage your group members to take part in a skit reenacting Peter's denial. Assign one person to be a "television reporter"; assign others to be the people around the courtyard fire, the other disciples (standing at a distance), and Peter himself. Ask the "television reporter" to interview each of the characters in turn, ending with Peter. The reporter should ask each what he or she saw, heard, and experienced at the moment of Peter's denial. Emphasize how the participants in this drama felt during the events and how they feel about the drama now. Sample questions: "Sir, can you show me where you were standing when Peter came up to the fire?" "What did you think when this stranger thrust his hands over the fire to warm them?" "Thomas, where were you when Peter denied Jesus? You had promised to go with Jesus all the way, but you disappeared that night in the Garden; how do you feel about Peter's actions—and about your own?" "Peter, do you recall if you answered immediately their questions about your relationship with Jesus, or did you carefully think through your answer to each one?"

As a whole group, discuss the insights you gained into the events through this role-play.

266

II. Explore the feelings and emotions within Peter.

As a whole group, list on the chalkboard or newsprint all of the reasons you can for Peter's actions. What caused him to do as he did? What motivated or propelled him to the point of denial? List these motivations carefully; do not evaluate them as they are called out by group members.

Once the list is complete, go back over it and discuss each item in some detail. Ask: Can you understand why this might have motivated Peter? Have you ever been similarly motivated? For example, one of Peter's motivations was fear. Help group members recognize those times when they act out of fear or anxiety (indeed, often a fear or anxiety much less real than Peter's was).

In all, help the group members recognize and affirm Peter as a very human person, as a person not unlike themselves, who failed when pressure was applied.

III. Identify and examine parallels of Peter's denial in contemporary life.

Do not leave the lesson at this point! Go on to the triumph and victory Peter experienced through the grace of Jesus Christ!

Make a short presentation reminding the group of Peter's race to the tomb on resurrection day, of his time with Jesus following the breakfast at Galilee when Jesus charged him directly to feed the lambs of the Lord, and of his outstanding leadership in the formation of the early church as recorded throughout the first part of the book of Acts. This presentation should emphasize that forgiveness and reconciliation are available to all, that when one repents and seeks the Lord, the Lord Jesus Christ will find and forgive and put to service. None of us has denied Jesus Christ so often or so shamefully that we are beyond forgiveness. None of us has rejected Jesus in a time of crisis to the extent that he has rejected us. The story of the denial of Peter is not the story of one man's failure but of our Lord's power to forgive, to reconcile, to set free! Despite the somber mood set by Peter's rejection of Jesus, make this a session of glorious affirmation of the forgiveness Christ offers. Despite bringing to the surface of their consciousness their own experiences of denying Jesus, make this a session in which group members feel forgiven and reconciled through the unmerited love of Jesus Christ.

Helping Class Members Act

The focus of this session is on the tasks Jesus calls us to do despite our failures and denials of him. Give each class member a small piece of paper or a three-by-five-inch card. Ask each to jot down for her or his own use at least one time she or he has denied Jesus Christ. Then ask each person to write on the other side of that piece of paper the specific task Christ is calling her or him to do and to be despite her or his failure and rejection. Suggest that group members keep these cards or pieces of paper in purse or wallet and refer to them frequently during the weeks ahead.

Planning for Next Sunday

Invite group members to read carefully John 18:28–19:26 before your next session. Suggest that as they read they jot down thoughts or ideas that come to mind. Tell them to read for feelings as well as for facts by putting themselves in the places of the persons in this drama.

Standing for the Truth

Background Scripture: John 18:28–19:16

The Main Question—Pat McGeachy

Sometimes, when I am having difficulty making a choice or a moral decision, I hear myself using the following argument: If I knew what was right, I would do it, but I just don't know. But then there comes back at me like a tennis volley the other side of that debate. The voice within me says, "You know what you ought to do, all right, you just won't do it." Now, of the two, I much prefer the former analysis of my difficulty. I feel that I can be forgiven more for lack of knowledge than for lack of will. (Though I have been told that ignorance of the law is not a good excuse.) I keep whining to my imaginary accusers things like, "Well, how was I to know?" or, "I didn't know any better."

This is the question that Pilate asks, in 18:38: "What is truth?" It is not a question in philosophy that can be answered with a response like, "Truth is beauty," or, "Truth is that which corresponds to reality." It is a disturbing moral question: "How can I make the right decision?" Pilate is depicted as a man agonizing to know what to do, consulting with his wife (Matthew 27:19) or Herod (Luke 23:6-12), scrubbing his hands as if to wash away the guilt (Matthew 27:24), and finally, in spite of his instincts, giving in to the crowd and hoping they will take the blame. For this "non-decision-making," Pilate was rewarded by being remembered forever wherever Christians gather and recite the Apostles' Creed. Not the wicked Herod or the cowardly Peter or the traitorous Judas but the wishy-washy Pilate is preserved in our ritual.

Our question, then, is twofold. The first part is Pilate's query, "What is truth?" and the second part is, Given the truth, how shall I find the courage and the will to act upon it? Perhaps those two are really part of the same question. Did not Jesus promise us that if we came to know the truth, it would set us free (John 8:32)?

As You Read the Scripture—Harry B. Adams

The scripture passage that serves as the basis for this lesson describes the first part of the trial of Jesus before the Roman governor, Pilate. John gives an extended account of the encounter between Jesus and Pilate, an account that extends beyond the printed scripture to John 19:16. Once again, the author of this Gospel is less interested in historical accuracy than in the theological interpretation of what this encounter between Jesus and the Roman governor means.

John 18:28-32. Verse 24 tells how Jesus was led from the house of Annas where he had been interrogated and taken to Caiaphas the high priest. John tells nothing of what happened before Caiaphas, quickly moving the scene to the praetorium, the residence of the Roman governor. John notes that it was early, that is, during the fourth watch from 3:00 to 6:00 A.M.

The Jews who brought Jesus to the Roman authority would not enter the praetorium, lest they be defiled. The author of the Gospel is surely pointing

up the irony that these people who would bring an innocent man before the authorities would want at the same time to keep their ritual purity.

John indicates that Pilate went out to see those who brought Jesus and asked what charges they were being brought against him. The accusers really have no answer to Pilate's question but simply assert that if Jesus were not an evildoer, they would have brought him before the authorities.

Throughout this entire account, Pilate is very reluctant to get involved in the affair, and here he tells the Jews to deal with the problem of Jesus themselves. The Jews respond that they don't have the authority to carry out the death penalty. It is not clear whether this is historically accurate, but again John is making a theological point, as is clear from verse 32. Jesus had said that "when I am lifted up from the earth, I will draw all men to myself." And then the author of the Gospel notes that "he said this to show by what death he was to die" (John 12:32-33). The Roman style of execution was by crucifixion, while the Jews stoned people, so that for Jesus to be lifted up on a cross he had to be tried and sentenced by the Roman authority.

Verses 33-38a. The scene now moves from outside, where Pilate had gone to deal with the Jews, to inside, where Pilate dealt with Jesus. Without any preparation, Pilate simply confronts Jesus with the question, "Are you the King of the Jews?" Jesus doesn't answer but wants to know whether Pilate was asking this on his own or whether someone had put him up to it. The other possibility for the author of this Gospel is that Pilate asks the question because he is an unconscious witness to the truth of God.

Pilate immediately denies that he is asking the question on his own, for he is no Jew. Jesus then acknowledges his kingship but interprets that claim in quite different terms from the way in which the world would hear it, for his kingship is not of this world.

John has Pilate repeat the question and gives Jesus the chance to interpret again who he is, that is, that he is the one who has come "to bear witness to the truth."

Verses 38b-40. Pilate again goes out to the Jews and declares that he can find no crime in what Jesus has done, and offers to release him in accord with the custom of releasing one man during the Passover. But the Jews ask that Barabbas be released instead of Jesus.

Selected Scripture

King James Version

John 18:28-40

28 Then led they Jesus from Caiaphas unto the hall of judgment: and it was early; and they themselves went not into the judgment hall, lest they should be defiled; but that they might eat the passover.

29 Pilate then went out unto them, and said, What accusation bring ye against this man?

30 They answered and said unto him, If he were not a malefactor, we would not have delivered him up unto thee.

Revised Standard Version

John 18:28-40

28 Then they led Jesus from the house of Caiaphas to the praetorium. It was early. They themselves did not enter the praetorium, so that they might not be defiled, but might eat the passover. 29 So Pilate went out to them and said, "What accusation do you bring against this man?" 30 They answered him, "If this man were not an evildoer, we would not have handed him over." 31 Pilate said to them, "Take him yourselves and judge

31 Then said Pilate unto them, Take ye him, and judge him according to your law. The Jews therefore said unto him, It is not lawful for us to put any man to death:

32 That the saying of Jesus might be fulfilled, which he spake, signifying what death he should die.

33 Then Pilate entered into the judgment hall again, and called Jesus, and said unto him, Art thou the King of the Jews?

34 Jesus answered him, Sayest thou this thing of thyself, or did others tell it thee of me?

35 Pilate answered, Am I a Jew? Thine own nation and the chief priests have delivered thee unto me: what hast thou done?

36 Jesus answered, My kingdom is not of this world: if my kingdom were of this world, then would my servants fight, that I should not be delivered to the Jews: but now is my kingdom not from hence.

37 Pilate therefore said unto him, Art thou a king then? Jesus answered, Thou sayest that I am a king. To this end was I born, and for this cause came I into the world, that I should bear witness unto the truth. Every one that is of the truth heareth my voice.

38 Pilate saith unto him, What is truth? And when he had said this, he went out again unto the Jews, and saith unto them, I find in him no fault *at all.*

39 But ye have a custom, that I should release unto you one at the passover: will ye therefore that I release unto you the King of the Jews?

40 Then cried they all again, saying, Not this man, but Barabbas. Now Barabbas was a robber.

him by your own law." The Jews said to him, "It is not lawful for us to put any man to death." 32 This was to fulfil the word which Jesus had spoken to show by what death he was to die.

33 Pilate entered the praetorium again and called Jesus, and said to him, "Are you the King of the Jews?" 34 Jesus answered, "Do you say this of your own accord, or did others say it to you about me?" 35 Pilate answered, "Am I a Jew? Your own nation and the chief priests have handed you over to me; what have you done?" 36 Jesus answered, "My kingship is not of this world; if my kingship were of this world, my servants would fight, that I might not be handed over to the Jews; but my kingship is not from the world." 37 Pilate said to him, "So you are a king?" Jesus answered, "You say that I am a king. For this I was born, and for this I have come into the world, to bear witness to the truth. Every one who is of the truth hears my voice." 38 Pilate said to him, "What is truth?"

After he had said this, he went out to the Jews again, and told them, "I find no crime in him. 39 But you have a custom that I should release one man for you at the Passover; will you have me release for you the King of the Jews?" 40 They cried out again, "Not this man, but Barabbas!" Now Barabbas was a robber.

Key Verse: Jesus answered, Thou sayest that I am a king. To this end was I born, and for this cause came I into the world, that I should bear witness unto the truth. (John 18:37)

Key Verse: Jesus answered, "You say that I am a king. For this I was born, and for this I have come into the world, to bear witness to the truth." (John 18:37)

The Scripture and the Main Question—Pat McGeachy

King Jesus

Jesus, as the Fourth Gospel describes him, was given to using the phrase "I am" as in, "I am the good shepherd," ". . . the door," ". . . the way," and so forth. But I know of no place in which he said, "I am the King." (Though he did answer, "I am," according to Mark 14:62, when Pilate asked him if he were the Christ.) The title of "king" is usually given to him by others: the wise men (Matthew 2:1) or the crowds on Palm Sunday (Luke 19:38). Even those who only believed in him for superficial reasons wanted to make him king (John 6:15). The title is only given to him on the occasion of his return in power (Revelation 17:14; 19:16), when every knee shall bow before him, "King of kings and lord of lords." Jesus' enemies tried to argue that he had claimed the kingship for himself (John 19:21), but Pilate insisted on giving Jesus the title himself, in three languages—Hebrew, Greek, and Latin.

As for Jesus, when his accusers ask him if he is king, his answers are strangely vague. He throws the question back on them: "You say that I am a king" (John 18:37; compare Matthew 26:64; Luke 22:70; 23:3). It is consistent with his whole approach to messiahship, beginning with the temptation in the wilderness. He simply will not make claims for himself that are not self-evident. It is as though Jesus says to us, "You look at me and decide for yourself who I am." When he healed people, he would often say, "Tell no one" (Mark 1:43-44), and when Peter made his great confession (Matthew 16:16), Jesus responded, "Nobody told you this but God." All of this is to say that we choose Jesus as King over our lives not because of claims Jesus makes about himself but *because his rule is self-evident.* Let us see how this works out in this dramatic encounter between Jesus and Pilate.

Before the Praetorium (John 18:28-32)

"Praetorium" is a word like "parsonage." The parsonage is where the parson lives, and the praetorium is where the praetor (that is, governor) lives. The Jewish leaders did not want to go into that Gentile house, lest they render themselves un-kosher for the coming Passover. So Pilate was accommodating enough to come out, where (verse 28) he asked, in effect, "What are the charges?" Their reply (verse 30) is descriptive of the whole trial: "You know he is guilty because we are accusing him." It is, in contrast to our legal tradition, a presumption of guilt. The trial was rigged from the beginning. And intent on killing Jesus, the religious authorities, themselves unable to carry out the death sentence, want the Romans to do their dirty work for them.

It is worth noting that both the religious and secular powers thus combine to bring an end to Jesus. We must not fall into the trap of blaming the Jews as a people for our Lord's death. It is the fault of the whole human race, including ourselves. We must confess, with Johann Heermann, "'Twas I, Lord Jesus, I it was denied thee;/I crucified thee" ("Ah, Holy Jesus, How Hast Thou Offended?").

Within the Praetorium (18:33-38a)

Pilate and the prisoner seem to be alone now; who could have recorded this dialog? The two lictors (magistrates) who accompanied every praetor to

do his bidding (Acts 16:35, 38)? However it got to John, we can be grateful that it did, because it contains some words we would be poorer without. Jesus seems to be almost flippant in his responses to this powerful Roman, as though he were saying (as he later does, 19:11), "You have no power over me." Jesus' three sentences, the most expansive of his courtroom responses, can be paraphrased as follows:

(1) Pilate, you had better ask yourself what you yourself believe, and not make your moral and ethical choices on what is popular (verse 34);

(2) Pilate, you are dealing with something greater than a merely political question here (verse 36);

(3) Pilate, you will have to answer the question of my kingship for yourself. I have come to tell the truth, both in word and deed. And if you know the truth, you will recognize me (verse 37).

Of course, those are not Jesus' words but an attempt to make it clear that Jesus is not defending himself at all; in fact, he is trying to convert Pilate! Here, faced with his own destruction, he concerns himself not with his own life but with the soul of his accuser! Is that not proof that he really is King Jesus?

Outside Again (18:38b-40)

And Pilate is almost persuaded! (compare Acts 26:28). He makes an attempt to say to the Jewish authorities, "I'm with Jesus. He's innocent. Let me release him." (Notice that Pilate is now calling Jesus "king.") But they will have none of it; they demand that he release the notorious rebel Barabbas (see Luke 23:19).

In Again for Punishment (John 19:1-3)

But Pilate's recognition of Jesus' kingship is not genuine. He turns it into mockery: The Crown is made of thorns. Jesus is both praised and beaten; it is the ultimate sarcasm: "Take this, you 'king'!"

The Final Appearance (19:4-16)

Pilate's scuttling in and out of his house is a symbol of his wishy-washy will. He is waffling, trying to avoid the responsibility of this deed. Three times he proclaims Jesus' innocence (18:38; 19:4, 6), but in spite of this he allows himself to be persuaded by two overwhelming factors: He is afraid of further angering this mob of Jewish citizens, whom he is supposed to be able to control (verse 8), and he is afraid of what might happen in relation to his superior, the Roman emperor (verse 12). Torn between his conscience and his fears, he obeys the latter. In other words, he refuses to accept the truth that Jesus has tried to show him.

Pilate makes me sad because even in his failure, he insists on calling Jesus "king" (verses 14-15). It is as though he knows in his heart he has made the most colossal blunder in all of history. And in one forlorn act of courage, at the very end, he refuses to back down on his assertion that Jesus really is king after all. "Take it back!" cry the Jews. "No," says Pilate, bowing up his back at last, too little and too late, "What I have written, I have written" (19:22).

Truth and Falsehood

Here we have an encounter between Truth himself and the representative of the secular powers. Pilate stands for all the posturing politicians of the world, all the pompous preachers, all the profiteers and their patrons. All those people are looking out for Number One, struggling to escape the ethical dilemmas of their lives and passing the buck to others. They (we) will not look Truth in the eye. We stand, like Pilate, in the presence of Incarnate Love, and we are afraid.

In contrast, Jesus remains free from bluster and pretense. "I am the Truth," he says to us, "and you can believe me if you have eyes to see." The common people heard him gladly; the publicans and sinners rejoiced at his coming. But his kingship was a threat to all persons in authority, from Herod to Pilate.

Who possessed the real power in that encounter (19:11)? Truth, the Law of God, is something like the law of gravity. You can't break that law; you can only break yourself when you try to defy it. So the enemies of Jesus break themselves, like waves breaking on a rock, and when the waters recede, he is found still standing. Because he has God eternally on his side, and also because he is in the right, which may be just another way of saying the same thing.

> Though the cause of evil prosper,
> Yet 'tis truth alone is strong;
> Though her portion be the scaffold,
> And upon the throne be wrong.
> Yet that scaffold sways the future,
> And, behind the dim unknown,
> Standeth God within the shadows,
> Keeping watch above his own.
> ("Once to Every Man and Nation")

Helping Adults Become Involved—John Gilbert

Preparing to Teach

Before you begin your actual preparations for teaching this lesson, spend some time in prayer. Pray unashamedly for yourself. You have been called by God to a sacred task; you have been appointed by God to teach in the Sunday school. God has chosen you through your church to lead and guide others in their growth in Christian faith and discipleship.

This is an awesome responsibility. But God has called you and equipped you for it. Therefore spend time in prayer seeking God's greatest influence and direction in your life. Ask God to purge from you all that would interfere with your total dedication to the teaching task. Ask God to constantly inspire you to give your very best to the teaching task, to make your communication of the Word of God the primary task of your life. And God has promised that this will be done.

Although the background Scripture for this lesson is John 18:26–19:16, reread the entire eighteenth and nineteenth chapters of John several times in order to place this conversation with Pilate in context. Develop a feel for the flow of events therein. Sense and internalize how this story is unfolding, how John has chosen his words and descriptions carefully to build a crescendo climaxing on resurrection morning.

If you have access to some commentaries, study them in order to gain insight into these passages. But two simple warnings: Again, do not get involved in detailed comparisons between John and the Synoptic Gospels. The purpose of this lesson is not to see how John is different from them. And do not spend a lot of time on governmental structures in the Roman territories. Some commentaries devote pages to that structure in order to identify precisely who Pilate was and what his duties were. Suffice it for the purpose of this lesson to know that Pilate was a Roman official with the power to save or condemn Jesus at this trial. The significant thing is that Pilate had the power and Pilate made a choice; exactly how and where he got the authority or power is not quite as significant.

The primary purpose of this lesson is simply to comprehend the strange conversation between Jesus and Pilate and to perceive how those words, directed to Pilate two thousand years ago, are also directed to us here today.

Plan your session around the concerns and needs of the members of your group, for you know those persons well. However, this outline might help you in your planning and preparation:

I. The events that brought Jesus to Pontius Pilate
II. The conversation between Jesus and Pilate
III. Pilate's questions and Jesus' responses for us today

Again, arrange your chairs for the most effective discussion. Can you arrange chairs so each group member can see every other group member easily? As always, have on hand Bibles, paper, and pencils, and a chalkboard and chalk or newsprint or other large sheets of paper and appropriate markers.

Introducing the Main Question

Post somewhere in your classroom where all can see it a large handmade poster that reads simply, "What is truth?" Do not draw attention to this poster; merely let its presence speak for itself. The goal of this session is to help persons recognize that this question cannot be answered intellectually but only through the development of a relationship with Jesus Christ as Lord. So, given the truth, how shall we find the courage and the will to act upon it?

Developing the Lesson

I. The events that brought Jesus to Pontius Pilate

Outline on the chalkboard or newsprint the processes and events that brought Jesus the Christ before the Roman ruler. Follow the sequence in John, pointing out as you do so that the other Gospels describe slightly different sequences. One caution: As you describe and discuss the trial of Jesus and all its attendant events, emphasize that only some of the Jews, some of the Pharisees, and some of the high priest's court were involved. We speak inaccurately when we ascribe the arrest and trial of Jesus to the "Jews." Biblical evidence clearly indicates that the actions of some of the religious leaders of the time did not reflect the will of all the Jewish leaders of the time, and that while a few Pharisees favored the execution of Jesus, we do the entire party of Pharisees a grave injustice when we make such

simplistic statements as "The Pharisees openly opposed Jesus." This point needs to be made repeatedly with your group; it is a point Pat McGeachy makes eloquently in his discussion of this session.

II. The conversation between Jesus and Pilate

Ask several persons to read aloud the dialogue that led up to Jesus' confrontation with Pilate and the conversation between Jesus and Pilate. You will need one person to read the part of Jesus, one to read the part of Pilate, and at least two to read in unison the part of the people who brought Jesus to Pilate and the crowd. Commence reading with John 18:29. Ask the assigned persons to read only the portions in quotation marks; the dialogue does not require a narrator. Ask the readers to put as much feeling into their reading as appropriate, to read Pilate's part just as Pilate would have spoken it, and so on. Your reading should end with John 18:40, although if you wished to add more readers you could continue, with appropriate actions, to John 19:16.

Dr. McGeachy in his lesson exposition describes Jesus as "flippant" in his conversation with Pilate. Discuss as a whole group whether or not this is a good characterization of Jesus' attitude. If group members do not accept "flippant," ask them to list some other words to describe this interchange.

Additionally, Dr. McGeachy holds that Jesus, caring not for himself, spent his time with Pilate trying to convert him. What does this say about Jesus? More significantly, what does this say about truth? Compare Dr. McGeachy's contention with Luke 23:34; what is Jesus' prime concern?

III. Pilate's questions and Jesus' responses for us today

Explore with the whole group the meaning of truth as the term is used in this conversation between Pilate and Jesus. To Pilate truth is simply that which is congruent with reality. To Jesus truth is that which is ultimate, unchanging, permanent, eternal; to Jesus truth is and can only be God, the relationship one develops with God, and the reliance one can place on that relationship. (This is the truth Paul echoed in Romans 8:38-39.) Truth, then, is that in which we put our ultimate trust and faith; it is that which we will never surrender; it is that which is life itself for us.

Discuss now some of the ways persons seek Pilate's kind of truth today. You will be talking about the quest for financial resources, material goods, power, prestige, social acceptance, and so on. But push your group members to think beyond these, to what is even more basic. Expect answers like health, security, friends, love, self-respect. Discuss briefly the ways in which contemporary American Christians seek these things—including almost frantic church activity.

Now discuss as a group how Jesus' answer to Pilate, how Jesus' offering of himself as the truth, answers the questions and fulfills the quest of those who are seeking truth. Jesus himself stated in John 14:6 that he is the truth. The truth is not an idea; it is a relationship. The truth is not an object; it is a contact with God. The truth is not an earth-bound fact; it is an eternal reconciliation.

Helping Class Members Act

Invite group members to keep a journal during the coming week and to record instances in which they perceive themselves or others pursuing truth

275

other than through a relationship with Jesus Christ. Call for careful introspection here; help members see themselves openly and honestly, as Pilate was finally forced to do.

Planning for Next Sunday

Assign all group members to read carefully the terrible story of the execution of Jesus, John 19:17-42. Again, encourage them to focus on feelings and attitudes as much as on facts.

LESSON 6 APRIL 8

Facing Death

Background Scripture: John 19:17-42

The Main Question—Pat McGeachy

"What I have written, I have written," said Pilate (verse 22). There is a finality about death that shakes our foundations. No longer can I explain to that person what I meant, or share that joke that only we two would have understood. I don't want it to be so final. But it is.

> The moving finger writes, and, having writ,
> Moves on: nor all thy piety nor wit
> Shall lure it back to cancel half a line,
> Nor all thy tears wash out a word of it.
> ("The Rubaiyat")

We don't want to admit or face this, so we devise dozens of devices to soften death or even deny it. Artificial grass covers the earth to which our dust returns at the cemetery; flowers and soft organ music cushion the shock; embalming creates the illusion of sleep. And we shy away from the word itself, saying instead, "passed away," "shuffled off," or "cashed in his chips." As an extreme example of this, I know of a woman who wheeled an empty baby carriage for years, pretending that it still contained her long-dead infant.

But if we are to rise above death, we must first learn to face it. Indeed, it has been suggested that the denial of death is the source of most neuroses (see Thomas Becker's book, *The Denial of Death*). We will all one day die, as will those we love. So did our Lord, and from him we can learn both how to do it and how to transcend death. There are some (myself among them) who regard this question as the most important one there is. To be able to die well is to be able to live well (and vice versa). Jesus taught us that we must die if we are to live (Luke (9:23-27; John 12:24; see also I Corinthians 15:36). Come, then, and

276

Calvary's mournful mountain climb;
There, adoring at his feet,
Mark that miracle of time,
God's own sacrifice complete;
"It is finished!" hear him cry;
Learn of Jesus Christ to die.
 ("Go to Dark Gethsemane")

The title of this lesson is "Facing Death." Your main goal or purpose is to help persons gain a renewed understanding of the events of the crucifixion and to internalize those events in such a way that Jesus' and our deaths take on renewed meaning and significance.

As You Read the Scripture—Harry B. Adams

All four Gospels give major attention to the crucifixion of Jesus. Each Gospel has certain details that are not found in the other three, but all the Gospels agree on the basic fact that Jesus was tried, convicted, and crucified by the Roman authorities.

John's account of the crucifixion in chapter 19 begins at verse 17. There are four episodes in this account, of which only the last is part of the printed scripture for today's lesson: (1) verses 17-22: giving Jesus the title "the King of the Jews"; (2) verses 23-24: casting lots for Jesus' clothes; (3) verses 25-27: Jesus and his mother; (4) verses 28-31: Jesus drinks the vinegar.

Throughout the Gospel of John it is evident that the author has included certain details in order to interpret the meaning of the events he is describing. In his description of the crucifixion, John has Pilate bear witness to Jesus by putting the title "the King of the Jews" on the cross. As the text makes clear, the soldiers divide his garments to fulfil the scripture and thus to fulfill the will of God. So also Jesus drinks the vinegar to fulfil the scripture. The incident with his mother indicates his care for her and also brings into the scene the familiar figure of "the disciple whom he loved."

John 19:28-30. John's account in these verses emphasizes again what he has repeated so often: Jesus is in control of the situation, even though he appears to be the victim. After he had drunk the vinegar, Jesus declared, "It is finished," and then he gave up his spirit. His life was not wrested from him but was given up by his will and his decision.

When Jesus declares, "It is finished," the meaning is not simply that his life is now over. Rather, by this declaration Jesus asserts that he has accomplished what he set out to do; he has reached the goal God intended him to achieve.

Verses 31-37. John gives a number of details here that the other Gospels do not have: not breaking the legs because he was already dead, the piercing with the spear, the presence of an eyewitness who has given the testimony. By these details John is emphasizing two things: one, Jesus was really dead, and, two, all that happened was in fulfilment of Scripture.

The blood and the water that flowed from Jesus when he was pierced with the spear echo references to water in John 4:10, where Jesus deals with the woman of Samaria, and to blood in John 6:53-55, where Jesus talks about drinking his blood.

Verses 38-42. All four Gospels describe the burial of Jesus, making clear that he really was dead and that the resurrection was not some trick of a man who had hidden himself for three days.

277

Joseph of Arimathea was a secret disciple "for fear of the Jews." Again, John often emphasizes the fear, for example, in 7:13; 9:22; and 12:42. Nicodemus appears only in this Gospel; he had been mentioned earlier in chapter 3 where he didn't understand Jesus at all and in chapter 7 where he urged that Jesus be listened to.

Selected Scripture

King James Version

Revised Standard Version

John 19:28-42

28 After this, Jesus knowing that all things were now accomplished, that the scripture might be fulfilled, saith, I thirst.

29 Now there was set a vessel full of vinegar: and they filled a spunge with vinegar, and put *it* upon hyssop, and put *it* to his mouth.

30 When Jesus therefore had received the vinegar, he said, It is finished: and he bowed his head, and gave up the ghost.

31 The Jews therefore, because it was the preparation, that the bodies should not remain upon the cross on the sabbath day, (for that sabbath day was an high day,) besought Pilate that their legs might be broken, and *that* they might be taken away.

32 Then came the soldiers, and brake the legs of the first, and of the other which was crucified with him.

33 But when they came to Jesus, and saw that he was dead already, they brake not his legs:

34 But one of the soldiers with a spear pierced his side, and forthwith came there out blood and water.

35 And he that saw *it* bare record, and his record is true: and he knoweth that he saith true, that ye might believe.

36 For these things were done, that the scripture should be fulfilled, A bone of him shall not be broken.

37 And again another scripture saith, They shall look on him whom they pierced.

John 19:28-42

28 After this Jesus, knowing that all was now finished, said (to fulfil the scripture), "I thirst." 29 A bowl full of vinegar stood there; so they put a sponge full of the vinegar on hyssop and held it to his mouth. 30 When Jesus had received the vinegar, he said, "It is finished"; and he bowed his head and gave up his spirit.

31 Since it was the day of Preparation, in order to prevent the bodies from remaining on the cross on the sabbath (for that sabbath was a high day), the Jews asked Pilate that their legs might be broken, and that they might be taken away. 32 So the soldiers came and broke the legs of the first, and of the other who had been crucified with him; 33 but when they came to Jesus and saw that he was already dead, they did not break his legs. 34 But one of the soldiers pierced his side with a spear, and at once there came out blood and water. 35 He who saw it has borne witness—his testimony is true, and he knows that he tells the truth—that you also may believe. 36 For these things took place that the scripture might be fulfilled, "Not a bone of him shall be broken." 37 And again another scripture says, "They shall look on him whom they have pierced."

38 And after this Joseph of Arimathaea, being a disciple of Jesus, but secretly for fear of the Jews, besought Pilate that he might take away the body of Jesus: and Pilate gave *him* leave. He came therefore, and took the body of Jesus.

39 And there came also Nicodemus, which at the first came to Jesus by night, and brought a mixture of myrrh and aloes, about an hundred pound *weight.*

40 Then took they the body of Jesus, and wound it in linen clothes with the spices, as the manner of the Jews is to bury.

41 Now in the place where he was crucified there was a garden; and in the garden a new sepulchre, wherein was never man yet laid.

42 There laid they Jesus therefore because of the Jews' preparation *day;* for the sepulchre was nigh at hand.

38 After this Joseph of Arimathea, who was a disciple of Jesus, but secretly, for fear of the Jews, asked Pilate that he might take away the body of Jesus, and Pilate gave him leave. So he came and took away his body. 39 Nicodemus also, who had at first come to him by night, came bringing a mixture of myrrh and aloes, about a hundred pounds' weight. 40 They took the body of Jesus, and bound it in linen cloths with the spices, as is the burial custom of the Jews. 41 Now in the place where he was crucified there was a garden, and in the garden a new tomb where no one had ever been laid. 42 So because of the Jewish day of Preparation, as the tomb was close at hand, they laid Jesus there.

Key Verse: **When Jesus therefore had received the vinegar, he said, It is finished: and he bowed his head, and gave up the ghost. (John 19:30)**

Key Verse: **When Jesus had received the vinegar, he said, "It is finished"; and he bowed his head and gave up his spirit. (John 19:30)**

The Scripture and the Main Question—Pat McGeachy

The Wondrous Cross (John 19:17-29)

It is hard for me, having worshiped in so many beautiful churches, not to think of the cross as a beautiful thing. But of course it isn't. As has been said so many times that the person who first thought of it has been forgotten, "Christ was not crucified on a cross of brass between two candles, but a cross of rough wood, between two thieves." There would have been flies, sweat, and stench. No one can find the place today, though if you visit Jerusalem, some will show you the Church of the Holy Sepulcher, which stands over the traditional Catholic spot. Others will take you outside the old wall and point out a craggy hill, which really does look like an empty-eyed skull. Called Gordon's Calvary, after the British officer who noticed it, it is a traditional site for Protestants. But who knows? The evidence is inconclusive.

"Calvary" is from the Latin *calvaria,* translating the Greek *kranion,* meaning "skull" (compare our word "cranium"), which, of course, translates the Hebrew word "Golgotha." It was a place of death, and no amount of calling it a "green hill" or describing it as having a "radiance beaming" from it that "adds new lustre to the day" (as a couple of familiar hymns have it) can take away that reality. We ought to think of it in connection with the skull, with its

staring dead eyes. Harsh as that reality is, it is still not as strong as the pounding of the hammer and the pain of the nails. The biblical account of the crucifixion neither flinches at its reality nor attempts to glorify it. We are simply told the story in its stark reality, and that we must be willing to face.

The Seamless Dress (19:23-24)

The garments of crucified criminals were one of the "perks" offered to the executioners. The typical dress of a man in Jesus' time was not very different from that of a rural Palestinian today: a headdress (a *burnoose*), sandals, undergarment, and outer garment, bound by a rope or thong girdle. John's detail adds a note of reality to the scene. The other garments could apparently be divided into four piles of almost equal value, but the tunic, the undergarment, was woven without seam, and more valuable than the others. They decided to "draw straws" for it, thus unwittingly re-enacting the vision of Psalm 22:18. That remarkable prayer (you should read especially verses 1, 6-7, and 14-18) is involved in the crucifixion also because of its opening cry, "My God, my God, why hast thou forsaken me," which Matthew, Mark, and Luke call to our attention. Jesus wasn't merely "quoting," when he cried out these words. When you are dying, you do not quote things, you cry out of the deep places of your heart. And Jesus knew the Psalms; he quotes more from them than from any other part of the Old Testament save the prophet Isaiah. It was from another (Psalm 31:5) that he sighed, "Into thy hands I commit my spirit" (Luke 23:46).

When somebody dies you have to go over their belongings and divide them up. (I call it "playing vulture.") But we have to be willing to let all those things go. My mother used to call her knickknacks "sacred trash." "They're sacred to me, but trash to anybody else," she would say, "When I'm gone I don't care what you do with them." That is what I mean by confronting the reality of death.

So Jesus has no more use for his earthly raiment. Naked he came into the world and was wrapped in swaddling clothes; naked he will now go out of it, wrapped in a shroud. Christians have sometimes made much in legend over Jesus' "seamless dress." Novels have been written about it *(The Robe)*, and it has been used as an image for everything from the healing power of Christ to the ecumenical movement. But the most important thing we can do with it for now is to discard it, as an act of coming to terms with the reality of Christ's death, and thus with our own, in anticipation of the new garment that is promised (Revelation 6:11).

Mother and Son (19:25-27)

Jesus had solemnly warned his disciples that faith in him might mean the breakup of traditional family relations (see Matthew 10:34-37). But what it loses on the one hand, it gains on the other. New relationships are created; here, the Lord gives his beloved friend John to his mother, and her to him. Thus does he give you and me to each other, so that forever after the cross we have not only a new robe but a new family (Mark 3:35).

"I Thirst" (19:28-29)

We have already alluded to the enormous spiritual dimension of Christ's suffering as summed up in his cry from Psalm 22:1 about separation from

God. But the physical pain must not be minimized. Thirst is more agonizing than hunger, and water is more necessary than anything in the world save air. (Is it an accident that baptism is a symbol of the coming of the Spirit?) Here too we may have a quote (Psalm 42:2: "My soul thirsts for God"), but I don't think so. I think Jesus was saying, as you or I would, in the plainest, most physical terms, "I'm thirsty." And they replied to his cry with vinegar (which also may be a quote from a Psalm: 69:21).

It Is Finished (19:30)

All done now (see John 17:4); for good or for ill, there is nothing more to be done. As weary bones and muscles relax into sleep at the close of day, so a weary life gives up its spirit (breath, ghost, wind—they all mean the same thing) when the time comes. Death may have its terrors, but those who have observed it much tell us that at the very end, it comes as relief. It may have been the last enemy, but being conquered, it becomes the final friend. One of the most difficult lessons in life is learning when to quit. Could it be that the "loud cry," recorded but not quoted in the other three Gospels, was a cry of victory?

Blood and Water (19:31-37)

Three mysterious events occur here:
1. Jesus' bones were not broken (as was the custom with crucified criminals), so that he might be considered the unblemished Passover Lamb (Exodus 12:46; Revelation 5:6-14).
2. His side was pierced so that, in spite of the preservation of his bones, it would be proven that a real death had taken place.
3. Blood and water came from his side. I'm not sure what medical phenomenon can account for this, though other fluids than blood are to be found in the body. Whatever it means physically, it has come to mean something spiritually; in "high church" eucharistic services, a little water is always added to the wine. As the old hymn "Rock of Ages" puts it:

> Let the water and the blood,
> From thy wounded side which flowed,
> Be of sin the double cure,
> Save from wrath and make me pure.

Jesus' Rich Friends (19:38-42)

At the end, Nicodemus and Joseph, who symbolize for us those members of the "establishment" who truly want to be disciples, give all they know how to give: property and money. But small as these things are in the eyes of God, they are accepted as gracious acts, giving blessing to our contemporary attempts to give nobility to death.

But the real nobility that comes with death is not the virgin tomb or the rich spices and linens; it is the gracious and courageous life of the one who is buried there. I am told that it says on the tomb of Christopher Wren, who designed St. Paul's Cathedral (and indeed much of the skyline of London in his day), "If you seek his monument, look around you." It is the same with our Lord. It is not in the discovery of the Holy Grail or the seamless robe or

the garden tomb but in the discovery of the Christ in the lives and deaths of you and me, and those of our sisters and brothers who faithfully follow him, through the realities of the valley of the shadow to the promises of the house of the Lord.

Helping Adults Become Involved—John Gilbert

Preparing to Teach

Find a quiet place for yourself, a place where you can be alone and undisturbed for a while. Now put from your mind all the cares and concerns of the moment. Turn in your Bible to John 19:17-42, and read very slowly. Read aloud, if you are comfortable doing so. Let the words sink in. Hear them for the first time. Try to experience in your heart and in your body all that is being described in these few verses. Now pray. Pray in whatever way you feel led to pray, having just immersed yourself in the story of the crucifixion of Jesus Christ. Pray about what is moving in your heart and soul. If you find yourself speechless before the story of the crucifixion, simply tell God that you are overwhelmed by the story and do not know what to say in face of the immensity of the story. But pray. Keep this prayer and the experience that stimulated it uppermost in your mind as you plan to discuss the crucifixion with the particular students in your adult Sunday school class.

As you begin your specific preparation, bear in mind that this session, of almost all sessions in this quarter, must not be an intellectual exercise. It must not be an abstract and objective discussion of cold facts or of minor inconsistencies in the several accounts of the crucifixion. Søren Kierkegaard, a Danish theologian of the last century, once wrote that the crucifixion is an ever-repeated and ever-repeatable event and that unless and until that crucifixion occurs within each of us, the execution of the man called Jesus on a hill called Golgotha in a time two thousand years ago has little meaning or relevance. This does not mean dwelling on the gore and the physical pain of the crucifixion, horrible as that was and continues to be. But it does mean that each member of the class becomes involved in the crucifixion, that each recognizes that she or he was and is the final cause, the purpose, the reason for the crucifixion. In short, the crucifixion is more a theological event and experience than it is an historical one. Treat it as such in this session.

As in the past several sessions, avoid getting "hung up" on the apparent discrepancies between the crucifixion accounts of the several Gospel writers. Some people get agitated trying to identify the exact seven last words or probing the subtle symbolism of the hyssop and the vinegar. But avoid these kinds of issues. Present the crucifixion straightforwardly, openly, honestly—precisely the way the crucified (and risen!) one deals with us in all things.

Your main goal or purpose in this session is to help persons gain a renewed understanding of the events of the crucifixion and to internalize those events in such a way that his and our death take on renewed meaning and significance.

You will need to know the particular members of your class well in order to bring this across successfully. And knowing your class members may

mean altering the suggested lesson outline. But to help you begin your planning, try the following lesson outline:

I. The events of the crucifixion
II. The theological meaning of the crucifixion
 for those who were present
III. Our participation in the crucifixion

Provide your students with a discussion-oriented classroom, with chairs placed in a circle if possible. Have on hand a chalkboard and chalk or newsprint or large sheets of paper and appropriate markers.

Introducing the Main Question

Can you arrange to have recordings of several Holy Week hymns playing as class members arrive? Hymns such as the Bach chorale "O Sacred Head Now Wounded" are especially appropriate.

Developing the Lesson

I. The events of the crucifixion

Make a brief presentation on the events of the crucifixion. You may want to go over the biblical passage for today, John 19:17-42, verse by verse. At the end of each verse or several verses, ask group members to describe both what is happening and how they are feeling in response to what they are describing. In other words, can a group member talk about the agony of Jesus on the way to the cross without some feeling response, without some emotional involvement?

Another way to make this presentation is to assign several group members to the several parts in the crucifixion story. For example, ask one or several persons to listen and observe the story as if they were the common people of the day; ask several others to listen as if they were the religious authorities responsible for delivering Jesus to the Romans to be executed; ask several others to listen as if they were Roman soldiers assigned to accompany Jesus to the hill and to nail him to the cross; ask several others to listen as if they were apostles or the women in the apostles' band, watching from afar; and ask one person to listen and respond as if he or she were Jesus himself. Again, a significant concern is getting at the emotional dimension of this story; ask persons assigned to listen as certain original participants might open up some of these feelings and help disclose the emotional level of learning so important here.

II. The theological meaning of the crucifixion for those who were present

If you have chosen the latter technique for dealing with the story of the crucifixion, let each of the persons who took the parts of participants and observers at the crucifixion describe how (if at all) they saw God present in the crucifixion. You might pose a question such as this: What do the events of the crucifixion of Jesus say about the nature of God?

If you choose the former suggestion, basically a presentation verse by verse of the events of the crucifixion, then discuss as a whole group the nature of God as presented through the crucifixion. Explore carefully what the crucifixion says about God and God's relationship both with Jesus and

with us. Then pose this question for general discussion: "Suppose the Gospel story ended with the crucifixion, that is, that the resurrection did not take place. What would this say about the nature of God? How would our faith in facing death be different if this were so?"

Expect a wide variety of responses; some you may wish to jot on the chalkboard or newsprint for later consideration. But help the group members discover that the crucifixion helps define the nature of God only as we internalize and reexperience the crucifixion in our own lives and situations.

III. Our participation in the crucifixion

In order to deal with the contemporary reality of the crucifixion, pose some or all of these questions for general discussion. Be ready yourself with some ideas for responses, in order to help the group members get started in their discussion.

How do we experience the crucifixion today in our own lives and times?

How are we shaped and molded as Christians by the reality of the historical crucifixion and by our own experience, at least theologically, of the crucifixion of Jesus Christ?

In the crucifixion a major leader was executed by his opponents. The same has happened in our time with a number of martyrs. (You might ask the group to name some such contemporary martyrs, i.e., those who have given their lives for their beliefs.) How does Jesus Christ differ from these contemporary martyrs? What is the difference between the crucified Christ and a martyred leader? (This question should move the group toward a deeper understanding of the nature of Christ and the whole event of the incarnation.)

Some suggest that Jesus' cry, "It is finished," was a cry of triumph, a cry of rejoicing that his task had been completed, that he had fulfilled the responsibility assigned to him. Do you agree or disagree with this analysis of his final cry? If you agree, in what way does his work remain unfinished until we respond? How does our response complete his work so that "It is finished" for both Christ and ourselves?

Helping Class Members Act

Invite class members to spend this week reflecting on the crucifixion of Jesus as if they knew nothing of the resurrection. That is, they are to try to think and feel as the apostles must have felt and thought during those terrible hours between the death of Jesus and the discovery of the empty tomb.

Planning for Next Sunday

Urge group members to read John 20 before your next session but to try to wait until Saturday night before they read it.

Resurrection and Faith

Background Scripture: John 20

The Main Question—Pat McGeachy

When I was a young seeker, struggling with my doubts and uncertainties about the faith, I remember making a statement something like this: I see how Jesus' death delivers me from sin, but I don't understand the need for the resurrection. I find purpose in his atoning life, but the promise of heaven seems to me to be a kind of "bribe" offered to make people believe.

Today, as I look back on my spiritual adolescence, I think I can be glad about two things: One is it pleases me that I believed in Jesus when I did not think there was much hope of reward, and the other is that like a child eating his spinach and okra first or the host at the wedding in Cana of Galilee (John 2:10), I inadvertently saved the best for the last, so that when the truth of the resurrection came over me at last, it was a deep and abiding joy! Like Mary in the garden, I had been blind to the risen Christ, but now I feel like running, like Peter and John, as fast as my legs can carry me, to see this miracle, the most exciting thing that ever happened since the Big Bang of Genesis 1:3.

The main question for me, and I trust for you, is this: How can there be any hope in the dark days in which we live? How can there be any convincing of the skeptic in me that life, not death, has the last word? Or, how can we become the people not of the funeral but of the resurrection?

This is not merely a question about the afterlife. It is also about joy, hope, and promise in *this* life. Our question is not so much how I can be sure there is a heaven (and that I am going to get there) as it is how I can make sense of this life and believe that in spite of all my guilt and grief I will be able to say with Jesus, "It is finished." The apostle Paul has worded it better than I can with his strong charge in I Corinthians 15:58: "Therefore, my beloved . . . be steadfast, immovable, always abounding in the work of the Lord, knowing that in the Lord your labor is not in vain."

As You Read the Scripture—Harry B. Adams

One of the particular interests in the Gospel of John is to show that the risen Lord fulfilled the promises he had made to the disciples, particularly in the conversation with them in chapters 14 to 17.

John 20:18. The verse concludes the account of Jesus' appearance to Mary Magdalene, which began at verse 11. Convinced by what had happened that the risen Jesus had come to her, she hastened to tell the disciples. She said that she had seen the Lord, a title that is repeatedly used by John in this account of the appearances of Jesus (for example, in verses 20 and 28).

Verses 19-23. This section recounts the appearance of Jesus to the disciples. Jesus had promised when he spoke to them earlier that he would come to them (14:18) and here he does come. He had also promised that he

would give them peace (14:27; 16:30) and here he declares, "Peace be with you," saying it to them not once but twice.

Jesus had also promised several times that the Spirit would be given to the disciples (14:26; 15:26; 16:7). Here in his first encounter with the disciples, he says to them, "Receive the Holy Spirit." But Jesus came to the disciples and bestowed peace and the Spirit upon them not simply for their own blessing. To be sure, the disciples experienced great joy in the presence of Jesus, for John says that "they were glad when they saw the Lord." But Jesus had work for them to do. In talking of his disciples in 17:18, Jesus had said that he had sent them into the world even as God had sent him into the world. When he confronts them as risen Lord, he says again, "As the Father has sent me, even so I send you." They were sent into the world to bring life, even as Jesus had brought life; to be obedient to God even as Jesus had been obedient; to make known the judgment of God, even as Jesus had been the judgment of God by his presence; to bring the forgiveness of God, even as Jesus brought that forgiveness.

Verses 24-29. When Thomas, who had been absent when Jesus appeared, came to the disciples, they told him, "We have seen the Lord," echoing the word of Mary in verse 18. But Thomas wouldn't believe unless he not only saw but touched, a demand that denies the very meaning of faith.

But again Jesus came to them and bestowed peace upon them. And then he met the demand of Thomas, who spoke the ultimate word of affirmation: "My Lord and my God!" This is one of the few places in the New Testament where Jesus is declared directly to be God, and it has echoes of the assertions about him of John 1, where it is said that the Word was God and came and dwelt among us.

Jesus then offers a blessing not only on Thomas but on all future generations who will believe in him.

Verses 30-31. In these verses John states explicitly the purpose for which he had written his book—that people may believe in Jesus and may have life because they believe.

Selected Scripture

King James Version

John 20:18-31

18 Mary Magdalene came and told the disciples that she had seen the Lord, and *that* he had spoken these things unto her.

19 Then the same day at evening, being the first *day* of the week, when the doors were shut where the disciples were assembled for fear of the Jews, came Jesus and stood in the midst, and saith unto them, Peace *be* unto you.

20 And when he had so said, he shewed unto them *his* hands and his side. Then were the disciples glad, when they saw the Lord.

Revised Standard Version

John 20:18-31

18 Mary Magdalene went and said to the disciples, "I have seen the Lord"; and she told them that he had said these things to her.

19 On the evening of that day, the first day of the week, the doors being shut where the disciples were, for fear of the Jews, Jesus came and stood among them and said to them, "Peace be with you." 20 When he had said this, he showed them his hands and his side. Then the disciples were glad when they saw the Lord. 21 Jesus said to them again, "Peace be with you. As the Father

21 Then said Jesus to them again, Peace *be* unto you: as *my* Father hath sent me, even so send I you.

22 And when he had said this, he breathed on *them*, and saith unto them, Receive ye the Holy Ghost:

23 Whose soever sins ye remit, they are remitted unto them; *and* whose soever *sins* ye retain, they are retained.

24 But Thomas, one of the twelve, called Didymus, was not with them when Jesus came.

25 The other disciples therefore said unto him, We have seen the Lord. But he said unto them, Except I shall see in his hands the print of the nails, and put my finger into the print of the nails, and thrust my hand into his side, I will not believe.

26 And after eight days again his disciples were within, and Thomas with them: *then* came Jesus, the doors being shut, and stood in the midst, and said, Peace *be* unto you.

27 Then saith he to Thomas, Reach hither thy finger, and behold my hands; and reach hither thy hand, and thrust *it* into my side: and be not faithless, but believing.

28 And Thomas answered and said unto him, My Lord and my God.

29 Jesus saith unto him, Thomas, because thou hast seen me, thou hast believed: blessed *are* they that have not seen, and *yet* have believed.

30 And many other signs truly did Jesus in the presence of his disciples, which are not written in this book:

31 But these are written, that ye might believe that Jesus is the Christ, the Son of God; and that believing ye might have life through his name.

Key Verse: **Jesus saith unto him, Thomas, because thou hast seen me, thou hast believed: Blessed are they that have not seen, and yet have believed. (John 20:29)**

has sent me, even so I send you." 22 And when he had said this, he breathed on them, and said to them, "Receive the Holy Spirit. 23 If you forgive the sins of any, they are forgiven; if you retain the sins of any, they are retained."

24 Now Thomas, one of the twelve, called the Twin, was not with them when Jesus came. 25 So the other disciples told him, "We have seen the Lord." But he said to them, "Unless I see in his hands the print of the nails, and place my finger in the mark of the nails, and place my hand in his side, I will not believe."

26 Eight days later, his disciples were again in the house, and Thomas was with them. The doors were shut, but Jesus came and stood among them, and said, "Peace be with you." 27 Then he said to Thomas, "Put your finger here, and see my hands; and put out your hand, and place it in my side; do not be faithless, but believing." 28 Thomas answered him, "My Lord and my God!" 29 Jesus said to him "Have you believed because you have seen me? Blessed are those who have not seen and yet believe."

30 Now Jesus did many other signs in the presence of the disciples, which are not written in this book; 31 but these are written that you may believe that Jesus is the Christ, the Son of God, and that believing you may have life in his name.

Key Verse: **Jesus said to him, "Have you believed because you have seen me? Blessed are those who have not seen and yet believe." (John 20:29)**

The Scripture and the Main Question—Pat McGeachy

All That Running

I don't know what the night before had been like, but I have my guesses. If you have ever sat up with a family in which there has been great grief, I suspect you have experienced something like the gloom that must have settled on the upper room that dark evening. Peter, nursing his guilty denial; John, shaking his head over lost dreams; Mary of Bethany, trying to comfort the pale and confused Lazarus—all of them in various attitudes of frozen despair, immobile in their sorrow.

But the next morning begins with running feet. Tentatively at first, the Magdalene approaches the sepulchre, and then, as in the dark before dawn she sees the shadowy interior of the open hole where the great stone ought to be, she begins to run. And then Peter and John are running, in a race that the younger man wins. After Peter's impetuous charge into the room and John's reflective analysis of the details, they go back home again. Did they run then, or were they walking slowly and shaking their heads in wonder?

One other point, before we leave this paragraph. Note that Mary said, "*We* do not know where they have laid him." Does this imply that the other women were with her, as the other three Gospels indicate?

The Invisible Jesus (John 20:11-18)

Resurrection is an incomprehensible idea. We can illustrate it by the image of a bright butterfly emerging from an apparently dead cocoon, or we can picture the shadowy image of a "ghost." But what would a real resurrection body look like? Paul struggles with this vision in his magnificent hymn to the resurrection, I Corinthians 15:35-50. "It is sown," he says, "a physical body, it is raised a spiritual body." What would such a body be like? After the process of decay or cremation is reversed, what sort of elements compose the new creation?

Such questions cannot be answered in the language of physics or chemistry. It is enough for us to picture the risen Christ through the eyes of those who saw (or did not see) him. Like Mary Magdalene, the two disciples from Emmaus (Luke 24:13-35) failed at first to recognize their best Friend. When they did, it was in a very simple, *physical* act, the breaking of bread. It is very complicated: On the one hand, Jesus says, "Don't touch me!" (verse 17) and seems to pass through locked doors (verse 19). But on the other, he invites Thomas to examine the physical nature of his wounds (verse 27), and in chapter 21 he apparently cooks and eats breakfast. The risen Christ appears to us in different ways, and each of us will have to discover him in our own way.

Mary's vision begins with two angels in white (verse 12) who attempt to comfort her (verse 13). This leads immediately to the sight of Jesus, whom she supposes to be the man in charge of the garden. But he speaks to her one word, her name (verse 16), and at once her vision clears. Whereas the two at Emmaus saw Christ in a nonverbal act, the breaking of bread, Mary recognized him in the spoken word, and turned again to look. Does this not remind us once more of the twofold nature of our worship: Word and Meal? Thus is the invisible Christ made known to you and me. On some occasions the preached Word gets through with special power; at other times it is the sacrament that moves us to understand.

The First Pentecost (20:19-23)

We know that the Spirit was given to the church some time later, as recorded in Acts 2. But this first appearance of Jesus to the disciples is surely a "little" Pentecost. Note the sequence of events:

1. In their fear, he surprises them with his presence.
2. He greets them with "Shalom."
3. He shows them his wounds, so that they are glad it is really he.
4. Again, he gives the peace.
5. He commissions them to go forth (compare Matthew 28:19-20 and Luke 24:46-49, as well as Acts 1:8).
6. He breathes on them (remember what "spirit" means; compare the wind of Acts 2:2) and they receive the Spirit.
7. They are empowered to set others free from their sins (compare Matthew 16:10).

Believing Thomas (20:24-29)

Let's not call him "doubting" Thomas any more, for he is not a cynic, merely a skeptic. He's a Missourian, from the "show me" state. If you will, he has the truly scientific attitude: "I'll wait until all the facts are in." But please note that when the facts *are* in, Thomas makes what is perhaps the clearest and strongest profession of faith in all the Bible. He calls Jesus both Lord and God.

Thomas is like the young man of Matthew 21:29, whose commitment came late but was stronger than that of his brother. (That parable, by the way, is not very different from the more familiar story of the two sons in Luke 15:11-32.) A skeptic is different from a cynic. The latter refuses to believe; the former is searching earnestly for the truth. The Greek root for "skeptic" is *skopeo*, "to look," from which we get words like "telescope" and "microscope." It is found in the New Testament in such places as I Corinthians 4:18: "We *look* not to the things that are seen but to the things that are unseen; for the things that are seen are transient, but the things that are unseen are eternal." Surely Thomas is such a seeker; when he sees the physical signs of Jesus' five wounds, he sees beyond them to the eternal truth of Jesus' lordship, and there his faith comes to rest.

Skepticism can only go so far. "To see through all things," said C. S. Lewis, "is to see nothing" *(The Abolition of Man)*. A window is transparent so that we can see the garden, but what if the garden were transparent too? Thomas demands a window through which he may see the Christ, but upon seeing the Christ, he bows in humble penitence and adoration.

The Purpose of This Gospel (20:30-31)

Apparently the Fourth Gospel originally closed with these verses, and what constitutes chapter 21 was added later either as an appendix by the original writer, or by a disciple. We are told that the author had to be very selective among many events (perhaps other post-resurrection appearances) but has chosen these for the specific purpose of bringing his readers to a saving faith. We can, thus, appropriately summarize here this series of lessons from John that we have been following for more than five months. John has been called "The Gospel of Light and Life," for these are its

principal images. It began (1:5) with the clear, lone candle shining in the darkness, an eternal flame that can never be extinguished. And it ends with the resurrection, the ultimate affirmation that "in him was life," and the life was the light for us all (John 1:4).

Helping Adults Become Involved—John Gilbert

Preparing to Teach

Chapter 20 of the Gospel of John is one of the most glorious chapters in the Bible. Before you begin preparing your lesson, read this chapter over and over again. Try to read it several times each day before Easter Sunday, then promise yourself that you will read it yet again the very first thing Easter Sunday morning. Make John 20 a part of you; immerse yourself in it; let its words flow over and into you so that you become shaped and molded by the words, by the Word.

Your lesson today should not be heavy on abstract thinking or precisely reasoned arguments, but a celebration of the resurrection morning. Devote other times and occasions to heavy theological issues; today rejoice in the Risen Lord and in the power of the resurrection to give us life now and forevermore!

You will want to bring the study of the Gospel of John to a logical conclusion, however, and this will require some attention both to the narrative story in the Gospel of John and to the actual impact of the resurrection on the followers of Jesus two thousand years ago and the followers of Jesus today.

A major purpose for this session is to help the members of your group know the resurrection story as told by John, including the skepticism of Thomas, and to discover how they themselves experience the resurrection in their own lives as part of their Christian faith. Like the crucifixion, the resurrection is an ever-repeated and ever-repeatable experience; to know and to profess Christ as Lord and Savior is to know the Risen Christ.

Use or adapt this simple outline for your session:

I. Outline the story of the resurrection.
II. Explore the meaning of the resurrection.
III. Celebrate and witness to the power of the resurrection in all of life.

Arrange chairs for good discussion. Have newsprint and markers or chalkboard and chalk available.

Introducing the Main Question

Practice and be ready to use the traditional Eastern Orthodox greeting, used not only at Easter but throughout the year. In most Orthodox communities the common greeting is not "Hello" or "How are you" but "Christ is risen!" The person being greeted always responds with equal enthusiasm, "Christ is risen indeed!" Note the exclamation points; this is a positive and enthusiastic affirmation; it is the most wonderful thing two persons can say to one another! Be prepared to teach this simple greeting to your class and encourage them to use it throughout the day—and longer!

The main question is, How can there be any hope in the dark days in which we live? How can we become the people not of the funeral but of the resurrection?

Finally, arrange your Easter morning schedule to be as unhurried and unharried as possible. Radiate in your own life the joy of the resurrection morn!

Developing the Lesson

I. Outline the story of the resurrection.

Greet your class members with "Christ is risen!" Make everything you do enthusiastic so that the class members catch your enthusiasm for resurrection day and share it with one another.

John 20 divides well into four parts, so divide your group into four teams. Assign one of the following groups of verses to each team, which its members are to read and be prepared to retell in their own words: 20:1-10; 20:11-18; 20:19-23; 20:24-29. When all the teams have had a few moments to read their assigned materials and to appoint one or several persons to make their reports, hear from each team. As each team is reporting, jot down major ideas on the chalkboard or newsprint. Invite members of the three non-reporting teams to raise questions with the members of the reporting team, especially questions about emotions. "What do you think Peter thought and felt first when the Magdalene told him that the Lord was not in the tomb?" "How do you think the apostles felt when they recognized Jesus standing in their midst?" "What do you think the other apostles thought of Thomas when he refused to believe in the resurrection without evidence?"

Let the whole group struggle with questions such as these as each team reports, but do not let the mood of joy or gladness at the resurrection dissipate in dissension or disagreement.

Be prepared to make some comment on verses 30 and 31, putting special emphasis on the purpose of the Gospel being to lead persons to believe and trust in the Lord.

II. Explore the meaning of the resurrection.

Last week you probed gently into the question, How would our faith be different if the resurrection had not happened? Discuss now as a whole group this question: How is our faith made complete by the resurrection? Try to help the group members move beyond simply discussing eternal life as the reward for belief (as Pat McGeachy points out). Instead, help them to see that the resurrection is a display and demonstration of God's ultimate power over all things. In dealing with this kind of question, you may want to help your group members come full circle in the Gospel of John and to discover the relationship between the resurrection story of John 20 and the prologue to the Gospel of John, studied several months ago. In short, the Word became flesh, lived as flesh, died as flesh, and arose as the Word, showing us the way to live in the flesh and yet be part of, joined to, the Word.

Then tell this story and ask for responses: A few years ago, a group of Protestant leaders were on a trip to China. It was Easter morning. As the bus was filling up to take the Americans to yet another site, one of the Americans burst through the bus door and shouted, "Christ is risen!" The Americans on the bus responded with "Christ is risen indeed!" Sitting next

to one of the Americans was a young Chinese interpreter. She turned to the American and said, "Who is this who is risen, and what difference does it make?" The American realized that he had about twenty minutes to tell this young woman who had never heard of Christ the story of the resurrection. Invite your group members to suggest what they might have said to the young interpreter had they been on the bus that morning. Can we retell the story of resurrection winsomely, enthusiastically, lovingly?

III. Celebrate and witness to the power of the resurrection in all of life.

Conclude this session by asking group members to share some of their favorite Easter customs, memories, and thoughts. Ask a few to name their favorite Easter hymns. If possible, sing some of these hymns. Ask the group members to think of new ways they could celebrate the resurrection and new ways they could use this day and all days to communicate the great good news of a risen Savior and Lord. Could the members of your group devise a new Easter custom that would have meaning just for your group, which could be repeated throughout the year to remind one another of this day and all it means?

Helping Class Members Act

Challenge each class member to talk to at least one friend or acquaintance this week about the resurrection and its meaning for her or him. Ask each class member to keep an informal record of these sharing experiences and to jot alongside that record any new insights he or she has gained into the meaning of the resurrection through the sharing.

Planning for Next Sunday

Invite all class members to read I John 1:1–2:17 before the next session. Remind them that the study shifts from a biography of Jesus to a letter written about the Christian faith. Challenge them to mark or note ideas or verses that are not immediately clear to them.

ABIDING IN LOVE
(A Six-Lesson Course)
Horace R. Weaver

SIX LESSONS **APRIL 22–MAY 27**

This six-week course based on I, II, and III John concludes the March-May quarter. The post-Easter series of studies focuses on the practical expression of the Easter faith. This course, "Abiding Faith," picks up the author's designation of deeds of faith as "love" rather than "works" (I John 3:23). The session titles reflect the tensions encountered by those who seek to express their faith in the world. They exemplify the author's particular awareness of the continuing presence of sin within the Christian community: "If we say we have no sin, we deceive ourselves" (I John 1:8).

The six lessons focus on the following aspects of love: "Forgiveness and Fellowship," April 22, asks, Are we capable, having experienced forgiveness, to have true fellowship with one another? "Knowing and Abiding," April 29, emphasizes a major issue for our day: How can youth and adults differentiate between what is true and what is false in the Christian faith? "Love and Hate," May 6, asks, Do I, deep down, know that I seek justice, thirst for righteousness, and long for the good of my neighbor? "Fear and Love," May 13, helps us see that Jesus came to call us to hope and courage, not terror and discouragement—not to fear but to love God. "Faith and Life," May 20, declares the unity of faith and love, which causes us to yearn to keep the deity's commandments. "Loyalty and Discipleship," May 27, declares grace, mercy, and peace to every loyal and loving disciple.

The Meaning of Love

Gail R. O'Day

If one were asked to identify the central theme for the Johannine Epistles, the most likely candidate would be the theme of "love." The verb "to love" (agapaō) occurs twenty-eight times in I John, the noun "love" (agapē) eighteen times. This is the highest frequency of agapē anywhere in the New Testament, and only the Gospel of John has more uses of the verb agapaō (thirty-seven times). When one compares the length of the Gospel and the epistle, however, it becomes apparent how heavy the concentration of the word "love" is in I John.

The starting point for the discussion of love in the Johannine Epistles is simple and direct: "God is love" (I John 4:8, 16). Everything else that is said about love in the epistles derives from this central affirmation. Love is neither of human origin nor invention but is an expression of the very character of God. We know God's love only because God chose to share Godself with us in love. That sharing in love is a gift we receive decisively in God's act in Jesus (4:10).

God loved us enough to send Jesus to us to offer us life (4:9). God's love does not end with the sending of Jesus, however. God's love is completed in Jesus' death: that Jesus laid down his life for us (3:16) as expiation for our sins (4:9). I John 4:18 speaks about the perfect love that casts out fear, and it is God's act in Jesus that provides this assurance against fear.

God's act of love in Jesus gives a new identity to those who believe (4:7). We are now God's children (3:1-2). As God's children, we are called to respond in kind to the gift of love and new identity we have received. Just as love is the essential trait of God's character, love is now to be the essential trait of the community's character (4:11). The children of God are called upon to love one another, to love their brothers and sisters, because in loving the child, they love the parent (2:10; 3:10; 4:20-21; 5:2). The central commandment that is repeated throughout the Johannine Epistles is that we are to love one another (3:23; 4:21; II John 5-6). The love of God must issue in action. It is not enough to say one loves God. One must act in love toward one's brothers and sisters (3:18).

Our love for one another is the final act in the drama that began with God's love for us. Jesus laid down his life for us; we ought to lay down our lives for our brothers and sisters (3:16). In loving one another, God's victory

in the death and resurrection of Jesus is completed (4:12), because we pass out of death into life (3:14). Without the love of God and without the enactment of that love in our own lives and relationships, we remain trapped in hatred and death. God has opened up a new world and a new way of life through the gift of love. Our response to this gift can only be to "follow love" (II John 6).

The meaning of love in the Johannine Epistles is captured in this one verse from I John: "We love, because he first loved us" (4:19). God has changed our lives through God's love offered to us. We are called to share God's gracious gift with others.

LESSON 8 APRIL 22

Forgiveness and Fellowship

Background Scripture: I John 1:1–2:17

The Main Question—Pat McGeachy

Sometimes it seems to us that honesty is the worst policy. I mean, if you *always* spoke the plain truth, how would you get along in this world? Most human conversations begin with a falsehood: "How are you?" "Fine!" This denies my guilt, my frustration, my weariness, and my fears, to say nothing of my arthritis. How could we survive without our coverups? Consider what life would be like if human conversation consisted of a constant flow of things like "What an ugly baby!" "This is the most boring party I have ever been to." "My dear, I am really tired of your company tonight; could you go out in the yard or something?"

Of course, the usual human cover-ups are relatively harmless—the sort of thing we call "white" lies. But it is an easy step from polite dissimulation to destructive dishonesty.

The opening paragraphs of I John call us to a kind of "sunshine law" by which to live. We are enjoined to "walk in the light," to come clean by confessing our sins, and to live in "fellowship with one another." The world in its hypocrisy cannot abide this sort of openness. We would rather "walk in darkness" and occupy ourselves with "the lust of the eyes and the pride of life." Is it possible to break out of the big lie in which we live? Can we really get honest with ourselves, with each other, and with God? Or must we forever live like those creepy things under the rotten log who flee from the light into the comforting darkness and decay?

It is the thesis of this letter that a spiritual sunshine law is possible. Moreover, it claims that only in such a law is complete joy possible. So the main question for us is, Can we claim complete honesty for ourselves?

As You Read the Scripture—Harry B. Adams

This session is the first in a series of six on the three epistles that bear the name of John. There has been much discussion by biblical scholars about the author and whether this John is the person who wrote the Gospel of John. It is a question that has no final answer, for although there are many similarities between John's Gospel and his epistles, there are also many differences in thought and style.

It would appear that the epistles were written during the first quarter of the second century as resources to be carried by missioners who were visiting churches in the region where they were working.

I John 1:1-4. This epistle or letter is not addressed to any person or any specific group; in fact, there is no salutation or closing in the first epistle of John. The author simply launches in with a long and complex sentence.

Three things can be said about this opening section of the epistle. First, there is an obvious echo of the beginning portion of the Gospel of John, which opens with the words, "In the beginning was the Word." Second, the author seeks to communicate the intensity and passion of his religious convictions. Third, the writing is so concentrated and intense that the precise meaning of the author is very difficult to sort out. For example, in this first verse it is not entirely clear what "that which was clear from the beginning" refers to, although at the end of the verse it appears that it refers to "the word of life" or Christian preaching.

But some basic words and ideas important to the author of these epistles do get stated here. There is strong emphasis on what is heard and seen and touched. The word proclaimed to the Christian community is grounded in what has been manifest.

The word that is made manifest brings eternal life, another key concept in both the Gospel and the epistles of John. This opening section also brings into focus the notion of *koinonia*, or fellowship, which the Christians have with each other and with God and God's Son. He closes this opening section with the purpose of his writing, that "our [or your] joy may be complete."

I John 1:5–2:6. This section begins with a contrast that is found repeatedly in John's Gospel and epistles, the contrast between light and darkness. The idea of fellowship with God returns and is closely related to right living or living according to the truth. John makes a close connection between the life of faith and the life of action, between the relationship with God and righteousness.

In verse 7 he speaks of Jesus' cleansing us from all sin and then goes into a rather extended discussion of sin in the life of the Christian. On the one hand, John is convinced that the Christian has been freed from sin, because Jesus cleanses persons and because they are in fellowship with God. Thus he writes to them, "so that you may not sin." On the other hand, John faces the reality that sin is an inescapable fact in the lives of all persons, for "if we say we have no sin, we deceive ourselves."

In I John 2:3 appears for the first time another idea that is central to the epistle; John uses the word "know" for our relationship with God. It is a word appearing some twenty-five times in this first epistle.

THIRD QUARTER

Selected Scripture

King James Version

I John 1:1-10

1 That which was from the beginning, which we have heard, which we have seen with our eyes, which we have looked upon, and our hands have handled, of the Word of life;

2 (For the life was manifested, and we have seen *it,* and bear witness, and shew unto you that eternal life, which was with the Father, and was manifested unto us;)

3 That which we have seen and heard declare we unto you, that ye also may have fellowship with us: and truly our fellowship *is* with the Father, and with his Son Jesus Christ.

4 And these things write we unto you, that your joy may be full.

5 This then is the message which we have heard of him, and declare unto you, that God is light, and in him is no darkness at all.

6 If we say that we have fellowship with him, and walk in darkness, we lie, and do not the truth:

7 But if we walk in the light, as he is in the light, we have fellowship one with another, and the blood of Jesus Christ his Son cleanseth us from all sin.

8 If we say that we have no sin, we deceive ourselves, and the truth is not in us.

9 If we confess our sins, he is faithful and just to forgive us *our* sins, and to clean us from all unrighteousness.

10 If we say that we have not sinned, we make him a liar, and his word is not in us.

I John 2:1-6

1 My little children, these things write I unto you, that ye sin not. And if any man sin, we have an advocate

Revised Standard Version

I John 1:1-10

1 That which was from the beginning, which we have heard, which we have seen with our eyes, which we have looked upon and touched with our hands, concerning the word of life—2 the life was made manifest, and we saw it, and testify to it, and proclaim to you the eternal life which was with the Father and was made manifest to us—3 that which we have seen and heard we proclaim also to you, so that you may have fellowship with us; and our fellowship is with the Father and with his Son Jesus Christ. 4 And we are writing this that our joy may be complete.

5 This is the message we have heard from him and proclaim to you, that God is light and in him is no darkness at all. 6 If we say we have fellowship with him while we walk in darkness, we lie and do not live according to the truth; 7 but if we walk in the light, as he is in the light, we have fellowship with one another, and the blood of Jesus his Son cleanses us from all sin. 8 If we say we have no sin, we deceive ourselves, and the truth is not in us. 9 If we confess our sins, he is faithful and just, and will forgive our sins and cleanse us from all unrighteousness. 10 If we say we have not sinned, we make him a liar, and his word is not in us.

I John 2:1-6

1 My little children, I am writing this to you so that you may not sin; but if any one does sin, we have an

with the Father, Jesus Christ the righteous:

2 And he is the propitiation for our sins: and not for our's only, but also for *the sins of* the whole world.

3 And hereby we do know that we know him, if we keep his commandments.

4 He that saith, I know him, and keepeth not his commandments, is a liar, and the truth is not in him.

5 But whoso keepeth his word, in him verily is the love of God perfected: hereby know we that we are in him.

6 He that saith he abideth in him ought himself also so to walk, even as he walked.

advocate with the Father, Jesus Christ the righteous; 2 and he is the expiation for our sins, and not for ours only but also for the sins of the whole world. 3 And by this we may be sure that we know him, if we keep his commandments. 4 He who says "I know him" but disobeys his commandments is a liar, and the truth is not in him; 5 but whoever keeps his word, in him truly love for God is perfected. By this we may be sure that we are in him: 6 he who says he abides in him ought to walk in the same way in which he walked.

Key Verse: **But if we walk in the light, as he is in the light, we have fellowship one with another, and the blood of Jesus Christ his Son cleanseth us from all sin. (I John 1:7)**

Key Verse: **If we walk in the light, as he is in the light, we have fellowship with one another, and the blood of Jesus his Son cleanses us from all sin. (I John 1:7)**

The Scripture and the Main Question—Pat McGeachy

The Physical Evidence (I John 1:1-4)

First-year seminarians are usually very familiar with I John because it is traditionally the first place where you begin to learn to translate the Greek New Testament. It is a short letter with an easy vocabulary; John is not given to four-dollar words. He is down to earth and simple. But you do not exhaust his message in the first year of seminary. For all its simplicity, this writing is profound; it touches the deep places of the heart.

It begins with the plain words of the senses: hearing, seeing, touching (verse 1), with the assurance of an eyewitness who sees and tells (verse 2), so excited that he cannot hold it in for himself. It is a conviction that demands to be shared (verse 3), that "draws a circle to take others in" to the fellowship. It is the fellowship of an intimate relationship with God and Jesus, and (verse 4) it is a source of utter joy, both to the writer and to those of us he includes in his invitation.

Several images come to mind: a small child running to its mother with a precious article of nature—a leaf, a flower—clutched in its hand, crying, "Look what I've found!" Or a scientist hurrying from the laboratory with a bubbling test tube and shouting, "Eureka!" Or a young woman introducing her fiancé to her friends. It is show-and-tell time! And John wants to share the precious thing he has discovered with all the world.

THIRD QUARTER

Stepping in the Light (1:5-10)

It is John's conviction that God is light. (There are approximately three hundred references to "light" in the Bible, about two hundred in the Old Testament and one hundred in the New.) The first chapter in the Bible begins with God calling light into being (Genesis 1:3), and the last chapter contains the promise that "the Lord God will be their light, and they shall reign forever and ever" (Revelation 22:5). And in between, the chapters are full of references to the bright shining of the Lord. Here are a few examples; you may wish to consult your concordance for others.

> Thy word is a lamp to my feet
> and a light to my path.
> (Psalm 119:105)

> The people who walked in darkness
> have seen a great light;
> those who dwelt in a land of deep darkness,
> on them has light shined.
> (Isaiah 9:2)

I am the light of the world. (John 8:12)

Like all metaphors, "light" is inadequate to explain God. In one of his novels Erskine Caldwell relates how disappointed a child is when her sister comes back from a "vision" saying that God looks like a light. The child can only picture the bare bulb hanging from the ceiling of her primitive home, and the image is not very satisfying. But there is one obvious characteristic of light that explains what John means about the nature of God: Light reveals things.

We can't pretend before the blinding light of God; we can claim to be sinless, but we are lying, and the light reveals the lie (verse 8). But the light of God is willing, when we face up to the truth, to surround us with the warm forgiveness of love. Like a brooder lamp (compare Matthew 23:37) God warms us, and like a refiner's fire (Malachi 3:3) God purifies us. The sun of righteousness (Malachi 4:1-2) comes "burning like an oven," but it also rises "with healing in its wings." The very light that our sin cannot stand, our hearts cannot live without.

Truth and Lies (I John 2:1-6)

John's distinction between truth and lies is really the same as the difference between day and night in the last chapter. Again, we must not fool ourselves. John does not want us to sin (2:1), but he knows that we will. He promises us the friendship and support of Christ. This promise is offered not only to us but to "the whole world" (verse 2). When I remember this, it makes a big difference in how I relate to persons outside my faith; this "foreigner," whoever he or she is, is one for whom Christ died. Their sins are forgiven too! I'm not the only one.

There are two kinds of people who do not receive forgiveness: those who don't know about it, and those who claim they don't need it and so don't ask for it. That is why Jesus went so often to "tax-collectors and harlots" (Matthew 21:31-32). The "good" people, on the other hand (verse 4), who

profess faith but live the lie, never hear the forgiving gospel because they think they are already good. (Do you suppose people in your church ever think this way?)

The Old and New Commandment (2:7-11)

This gospel of light and dark, grace and sin, has been around for a long time. God did not call Abraham out of Ur or Moses and his friends out of Egypt because of their righteousness, but because God is love. (See, for instance, Deuteronomy 7:7-8.) God has always acted, in spite of our unfaithfulness (compare Jeremiah 31:31-34), to save and help all those who would ask for it (Psalm 145:18-19).

But in another sense, this *is* a new commandment (2:8) because Jesus, the light of the world, has cast a shining new awareness on the world. In Jesus we can see clearly what was not always entirely visible in the Old Testament: that God is 100 percent for us. It was always true (see, for instance, Jeremiah 31:3, "I have loved you with an everlasting love"). But the Hebrew Bible, for all its grace, has often been seen by people of God primarily as legalistic, as placing a heavy burden of morality upon us. And we never seem to be able to live up to its requirements. Instead we cry out with Paul, "I'm wretched! How can I escape?" (Romans 7:24). It is only in Jesus that we clearly hear anew the old news that nothing can separate us from the love of God (Romans 8:38-39).

As long as we deny this grace (and continue hating our brother [verse 9], which is the same thing), we continue to stumble like those walking in darkness (think again of Isaiah 9:2). We are, as Jesus said, the "blind leading the blind" (Matthew 15:14), and we can expect to stumble.

The Tough Decision (2:12-17)

Hard as it is to see in the dark, in the light of Christ it is clear that we must make a break with our old love for the world. Of course, there is one sense in which we must love the world, for God loves it (John 3:16), and we ought to be like God. We should learn to become rightly related to nature, all persons, ourselves, and our fellow human beings. But in another sense we dare not love the world. In other words, we must be in the world but not of it (John 17:9, 14-18). This is not because the world is evil; when God created the world, it was very good (Genesis 1:31). It is because the world is penultimate (John 2:17). That's a four-dollar word, but I need to use it because it says exactly what I mean: The world isn't permanent; it "passes away." And we must not put our trust in that which cannot last (see Matthew 6:19-21, 33). Lesser gods (money, power, pleasure, nation, family, and self) may promise all sorts of things, but ultimately they cannot save us. Sadly, however, they do possess the power to destroy.

That is why John calls so earnestly for us to commit ourselves to God made known in Christ. In verses 12-14 he calls out to all generations:

> Children! God forgives you!
> Oldsters! You know what I'm saying!
> Young folks! Use your strength!
> Children! You know God!
> Oldsters! You have long known God!
> Young folks! Put your strength to work!

THIRD QUARTER

In every generation we have special gifts to put at the disposal of the Lord. Children have their innocent faith, older people have their tested experience, those in the prime of life have their energy and enthusiasm. John is saying, "Let's put all these resources to work on behalf of the light, that the darkness may not overcome us" (John 1:5).

Helping Adults Become Involved—John Gilbert

Preparing to Teach

For the remainder of this quarter you will be studying the three epistles of John, with a special emphasis on the first epistle of John. Pause right now, seek God's guidance in prayer, then carefully read the three epistles of John. Try to read them with fresh eyes and an open mind. Let John speak to you anew and afresh through the words of these epistles. Let him speak to you as directly and with as much originality as he addressed the first readers of these epistles. Keep in mind that while the books of the Bible were indeed written for specific situations at specific times, those who formed the books of the Bible into the collection, the *canon*, felt that each book included in the Holy Scriptures had a timeless value, a message for any time, situation, or circumstance. So it is with the epistles of John. They were addressed to specific situations almost two thousand years ago, but they speak directly to us as well.

Once you have read through these three epistles and let them speak to you, go back and reread the first epistle once again. This time, make a list of the images or pictures John uses in describing Jesus Christ. Give special attention to the images in the first two chapters. Next, alongside each image you have noted from the first epistle of John, note other places in the Bible where this image is paramount. Begin to tie biblical themes and images together so that the overall sweep of the biblical message becomes clear. A study of the epistles of John enables this to take place most effectively.

(For example, you will probably note that John uses the image of light in referring to Jesus. You will want to jot down that the Gospel of John uses this image, as does the prophecy of Isaiah, and indeed the book of Genesis in the creation epic itself.)

Now pray for each of your group members by name; seek guidance and inspiration for each.

As you begin your detailed planning for this session, you might want to consider using this simple outline, realizing, of course, that you may need to adapt it for the needs of your own group members:

> I. John's evidence of Christ's presence with us
> II. The universal reality of sin in the world
> III. God's solution for human sin

This session will require as much conversation, discussion, and sharing as possible. Can you arrange the chairs in your meeting room to make discussion easier? Have on hand a chalkboard and chalk or large sheets of paper with appropriate markers. Always have on hand extra Bibles, perhaps in several translations, for the use of group members.

Introducing the Main Question

The main question of this lesson is simply, How can we emerge from the big lie in which we live—our excuses, rationalizations, self-justification, blatant hypocrisy—and admit that we are sinners, unable to save ourselves and in need of God's saving grace? One way to point this up for the group members might be to print on small sheets of paper then mount around your classroom a number of excuses people use for their own shortcomings, such as, "It wasn't my fault," "It was her idea," "I didn't have time to check it out," "No one told me what would happen," "I was only following orders," and so on. Include among your small posters the references I John 1:8 and I John 1:10. Do not write out these verses; simply post the biblical references, and allow group members to look them up for themselves.

Developing the Lesson

When all have assembled, open the session with prayer, especially praying for those who are absent for whatever reason. Be sure all group members have a Bible, then take care of any class business with dispatch.

I. John's evidence of Christ's presence with us

Ask group members to read silently I John 1:1-3. Invite group members to call out the senses John uses to verify the experience of Jesus—especially seeing, hearing, touching. Discuss in what ways John may have seen, heard, and touched Jesus Christ, either directly or indirectly.

Pose this question: In what ways, besides our senses, do we have evidence of Christ's presence and power with us? In what ways can we proclaim the presence and power of Christ with us to others, in addition to speaking our witness?

Make a brief presentation on the concept of Christ as the light, especially the perfect, shadowless light that brings into sharp focus all that is hidden and all that is open. Refer to other biblical examples of light, and draw parallels between John's use of light in these epistles and the use of light in the Gospel of John. (Do not get entangled in the complex question of the authorship of the epistles of John. The author may have been John the evangelist, the author may have only attributed the letters to John the evangelist, or the author may have been another John altogether. In fact, scholars simply do not know for certain who wrote these epistles.)

II. The universal reality of sin in the world

Invite group members to read I John 1:5-10 silently, then lead a discussion on the universality of sin. Invite group members to list ways persons walk in the darkness by denying their sinfulness, by putting the responsibility for their sin on others, or by simply excusing their sin with an "everybody's doing it" attitude. List on chalkboard some of the ways persons say they have no sin, besides simply saying aloud that they have no sin. Suggestions: frantic religious activity, strained external piety, a generally judgmental attitude towards others. Expect some comments regarding the small posters you have hung around the room during this discussion. Summarize this discussion by again emphasizing how in the light of the presence of Jesus Christ, all sin is exposed and nothing is hidden.

III. God's solution for human sin

Ask your group to read aloud together I John 2:1-6 (if all have access to the same translation *or* if your student quarterly contains a printed version of this passage). If you are reading from the Revised Standard Version of the Bible, hold a brief discussion of words such as "advocate" and "expiation," drawing on contemporary examples to illustrate and illuminate the meanings of these terms. A significant dimension of this passage is the second verse of the second chapter. Christ is described as the solution of the sins of all, not just the chosen few. The phrase "the whole world" includes all time as well as all space. Explore with the group members the meaning of Christ's sacrifice for all peoples everywhere and at all times.

Pose this question: How can we claim for ourselves that expiation of our sins? How can we know, that is, feel and experience, that Christ is our advocate?

Helping Class Members Act

Challenge class members to begin every day this week with a prayer to God that they may be open and honest in perceiving themselves, that they may stand in the perfect light of Christ and see themselves as they really are. Challenge class members to acknowledge silently before God each day at least one sinful habit or attitude, then to seek God's guidance in overcoming that habit, just for that day.

Planning for Next Sunday

Ask group members to read all of the first epistle of John prior to your next session, but to give special attention to I John 2:18-29.

LESSON 9 APRIL 29

Knowing and Abiding

Background Scripture: I John 2:18-29

The Main Question—Pat McGeachy

There are many voices calling to us these days. When I was a youngster growing up in a small rural American town, I knew some Baptists, Methodists, and Presbyterians, and a few other Protestants, but I do not remember speaking to a Roman Catholic until I was eleven years old. I first met a Jew as a teenager, and I never spoke to a Buddhist until I was in my twenties. Now *my* children (who are in their thirties today) had met all the above before they finished junior high school and had talked as well with "secular humanists" (whatever one of those is), agnostics, and atheists. Who knows what tempting cultic voices *their* children are currently hearing?

Of course, many of the voices mentioned above are friendly ones, as were many of those heard by the early Christians. But there are others. When our young folks turn on the television or go into the marketplace or leave home for college, what do they hear? Sometimes they encounter ideas openly hostile to the faith in which they were raised. How do we advise them to deal with the questions they hear being asked?

Frankly, I think today's youngsters are more fortunate than we were! The challenge of the questions they confront may indeed be disturbing, but they also challenge young minds to sharpen their defenses and deepen the roots of their faith. I give them this one-sentence counsel as they go forth to meet the foe: Drive a stake into this one truth, "Jesus is Lord," and then feel free to wander wherever your spiritual quest leads you. If you give allegiance to Jesus, no other "christ," however persuasive, can claim your loyalty. "If what you heard from the beginning abides in you, then you will abide in the Son and in the Father (I John 2:24)." And all the pathways of life are yours to explore. Can you hold on to Jesus?

As You Read the Scripture—Harry B. Adams

It is evident in many of the letters of Paul that he wrote because the community was under attack from the outside or facing division from within. The verses from the second chapter of I John that provide the basis of discussion in this session indicate that this author also detected threats to the faith and life of the communities to which he was writing.

I John 2:18. This section begins with John addressing his readers affectionately as children, writing "little children" (2:1, 12, 28; 3:18) or "beloved" (4:1, 7).

His first word to "the children" here is that "it is the last hour." On what basis does he make that judgment? He believes that it will be the last hour when the antichrist comes. Many antichrists have come. Therefore it must be the last hour.

The New Testament presents a rich diversity of thought about the last hour, the end, the final culmination. Some strains of thought find in Christ and the life he brought the presence and the fulfillment of God. Some strains, of that John here is representative, find Christ only the foretaste of the end that is yet to be realized. John also finds opposition to the Christian message to be the sign of the coming end.

Verse 19. Who are the antichrists who appear to John to be the sign of the last hour? He indicates that they are those who have separated themselves from the community. This kind of division indicates painful developments that were taking place within the church. In his letters Paul certainly makes clear that there is plenty of argument and disagreement, but he gives no evidence of expulsion or separation.

Verse 20. Those to whom John is writing are right and know the truth because they have been anointed. He refers again to the anointing in verse 27, where he indicates that the anointing teaches about everything. John doesn't say explicitly, but presumably the anointing comes at the baptism.

Verses 21-23. John draws out the contrast between those who know and speak the truth and those who lie. Who is the liar? Who is the antichrist? What is the issue that has led to the schism in the community? John discerns two related problems. There are those who deny that Jesus is the Christ, that is, the Messiah, the Anointed One of God. These people deny the truth

that John believes to be the basic conviction of the Christian. Then there are those who deny "the Father and the Son." These people deny a commitment to God and to the Son. Because they don't confess the Son, they don't know God either.

Verses 24-25. John began his book talking about what was "from the beginning," and here urges the community to let what they have heard "abide" in them. He goes on to talk here and in verse 28 about abiding in the Son and in the Father. If they let the truth that they know permeate and sustain their lives, then they can have an enduring and intimate relationship with God.

And that relationship will bring blessing, the blessing described as eternal life in verse 25 and as confidence in his coming in verse 28.

Selected Scripture

King James Version

I John 2:18-29

18 Little children, it is the last time: and as ye have heard that antichrist shall come, even now are there many antichrists; whereby we know that it is the last time.

19 They went out from us, but they were not of us; for if they had been of us, they would *no doubt* have continued with us: but *they went out,* that they might be made manifest that they were not all of us.

20 But ye have an unction from the Holy One, and ye know all things.

21 I have not written unto you because ye know not the truth, but because ye know it, and that no lie is of the truth.

22 Who is a liar but he that denieth that Jesus is the Christ? He is antichrist, that denieth the Father and the Son.

23 Whosoever denieth the Son, the same hath not the Father: *[but]* *he that acknowledgeth the Son hath the Father also.*

24 Let that therefore abide in you, which ye have heard from the beginning. If that which ye have heard from the beginning shall remain in you, ye also shall continue in the Son, and in the Father.

25 And this is the promise that he hath promised us, *even* eternal life.

Revised Standard Version

I John 2:18-29

18 Children, it is the last hour; and as you have heard that antichrist is coming, so now many antichrists have come; therefore we know that it is the last hour. 19 They went out from us, but they went not of us; for if they had been of us, they would have continued with us; but they went out, that it might be plain that they all are not of us. 20 But you have been anointed by the Holy One, and you all know. 21 I write to you, not because you do not know the truth, but because you know it, and know that no lie is of the truth. 22 Who is the liar but he who denies that Jesus is the Christ? This is the antichrist, he who denies the Father and the Son. 23 No one who denies the Son has the Father. He who confesses the Son has the Father also. 24 Let what you heard from the beginning abide in you. If what you heard from the beginning abides in you, then you will abide in the Son and in the Father. 25 And this is what he has promised us, eternal life.

26 These *things* have I written unto you concerning them that seduce you.

27 But the anointing which ye have received of him abideth in you, and ye need not that any man teach you: but as the same anointing teacheth you of all things, and is truth, and is no lie, and even as it hath taught you, ye shall abide in him.

28 And now, little children, abide in him; that, when he shall appear, we may have confidence, and not be ashamed before him at his coming.

29 If ye know that he is righteous, ye know that every one that doeth righteousness is born of him.

26 I write this to you about those who would deceive you; 27 but the anointing which you received from him abides in you, and you have no need that any one should teach you; as his anointing teaches you about everything, and is true, and is no lie, just as it has taught you, abide in him.

28 And now, little children, abide in him, so that when he appears we may have confidence and not shrink from him in shame at his coming. 29 If you know that he is righteous, you may be sure that every one who does right is born of him.

Key Verse: **If that which ye have heard from the beginning shall remain in you, ye shall also continue in the Son, and in the Father. (I John 2:24)**

Key Verse: **If what you heard from the beginning abides in you, then you will abide in the Son and in the Father. (I John 2:24)**

The Scripture and the Main Question—Pat McGeachy

Antichrists (I John 2:18-19)

"Antichrist" means one who is "against Christ." People charged with that name are not usually found outside the church, attacking it in the name of the devil, but within the church, trying to make a name for themselves. Perhaps you know of some "cultic" leader who has persuaded some well-meaning Christian friends to go off on a crazy tangent. Not too long ago, a man persuaded nearly a thousand of his followers to commit suicide by drinking cyanide-laced Kool-Aid in a kind of hideous parody of the sacrament. Such a destructive leader might very well be called "antichrist" by us today.

What would cause otherwise intelligent people to fall for such a charlatan? It would take a wiser psychologist than I to know the full answer to that question, but it seems that part of the answer is found in our sense of helplessness. When the world seems to be tumbling in around us, we clutch for straws, and if a false savior comes along with easy answers and glib promises, it is hard not to be tempted. At the time when John was writing this letter, the young church was under terrible persecution. John himself suffered imprisonment, as did many of his followers. It seemed to them that history was coming to a climax in their own lifetimes. I suppose that everyone feels this way to some extent, but the sense of the imminent end of all things was especially strong in those New Testament days. Thus John warns his readers that "it is the last hour" and that they can expect the antichrist to show up. If you feel the same way about the time in which you are living, then you too should be on guard for an unscrupulous "deliverer" with an easy out.

THIRD QUARTER

Life in Christ (2:20-25)

While you are guarding against falling for a false christ, don't harden your heart so that you forget your commitment to the true Savior. We really do know who Jesus is (verse 21). If, like me, you have been influenced by the hundreds of Sunday school pictures of Christ that you have looked at over the years, you may have formed a picture in your mind. But that is not the image I mean. I mean an image based not on pictures but on the nature of Jesus, his life and his work, his teachings and his actions, his death and his resurrection—the sort of things that the early sermons in Acts tell about him (for a short one, read Acts 10:36-43). Every one of us, as we live out our Christian life, continues to shape such a picture in our minds until we really *do* know who Jesus is, even though we have never seen him in the flesh.

Anyone who denies that Jesus, John says (verse 22), is a liar, and we shouldn't fall for such a one. Perhaps in your circles you rarely encounter someone who says aloud, "I don't believe that Jesus is the Christ." Rather, it is more likely that their denial takes the form not of words but of deeds, or the lack of them. It has been suggested that today's world does not suffer so much from "theoretical" atheism as from "practical" atheism. That is, most folks *say* they believe, but their lives belie their claims. We do not have to look far for examples of this: Professing Christians who have no interest in feeding the hungry, welcoming the stranger, or visiting the prisoner (see Matthew 25:31-46) are clear examples of those who deny Christ even without knowing it (Matthew 25:44).

But there are other, more subtle examples of denial through behavior. It is possible to deny Christ through a rash of good deeds! Those who claim to believe in the Son and the Father (verse 22) but who live as though they are carrying the whole world on their shoulders are in effect denying Christ by trying to live without him. To live a frantic, worried, burdened life is to deny Christ as surely as to live a life apart from Christ's commands. Indeed, such a life *is* apart from his command, "Do not be anxious about your life" (Matthew 6:25).

But what if, after giving it my best shot, I am still found denying Christ, either by sins of commission or omission (or, more likely, both)? In that case, which is the case of all of us, only my affirmation in word and worship will prove my faith. If I have denied Christ by the way that I have lived, I can at least affirm him by confessing my failure and asking God to help me.

In the long run, it was only by the gift of the Holy Spirit that I became a Christian in the first place. That, I suspect, is what John means when he says (verse 20), "You have been anointed by the Holy One, and you know." My knowledge of Christ was from the beginning a gift: a gift from the family in which I was born, the church in which I was nourished, and the faithful folk who have witnessed to me over the years. If I have any doubts now, then I must turn (verse 24) to what I heard in the beginning and test my present-day faith by those precepts. This is not a reactionary call to "that old time religion" but a radical call to our roots (that is what "radical" means). If our current spiritual life seems shaky, perhaps we ought to "look to the rock from which we were hewn, and the quarry from whence [we] were digged" (Isaiah 51:1).

If we do turn to those basics, we will remember (verse 25) that he has promised us eternal life, so that we do not need to be afraid of any of the symptoms of the "last hour." Even if the structures of our society are

crashing down around us, we need not flee after an antichrist. The Christ himself will be our good Lord, and we can go safely through this Jordan.

Looking Backward and Forward (2:26-29)

We not only must return to our roots, but we must anticipate the coming of Christ. Let me illustrate this by describing what I think is good advice to people moving to a new town to undertake a new job. The strangeness makes you uneasy, and you don't know how long the job is going to last. But if you are wise, you will put roots down and become a solid part of the new community. Join a church there as soon as possible, begin to take part in local politics and humanitarian concerns; in short, live as though you have settled in for good. This is looking backward and settling in as though you had lived there forever.

But in another sense, it is a good idea to carry a letter of resignation around in your mind. (Not in your pocket; you might be tempted to whip it out and turn it in at the wrong time!) You need to adopt the attitude that any time you want to, you can tell them to take this job and file it (or whatever). You have a far more permanent existence than this; you're a citizen of an eternal kingdom and not dependent on this one for your deepest satisfactions. In other words, you can stay uncommitted to this world, for you have one foot in another.

Thus, though I have much to learn, there is a sense (verse 27) that I don't have to depend on anybody else to explain to me what life is all about. *I know* because I know Christ. That is why some Buddhists like to say, "If you meet the Buddha on the road, kill him." To be fully mature spiritually is to need no guru. As long as I continue to find my religious strength in another, I am not quite grown up in my faith. When I know that Christ has set me free, I can trust myself in the teaching I received in his anointing (verse 27).

But, of course, there is another sense in which I am completely ignorant. I must not be arrogant in my faith, for ultimately Christ must teach me what it really means. I can await confidently his coming (verse 28) and rush forward to meet him with open arms. I know that I will recognize the true Christ when he comes, and no antichrist can confuse me. In that day he will fill in all the blanks in my spotty understanding of the truth. "Now I know in part; then I shall understand fully, even as I have been fully understood" (I Corinthians 13:12).

Helping Adults Become Involved—John Gilbert

Preparing to Teach

Did you read all of the first epistle of John in preparation for last week's lesson? If not, read the entire epistle now. If you did read it in preparation for last week, please read it again, preferably in a different translation or paraphrase. Give special attention to the writer's development of ideas and thoughts. Some scholars suggest that the John who wrote this letter was writing a general letter to be shared with all Christians everywhere; others hold that he was writing to a particular group of Christians about particular situations and concerns. While no one will ever know the answer for sure, the weight of New Testament evidence seems to suggest the latter choice, namely, that John was writing to a particular group of people about a

particular problem or situation. We can understand the letter most effectively and follow its logical development most clearly if we can identify with the issue or situation that John is addressing.

Rather clearly in the section chosen for today's lesson—I John 2:18-29—the issue is the problem of false teachers and preachers, that is, persons who lie about their faith. (Refer to Pat McGeachy's "The Main Question.") John's note of urgency, sounded in the first verse of this section, echoes a notion very commonly held in the first two centuries of the Christian church, that the return of Jesus Christ was imminent.

Because the message of I John 2:18-29 is rather brief and direct, your outline for this session might also be brief and direct. You might want to adapt the following outline; remember, no outline will exactly fit your group without some adjustment and adaptation.

 I. John's message to the church
 II. The times of today
 A. The antichrist today outside the church
 B. The antichrist today within the church
III. The Christian and overcoming—steadfastness
 in the faith

You will want a chalkboard and chalk or large sheets of paper and appropriate markers, placed where all can see them for this session. A horseshoe shape is a desirable seating arrangement, as it allows for a focus of attention yet facilitates discussion among the group members. Are you remembering to have on hand a supply of Bibles for those who do not bring theirs each Sunday? Do you have available paper and pencils for those who wish to make notes?

Introducing the Main Question

As group members arrive for this session, ask each to jot down on the chalkboard or one of the large sheets of paper the name or profession or business of one of the "deceivers" or antichrists afoot in the contemporary world (or in the world of recent history). To get group members started, you might put this heading across the top of the chalkboard or sheet of paper: "Persons or positions that have led Christians away from the truth." Note that the purpose of this exercise is not to judgmentally compose a list of names and titles for debate, but to help group members recognize the wide variety of powers that tempt Christians to abandon their trust in Jesus Christ alone. This exercise should also help reinforce the idea that John made at the beginning of today's Scripture passage: "Children, it is the last hour."

Developing the Lesson

Begin this session by inquiring about the health and safety of class members who are absent, then lead the class in a moment of devotion and prayer. A companion piece to this volume, *Class Devotions,* offers short devotional aids designed to accompany the biblical passages you are to study this quarter.

I. John's message to the church

The Scripture passage for today consists of twelve verses: I John 2:18-29. If your group numbers twelve persons or more, assign one verse to each

person or small team of persons. If your group numbers less than twelve persons, assign several verses to each person so that all the verses are assigned. Ask each person or team to read and paraphrase the assigned verse or verses. That is, the person or team is to put into her, his, or their own words the Bible verse assigned.

After giving group members a few moments to work on their paraphrases, read the entire passage aloud as paraphrased by the group. Which verses were easiest to paraphrase? Which gave the most problem? Why? In what ways might your modern paraphrase be addressed to Christians of today who are facing many of the same kinds of issues faced by John's readers?

As teacher, be ready to comment on the paraphrases, helping group members perceive the message John was attempting to communicate and leading group members to a more accurate paraphrase at those points where the central point of the message may have been missed.

II. The times of today
A. The antichrist today outside the church

One of the major issues John writes about in this passage is the presence and the power of the antichrist. Help group members grasp that John is not referring to a single satanic figure such as appears in Revelation but instead is referring to a wide variety of satanic forces both within and beyond the church, forces that would lure Christians from their absolute allegiance to Jesus Christ as Lord.

As a group, discuss the presence and power of such antichrists in the world of today. Begin this discussion by focusing on forces outside the church. Pose questions such as these: What powers or pressures are tempting us to forego our allegiance to Jesus Christ today? Are antichrists always persons? In what ways do dimensions of our culture lure us from trust in Christ Jesus alone? Anticipate some discussion of such antichrists as lust, greed, confidence in violence, hedonism, "quick fixes," and possessions or property, all forces that can keep us from our allegiance to Jesus Christ.

B. The antichrist today within the church

Now, as a group, discuss antichrists within the church: those temptations that would keep Christians from their commitment to and reliance on Jesus Christ as Lord. Expect that examples will be more difficult to isolate, but help group members recognize that such practices as the quest for salvation through works of righteousness, false piety, and hypocritical shows of devotion are all tendencies that could have the committed Christian from allegiance to Jesus Christ as Lord. Emphasize that John was writing not of antichrists in the world, such as the Roman empire, but of antichrists within the church itself, such as false teachers and those who would alter the word of God to make it easier, more palatable, more agreeable.

III. The Christian and overcoming—steadfastness in the faith

In discussing Christian steadfastness in faith, refer to lesson 1 in this quarter (page 236), in which the concept of abiding was discussed with reference to John 14–16. Remind group members that steadfastness comes through abiding in Christ, through trusting completely in and on Christ, through throwing the entire self on Christ as Lord and Savior and at the same time recognizing our severe limitations as human beings in terms of earning our justification before God. Pat McGeachy uses an excellent visual image in speaking of abiding. He counsels that we "drive a stake" into the

one truth that Jesus Christ is Lord; from this tether we can explore a wide variety of beliefs and issues. As a whole group, discuss how Christians can firmly plant themselves on the fact that Jesus is Lord and determine never to depart from that central point.

Helping Class Members Act

Invite class members to observe very carefully during the week ahead all those forces, subtle and direct, that would tempt the Christian to break loose from a commitment to Jesus Christ. For example, what advertisements seem to promise the happiness and joy that the Christian can find only into commitment to Christ? Some group members may want to report their findings at your next session.

Planning for Next Sunday

Remind group members to read the entire first epistle of John, giving special attention to I John 3:11-24 for next Sunday.

LESSON 10 MAY 6

Love and Hate

Background Scripture: I John 3:11-24

The Main Question—Pat McGeachy

The question here is one that we must answer for ourselves, not for others. We have been forbidden by our Lord to judge others (Matthew 7:1-5). This means judge in the sense of condemning; of course we are expected to use good judgment in approving or not approving of the other's behavior. We are to accept the person even though we disapprove of the behavior, or, love the sinner while hating the sin. Good people and bad will continue to live in this world until the Day of the Lord (Matthew 13:24-30, 36-43) when God, who alone has the right to judge, will set things right. If we condemn each other, we are violating the very principle of love by which we are choosing, saying in effect, "I hate you because you are not loving!"

But as for ourselves and our own hearts, how can we be sure that we are right? I deeply desire to be on God's side; am I? Can I be sure of my salvation? John's answer is yes: "We know that we have passed out of death into life, because we love the brethren" (I John 3:14). This is similar to Jesus' promise in Matthew 5:6: "Blessed are those who hunger and thirst for righteousness, for they shall be satisfied." Do I know deep down that I seek justice, that I long for the good of my neighbor, that I devote my life to my neighbors, that Christ's life was offered for me (verse 16), Then I know that I am on the side of love, not hate, and so I belong to God, who is love (4:7-8).

The great question for each of us then is this: "Am I for love rather than hate?" Of course nobody is going to vote for hate! But some of us do live as

310

though we hate others; we draw the covers around ourselves as if to shut the world out. This is especially tempting when wordly goods are too important to us (3:17); Jesus has warned us that it is hard for rich people to get into the kingdom of God (Mark 10:23). Which side am I on?

As You Read the Scripture—Harry B. Adams

This is the third session based on the first letter of John. John's thought is rich and complex, and a number of ideas have been lifted up in the two previous sessions. The material serving as the basis of this session focuses on the possibility and responsibility of those in the Christian community who know the love of God to love one another.

I John 3:11-13. Here again John reminds his readers of what they "have heard from the beginning," as he did in the very first verse of the letter and again at 2:7 and 2:24. What is this message? "That we should love one another." He then points to Cain as the terrible example of a person who failed to obey the commandment to love his brother; he failed, John says, because he "was of the evil one." Evil stands against the good and tries to destroy the good. John sees the devil at work in the world, and warns that those who share the goodness and love within the Christian community will be hated by the world.

Up to this point, John has addressed his readers as little children or as beloved, but here he calls them brothers, as he identifies with them in the love they have for each other.

Verses 14-15. The one sure sign that we have left an old way of death and entered a new way of life is the capacity to love others. In emphatic terms John declares that one who does not love is dead, that one who hates in effect murders.

There is no doubt for John that love is evidence of life, eternal life abiding in us. He says that "we know" that we have entered life when we can love.

Verse 16. How do we know what love is? Why should we love others? How should we love others? The answers to all of those questions is found in the one who laid down his life for us. We know love because we have been loved so profoundly by Jesus that he died for us. We are called to love others because we have been so loved by him. And we are to love so deeply that we are willing to lay down our lives for others.

Verses 17-18. The way of fulfilling the demands of love shifts significantly from verse 16 to verse 17, from the demand to lay down our lives for others to the demand to share our world's goods with others. In a way, the demand of love is softened by this shift, but it is a move from love in a crisis situation to love that can be manifest in daily living. And our love has to be more than just verbal assertions; we are to love by our actions.

Verses 19-22. John talked in verse 14 of what "we know," and here again declares that "we know" we are right and true and have assurance before God because we love others. He talks of our confidence before God, which grows both out of God's knowledge of us and out of our capacity to keep God's commandment to love.

Verses 23-24. Here John asserts that the commandment under which we live is a dual one: to believe in the name of Jesus and to love one another. John doesn't get specific about what it means to love; he doesn't give ethical rules or define how love is expressed in dealing with ethical problems.

But love for others brings us into a profound and sustained relationship

with God. John puts it in two ways: those who keep the commandment to love abide in God, and God abides in those who love.

Selected Scripture

King James Version

Revised Standard Version

I John 3:11-24

11 For this is the message that ye heard from the beginning, that we should love one another.

12 Not as Cain, *who* was of that wicked one, and slew his brother. And wherefore slew he him? Because his own works were evil, and his brother's righteous.

13 Marvel not, my brethren, if the world hate you.

14 We know that we have passed from death unto life, because we love the brethren. He that loveth not *his* brother abideth in death.

15 Whosoever hateth his brother is a murderer: and ye know that no murderer hath eternal life abiding in him.

16 Hereby perceive we the love *of God,* because he laid down his life for us: and we ought to lay down *our* lives for the brethren.

17 But whoso hath this world's good, and seeth his brother have need, and shutteth up his bowels *of compassion* from him, how dwelleth the love of God in him?

18 My little children, let us not love in word, neither in tongue; but in deed and in truth.

19 And hereby we know that we are of the truth, and shall assure our hearts before him.

20 For if our heart condemn us, God is greater than our heart, and knoweth all things.

21 Beloved, if our heart condemn us not, *then* have we confidence toward God.

22 And whatsoever we ask, we receive of him, because we keep his commandments, and do those things that are pleasing in his sight.

23 And this is his commandment,

I John 3:11-24

11 For this is the message which you have heard from the beginning, that we should love one another, 12 and not be like Cain who was of the evil one and murdered his brother. And why did he murder him? Because his own deeds were evil and his brother's righteous. 13 Do not wonder, brethren, that the world hates you. 14 We know that we have passed out of death into life, because we love the brethren. He who does not love remains in death. 15 Any one who hates his brother is a murderer, and you know that no murderer has eternal life abiding in him. 16 By this we know love, that he laid down his life for us; and we ought to lay down our lives for the brethren. 17 But if any one has the world's goods and sees his brother in need, yet closes his heart against him, how does God's love abide in him? 18 Little children, let us not love in word or speech but in deed and in truth.

19 By this we shall know that we are of the truth, and reassure our hearts before him 20 whenever our hearts condemn us; for God is greater than our hearts, and he knows everything. 21 Beloved, if our hearts do not condemn us, we have confidence before God; 22 and we receive from him whatever we ask, because we keep his commandments and do what pleases him. 23 And this is his commandment, that we should believe in the name of his Son Jesus Christ and love one

That we should believe on the name of his Son Jesus Christ, and love one another, as he gave us commandment.

24 And he that keepeth his commandments dwelleth in him, and he in him. And hereby we know that he abideth in us, by the Spirit which he hath given us.

another, just as he has commanded us. 24 All who keep his commandments abide in him, and he in them. And by this we know that he abides in us, by the Spirit which he has given us.

Key Verse: **Hereby perceive we the love of God, because he laid down his life for us; and we ought to lay down our lives for the brethren. (I John 3:16)**

Key Verse: **By this we know love, that he laid down his life for us; and we ought to lay down our lives for the brethren. (I John 3:16)**

The Scripture and the Main Question—Pat McGeachy

Cain Versus Abel (I John 3:11-13)

It has been said that the world is divided into two kinds of people: those who divide the world into two kinds of people and those who don't. Perhaps in the idyllic garden before the Fall there was a sense of the oneness of the race; Adam and Eve weren't even sensitive about their sexual differences until after their encounter with the forbidden fruit (Genesis 3:7). But as soon as the human race ate of the tree of the knowledge of good and evil (Genesis 3:5), we started acting like God and making judgments. And we passed this on to our offspring, so that they murder one another, if not in deed at least in their hearts (I John 3:15; Matthew 5:21-22).

Why did Cain kill Abel? Was the seed in his heart sown by the devil (Matthew 13:39), so that he was "predestined" to do evil? To adopt this notion of dividing the world into two kinds of people is to avoid the issue of personal moral responsibility. For one thing, we know that God loved Cain and tried to protect him, even after his crime (see Genesis 4:15). John says (verse 12) that the motivation in Cain's heart was jealousy, born of the realization that his own deeds were evil while those of his brother were righteous. In the Genesis account (4:4-5) we are simply told that the Lord liked Abel and his offering, but not Cain and his. Was this merely an arbitrary judgment on God's part? Perhaps it is okay for God to make judgments, based on divine reasons that you and I cannot understand, but usually, at the heart of things, we can discover the theology (God-idea) that lies behind the things God does.

Here's the way I interpret the Cain versus Abel business. There was one great distinction between them: Abel was a shepherd and Cain was a farmer. That is, Able was a nomad, wandering from oasis to oasis with his flocks, and Cain was a settler with a permanent dwelling place. If we study the history of the Hebrew people we will discover that they always had a preference for wanderers (in fact, the very name "Hebrew" may mean "a wanderer"). Eventually they settled in the promised land and became farmers and city dwellers, but always they admired their tent-dwelling ancestors. (See the account of the Rechabites in Jeremiah 35:1-19, who had taken a vow never to build houses.) To this day, the Jews celebrate annually

a feast of booths (Succoth; see Genesis 33:7 and Leviticus 23:39-43). Somehow, at the heart of Jewish consciousness, is the notion that God really approves of the person who remembers that we live by grace, not by our own works. Nomads, wandering on the open range, are dependent utterly on God to lead them to "green pastures and still waters," while city dwellers foolishly begin to think that they are self-contained. (But just let the power or the water get shut off for a little while and see how they behave!)

Even today we have natural feuds between farmers and cowboys. (Remember the song from *Oklahoma* called "Territory Folks"?) So I think that Cain was jealous of Abel's free life of grace before God. He didn't have to plow or sow or reap, he just "abided in the fields" like a good shepherd. And God seems to approve of such "irresponsibility." But "the farmer and the cowboy should be friends; territory folks must stick together!" We have known from the beginning (verse 11), that is, from the first time we met Jesus, that we ought to love one another. And when, like Cain, we are full of hate, we deny the grace under which we live. When, like Abel, we live glad, free lives, we can expect others to be jealous of us (verse 13).

How Do We Know? (3:14-15)

The only unforgivable sin is the one that will not be confessed: the sin of claiming righteousness for myself and calling good in others evil (see Matthew 12:15-32 and 6:15). When we desire the good of others and forgive them, then we know we have passed through that door that divides death from life (verse 14). To continue to nurture our grievances, to rejoice in a brother or sister's downfall, and to go about in a spirit of vengeance is to commit murder in our hearts (Matthew 5:22) or to side with death rather than life. We know that we have passed from death into life when we know that we are on the side of life, that is, when we choose love rather than hatred.

How Can We Test It? (3:16-18)

If there is any doubt in your mind as to whether or not you are on the side of love, ask yourself, "What form do my actions take?" It is the age-old doctrine that actions speak louder than words, that "faith without works is dead" (James 2:20). This does not necessarily mean that you must always give everybody everything they ask for; sometimes we may know what is best for a person, and rather than give him a dollar that he will surely spend on a drink, we may give him a meal or a night's lodging or even say, "Come back when you're sober." But the question at heart is, Do I will this person's good or my own? Or, Is my life given for others?

Many people erroneously believe that living such a life is a constantly painful sacrifice, but in practice it turns out to be the opposite. Jesus taught us that to lose life for the Lord's sake (and thus for others) is to find it (Luke 9:24). A husband and wife who give themselves to each other find their troubles halved and their pleasures doubled. Christians who live in constant concern for those around them, who "lay down their lives" for their neighbors, find that they are rich in the joys of comradeship and deep satisfaction. Those, on the other hand, who build a moat around themselves and hide from the pain of the world ultimately die of a worse pain. As George MacDonald once said, "The first principle of hell is, 'I am my own.'" Conversely, the first step to happiness is, "I belong to others." Or, as Jesus put it, "Happy are the poor in spirit" (Matthew 5:3).

Abiding (3:19-24)

We are to live under grace, like shepherds "abiding" in their fields (verse 24). What a wonderful word "abide" is. It speaks of peaceful nights under the stars, of the warmth of a fireside, of quiet confidence and trust. Can we really "abide" in a world so full of pain and trouble, when we know that the guilt in our own hearts condemns us? (verse 20). Yes, when we remember that God is greater than our hearts.

This can be taken in two senses: On the dark side we must realize that no matter how hard we try to be righteous, God's righteousness will always exceed our own. We dare not claim purity of motive; there is no one good but God (Mark 10:18). Therefore we must learn to trust the ultimate Righteousness that promises forgiveness when we do not deserve it. It is true that love conquers all, but it is not *our* love that conquers, it is the divine love (I John 4:10; Romans 5:8). When Paul speaks his great hymn to love in I Corinthians 13, the love that never seems to get upset and is forever patient and kind, it is clear that he is not talking about *my* love! I am forever losing my temper and forgetting to lay down my life for others. But God's love never ends, and in that I can abide.

On the other hand, just as I must admit that God is greater than my heart, so that I must be ashamed of my poor efforts at righteousness, I can also hope that God, who is greater than my heart, can give me strength beyond myself. When I really believe in Jesus (verse 23), I will be empowered to love others as he has commanded me. Jesus not only sets high (impossible) standards of love for us to follow, he also provides us with the motive and the means to do it. When my fickle heart wants to turn aside from the traveler in the ditch or the stranger at my gates, the great heart of God in Jesus moves me with a strength beyond my own. Thus surrounded by Love, I can abide.

Helping Adults Become Involved—John Gilbert

Preparing to Teach

As you start every session preparation, you will want to commence by going to God in prayer. Earnestly seek God's direction in your life. Let God speak to you of the ways you have been judgmental, less than loving, careless about another, insecure in your faith in Jesus Christ as Lord and Savior.

In short, never begin preparing a Sunday school lesson nor present a Sunday school lesson without beginning with prayer. You have been called by God to be a teacher in the Sunday school; this is a sacred task. It demands your very best, and it requires the intimate assistance of God in all ways.

The brief passage from I John 3:11-24 is a difficult passage. You may be tempted to dismiss it because of its brevity or to scan it quickly and focus on one or two isolated verses that strike your attention. But I John 3:11-24 is a unified passage of Scripture, called a *pericope* by Bible scholars, and it deserves attention as a whole unit rather than as fragmented verses.

Read this passage in several translations. Try putting the main ideas of the passage into your own words. Reread the entire first letter of John in order to place this significant section in context. Ask yourself again and again, What was John trying to tell his original readers? And what is John saying to me here and now?

THIRD QUARTER

In setting your purpose or goal for this session, keep in mind this passage's emphasis on the significance of love one for another and the relationship of the way we love one another to the way we love God and accept the love of God as demonstrated through Jesus Christ. Therefore, your purpose for this session might be to explore with the group members the relationship between the love Christians have for one another and the love of God for us collectively and individually.

Therefore, you might want to use an adaptation of this outline as your session outline:

> I. Manifestations of love between persons
> A. Righteous or honest love
> B. Shallow or self-seeking love
> II. The love of God as manifested in our love for one another

Can you arrange your classroom to facilitate discussion? If you have moveable chairs in your classroom, try arranging them in a circle. Be creative in teaching adults. Have a chalkboard and chalk or large sheets of paper and appropriate markers handy. One word of caution: Be careful lest one or two especially talkative members of the class dominate discussions. Try to draw every class member into the discussions.

Introducing the Main Question

The main question for this session revolves around the relationship of love (or hate) for others to love (or hate) for God. This question in itself is provocative enough to stimulate thought, so you might jot it down on the chalkboard or newsprint for all to see as they arrive. Or you might think of illustrating the question in some way, perhaps by commencing the session with a quick review of the story of the Good Samaritan (Luke 10:30-37). How was the priest's love for God reflected—or not reflected—in his treatment of the man who had fallen among robbers? Do not get bogged down in discussing this parable, however. It is only one of many illustrations of the relationship between love for others and love for God.

Developing the Lesson

Are you commencing each session with a word of concern for those who are absent, and with a prayer led by you or by a member of the class? You might even pose a question such as this: How does our attitude toward those who are absent, especially those who are sporadic attenders, reflect our attitude toward God?

Invite the group members to read I John 3:11-24 before you begin your discussions of this passage. You might ask group members to read either silently, or in unison. Then invite group members to share questions they may have about the meaning of the text. Open these questions for full group discussion. One word of caution: Do not become bogged down in rehashing the Cain and Abel story. John uses this familiar story as one illustration; but the illustration is not the main point. Note how Pat McGeachy devotes several sentences to discussing this question: Why did Cain hate Abel?

I. Manifestations of love between persons
 A. Righteous or honest love
Deal with the concept of love and hate between persons. Clarify that you
are not discussing romantic love (the love between man and woman based
on mutual attraction), but love that is passionately concerned about the soul
of the other. Be prepared to offer several examples of this kind of love,
drawn both from the biblical witness—Jesus' love for Zacchaeus and others
or the Samaritan's love for the man at the side of the road—and from
contemporary times. Who in the world and the local community manifests
the kind of love about which John speaks? Be prepared also to offer
examples of of love's opposite, hatred.
 B. Shallow or self-seeking love
Move on to a recognition that a love less than this kind of love is shallow,
self-seeking, and self-righteous. A loveless person easily moves to ill will and
hate. The "righteous" man who prayed a prayer of thanksgiving that he was
not a sinner like the man next to him (Luke 18:9-14) is a classic example of
this kind of love. You might discuss some of the contemporary ways persons
exhibit their lack of love (i.e., hate) for others in showy or elaborate ways.

II. The love of God as manifested in our love for one another
Now you are ready for John's main point, that the love we have for one
another reflects the love we have for God and the degree to which we abide
in him in truth and in love. Pose this question: How can we know if we abide
fully in God's love? John's answer is simple and direct. We find the
assurance of our oneness with God and our abiding in God's love when we
love one another unselfishly, openly, honestly. Now flip this around: If we
are not assured of God's love in our life, can we assume that we are not
loving as he first loved us? If your group members are honest, they will
probably admit that Christians are seldom completely assured of God's
grace in every way and that this fact alone points out that all of us are
sinners, that no one of us loves as perfectly and as fully as God calls us to do.
Emphasize the grace of God operative at just such a time. God continues to
love us in spite of our inability to love as fully as God calls us to love.
Discuss also how no person who dislikes or hates God's purposes loves
God.

Helping Class Members Act

Invite class members to keep careful note this week of their ability to love
in at least three ways. Do this: Ask class members to be very aware this week
of the ways they demonstrate love first toward a family member, second
toward a grouchy co-worker or friend, and thirdly toward an obviously
needy stranger. Each class member should ask herself or himself this
question: How can I show christlike love toward this person? Some of the
class members may want to make brief reports at your next session.

Planning for Next Sunday

Urge class members to read I John 4:7-21 before your next session
together. Pray now for wisdom and insight as class members study both
their Sunday school lesson and the text on which it is based.

Fear and Love

Background Scripture: I John 4:7-21

The Main Question—Pat McGeachy

This passage contains what may be the most important three words in all the language: "God is love" (I John 4:8). These three one-syllable words, memorized by every church school kindergartner, summarize all of Christian belief, just as "Be kind one to another" (Ephesians 4:32) contains all of Christian ethics. But love, especially perfect love, is hard to believe and harder to take. Little children and teenagers (and some insecure adults) test their parents' love and God's by rebelling, sometimes in outrageous ways. Some of us, insecure in our understanding of God, draw into our shells, seeking false security in everything from alcohol to national pride. We find it hard to believe that God could really love us, sinful as we are. If we allow ourselves to think about God at all, we picture an angry judge, waiting to punish us for our wicked thoughts and deeds.

This is the way many primitive religions seem to be: The angry gods of the thunder and the volcano cry out for appeasement. And not too far above this is the ancient Hebrew idea of sacrificing the first fruits of the flock to please God. But throughout the Hebrew Scriptures, rising like a trumpet call above the rest of the orchestra, is the realization that God is not calling us to death but to life. "I desire steadfast love and not sacrifice," says the Lord (Hosea 6:6), "the knowledge of God, rather than burnt offerings."

Perfect love (that is, God) does away with fear (verse 18). Jesus came to call us to hope and courage, not terror and discouragement. He came to disturb the self-righteous, yes, but principally to call the prodigal home. The main question, then, for me is this: Am I afraid of God? If so, my style would be to cheat and lie and hide, like Adam in the garden. But if perfect love casts out fear, my style would be to be open before God, to confess my sin, and to live joyfully as God's forgiven child. Which is it for you and me: fear or love?

As You Read the Scripture—Harry B. Adams

Many of the ideas in the first part of the scripture that serves as the basis for this session have been expressed before in this letter and are characteristic of the thought of John. In the later verses John does deal with a new notion, namely, the contrast between love and fear.

I John 4:7. The verse begins with an exhortation that we are to love one another. Why? John has a theological answer to that question. We are to love one another because "love is of God," love is the will of God, love is the way of God, love is the very being, the essence, of God. When we can love others we are both born of God and know God.

Verse 8. This verse begins with a negative assertion of what had just been stated positively, but then John moves to a bold and climactic affirmation: "God is love." "God is" can be followed by many words, but to declare that God is love surely expresses the essential Christian understanding of the character of God.

Verse 9. Having asserted what God is, namely, love, John now declares that God's love is known to us in the sending of Jesus, the only Son, into our world. God's love can be seen in many aspects of our world but it is in Jesus Christ that we see most assuredly that God is love.

Verse 10. As he has before in this epistle, John now declares the priority of God's love. We know love not because we love each other but because God loves us. And, again, that love is known in the Son who was sent to be "the expiation for our sins." John had referred to expiation earlier, in 2:2. Christ is God's offering for our sin, God's gift to remove our sin.

Verse 11. The love of God issues in a moral command. He repeats here the assertion made in verse 7, that we "ought to love one another." It is never sufficient for John to urge people to respond to God's love by loving God. The response to God's love must move people to love for others.

Verse 12. John does not accept that any ecstatic vision has enabled a person to see God. Rather, God is known and abides in us as we are able to express love for one another.

Verses 13-16. The idea that we abide in God and God abides in us is repeated and amplified in these verses. We know that we are in this relationship with God when we love one another. This relationship with God is established when we are able to confess "that Jesus is the Son of God." When our lives are permeated with love, then we abide in God and God abides in us. There is no reason to fear God if we love God.

In verse 14 John expresses an understanding of the work of Christ. The emphasis here is not that he came to reveal God but that he came to do the work of God in the world. Most of the focus in these letters of John is on how Jesus' teachings influence the community of believers, that is, "the brethren," and the world is often seen in quite negative terms, as in 2:15-17, for example. But here and in 2:2 John does write of the Son as Savior of the world and as expiation for the sins of the world.

Verses 17-21. Love not only transforms our lives and relationships in the present but also gives us confidence for the future, "for the day of judgment." John *contrasts love and fear* here and insists that where there is love there is no fear.

This chapter concludes with an assertion again of the priority of God's love and of the essential connection between our love for others and our love for God. Verse 21 echoes the words of Jesus when he gave the two great commandments.

Selected Scripture

King James Version

Revised Standard Version

I John 4:7-21

7 Beloved, let us love one another; for love is of God; and every one that loveth is born of God, and knoweth God.

8 He that loveth not knoweth not God; for God is love.

9 In this was manifested the love of God toward us, because that God sent his only begotten Son into the

I John 4:7-21

7 Beloved, let us love one another; for love is of God, and he who loves is born of God and knows God. 8 He who does not love does not know God; for God is love. 9 In this the love of God was made manifest among us, that God sent his only Son into the world, so that we might live through him. 10 In this is love,

world, that we might live through him.

10 Herein is love, not that we loved God, but that he loved us, and sent his Son *to be* the propitiation for our sins.

11 Beloved, if God so loved us, we ought also to love one another.

12 No man hath seen God at any time. If we love one another, God dwelleth in us, and his love is perfected in us.

13 Hereby know we that we dwell in him, and he in us, because he hath given us of his Spirit.

14 And we have seen and do testify that the Father sent the Son *to be* the Saviour of the world.

15 Whosoever shall confess that Jesus is the Son of God, God dwelleth in him, and he in God.

16 And we have known and believed the love that God hath to us. God is love; and he that dwelleth in love dwelleth in God, and God in him.

17 Herein is our love made perfect, that we may have boldness in the day of judgment: because as he is, so are we in this world.

18 There is no fear in love; but perfect love casteth our fear: because fear hath torment. He that feareth is not made perfect in love.

19 We love him, because he first loved us.

20 If a man say, I love God, and hateth his brother, he is a liar: for he that loveth not his brother whom he hath seen, how can he love God whom he hath not seen?

21 And this commandment have we from him, That he who loveth God love his brother also.

Key Verse: **There is no fear in love; but perfect love casteth out fear. (I John 4:18)**

not that we loved God but that he loved us and sent his Son to be the expiation for our sins. 11 Beloved, if God so loved us, we also ought to love one another. 12 No man has ever seen God; if we love one another, God abides in us and his love is perfected in us.

13 By this we know that we abide in him and he in us, because he has given us of his own Spirit. 14 And we have seen and testify that the Father has sent his Son as the Savior of the world. 15 Whoever confesses that Jesus is the Son of God, God abides in him, and he in God. 16 So we know and believe the love God has for us. God is love, and he who abides in love abides in God, and God abides in him. 17 In this is love perfected with us, that we may have confidence for the day of judgment, because as he is so are we in this world. 18 There is no fear in love, but perfect love casts out fear. For fear has to do with punishment, and he who fears is not perfected in love. 19 We love, because he first loved us. 20 If any one says, "I love God," and hates his brother, he is a liar; for he who does not love his brother whom he has seen, cannot love God whom he has not seen. 21 And this commandment we have from him, that he who loves God should love his brother also.

Key Verse: **There is no fear in love, but perfect love casts out fear. (I John 4:18)**

The Scripture and the Main Question—Pat McGeachy

God Is Love (I John 4:7-12)

Whoever loves is born of God! I use an exclamation point to underscore the radical nature of that statement. One verse later, John is to say, "God is love," which is radical enough, but here he puts it the other way around: "Love is God!" Can that really be true? Is *all* love "of God"? Yes, however corrupted. There is no such thing as wicked love (that would be an oxymoron, like "jumbo shrimp"). We can love the wrong things (money—I Timothy 6:10), and our love can become corrupted into lust (Matthew 5:28), but our capacity for love is part of our being created in the image of God (Genesis 1:27-28). The very first command given by the Creator to the newly made human race is our sexual marching orders, and the second (1:29) has to do with our appetite! God created us to long for each other and to desire the fruits of the earth. And what is more, God calls all this "very good" (Genesis 1:31). Even the distorted desire of a man for a prostitute, or the confused passion of a ripening adolescent, would not have come into being had we not been fashioned from the beginning after the God who gave birth to the universe.

Four types of love are used in the Bible as metaphors for the love between God and the human race:

Affection (familial love): God is Father (Psalm 103:13) and Mother (Isaiah 66:13), Christ our Brother (Mark 3:35).

Friendship: James 2:23; II Chronicles 20:7; John 15:14.

Passion (sexual love): Jeremiah 31:32; Hosea 3:1; Ephesians 5:25. Christ is the Bridegroom (Mark 2:19), and the love story ends happily (Revelation 19:6-9; 21:2). (See also, of course, the Song of Solomon.)

Charity: This is the word (in Greek, *agape*) used here by John and elsewhere in the New Testament for the love of God for the undeserving sinner (Romans 5:8; I Corinthians 13:1-13). It is akin to our word "grace" and to the Hebrew word translated "mercy" in the King James Version and "steadfast love" in the Revised Standard Version. It appears in every verse of Psalm 136.

(For an in-depth study of these four types, see C. S. Lewis, *The Four Loves*, Harcourt, Brace, Jovanovich, 1960.)

Sometimes critics of the faith will ask, "If God is really good, where did evil come from?" I think a more difficult question is, Without God, where did love come from?

If all love is from God, then in living out our lives as those made in God's image, we should love one another (verse 7). Though the lesser loves strive toward it, what John means here is clearly charity, not merely natural affection, cooperative friendship, or passionate desire. This love is modeled on the example of God (verse 9) in sending Christ into the world (compare John 3:16-17). It is not based on God's need for us but on God's self-giving (verse 10). It's not that we are all that lovable or desirable, but that God is Living Love, and acts accordingly. Therefore, we ought to do it too (verse 11). Insofar as we do, we are part of God and serve as witnesses to others to God's nature. No one can see God (verse 12). The finite cannot comprehend the infinite, any more than a character in a novel can meet the author. (Unless, of course, one of the characters in the novel *is* the author, as some say is the case in our story.) But if you and I love, then those around us will be able to see a little more clearly what God is like. If this is true for you

and me, how much more true must it be that when we look at Jesus we are getting a glimpse of God (John 14:9)!

Love Versus Fear (4:13-18)

Verse 13 is another of the practical tests John offers us (see 3:14, 24) by which we may reassure ourselves that we are true subjects of God's rule. We know because we have the gift of the Spirit. Now, of course, not every voice that speaks in the night is the Holy Spirit of God. Sometimes we are moved by evil spirits or bad dreams. But we know that the fruit of the Spirit is love, and its consorts are joy, peace, patience, kindness (see Galatians 5:22-23). Moreover, we have the hard evidence (verse 14) of Jesus' presence in the world. All we have to do is say that this is what we believe, and Love abides in us (verse 15). This affirmation is not empty words but an act of worship, in which, by speaking, we confirm the truth that is within us. As Paul put it in Romans 10:10, a Christian believes in the heart and confesses with the lips and so is saved.

So we know it, and we believe it (verse 16). And here come those three wonderful words again: God is love. It is hard to say them too often, for it is imperative that we remember that we are surrounded by love. In God we "live and move and have our being" (Acts 17:28). Kabir, the Hindu mystic, said, "I laugh when I hear that the fish in the water is thirsty." We are surrounded by God, and yet, using all the clever rationalizations of substance abusers, we delude ourselves into thinking we are sufficient unto ourselves. How much better if we would open our eyes and see God in the world and the people around us, and reach out in love to them. Because they may not yet have understood what love means, they may hurt us by their cold response. But because we "abide in love," that is, in God, nothing can harm us (Colossians 3:3), and sooner or later we can draw a circle to include them in our abiding place.

Certainly the world is a dangerous place, and the day of judgment will be more dangerous still, but neither now nor then need we be afraid. "In the world you have tribulation," Jesus said (John 16:33), "but be of good cheer, I have overcome the world." Like Kabir's fish, we need have no fear of drowning; what surrounds us is love, and love casts out fear (verse 18). It is surely true that the fear of (reverence for) the Lord is the beginning of wisdom (Proverbs 1:7), but that is not the end of wisdom. Fear is penultimate; joy is our ultimate expectation. The time will come when God will camp out with us and wipe away every tear from our eyes (Revelation 21:3-4). We know that God does not want us to perish (Matthew 18:14). God did not send the Son into the world to condemn the world, but that the world through him might be saved (John 3:17). There is no place for fear for those who love.

The Ultimate Lie (4:19-21)

Love originates with God, who *is* love (verse 19), so in one sense we are incapable of love unless God sows love in our hearts. But that is what God has been up to from the beginning. When the world was created and God breathed into us the breath of life (Genesis 2:7), it was the breath of Love. (Perhaps human pleasure in conceiving children is somehow, however far removed, related to God's pleasure in making the universe.) We are helped

by God to love just as we are helped to pray (Romans 8:26). If all prayer is God talking to God, then all love is God loving God. That is one reason we Christians talk about God as being more than one person.

It is hard to believe, but much of the church's history has involved our casting people out, and even putting them to death, in the name of God. This is a colossal lie (verse 20). It has all the logic of a pacifist carrying a gun to enforce the peace or of a nature lover shooting a deer to stuff for a trophy room. It is hard not to hate; when we have been raised to believe in purity of the faith, then it is easy to want to destroy those whose faith is not as pure as ours (remember Saul of Tarsus). But when we remember with astonishment that we ourselves are not righteous while the other person is evil, but that *both* of us, like all the rest of creation, have sinned and fallen short of the glory of God, then that brother or sister becomes in our eyes not the enemy but one for whom Christ has died. The best evidence of all that we love God is if we have the courage to love one another. The closer we get to perfection in that, the further away our fear is driven.

Helping Adults Become Involved—John Gilbert

Preparing to Teach

Before you begin your preparations for this session, take a sheet of paper and write down in a column on the left side the names of the class members, one name to a line. Next, write alongside each name at least one specific way you can communicate the love of God to the person whose name begins that line. In what way can you be a conduit of God's love and grace to each of the persons in your class? Commit yourself to completing this list, and promise yourself that you will not repeat yourself anywhere on the list. This will force you to consider each class member individually and personally and to isolate the way in which each member needs to hear and know of God's perfect love.

Read I John 4:7-21 in as many translations and paraphrases as you can find. Read carefully, then go back and read last week's scripture passage, I John 3:11-24. Jot down all the ways in which these passages are different. The great temptation is to believe that today's lesson is simply a repeat of last week's, but nothing could be further from the truth. Write on the board the two titles, "Hate and Love" and "Fear and Love." Today's lesson augments last week's lesson and further defines and describes the perfect love of God. List for yourself at least three points you want to make in your Sunday school class—points that are unique to today's passage, ideas that you want to lift up that will be new or informative to your class members. The first epistle of John is an exceedingly rich letter; the danger in studying it quickly is to assume that it is a "one-message" epistle and that that message is simply "God is love." God *is* love, true, but the letter contains much more than just this, and it elaborates on this simple fact in beautiful ways.

Thus your goal or objective for this session may be to explore the rich ways in which God leads us on to perfection when we live in love with God by living in love with our sisters and brothers. That perfection is that state of life in which fear is eliminated and the motivating force in our lives is our response to God's perfect love.

You might want to use or adapt the following outline for your session. Be sure your outline fits the needs and situations of your group members.

THIRD QUARTER

 I. The intimate relationship between God's love
 and our love for one another
 II. The ways in which love overcomes fear
 A. The source of love and of fear
 III. On to perfection in love

Again, a discussion setting would be ideal for your class this morning. Are your chairs moveable? If you sit in church pews, how can you stimulate conversation and dialogue, especially a conversation that involves all group members? Have on hand a chalkboard and chalk or large sheets of newsprint or other kinds of paper and appropriate markers. Are you keeping a supply of Bibles on hand? Paper and pencils for those who wish to make notes?

Introducing the Main Question

The main question this week is similar to last week's main question, for chapter 4 of the first letter of John further explores our relationship with God through our relationship with one another. Therefore, try this: Write on the chalkboard or large sheet of paper this question: In what specific ways can we show our love for one another and thereby demonstrate our love for God? Invite each group member as she or he arrives to add an idea or several ideas as possible answers to this question, jotting those ideas on the chalkboard or newsprint. When all have arrived, you will want to go over some of the ideas listed. Do not at this point be critical of the ideas; merely read them out so all might know of their general nature.

Developing the Lesson

Commence this session with a word of concern for those who are absent, especially those whose interest in their religious life seems to have slipped. Pray for any special concerns brought to your class by the members of your group. Share together and pray for joys as well as sorrows, suffering, and doubt. "It is a good thing to give thanks unto the Lord!"

As you did last week, invite group members to read today's biblical passage. Ask each to read I John 4:7-21 silently, aloud in unison, or verse by verse in rotation. Can you use a technique here other than the technique used at last week's session? If several group members have different translations or paraphrases of the Bible, hear these aloud, as well.

I. The intimate relationship between God's love and our love for one another

Review some of the major ideas developed at your last session, focusing especially on the ways in which our relationship with others is a reflection of our relationship with God: one of either hate and fear or of love.

Pose this question: Can we love God more than we love another, or can we love another more than we love God? Expect some discussion on this question, then share with the group Pat McGeachy's information on the four types of love. Help group members see that their answers to the question depend in part on the type of love being considered, and that the type of love the epistle writer John is discussing is the perfect love of God and our reflection of that perfect love in human relationships. Ask group members to paraphrase—put into their own words—verse 7*b*, "he who loves

is born of God and knows God." Share some of these paraphrases in the whole group. What does it mean to be "born of God"? Recall John, chapter 3, on Nicodemus's visit with Jesus at night.

II. The ways in which love overcomes fear
A. The source of love and of fear

As a whole group, explore the sources of love and the sources of fear. You might write "love" on one side of the chalkboard, "fear" on the other. Ask group members to call out ideas about the sources of each. Expect under fear to have listed such ideas as ignorance, broken relationships, guilt, separation, sin, despair, loneliness, insecurity, and under love terms such as God, relationship, assurance, peace, and so on.

Now explore the life based in fear and the life based in love. Ask group members to describe how these kinds of lives are different. Then make the point that the life lived in love is a life of grateful response; the life lived in fear is a life of anxiety over punishment. Draw the point this way: Christians live the good Christian life not in fear of what God will do if they don't but in grateful response for what God has already done through love in Jesus Christ. A life motivated by fear shrinks in dread of tomorrow. A life lived in love faces tomorrow with the assurance that God is already in that future, calling the world to God.

Bring this down to practical terms. Ask: How will we live differently when we are motivated by love rather than motivated by fear? List as many ideas as possible on the chalkboard or paper.

III. On to perfection in love

John in this letter makes the point that we are perfected in love. Make a brief presentation on this concept. In some denominations the concept of sanctification is important. This is the concept that once we are justified by God's grace, that is, when we become aware of and accept God's love, then God starts the process of sanctifying us or making us perfect in love. Our task as Christians is not complete when we accept Christ; we only begin at that point, then continue to grow in grace and knowledge and the love of God. While all denominations do not subscribe to the word "sanctification," most hold to the idea that by God's grace and love, and when we love in return as manifested in our relationships with others, we become more and more Christlike in our words, our actions, and our relationships.

Close this session with a prayer for guidance and for the courage to love as he first loved us.

Helping Class Members Act

Challenge class members to think of one person each that they have trouble loving in a Christlike way. Challenge each class member to contact the person she or he has called to mind and to make a genuine effort to express some form of Christian love for or toward that person. Will some report on their experiences at the next session?

Planning for Next Sunday

Invite group members to read I John 5:1-15 prior to the next session.

Faith and Life

Background Scripture: I John 5:1-15

The Main Question—Pat McGeachy

With this chapter, John brings his letter to a close, and like most of us, he seems to be struggling to make sure he has gotten his point across. He's a preacher taking one last "shot" at his congregation. In doing so, he provides us with a summary of what the whole point of his epistle has been and gives us a few fresh verses to drive home its central truth: that faith must be translated into living.

Years ago, Dr. Kenneth Foreman invented a lovely parable that he called "The Ford in the Parlor." It was the story of an eccentric farmer who was so proud of his brand new Model-T Ford that he wouldn't let anyone touch it. He first kept it in the barn, but eventually took out a section of the wall of his house and moved it into the parlor. Present-day house owners don't understand parlors; they were a kind of second living room that was only used when the minister or other dignitaries came to call; today we call the same two rooms the family room (or den) and the living room (where nobody ever lives). The farmer polished the Ford every day and would sometimes let special friends in to admire it. But eventually, worried about fingerprints on it, he kept the parlor locked at all times. Of course, after the old man died and his home was sold at auction, the prize was a brand new, spit-clean Model-T, which was bought by two young men, who immediately took it out on country roads where it got very dirty. In spite of the old man's "love" for his car, he had failed to see that it had been built for the purpose of getting dirty on the road!

Is our faith like that? Do we keep it in church and polish it on Sunday, or do we take it out into the roads of life and get it dirty in the business of loving the world? "For this is the love of God, that we keep his commandments." "And," verse 3 continues, "his commandments are not burdensome." It's fun to take your faith on the road!

As You Read the Scripture—Harry B. Adams

The verb "believe" occurs six times in I John 5:1-13, the part of the letter serving as the basis for this session. There are only three other uses of the verb in the entire letter, and the only use of the noun "faith" occurs in verse 4. A number of familiar ideas appear in this section, ideas about love of God and love of others, but the ideas are interpreted in relation to the importance of believing.

I John 5:1. This verse focuses attention on the importance of believing. John notes a specific content for what is to be believed, namely, that Jesus is the Christ (the Messiah). In 3:23 John had talked about God's commandment to "believe in the name of his Son Jesus Christ."

Everyone who believes is a child of God. It is not our faith that gives us the status of children of God but our ability to affirm that Jesus is the Christ.

In the second half of the verse it seems clear that to love the parent is to

love God, but it is not so clear whether the child that is loved is Jesus or other persons. The latter interpretation ties this verse more closely to the next one.

Verse 2. There are the familiar ideas of loving others and loving God and obeying God's commandments, but it is not clear what John means when he writes that loving God *enables* us to "know that we love the children of God."

Verse 3. John defines again what it means for us to love God, namely, that we keep God's commandments, which are to believe in Jesus Christ and to love one another (3:23). The commandments are not a burden because God makes the keeping of them a joy and delight (see Psalm 1).

Verses 4-5. These verses assert that the power of faith of the believer will overcome the world. Our faith is born of God and overcomes the world. Perhaps it is better put in verse 5, where it is not the faith itself that overcomes the world but the one who believes Jesus is the Messiah.

Verses 6-8. These three verses introduce the ideas of the Spirit, the water, and the blood. There are many ways of interpreting what John means, and there is no way to know precisely what he had in mind when he wrote.

Several connections might be made to the life of Jesus. When the spear was thrust into his side on the cross, blood and water came out (John 19:34). Or the reference could be to the beginning and end of Jesus' life, for the Spirit came upon him when he was baptized in the water of the Jordan, and his blood was shed on the cross. At any rate, all three appear as witnesses, and the witnesses agree. For the Christian community, the Spirit comes in the truth that the community knows and communicates, the water comes in baptism, and the blood in the Eucharist.

Verses 9-13. These verses develop the idea of testimony. The witness to the Son that the Christian has received is from God, and those who believe have received that testimony. Those who don't believe actually make God out to be a liar. The result of receiving the testimony is eternal life, given in the Son.

Verse 13. John here sums up the purpose for writing this letter, namely, that those who believe may know for sure that they have eternal life.

Selected Scripture

King James Version

I John 5:1-13

1 Whosoever believeth that Jesus is the Christ is born of God: and every one that loveth him that begat loveth him also that is begotten of him.

2 By this we know that we love the children of God, when we love God, and keep his commandments. ·

3 For this is the love of God, that we keep his commandments: and his commandments are not grievous.

4 For whatsoever is born of God overcometh the world: and this is

Revised Standard Version

I John 5:1-13

1 Every one who believes that Jesus is the Christ is a child of God, and every one who loves the parent loves the child. 2 By this we know that we love the children of God, when we love God and obey his commandments. 3 For this is the love of God, that we keep his commandments. And his commandments are not burdensome. 4 For whatever is born of God overcomes the world; and this is the victory that overcomes the world, our faith. 5 Who is it that overcomes

the victory that overcometh the world, *even* our faith.

5 Who is he that overcometh the world, but he that believeth that Jesus is the Son of God?

6 This is he that came by water and blood, *even* Jesus Christ; not by water only, but by water and blood. And it is the Spirit that beareth witness, because the Spirit is truth.

7 For there are three that bear record in heaven, the Father, the Word, and the Holy Ghost: and these three are one.

8 And there are three that bear witness in earth, the Spirit, and the water, and the blood: and these three agree in one.

9 If we receive the witness of men, the witness of God is greater: for this is the witness of God which he hath testified of his Son.

10 He that believeth on the Son of God hath the witness in himself: he that believeth not God hath made him a liar; because he believeth not the record that God gave of his Son.

11 And this is the record, that God hath given to us eternal life, and this life is in his Son.

12 He that hath the Son hath life; *and* he that hath not the Son of God hath not life.

13 These things have I written unto you that believe on the name of the Son of God; that ye may know that ye have eternal life, and that ye may believe on the name of the Son of God.

the world but he who believes that Jesus is the Son of God?

6 This is he who came by water and blood, Jesus Christ, not with the water only but with the water and the blood. 7 And the Spirit is the witness, because the Spirit is the truth. 8 There are three witnesses, the Spirit, the water, and the blood; and these three agree. 9 If we receive the testimony of men, the testimony of God is greater; for this is the testimony of God that he has borne witness to his Son. 10 He who believes in the Son of God has the testimony in himself. He who does not believe God has made him a liar, because he has not believed in the testimony that God has borne to his Son. 11 And this is the testimony, that God gave us eternal life, and this life is in his Son. 12 He who has the Son has life; he who has not the Son has not life.

13 I write this to you who believe in the name of the Son of God, that you may know that you have eternal life.

Key Verse: **And this is the record, that God hath given to us eternal life, and this life is in his Son. (I John 5:11)**

Key Verse: **This is the testimony, that God gave us eternal life, and this life is in his Son. (I John 5:11)**

The Scripture and the Main Question—Pat McGeachy

To Love Is to Obey (I John 5:1-4)

The pendulum of the Christian faith swings back and forth between faith and works, and between God and Jesus. In verse 1 John says, "If you believe in Jesus you are born of God." And then he says it the other way around: "If

you believe in God [the parent], then you know that God must be somehow like Jesus [the child]." It is a little like the old argument about the chicken and the egg. Some Christians begin their faith journey by saying something like this: "I don't know who God is, or what God is like, but deep down I know that for the universe to have come into being and for morality to make any sense, God must be there, so I believe." But this same person, continuing on the journey, will have to ask, "But what is God like?" And eventually, Christians are convinced, that person will come to the realization that God is like Jesus: loving, healing, a friend of sinners, doing good and giving life to the world.

But other disciples begin their journey with Jesus. Beginning with him and his teachings, with no more understanding than that of the woman who clutched his robe and felt his power ("energy," Mark 6:56) or that of the anxious father who cried, "I believe; help my unbelief!" (Mark 9:24). We journey with him until we arrive at the realization that he is the Christ of God (Luke 9:20). In other words, like the pendulum, faith can move from God to Jesus, or from Jesus to God. In most of us it swings back and forth constantly and keeps our spiritual machinery ticking.

The same back and forth movement (or, if you prefer, breathing in and out) takes place between faith and works. As verse 2 tells us, when we love God's children we are loving God, and vice versa. Remembering 4:20, we can say, "One who claims to love God but hates others is a liar." But we can equally say, "One who claims to love people but hates God is a liar" (or at the very best is fooling himself). For love comes from God alone (4:7), and there is no way I can really be a lover apart from the grace of God.

Overcoming (5:4-5)

These two verses need to be coupled with the wonderful promise in John 16:33, as they remind us of the glad assurance that our story has a happy ending. No matter how dark things get, as in the days of slavery, the oppressed can sing with confidence,

> We shall overcome;
> We shall overcome;
> We shall overcome some day.
> Oh, deep in my heart I do believe
> We shall overcome some day.

This promise sustains the Christian when things go very wrong, not only in our outward circumstances but when those inner slavemasters beset us: pride, lust, and the like. Even the substance-abuser can hope to overcome. But note that it does not happen through *willpower*. In my own experience, gritting my teeth and swearing great oaths only seems to make things worse. What has to happen is what verse 4 describes: a rebirth (being born of God) and a faith. And the faith is in Jesus, God's Son. The cry of the atheist is "I am lost!" The cry of the religionist is "I can do it!" The Christian's cry is "Jesus is Lord!" The first two cries fail; the third overcomes. The "we" in "We shall overcome" is not merely me and my comrades in the struggle; it includes the only One who does have the power to make the victory possible.

So love for God must be translated into action. But this is not a burden (verse 3). When Jesus calls us to take up our crosses, to carry his yoke, he also

assures us that his yoke is easy and his burden is light (Matthew 11:30). In my own experience this has invariably proven true. I put off with great rationalizations some unpleasant task (going to visit someone), and when finally I do it, knowing that I ought to, it turns out to be a joy rather than a pain. I give to someone whom I think doesn't deserve it, and it turns out to be more fun for me than for that person. Do you suppose maybe God really gets deep pleasure out of being gracious and good to us sinful human beings?

The Testimony (5:6-12)

There are some difficult verses in this section, but its central message is clear: There is plenty of testimony to the Christian faith. Anyone who fails to see it is truly spiritually blind. (There is an extra verse in the King James Version between verses 7 and 8, which reads, "For there are three that bear record in heaven, the Father, the Word, and the Holy Ghost: and these three are one." This sentence does not occur in the earliest Bible manuscripts but was added at least four hundred years after Christ, probably by commentators who wished to point out that the three witnesses mentioned in verse 8 form a trinity.) The three witnesses that John mentions are the Spirit, the water, and the blood.

The Spirit is God's own self speaking to us, in preserving the testimony of the Bible through the ages for us, inspiring those who teach us, and convincing us with the inner voice that we sometimes call conscience. Even in our prayers it is often not our own voice speaking but that of the Spirit, God helping us to find the right words (Romans 8:26). Everything that we know is ultimately taught us by the Spirit of God (I Corinthians 2:10; John 16:13). It is this inner conviction, and not just the fact that "this is the way I was raised," that enables me to say, "I believe."

The water is, of course, baptism, both Jesus' baptism (verse 6) and ours. With his baptism by John, Jesus' ministry was begun, and by baptism you and I entered into fellowship with him and with all other Christians. The great German reformer, Martin Luther, is said to have valued his baptism more than his ordination to the priesthood. In baptism all of us have been chosen by God and called to a life of ministry. Nothing can take that away from us! The water of baptism has sealed us forever as children of God. In it, God gave us an assurance like that given to Jesus (Mark 1:4): "You are my beloved child, I am well pleased with you."

The blood is Christ's crucifixion, his death on our behalf. It of course suggests the other sacrament, the Lord's Supper, which renews the promise regularly within us as we celebrate communion (whereas baptism sealed it at the beginning). And as we were baptized with Christ, so are we to suffer with Christ in the valley of the shadow, in the ultimate hope of resurrection. Fortunately, we do not have to do it alone. The old spiritual is mistaken in saying of that lonesome valley, "You have to walk it by yourself." One has gone before us, and his rod and staff comfort us in that dark way. His commandments are not burdensome (verse 3), for we do not have to bear the cross alone.

In our daily life as Christians, this trinity of witnesses surrounds us: *The Spirit* speaks to us in the Bible as read and preached, in the fellowship of the church, and in the inner voice of conscience. *The water* confirms our call from God in baptism, which is an eternal promise. *The blood* reminds us of

Christ's sacrifice, which redeems us, and the duty that is ours to die with him. As we began at the Jordan of baptism, we will ultimately cross that other Jordan, which symbolizes our own death. But even then we need not fear. God has given us eternal life in Jesus (verse 11), and if we have Jesus (verse 12), nothing can take this life away from us. Let us then get our faith dirty. Let us drive a stake into the truth of Christ's lordship and head bravely down whatever roads may lie ahead, doing good, loving neighbor, serving God; that way the evil one will never get us. Not even our own fears and failures can keep us from the happy ending.

Helping Adults Become Involved—John Gilbert

Preparing to Teach

The completion of a biblical book or letter, such as the completion of the first letter of John at this coming session, gives a teacher an excellent opportunity to evaluate progress and to determine the directions her or his teaching ought to take. All teaching must be person-centered; it must be designed around the needs, interests, and capabilities of the learners in a particular group. But some teachers run the danger of concentrating so intensively on content, on the ideas to be communicated, that they forget the group members. This can be a danger in a difficult letter such as John's first epistle.

Therefore commence this preparation time by reviewing the last several sessions of your class. Consider who did and who did not participate in discussions and sharing. Can you identify why some persons were silent while others were vocal? Note especially any changes. Did anyone who is usually vocal fall silent over several sessions? Did anyone who is usually silent become actively involved in the sessions? And what was the overall level of interest, both in the class discussions and in the content being discussed?

Out of this evaluation, consider what changes you as the teacher may need to effect in order that your sessions will be more informative and that all may grow together in Christian faith and discipleship. In other words, evaluate your own role in the class sessions carefully, too. Are you stimulating or stifling conversation and discussion? Are you taking the time to meet individual needs and concerns? Most importantly, are you growing yourself as a result of your teaching and as a result of the ideas generated by the group?

When you have considered all of these points carefully, place them before God in prayer. Let God speak to you and to the concerns you have raised.

As you begin your specific planning for this session, read all of the first epistle of John again. Can you find time to read it in several translations and paraphrases? Note and recall again the major points made at each of the sessions devoted to this complex but fascinating letter. Then note and refer to the ways in which Pat McGeachy characterizes this fifth chapter of John's first letter as a summary or a restatement of all that has gone before. Make up your own mind: Does the fifth chapter contain new ideas, or does it merely reinforce the ideas John communicated in the first four chapters?

As you contemplate your goal for this session, consider focusing on the assurance of God's love that John seeks to describe over and over again in

this epistle. Couple this emphasis on God's love with an emphasis on our response of love one to another.

You will want to devise your own teaching outline, but you may consider modifying this plan:

I. The nature and results of faith in Christ
II. The uniqueness of Jesus Christ
III. The assurance of life abundant and everlasting

Arrange your chairs for a discussion, if possible. Be sure to have a supply of Bibles on hand, along with paper and pencils for note taking. Are you encouraging group members to bring their own Bibles and to mark in them ideas or verses they want to remember? As always, a chalkboard or large sheets of paper would be helpful at this session.

Introducing the Main Question

Keep in mind the key words in the title of this lesson: faith and life. Tell Pat McGeachy's parable of the Lord in the parlor. Ask for discussion. The focus of this session is on the assurance God provides the Christian. You might probe this idea as a question by inviting persons, as they arrive, to jot down for their own use the two or three reasons they know they are part of God's kingdom. Suggest that jotting down uncertainty is equally appropriate, if such is the case.

Developing the Lesson

As you commence every session, commence this session with a word of concern for those who are absent, and with a prayer. Are you consistently inviting group members to lead in these prayers?

As you have practiced throughout this study of John's first epistle, do again at this session: Invite group members to read I John 5:1-3 silently, aloud in unison, or verse by verse in turn. (Be sensitive to those adults who do not read well.) Encourage persons with different translations or paraphrases of the New Testament to indicate how the translations they hold differ from what was read in the group. Entertain questions about the meaning of the passage read before getting into a careful consideration of the application and the contemporary meaning of these special words.

Discuss at length the main question: How and why are faith and life so interdependent on each other?

Share Pat McGeachy's insights about John's use of the summary technique for this chapter. This is not a criticism of John's approach at all; John was simply using excellent rhetorical techniques by reinforcing for his hearers the main points that he had sought to make for them. John was doing what most accomplished speakers and writers of even our time do.

I. The nature and results of faith in Christ

Open your discussion of the content by talking as a whole group about John's understanding of the nature and results of belief (faith) in Christ. Invite group members to ponder these questions, and jot down major insights from their answers onto the chalkboard or large sheets of paper: What does being a child of God mean? How can one know if she or he is a child of God? How is one "born of God?" In what ways is John's use of the

concept of being born of God similar to Jesus' concept as he discussed rebirth in the garden with Nicodemus? (John 3). Then ask group members to call out responses to the question, What are the benefits of being born of God and being a child of God? One answer should be that the one who is born of God overcomes the world. Explore the meaning of this idea; can one overcome the world and still make his or her faith active in that world? How?

II. The uniqueness of Jesus Christ

Pat McGeachy recognizes that verses 6 through 12 of I John 5 are complex and perhaps somewhat confusing. But share with the group members some of the context of these words. Recall for them that in John's day groups other than Christians practiced forms of baptism, that some groups focused on the "spirit world," and that some groups, including Judaism, put great stock in blood sacrifice. But point out that John was indicating for his readers that only in Christ Jesus were the three brought together—the blood sacrifice (implied in the crucifixion), the baptism, and the reality of the Holy Spirit. In essence, this is the uniqueness of Christianity, the uniqueness of Jesus Christ. While the exact audience of John's letter cannot be known, the chances are high that some in his audience asked what was so special about Jesus, in the same way some persons today ask that question.

III. The assurance of life abundant and everlasting

John closes out this passage in his letter by emphasizing two gifts that God provides God's people. These are the assurance of heard and answered prayer and the assurance of life eternal, of membership, as it were, in the kingdom of God here and throughout all eternity. These are basic Christian ideas and should be discussed at some length. You might ask one half of your group to discuss John's statement about answered prayer and the other half to discuss the concept of the gift of eternal life. These discussions might be the source of short reports by each of the two teams. Or, you might ask each team to discuss its ideas in front of the other team, the listening team taking notes and raising questions at the appropriate time.

Summarize this time by pointing out clearly that John never argued for belief in Jesus Christ and love of God in order to obtain these two gifts. Instead, John argues for belief in Christ and love for God simply because God alone is the source of all that is. As Dr. McGeachy points out, the question is not why sin abounds but how God could love us so much to bless us so.

Conclude your session with a word of prayer, especially thanking God for the gift of God's word through the Holy Scriptures.

Helping Class Members Act

Ask each group member to spend a few moments this week jotting down what she or he has learned about her or his relationship with God through Christ as a result of this study of the first epistle of John. Some group members may be willing to share their ideas with the whole group at your next meeting.

Planning for Next Sunday

Invite group members to read the second and third epistles of John prior to the next session. If some have time, they will want to reread the first epistle as well.

Loyalty and Discipleship

Background Scripture: II John; III John

The Main Question—Pat McGeachy

A moving conversion experience like Paul's (Acts 9) may capture our imagination, and a martyrdom like Stephen's (Acts 7) may fill us with admiration, but I'd like to suggest that the real heroes of the faith are the ordinary folk, the footsoldiers in the great conflict. Perhaps the toughest task the saints have to perform is the everyday one of getting from breakfast to bedtime!

God never promised us a rose garden. In the first euphoria after a mountaintop experience, we feel like Simon Peter (Matthew 26:35) that we could never let Jesus down. But when standing up for the faith turns out to be embarrassing or dangerous or even just plain boring, or when temptation becomes irresistible, being a Christian isn't easy. In such times we need a special gear to shift into.

In these two letters John congratulates faithful Christians for "hanging in there." Some of the children of the "elect lady" (II John 4) have been keeping the faith of their parents, and so have Gaius and his friends (III John 4). It has never been easy to be a Christian, but until the conversion of the emperor Constantine in the fourth century, the early church lived with constant fear and persecution. If we can discover from these two little letters some clues to help us understand how they managed under those conditions, surely that would give us some skills for getting through the day in our own time.

The main question for us then, as we intercept this early Christian correspondence, is, Can we glean from what we learn about their lives five hints for daily Christian living? We have worked our way through the powerful spiritual messages of John's great Gospel, and the inspiring letter on love, I John. Now we must ask ourselves, Can we put what we have learned into practice? The proof of the pudding is not in how fancy it looks but in the eating.

As You Read the Scripture—Harry B. Adams

The second and third letters of John repeat some of the themes developed in the first letter without making any very substantial addition to the thought. They do have some different nuances and give some additional perspective on the situations to which the letters are addressed.

II John 1-3. Unlike the first letter, this one has the typical opening of a letter of that time, with three items: the name of the writer, the name of the person addressed, and an expression of greeting.

Both the second and third letters are from "the elder." It is not entirely clear what role an elder had in the early church, but apparently he had some official pastoral concern and authority for the life of a congregation.

The letter is from "the elder" and to "the elect lady," apparently a term for a Christian congregation. And the greeting is of grace, mercy, and

peace, words of greeting that are found in various combinations in many of the letters of the New Testament.

The word "truth" is found five times in the first four verses of this letter. When he writes in the first verse that he loves "in truth," he probably means that he loves genuinely, really, honestly. But when he says that he is joined by "all who know the truth" in love for them, he means all who are assured that God's saving love has come in Jesus, who is the Messiah and "the Father's Son." To speak of *knowing* the truth and of the truth *abiding* in us is characteristic of John.

Verses 4-6. John says that "some of your children" are following the truth, which suggests that some are not and that John is writing to a church that is divided.

In verse 4 John writes that the command of God is to follow the truth, and in verse 5 he says that the command is to "love one another." In accord with the very beginning of the first letter of John, the author here emphasizes that he is not writing them a new commandment, "but the one we have had from the beginning."

It must be said that verse 6 is not the most profound statement in the New Testament, but it is an example of the way in which the author likes to play with words. He writes that love is to follow the commandments, and that the commandment is to follow love.

III John 1-4. For the first time in the three letters, there is an address to a specific person, Gaius. Apparently there was frequent contact between the author and this church, for he refers to the arrival of "the brethren."

Again there are familiar Johannine words in this passage: beloved, love, truth, life. He writes of his assurance that all is well with the soul or spirit of Gaius, and of his prayer that all may be well with his physical health. He also writes of his joy, joy that "my children follow the truth."

Verses 5-8. In these verses John describes a specific expression of loyalty to the truth, namely, the help offered "to the brethren." He is here describing the situation in which the Christians help and support those who have come to minister for the sake of Christ. Even though they are strangers, they are still "brethren" and thus ought to be supported.

Selected Scripture

King James Version

Revised Standard Version

II John 1-6

1 The elder unto the elect lady and her children, whom I love in the truth; and not I only, but also all they that have known the truth;

2 For the truth's sake, which dwelleth in us, and shall be with us for ever.

3 Grace be with you, mercy, *and* peace, from God the Father, and from the Lord Jesus Christ, the Son of the Father, in truth and love.

4 I rejoiced greatly that I found of thy children walking in truth, as we

II John 1-6

1 The elder to the elect lady and her children, whom I love in the truth, and not only I but also all who know the truth, 2 because of the truth which abides in us and will be with us forever:

3 Grace, mercy, and peace will be with us, from God the Father and from Jesus Christ the Father's Son, in truth and love.

4 I rejoiced greatly to find some of your children following the truth,

have received a commandment from the Father.

5 And now I beseech thee, lady, not as though I wrote a new commandment unto thee, but that which we had from the beginning, that we love one another.

6 And this is love, that we walk after his commandments. This is the commandment, That, as ye have heard from the beginning, ye should walk in it.

III John 1-8

1 The elder unto the well-beloved Gaius, whom I love in the truth.

2 Beloved, I wish above all things that thou mayest prosper and be in health, even as thy soul prospereth.

3 For I rejoiced greatly, when the brethren came and testified of the truth that is in thee, even as thou walkest in the truth.

4 I have no greater joy than to hear that my children walk in truth.

5 Beloved, thou doest faithfully whatsoever thou doest to the brethren, and to strangers;

6 Which have borne witness of thy clarity before the church: whom if thou bring forward on their journey after a godly sort, thou shalt do well:

7 Because that for his name's sake they went forth, taking nothing of the Gentiles.

8 We therefore ought to receive such, that we might be fellow-helpers to the truth.

Key Verse: **Beloved, thou doest faithfully whatsoever thou doest to the brethren, and to strangers. (III John 5)**

just as we have been commanded by the Father. 5 And now I beg you, lady, not as though I were writing you a new commandment, but the one we have had from the beginning, that we love one another. 6 And this is love, that we follow his commandments; this is the commandment, as you have heard from the beginning, that you follow love.

III John 1-8

1 The elder to the beloved Gaius, whom I love in the truth.

2 Beloved, I pray that all may go well with you and that you may be in health; I know that it is well with your soul. 3 For I greatly rejoiced when some of the brethren arrived and testified to the truth of your life, as indeed you do follow the truth. 4 No greater joy can I have than this, to hear that my children follow the truth.

5 Beloved, it is a loyal thing you do when you render any service to the brethren, especially to strangers, 6 who have testified to your love before the church. You will do well to send them on their journey as befits God's service. 7 For they have set out for his sake and have accepted nothing from the heathen. 8 So we ought to support such men, that we may be fellow workers in the truth.

Key Verse: **Beloved, it is a loyal thing you do when you render any service to the brethren, especially to strangers. (III John 5)**

The Scripture and the Main Question—Pat McGeachy

Greetings! (II John 1-3; III John 1)

Don't you like the way the first-century letter writers arrange things on the page (papyrus, probably)? It is our custom to leave the signature to the end, so that unless your handwriting is recognized, the reader either has to look at the end first or just wait for a while to find out who it's from. In this

case, John doesn't give his name at the beginning, as Paul and Peter do (see the first verses of Romans, Corinthians, I Peter, etc.). Instead, he calls himself "the elder" (presbyter). This may be an elected office or merely a title of respect (it is applied by Peter to himself; see I Peter 5:1). Tradition has it that John was well along in years when he wrote these letters; the way that he refers to his hearers so often as "children" would lend support to this conclusion.

We do not know who the elect lady was. Some interpreters suggest that this may be John's way of addressing a church, but the letter sounds very personal and is written in the manner of ordinary personal letters of the time. Nor do we know who Gaius was; it would only be a guess to identify him with Gaius of Corinth, whom Paul baptized (I Corinthians 1:14), though he was known for his hospitality (Romans 16:23) like this Gaius. The point is that these letters are sent as friend to friends, so that we can expect to find in them what we write in ours, namely, counsel and encouragement.

The greeting in II John contains a rich benediction. ("Benediction" does not mean a closing prayer; it means "saying good stuff" and it can come just as well at the beginning as at the end. If we weren't so conditioned to it as a conclusion, we could say "Good-bye" at the beginning of our conversations; it is a short blessing.) This one includes five blessings: grace, mercy, peace, truth, and love. We can learn much from the gracious way the early Christians greeted one another (see, for example, I Corinthians 16:20 and 24; Ephesians 6:23-24; Philemon 3).

The first answer we have to our basic question about how Christians can get from breakfast to bedtime is, then, to bless our friends and so help each other through the day.

Follow Love (II John 4-6)

Our second hint for successful discipleship is "Follow love" (verse 6). We won't say much here because, as John himself says, we have heard this before. This is the message of I John, and we heard it in the Gospel of John (15:12, etc.). But let us not assume that this is "old stuff." We have heard it before because it is absolutely essential. If we abide in love (I John 4:16), we are surrounded by the very nature of God, and it will give us protection against "the destruction that wastes at noonday" (Psalm 91:6).

Beware the Antichrist (II John 7-11)

We can be sure, on our journey through the day, to meet those who do not abide in the doctrine (verse 9). In this case, John tells us, the antichrist (one against Christ) is one who "will not acknowledge the coming of Jesus Christ in the flesh" (verse 7). Fundamental to John is the fact that Jesus is *real*. In that day there were those who claimed that he only seemed to be a human being, for it is so hard to believe that God could really come in human form. But that is essential for John's faith and ours. We know that we can make it through the day because Jesus made it through the day, *and he was flesh and blood just like we are* (Hebrews 4:15). It is our faith that God, in Jesus, fully understands our hurt (Psalm 103:14) and walks with us in our difficulties (Psalm 23:4). Not only does he bring to us the power of divinity but also the heart and soul of humanity; he gives us hope.

Joy in the Truth (III John 2-4)

John rejoices when his children follow the truth (verse 4). Strange as it may seem, this is a rare virtue. True scientists have it, and good teachers, but a vast number of us prefer lies. We don't want to hear the truth about our children; give us a good report. We fall for everything from astrology to reincarnation if we think it will make us feel better. We believe what it pleases us to believe or what our fears force us to think. But for the Christian, this will never do. We must face the reality of our own sinfulness with open eyes, that we may apprehend the greater ability of God's forgiving love in Christ. And we ought to rejoice when we feel the same way.

Hospitality and Generosity (III John 5-8)

It is hard to put ourselves in the shoes of the people of that long ago time. Even with our planes, cars, and buses, travel is difficult, but think what it must have been like in those days of footing it across the miles. And what sort of treatment would Christians receive in pagan inns? For that matter, could they afford to stay in such places? We know that the early church consisted mostly of poor people.

In such a time the hospitality of the church would be of special importance. Vestiges of this survive in our time with the tradition of "entertaining" the preacher and providing a parsonage. The circuit riders of a few decades ago could not have managed without it; certainly it would have been true in the first century after Christ.

It is important to note that they refused to take money (verse 7) from the non-Christians with whom they labored. This must have been to make sure that there not be the slightest hint that Christianity is for sale (Acts 8:20). One of the sure tests of a false prophet is, How much money does he charge? It may well be that the laborer deserves what others give (Matthew 10:10), but it is equally true that our faith is a free gift that cannot be sold.

Two important rules, then, for survival in the daily business of being a Christian are (1) always be good to strangers (Hebrews 13:2), and (2) share the gospel as a free gift.

Happy Are the Poor in Spirit (III John 9-10)

Diotrephes (III John 9) represents the opposite of what Jesus describes in the Beatitudes (Matthew 5:3-12). When such characters prevail, the church has a hard time functioning. His presence in this otherwise happy letter makes us uncomfortable, but isn't it also sort of comforting to realize that the early Christians had the same kinds of problems that we do? If they, putting up with selfish people and troublemakers, could turn the world upside down, how much more ought we to be able to do it? What would it be like if we went about like them, joyfully and freely sharing the good news? Are we not more inclined to be like Diotrephes?

Jesus	Diotrephes
Happy are the poor in spirit.	Happy are the ones in charge.
Happy are the mourners.	Happy are the laughers.
Happy are the ones who hunger for the right.	Happy are the self-righteous.

Try making your own list. Clearly, one tip for getting from breakfast to bedtime is that if you want to find your life, you must lose it (Luke 9:23-25).

Let's Get Together (II John 12-13; III John 13-15)

Regardless of what we think about the "electronic church," the truth is, Christians need to be face to face. Of all the clues these letters contain about getting through the day as faithful disciples, none is more central than mutual support and love. John needs Gaius and the elect lady, and their flocks, and they need John and each other. Indeed, in those early days as now, the church is a community of belonging, without which we cannot survive. That may be one of the reasons at the heart of God's decisions to create the human race, sorry as we are.

Helping Adults Become Involved—John Gilbert

Preparing to Teach

As you come to the end of this quarter, spend some time evaluating your teaching, your class members' progress, and your ministry as a Christian. Be firm with yourself, but be gracious. Be honest with yourself, but be forgiving. Not one of us is as good a teacher as he or she feels called to be; none of us ever spends as much time in preparation as ought to be spent. But bear in mind that God does not call us to be perfect; God calls us only to be obedient and loyal.

And Christian loyalty in discipleship is precisely the subject of the last two letters of John, and the subject of this lesson. As we are called to be loyal in our teaching, so did John call the readers of his correspondence to be loyal—in fact, tenaciously loyal.

These two letters of John are so short—a total of just twenty-eight verses—that many Bible readers skim over them or treat them lightly in their reading. I recall talking with one person whose habit it was to read the Bible through cover to cover on a regular basis. He once remarked that he could not wait to get through "that John and Jude stuff" in order to get to Revelation. He missed some real gems of the Scriptures by that attitude!

Read II and III John slowly and carefully. Use a pen or marker to underline ideas that jump out at you. Remember, a Bible is a book to be read, used, lived in. It is not in itself a sacred object. Get into your Bible! If you can read the second two letters of John in several translations and if you can consult a commentary as you read, so much the better.

Your purpose for this session may be to help group members comprehend the concept of tenacious Christian loyalty in the face of hardship and temptation, and to find that loyalty both as a resource and as a gift in their everyday lives. You may need to adapt this aim for the members of your own group, for only you know their particular needs and concerns.

A subsidiary goal for this session is to wind up the study of John's material in the New Testament, a study that you commenced several months ago as you explored the Gospel of John. Next Sunday's lesson will be on the wisdom literature of the Old Testament, specifically Psalms, so you will want to put an appropriate closure on this pivotal New Testament study of John.

THIRD QUARTER

Use or adapt this simple outline for your session:

> I. The Second Letter of John
> A. To whom addressed
> B. Main points
> C. Contemporary applications
> II. The Third Letter of John
> A. To whom addressed
> B. Loyalty

As always during this study of the literature of John, you will want to make room for discussion by the way you arrange your chairs. Have extra Bibles on hand, as well as paper and pencils for those who wish to make notes. A chalkboard and chalk or large sheets of paper and markers would add to the interest in this session.

Introducing the Main Question

Pat McGeachy suggests that the main question is simply, How do we get from breakfast to bedtime as loyal Christians? On the chalkboard jot down time periods such as these: early morning; workday; mealtime; afternoon; evening; leisure; family relationships. As persons arrive ask them to jot down some of the barriers to Christian loyalty in one or more of these time or activity periods. For example, what temptations do we face at work? What tempts us to be disloyal Christians during our leisure time?

Developing the Lesson

Begin the session with prayer. Ask each person in the group to pray silently for the person sitting next to her or him. Seek God's blessing for that person. You might want to conclude with a brief prayer of your own.

I. The Second Letter of John
 A. To whom addressed
Invite group members to read the Second Letter of John silently, or invite one person who is a good reader or speaker to read the letter aloud while the rest of the group members follow along in their Bibles. If some of your group members are using a translation of the Bible other than the Revised Standard Version, invite that person to call out differences in the text.

Now direct all the group members to go back and reread the first six verses of II John. When all have read these verses, emphasize these points: This letter is clearly addressed to one person, a woman. In this II John is somewhat unique among the Scriptures, and it demonstrates the status of women in the early Christian church. For first-century Christians women were not second class citizens!
 B. Main points
John has obviously visited this woman and her family, for he rejoices at discovering the faith of her children. As a whole group, list some of the ways our children manifest faith in the Lord Jesus Christ in such ways that a visitor would notice it and comment on it. Another way to focus this concern is through this question: If a stranger visited your home and met your family, how would that visitor know you were Christians?

340

C. Contemporary applications

Finally, in these six verses John is calling the woman and her family—and all other Christians—to focus on love, love for God as demonstrated through unselfish love one for another. But as Dr. McGeachy points out, maintaining that kind of love through the rigors of our routines and our typical days is difficult. Ask group members to call out some of the factors in our contemporary culture that make consistent love for one another difficult. For example, competition is one factor; distrust of strangers is another. Jot these factors down as group members call them out, then go back over the list as a group and suggest ways each of these might be remedied by being loyal to faith in Jesus Christ, as demonstrated through love.

II. The Third Letter of John

A. To whom addressed

Next, invite group members to read the first eight verses of II John. Challenge group members to think about how they might put these first eight verses into a single sentence.

As Pat McGeachy points out, the identity of Gaius is unknown, and that fact makes him all the more interesting. For John wrote not to the rich and powerful and famous, but to very ordinary persons like us. He knew that the common people are the backbone of Christ's church on earth.

B. Loyalty

Help group members focus on the issue of loyalty, so central in John's letters. Pose and discuss questions such as these: Can anyone be loyal to Christ at all times? Why or why not? Do some people have less trouble being loyal than others? Why or why not? What is the greatest single impediment to loyalty to Christ today? How can the church work to overcome this impediment?

Summarize your several months of study of the literature of John in the New Testament by reviewing several key elements, such as the emphasis on Christ as eternally with God, on the centrality of love, on the demonstration of love for God through love for persons, and on the abundant and everlasting life Christ offers to all who trust and believe.

Helping Class Members Act

Challenge your class members to share what they have learned about Christ, about love, and about themselves through this study of John with at least three persons in the coming week. Or, ask group members to intentionally put into practice what they have learned through John and to be ready to report on their experience at the next session.

Close the session with a prayer of thanksgiving for the writings of John, then read aloud John 20:30-31.

Planning for Next Sunday

Ask group members to read Psalm 1 before the next session. How does it reflect ideas from John?

Wisdom as a Way of Life

UNIT I: WISDOM IN THE PSALMS
Horace R. Weaver

THREE LESSONS **JUNE 3–17**

This quarter's study focuses on wisdom literature as found in both the Old and New Testaments. Scripture selections are from Psalms, Proverbs, Ecclesiastes, Matthew, and James.

The thirteen lessons are divided into four units of study: "Wisdom in the Psalms," "Proverbs of the Wise," "The Limits of Human Wisdom," and "Wisdom in the New Testament."

Unit I, "Wisdom in the Psalms," is a study of three typical wisdom psalms. The first of these lessons, on Psalm 1, deals with the Hebrew emphasis on two ways of living. The second lesson deals with the problem of the inequities of life. The third lesson deals with the reality of death and concludes that God is the only source of true security. "Two Ways of Living," June 3, describes two lifestyles from which every person must choose, the question being, Which side are you on? "Is Life Fair?" June 10, deals with this basic question of human life. "Security Only in God," June 17, raises a disturbing question: Ultimately, whom do you serve?

Contributors to the fourth quarter:

Boyce A. Bowdon, Director of Communications and Public Relations, Oklahoma Conference of The United Methodist Church, Oklahoma City, Oklahoma.

Pat McGeachy.

Ronald E. Schlosser, Director of American Baptist Films/Video, Valley Forge, Pennsylvania.

Horace R. Weaver.

Mike Winters, Pastor, The Presbyterian Church of Berwyn, Chicago, Illinois.

I. Teachers Make a Difference

Boyce A. Bowdon

Can teachers of adult Sunday school classes really make a difference in the lives of their students and in the mission of their churches?

A clear-cut answer to that question came recently when I invited readers of *Contact*—the United Methodist weekly newspaper for Oklahoma, which I edit—to nominate their favorite teachers for awards our paper was presenting to twelve master teachers.

In response, more than 150 persons submitted nominations.

When our selection team examined the letters, we became more aware than ever that teachers of adult Sunday school classes are loved and respected and are having a significant impact upon their students and their churches.

Over and over again we found in the letters references to four basic contributions that adult Sunday school teachers are making.

1. Master Sunday school teachers help their students grow spiritually. "Mrs. Howard Twilley has helped her students know their infinite worth in Christ, learn the Word of God, respond to Jesus Christ as Lord, and demonstrate their commitment to Christ in their daily lives," wrote Dr. James Buskirk, pastor of First United Methodist Church in Tulsa, where Mrs. Twilley has taught for more than ten years.

Comments like that were contained in dozens of the letters we received. Undoubtedly the most frequent—and highest—compliment contained in the letters of nomination was that teachers had helped their students grow spiritually.

One letter nominated Richard Eldridge, a practicing attorney and former district court judge who teaches the "Couples for Christ" class at Asbury United Methodist Church of Tulsa.

"Richard's exceptional lessons have helped me discover the true meaning of being a Christian, and have caused me to want to make Christ the focal point of my life," wrote Gerry Robinson.

Gerry went on to say she and her husband joined the class at a time when they realized their lives were not complete. She said that through Richard Eldridge they "found Christ, peace, and the ability to deal with life a day at a time with the helping hand and love of God."

Another member of the same class explained in his letter that a chronic health problem caused him to drop out of Sunday school because the classroom was in the basement, there was no elevator, and the stairs were difficult for him to negotiate. After attending the class once, he was so inspired by Richard's lesson that the stairs ceased to be a problem. "With God's help and Richard's inspiration, not only have I been able to go up and down the basement stairs, I've been able to take on other obstacles that I used to shy away from," the student wrote.

2. Master teachers build Christian community. Judging from the letters of nomination we received, Sunday school teachers play a major role in helping people feel they are part of their church.

Betty Tam is such a teacher, according to Pauline Wilson of the TNT class at First United Methodist Church in Miami, Oklahoma. "Betty has brought our class to trust one another to the point we are able to express our innermost thoughts. She has led us to support and care for one another in a way that makes each of us realize we are one in Christ."

Another example is Paul Eichling. "The warmth and support we feel toward each other is definitely due to Paul and his leadership and example," writes Bob Rowe of Gore, Oklahoma. Bob explains that the age span of his Sunday school class runs from twenty-two to ninety. Three generations in one family participate.

"Paul helps each member feel important and invaluable to others in the class. He exemplifies Christian teaching by reminding us that we have something important to offer one another, that the wisdom of the older adults is invaluable to the young, and the eagerness of the young tends to invigorate the older members. A family-of-God atmosphere pervades our group, thanks to Paul."

3. Master Sunday school teachers help their churches face up to difficulties. Some letters we received from small rural churches told inspiring stories about

Sunday school teachers who provide stability to churches during times of struggle.

In some instances—such as when churches are without pastors for several weeks or months—churches might have closed their doors had it not been for Sunday school teachers who remained at their posts. Teachers who have helped in times of crisis include Clinton Wilson, nominated by Teressa Ashley of Goodrich Memorial United Methodist Church in Norman, Oklahoma.

"On December 23, 1986, our church caught on fire and little more than a shell was left," Teressa writes. "That evening after the fire, I was with some other members who had heard the news and gathered in the fellowship center across from the church. As I turned to talk to Clinton, I was emotionally drained and teary-eyed. He looked me squarely in the eyes and said: 'This fire has destroyed our building but it hasn't destroyed our church. We will build back a better building than we lost. You watch. We will be stronger than ever.' And Clinton didn't limit himself to saying consoling words. He went to work helping with the clean-up. Before Sunday came, he had converted a large storage closet into a place for my sixth grade class to meet. And he was right about the fire. One month after we lost our building, our church set a record attendance for Sunday school."

4. Master Sunday school teachers help their churches extend their missions and ministries. An example is June Mapp, who helped First United Methodist Church in Stillwater, Oklahoma, establish a Sunday school class for mentally handicapped adults.

"Jane's caring encouraged our church members to see and respond to the need for the class," writes Sallie Willis. "She helped secure a classroom that would be accessible to handicapped persons. She visited group homes in our community to invite residents to Sunday school, and she helped find appropriate curriculum resources. She has worked lovingly and tirelessly with members of the class, adapting and developing a curriculum for them, enabling them to participate in the life of the church in many ways in addition to Sunday school."

Clara Altaffer is another teacher who has helped her church extend its mission. A professor at Central State University and a member of First United Methodist Church in Edmond, Oklahoma, she teaches a Sunday school class at Mable Bassett, Oklahoma's maximum security prison for women. Since it began five years ago, the class has become a vital support structure and has helped students rebuild their lives.

These excerpts from the letters of nomination we received demonstrate the tremendous impact teachers of adult Sunday school classes can have upon their students and the churches in which they serve. Is there any wonder that these teachers are loved and respected?

In the next article we will examine the qualities students appreciate most in their adult Sunday school teachers.

II. What Makes Teachers Make a Difference?

Boyce A. Bowdon

Sunday school teachers who really make a difference in the lives of their students and in the mission of their churches generally possess seven characteristics.

That conclusion is based on responses to the invitation by *Contact* to nominate favorite Sunday school teachers, mentioned in the preceding article.

The twelve finalists chosen by our selection committee differ in terms of age, race, educational background, social and economic status, and theological viewpoints. But they also have much in common. Seven characteristics stand out in each of them.

1. Teachers who make a difference are sustained, challenged, and empowered by faith in God. Nothing a teacher does or says means more to students than the assurance that she or he genuinely trusts in God and has committed her or his life into God's hands.

This view is expressed by Dorothea Buick, president of the Kumdubl Sunday school class at the United Methodist Church in Grove, Oklahoma, who has this to say about her teacher, Lucille Prine: "In 1959 Lucille's home and practically all of her possessions were destroyed by fire. In 1964 her sixteen-year-old son—her only child—drowned in Grand Lake at a school picnic. In 1972 she suffered a cerebral hemorrhage and almost died. In 1976 her husband died after suffering several strokes and being an invalid for several years. In 1986 she was severely injured in an automobile accident. She had extensive surgery and her jaws were wired for several weeks. But Lucille Prine has not grown bitter. After all she has gone through, her faith is even stronger, her love for God is even greater, and so is her desire to serve her church and community."

Across the years, class members have observed that Lucille Prine's faith in God has made a tremendous difference in her life. Since her students know she takes seriously what she teaches, they are more inclined to take her lessons seriously. This helps them in their own faith development.

2. Teachers who make a difference are caring, and they demonstrate their concern for class members and all people. Letters we received cited specific examples of how teachers reveal their concern for students by attitudes and by actions. It makes a difference when their teachers call them by name, send them birthday cards, and greet them warmly when they meet during the week somewhere away from church.

"Lily Oden is always ready to listen and help," writes Sandy Thomas of Altus, Oklahoma, about her favorite Sunday school teacher.

Another letter, written by N. J. Beebe of First United Methodist Church in Enid, Oklahoma, says: "Tom Sailors is available every day of the week. All he needs to know is that one of his class members needs his help. He is eager to do whatever he possibly can to assist."

3. Teachers who make a difference prepare their lessons and themselves—spiritually, emotionally, and physically, as well as mentally. Norma Moe of Nicols Hills United Methodist Church in Oklahoma City is such a teacher. She has been teaching Sunday school for more than twenty years, but she still realizes she has a lot to learn about teaching.

Judy Knott, who nominated Norma for the favorite teacher award, points out that she takes advantage of the training opportunities her denomination provides, including short-term religion courses at a nearby United Methodist university. "We appreciate the time and effort she devotes to being our teacher," writes Judy.

4. Teachers who make a difference relate the Sunday school lesson to everyday life. Travis Harris lost his sight in 1926, but blindness hasn't prevented him from living a useful and rewarding life. He retired in 1985 after a forty-nine-year distinguished career with the Oklahoma Department of Visual Services. Harris says he has managed to do just about everything he has ever wanted to do, including teach a Sunday school class at May Avenue United Methodist in Oklahoma City.

"Travis knows the Bible," says class president Lee Sullivan. "He often quotes long passages word for word, but it isn't his remarkable memory that impresses us most. It's his ability to apply the lesson to everyday life. He knows what is happening in the world. He can reconcile biblical concepts and scientific thought in a way that makes sense to the average lay person. He meets us where we are, and helps us move along to where we ought to be."

5. Favorite teachers encourage students to think. One way Travis Harris helps class members relate the Sunday school lesson to their daily lives is by encouraging them to think and to express themselves freely in class discussion.

"Travis has thought through what he believes, but he isn't dogmatic," Lee Sullivan observes. "If we don't agree with him, or with one another, he doesn't feel the least bit threatened or uncomfortable. We feel free to say what we think, even when we are not positive what we think. And this helps us grow."

6. Teachers who make a difference present interesting as well as inspiring lessons. Judging from the letters of nomination we received, adults don't expect their Sunday school teachers to be entertainers, but they do appreciate good communication skills and lessons that are interesting. "Richard Eldridge is not only an insightful scholar of Scripture. He's a story-weaver who can take a passage of the Word and make it come alive for all of us," writes Bob Carpenter of Asbury United Methodist in Tulsa.

7. Teachers who make a difference are supportive of their church. Some Sunday school teachers—especially those who have taught the same class for decades—tend to develop "their class" into a church within the church. Their loyalty is limited to the class, and they do little to encourage class members to become involved in other areas of the church. Such is not the case with the twelve persons chosen as master teachers by our selection committee. Each of them is an active member of the church.

John Strange is an example. According to Lavita Ward of First United Methodist Church in Hobart, Oklahoma, if the church doors are open, John is there. She writes, "In addition to being an excellent Sunday school teacher, John is chairman of our administrative board. If something needs to be fixed, if a fund drive needs to be led, or if a new project needs a boost, there you will find John Strange helping get the job done."

The letters of nomination we received pinpointed several other characteristics adults appreciate in Sunday school teachers. For example, a sense of humor, enthusiasm, and creativity were frequently mentioned. But

the seven characteristics we have listed are the ones that seem to stand out most in the eyes of students.

Cultivate these qualities and you will also be a Sunday school teacher who makes a difference in the lives of your students and in the mission of your church.

Two Ways of Living

Background Scripture: Psalm 1

The Main Question—Pat McGeachy

Like Jesus' Sermon on the Mount, the book of Psalms begins with the word "blessed," which may be translated "happy." (It ends with "Hallelujah!") For Americans it is a commonplace that one of our inalienable rights is the pursuit of happiness, so we ought to be pleased at finding the secret here. And it takes this form: If you want to be happy, you must take a clear choice between good and evil.

Wisdom literature in the Bible is found, in its simplest form, in concise couplets called *proverbs*. These are usually written in *synthetic* form (both lines agreeing), as, for example:

> To get wisdom is better than gold;
> to get understanding is to be chosen rather than silver.
> (Proverbs 16:16)

Or they may be in *antithetic* form (the two lines in opposition):

> A wise son makes a glad father,
> but a foolish son is a sorrow to his mother.
> (Proverbs 10:1)

It is easy to see that Psalm 1 is an expanded antithetical proverb, which can be reduced to

> A good person will prosper,
> but a bad person will perish.

Of course, anyone with two eyes can see that life isn't always like this; everyone knows some healthy wicked people and some suffering good folks. And the wicked world will use this evidence to claim that there is no point in trying to behave yourself. But all of the Bible can be boiled down to one courageous faith statement: In spite of the apparent prosperity of evil, let us side with goodness. Happiness demands that we choose! We cannot spend our lives limping between the two (I Kings 18:21). Even when

goodness seems impossible to attain, we must choose it. Jesus put it this way: "Blessed are those who hunger and thirst for righteousness, for they shall be satisfied" (Matthew 5:6). It is a time to decide (Joshua 24:15). The main question of this lesson (and of life itself) is, Whose side are you on?

As You Read the Scripture—Mike Winters

Psalm 1. As an introduction, this psalm strikes a keynote for those of faith who would indulge in Psalms seriously. Rather than being for liturgical purposes, Psalm 1 is meant to instruct its readers in a way of life pleasing to God. Thus it is considered to be a part of the *wisdom literature* of the Bible.

This psalm was written after the Babylonian exile and reflects the influences of Ezra (about 397 B.C.), who was responsible for the reorganization of the returned exiles into a community of faith centered in the law of God.

Verse 1. There is no religious mysticism in this blessing. The Hebrew word for "blessed" means "happy." This happiness is not a condition for men only. The Hebrew word translated as "man" in this verse is to be interpreted as a specific individual, male or female.

Here the righteous learn what they are not to do. They do not take advice from the godless. They avoid the well-worn path of the conscienceless sinner. They do not gather with those who scorn the way of God.

Verse 2. The righteous take pleasure in and desire the law of the Lord. This law is not only the Ten Commandments but also the ordinances and statutes of the entire Judaic code.

The familiar and frequently used name for God, Lord, does not define God's sex. God is neither male nor female, Lord nor Lady. When we talk about God we must admit to the inadequacies of our language. When we have said our best and that which is most meaningful to us about God, we must affirm that God is more than what we are able to say.

The Hebrew word translated "meditate" means "to mutter." The image of this word is that of the righteous reading or reciting half-aloud the laws of God. It is a continuous meditation, not reserved for a quiet moment but merged with every activity of the day and night.

Verse 3. In the simile the righteous are like a tree cultivated and irrigated, producing its fruit (compare Jeremiah 17:5-8). Cultivation and irrigation suggest intentionality. The tree's growth and productivity is not left up to natural forces. The tree prospers even in times of drought because someone worked hard to be sure it would survive and bear fruit. So it is with the righteous. Taking delight in and meditating on the law of God is a deliberate, intentional act of discipleship. It is hard work that pays dividends to the disciplined.

The dividends sometimes are hard to see. Not everyone would say that the righteous are blessed. The entire book of Job is about a righteous man who suffered much. Yet the psalmist writes that the righteous prosper. The question of why the righteous suffer is far from the mind of the psalmist because the psalmist sees the day when all wrongs will be set right.

Verse 4. The wicked are like chaff. This is a picture of the threshing floor where the grain together with the lighter chaff is tossed in the wind, and the chaff blows away.

Verse 5. The psalmist did not envision a futuristic apocalyptic judgment of the wicked. Rather, this was an imminent judgment. God's divine justice

is not otherworldly, at the last day, but is present and working in the world, righting all wrongs.

The "congregation of the righteous" is an allusion to Judah, returned from Babylonian exile with new commitments to faithfulness.

Verse 6. The righteous will prevail, while the wicked will perish.

Selected Scripture

King James Version

Psalm 1

1 Blessed *is* the man that walketh not in the counsel of the ungodly, nor standeth in the way of sinners, nor sitteth in the seat of the scornful.

2 But his delight *is* in the law of the Lord; and in his law doth he meditate day and night.

3 And he shall be like a tree planted by the rivers of water, that bringeth forth his fruit in his season; his leaf also shall not wither; and whatsoever he doeth shall prosper.

4 The ungodly *are* not so: but *are* like the chaff which the wind driveth away.

5 Therefore the ungodly shall not stand in the judgment, nor sinners in the congregation of the righteous.

6 For the Lord knoweth the way of the righteous: but the way of the ungodly shall perish.

Key Verse: **For the Lord knoweth the way of the righteous: but the way of the ungodly shall perish. (Psalm 1:6)**

Revised Standard Version

Psalm 1

1 Blessed is the man
who walks not in the counsel of the wicked,
nor stands in the way of sinners,
nor sits in the seat of scoffers;

2 but his delight is in the law of the Lord,
and on his law he meditates day and night.

3 He is like a tree
planted by streams of water,
that yields its fruit in its season,
and its leaf does not wither.
In all that he does, he prospers.

4 The wicked are not so,
but are like chaff which the wind drives away.

5 Therefore the wicked will not stand in the judgment,
nor sinners in the congregation of the righteous;

6 for the Lord knows the way of the righteous,
but the way of the wicked will perish.

Key Verse: **The Lord knows the way of the righteous, but the way of the wicked will perish. (Psalm 1:6)**

The Scripture and the Main Question—Pat McGeachy

It is easy to compromise with evil. One is tempted to say of life that it is not really *either/or*, as this psalm insists, but *both/and*. "There's a little bit of good in everybody. Didn't Jesus associate with tax collectors and sinners?" Okay, you have a point. Maybe life is both *either/or* and *both/and*. (That's as far as I intend to carry this.) But the beauty of this psalm is that it plows right through the moral ambiguities of our world to take sides. Let's journey with it into the two halves, which are the way of goodness (verses 1-3) and the way of evil (verses 4-6).

FOURTH QUARTER

The Downward Slide (Psalm 1:1)

When I was a small boy, my grandmother walked with me to the top of Stone Mountain, in Georgia. There used to be a flimsy fence on the top of that monolith, where the dome began to slope more rapidly, marked "Danger! Do Not Go Beyond This Point!" I remember, even in those tender years, thinking that a life of sin needed such warnings. There is a point (who knows for sure where it is?) beyond which there is no turning back. The first verse of Psalm 1 describes a person who is getting dangerously near such an edge. Notice the downward progression; we have to do with a person who is careful to:

<div align="center">

walk not
 stand not
 sit not

</div>

with

<div align="center">

the wicked
 the sinners
 the scoffers.

</div>

It is a movement from casual encounter through deliberate participation to comfortable involvement with the things of evil. Our temperance ancestors might have put it, medicinal wine from a teaspoon, then beer from a glass, then whiskey from a bottle. The point of this psalm, simply put, is, don't compromise with evil.

Love for the Law (1:2)

"Law," for the Hebrew, meant the whole counsel of God, declared in Scripture and tradition and particularly the five books of Moses (Genesis through Deuteronomy). Thus, in the particular sense it means the Law (Moses) as opposed to the Prophets (Elijah, Amos, Isaiah, etc.), but in the case of this psalm, it is clearly meant in the general sense: both the Law *and* the Prophets (see Matthew 5:17).

It is hard for us "moderns" to understand the passion that the ancient Jew had for God's law. Perhaps that is partly because we have grown up in a world in which respect for law (and order) have been ingrained in us. But our psalmist may well have been thinking, while writing this psalm, of the pagan nations round about which seemingly had no rules. (This idea is not unknown to moderns; see Kipling's lines in his poem, "Recessional": "Such boastings as the Gentiles use,/Or lesser breeds without the Law.") In a world in which chaos seems to reign, how wonderful it is to have rules! In such a world, a pious Hebrew might well cry out,

<div align="center">

Oh, how I love thy law!
It is my meditation all the day.
Thy commandment makes me wiser than my enemies.
(Psalm 119:97-98)

</div>

Psalm 119 rings the changes on the Jewish love for the law through all the letters of the Hebrew alphabet. And the metrical version of that psalm begins:

<div align="center">

How I love thy Law, O Lord!
Daily joy its truth afford.
("How I Love Thy Law, O Lord")

</div>

In a chaotic world, rules bring stability and thus hope for sanity. Unfortunately, when the rules become ends in themselves they become burdensome to people. Thus Paul cries out against the law, saying: "No human being will be justified . . . by works of the law, since through the law comes knowledge of sin" (Romans 3:20) and, "The law brings wrath, but where there is no law there is no transgression" (Romans 4:15). And yet, in the spirit of Psalm 1, Paul must also sing, "For I delight in the law of God, in my inmost self" (Romans 7:22). The law may be burdensome to us, but it was given to us by God as a gift. So Jesus says (Matthew 5:17): "Think not that I have come to abolish the law and the prophets; I have come not to abolish them but to fulfill them."

Permanence (1:3)

There is no lovelier metaphor in the Bible than this description of the palm (surely that is what it was; that's what you see growing by the waters in Israel, though willows are not uncommon, and in modern times the eucalyptus), nurtured by the waters of the river and bringing forth fruit (dates). I cannot read this verse without thinking of comparable images in Ezekiel 47:12 and Revelation 22:2. And there comes also to mind the old camp-meeting song I grew up on as a child:

> I shall not be, I shall not be moved!
> I shall not be, I shall not be moved!
> Just like a tree, that's planted by the water,
> I shall not be moved!

Note, please, that the keeper of the law will not merely stand still, secure and safe in legalism, but will branch out and bear fruit. There will be not only the righteousness of abstinence but positive works of righteousness. (See also Matthew 13:23; John 12:24, and 15:5.)

Chaff in the Wind (1:4)

Winnowing by fork is not too common in today's world, but some of your people may have tried it. Pitch some wheat into a stiff breeze; the heavier grain falls to the ground, the lighter straw blows away. (A similar act is performed by the miner who pans for gold; the swirling action of the water causes the heavier gold dust to gather together, while the lighter gravel is washed aside.)

Evil often looks to be more solid and secure than goodness (which seems so often to be weak). But consider a couple of reminders from hymns:

> Though the cause of evil prosper,
> Yet 'tis truth alone is strong;
> Though her portion be the scaffold,
> And upon the throne be wrong,
> Yet that scaffold sways the future,
> And, behind the dim unknown,
> Standeth God within the shadow
> Keeping watch above his own.
> ("Once to Every Man and Nation")

> . . . though the wrong seems oft so strong,
> God is the ruler yet.
> ("This Is My Father's World")

351

Or, better still, read Psalm 73. Though the wicked seem successful, they are really quite insecure (verse 18).

In the End (1:4)

Ultimately (and this refers to either the final judgment day spoken of by both the Old and the New Testaments or the regular, almost daily, way we get our comeuppance) the truth will win out. Those who hunger and thirst after righteousness *will* be filled. We have tribulation in the world, but Christ *has* overcome the world. Nothing can separate us from the love of Christ. The truth will out. What goes around comes around. If you abide in the law, you can expect to be vindicated.

Now, the biblical writers were not fools; the entire book of Job tells us that sometimes righteous people suffer. Jesus made it clear that not all suffering is directly related to sin (Luke 13:1-5; John 9:1-3). But the guiding principle remains the same: If you want to be happy, aim for what is lawful, true, and good, not what is evil. In your quest for good you may have a lot of trouble, but in your quest for evil, you can count on certain failure.

Summary (1:6)

As Psalm 1 serves as summary and introduction to the entire book of Psalms, so verse 6 serves as summary and conclusion to the entire first psalm.

> for the Lord knows the way of the righteous,
> but the way of the wicked will perish.

I don't know how to put it any plainer than that.

Helping Adults Become Involved—Ronald E. Schlosser

Preparing to Teach

When we think of wisdom literature in the Bible, the book of Proverbs usually comes to mind. However, there are elements of the didactic style of wisdom literature contained in some psalms. Psalm 1 for study today is an example of such a wisdom psalm.

For background information on wisdom literature in general and Psalm 1 in particular, you may wish to refer to a good Bible commentary, such as *The Interpreter's Bible* or *The Abingdon Bible Commentary*. As you prepare the lesson, be sure to read carefully the preceding sections in this *Annual* headed "As You Read the Scripture" and "The Scripture and the Main Question." The ideas, insights, and comments contained in these sections form the heart of the lesson. Suggestions will be given below as to how these resources can be employed throughout your lesson plan.

The learning goals of today's session are (1) to analyze the two ways of life presented in Psalm 1, (2) to consider how the truths of this psalm relate to choices we make in life and the lifestyles we choose, and (3) to resolve to set aside time each day to study and meditate on God's Word.

Have available in your classroom a chalkboard or newsprint pad on which to write the statement by Dr. McGeachy to introduce the main question. Then use the following outline to organize the lesson:

 I. Considering the nature of wisdom literature
 II. Analyzing Psalm 1
 A. The downward slide (verse 1)
 B. Love for the law (verse 2)
 C. Permanence (verse 3)
 D. Chaff in the wind (verse 4)
 E. In the end (verse 5)
 F. Summary (verse 6)

If you can find a copy of Watchman Nee's book *Sit, Walk, Stand* (Tyndale, 1977) in your church library, it would provide helpful insights as you involve your class members in the concluding activity of the session.

Introducing the Main Question

Basic and helpful ideas are presented in the section "The Main Question." These ideas are essential in helping to identify the purpose of the lesson and getting your session started.

To begin, write on the chalkboard or newsprint the following statement, which Dr. McGeachy sees as a summary of Psalm 1: "A good person will prosper, but a bad person will perish." Ask your class members whether or not they agree with this observation. Is it true that the good will always prosper and the evil will always perish? Can life always be seen as being composed of either/or choices and consequences? Dr. McGeachy suggests that life may also be a *both/and* proposition. What do your class members think?

Developing the Lesson

I. Considering the nature of wisdom literature

Briefly give your class some background on the nature of wisdom literature. Dr. McGeachy provides some information in the section "The Main Question." Indicate that the lessons next month will look more closely at the book of Proverbs, but that there are also didactic or teaching elements in the Psalms. In fact, there are verses in the Psalms that have parallels in the book of Proverbs (compare, for instance, Psalm 111:10 with Proverbs 1:7, or Psalm 1 with Proverbs 2:20-22).

II. Analyzing Psalm 1

Read aloud Psalm 1, perhaps asking six class members each to read a verse. Then use the major part of the session to discuss what the verses say to the class. Refer to the comments by Dr. McGeachy and Dr. Winters on these verses, as you go along.

A. The downward slide (verse 1)

Note the downward progression (or regression) of the imagery—from casual encounter (walking with), to deliberate participation (standing with), to comfortable involvement (sitting with). A modern-day image might be helpful. When going shopping, we walk by a store or a counter and glance at the merchandise. If it looks interesting we will stop and examine it more carefully. If we are shopping for shoes or clothing, the final step before purchase is to try it on. Martin Luther once said, in speaking of temptation, that you can't stop birds from flying over your head, but you can prevent them from building a nest in your hair!

B. Love for the law (verse 2)

How do your class members feel about law in the secular sense? Do they have respect for it? What are the positive values of laws and rules? What are the negative aspects of law? (Leads to narrow legalism or, in some cases, to attempts to find loopholes.)

Consider the positive values of God's law. Refer to Psalm 19:7-10, where the psalmist declares God's law to be perfect, sure, right, pure, clean, and true. It revives the soul, gives wisdom to the teachable, rejoices the heart, enlightens the eyes, and endures forever.

C. Permanence (verse 3)

Ask your class members to close their eyes and picture a scene containing a tree. Perhaps as a child they remember a favorite tree in their yard. What do they notice about the tree? Have the members share thoughts about trees. What are some of their characteristics? In their imaginations, did they picture a fruit-bearing tree or a shade tree? How do trees resemble the lifestyles of people? Refer to the words of Jesus: "By their fruits you shall know them" (Matthew 7:16-20).

D. Chaff in the wind (verse 4)

Have any class members seen or actually done winnowing (or panning for gold)? Ask them to describe the experience. Consider other images from nature that might illustrate the ungodly (for example, plants or weeds with shallow roots, sandstone that crumbles with slight pressure, the short life cycle of a moth, etc.).

E. In the end (verse 5)

How do we answer people today who say that the wicked sometimes prosper? Refer to Psalm 73. Can we unequivocally say that evil ultimately will fail? Indicate that next week's lesson will look at this in more depth.

F. Summary (verse 6)

Ask class members to think of illustrations that underscore the truth of this verse. When has evil seemingly triumphed, yet later failed?

Helping Class Members Act

For many people in the West, the great Chinese writer and preacher Watchman Nee was a symbol of Christian steadfastness under the pressure of a totalitarian government. In his book, *Sit, Walk, Stand,* he describes the Christian life as a progression, but reversed from the downward progression of Psalm 1. The Christian first is seated and enjoying the fellowship of God in Christ (Ephesians 2:6); next the Christian walks in the world with Christ (Ephesians 5:8); and finally the Christian is to stand with Christ in facing the forces of evil (Ephesians 6:11).

Dr. Winters talks about the need for discipline in meditating on the law of God. Challenge your class members not only to set aside time each day to study the Bible and to pray, but to try to reflect on God's presence consciously as they go about their daily activities. Pray for this resolve in a closing prayer.

Planning for Next Sunday

Ask the class members to think about the question, Is life fair? They should read Psalm 37 in preparation for next week's session.

Is Life Fair?

Background Scripture: Psalm 37

The Main Question—Pat McGeachy

There is no use in my trying to frame the main question for this lesson, for it is already there in the title. So let me tell you a story. I got it from William Goldman, the screenwriter who introduced us to an old European fairytale called "The Princess Bride." This is not exactly the way Goldman told the story (you will want to read his book of the same title for yourself), but it is the way I remember it. The hero, a commoner, had been searching endlessly for the lovely princess, who had been captured by the Black Pirate. And every time that it seemed he was just about to rescue her, something (giant rats, or fell swordsmen, or unclimbable cliffs) would intervene, and the evil pirate would escape with his prey. Finally, in frustration, the hero turned aside into the tent of a wise man and, burying his face in his hands, pounded the ground with his fists, saying, "It's not fair!"

"Of course not," answered the guru. "It's not supposed to be."

"I never knew that!" cried the young man, and, leaping up, he rushed out to continue his quest with renewed strength and joy.

You see, if you think life is fair, then every bad thing that happens to you will cause you to question yourself. "What have I done to deserve this?" you must logically ask. And the same question goes for anything good that happens. But if it *isn't* fair, then you can ignore such questions and get on with the business of living, free from guilt or second guesses.

Well, is it? In a way, all of the wisdom literature in the Bible was written out of struggle with this one problem. It may be the main question not only of this lesson but of life itself. The whole book of Job asks it: Why did such a righteous man suffer? You can spot it in many places: Psalm 1, (our last lesson); Luke 13:1-5; John 9:1-3; Romans 6:23; Galatians 6:7; Colossians 4:1; Revelation 16:7. What answer can we give?

As You Read the Scripture—Mike Winters

Psalm 37. There are two sides to justice in the Bible. There is the side of individual and corporate responsibility. As such, it is a concept of truth and honesty. It is a lifestyle based on doing what is right no matter what the cost. The other side of justice is the perspective of the victims of injustice. For them, justice is the expectation that God's people will vindicate them and will allow them to be vindicated. Justice is their "Bill of Rights." Justice in the Bible speaks volumes of hope to people who despair in the face of inequities and oppression.

Psalm 37 is the psalm of victims. The theme is patience. The God of justice will vindicate them.

Verse 1. The victims are given two imperatives. One, do not worry that the wicked might succeed. Implied is that they will not. Two, do not be jealous of the successes of the wicked. The last thing the world needs is

victims of injustice who have been vindicated only to become unjust like their persecutors.

Verse 2. By using the terms "grass" and "herb," the writer was suggesting that the wicked are like hay that will be cut down and like the tender grass that withers in drought and dies with the frost.

Verses 3-5. These verses offer conditional promises. If the people will trust, delight in, and commit to God, then God will act (verse 5).

Verse 3. Victims of injustice are to lean on God, be confident in God. They are to do good (see Isaiah 1:17).

The promise of the land is a part of God's covenant with Abraham (Genesis 17:8) and God's promise to the Hebrews in the wilderness as they prepared to possess the land "across the Jordan" (Deuteronomy 11:8-32).

Security is a geopolitical term, in this instance. Security is not in treaties with foreign nations, nor in armaments, but in the Lord (Isaiah 31:1). The King James Version expresses this sense of security in nutritional-agricultural terms: "Thou shalt be fed."

Verse 5. The Hebrew word translated as "commit" means "to roll." The image of rolling as it relates to an understanding of commitment is the sense of coming around again and again. Commitment to God is a going to God again and again.

Verse 6. Vindication means "to bring forth justice." All injustice will be brought out of the darkness where it flourishes into the light, where it can be seen for what it is. The word "right" means judgment. Judgment comes at high noon.

Verse 7. Victims of injustice are called to patience. Even when there is no one to do justice, God will intervene (Isaiah 59:16).

Verse 8. Here is the foundation of peaceful resistance for activists who struggle for justice. Here is also a warning that goes back to verse 1.

Verse 9. Here are two more promises. One is unconditional: No matter what, the wicked will fail. The other is conditional: Waiting for and trusting in God will result in possession of the land.

Verse 10. The wicked tormentors will perish, never to return again. It will be like waking from a bad dream. There will be the sudden relief that it is over, and no amount of coaxing will bring the mind to recall the specifics.

Verse 11. Blessed are the meek, for they shall inherit the earth (Matthew 5:5). Here is a basis for domestic and foreign policy.

Selected Scripture

King James Version	Revised Standard Version
Psalm 37:1-11	*Psalm 37:1-11*
1 Fret not thyself because of evildoers, neither be thou envious against the workers of iniquity.	1 Fret not yourself because of the wicked, be not envious of wrongdoers!
2 For they shall soon be cut down like the grass, and wither as the green herb.	2 For they will soon fade like the grass, and wither like the green herb.
3 Trust in the Lord, and do good; *so* shalt thou dwell in the land, and verily thou shalt be fed.	3 Trust in the Lord, and do good; so you will dwell in the land, and enjoy security.

4 Delight thyself also in the Lord; and he shall give thee the desires of thine heart.

5 Commit thy way unto the Lord; trust also in him; and he shall bring *it* to pass.
6 And he shall bring forth thy righteousness as the light, and thy judgment as the noonday.

7 Rest in the Lord, and wait patiently for him: fret not thyself because of him who prospereth in his way, because of the man who bringeth wicked devices to pass.

8 Cease from anger, and forsake wrath: fret not thyself in any wise to do evil.

9 For evildoers shall be cut off; but those that wait upon the Lord, they shall inherit the earth.

10 For yet a little while, and the wicked *shall* not *be:* yea, thou shalt diligently consider his place, and it *shall* not *be.*

11 But the meek shall inherit the earth; and shall delight themselves in the abundance of peace.

Key Verse: **For the Lord loveth judgment, and forsaketh not his saints. (Psalm 37:28)**

4 Take delight in the Lord, and he will give you the desires of your heart.

5 Commit your way to the Lord; trust in him, and he will act.

6 He will bring forth our vindication as the light, and your right as the noonday.

7 Be still before the Lord, and wait patiently for him; fret not yourself over him who prospers in his way, over the man who carries out evil devices!

8 Refrain from anger, and forsake wrath! Fret not yourself; it tends only to evil.

9 For the wicked shall be cut off; but those who wait for the Lord shall possess the land.

10 Yet a little while, and the wicked will be no more; though you look well at his place, he will not be there.

11 But the meek shall possess the land, and delight themselves in abundant prosperity.

Key Verse: **The Lord loves justice; he will not forsake his saints. (Psalm 37:28)**

The Scripture and the Main Question—Pat McGeachy

Don't Worry (Psalm 37:1-2)

It is ordinarily my custom, in organizing these lessons, to go through the passage verse by verse, following the outline of the Bible writer. But in this case I'm going to do it a little differently, for this psalm is not like most other passages of Scripture. Although it is attributed to David, it sounds more like Solomon and the book of Proverbs. And it appears to follow no particular outline or order. Instead, it seems to be a collection of one-liners setting forth fundamental statements about justice and fair play. The clue to its arrangement can be found in the Hebrew. It is an acrostic of twenty-two

stanzas, each stanza beginning with one of the twenty-two letters of the Hebrew alphabet. For an even more dramatic example, see Psalm 119, whose twenty-two stanzas each begin with one of the twenty-two letters, so that every line of stanza one begins with *aleph,* every line of stanza two with *beth,* and so on. Some versions of the Bible indicate the Hebrew letters before each stanza. (Let me remind you that our word "alphabet" comes to us from the Hebrew letters *aleph-beth* by way of the Greek *alpha-beta.* The ancients referred to their alphabets by their first few letters, just as children today refer to our letters as the ABCs).

The first two verses set the tone for the whole poem. It *is* a poem, properly found in Psalms rather than in Proverbs, even though like Psalm 1 it contains "proverbial" thoughts. They tell us at the outset to relax, everything is going to be all right, God is in charge. This psalm would not have been written if some doubts about the question had not been raised. And we can be sure they were, for every society knows some wicked people who seem to get away with everything (see Psalm 73) and some good people who seem to have more than their share of misfortunes (see Job 1–2 and 42; the middle chapters are simply expansions of the theme).

In spite of what the psalmist says in verse 25, every one of us *has* known of righteous people who have been forsaken and whose children have gone hungry. I am thinking as I write this of a couple who are pillars in their church. A few years ago their oldest son was killed in a senseless auto accident involving drunkenness. Then their *other* son, a college sophomore, ran into a bridge abutment and is not likely to recover from his head injuries. And they have been "good" people ever since anyone had known them. Meanwhile, I can name a dozen "fat cats" who are off in the Caribbean cruising on their ill-gotten gains. Is life really fair?

To complicate matters for the Hebrews at the time of this psalm (I'm inclined to date it about three hundred years before the time of Christ), the little country had long been suffering from captivity by everyone from the Babylonians to the Greeks. And the innocent had suffered along with the guilty. Who can blame the pious Jew for coming to his rabbi and asking (as a modern rabbi asked just recently) where God is when bad things happen to good people?

The psalmist seems to duck the question. "Never mind all the bad things, and the wicked who prosper," is the opening line. "They'll get what's coming to them. You trust the Lord and behave yourself, and everything will be okay" (verse two). All right, fine, I appreciate that, but will that preach to the family of the two boys I just described above? Or to the parents of a newborn with Down's syndrome? Or the families of the marines killed in the Shiite suicide attack in Beirut? Or to the kid in the eighth grade who (for once) has studied hard, only to have the teacher ask a question on an area she didn't tell them to look at?

I think it will hold water, but only if we back off and take a fresh look at what the psalmist is *really* saying.

Quality, Not Quantity (37:16)

> Better is a little that the righteous has
> than the abundance of many wicked.

We must not measure things the way the world does. Remember the widow with the two cents (Mark 12:41-44). So what if that villain appears to be

wealthy—it is better to have the moon and the stars and a song in your heart. "The best things in life are free."

Time Is on Our Side (37:10-11)

Things may look fine for the wicked at the moment, but just wait! See Psalm 73:15-20. Or, more significantly, see the third Beatitude (Matthew 5:5), where Jesus himself quotes this psalm. The meek (not the smarmy, aw-shucks, self-conscious milksop, but the quiet, cool, self-contained person who trusts in God) will win the earth. It may not seem so today, but in God's eyes a thousand years may be only a watch in the night. Wait for it (Habakkuk 2:3-4), it will come. As for the wicked, they have their earthly reward (Matthew 6:2); in the end, so will you (Matthew 6:4), but in heaven (Matthew 6:19-21). So be patient (Psalm 37:7, 34).

The Deepest Reality (37:39-40)

On the surface, life is not fair. The rain falls on the just and the unjust alike, and the sun shines on the evil as well as the good (Matthew 5:45). God, Jesus says, is perfect (Matthew 5:48), so we can rest assured that at the bottom line things are going to be all right. The guru in "The Princess Bride" is right: Life isn't supposed to be fair. Everyone has to take the risk just like everybody else. When calamities strike, we mustn't try to second-guess the workings of God. Sometimes the innocent suffer. (Remember those babies who were born in Bethlehem about the same time as Jesus, in Matthew 2:16?) Sometimes people are born blind (John 9:2-4). That's just the way things are. In a universe where freedom exists, it is possible for a toddler to wander into the path of a drunken driver. In a world where everyone is unique, some of us must have five talents and others only one or two (Matthew 25:15). That's just the way things are, and we needn't complain. God has made this deal with us, and we will get paid justly in the end. We are not to covet what others have or question the divine fairness. Look again at the wonderful story of the laborers in the vineyard in Matthew 20:1-16.

What is even more important is that *if God were actually fair we would all be in trouble!* We are not all that innocent. There is not one righteous, and we all deserve the wrath of God (Psalm 51:4). Thank God that the divine way is not justice but mercy! God does not reward us as we deserve (Psalm 103:10). Instead, though we are sinners, Christ has died for us (Romans 5:8).

Thus at the deepest level God's fairness exceeds ours! On the ordinary level of human life, we must live with the simplest sort of fair play. But when we touch the heart of God, we begin to discover that we can no longer demand "an eye for an eye." We must learn to turn the other cheek and to live according to God's fairness, not that of the world (see all of Matthew 5).

So What Shall We Do? (37:3-5, 27-28)

We will get on with the business of living. We must not devote our energies to demanding our rights, but to living as fairly and as justly as the ways of the world will permit. Never mind how unfair it may seem—that's just the way things are, and at the deeper level the faithful person knows that God can be trusted. (If not God, who then *can* be trusted?) There is nothing to it but to get on with living a life obedient to God. And no matter

how well others do, we must keep on keeping on. We must hear always the clear call of Jesus, who says to us what he once said to Peter (John 21:22), when it looked as though John was going to get a better deal, "What is that to you? Follow me!"

Helping Adults Become Involved—Ronald E. Schlosser

Preparing to Teach

In a short religious film entitled *Nikolai,* produced several years ago, the fourteen-year-old son of an evangelical Christian in the Soviet Union complains to his father about constant KGB harassment.

"It's not fair, none of it," the boy exclaims. "They're always humiliating us, treating us like we're some sort of criminals."

His father responds, "Our Lord never promised that things would be fair. . . . When he died on the cross, it was not to make things fair; it was to forgive us our sins, to allow anyone who wants to become friends with God."

This attitude toward life's injustices is similar to the response of the guru in the fairy tale "The Princess Bride," referred to by Dr. McGeachy in "The Main Question." It is the point at which you may want to begin today's session.

There are two primary learning goals for the session: (1) to grapple with the question "Is life fair?" and (2) to make a personal affirmation about the justice of God prevailing over the apparent injustices of life.

Carefully read the sections "As You Read the Scripture" and "The Scripture and the Main Question." These form the heart of the lesson. The ideas, insights, and suggestions in these sections should be employed throughout your lesson plan.

After introducing the main question, organize your lesson into two major sections:

> I. Examining the structure of Psalm 37
> II. Summarizing the content of selected stanzas

In preparing for the concluding activity described under "Helping Class Members Act," think through your own choice of Scripture passages and statements that can be introduced by letters of the alphabet. With a little creative preparation, this could be a very meaningful exercise for your class.

Also, in relation to the concluding activity, when you will ask the class to respond to a story Dr. McGeachy tells, see if you can borrow the book *When Bad Things Happen to Good People* by Rabbi Harold S. Kushner. It might prove helpful in dealing with the question being considered.

Introducing the Main Question

Basic and helpful ideas are presented in the section "The Main Question." These ideas are essential in helping to identify the purpose of the lesson and getting your session started.

Begin by writing on the chalkboard the question, Is life fair? Ask for opinions from your class. Note the comments made by Dr. McGeachy in "The Main Question." Refer to the Scripture passages he mentions: Luke 13:1-5 (tower of Siloam); John 9:1-3 (man born blind); Romans 6:23 (the

wages of sin); Galatians 6:7 (what a person sows); Colossians 4:1 (just and fair treatment of servants); Revelation 16:7 (God's righteous judgments); and the theme of the entire book of Job (why does a righteous person suffer?).

Developing the Lesson

I. Examining the structure of Psalm 37

Read aloud the first eleven verses of Psalm 37, preferably from the Revised Standard Version or another version that clearly shows the grouping of the verses. Ask your class members to comment on what they observe to be the *structure* of the psalm. They will probably notice the couplet-like format and the similarity to the book of Proverbs. Share with them the information about the acrostic format and identify the twenty-two stanzas. (In the RSV, the break between verse 28a and 28b is not clearly discernible. *The Jerusalem Bible* not only shows the twenty-two stanzas but labels each of them with its Hebrew letter.)

In case the question of authorship and dating is raised, indicate that the universal appeal of the psalm makes such a discussion secondary. You might observe, however, that the frequent use of phrases such as "possess the land" and "dwell in the land" (verses 3, 9, 11, 22, 29, 34) seems to favor a dating after the time of David, even after the Babylonian captivity.

II. Summarizing the content of selected stanzas

Divide the class into ten groups, either as threesomes, twosomes, or individuals. Assign each group (or individual) one of the following passages from Psalm 37: verses 1-2, 3-4, 5-6, 7, 8-9, 10-11, 16-17, 17-28a, 34, 39-40. (If your class has less than ten members, eliminate the latter passages). Ask each group to summarize what its passage says in a brief sentence, preferably using words different from those in the passage. Allow about five minutes for this activity, then call the class together for sharing.

In his comments on these verses, Dr. McGeachy does much the same thing that you asked your class to do. Share his comments as class members discuss their passages. Wherever Dr. McGeachy refers to other Scripture passages, have the class turn to them and read them aloud.

Helping Class Members Act

Refer to the story Dr. McGeachy tells of the church couple who lost their oldest son in an automobile accident and whose other son was injured in another accident. How would your class members answer the question of why, which this couple asked? Suggest that the members gather again into the small groupings they were in earlier to discuss the question. What would they say to any person who wonders about the fairness of life?

To challenge your class to do some creative thinking, suggest that each group compose a one-sentence statement beginning with one letter of the English alphabet, from A to J. This would resemble the format of the acrostic psalm they have been studying. The statement might be a Scripture verse or a paraphrase of a Scripture verse. Here is one possible grouping:

A—All things work together for good to them that love God (compare Romans 8:28).

B—"Be of good cheer; I have overcome the world" (John 16:33).

C—"Cast all your anxieties on him, for he cares about you" (I Peter 5:7).

D—"Draw near to the throne of grace, that we may receive mercy and find grace to help in time of need" (Hebrews 4:16).

E—Earnestly seek God's will in all things (compare Luke 22:42).

F—Fix your eyes on Jesus; he will keep you from falling (compare Matthew 14:28-33).

G—God's ways are higher than our ways, God's thoughts higher than our thoughts (compare Isaiah 55:9).

H—He will be kept in perfect peace whose mind is stayed on God, because he trusts in God (compare Isaiah 26:3).

I—"In all your ways acknowledge him, and he will make straight paths" (Proverbs 3:6).

J—Jesus never fails.

After each group has shared its statement aloud, you might close with this thought: When a hawk is attacked by crows or kingbirds, as it is occasionally, it does not counterattack. Rather, it soars higher and higher in ever-widening circles, until its tormentors leave it alone. So, too, in our lives, when the things of this earth seem to overwhelm us, we need to rise to a higher level of living, where patience and endurance and hope are attainable with God's help. (See Romans 5:1-5.)

Planning for Next Sunday

Ask your class members to read Psalm 49. They should also think about what people fear most in life. What gives people the greatest sense of insecurity?

LESSON 3 JUNE 17

Security Only in God

Background Scripture: Psalm 49

The Main Question—Pat McGeachy

Do you remember the story about the man who was buried in his Cadillac? It seems that he had loved the customized luxury car so much that he left instructions that he be embalmed, seated in the driver's seat, and buried car and all. According to the tale, the gravediggers, fascinated at the gigantic hole they had had to excavate, stood around and watched as the huge vehicle was lowered into the ground. After a few moments, one turned to another and murmured in awe, "Man, that's really living!"

In our heads we know "You can't take it with you," but most of us deny this in our hearts. We invent ways to deny the reality of our own deaths (more about this later), and we deny our involvement in the materialistic culture of which we are a part. We deny it just as surely as a substance abuser

denies an addiction to drugs or alcohol. But just let the electricity go off for an hour or two, and see how well we function! Or watch the way most middle-class Americans behave on a camping trip or while traveling in a foreign country, when they can't get the amenities they are accustomed to. (How long has it been since you used an outhouse?)

Jesus, we are told, had no place to lay his head (Matthew 8:20). "Give away everything," he commanded a rich young man, "and follow me" (Mark 10:21). He called his disciples to follow him to his death (Matthew 16:21-23), and his disciples (especially Peter) couldn't handle it at all. Not until Jesus had called Peter "Satan" would they be silent. Are you and I willing to turn loose of life? Of our culture? Of our favorite crutches? Can we face the truth about our own addiction to false securities?

The main question raised by Psalm 49 is a *bottom line* question: Ultimately, whom do you trust? By what standard do you measure your own worth or that of others?

As You Read the Scripture—Mike Winters

Psalm 49. Each psalm treated so far (Psalms 1, 37) has attempted to answer the thorny question of why the wicked flourish while the righteous suffer. The one psalm promises the righteous that the wicked will be judged. The other offers the promise of retribution. Psalm 49 also attempts to answer the question. Its conclusions are that the power and wealth and influence of the wicked are not worthy objects for the righteous to desire. The security they provide people is lost at death. Only God provides security that transcends death.

Verse 1. The psalmist's message is for everyone, Jews and Gentiles alike.

Verse 2. The Hebrew words *ish* ("high") and *adam* ("low") may both be rendered the same. *Adam* is especially familiar to readers, as it is the name of the first man. Though it is a word that names all of the human race, in this sense it is to mean the common person, who is different from the high *(ish)* person. The message is for rulers and people of power as well as for the commoner. The message is for rich and poor.

Verse 3. The Hebrew word translated "wisdom" in this verse means "skill" rather than understanding or intelligence.

Verse 4. "Proverb" and "riddle" here are contrasted. The solution to the problem is both at once obvious and obscure.

Verses 5-6. In these verses the question is posed rhetorically. The obvious answer is those who trust God have no reason to fear persecution. In this trust the oppressed have a sense of inner freedom that their enslaving oppressor cannot take from them. They know they are saved, and they have joy. They laugh. It is laughter the oppressor cannot understand. The wicked, on the other hand, have trusted objects that cannot save them, namely wealth and riches.

Verses 7-12. Compare Luke 12:16-20.

Verse 7. The Hebrew word for "ransom" ("redeem" in the King James Version) actually means "a covering." The sense here is that wealth can buy everything except a covering over death.

Verse 8. The Hebrew word also translated here as "ransom" means "redemption." Life is costly, rare, and precious. Life is priceless and uninsurable.

Verse 9. The Pit is the place of corruption. The Pit is equated with Sheol (verse 14).

Verse 10. At death all possessions are left for others. The imagery here is not necessarily that of friendly heirs. The homes Central American refugees leave may be ransacked and burned to the ground.

Verse 11. In their deaths, the wicked who trust in riches, though their names are known throughout the land, are mentioned only with scorn.

Verse 12. This verse is repeated like a refrain at verse 20.

Verse 13. There is nothing after death for those who trusted in wealth.

Verse 14. Sheol, or the grave, is the unseen state. It is the place of the dead with no hope for life.

Verse 15. There is a question whether this means that the psalmist has escaped death (Psalm 89:47-48) or whether this is a reference to life after death (Isaiah 26:19).

Selected Scripture

King James Version	Revised Standard Version

Psalm 49:1-15

Psalm 49:1-15

1 Hear this, all *ye* people; give ear, all *ye* inhabitants of the world:

1 Hear this, all peoples!
 Give ear, all inhabitants of the world,

2 Both low and high, rich and poor, together.

2 both low and high,
 rich and poor together!

3 My mouth shall speak of wisdom; and the meditation of my heart *shall be* of understanding.

3 My mouth shall speak wisdom;
 the meditation of my heart shall be understanding.

4 I will incline mine ear to a parable: I will open my dark saying upon the harp.

4 I will incline my ear to a proverb;
 I will solve my riddle to the music of the lyre.

5 Wherefore should I fear in the days of evil, *when* the iniquity of my heels shall compass me about?

5 Why should I fear in times of trouble,
 when the iniquity of my persecutors surrounds me,

6 They that trust in their wealth, and boast themselves in the multitude of their riches;

6 men who trust in their wealth
 and boast of the abundance of their riches?

7 None *of them* can by any means redeem his brother, nor give to God a ransom for him:

7 Truly no man can ransom himself,
 or give to God the price of his life,

8 (For the redemption of their soul *is* precious, and it ceaseth for ever:)

8 for the ransom of his life is costly,
 and can never suffice,

9 That he should still live for ever, *and* not see corruption.

9 that he should continue to live on for ever,
 and never see the Pit.

10 For he seeth *that* wise men die, likewise the fool and the brutish

10 Yea, he shall see that even the wise die,

person perish, and leave their wealth to others.

11 Their inward thought *is, that* their houses *shall continue* for ever, *and* their dwelling places to all generations; they call *their* lands after their own names.

12 Nevertheless man *being* in honour abideth not: he is like the beasts *that* perish.

13 This their way *is* their folly: yet their posterity approve their sayings. Selah.

14 Like sheep they are laid in the grave; death shall feed on them; and the upright shall have dominion over them in the morning; and their beauty shall consume in the grave from their dwelling.

15 But God will redeem my soul from the power of the grave: for he shall receive me. Selah.

Key Verse: **God will redeem my soul from the power of the grave; for he shall receive me. (Psalm 49:15)**

the fool and the stupid alike must perish
and leave their wealth to others.

11 Their graves are their homes for ever,
their dwelling places to all generations,
though they named lands their own.

12 Man cannot abide in his pomp, he is like the beasts that perish.

13 This is the fate of those who have foolish confidence,
the end of those who are pleased with their portion.

14 Like sheep they are appointed for Sheol;
Death shall be their shepherd;
straight to the grave they descend,
and their form shall waste away;
Sheol shall be their home.

15 But God will ransom my soul from the power of Sheol,
for he will receive me.

Key Verse: **God will ransom my soul from the power of Sheol, for he will receive me. (Psalm 49:15)**

The Scripture and the Main Question—Pat McGeachy

The Riddle of Life (Psalm 49:1-4)

Psalm 49 is what folk singers call a "comeallye," that is, a ballad that begins with a request for everyone to gather around and listen (as Mark Anthony said, "Friends, Romans, countrymen, lend me your ears"). Furthermore, because it is a riddle to be sung to a stringed instrument (verse 4), I couldn't resist putting it to an old English lullaby called "The Riddle" (you may know it as "I Gave My Love a Cherry"). If you want to sing it, you can find the tune in most any good book of folk songs.

> Attention all you people,
> and give to me your ear;
> And I will sing you wisdom,
> for all the world to hear.
> I'll ask of you a riddle
> about the things you fear,
> And in my six string'd music
> the answer will be clear.

How can we be happy,
 with rich folk all around?
With power and with glory
 they everywhere abound.
But listen! In their money,
 no ransom can be found,
And like the lowly beggar,
 they'll end up in the ground.

The wise are like the foolish
 in all the human race.
They leave their wealth to others
 and vanish without trace.
The common cemetery
 will be their dwelling place,
And there is no salvation,
 save God's amazing grace.

So worship not your money,
 but share it with the poor.
And do not fear the wealthy;
 their boast is premature.
For like the beasts that perish
 their overthrow is sure.
But those who trust the Savior
 will rest in him secure.

The riddle of life with which this psalm deals is really the main question of the last lesson (Psalm 37): Is life fair? Yes it is, answers the psalmist: Death comes to us all, beasts and humans, rich and poor. The ransom of human riches cannot save us; our only hope is in the ransom of God.

You Can't Buy Happiness (49:5-9)

A life that is forfeit to another human being can perhaps be bought back. (Consider the payment of a ransom to kidnappers for the safe return of a hostage.) But you can't bribe God to give you longevity (verse 7). When your time has come (as the popular expression has it), there is no escaping death.

Strange as it may seem, most of us do not really believe that last statement. We act as though Mammon (the god of material things) were just as able to save as God. But see the warning given by Jesus in Matthew 6:19-24. False gods give the illusion that they can save, though they cannot. However, they *can* destroy! Those who "trust in their wealth" (verse 6) are eventually strangled by it. To build a moat around your house, to pull up the draw-bridge, and to place armed guards at every entrance may create the illusion that you are safe from the wicked world. But, in fact, you take that world with you into the fortress, and you will drown in the juice of your own lonely ego.

What makes us think we can live forever? (verse 9). I can only tell you that when all my bills are paid, I feel happy and secure, but when there is not enough in the bank to cover them, I get very nervous. Because money is a wonderful thing and can buy many blessings (an education, a warm home, a vacation in the tropics), we tend to think of it as an end in itself. But when it becomes an end, it becomes the root of all evil (I Timothy 6:10). It can lull us

into a false security, which can fool us right up the moment when we are buried in our Chevrolets (or whatever it is you drive).

The Certainty of Death (49:10-15)

The image of the shepherd named Death (verse 14) is a frightening one, all the more so because of its contrast with the Good Shepherd (John 10:1-29; Psalm 23). I can't even picture the dark shepherd in my mind without a vision of the Grim Reaper, empty eye sockets, grinning teeth, sharp scythe, and all. I think I owe that vision to Longfellow ("The Reaper and the Flower") and Milton ("Grim Death," *Paradise Lost*), and a thousand newspaper cartoonists who have drawn the specter for me. We don't want to face such a formidable foe!

Yet face it we must. It is the "last enemy" (I Corinthians 15:26), but we must face it. Wise or stupid (verse 10), it is a reality we must deal with. To wrap ourselves in the cloak of materialism is only to fool ourselves. There is but one hope: the ransoming power of God (verse 15).

The Hebrew Scriptures do not have much to say about resurrection. For the most part they speak of death, as does this psalm, in shadowy metaphors: the Pit (verse 9), the grave (verse 14), Sheol (verse 15). Sheol simply means "the abode of the dead." It is not *hell;* that is a New Testament word (Matthew 5:22). Generally, the Old Testament agrees with Ecclesiastes 9:10: "Whatever you hand finds to do, do it with your might; for there is no work or thought or knowledge or wisdom in Sheol, to which you are going." This promise in Psalm 49:15 probably does not refer to the resurrection. But it belongs with a number of Old Testament passages that make us celebrate with the prophets their indomitable trust in the power of God (Job 19:25-26 is the best one): In spite of the reality of death, God can make my life worth living.

In the seventeenth century George Herbert helped us change the image of death from enemy to friend, from the Grim Repeaer to the doorway into life, by reminding us of the power of Jesus:

> Death, thou wast once an uncouth hideous thing, nothing but bones
> ...
> But since our Savior's death did put some blood into thy face,
> Thou art grown fair and full of grace.
>
> <div align="right">("Death")</div>

Don't Envy the Fat Cats (49:16-20)

Since we are all doomed to die, we need not let our neighbor's riches get us down, concludes the psalmist, because "you can't take it with you." The final step the Christian must take is, of course, to trust in the power of the resurrection. But before we can take that step, we must take step one: admission of our mortality. You have only to attend a modern American funeral to recognize that we are not as honest as this ancient Hebrew folk singer, the son of Korah (look at the title). He knew nothing of astroturf, or whatever you call that artificial grass we put over the brown dirt excavated from our graves. He had never heard of recorded organ music or plastic flowers or perpetual-care cemeteries. (I suspect he did know something

about embalming; after all, his ancestors had come from Egypt; see Genesis 45:26). Basically, the psalmist is a realist.

You and I invent ways to pretend that death has never happened. We say, "Doesn't he look natural," or, "She's not really dead, she's only asleep." We rarely even use the word "death" or "dying," preferring "passed away" or more irreverent terms: "kicked the bucket," "cashed in his chips." We talk about that strange teaching of Plato, "the immortality of the soul." But the soul is not immortal (Matthew 10:28); what we trust in is another doctrine entirely, one that the author of Psalm 49 did not know: the doctrine of the resurrection. This good, glad news can help us overcome the power of Sheol through the ransoming power of God. But we can only get to it by beginning where the psalmist begins: looking death in the face and trusting no resource save that of God to give us the victory.

Helping Adults Become Involved—Ronald E. Schlosser

Preparing to Teach

Dr. McGeachy's comment in "The Scripture and the Main Question" about people who think they can remain secure by withdrawing from the world around them brings to mind Edgar Allan Poe's suspenseful short story, "The Masque of the Red Death." You may remember it. In the Middle Ages a prince and his subjects isolate themselves in a remote castle to escape the terror of the plague, or Red Death, that was decimating Europe. The prince holds a costumed ball one evening, and at midnight a masked figure in graveclothes mingles with the revelers. Outraged and frightened, the prince pursues the figure through various rooms of the castle until he confronts him in the seventh room, which is draped in black with scarlet windows. The prince is about to plunge a dagger into the trespasser when he suddenly gasps and falls dead. The other revelers seize the figure but find the graveclothes empty. It is the Red Death, and in the end all are claimed by him.

Some people today compare the AIDS epidemic with the plague of the Middle Ages. An irrational fear grips them—a fear of the unknown, a fear of death. They seek to withdraw from any contact with people exposed to the AIDS virus.

The learning goals for today's lesson will address such fears. The goals are (1) to consider the inevitability of death and the way people face it, (2) to recognize that wealth and power are not adequate means of providing ultimate security, and (3) to affirm that there is no security without God.

To give your session a different flavor, you might try several unusual activities. If there is a class member who can sing folk songs, give the person the poem written by Dr. McGeachy (a paraphrase of Psalm 49:1-4), to be sung to the tune of "The Riddle." Look up Poe's story "The Masque of the Red Death" and plan to tell it in your own words. Also check the references to the poems by Longfellow and Milton mentioned by Dr. McGeachy. If you can find a picture of the Grim Reaper—or if someone can draw it—bring it to the session. Have on hand pencils and paper for a drawing exercise. Also have hymnbooks if you want to close with a hymn.

The heart of the lesson follows this outline:

I. Considering Psalm 49
II. Examining attitudes about money
III. Exploring feelings about death
 A. Visions of death
 B. Personal feelings
 C. Sharing in twosomes
 D. Group discussion

Introducing the Main Question

Basic and helpful ideas are presented in the section "The Main Question." These ideas are essential in helping to identify the purpose of the lesson and getting your session started.

Begin by writing on the chalkboard or newsprint two questions: (1) What do you think most people fear in life? (2) What do they do to try to cope with their fears?

Pass out pencils and paper and ask the class members to jot down their answers to these questions. Allow two or three minutes for thinking and writing, then have the members share aloud their responses. For question 1, illness, death, and poverty may be high on the list; for question 2, alcohol, drugs, money, and a carefree lifestyle might be given as answers.

Developing the Lesson

I. Considering Psalm 49
Read aloud Psalm 49:1-15. Ask the class: How would the psalmist answer the above two questions? Encourage the members to express their opinions. Note the comment by Dr. Winters (in the first paragraph of his material) that power, wealth, and influence do not bring security. Only God can provide it.

II. Examining attitudes about money
Look more closely at verses 5-9 of Psalm 49. According to the psalmist, what security does money give us? Discuss with your class the place money should have in the life of a Christian. Is having money bad? Is money, or the love of it, the root of all evil? (See I Timothy 6:10.) What are the limitations of money? What can't money buy?

You might tell this story: Some years ago, a wealthy man and his wife employed numerous servants to take care of their children and manage the home while they looked after business and social matters. Then several financial reverses struck, and the family found itself bankrupt. The servants were discharged and the family moved into a small apartment. The father secured a modest job and stayed home evenings with his family. One evening his little girl climbed on his knee and, hugging him tight, said, "Daddy, don't get rich again. When you were rich you were too busy to play with us. It's so much more fun to be poor."

III. Exploring feelings about death
 A. Visions of death
Refer to verses 10-15. Point out the image of the shepherd named Death in verse 14. Note Dr. McGeachy's comments about the vision of death as the

369

Grim Reaper. You may have a picture available to show the class. Recall the vision of the four horsemen of the Apocalypse in Revelation 6:1-8. Refer to Poe's story "The Masque of the Red Death," mentioned earlier.

B. Personal feelings

Ask the members to draw their own image of death on the reverse side of the paper used earlier for answering questions. If they find it difficult to draw a picture, ask them to write down words or phrases that express their feelings about death.

C. Sharing in twosomes

Suggest that the members pair up and talk about what they have written or drawn. Also ask them, if they feel comfortable doing it, to recall their first encounter with death (perhaps the death of a pet or of a grandparent).

D. Group discussion

Call the class together for a time of total sharing. First ask how the members felt about the activity. Are people comfortable talking about death? Why or why not? Note what Dr. McGeachy says at the end of his comments concerning the way people avoid using the word "death." Then have the members share their personal feelings about death. What images come to mind? How did they cope with their first encounter with death? What did they learn?

Helping Class Members Act

Dr. McGeachy believes the promise in Psalm 49:15 probably does not refer to the resurrection. Dr. Winters leaves the question open. What do your class members think? In any event, note the conclusion that can be drawn from this and other Old Testament wisdom passages: "In spite of the reality of death, God can make my life worth living."

As Christians, what image of death can be drawn that is positive and full of hope, not negative and full of fear? Black spirituals speak of crossing Jordan. Gospel songs picture persons being safe in the arms of Jesus. Death is seen as a doorway into life, a stairway to God's presence, a winged flight to worlds unknown. Can your class suggest other images?

If someone has been asked to sing the poem by Dr. McGeachy paraphrasing Psalm 49, use the song to close the session. Otherwise, the class could read or sing together the words of a hymn such as "Sunset and Evening Star," "He the Pearly Gates Will Open," or "Sing the Wondrous Love of Jesus."

Planning for Next Sunday

Ask your class members to write down five or six familiar proverbs. They should also read next week's background scripture, Proverbs 1.

UNIT II: PROVERBS OF THE WISE

Horace R. Weaver

FIVE LESSONS **JUNE 24–JULY 22**

"Proverbs of the Wise" is devoted to a study of selections from the book of Proverbs. It is interesting to note that the word for wisdom in both Greek *(sophia)* and Hebrew *(kochma)* is feminine in gender. (This is also true for the word "spirit": *ruach* in Hebrew, *pneuma* in Greek. So activities are often feminine, as in creation and wisdom).

The five scripture selections chosen for study emphasize the importance of wisdom, exhibit key figures of speech and other literary features of wisdom literature, and reveal the origins of wisdom in God's own creative activity. These lessons also deal with ways of practicing wisdom in life.

"The Beginning of Knowledge," June 24, helps readers seek and find true wisdom. "The Priority of Wisdom," July 1, suggests that when you must choose between head and heart, choose wisdom at all costs. "The Value of Wisdom," July 8, asks, How can we find wisdom and restore our world to some sort of sanity? "Lessons from Life," July 15, lists sixteen biblical truisms, each one a valuable asset! "Proverbs in Pictures," July 22, describes the scripture selection in terms of a gallery of small pictures whose study enables one to see how to become rightly related to nature, to oneself, to one's fellow human beings, and to God.

LESSON 4 **JUNE 24**

The Beginning of Knowledge

Background Scripture: Proverbs 1

The Main Question—Pat McGeachy

Everybody is in favor of wisdom; if you asked the average person on the street, "Which do you prefer, wisdom or folly?" you would get some funny looks. Of course wisdom is better than stupidity! And yet human history is full of evidence that many of us, at one level, seem to prefer senseless behavior to wise. Witness the amount of time we human beings spend indulging in wasteful practices, bad habits, and unhealthy or dangerous activities. Every civilization, like that of our Hebrew ancestors, has collected its practical advice in the forms of maxims or proverbs.

There are African proverbs: When the elephants dance, the grass hurts. There are Pennsylvania Dutch proverbs: We grow too soon old and too late smart. There are the proverbs of Aesop: The squeaking wheel gets the grease. There are Ben Franklin's proverbs: The Lord helps those who help themselves. If you look, you can find folk wisdom in every corner of life. My mother used proverbs in helping me through the 1930s: Every tub must stand on its own bottom. If at first you don't succeed . . . but you know

them. And you have others that *your* mother taught you. But where does wisdom ultimately begin?

The Hebrew word for proverb *(mashal)* means principally "a likeness." As in other cultures, Hebrew proverbs are pithy, epigrammatic sayings that have passed into common use, often employing some form of analogy from nature. But unlike the "natural" proverbs of most civilizations, those of the Hebrews all harken back to one fundamental principle: All wisdom, instruction, prudence, knowledge, discretion, learning, and understanding (see verses 2-6) have a basic starting point. And that is the main question raised by this chapter: Where does wisdom come from?

As You Read the Scripture—Mike Winters

Proverbs 1. Chapters 1–9 contain the first of the three books that make up our Bible's book of Proverbs. Chapter 1 lays out the purpose and the theme of book 1, which consists of a series of warnings to those who would abandon the teachings of their ancestors.

Verse 1. Solomon's name is attached to Proverbs because of his reputed wisdom (I Kings 3:9; 4:29-30). The title "King of Israel" is intended for Solomon rather than David.

Verses 2-6. These verses present the reasons for teaching; more than simply transmitting information, teaching helps the individual to discern and perceive that which is not always obvious. The object of wisdom is not only to know but also, more importantly, to live the law and traditions of Jewish life. Here is advocated a "trickle-down theory" of wisdom. Simply educate the people and the outcome will be a community that reveres and lives the law.

Verse 2. Everyone is called to submit to instruction in wisdom. Wisdom and instruction go hand in hand. The Hebrew word translated as "instruction" also means "chastisement." The sense is discipline. Wisdom doesn't happen without discipline. Wisdom is knowledge of the law and a lifestyle that evidences that knowledge.

Verse 3. This verse goes hand in hand with verse 2. Wisdom is "wise dealings," "righteousness," "justice," and "equity." The Hebrew word translated as "wise dealing" means to become wise or intelligent; it means "good sense." The Hebrew word translated as "righteousness" means "straight" or "right" (Psalm 23:3). Whereas "righteousness" has the sense of right and good personal character, "justice" has the sense of right and good relationships with other people. In the Hebrew, the word translated "equity" means "upright things," "smooth," or "on the level" (see also Isaiah 26:7).

Verse 4. The Hebrew word translated as "prudence" can also mean "craftiness." The word translated as "discretion" actually means "thought-fulness," in the sense of being analytical. The simple, those eager for learning, and the young are those who could fall under the influence of wrong teaching. They need special guidance to develop prudence and discretion.

Verse 5. The Hebrew word translated as "skill" comes from a Hebrew nautical term meaning "steering." From this word comes our present day word "govern."

Verse 6. Verses 20-33 are a "figure" or allegory. Verses 25:14 and 26:7

are "riddles" or analogies. In a riddle, the meaning is hidden in the literary picture.

Verse 7. This verse is the theme of book 1. Reverence for God is lodged in the very source of knowledge and is the purpose of knowledge. "Beginning" gives the sense of both "first thing" and "theme."

The fools are the evil ones. Their plight is contrasted in verses 29-31.

Verse 8. "Father" and "mother" come from Hebrew words that also mean "ancestor." The Hebrew word for "teaching" is "torah," which is also the name given to the Jewish law.

Verse 9. The teachings of the ancestors and parents are a "wreath of favor" (garland) and pendants, like medals of commendation worn around the neck. They serve as a constant reminder to the tradition and the law.

Verses 20-21. This is an introduction to the oracle of wisdom, personified as a woman. Her method is evangelical, suggesting urgency and appealing to the widest audience possible.

Verse 22. Wisdom cries out to the naïve and the contemptuous.

Verse 23. Wisdom is bubbling over with a fermenting spirit to reproof or correct.

Selected Scripture

King James Version

Proverbs 1:1-9, 20-23

1 The proverbs of Solomon the son of David, king of Israel;

2 To know wisdom and instruction; to perceive the words of understanding;

3 To receive the instruction of wisdom, justice, and judgment, and equity;

4 To give subtilty to the simple, to the young man knowledge and discretion.

5 A wise *man* will hear, and will increase learning; and a man of understanding shall attain unto wise counsels:

6 To understand a proverb, and the interpretation; the words of the wise, and their dark sayings.

7 The fear of the Lord *is* the beginning of knowledge: *but* fools despise wisdom and instruction.

Revised Standard Version

Proverbs 1:1-9, 20-23

1 The proverbs of Solomon, son of David, king of Israel:

2 That men may know wisdom and instruction,
 understand words of insight,

3 receive instruction in wise dealing,
 righteousness, justice, and equity;

4 that prudence may be given to the simple,
 knowledge and discretion to the youth—

5 the wise man also may hear and increase in learning,
 and the man of understanding acquire skill,

6 to understand a proverb and a figure,
 the words of the wise and their riddles.

7 The fear of the Lord is the beginning of knowledge;
 fools despise wisdom and instruction.

8 My son, hear the instruction of thy father, and forsake not the law of thy mother:

9 For they *shall be* an ornament of grace unto thy head, and chains about thy neck.

...

20 Wisdom crieth without; she uttereth her voice in the streets:

21 She crieth in the chief place of concourse, in the openings of the gates: in the city she uttereth her words, *saying,*

22 How long, ye simple ones, will ye love simplicity? and the scorners delight in their scorning, and fools hate knowledge?

23 Turn you at my reproof: behold, I will pour out my spirit unto you, I will make known my words unto you.

Key Verse: **The fear of the Lord is the beginning of knowledge: but fools despise wisdom and instruction. (Proverbs 1:7)**

8 Hear, my son, your father's instruction,
 and reject not your mother's teaching;

9 for they are a fair garland for your head,
 and pendants for your neck.

...

20 Wisdom cries aloud in the street;
 in the markets she raises her voice;

21 on the top of the walls she cries out;
 at the entrance of the city gates she speaks:

22 "How long, O simple ones, will you love being simple?
 How long will scoffers delight in their scoffing
 and fools hate knowledge?

23 Give heed to my reproof;
 behold, I will pour out my thoughts to you;
 I will make my words known to you."

Key Verse: **The fear of the Lord is the beginning of knowledge; fools despise wisdom and instruction. (Proverbs 1:7)**

The Scripture and the Main Question—Pat McGeachy

The Fear of the Lord (Proverbs 1:1-7)

The book of Proverbs is a collection of Hebrew epigrams used for the instruction of the young, to help them develop a satisfying and well-balanced life. We cannot say when the individual proverbs were written, since wisdom runs deep in Hebrew history (see, for example, I Kings 4:29-34), but they were compiled in their present form in an age much like our own: the Hellenistic period after the exile. During that time, since Alexander had conquered the known world, all sorts of worldly wisdom had begun to spread in the little nation along the Jordan. The superstitions of the Babylonians and the philosophies of the Greeks were tempting the Hebrews' young people with strange ideas and ways of thinking unsettling to pious Jews. They needed to train their young with special skill against such outside influences. Do you not feel pretty much that way about our society and young people today?

The book is really an anthology of several books, with clearly marked divisions.

Chapters 1–9 are an introduction to the whole collection; chapter 1 presents the title (verse 1) and the basic theme (verse 7). Chapters 10–22:16

are proverbs attributed to Solomon. 22:17–24:34 are words of the wise men, or sages. The style of this selection is very different, and there is a parallel between these verses and some ancient Egyptian writings.

Chapters 25–29 contain more Solomonic sayings. Chapters 30–31 contain three or four further divisions: the words of Agur (chapter 30), the words of Lemuel's mother (31:1-9), and the description of an ideal wife (31:10-31). In this lesson we concentrate on the reason for the entire book and the basis on which its wisdom is established. Let us then give our main attention to the first half of verse 7, which should perhaps be written in large capital letters:

THE FEAR OF THE LORD
IS THE BEGINNING OF KNOWLEDGE

First, a reminder that this is not the only place this message is to be found. Among many references, you may want to look at Psalm 115:11; Job 28 (the whole chapter, and especially verse 28); Psalm 19:9; and Proverbs 9:10.

Second, remember that "fear" in this case is not exactly the same as the fear of lions and tigers, or the fear of failure, or phobias. It is more akin to "reverence," but that English word is not strong enough to bear the meaning. Rudolph Otto, a German theologian, felt that there is no European word to define what is meant here and coined a new one. He called such holy fear a sense of the "numinous"—a fear with something of all the above fears in it but higher and holier than any of them. It is akin to the awe that one feels in a redwood forest or on the edge of the Grand Canyon. It is the sense of being in the presence of that which is far greater than ourselves.

Furthermore, the idea of "fear of God" is found throughout the Bible, often applied to Gentiles who, though they did not follow the ritual laws of Israel, did believe in and worship the one God whom the Jews proclaimed. An example of such a use is at the beginning of Paul's sermon at Antioch (Acts 13:16): "Men of Israel, and you that fear God." This simply means "Jews and believing Gentiles." Christians are often enjoined to fear God, as in I Peter 2:17.

Finally, we should try to paraphrase the key verse in our own words. I think I would say it like this: We cannot become wise if we look merely to our own common sense. The only possible source of true wisdom is holy reverence before God, the author of all wisdom. The starting point on the journey to understanding is the realization that I am not God.

This in no way prevents us from wholesome creative use of our own God-given intelligence and imagination. We are free to do research into all the wisdom of the world, so long as we keep a stake driven in the central truth that wisdom ultimately belongs to God and that no clever design of mine can originate it.

In many shopping centers there are maps of the layout of stores and usually a red arrow pointing to a certain spot, with the words "You Are Here." What we need is a map of the shopping center for ideas, with a red arrow based on Proverbs 1:7. It says loudly and clearly: "Begin Here!" To start anywhere else is to get lost along the way.

Passing on the Wisdom (1:8-19)

It may be that the parallelism of the proverbs is based not only on the traditional style of Hebrew poetry but also on its value as a teaching device.

FOURTH QUARTER

Some scholars think that many of the proverbs were spoken antiphonally by teacher and pupil to aid in their memorization. For example:

Teacher: The fear of the Lord is the beginning of knowledge.
Pupil: Fools despise wisdom and instruction.
Teacher: A wise son makes a glad father.
Pupil: But a foolish son is a sorrow to his mother.

At any rate, it is clear that the rabbis of that era took serious the injunction of Deuteronomy 6:6-7: "These words . . . shall be upon your heart; and you shall teach them diligently to your children." Jesus must have learned many of them from his mother and father, as well as from the teachers of Nazareth and the elders in Jerusalem, for he too spoke in proverbs, as we shall clearly see in a later lesson. For example, Matthew 5:42: "Give to him who begs from you, and do not refuse him who would borrow from you."

Verses 8-19 remind us very much of the first psalm. They are a solemn warning to the young to make a clear distinction between the world of sinners and the world of the wise. They make me think of the constant nagging of my Depression-era parents: "Son, if you don't save your money you will end up in the poor house." (The same thing applied to my not doing my homework, smoking cigarettes, and many other evils.) I grew up knowing clearly what my parents thought was right and wrong. I'm not sure that my own children have had such a clear heritage because so many voices speak to the youth of today, from television, newsstands, and all corners of this global world. Do we need to write a book of proverbs for today's young, something like the McGuffey readers of a few years ago? Remember:

A little play does not harm anyone, but does much good.
After play we should be glad to work.
(from *McGuffey's Second Reader*)

My Lady Wisdom (1:20-33)

Wisdom, personified as a woman, is seen in these verses as calling to the scoffers of the world who will not choose the fear of the Lord (verse 29). She is pretty skeptical of their ever paying attention (verse 28), but she keeps on calling (verse 22) in the hopes of rescuing some from the terrible fate of fools and scoffers, at whose end she will one day laugh (verses 26-27). We will meet Lady Wisdom again in chapter 8 and, if we choose, can find her arch rival, Dame Folly, pictured in the surrounding verses (7:1-23; 9:13-18). Again, as in the case of Psalm 1, there is a clear choice to be made between good and evil, between wisdom and folly. "Whoever chooses me," says Wisdom in 1:33, "will find true security." You can almost hear the psalmist replying, in typical proverbial form, "The ungodly are not so, but are like the chaff which the wind drives away."

Helping Adults Become Involved—Ronald E. Schlosser

Preparing to Teach

With this lesson, we move to a study of the book of Proverbs. To enhance your understanding of the scripture for study each week, have in hand

several different translations of the Bible. Comparing passages in various versions will throw new light upon expressions used in the text.

Before the session begins, write on the chalkboard or newsprint the words of Proverbs 1:7, as Dr. McGeachy suggests. Write out the whole verse rather than just the first part of it. One of the activities of the session will be to have the class work on a paraphrase of the verse.

Have paper and pencils ready to distribute to the members for this activity and for the quiz you will be giving at the start of the session. As you prepare for the session, try to think of as many modern proverbs as you can. You might wish to jot them down.

Carefully read the sections "As You Read the Scripture" and "The Scripture and the Main Question." These form the heart of the lesson. The ideas, insights, and suggestions in these sections should be emphasized throughout your lesson plan.

The learning goals for the session are (1) to gain insight into the purpose and nature of the book of Proverbs, (2) to explore the meaning of wisdom as it is used in Proverbs, and (3) to recognize that reverence toward God is the doorway to true knowledge and understanding.

After introducing the main question, the lesson may be developed as follows:

 I. Delving into the background of Proverbs
 A. Author
 B. Structure
 C. Purpose
 II. Examining Proverbs 1:2-7
 A. The meaning of wisdom
 B. The meaning of fear of God
 C. Writing a paraphrase
 III. Comparing Proverbs 1:8-19 with Psalm 1
 IV. Meeting Lady Wisdom (Proverbs 1:20-33)

Introducing the Main Question

Begin the session by reading or referring to the opening paragraphs in the section "The Main Question." After sharing the various examples of proverbs given by Dr. McGeachy, indicate to your class members that you would like them to take a fun quiz. Pass out pencils and paper and ask the class to write down whether the ten proverbs you will read come from the Bible or from some other source. Read each proverb twice. The members should write "Bible" or "other" next to the number of the proverb as it is read.

1. "Pride goeth . . . before a fall" (Proverbs 16:18 KJV).
2. "Where there is no vision, the people perish" (Proverbs 29:18 KJV).
3. "Cleanliness is next to godliness" (Phineas Ben Yair).
4. "When the well is dry, we know the worth of water" (Ben Franklin).
5. "It is a wise father that knows his own child" (Shakespeare, *Merchant of Venice*).
6. "A soft answer turns away wrath" (Proverbs 15:1).
7. "A word to the wise is sufficient" (Ben Franklin).
8. "A wise son makes a glad father" (Proverbs 10:1).

9. "Words without thoughts never to heaven go" (Shakespeare, *Hamlet*).

10. "A cheerful heart is a good medicine" (Proverbs 17:22).

Following the quiz, ask your members to quote secular or Bible proverbs they know. From the examples given, draw up a definition of a proverb. (Try this for a starter: "A proverb expresses in a succinct phrase the wisdom distilled from centuries of human experience.") Share Dr. McGeachy's description in the last paragraph of "The Main Question."

Developing the Lesson

I. Delving into the background of Proverbs
 A. Author

Ask: Who wrote the book of Proverbs? The class probably will respond, "Solomon." Although Solomon is credited with three thousand proverbs (I Kings 4:32) and his name appears at the head of three of the five main divisions of the book, it is hardly possible that he wrote everything in Proverbs. See the comments of both Dr. McGeachy and Dr. Winters on this.

 B. Structure

Refer to the outline of the book given by Dr. McGeachy.

 C. Purpose

The purpose is clearly stated in verses 2-6 of the first chapter. Note Dr. Winters's comment on the relation of wisdom to discipline in verse 2.

II. Examining Proverbs 1:2-7
 A. The meaning of wisdom

Ask the class to define "wisdom." Someone has said, "Wisdom is the knowledge of right living." In the Bible, wisdom is the power or insight to judge what is right and pleasing to God, to discern what is one's moral duty and to do it. Have the class suggest synonyms. Note the words Dr. Winters uses in commenting on verses 3 and 4. Wisdom encompasses knowledge. It is knowing how to apply knowledge to life, how best to conduct oneself in God's world.

 B. The meaning of fear of God

Refer to verse 7, which can be considered the theme of the book of Proverbs. (See also similar statements in Proverbs 9:10; Psalm 111:10; Psalm 115:11; and Psalm 19:9.) What does the phrase "the fear of the Lord" mean to your class? See Dr. McGeachy's comments on the term.

 C. Writing a paraphrase

Suggest that the members take a few minutes to write a paraphrase of verse 7. Then have them read their paraphrases aloud. You may wish to share Dr. McGeachy's paraphrase also.

III. Comparing Proverbs 1:8-19 with Psalm 1

Read aloud verses 8-19. Ask the class to compare this passage with Psalm 1. Identify thoughts and phrases that convey similar ideas. Note Dr. McGeachy's comments on this. He remarks that he grew up knowing clearly what his parents thought was right and wrong. Do most children today receive the same knowledge of right and wrong from their parents? What are the voices today that compete with the moral authority of parents?

IV. Meeting Lady Wisdom (Proverbs 1:20-33)

If time allows, refer to verses 20-33. Indicate that a more detailed study of wisdom personified as a woman will be made in the lesson for July 8. Note

the emphasis again on choosing between good and evil, the theme of Psalm 1. The image pictured is that of an evangelist calling the people who pass by to repentance.

Helping Class Members Act

To summarize the lesson and give the class a feel for the structure of Proverbs, suggest that the members create their own proverbs using the formula found throughout the book of Proverbs: The wise man (son, person) . . . , but the foolish man (son, person). . . .
See, for example, Proverbs 10:1, 8, 14.
Close the session with each member reading aloud his or her proverb. At the conclusion, all might then repeat in unison the key verse (Proverbs 1:7).

Planning for Next Sunday

The scripture to read in preparation for next week's session is Proverbs 4. Ask your class members to think about the influence their parents had in teaching them values. Who or what else helped to shape their lives?

LESSON 5 JULY 1

The Priority of Wisdom

Background Scripture: Proverbs 4

The Main Question—Pat McGeachy

These days it is popular among amateur scientists to divide the activities of the brain between its two halves, as follows:

Left Brain	Right Brain
Reason	Emotion
Mathematics	Feelings
Accountants	Artists
Surgeons	Psychiatrists
Theologians	Pastors
Work	Play
Logic	Intuition

(Those wishing to pursue this theory are encouraged to look up Carl Sagan's book *The Dragons of Eden.*) Of course, every normal person has two brain hemispheres; no one is purely one or the other. But one half seems to dominate in most of us, so that we follow the careers and lifestyles appropriate to our dominant hemispheres.

Another way along the same lines to dividing people by their personalities is to distinguish between the brain and the belly:

Head	*Heart*
Cerebral	Visceral

(If you have a King James Version Bible, notice how often it uses the word "bowels," whereas the Revised Standard Version says "heart." Today we might speak of "gut feelings.")

All this is to ask a question that could be worded in many different ways: When you must choose between head and heart, or left-brain and right, which should be given priority? The book of Proverbs seems to be saying, "Choose wisdom at all costs." The heart, unless it is informed and controlled by the head, is likely to be fickle. Love is not enough; we must be governed by wisdom. It alone must have priority in our lives. Do you agree?

As You Read the Scripture—Mike Winters

Proverbs 4:1. The writer pictures himself as a father to his readers, whom he calls children. He wants his children to be disciplined (gain insight).

Verse 2. The teacher is a reliable source of instruction in wisdom.

Verse 3. He compares the education of his readers to the experience he had as a son in his parents' home. The precepts he will teach are the precepts his father and mother taught him.

"Tender" is a word that is often used in the Old Testament to describe the condition of children (Genesis 33:13 KJV).

Verses 4-9. His father taught him to get wisdom, to love wisdom, and to prize wisdom.

Verses 4-5a. Before any teaching could occur, the student had to acknowledge the teacher's proficiency. This was the teacher's requirement. It was as much the expectation to honor one's mother and father as it was to respect one's teacher.

Whereas the Hebrew writer used the word "heart," a modern writer would have used "mind." (See I Kings 10:24.) The "words" to which the student is to hold fast are the object of the lesson, namely wisdom. The commandments are the specific lessons of the teacher. Learning the lessons and incorporating them into a lifestyle results in longevity. The promise is perhaps not so much a long life as a blessed, full, and prosperous life. It is a common theme in Proverbs (3:16; 4:10).

Verse 5b. The first lesson the writer's parents taught him was "Get wisdom; get insight." The word translated from the Hebrew as "insight" can also mean "intelligence."

Verse 7. This verse follows verse 5 more smoothly than verse 6. The writer is no longer recollecting an education experience in his home. Instead, he is now teaching his first lesson to his readers. That lesson is "Get wisdom, . . . get insight." He says, "No matter what the cost, even if it costs you everything, get insight."

Verses 6, 8-9. Wisdom and insight are personified as a woman. Only four things are required to have a relationship with her. The first is "Do not forsake her." Fidelity is the foundation of any relationship. The second is "Love her." This is the kind of love spouses have for each other. Love and adoration are the building blocks of any relationship. The third is "Prize her highly." Honor and respect are like a roof that protects a relationship from

external onslaughts. The fourth is "Embrace her." Affection is like a security lock on a door.

Verse 6. "She will keep you," or wisdom will *preserve* you. "She will guard you," or wisdom will *watch* you.

Verse 8. "She will exalt you." The Hebrew word translated as "exalt" in the King James Version means "cast up a highway." As you can see, this would be a difficult phrase to understand, except for the phrase that follows: "She will honor you," or wisdom will *promote* you.

Verse 9. The image here is that of a coronation (see verse 1:9).

Verse 10. The writer pleads to the readers (see verse 4 about the promise of long life).

Verses 11-12. The wise will not be hampered or stumble in the pursuit of righteousness, wisdom's object. The word translated "hampered" means "distressed." Its root is "to be narrow." The narrow way leads to adversity.

Verse 13. "Instruction" here is the same word as "insight" in verse 1. It means discipline.

Selected Scripture

King James Version

Proverbs 4:1-13

1 Hear, ye children, the instruction of a father, and attend to know understanding.

2 For I give you good doctrine, forsake ye not my law.

3 For I was my father's son, tender and only *beloved* in the sight of my mother.

4 He taught me also, and said unto me, Let thine heart retain my words: keep my commandments, and live.

5 Get wisdom, get understanding: forget *it* not; neither decline from the words of my mouth.

6 Forsake her not, and she shall preserve thee: love her, and she shall keep thee.

7 Wisdom *is* the principal thing; *therefore* get wisdom: and with all thy getting get understanding.

8 Exalt her, and she shall promote thee: she shall bring thee to honour, when thou dost embrace her.

Revised Standard Version

Proverbs 4:1-13

1 Hear, O sons, a father's instruction.
 and be attentive, that you may gain insight;

2 for I give you good precepts;
 do not forsake my teaching.

3 When I was a son with my father,
 tender, the only one in the sight of my mother,

4 he taught me, and said to me,
 "Let your heart hold fast my words;
 keep my commandments, and live;

5 do not forget, and do not turn away from the words of my mouth.
 Get wisdom; get insight.

6 Do not forsake her, and she will keep you;
 love her, and she will guard you.

7 The beginning of wisdom is this: Get wisdom.
 and whatever you get, get insight.

8 Prize her highly, and she will exalt you;
 she will honor you if you embrace her.

9 She shall give to thine head an ornament of grace; a crown of glory shall she deliver to thee.

9 She will place on your head a
 fair garland;
 she will bestow on you a
 beautiful crown."

10 Hear, O my son, and receive my sayings; and the years of thy life shall be many.

10 Hear, my son, and accept my
 words,
 that the years of your life may
 be many.

11 I have taught thee in the way of wisdom; I have led thee in right paths.

11 I have taught you the way of
 wisdom;
 I have led you in the paths of
 uprightness.

12 When thou goest, thy steps shall not be straitened; and when thou runnest, thou shalt not stumble.

12 When you walk, your step will
 not be hampered;
 and if you run, you will not
 stumble.

13 Take fast hold of instruction; let *her* not go: keep her; for she *is* thy life.

13 Keep hold of instruction, do not
 let go;
 guard her, for she is your life.

Key Verse. Wisdom is the principal thing; therefore get wisdom: and with all thy getting get understanding. (Proverbs 4:7)

Key Verse: The beginning of wisdom is this: Get wisdom, and whatever you get, get insight. (Proverbs 4:7)

The Scripture and the Main Question—Pat McGeachy

The Great Prize (Proverbs 4:1-9)

"Whatever you get," says the writer of Proverbs 4, "get insight" (verse 7). This advice goes deep into the writer's early consciousness. In verse 3 he describes himself as a firstborn son (at this stage, he seems to have no siblings with which to be in rivalry). Here, like most eldest children, he benefits from the undivided attention of both his parents. Those of us who have grown up under such conditions know that it can be both a blessing and a bane to have *all* of your parents' attention. They worry more about you than they will over your younger siblings. (Look at how many photographs they took of you as compared with the later children!) As a result, they are not as relaxed around you, and you don't have nearly as much free time as the other kids will get when your parents discover that if kids are left alone they will grow up anyway. But, on the good side, they give you lots of advice, and that is what our writer remembers.

Can't you just hear a modern-day version of our writer saying to his friends, "Now, my daddy always used to say . . . " and then coming up with a well-worn aphorism. In my own case, it was my mother who laid the proverbs on me; my father was a pastor and rarely had much time for his own household. But the principle is the same. When I shut my eyes, I can hear her talking in proverbs:

"If you want to have friends, you've got to *be* a friend."

"A good name is to be chosen rather than great riches." (She didn't make this one up; can you find it?)

When you shut *your* eyes, what do you hear your father or mother saying? What's the basic principle of life that they tried to leave you?

There are so many things we learn from our parents, many of which they teach us without our knowing it. For example, if your parents seem to be excessively stingy or are fond of putting on an expensive display of things like clothes and cars, you can get the idea that money is mighty important. I grew up during the Depression, and both my parents worried a lot about money, so I do too. But our writer is telling us that money is not the most important thing there is. Compare his attitude to that of the writer of Psalm 19, who says of the laws of God, "More to be desired are they than gold, even much fine gold; sweeter also than honey, and the drippings of the honeycomb" (verse 10). Look back at Proverbs 3:13-16. There we are told that wisdom is better than cash, but we are also told that if we are wise, we'll get the cash too, eventually! This makes me think of Jesus, who, concluding his warning against being anxious about material things, said, "Seek first [God's] kingdom and righteousness, and all these things shall be yours as well" (Matthew 6:33).

A search through the Proverbs will quickly lead us to a long list of false trails to happiness, which we should guard against at all costs. Like foolish children, we may think that the best thing in life would be to have nothing to do, but look at Proverbs 6:6. We may be tempted to misuse our sexual gifts in search of pleasure, but see 6:32. Sometimes, in our ignorance, we think that real power lies in guns and glory and that the ideal hero is Rambo, but see 3:31. Perhaps the most dangerous idol of all is pride in self. We think happiness will be found in seeking our own will, but look at Proverbs 3:5-6. (That is what *my* father wrote in the front of my Bible when I went off to college, and when I have remembered to live by it, I have been a happy man.)

The other temptresses—pleasure, power, and pride—may look beautiful, but do not forsake Lady Wisdom. "Love her, and she will guard you" (4:6).

The Ignorance of the Wicked (4:10-19)

In our folly, we sometimes think that villains are more interesting than heroes, but in fact they are all alike, from Genghis Khan to Hitler. Think of the heroes of history: artists, explorers, astronomers, philosophers, evangelists, missionaries, architects, poets, teachers. "The path of the righteous is like the light of dawn"; a steady keeping of the rules of wisdom will cause things to "shine brighter and brighter until full day" (verse 18). But the villains of the piece (verses 14-17), trying to find a shortcut on the road to glory, bury themselves deeper in their own darkness.

Those "wicked" folk remind me of the steam engine in the old parable. You remember how he wished that he didn't have to run on the tracks (wisdom) because they only ran monotonously in place. "If only I could get off the tracks," he would think, "I could go anywhere I wanted to." So, of course, one day he jumped the track and was almost immediately mired down in a cornfield (folly) and couldn't go anywhere. The truth is, there are a lot of switches, and those tracks go to all sorts of interesting places, concerning which Paul wrote, "no eye has seen, nor ear heard, nor the heart of men conceived, what God has prepared for those who love him" (I Corinthians 2:9). No, the way is the Way, and it leads to wonderful surprises.

FOURTH QUARTER

Keep on Keeping on (4:20-27)

"No one," said Jesus, "who puts his hand to the plow and looks back is fit for the kingdom of God" (Luke 9:62). Or, as a lesser philosopher (Satchel Paige) put it, "Don't look back; somebody may be gaining on you." The way of wisdom is not always easy. Like the road that leads to life, it is "straight and narrow." The temptation for all of us is to drift off to one side or the other; to go after the quick fix, the shortcut, the magic solution. It leads us to everything from astrology to Jonestown. In such times, the pursuit of wisdom is the more essential. When crooked speech and devious talk (verse 24) would tempt you to turn aside, remember that it is the faithful step, however plodding, that ultimately leads to the dawn. The way is the Way, whatever dark valley it may lead through. It is then above all that I need to remember that God's word is "a lamp to my feet, and a light to my path" (Psalm 119:105). We need to pray Cardinal Newman's prayer:

> Lead, kindly light, amid th'encircling gloom; Lead thou me on!
> The night is dark, and I am far from home; lead thou me on!
> Keep thou my feet; I do not ask to see
> The distant scene; one step enough for me.
>
> ("Lead, Kindly Light")

At this point, being on the edge of discouragement, we will do well to think not so much in terms of law but of grace. It is not by sheer willpower that we "keep on keeping on." It is the Good Shepherd who walks through the dark vale with us, touching us with the comforting rod and staff. It is the unsleeping Keeper of Israel who watches over our goings and comings (Psalm 121) and who will not let our feet be moved.

The hard part is really believing that wisdom works. Folly *looks* so prosperous, on the surface. Does not happiness go with the beautiful people? Doesn't it make sense, the world being like it is, for me to look out for Number One? If I don't, who's going to? But no matter how loud such worldly voices call to us, let us remember the quiet words of our Lord, reminding us that it is the poor in spirit, the meek, and those who long for righteousness who will be satisfied. Those who go after folly are doomed to die (Proverbs 7:27), but they that wait upon the Lord will find healing (4:22).

Helping Adults Become Involved—Ronald E. Schlosser

Preparing to Teach

What influence did your parents have in teaching you values? Dr. McGeachy speaks about the proverbs his mother laid on him and of the habit of worrying about money that he got from his parents while he was growing up during the Depression. During the session you will be asking your class members to reflect on the influences that shaped their lives, so take a moment to consider such influences in your own life. What good things did you learn from your parents?

Carefully read the sections "As You Read the Scripture" and "The Scripture and the Main Question." These form the heart of the lesson. The ideas, insights, and suggestions in these sections should be employed throughout your lesson plan.

The learning goals for the session are threefold: (1) to recognize wisdom as one's primary quest in life, (2) to consider the influences in life that may shape one's priorities, and (3) to determine what place teaching moral values should have in one's home.

After introducing the main question, the lesson can be outlined as follows:

 I. Considering influences in our lives
 A. The influence of parents
 B. Other influences
 II. Examining the nature of wisdom
 A. Wisdom personified
 B. The promise of wisdom
 C. The way of wisdom
 III. Exploring implications for teaching moral values

Plan to have hymnbooks available containing the hymn "Lead, Kindly Light."

Introducing the Main Question

Basic and helpful ideas are presented in the section "The Main Question." These ideas are essential in helping to identify the purpose of the lesson. Begin by referring to the dichotomy between the two hemispheres of the brain, mentioned by Dr. McGeachy in this section. Then pose the question as he does: "When you must choose between head and heart, or left-brain and right, which should be given priority?"

Discuss the question with the class for a brief time, encouraging all the members to share their opinions. Then indicate what the book of Proverbs says: "Choose wisdom at all costs." Note Dr. McGeachy's comment: "Love is not enough; we must be governed by wisdom." Does your class agree? Why or why not?

Developing the Lesson

I. Considering influences in our lives
 A. The influence of parents
Read aloud Proverbs 4:1-9. Note in verse 3 that the writer was, at the time, the only child of his parents. Refer to Dr. McGeachy's comments about the advantages of being the firstborn or an only child. Studies have shown that more firstborn or only children become doctors and lawyers than do other siblings. Have your class members discuss the influence parents have on their children and whether there are any differences in raising several children in a family. Encourage the members to speak from their own experiences both as children and as they raised their own children. What values or life principles did they learn from their parents? What do they hope to teach their children?
 B. Other influences
Next ask: What are some other influences that shape one's life as one is growing up? Dr. McGeachy lists a number of things he calls "false trails to happiness."

1. *Possessions:* For some, the pursuit of financial wealth becomes a lifelong obsession. Yet the Bible tells us that money should not be as important as knowing and following God's laws. See Psalm 19:10; Proverbs 3:13-16; Proverbs 4:7; Proverbs 8:10-11 (to be studied next week); Matthew 6:33.

2. *Pleasure:* The writer of Proverbs 7 warns against sexual temptations. See also Proverbs 6:23-32. Idleness is also condemned (Proverbs 6:6-11).

3. *Power:* Lord Acton's observation that "power tends to corrupt, and absolute power corrupts absolutely" is a proverb for our time. Whether it is the power of political influence or the power of violence, the Bible warns against making power life's guiding principle. (See Proverbs 3:31; Proverbs 6:16-19; Matthew 26:52.)

4. *Prestige:* From the earliest chapters of Genesis, in the stories of Cain and Abel and of the tower of Babel, self-centeredness and pride have been condemned. The only rightful honor one should seek is the honor bestowed by wisdom (Proverbs 4:7-9).

II. Examining the nature of wisdom
A. Wisdom personified
Throughout Proverbs, wisdom is personified as a woman ("Lady Wisdom" in the words of Dr. McGeachy). In last week's lesson she was pictured as an evangelist crying aloud in the streets (Proverbs 1:20-23). In next week's lesson she will be seen again in this role (Proverbs 8:1-4) and also as a helper and support for the Creator (Proverbs 8:30-31). In Proverbs 9:1-6 she is seen as a hostess inviting persons to feast with her. In today's passage (Proverbs 4:6-9) wisdom is pictured as a bride (or life's companion) to be loved and adored. Refer to Dr. Winters's comments on these verses. As in any marital relationship, there should be faithfulness (fidelity), love, respect, and affection.

B. The promise of wisdom
When one has wisdom, one has life (Proverbs 4:10, 13). Ask your class if "many years" is a promise to be taken literally (verse 10). Could long life refer to the *quality* of life as well as to *length* of life? Wisdom allows one to live life to the fullest (abundantly) regardless of length of days.

C. The way of wisdom
If time allows, consider the rest of Proverbs 4. Dr. McGeachy's comments on verses 14-27 are helpful. Note the imagery of the right and wrong paths and the observation that the way of wisdom is not always easy. What are the roadblocks and obstacles that hinder one's walk along the pathway of wisdom? What are the shortcuts people try to take?

III. Exploring implications for teaching moral values
In light of the importance of acquiring wisdom for a full and fruitful life, discuss with the class how best to teach moral values to children. Certainly they should be taught in the home and in the church. Should they also be taught in school? Is it the role of public school to help students gain the kind of wisdom the Bible speaks of as enabling the good life? Or should school merely teach information and knowledge about how to survive and make a living? What should be the place of values-instruction in school?

Helping Class Members Act

Refer to Dr. McGeachy's reference to God's word being symbolized by light (Psalm 119:105). Proverbs 6:23 says the same thing. Isaiah 9:2-3

anticipates the coming of the Messiah, the Light that will lead all persons to God (John 1:4-5; 8:12). Close the session by making the tie-in to today's theme—how seeking the will of God through the illumination given by Christ, the light of the world, helps one to live the abundant life.

Ask the class to read together (or sing) the words to the hymn "Lead, Kindly Light," then close in prayer.

Planning for Next Sunday

The background scripture for next week is Proverbs 8. Verses 22-31 speak of wisdom being present with God at creation. Using these verses and Psalm 104, ask the class members to try to draw a picture of the world as people in Bible times thought of it.

LESSON 6 JULY 8

The Value of Wisdom

Background Scripture: Proverbs 8

The Main Question—Pat McGeachy

Does the world make sense? Psychiatrist R. D. Laing once described a scene in which a physician was examining a catatonic patient in the presence of a group of medical students. The doctor made faces at the patient, punched and poked him, and finally stuck a pin in the patient's forehead. He then turned to his audience and said, "You see, this patient has become so withdrawn that he does not react at all to stimuli from the real world." The question Dr. Laing raised about this scene was simply, Who is really crazy? The withdrawn patient, or the man who makes silly faces and sticks pins into people's heads? Maybe the schizophrenics of the world know more than we do.

Now, it is the conviction of the writers of Proverbs that the world *does* make sense and that it is up to us to discover its meaning. Moreover, it is the conviction of the writer of the first nine chapters, and particularly chapter 8, that *sense lies at the heart of all things*. Wisdom (*sophia* in the Greek, *kochma* in the Hebrew), speaking in first person (verse 22), declares that she was with God in the very beginning, the first act of creation. The passage makes us think of another description of the creation—the opening verses of the Gospel according to John: "In the beginning was the Word, and the Word was with God, and the Word was God. He was in the beginning with God; all things were made through him" (1:1-3). It is the affirmation of both the Old and the New Testaments that life makes sense, that a rational principle has run through the created universe from the beginning.

If that is so, then why does the world sometimes seem so crazy? In a rational universe, why do we have painful wars, tragic accidents, and birth

defects? Why are our city streets populated with mental patients? If we affirm that the world is ultimately rational, then the reason for these things must lie elsewhere. How can we find it and restore our world to some sort of sanity?

As You Read the Scripture—Mike Winters

Proverbs 8. Wisdom is personified as a woman (verse 1). Her message begins at verse 4 (compare 1:21). Truth, righteousness, and justice, the objects of wisdom, are more valuable than wealth (verses 7-21). Wisdom was the first thing created (verses 22-31). Wisdom is its own blessing (verses 32-36).

Verses 22-31. Wisdom was created first in order to contribute to and preside over the rest of creation, especially humanity.

Verse 22. In John 1:1-3 and Colossians 1:15-16, Jesus (the Word) is first at creation with God. Unlike wisdom, however, Jesus was not created. The word translated as "created" in the Revised Standard Version was translated as "possessed" in the King James Version. See Proverbs 3:19-20.

Verse 23. The Hebrew word translated "set up" means "poured out" or "anointed." Wisdom was poured out upon the earth like the Spirit on the day of Pentecost (Acts 2). This pouring out was the first activity of Wisdom.

Verse 24. See Genesis 1:2. Wisdom even preexisted the primeval waters.

Verses 25-29. The writer of Proverbs had a primitive view of the earth as flat and covered with a dome supported by mountainous pillars. In this primitive view there were two dimensions: the horizontal (land and water) and the vertical (the heavens and the earth). Wisdom was present at creation.

Verse 25. The mountains were sunk to their foundations.

Verse 26. Wisdom attended the creation of the earth, of its fields, and of the clay (dust) that formed the first human life (Genesis 2:7).

Verses 27-28. The dome of heaven, with its holes for the sun and moon and stars, was set in place, defining the circle of "horizon" (Genesis 1:6-8; Job 26:10-11).

Verse 29. In this mythological understanding of the created order, the boundaries of the coastlands were rigid and unchanging. They were established by the decree that came from the mouth of God. Such is the sense, in the Hebrew, of "when he assigned to the sea its limit [or "decree"] so that the waters might not transgress his command [or "mouth"]." They were "marked out" or engraved.

Verses 30-31. Day by day, like a little child, Wisdom was God's delight. Wisdom made sport (laughed) during God's creation activities, like a little child who won't allow a busy parent to ignore it. Wisdom played in God's new creation, which was fruitful ("inhabited") or, in the King James Version, "habitable"). And of all of God's creation, because of its reasoning abilities the human being was Wisdom's favorite playmate.

Verses 32-36. In these verses are the blessings of Wisdom.

Verse 32. Wisdom now speaks as one who created, referring to its hearers as the fruit of her womb. Happy or blessed are those who walk along Wisdom's familiar path.

Verse 33. The Hebrew word translated as "instruction" means "discipline." The word for neglect means "to make free." The verse may read, "Do not allow discipline to escape."

Verse 34. Happy are they who listen, who watch (are awake), who wait (observe attentively) at Wisdom's door like sports fans lining up before dawn to buy tickets to a championship game.

Verses 35-36. These verses contrast life and death.

Selected Scripture

King James Version

Proverbs 8:22-36

22 The Lord possessed me in the beginning of his way, before his works of old.

23 I was set up from everlasting, from the beginning, or ever the earth was.

24 When *there were* no depths, I was brought forth; when *there were* no fountains abounding with water.

25 Before the mountains were settled, before the hills was I brought forth:

26 While as yet he had not made the earth, nor the fields, nor the highest part of the dust of the world.

27 When he prepared the heavens, I *was* there: when he set a compass upon the face of the depth:

28 When he established the clouds above: when he strengthened the fountains of the deep:

29 When he gave to the sea his decree, that the waters should not pass his commandment: when he appointed the foundations of the earth:

30 Then I was by him, *as* one brought up *with him:* and I was daily *his* delight, rejoicing always before him;

31 Rejoicing in the habitable part of his earth; and my delights *were* with the sons of men.

32 Now therefore hearken unto me, O ye children: for blessed *are they that* keep my ways.

Revised Standard Version

Proverbs 8:22-36

22 The Lord created me at the beginning of his work,
the first of his acts of old.

23 Ages ago I was set up,
at the first, before the beginning of the earth.

24 When there were no depths I was brought forth,
when there were no springs abounding with water.

25 Before the mountains had been shaped,
before the hills, I was brought forth;

26 before he had made the earth with its fields,
or the first of the dust of the world.

27 When he established the heavens, I was there,
when he drew a circle on the face of the deep,

28 when he made firm the skies above,
when he established the fountains of the deep,

29 when he assigned to the sea its limit,
so that the waters might not transgress his command,
when he marked out the foundations of the earth,

30 then I was beside him, like a master workman,
and I was daily his delight,
rejoicing before him always,

31 rejoicing in his inhabited world
and delighting in the sons of men.

32 And now, my sons, listen to me:
happy are those who keep my ways.

33 Hear instruction, and be wise, and refuse it not.

34 Blessed *is* the man that heareth me, watching daily at my gates, waiting at the posts of my doors.

35 For whoso findeth me findeth life, and shall obtain favour of the Lord.

36 But he that sinneth against me wrongeth his own soul: all they that hate me love death.

Key Verse: **Hear instruction, and be wise, and refuse it not. (Proverbs 8:33)**

33 Hear instruction and be wise, and do not neglect it.

34 Happy is the man who listens to me, watching daily at my gates, waiting beside my doors.

35 For he who finds me finds life and obtains favor from the Lord;

36 but he who misses me injures himself; all who hate me love death.

Key Verse: **Hear instruction and be wise, and do not neglect it. (Proverbs 8:33)**

The Scripture and the Main Question—Pat McGeachy

The first nine chapters of the book of Proverbs are clearly an introduction to the whole and were perhaps written at the time the book was compiled (the Hellenistic era, about three hundred years before Christ). The principal theme of this introduction, as we have seen, is to call people to fear (worship) God, which is the beginning of wisdom, and, moreover, to identify wisdom as the guiding spirit who is with God at the heart of all reality.

We ought to spell wisdom with a capital *W*, as we do "Word" in John 1, for she is clearly *personified,* that is, "named as a person" by Proverbs. Moreover, wisdom is personified as feminine. I wonder why?

The answer to the question of why wisdom is feminine may have to do with the Greek influence (remember that Alexander had conquered the known world shortly before Proverbs was collected in its present form). The Greeks and the Romans both had a goddess of wisdom: Athena (Minerva), who "sprang from the head of Zeus." The addition of a feminine principle in the largely male-chauvinist culture of ancient Israel would have been welcome. The Old Testament had long known that God contained the feminine principle; note that in Genesis 1:27 we are assured that both male and female are in God's image. And consider what Isaiah said about God's distaff side: "As one whom his mother comforts, so I will comfort you" (66:13). But in that male-dominated world, such thoughts did not come to the surface very often. Could it be that the Spirit that brooded upon the waters in Genesis 1:2 represents the pondering heart of God the mother (cf. Luke 2:19)? Note also that the Hebrew word for "spirit" is *ruach*—a feminine-gender noun.

Of course, we need to point out that folly, the opposite of wisdom, is also personified in Proverbs as female. See especially 7:6-27 and 9:13-18, the sections that surround our chapter for this lesson. Perhaps it is worth noting also that Genesis 3 depicts the *woman* as the principal agent in the Fall. It was she who ate the forbidden fruit and seduced her husband into doing the same. But by the time you get to the New Testament, Eve has been forgotten, and it is Adam who sinned (I Corinthians 15:21, etc.; but maybe not—see also I Timothy 2:14). At any rate, in Proverbs Dame Folly and Lady Wisdom, the wicked woman and the heroine, represent the two

conflicting forces in the human struggle, between which, from the standpoint of Proverbs, the choice is clear.

The Clear Call of Wisdom (Proverbs 8:1-21)

Wisdom climbs to a vantage point where all can see her (verses 1-3) to deliver her message. In other words, the superiority of wisdom over folly ought to be obvious to the world (cf. Romans 1:19-20). From her position (where the men of the city are accustomed to speak), she asserts her own authority: "I am here to teach the simpleminded and foolish, who have not been listening [verses 4-6]. You have become accustomed to hearing double-talk, but I, Wisdom, will speak only straight things [verses 7-9].

"The thing that tempts you most in this world is greed for profit, but I am worth more than money [verses 10-11]. If you really worship God you will be wise enough to hate evil and to overcome your tendency to pride and self-worship [verses 12-13]. There is no genuine statecraft, no proper preaching, and certainly no advice giving apart from wisdom [verses 14-16]. In the long run, if you seek wisdom there will be a payoff for you in terms of riches and honor. If you seek those things first, they will destroy you, but if you seek me first, all these other things will be yours as well [verses 17-21; cf. Matthew 6:33]."

Wisdom the Architect (8:22-31)

There are many creation stories in the Bible. In addition to Genesis 1, there is, of course, Genesis 2-3. But there are others like this section of Proverbs 8—Job 38:4 and following and John 1:1-5, for example. This creation story depicts wisdom almost as a living person; at some stages in church history she has been identified with Jesus, the second person of the Trinity. Part of the reason for this is that the words "master workman" in verse 30 are not too clear. The Hebrew might be translated "little child" or "nursling." But in light of the rest of the passage, it seems clear that a kind of engineering process is going on and that Wisdom must be an architect. In its simplest form, this section means that there is a principle of order and reason in God's creation.

Albert Einstein, disturbed by discoveries in modern physics that seem to indicate a basic uncertainty at the heart of reality, is reputed to have rejected such theories, saying, "God doesn't play dice with the universe." I think he meant by that that you can expect to find that reality ultimately makes sense. Subatomic particles may *appear* to operate at random, but when we know all the rules we will see that they too are following the wise instruction of their Creator. You can trust the heart of reality to be dependable. Listen to Wisdom:

I am a part of creation (verse 22).
I am older than the earth (verse 23).
It was I who provided you with water (without which there would be no life on earth; verse 24).
The mountains and the fields are there for a purpose (verses 25-26).
The great circle of the sky is filled with meaning (verses 27-28).
The vast ocean is under my control, and the earth stands secure (verse 29).
God and I together planned the world, and rejoice in the human race (verses 30-31).

The earth may have been without form and void in the very beginning (Genesis 1:2), but it makes sense now. When you and I read these verses, we recognize ideas that come from the day when people did not have a very sophisticated view of the solar system. They still talked about the "waters under the earth" (springs) and the "foundations of the earth," as though it stood on the back of a sacred elephant, as the ancient Hindus taught. But the message is clear to us today, even though couched in terms of a three-storied universe: At the heart of all things stands Wisdom; therefore it behooves us to trust God and seek to be wise ourselves.

Conclusion (8:32-36)

The bottom line for us is that we must listen to Wisdom's speech in the gate and follow her ways. To choose folly is to choose death (verse 36). The world may not *appear* rational some of the time. If it always did, there would have been no reason to write Proverbs. Religious faith is the affirmation in the face of a seemingly irrational world that God reigns and truth will prevail. The secret of happiness (verse 34), as we found in Psalm 1 and in the Beatitudes, is not in one's own self-affirmation but in the affirmation that God alone is truth. The me-generation may be crazy, but the Thou-generation, that is, those who glorify God and love their neighbors, will remain rational through it all, until at last the Spirit makes it plain (John 14:26).

Helping Adults Become Involved—Ronald E. Schlosser

Preparing to Teach

Last week, as an assignment for today's lesson, you asked your class to draw a picture of the world as people in Bible times thought of it, using Proverbs 8:22-31 and Psalm 104 as guides. In his lesson comments, Dr. McGeachy speaks of the three-storied universe that the ancient people imagined. It might look something like this:

Note the two-layer firmament or dome over the earth. The upper layer contained a storage area for rain and snow. The sun and moon traveled across the top of the firmament from horizon to horizon. Under the surface of the earth was another water supply that fed the rivers and lakes. Everything emptied into the ocean, which was connected to the underground water storage area. You might copy this drawing on newsprint to show to your class.

If you have a Bible containing the Old Testament Apocrypha, read chapters 7–10 of the Wisdom of Solomon. Here is a rather detailed picture of wisdom personified as Solomon's life companion and as the creative and guiding force of the early history of the Hebrew people. These images have parallels in the book of Proverbs.

The learning goals for this session are (1) to see the relation of wisdom to the creative activity of God, (2) to sense how wisdom brings delight to those who value it, and (3) to develop a personal appreciation for wisdom through fresh words and images.

Carefully read the sections "As You Read the Scripture" and "The Scripture and the Main Question." These form the heart of the lesson. The ideas, insights, and suggestions in these sections should be employed throughout your lesson plan.

After introducing the main question, the lesson can be outlined as follows:

I. Finding answers in Proverbs 8
 A. Words and images
 B. Insights and ideas
II. Reporting on findings
 A. Proverbs 8:1-11
 B. Proverbs 8:12-21
 C. Proverbs 8:22-31

The concluding activity will involve the class in composing a five-line poem known as a cinquain (sin-kane). On newsprint make a copy of the cinquain format described in the section "Helping Class Members Act." Also have on hand a supply of pencils and paper.

Introducing the Main Question

Basic and helpful ideas are presented in the section "The Main Question." These ideas are essential in helping to identify the purpose of the lesson and getting your session started.

Begin by referring to Albert Einstein's famous quotation: "God doesn't play dice with the universe." Ask your class members what they think Einstein meant by this. After a number have shared their opinions, note what Dr. McGeachy says. Does your class agree that a rational principle runs through the universe? If so, how can we explain wars, accidents, illness, and the other tragedies that afflict our life here on earth?

Developing the Lesson

I. Finding answers in Proverbs 8
 A. Words and images
Divide the class into three sections. Ask one section to read Proverbs 8:1-11, another Proverbs 8:12-21, and the third Proverbs 8:22-31. Ask the

class members in each section to silently think through the following questions as they consider their assigned passage: (1) What picture of wisdom does your passage paint? What is striking about the imagery? (2) How can the message or essence of the passage be stated in a summary sentence or two? (3) What modern image could be used to visualize the nature and importance of wisdom for today?

B. Insights and ideas

Allow the members to work individually on the questions for about five minutes. Be sure everyone has pencil and paper for recording his or her thoughts. Then ask each section to gather together for sharing insights and ideas.

II. Reporting on findings

After the sections have had time for discussion, call the whole class together to report on members' findings.

A. Proverbs 8:1-11

Someone might point out the similarity of this passage to Proverbs 1:20-23, studied two weeks ago. Wisdom, pictured as a woman, is visualized as an evangelist crying out in the streets. Discuss the personification of wisdom as feminine. Note Dr. McGeachy's comments on this. Refer to Solomon's love of wisdom as a bride and his life's companion as discussed in chapters 7 and 8 of the Old Testament apocryphal book, the Wisdom of Solomon. The passage might be summarized with the words of Proverbs 8:11. A modern image might be that of a teacher. Some might also liken wisdom to a perfectly functioning computer. When a computer is properly programmed, it is a joy to work with. But such a high-tech piece of equipment is impersonal and lacks the "personality" of Old Testament images.

B. Proverbs 8:12-21

Wisdom is pictured as a guide and counselor for kings. In our day the image might be of one who counsels presidents and heads of state. Chapters 8 and 10 of the Wisdom of Solomon show how wisdom guided the history of the Hebrew people from the time of Adam. Dr. McGeachy's comments on verses 17-21 of Proverbs 8 serve as summary of the whole passage.

C. Proverbs 8:22-31

Wisdom here is pictured as an architect or master worker assisting God with creation. See the comments on this passage by Dr. McGeachy and Dr. Winters. You might refer to the drawing of the world as it was understood by the ancient Hebrews. This passage says that wisdom is both behind and an integral part of creation. The passage is an affirmation of Albert Einstein's observation that "God doesn't play dice with the universe." A similar idea is presented in the book of Sirach (1:1-20) in the Old Testament Apocrypha. In our modern day, wisdom might be likened to the technical ingenuity that is putting humans into space. Yet even this expertise has its limitations and failures. Despite our space-age mentality, it is important to recognize that it is not science but Jesus Christ who holds all things together (Colossians 1:17).

Helping Class Members Act

Proverbs 8:32-36 provides a summation or moral, or, in the words of Dr. McGeachy, the "bottom line" of the passage. Close the session by asking

your class to try to write a cinquain describing wisdom. A cinquain follows a specific format to provide an insightful look at a particular subject. Display the newsprint you prepared containing the following outline:

> First line: one word, giving subject.
> Second line: two words, describing subject.
> Third line: three words, expressing an action.
> Fourth line: four words, expressing a feeling.
> Fifth line: one word, a synonym for the subject.

Write the word "wisdom" as the one-word first line. Then ask the class members to work together to complete the remaining lines of the cinquain. Here is a sample to guide you:

> Wisdom
> spiritual insight
> following God's guidance
> sensing meaning in life
> discernment

Close with prayer, asking for God's wisdom to lead us throughout our lifetimes.

Planning for Next Sunday

In addition to reading Proverbs 22:1-16, ask the class members how they might state their philosophy of life in one sentence.

Lessons from Life

Background Scripture: Proverbs 22:1-16

The Main Question—Pat McGeachy

Nearly everybody I know has a quote or two that they use more than any other. You might stop for a few minutes and ask yourself what epigrams, proverbs, or one-liners stand out in your mind. For me there are two, and both of them are from Jesus:

> In the world you have tribulation; but be of good cheer, I have overcome the world. (John 16:33)

> Blessed are those who hunger and thirst for righteousness, for they shall be satisfied. (Matthew 5:6)

I suspect that you have some rules that you go by, too. How about these?

> Honesty is the best policy.
>
> The majority rules.
>
> To thine own self be true.

There could be a million others, but that will give you some idea of what I mean. Take a slip of paper and write down what *your* basic one-liners are.

Of course, you can escape this question with a broad statement such as "I believe the whole Bible." Well, sure, but unless you are a really remarkable genius you can't quote the whole Bible. I certainly can't. What basic convictions would you write down, if asked at the last to summarize your faith? Jesus is Lord? Never put off till tomorrow what you can do today?

This brief section of Proverbs contains as many good, basic rules for living as any sixteen sentences I know. They have stood the test of time and are worth a second, third, or even fourth look. Let's stop at this springhouse and skim the cream off of these rich maxims. They will refresh our lives and, simplistic as they may be, deepen our understanding. As we peruse them, let me suggest that you ask yourself the following question as we go along: What's the main sentence in *my* life?

As You Read the Scripture—Mike Winters

Proverbs 22:1-16. These are rules of personal character and conduct in society. Paul, in his epistles, often listed "house" or "table rules." See Colossians 3:18–4:6, for example.

The proverbs in these verses fall into five categories. Verses 2, 7, and 16 are about relationships between the rich and the poor. Verses 6 and 15 are about child-rearing. Verses 4, 9 and 11 are about blessings and rewards. Verses 1, 3, 5, and 10 are sayings to encourage and guide the wise. Verses 8 and 12-14 are verses for those bent on self-destruction.

Verse 1. Personal integrity is the most valued possession one can have.

Verse 2. God has created all people equal. The distinctions of class and race are human distinctions. Compare verse 29:13.

Verse 3. This verse is repeated in Proverbs 27:12. This is another way of saying "Discretion is the better part of valor." "Simple" is contrasted with "prudent" and means foolish. The Hebrew word translated "suffer" here also means "fined," as a penalty.

Verse 4. Compare this verse to verse 1:7. The Hebrew word translated as "humility" also holds the sense of being bowed down to, in the sense of kneeling or prostrating oneself, and is synonymous with the Hebrew words for fear or reverence.

Verse 5. The Hebrew word for "perverse" also means "devious," in the sense of one who turns away from what is right, a deviant. The way of the deviant is difficult.

Verse 6. This familiar verse is the very heart of religious education. The Hebrew word translated here as "train up" is transliterated as *chanak*. It means "to dedicate." *Chanak* is the root of a familiar word: *Hanukkah*, the Jewish Feast of Lights. This feast celebrates the rededication of the temple after the great sacrilege of Antiochus.

See verses 23:15 describing the parent's pride and 17:21 describing a parent's grief.

Verse 7. Verses 30:8-9 are the guide for the wise who desire neither wealth nor poverty. "Borrower" is from the Hebrew word "to be joined."

"Lender" is from the word meaning "cause to be bound." In Jewish usage, lending was an act of enslaving another person.

Verse 8. This is a difficult verse. It means oppression will fail and the oppressor's transgression will be ended.

Verse 9. Compare verse 19:17. Though God creates all people equal (verse 2), the state of the poor provokes God's special and immediate providence (see Amos 2:6-7, where the prophet cites the reason for God's judgment).

Verse 10. The scoffer is one who scorns or laughs.

Verse 11. The pure in heart are especially blessed (Matthew 5:8). The person described is of ambassadorial quality.

Verse 12. The faithless, as suggested by the Hebrew, are dealers in treachery, deceivers. Since "knowledge" and "faithless" are contrasted, the meaning is that deception will fail, while true knowledge will succeed.

Verse 13. See verse 26:13. This is a humorous excuse for failure to act prudently.

Verse 14. The loose woman is a partner in adultery rather than a prostitute. Adultery makes God angry.

Verse 15. Folly, or foolishness, can be controlled in a child by rigorous discipline. See Proverbs 23:13-14.

Verse 16. See verse 7 and comments on verses 8-9.

Selected Scripture

King James Version

Proverbs 22:1-16

1 A *good* name *is* rather to be chosen than great riches, *and* loving favour rather than silver and gold.

2 The rich and poor meet together: the Lord *is* the maker of them all.

3 A prudent *man* forseeth the evil, and hideth himself: but the simple pass on, and are punished.

4 By humility *and* the fear of the Lord *are* riches, and honour, and life.

5 Thorns *and* snares *are* in the way of the froward: he that doth keep his soul shall be far from them.

6 Train up a child in the way he should go: and when he is old, he will not depart from it.

7 The rich ruleth over the poor, and the borrower *is* servant to the lender.

Revised Standard Version

Proverbs 22:1-16

1 A good name is to be chosen rather than great riches, and favor is better than silver or gold.

2 The rich and the poor meet together; the Lord is the maker of them all.

3 A prudent man sees danger and hides himself; but the simple go on, and suffer for it.

4 The reward for humility and fear of the Lord is riches and honor and life.

5 Thorns and snares are in the way of the perverse; he who guards himself will keep far from them.

6 Train up a child in the way he should go, and when he is old he will not depart from it.

7 The rich rules over the poor, and the borrower is the slave of the lender.

8 He that soweth iniquity shall reap vanity: and the rod of his anger shall fail.

9 He that hath a bountiful eye shall be blessed; for he giveth of his bread to the poor.

10 Cast out the scorner, and contention shall go out; yea, strife and reproach shall cease.

11 He that loveth pureness of heart, *for* the grace of his lips the king *shall be* his friend.

12 The eyes of the Lord preserve knowledge, and he overthroweth the words of the transgressor.

13 The slothful *man* saith, *There is* a lion without, I shall be slain in the streets.

14 The mouth of strange women *is* a deep pit: he that is abhorred of the Lord shall fall therein.

15 Foolishness *is* bound in the heart of a child; *but* the rod of correction shall drive it far from him.

16 He that oppresseth the poor to increase his *riches, and* he that giveth to the rich, *shall* surely *come* to want.

Key Verse: **A good name is rather to be chosen than great riches, and loving favour rather than silver or gold. (Proverbs 22:1)**

8 He who sows injustice will reap calamity,
 and the rod of his fury will fail.

9 He who has a bountiful eye will be blessed,
 for he shares his bread with the poor.

10 Drive out a scoffer, and strife will go out,
 and quarreling and abuse will cease.

11 He who loves purity of heart,
 and whose speech is gracious,
 will have the king as his friend.

12 The eyes of the Lord keep watch over knowledge,
 but he overthrows the words of the faithless.

13 The sluggard says, "There is a lion outside!
 I shall be slain in the streets!"

14 The mouth of a loose woman is a deep pit;
 he with whom the Lord is angry will fall into it.

15 Folly is bound up in the heart of a child,
 but the rod of discipline drives it far from him.

16 He who oppresses the poor to increase his own wealth,
 or gives to the rich, will only come to want.

Key Verse: **A good name is to be chosen rather than great riches, and favor is better than silver or gold. (Proverbs 22:1)**

The Scripture and the Main Question—Pat McGeachy

Keeping Your Reputation (Proverbs 22:1)

No doubt it is possible to overdo any aphorism. By definition, proverbs are short and so cannot contain all the truth. If that were possible, the Bible could be only one sentence long! The other side of this one is equally true: You can value your reputation so much that you never dare to take the risk of living. What if Jesus had spent his life asking, "What will other people think?" Thank goodness he went ahead, regardless of the cost to his reputation, and ate with us publicans and sinners. Nevertheless, this old saw is worth carrying in your wallet. Let me phrase it slightly differently: I'd rather be right than rich. Would you agree with that?

Equality (22:2)

Mistakenly, we humans make much of economic and social differences. Jesus never did, or if he did, it was always to side with the lower end of the spectrum, as if to offset our human prejudice on behalf of the well-to-do. This proverb makes it clear that the world is not divided into two kinds of people. Creatures living in the film on the surface of swamp waters may think that they are superior to those swimming a few millimeters beneath them, but to the snowy egret, high in the cypress, they all look alike. From God's point of view, the status of all humans is the same; the ground is level at the foot of the cross.

Keep Your Eyes Open! (22:3)

It seems strange that this apothegm would have to be repeated; surely *everyone* knows to avoid trouble. Yet everyone knows that "fools rush in where angels fear to tread." And what child has not been forced by mother or father to memorize these ominous words?

> Stop, look, and listen,
> before you cross the street.
> Use your eyes, and use your ears,
> and then use your feet.

Even the wisest among us does dumb things. We all need to listen to this simple dictum.

To Lose Life Is to Find It (22:4)

Although the world may believe that the way to success is through the power play, the Madison Avenue image, or the me-first approach, true wisdom teaches that it is exactly the other way around. It is the humble and reverent person who in the long run reaps the reward offered by God. Compare this with any number of sayings of Jesus, but particularly those of Matthew 6 about rewards. It is not accidental that Jesus is considered one of the teachers of the Wisdom School of the Bible.

Perversity Leads to Ruin (22:5)

The flip side of every proverb is a truth, as we have said. The flip side of this one is that, sometimes, in the name of the truth, one has to deviate from the norm. Certainly Jesus was a sort of "deviant." He didn't do things the way they had always been done (see, for example, Matthew 7:29 and John 4:9, among many). Nevertheless, other things being equal (which they often aren't), we ought to behave ourselves. What a neutral expression! Behave yourself? Surely all human activity is some form of behavior. What we mean is behave normally, not perversely. And as every wise man knows, that usually works.

Good Raising Will Tell (22:6)

When I was young, my family spent many hours reciting scriptures until we had them all memorized. At the time I thought it was boring, Mickey

Mouse, and even destructive. But now that I am grown, I am grateful for the knowledge of the Bible that I acquired so painlessly. Sometimes young people rebel against their upbringing; I did for a time. But eventually, in most cases, the teaching will tell.

Them as Has, Gets (22:7)

There is a current bumper sticker that says, "The Golden Rule: Those that have the gold make the rules." This is nothing new or surprising; the writer of Proverbs knew that "money talks." It may not be a pleasant state of affairs, but that's how things are. Part of wisdom is simply being in contact with reality, that is, knowing the score.

What You Give, You Get (22:8)

Saint Paul said it also, in Galatians 6:7: "God is not mocked, for whatever a man sows, that he will also reap." Though it may appear (Psalm 73) that the wicked are getting fat through their greedy perversity, we know that they have been set in slippery places and will eventually come tumbling down.

To Give Is to Get (22:9)

Again we have a dictum that the world cannot comprehend: Give it away and you'll get it back. But consider what Jesus taught about losing your life, or what Ecclesiastes (11:1) said about casting your bread upon the waters. Even the world sometimes knows how to say this in its own fashion: You get out of it what you put into it.

Or, in computerese: Garbage in, garbage out. To live a holy, generous life is ultimately to find happiness. Ask anyone who has tried it.

No Cynics Allowed (22:10)

Freedom of speech is a great thing, but there comes a time when you just have to say to the curmugeons in your midst, "All right, beat it! Let's quit complaining and get to work."

Purity Within and Without (22:11)

"Happy," said Jesus, "are the pure in heart; they shall have a vision of God." This proverb is an earthy version of that spiritual statement, and it contains an additional promise: If you are pure without as well as within, you'll go places. There is a street proverb these days that sums this up: You gotta walk the walk if you wanta talk the talk. Anyone who does both is rare indeed and probably *will* be a friend of kings.

God's Checking on Us (22:12)

Violating the rules of wisdom is a little like violating the law of gravity. You can't really do it. You can only break yourself against it. It is not as though God is arbitrarily picking people to zap with lightning; rather, God's lightning strikes those folks whose faithlessness stands above the skyline like the tallest steeple. When you misbehave, you can count on negative results.

Any Excuse Will Do (22:13)

People who are substance abusers tend to deny this fact, even to themselves; in like manner a really lazy person develops patterns of pretense. Here, our sluggard claims that the reason for not going to work is fear of lions, but the real reason is fear of work. You may have other and better excuses.

Fear the Adulteress (22:14)

I don't think I will comment on this proverb, because I suspect everybody has strong opinions on it already.

Spare the Rod and Spoil the Child (22:15)

The real issue here is not corporal punishment but whether we intend to take instruction seriously. The important question is not "Do you beat your children?" but "Are you firm and consistent in your discipline?" The wishy-washy parent lets children get away with things not out of too much love but out of too little.

Oppress the Poor or Court the Rich, in Either Case You Lose (22:16)

When we exploit people, we use them as means to an end. It has been said, "The trouble with the world is that we *love* things and *use* people." This proverb warns us against both.

Conclusion

Now that you have looked at these sixteen biblical truisms, do you want to change the one you wrote down on that slip of paper at the beginning of the lesson? I think I want to sum up life with these words of Augustine's: "Love God and do as you will." What's your one-liner?

Helping Adults Become Involved—Ronald E. Schlosser

Preparing to Teach

Prior to the session, duplicate the fifteen statements you will be asking your class to react to in the main part of the lesson (see "Developing the Lesson"). These statements are rephrasings of aphorisms related to the proverbs in today's scripture. If you do not have access to duplicating equipment, write out the statements on newsprint. Also have available pencils and paper for a writing activity at the beginning of the lesson.

Carefully read the sections "As You Read the Scripture" and "The Scripture and the Main Question." These form the heart of the lesson. The ideas, insights, and suggestions in these sections should be employed throughout your lesson plan.

There are two learning goals for the session: (1) to react to statements that reflect truths about reality, and (2) to summarize one's own philosophy of life in a brief statement.

FOURTH QUARTER

After introducing the main question, the lesson can be outlined as follows:

> I. Reacting to statements
> II. Sharing responses and feelings
> III. Summarizing statements

Introducing the Main Question

Basic and helpful ideas are presented in the section "The Main Question." These ideas are essential in helping to identify the purpose of the lesson and getting your session started.

Begin by handing out pencils and paper to your class and asking them to write down four things: (1) their favorite color; (2) what animal they would like to be if they could change into an animal; (3) the car that best reflects their personality (for example, are they practical VW people, BMW trendsetters, down-to-earth Ford pickup types, or classy like an elegant Cadillac?); (4) a statement that expresses their philosophy of life or a rule that they live by (see examples given by Dr. McGeachy in "The Main Question").

After the class members have written down their responses, ask them to put their initials in the upper right-hand corner and give you their papers. Then, for fun, read off the responses on each paper and ask the class to guess who the writer is. If appropriate, question individuals as to why they answered as they did. The class members may learn some very interesting things about the interests and attitudes of one another.

Developing the Lesson

I. Reacting to statements

Give to each of your class members a copy of the following statements, duplicated beforehand (or post a sheet of newsprint on which they are written for all to see):

1. I'd rather be right than rich.
2. All persons are created equal.
3. It is better to hide from danger than to face it squarely.
4. God ultimately rewards those who worship him.
5. It is good for one to be unpredictable sometimes.
6. There is value in insisting that children memorize scriptures.
7. Neither a borrower nor a lender be.
8. Whatever you sow, you will also reap.
9. You get out of life what you put into it.
10. Have nothing to do with people who always complain.
11. The pure in heart and the soft-spoken will never lack friends.
12. God will ultimately punish those who are faithless.
13. A person is known by his or her lifework.
14. Spare the rod and spoil the child.
15. Money is the root of all evil.

After each statement the members should write "yes" if they agree with it, "no" if they disagree with it, or "depends" if they feel the statement is

ambiguous. Ask them to rephrase ambiguous statements to clarify their positions on them.

II. Sharing responses and feelings

When you sense everyone has had a chance to write responses to the statements, discuss each statement in turn. First, have the members share their responses to the statement, then note the way the idea is expressed in Proverbs (verses 1-13, 15-16 respectively, verse 14 being omitted), and, finally, refer to the comments of Dr. McGeachy and Dr. Winters. If there are differences of opinion or objections that a statement doesn't say it the way the class likes, work together as a class to rewrite the statement so all can endorse it. For example, statement 15 is not an accurate rendition of I Timothy 6:10. The statement should really read: "The *love* of money is the root of all evil." Or it could be rephrased to express better the idea contained in Proverbs 22:16.

A statement that might provoke a great deal of discussion is number 14, pertaining to corporal punishment of children. It is related to Proverbs 22:15 and has parallels in Proverbs 13:24, Proverbs 23:13-14, and Proverbs 29:15. Here parents are instructed to use, when necessary, means of physically punishing their child as a part of his or her upbringing. Such action is unpopular with many today because of the growing concern about child abuse. Certainly parents should hesitate to use physical punishment if some other means of correction can serve as well or better. But are there times when this type of punishment is a necessary part of the child's training? What does your class think? Note Dr. McGeachy's comment on this issue.

III. Summarizing statements

In summary, it must be remembered that no list of rules can replace the inspirational value of the example of parents, grandparents, teachers, or other role models who themselves are disciplined Christians and live according to the ideals of the kingdom of God. This was affirmed in the lesson for July 1 (two weeks ago).

The statements, moreover, point to a truth underlying all of them: The truly wise person is one who has developed self-discipline and acts accordingly. Self-discipline preserves the self-respect and dignity which God intends that we as Christians should have. Self-discipline safeguards us from the destructive force of uncontrolled emotions. It also makes for a strong society. There are countless examples where lack of self-discipline has brought persons and nations to ruin.

Helping Class Members Act

Dr. McGeachy concludes his comments by asking us to consider again the statement expressing our life philosophy, or rule to live by, which the class individually wrote down at the beginning of the session (item 4). Ask your class members to take a few minutes now to do this. If time permits, you might like to get members' reactions to Dr. McGeachy's own summary, quoting the words of Augustine: "Love God and do as you will." How does your class react to this guideline for life?

Have the members share aloud their statements, then close the session with prayer.

Planning for Next Sunday

The scripture for next week is Proverbs 30:18-33. It expresses the writer's sense of wonder over events in nature and human life. Ask class members to come to the session prepared to tell some of the things in life that give them a sense of wonder and awe.

LESSON 8 JULY 22

Proverbs in Pictures

Background Scripture: Proverbs 30

The Main Question—Pat McGeachy

When God created the human race, the first commandment was given: "Be fruitful and multiply, and fill the earth and subdue it" (Genesis 1:28). We have pretty well managed to fill the earth, but the second half of the command eludes us. Indeed, it almost seems that we have misread the command of God and believe that we have been ordered to *abuse* the earth. Certainly the rivers are no better off for our having been here, nor are endangered species or the forests or the atmosphere itself.

Agur, son of Jakeh of Massa, an unknown sage of the wisdom school, gives us a fresh way to look at the earth, a way that combines both humility on our parts with profound respect for the natural world. Agur is not the only writer of Proverbs to celebrate the natural world. We have already been told in the introduction (Proverbs 6:6) to look at the ant. Jesus uses many such illustrations from nature, in the Sermon on the Mount and elsewhere. But Agur has one gift that makes him a little different: He is a poet. The numerical proverbs (verses 15-31) offer us a brand new (to us Westerners) poetic form, which reminds us a little of Japanese haiku, in that it draws on nature and in a highly stylized form presents a simple idea. The poems draw on images in the world and are approached with a rare humility, which is described in verses 1-14.

With what question shall we approach our text for today? Let me suggest one with two parts. First, with regard to myself, am I a truly humble person with a sense of wonder at the world? And second, with regard to that world, do I accept it as having rights of its own and approach it, in Martin Buber's terms, as an "I" to a "Thou," not an "I" to an "It"? It is the task of the church to enable those for whom we are responsible to become rightly related to nature, to themselves, to their fellow human beings, and to God. Are we doing it right?

As You Read the Scripture—Mike Winters

Proverbs 30. This is one of three sections of Proverbs not actually credited to Solomon (see 24:23; 30:1; 31:1). Verses 1-9 are an honest

404

questioning of one who is searching for wisdom. Verses 10-33 are tied together by a common Semitic rhetorical form (verses 15-16, 18-19, 21-23, 24-28, 29-31). In this form, the images are numbered. The progression of images amplifies the impact of the last image in the series (verses 6:16-18, and especially Amos 1:3–2:8, where the entire book depends on the last image in the progression beginning at 2:6).

Verses 18, 21, 24, 29. The formula is the same in each of these verses. Each verse introduces a set of images and defines the relationship of each image in a set.

Verses 18-19. These four images produce awe in the writer.

Verse 19. The flight of the eagle inspires awe, first because of its large size, but more importantly, in Jewish understanding, because it is a symbol of eternal youth.

The serpent is considerably more difficult to understand as awe-inspiring, because of its association in Jewish thought with evil. Presumably, the object is the serpent's manner of locomotion. That would be consistent with the eagle and the ship in this set of images.

The image of the ship is of a small vessel sailing the open waters to its destination. To the early mind this was as awe-inspiring as the concept of "lift" is to airline passengers.

The maiden is a young woman. The Hebrew word translated as "maiden" can also mean "a young woman" or "a virgin." The power of sexual attraction and love is as awe-inspiring as anything in the world.

Verse 20. The *way* of adultery is contrasted with the *way* of a man with a maiden in verse 19. The crime of adultery lies as much in the deception involved as in the crime itself.

Verses 21-23. These are images of arrogance and intolerable personalities. Two of the images are male (verse 22), and two are female (verse 23).

Verse 23. The unloved woman is hated. Another understanding of the Hebrew word translated as "mistress" is "a mighty one." The maid, or servant, is elevated to a position of power.

Verses 24-28. These verses extol all things small but wonderful.

Verse 25. The ant is a universal symbol of industry. Here the ant displays the virtue of forethought.

Verse 26. The rock badger is a small animal with short legs and ears and padded feet. It resembles the hippopotamus. It is relatively defenseless, making its home in the clefts of rocks.

Verse 27. The individual locust is no threat at all, but when it swarms it is devastating.

Verse 28. The impact of this image is difficult to understand. Clearly, because of its smallness the lizard can make its way into places no one else can.

Verses 29-31. These are images of things that are prideful in their manner.

Verse 30. This is an old lion, the dominant male in the pride.

Verse 31. The Hebrew words translated as "strutting cock" are obscure. The translation fits the context well.

The he-goat is a measure of wealth in the Bible (II Chronicles 17:11).

The phrase translated as "a king striding before his people" is from a Hebrew phrase, the meaning of which is uncertain. The Revised Standard Version has captured the meaning from the context.

FOURTH QUARTER

Verse 32. Think first! Do all things in moderation. These two ideas capture the meaning of this verse.

Verse 33. The Revised Standard Version translation acknowledges that the King James Version translations "churning," "wringing," and "forcing" are all from the same Hebrew word.

Selected Scripture

King James Version	Revised Standard Version

Proverbs 30:18-33

18 There be three *things which* are too wonderful for me, yea, four which I know not:

19 The way of an eagle in the air; the way of a serpent upon a rock; the way of a ship in the midst of the sea; and the way of a man with a maid.

20 Such *is* the way of an adulterous woman; she eateth, and wipeth her mouth, and saith, I have done no wickedness.

21 For three *things* the earth is disquieted, and for four *which* it cannot bear;

22 For a servant when he reigneth; and a fool when he is filled with meat;

23 For an odious *woman* when she is married; and an handmaid that is heir to her mistress.

24 There be four *things which are* little upon the earth, but they *are* exceeding wise: ˙

25 The ants *are* a people not strong, yet they prepare their meat in the summer;

26 The conies *are but* a feeble folk, yet make they their houses in the rocks;

27 The locusts have no king, yet go they forth all of them by bands;

28 The spider taketh hold with her hands, and is in kings' palaces.

Proverbs 30:18-33

18 Three things are too wonderful for me;
four I do not understand:

19 the way of an eagle in the sky,
the way of a serpent on a rock,
the way of a ship on the high seas,
and the way of a man with a maiden.

20 This is the way of an adulteress:
she eats, and wipes her mouth,
and says, "I have done no wrong."

21 Under three things the earth trembles;
under four it cannot bear up:

22 a slave when he becomes king,
and a fool when he is filled with food;

23 an unloved woman when she gets a husband,
and a maid when she succeeds her mistress.

24 Four things on earth are small,
but they are exceedingly wise:

25 the ants are a people not strong,
yet they provide their food in the summer;

26 the badgers are a people not mighty,
yet they make their homes in the rocks;

27 the locusts have no king,
yet all of them march in rank;

28 the lizard you can take in your hands,
yet it is in kings' palaces.

29 There be three *things* which go well, yea, four are comely in going:

30 A lion *which* is strongest among beasts, and turneth not away for any;

31 A greyhound; an he goat also; and a king, against whom *there is* no rising up.

32 If thou hast done foolishly in lifting up thyself, or if thou hast thought evil, *lay* thine hand upon thy mouth.

33 Surely the churning of milk bringeth forth butter, and the wringing of the nose bringeth forth blood: so the forcing of wrath bringeth forth strife.

29 Three things are stately in their tread;
 four are stately in their stride:

30 the lion, which is mightiest among beasts
 and does not turn back before any;

31 the strutting cock, the he-goat,
 and a king striding before his people.

32 If you have been foolish, exalting yourself,
 or if you have been devising evil,
 put your hand on your mouth.

33 For pressing milk produces curds,
 pressing the nose produces blood,
 and pressing anger produces strife.

Key Verse. If thou hast done foolishly in lifting up thyself, or if thou hast thought evil, lay thine hand upon thy mouth. (Proverbs 30:32)

Key Verse: If you have been foolish, exalting yourself, or if you have been devising evil, put your hand on your mouth. (Proverbs 30:32)

The Scripture and the Main Question—Pat McGeachy

The Ignorant Sage (Proverbs 30:1-14)

I must confess that I don't know why verse 1 is here, or who any of those people are, so I'm just going to skip it and go on to verse two. Here there begins a remarkable statement of humility on the part of Agur, the wise one. The beginning of wisdom is not only the fear of the Lord but also a healthy acceptance of one's own ignorance. In that regard, I need to confess my own sins: I am one of those people who hates to ask for directions. On taking shortcuts through strange towns, I have been known to lose my way out of arrogance and have been late for more than one important undertaking just because I didn't want to say, "There's something I don't know." But Agur admits to ignorance and thus joins the ranks of the truly wise. To know all things is to know little; to know nothing is to begin the journey to knowledge.

Verses 3-4 makes us think of Job's supreme ignorance, as described in Job 38 and 39. (See especially 38:4-5.) Agur is clearly admitting ignorance about those things that the human mind cannot know. The modern physicist may talk of "the big bang," in all sorts of erudite terms, but the truth is, the *"how"* of creation is still just as much a mystery as it was in Agur's day. Perhaps more so—today's scientist may not know who lit the big bang; at least Agur knows that it was "the Holy One." Perhaps the big bang happened when

God said, "Let there be light." The point is, neither you, nor I, nor Agur, nor Carl Sagan, nor anybody else really knows. We can be grateful that Agur at least knows that he knows not.

The positive side of ignorance is wonder. That is why the child is so near to the kingdom of God. See Matthew 21:15-16, and, of course, Psalm 8, the Old Testament's song of wonder. You might even like to sing it to the tune of "I Wonder, as I Wander," an Appalachian folk carol:

> I wonder as I wander out under the sky,
> How great is your name in the earth, Lord most high,
> Whose glory is heard in the little one's cry.
> I wonder, as I wander out under the sky.
>
> When I look at the heavens the work of your hand,
> The moon and the stars like the grains of the sand,
> I cannot help asking of woman and man,
> That you should include us as part of your plan.
>
> You've crowned us with glory as daughter and son,
> And placed us in charge of the creatures that run,
> And giv'n us the earth for our work and our fun.
> O God, how I wonder at what you have done!

What do you do, if you admit that you are an ignorant person? The answer is, search for the truth at all costs (verses 5-7) and stay away from self-indulgence (verses 8-14). The two things most likely to turn a child from innocent wonder to selfishness are self-deception and greed. A child, being full of wonder at the universe, can be fooled into thinking all sorts of unreal things. Such an infant may grow up believing that ultimate happiness is found in escape or in earthly pleasure or in other lesser gods. *Some* happiness is found in these, of course, but not ultimate happiness. In like manner, the child, being at the center of the universe, may develop a kind of me-first attitude, a sort of nursery-sized delusion of grandeur. But Agur, the realist, refuses to flee into such escapes. "Give me the truth, the whole truth, and nothing but the truth!" he cries.

In contrast to the self-denying Agur, we have another kind of denial: those who deny their own filth (verse 12) and rapacity (verse 14). Flee them like the plague, he warns us.

Hebrew Haiku (30:15-33)

There now follows some of Agur's wisdom, expressed in a formal poetic structure that is built around numbers. Out of his humility Agur speaks, drawing on nature and life for illustrations and describing them in delightful images.

1. The leech (verses 15-16): The sentence about the leech (if that is indeed what the word means) and its insatiable daughters doesn't exactly fit the form and may have been added later. But the four devourers are clear: death (Sheol simply means the abode of the dead), the empty womb, the dry land (that part of the world understands drought), and fire.

While we're at it, we should add that verses 17 and 20 don't exactly fit in with these poems, but their proverbial meaning is clear.

2. Four wonders (verses 18-19): I almost hesitate to comment on this; poetry ought to be left alone, and this is one of my favorite passages in the

Bible. I think I will just say that it bears out what we have been saying about Agur's sense of wonder and let the poem speak for itself.

3. Four unbearable types (verses 21-23): There are two types of each sex here, but all are based on the same principle: The starving person at the banquet table is in danger of self-destruction. Nobody can stand a big shot, but the worst one of all is the big shot who is an ex-little shot. No one preaches more loudly than the person who has just given up the habit. You really want to forgive these four people because, suddenly thrust into positions of power, they don't seem to be able to handle it. But they should have known. They, like all of us, have forgotten the humility that Agur had, or that to which Jesus calls us. They want to sit on the Lord's right hand or left, but that is not for Jesus to permit (see Mark 10:35-45). The proper aim in life is not to be great but to serve, and in that, true greatness is ultimately found.

4. Four small things (verses 24-28): As if in contrast to the greedy folk newly in power, we now have the little folk whose power is greater than we could have guessed: ants, rock badgers, locusts, and lizards. No one who has experienced a locust swarm can doubt their power; no one who has spent any time watching ants can doubt their industry. The badgers are a little harder to understand; it seems Agur is saying that even though they are small, they are secure. And as for the lizards, they dwell in palaces. (An elephant could never sneak into a palace!)

Agur does not venerate bigness. Remember the widow with two cents, whom Jesus said put more in the plate than all the rich? So do little people, the poor in spirit, the meek, the peacemakers, and those who long for righteousness ultimately overthrow the powers of darkness. When the time came to upset the history of the world, God sent us not legions of angels or spectacles in the sky, but a baby, born in a borrowed barn.

5. Proper dignity (verses 29-31): Now the argument is turned the other way around, and Agur lets us know that there *is* a place for pomp and pageantry. When is it proper? Why, when it is proper! The slave in verse 22 couldn't handle being king, but a king can. Humility does not consist in being milquetoasty and smarmy but in knowing your place. We don't like to see a lion slinking away with its tail between its legs, and we don't want to see a king acting like a coward.

6. Control yourself (verses 32-33): With these somewhat prosaic verses, Agur closes out this section of poetry. It's a good idea, the poet tells us, to stay clear of unnecessary trouble.

Conclusion

We have journeyed for a time with a poet who is both a humble person and a lover of nature. What of our initial question about ourselves? Do I love and glorify God enough to put myself in the proper place, humble before the wonder and majesty of the creation? And do I love and celebrate the creation enough to put myself in proper relationship with the universe, the earth, my fellow human beings, and my fellow creatures? How would you answer?

Helping Adults Become Involved—Ronald E. Schlosser

Preparing to Teach

Today's lesson, "Proverbs in Pictures," reminds us of the many illustrations and parables from nature that Jesus used in his teaching. To

him, lilies spoke of God's care, leaven depicted the way in which the kingdom of God grew in the world, and a mustard seed was an example of the growth of truth. Many of our Lord's simplest yet most profound teachings were drawn from nature. Sparrows, seeds and tares, fig trees, salt, and many other objects of nature spoke to him of spiritual truths.

The learning goals for the lesson are threefold: (1) to gain a greater sense of awe of the wonderful world in which we live, (2) to learn new truths that the natural world reveals, and (3) to recognize our human limitations in understanding the world around us.

Carefully read the sections "As You Read the Scripture" and "The Scripture and the Main Question." These form the heart of the lesson. The ideas, insights, and suggestions in these sections should be employed throughout your lesson plan.

Try to locate the music to the Appalachian folk carol "I Wonder as I Wander," mentioned by Dr. McGeachy in his lesson comments. Write his paraphrase of Psalm 8 on newsprint, or duplicate it to hand out to the class for a concluding worship experience. (You could substitute the hymn "How Great Thou Art!") You will also need paper and pencils for two writing activities.

After introducing the main question, you can develop the lesson using the following outline:

 I. Introducing Proverbs 30
 II. Examining comparisons
 III. Sharing insights
 IV. Summing up

Introducing the Main Question

Basic and helpful ideas are presented in the section "The Main Question." These ideas are essential in helping to identify the purpose of the lesson.

Begin the session by handing out paper and pencils. Indicate that you will read ten phrases that begin a simile (comparison), and that the class members should complete the sentences. For example, you might say, "Pretty as . . ." and they would complete the sentence: "a picture" or "a flower." They should write down the first thought that comes to mind. Here are the ten phrases to be completed:

1. Cool as . . .	6. Straight as . . .
2. Sharp as . . .	7. Small as . . .
3. Wise as . . .	8. Poor as . . .
4. Quiet as . . .	9. Light as . . .
5. Busy as . . .	10. Snug as . . .

After you have read off the ten phrases, ask the members to share their responses. More than likely most of the responses will be the same (for example, cool as a cucumber, sharp as a tack, wise as an owl). Note which of the comparisons come from the world of nature. Then, as a class, brainstorm together other responses to the phrases—responses that specifically come from nature. For example, "sharp as a tack" could also be "sharp as a thorn."

Note that today's scripture for study (Proverbs 30) contains numerous comparisons from the world of nature, which illustrate striking truths.

Refer to the two-part question that Dr. McGeachy sees as the focus for the study: (1) Are we truly humble persons, possessing a sense of wonder at the world? (2) Do we relate to the natural world, to ourselves, to our fellow human beings, and to God in the right way?

Developing the Lesson

I. Introducing Proverbs 30

Have the class turn to Proverbs 30 and read verses 1-5. Introduce Agur, the writer (see Dr. McGeachy's comments). Then compare this passage to Job 38:1-7 and Job 42:1-3. Even as Job admitted he didn't understand the wonderful works of God, so too does Agur. All any of us can do is exclaim in awe and affirmation, "How great thou art!"

II. Examining comparisons

Move next to a closer look at verses 18-31 of Proverbs 30. Divide the class into four groups, each to study one of the following passages: (1) verses 18-19—four things too wonderful to fully understand; (2) verses 21-23—four things that spell trouble for the world; (3) verses 24-28—four things that are small but teach us a lesson; (4) verses 29-31—four things that can be admired for their majesty and strength.

Each group should do two things: (1) Explore what is unique about the things mentioned in the passage—why is an eagle wonderful, a fool full of food dangerous, a strutting cock stately? (2) Select four different examples from nature or life today to illustrate the same things—the growth of a flower, the greed of unscrupulous investment counselors, the wisdom of a spider, the graceful majesty of a ballerina.

Allow the class about ten minutes to do this work in small groups.

III. Sharing insights

Call the class together for the groups to share their discoveries and insights. Refer, when appropriate, to the comments of Dr. McGeachy and Dr. Winters on these verses. In addition to the examples given above, other things that might be listed as wonderful are the intelligence of a porpoise, the intricacy and speed of a computer, and the love of a mother for her baby. Other things that spell trouble for the world are toxic wastes blighting the land, persons who deal in drugs, and terrorists who have no regard for human life. See James 3:3-5 for examples of other small objects that can do good (or bad) things. Other things that show proper dignity and power are the roaring take-off of a jet liner, the pomp and precision of a marching band, and a parade of trained elephants at the circus. Encourage your class to suggest other examples in each category.

IV. Summing up

Turn the thoughts of the class again to the wonder of nature. Recall the words of the poet William Wordsworth: "My heart leaps up when I behold/A rainbow in the sky." Who hasn't had a sense of wonder when seeing a rainbow? Its colors are always arranged the same; red, orange, yellow, green, blue, indigo, and violet blend imperceptibly into each other. Contrast the natural wonder of a rainbow to the mechanically made color bars on a videotape. They are the same colors, but they don't elicit the awe that a naturally made rainbow does. Who can gaze on one without thinking about the greatness and goodness and glory of God?

Helping Class Members Act

Conclude the session by singing or reading together the paraphrase of Psalm 8 mentioned earlier, or the hymn "How Great Thou Art!" Offer a prayer of thanks to God for the wonderful world that was created for us to learn from and enjoy.

Planning for Next Sunday

The scripture for next week is from Ecclesiastes 1–2. Ask the class to read these two chapters and to consider whether there is a sameness about life. Does history repeat itself?

UNIT III: THE LIMITS OF HUMAN WISDOM
Horace R. Weaver

TWO LESSONS **JULY 29–AUGUST 5**

"The Limits of Human Wisdom" turns our attention to the dismal perspective on life set forth by Ecclesiastes. Ecclesiastes is concerned with the inability of human wisdom to provide meaning in life. "The Failure of Human Wisdom," July 29, proclaims that life is boring and meaningless unless we permit God to give it meaning. "God's Acts Endure," August 5, raises a haunting question: Given the fact that we live in a world where events come and go with seeming futility, how can an ordinary human being hope to cope?

LESSON 9 **JULY 29**

The Failure of Human Wisdom

Background Scripture: Ecclesiastes 1–2

The Main Question—Pat McGeachy

Ecclesiastes may be the high point of the Old Testament. Either that, or the low point. It represents, for me, the ultimate, disturbing, despairing question that demands the good news in answer. In other words, it is an unresolved chord at the end of the first movement of the Holy Scriptures, which leaves us longing for the second movement: the New Testament. When we finish reading Ecclesiastes, we are left waiting for the other shoe to drop.

I have a tremendous admiration for Ecclesiastes. (Let me say as an aside that I prefer to call the author Ecclesiastes. Some like to say "the Preacher," which is one way to translate it; others prefer the Hebrew word that "preacher" translates: *Koheleth*. But "Ecclesiastes" is the Greek word that means the same thing, and I grew up calling it that.) He had the courage to say aloud that everything in the world seems to be vanity, that is, emptiness, and yet he would not give up his ultimate faith in the judgment and purpose of God. Let me give you my favorite verse: "Whatever your hand finds to do, do it with your might; for there is no work or thought or knowledge or wisdom in Sheol, to which you are going" (Ecclesiastes 9:10). Well, if you believe that, then what's the point? "Gather ye rosebuds while ye may"? Or just give up? Not Ecclesiastes—"Fear God, and keep his commandments," he orders (11:13). This is our whole duty.

How does he do it? How, believing that all is vanity, does he go on trusting God? And indeed, when you and I look at the sad and tragic world around us, what keeps *us* going?

As You Read the Scripture—Mike Winters

Ecclesiastes 1–2. The theme of the book is laid out in these two chapters. Because everyone comes to the same end, namely death, all is in vain. All accomplishments, worthy or worthless, righteous or wicked, are in vain. So why choose the more difficult life of worth and righteousness? The answer is in 2:24-25. Here the book is transformed from a treatise on philosophical despair to one on theological hope.

Ecclesiastes 1:2. "Preacher" is the English translation of the book title from the Greek Septuagint, and the name of the author. The Greek word actually means "one who assembles" or "caller." The book generally reflects Greek thought from the third century B.C. Thus it is unlikely that Solomon was its author.

The Preacher experiences despondency and despair at the cyclical pattern of life.

Verse 3. The Hebrew word translated as "gain" also means "what is over and above," as in profit. The Hebrew word translated as "toil" comes from the word meaning "perverseness" and "misery." It is used by the Jews fleeing out of Egypt (Deuteronomy 26:7) and in one of Jeremiah's laments (Jeremiah 20:18).

Verses 4-7. The author points to nature as an example of the vain, cyclical pattern in all of creation.

Verse 4. The Hebrew word translated as "generation" comes from the Hebrew word for circle. Contrasting is the word "remain," from the Hebrew word meaning "to stand still." There is a cyclical pattern to human life that is amplified in the face of the changeless earth.

Verse 5. But the cyclical pattern is in all of nature. The sun is a sign of life. Each day it rises and hastens across the sky.

Verse 6. The author describes the north wind, a cold wind favorable to agriculture (Song of Solomon 4:16). The view of the wind's course was cyclical, returning to its origins after visiting the surrounding country.

Verse 7. The stream is the perennial valley brook, or *wadi*, which is awash in the winter but dry in the summer.

Verse 8. The Hebrew word translated as "weariness" has been translated as "toil" in verse 1:3.

Verse 12. An ascription to Solomon.

Verse 13. The Hebrew word translated as "mind" can also be translated "heart" (see King James Version), the seat of wisdom. The Hebrew word both the Revised Standard Version and the King James Version interpret as "seek" also means "inquire," and the word both translations interpret as "search" also means "spy out." The Hebrew word translated as "unhappy" also means "evil." The Hebrew word translated as "busy" also means "to be afflicted" or "humbled."

Verse 14. The author's conclusion after experiencing everything is that all is in vain. Vanity is defined as a striving after wind. The Revised Standard Version notes an alternative translation, "a feeding on wind," and refers to Hosea 12:1.

Verse 15. The Hebrew word translated in both versions as "crooked" also means "perverted." Both versions also translate as "straight" a Hebrew word that also means "to be made right."

Verse 16. "I said to myself" is from the Hebrew idiom that the King James Version translates literally as "I communed with mine own heart." The author is the most qualified to draw a conclusion about this matter of vanity.

Verse 17. The Hebrew word translated as "apply" is *nathan* (both a word and a name). It is from the Hebrew verb meaning "to give." Remember how Nathan "gave" advice to David (II Samuel 12)? The word for madness also means "foolishness." The Hebrew word both versions translate as "folly" also means "thickheadedness."

Ecclesiastes 2:24-25. The final conclusion, which hones a dark philosophy into a beautiful theology, is that God gives value to the toil and labor of life, value that is inherent in the laboring.

Selected Scripture

King James Version

Revised Standard Version

Ecclesiastes 1:2-8, 12-17

2 Vanity of vanities, saith the Preacher, vanity of vanities; all *is* vanity.

3 What profit hath a man of all his labour which he taketh under the sun?

4 *One* generation passeth away, and *another* generation cometh: but the earth abideth for ever.

5 The sun also ariseth, and the sun goeth down, and hasteth to his place where he arose.

6 The wind goeth toward the south, and turneth about unto the north; it whirleth about continually, and the wind returneth again according to his circuits.

7 All the rivers run into the sea; yet the sea *is* not full; unto the place

Ecclesiastes 1:2-8, 12-17

2 Vanity of vanities, says the Preacher,
vanity of vanities! All is vanity.

3 What does man gain by all the toil
at which he toils under the sun?

4 A generation goes, and a generation comes,
but the earth remains for ever.

5 The sun rises and the sun goes down,
and hastens to the place where it rises.

6 The wind blows to the south,
and goes round to the north;
round and round goes the wind,
and on its circuits the wind returns.

7 All streams run to the sea,
but the sea is not full;

from whence the rivers come, thither they return again.

8 All things *are* full of labour; man cannot utter *it:* the eye is not satisfied with seeing, nor the ear filled with hearing.

..

12 I the Preacher was king over Israel in Jerusalem.

13 And I gave my heart to seek and search out by wisdom concerning all *things* that are done under heaven: this sore travail hath God given to the sons of man to be exercised therewith.

14 I have seen all the works that are done under the sun; and, behold, all *is* vanity and vexation of spirit.

15 *That which is* crooked cannot be made straight: and that which is wanting cannot be numbered.

16 I communed with mine own heart, saying, Lo, I am come to great estate, and have gotten more wisdom than all *they* that have been before me in Jerusalem: yea, my heart had great experience of wisdom and knowledge.

17 And I gave my heart to know wisdom, and to know madness and folly: I perceived that this also is vexation of spirit.

Ecclesiastes 2:24-25

24 *There is* nothing better for a man, *than* that he should eat and drink, and *that* he should make his soul enjoy good in his labor. This also I saw, that it was from the hand of God.

25 For who can eat, or who else can hasten *hereunto,* more than I?

Key Verse: I have seen all the works that are done under the sun; and behold, all is vanity and vexation of spirit. (Ecclesiastes 1:14)

to the place where the streams flow,
there they flow again.
8 All things are full of weariness;
a man cannot utter it;
the eye is not satisfied with seeing,
nor the ear filled with hearing.

..

12 I the Preacher have been king over Israel in Jerusalem. 13 And I applied my mind to seek and to search out by wisdom all that is done under heaven; it is an unhappy business that God has given to the sons of men to be busy with. 14 I have seen everything that is done under the sun; and behold, all is vanity and a striving after wind.

15 What is crooked cannot be made straight,
and what is lacking cannot be numbered.
16 I said to myself, "I have acquired great wisdom, surpassing all who were over Jerusalem before me; and my mind has had great experience of wisdom and knowledge." 17 And I applied my mind to know wisdom and to know madness and folly. I perceived that this also is but a striving after wind.

Ecclesiastes 2:24-25

24 There is nothing better for a man than that he should eat and drink, and find enjoyment in his toil. This also, I saw, is from the hand of God; 25 for apart from him who can eat or who can have enjoyment?

Key Verse: I have seen everything that is done under the sun; and behold, all is vanity and a striving after wind. (Ecclesiastes 1:14)

The Scripture and the Main Question—Pat McGeachy

Introduction

Ecclesiastes (or Koheleth, or the Preacher) is identified as Solomon in the superscription (Ecclesiastes 1:1). But that title is soon dropped. Indeed, in verse 12 he says that he *was* king over Israel; Solomon, of course, died in office. Most commentators think that Ecclesiastes adopted the role of Solomon to make clear his analysis of what it was like to be in power and to claim encyclopedic knowledge. But you may interpret it either way. (Indeed, one commentator has it *both* ways, calling him Koheleth/Solomon.)

However we may settle that question, we will agree that it is an interesting book, disturbing to some, hopeful to others. To me it is the high point of the Hebrew writings. Its inclusion in the canon was debated at some length, and it was not finally accepted as part of the Bible until about one hundred years before Christ. I am deeply grateful to the courageous rabbis who voted to accept it, for it serves not only as a springboard to the New Testament but, more than that, as a clear command to all of us to humble ourselves in the presence of the great mystery of life.

All Is Vanity (1:1-11)

In poetic form, Ecclesiastes describes the futility of life. Generations rise and fall, seasons come and go, the wind blows round and round, streams run to the sea and back again to springs (here Ecclesiastes anticipates modern meteorology), and it's all utterly boring. "There's nothing new under the sun." Sometimes people *think* there is something new, but that's just because history is forgetful (verse 11), and the same old things keep repeating.

You have to admit that the old boy was a pretty good student of life. Things *do* seem to go round and round. We fail to learn the lessons of history and are thus condemned to repeat it. Even today, with all the incredible discoveries in science and psychology, there is a sameness about life. All the ridiculous triangles on soap operas have a disheartening sameness about them. Every dictator, whether Hitler or Stalin, appears in the same dreary guise, and once their cruelty is put down another one arises. The world is like a giant banana republic, throwing over one dictatorship and replacing it with another. Every generation gets into the same troubles their grandfathers did (my own father, who was in college seventy years ago, told me that substance abuse was the most serious problem on campus). It doesn't seem to be getting any better. I'll bet if you whistled up Ecclesiastes, he would take a quick survey and conclude once more, "Behold, it's all vanity, and a striving after wind."

A Try at Being King (1:12-18)

So Ecclesiastes tried being King Solomon, and it was no better. Not even the king can straighten out the crooked (verse 15) or count something that isn't there. (However, some politicians do seem to think they can accomplish both of those miracles.) In fact, in spite of all of Solomon's wisdom, his kingdom ended up divided after his death, split by grievous tax burdens and an unfeeling Rehoboam (see I Kings 12). Whether through wisdom or madness (verse 17), it all came to nothing.

416

A Try at Pleasure (Proverbs 2:1-11)

So Ecclesiastes had a go at pleasure: wine, women, and song. And again, he reports failure. Power didn't do it and neither did Epicureanism. Laughter is no fun when it all leads to naught (verse 2). What's the good of gardens and pools, houses and vineyards, singers and concubines, if it only lasts for fleeting moments, and you sink to the grave like everyone else?

I see signs of this attitude in my day too. A rather wealthy friend of mine was overheard to say, "I've been around the world seven times, and I still don't have a good time." How many suicides have we witnessed recently among the famous and well-to-do? No, pleasure doesn't cut it.

A Try at Wisdom (2:12-17)

Ecclesiastes doesn't give up; the experiment goes on. He tries wisdom. And lo, the wise man and the fool experience the same fate (verse 16). He tries wisdom and it doesn't work, so he hates life (verse 17). What a deadly conclusion! A sage climbs to the top of life's mountain, and what is the result? "I hate life." Ecclesiastes is chronically depressed!

A Try at Work (2:18-13)

When I'm depressed, some wiseacre is always telling me to get to work. "Staying busy is the secret to getting over grief," she will say. But I'm with Ecclesiastes. All that work just *adds* to my depression. The least I can do when I'm down is take a well-deserved vacation. But wait a minute! I tried that, and it didn't work either. So I agree with Ecclesiastes; you work all your life, and what does it get you? Some lazybones who never worked a day in his life inherits it (verse 21). I give up!

Conclusion (2:24-26)

The result of all of this, says Ecclesiastes, is that we should eat and drink and do the best we can to get a little fun out of life. (See the similar verses in 9:7-10.) But don't count on it, for God, pleased with some, sends blessings, and disliking others, sends pain and toil (verse 26). Compare this with the "arbitrary" decision of God between Cain and Abel (Genesis 4:4-5) and Jacob and Esau (Malachi 1:3; Romans 9:13). It seems that Ecclesiastes, skeptic that he is, says that we must do our best, but even that may not provide us with much joy, unless God decides to favor us.

Then what hope is there? If that is Ecclesiastes's conclusion, what will ours be? We have an answer that Ecclesiastes never heard, that he could only anticipate and long for. And it is summed up in Paul's words in Philippians 1:21: "To me to live is Christ." You see, Ecclesiastes is exactly right about life. It *is* boring and ultimately meaningless unless God gives it meaning. No matter how great and wise and good we become, we cannot achieve salvation apart from the grace of God (compare Ephesians 2:8). No matter how much we try to find pleasure in our daily toil, or our day off, it will not truly satisfy unless God gives us joy in it. The reason I think Ecclesiastes is the high point of the Old Testament is that he drives us squarely back upon the certainty that we cannot save ourselves.

The members of Alcoholics Anonymous outline twelve steps that they say one must follow in order to overcome an addiction. And the first of these is

the most important and the most difficult: I must admit that I am powerless over alcohol. What an astonishing discovery, flying in the face of all that the world teaches. The world is the great cheerleader: "You can do it, Louie!" But Louie cannot. And Ecclesiastes was perhaps the first person in history to spell this out in completeness.

Of course, it had been hinted at before. The Old Testament had long claimed that it was God, not Israel, who had conquered the Pharaoh and led the children out. David, after his sin with Bathsheba and the confrontation with Nathan the prophet, knew full well that only by the grace of God could he escape damnation. Read again Psalm 51, in which David begs God to create in him a new heart. Yes, the Old Testament had known grace, but always there had been in the back of the pious Jew's mind the notion that if he could only be righteous for just one day, Messiah would come. But it can't be done. And now, thanks to Koheleth/Solomon/Ecclesiastes/the Preacher, you and I know it, and there is nothing for us to do but to turn to Jesus and ask him for the everlasting mercy.

Helping Adults Become Involved—Ronald E. Schlosser

Preparing to Teach

Do you believe that history repeats itself? Are there things happening today that seem to have happened before? Look at the headlines and news stories in your local newspaper. Do you get a sense that these are things that you have read about before—terrorist attacks, street crime, natural disasters, political intrigue?

Some people do believe that history is cyclical; that is, events occur in cycles. Others see history as moving randomly, with a mixture of the old and the new. Still others view history as moving forward purposefully toward an end goal. Most Christians hold to this last interpretation—that God is directing the course of history, and that it will be consummated with the return of Christ and his reign in the kingdom of God.

The writer of Ecclesiastes holds to a negative form of the cyclical view of history. Not only is there nothing new under the sun but everything that is done seems purposeless (Ecclesiastes 1:14). In today's session your class members will be examining this attitude and making their own conclusions about the meaning of life. There are two primary learning goals: (1) to reflect on times of discouragement and remember what provided hope and encouragement, and (2) to affirm that God gives meaning and purpose to life.

Carefully read the sections "As You Read the Scripture" and "The Scripture and the Main Question." These form the heart of the lesson. The ideas, insights, and suggestions in these sections should be employed throughout your lesson plan.

Bring to the session copies of the past week's newspapers. You will need them to introduce the main question. The rest of the lesson can be outlined as follows:

I. Introducing Ecclesiastes
 A. Initial impressions
 B. Background on the writer
II. Thinking about the meaning of life
 A. The Preacher's search
 B. The Preacher's conclusion

Introducing the Main Question

Basic and helpful ideas are presented in the section "The Main Question." These ideas are essential in helping to identify the purpose of the lesson.

Begin by distributing the newspapers you have brought in. The newspapers can be taken apart and individual pages or sections given to each class member. Ask the members to glance over the headlines and stories in their sections of the paper. Are the news items upbeat or depressing? Are there more negative or positive stories? Are there things that seem repetitious—events that have occurred before or that happen repeatedly?

Pose the question, Does history repeat itself? Is there a sameness about life? Go around the class and get an opinion from every member.

Share the different theories of history mentioned above. Note what the writer of Ecclesiastes says in 1:14. Do your class members agree with this observation?

Developing the Lesson

I. *Introducing Ecclesiastes*
 A. *Initial impressions*
 Ask the class to silently read Ecclesiastes 1:1-11. How do the members feel about the attitude of the writer? Is he unduly negative and pessimistic? Is there some truth in what he is saying? Refer to the comments by Dr. McGeachy and Dr. Winters on this passage. Some class members may remember the old song by Peggy Lee, "Is That All There Is?" which reflects much of the same outlook on life.

 B. *Background on the writer*
 Ask: Who was the writer of Ecclesiastes? Some members may point to verse 12 and suggest Solomon was the writer. Note the lesson commentators' views on this. Because Solomon was considered the wisest king who ever lived, it was natural for writers of the time to cast themselves in the role of this great sage to give prestige to their work. This was a common practice in ancient times and should not be regarded as deceptive. In terms of inspiration and authority, the Spirit of God could certainly have used the Preacher, whoever he was, as well as Solomon.

II. *Thinking about the meaning of life*
 A. *The Preacher's search*
 Consider with the class the things the Preacher looked to in order to find meaning in life.
 1. Wisdom (1:16-18; 2:12-17). Even Solomon, the wise king, failed at bringing unity and harmony to his kingdom. Human wisdom has its limitations. Proverbs 3:5, 7 warns against relying on one's own understanding and being wise in one's own eyes.
 2. Pleasure (2:1-3). People try alcohol and drugs both to bring pleasure to life and to escape the meaninglessness of life. How ironic that what is looked to as the solution to a problem becomes a problem itself.
 3. Material possessions (2:4-11). The description of what the Preacher did to acquire more and more material goods reminds us of the parable of the rich fool told by Jesus (Luke 12:16-21). See also Ecclesiastes 5:10.

4. Work (2:18-23). When we hear such phrases as "the dignity of labor," "honest toil," and "the Protestant work ethic," we assume that life's purpose can be found in good, hard work. How often, when meeting a person, do we ask, "What do you do?" We tend to identify (even judge) individuals by their jobs. Yet the Preacher seeks work as vanity also. Does your class agree? Should not work give meaning to one's life? Is all work toil? If one's job does not give meaning to life, should one find another job?

B. The Preacher's conclusion

Read Ecclesiastes 2:24-26. Also have two class members read aloud Ecclesiastes 5:18-20 and 9:7-10. What do these passages say to your class? Note Dr. McGeachy's comment on this and the main point that life has no meaning apart from God (Philippians 1:21). We cannot save ourselves from the futility and sin of life. Only Christ can do this (Ephesians 2:8-10).

Helping Class Members Act

Ask your class members to think about times when they felt life was futile or when they felt discouraged, even depressed. What turned them around? What brought encouragement and hope to them? Invite those who are willing to share their experiences with the class. Some may feel comfortable giving a testimony to God's grace in helping them overcome a pessimistic or depressed spirit. However, if no one volunteers, do not press the class but move to another activity.

Suggest that the class members call out words or phrases that convey to them the real meaning of life. Words such as "God," "love," or "redemption" might be used, or phrases such as "Jesus is Lord," "abide in Christ," or "doing the will of God." As the words and phrases are mentioned, write them on the chalkboard. Note that most of these words and phrases are New Testament concepts. The pessimism of the Preacher drives us to the optimism of the New Testament.

Close the session with a time of sentence prayers. Encourage the class members to offer a prayer of thanks to God for specific blessings they have received from the Lord.

Planning for Next Sunday

Ecclesiastes 3, the scripture for next week, contains a very familiar passage (verses 1-9). Several popular songs have been written based on the words of this passage. Ask class members if they can find these songs, either in sheet music or recordings, and bring them to class.

God's Acts Endure

Background Scripture: Ecclesiastes 3

The Main Question—Pat McGeachy

This is a lovely chapter, as well quoted as any part of the Bible. It was read at President John F. Kennedy's funeral. It has been set to music by popular vocalists and has risen to the top of the charts. It is the favorite of many. And it is misunderstood by nearly everybody.

It is *not* a statement in favor of moderation and balance ("Sometimes you should be silent, and sometimes you should speak"). It is, rather, a description of the futility of human effort, very much in the spirit of Ecclesiastes 1:1-14. The word "time" is meant here in the sense of "occurrence" or "happening." It is in the haunting sense of the old spiritual:

> Sometimes I'm up, sometimes I'm down,
> Oh, yes, Lord.
> Sometimes I'm almost to the ground,
> Oh, yes, Lord.
> Oh, nobody knows the trouble I've seen.

Time goes by in its same old round, and what gain do I have from all of my labors? (verse 9) It is true that God has made everything beautiful and put eternity in my heart (verse 11). But not so's I can understand it! All I know is, there is wickedness in the world, even in the courts, where there should be justice (verse 16). Maybe God will judge the wicked, but in the end we all end up with the beasts (verse 20).

The main question, then, for us, as we ponder this chapter, is this: How do we get from breakfast to bedtime? In other words, given the fact that we live in a world where events seem futile, how can an ordinary human being hope to cope? What can we do with the tiny hint of eternity in our hearts? Must we live in anguished ignorance about tomorrow? (verse 22). In this chapter Ecclesiastes is asking the same question that Job asked and attempted to answer (Job 14 and 19): "How can I find meaning and a vindication of the purpose in my life, in a world devoid of meaning?" Many are asking that question today.

As You Read the Scripture—Mike Winters

Ecclesiastes 3:1-15. This Hebrew poem expresses a deterministic philosophy of life. Its conclusions are fivefold: (1) The task is defined, as per verses 2-8 (verse 10); (2) continuity is lost from one generation to the next (verse 11); (3) make the best of every situation (verses 12-13); (4) life is predetermined (verse 14); and (5) the future pursues the past.

Verses 1-9. Each verse presents two pairs of contrasted words. The two pairs of words within a verse are parallel in order and meaning. Compare the meaning with Ecclesiastes 1:2-11.

Verse 1. The same Hebrew word has here been translated as both "season" and "time"; these two words complement each other, amplifying

the idea that there is an appointed time for everything. It is this appointed time that the poem illustrates.

Verse 2. "Born" and "die," "plant" and "pluck up what is planted," are parallel pairs. They describe the giving and taking of life in the cycle of time or seasons.

Verse 3. "Kill" and "heal," and "break down" and "build up," are parallels. They are linked by the theme of destruction and restoration.

Verse 4. The parallel words in this verse are "weep" and "laugh," "mourn" and "dance." They point to the repeating rhythm of joy and sorrow.

Verse 5. The words "cast away stones" and "gather stones together" translate a Hebrew idiom referring to sexual intercourse. They are parallel to "embrace" and "refrain from embracing," sharing the theme of intimacy.

Verse 6. "Seek" and "lose," and "keep" and "cast away" are descriptive of relationships with tangible and intangible possessions.

Verse 7. The parallel pairs "rend" (the ritualistic tearing of a garment at a time of mourning—see Genesis 37:29, 34) and "sew," "keep silence" and "speak," share the agony of sorrow (compare II Samuel 12:15-20).

Verse 8. While the relationship of the pairs in verses 2-7 is parallel (i.e., in verse 7 the words "rend," from the first pair, and "keep silence," from the second pair, both appear first in their sequence), here the sequence is opposite. "Love" in the first pair is opposite "war" in the second, and "hate" in the first pair is opposite "peace" (shalom) in the second. They both describe the ebb and flow of human relationships.

Verse 9. Compare with verse 1:3. This question is based on the verities of human life and is illustrated in verses 2-8.

Verses 10-15. In these verses is the response to the question in verse 9.

Verse 10. Compare with verse 1:13. Verses 2-8 describe the "business" or "occupation" of humanity. They are general occupations, meaning they are the labor of every human regardless of training or skill in other occupations.

Verse 11. This is a most difficult verse, made difficult by the word translated from the Hebrew as "eternal" ("world" in the King James Version). The meaning of the verse might best be described in this illustration. When World War II was brought to the cities of Europe and the centers of culture, much of their art, literature, museums, and architecture was destroyed. After the war, the restoration of civilization was begun in a cultural vacuum, without point of reference. Even though there is a timelessness about some things, all things are temporal. This temporal sphere is the point of reference from which humanity tries to measure God's eternity—a hopeful but futile task.

Verses 12-13. See comments on verse 2:24 in lesson 9.

Verse 14. Life is unchangeably predetermined by God.

Verse 15. This verse describes time and life in a repeating cycle.

Selected Scripture

King James Version	Revised Standard Version
Ecclesiastes 3:1-15	*Ecclesiastes 3:1-15*
1 To every *thing there is* a season, and a time to every purpose under the heaven:	1 For everything there is a season, and a time for every matter under heaven:

2 A time to be born, and a time to die; a time to plant, and a time to pluck up *that which is* planted;

3 A time to kill, and a time to heal; a time to break down, and a time to build up;
4 A time to weep, and a time to laugh; a time to mourn, and a time to dance;

5 A time to cast away stones, and a time to gather stones together; a time to embrace, and a time to refrain from embracing;

6 A time to get, and a time to lose; a time to keep, and a time to cast away;
7 A time to rend, and a time to sew; a time to keep silence, and a time to speak;
8 A time to love, and a time to hate; a time of war, and a time of peace.
9 What profit hath he that worketh in that wherein he laboureth?
10 I have seen the travail, which God hath given to the sons of men to be exercised in it.
11 He hath made every *thing* beautiful in his time: also he hath set the world in their heart, so that no man can find out the work that God maketh from the beginning to the end.
12 I know that *there is* no good in them, but for *a man* to rejoice, and to do good in his life.
13 And also that every man should eat and drink, and enjoy the good of all his labour, it *is* the gift of God.
14 I know that, whatsoever God doeth, it shall be for ever: nothing can be put to it, nor any thing taken from it: and God doeth *it,* that *men* should fear before him.
15 That which hath been is now; and that which is to be hath already been, and God requireth that which is past.

2 a time to be born, and a time to die;
 a time to plant, and a time to pluck up what is planted;
3 a time to kill, and a time to heal;
 a time to break down, and a time to build up;
4 a time to weep, and a time to laugh;
 a time to mourn, and a time to dance;
5 a time to cast away stones, and a time to gather stones together;
 a time to embrace, and a time to refrain from embracing;
6 a time to seek, and a time to lose;
 a time to keep, and a time to cast away;
7 a time to rend, and a time to sew;
 a time to keep silence, and a time to speak;
8 a time to love, and a time to hate;
 a time for war, and a time for peace.
9 What gain has the worker from his toil?
10 I have seen the business that God has given to the sons of men to be busy with. 11 He has made everything beautiful in its time; also he has put eternity into man's mind, yet so that he cannot find out what God has done from the beginning to the end. 12 I know that there is nothing better for them than to be happy and enjoy themselves as long as they live; 13 also that it is God's gift to man that every one should eat and drink and take pleasure in all his toil. 14 I know that whatever God does endures for ever; nothing can be added to it, nor anything taken from it; God has made it so, in order that men should fear before him. 15 That which is, already has been; that which is to be, already has been; and God seeks what has been driven away.

The Scripture and the Main Question—Pat McGeachy

Times and Seasons (Ecclesiastes 3:1-9)

I don't believe it will be necessary to interpret this section verse by verse, since the meaning of most of the words is quite clear. They deal with the commonplace things of life: love, laughter, weeping, killing, dying, healing, embracing, rending and sewing, war and peace. And all these things just seem to happen. I have been seeing lately on some rather tired looking automobiles a yellow bumper sticker that says, in effect, "Stuff Happens." And so it does. I have watched it in my lifetime. Four seasons of relative peace sandwiched in between three wars. Happy times and sad. The breaking up of relationships and the establishing of new ones. Rending and sewing, birth and death, grief and gladness.

A friend of mine applied for a job as a counselor at a mental hospital. During part of the examination, a psychologist said to him, "I perceive that you are a strong person." "I never thought of myself that way," he said. "Why do you say that?" "Because," said the counselor, "according to your bio, you are thirty-five years old, and you have moved thirty-six times in those thirty-five years. Anyone who can go through that much grief in the breaking off of relationships and still remain fairly stable is bound to be a strong person." I agree. In fact, I think it is a wonder that most people do as well as they do in this up-and-down staircase of a world. Perhaps we are stronger than we know. At any rate, Ecclesiastes is plenty strong. He has the courage to stand looking objectively at the world in which he lives and face with honesty its seemingly gainless turning and turning. "For everything there is a season."

It helps me, in dealing with the problem of time, to make a distinction between what I call "clock time" and "quality time." Clock time is duration—the ticking of a watch, or the turning of pages on a calendar. It sometimes moves fast or slow, depending on the relative enjoyment we are experiencing. Quality time, on the other hand, has no movement at all. It is the time that we have when we are totally absorbed in what we are doing, and altogether unconscious of the passage of clock time. It does not have to last long in terms of minutes or hours to be very useful. If parents would spend more quality time with their children, they could worry less about how much clock time they have for them in these busy days. Husbands and wives should make quality time for each other, and each of us should spend quality time with ourselves and God. When I am conscious of quality time, I am much more able to cope with the seeming meaninglessness of the kinds of times Ecclesiastes is talking about.

A Dream of Eternity (3:10-15)

When I was in the kindergarten class in my church, I remember seeing a beautiful picture of autumn leaves, with a shiny-eyed child looking at them

in wonder. Overhead a bird perched and sang. Clouds drifted by in an October sky. The picture touched my childish heart, and I read with gladness the caption beneath it: "God Has Made Everything Beautiful in Its Time." Those words touch me still as I read them. But it was not until I was grown that I found that my kindergarten teachers had not told me the whole story. The verse does not end there. It goes on to say, "also [God] has put eternity into man's mind, yet so that he cannot find out what God has done from the beginning to the end."

The vision of eternity, like the autumn leaves, is fragile and fleeting; today it is alive, and tomorrow it is cast into the oven (Matthew 6:30; see also Psalm 90:5-6). "What do we know of God's plans?" asks Ecclesiastes. We are to eat and drink and enjoy our work (verse 13), but there is nothing we can do to change what God has done or is doing or will do (verses 14-15).

I don't know what Ecclesiastes meant by eternity. For me, it does *not* mean endless time; certainly not endless clock time. The old gospel song promises us that the day will come when "the trumpet of the Lord will sound and time shall be no more." Then we will enter, I suppose, into a state *qualitatively* different from that which we are in now. But what do I know? Like Ecclesiastes, I am not privy to the secret plans of God. Not even Jesus was! Remember how he said, "It is not for you to know times or seasons" (Acts 1:7), and before that, "Of that day and hour no one knows, not even the angels of heaven, nor the Son, but the Father only" (Matthew 24:36). All I do know is that there is a longing for eternity in my heart, which will not let me alone. As Augustine said, "Thou hast made us for thyself, O God, so that our hearts are restless, till they rest in thee." But, Ecclesiastes would add, when will there ever be an end to all this unrest?

The Dust Gets Us All (3:16-22)

In this section, Ecclesiastes concludes that we are like the beasts. In this, he is consistent with modern science, which has made it pretty clear that we are made out of the same stuff as the creatures "under our feet" (Psalm 8:6). The difference between ourselves and the other animals is slight. I think it was Mark Twain who said, "Man is the only animal who blushes," and then added, "or needs to." But I believe that what makes us different from the beasts and give us the "image of God" of Genesis 1:27 is our capacity to reflect. Indeed, it is our capacity to write a book like Ecclesiastes. A bear and a man may both pick blackberries, but the bear will not dwell on it. It takes a man to ask, "Why do I pick blackberries day after day, among the chiggers and the thorns? Vanity of vanities; all is vanity."

As we pointed out at the beginning, this chapter of Ecclesiastes makes us think of Job's agonizing speculations about life and its meaning in Job 14 and 19. Of course, Job's concerns were born out of the agony of wretched suffering, and, so far as we know, Ecclesiastes was in good health. Job's pain goes deeper and his hope soars higher, as he declares, almost defiantly, in chapter 19:25-27:

> For I know that my Redeemer lives,
> and at last he will stand upon the earth;
> and after my skin has been thus destroyed,
> then from my flesh I shall see God,
> whom I shall see on my side,
> and my eyes shall behold, and not another.

Job is saying, "Somewhere, someday, somebody is going to set things right." He is affirming his faith in the ultimate justice and goodness of God.

Ecclesiastes does not go as far as Job, but he does dig more thoroughly into the problem of life and concludes that apart from intervention by the grace of God, there is no hope for us. So verse 22, and others—there is nothing for it but to get on with the business of living.

And into the breach steps Jesus, and he gives the answer, not so much in terms of his own wisdom teaching, though it is there, but in his own life, death, and resurrection. That is the good news that Ecclesiastes doubted and Job predicted; a dawn that neither of them could have quite comprehended but which rose like the sun "with healing in its wings" (Malachi 4:2).

How, then, do we get from breakfast to bedtime? By admitting with Ecclesiastes that our times are in the hands of God alone, and by trusting in God to bring things round. "This is the end of the matter," he says in the last verses of his last chapter. "All has been heard. Fear God and keep his commandments; for this is the whole duty of man. For God will bring every deed into judgment, with every secret thing, whether good or evil." What a courageous statement for a man who never heard a Christian sermon!

Helping Adults Become Involved—Ronald E. Schlosser

Preparing to Teach

Ralph Waldo Emerson advised, "Adopt the pace of nature: her secret is patience." A young biology student was studying a cocoon from which a butterfly was struggling to free itself. Desiring to help the little creature, he cut away the fragile walls of the cocoon with his small knife. What emerged was not a beautiful butterfly but a helpless creature with shriveled wings, unable to fly or even to walk. The cocoon had been opened too soon. The time for the butterfly to develop strength and maturity through struggling had been bypassed. In his eagerness to speed the natural process, the youth actually hurt what he was attempting to help.

In today's session the class will be exploring the meaning of time and how it affects our day-to-day lives. The scripture to be studied contains the familiar passage in Ecclesiastes about time, from which have come the lyrics of several contemporary songs. The most popular of these is "Turn, Turn, Turn" by the Byrds. If you have a recording of this song, you might bring it to the session.

In planning your lesson, carefully read the sections "As You Read the Scripture" and "The Scripture and the Main Question." These form the heart of the lesson. The ideas, insights, and suggestions in these sections should be employed throughout your lesson plan.

There are three suggested learning goals: (1) to see the futility of human existence when it lacks a purpose rooted in faith in God, (2) to analyze how we cope with problems, and (3) to resolve to try new ways of coping based on a commitment to seek God's help.

Have a supply of pencils and three-by-five-inch index cards on hand for use in the session. Also prepare copies of the "Self-Analysis Form" described in the concluding activity of the lesson plan. In developing the lesson, the following outline may be used after introducing the main question:

 I. Considering Ecclesiastes 3:1-9
 A. Times and seasons
 B. Clock time and quality time
 II. Considering Ecclesiastes 3:10-15
 A. A vision of eternity (verses 10-11)
 B. God's gift (verses 12-13)
 C. God's omnipotence (verses 14-15)
 III. Considering Ecclesiastes 3:16-22

Introducing the Main Question

Basic and helpful ideas are presented in the section "The Main Question." These ideas are essential in helping to identify the purpose of the lesson.

Begin by asking the class to think about the following questions: (1) What is your favorite season? Why? What things do you like to do at that time of the year? (2) What is your favorite time of day? Why? What is the hardest part of the day for you?

Write these questions on the chalkboard or newsprint. Ask the class to divide into groups of twos or threes to discuss them for a brief time. After about five minutes, call the class together for general sharing. Then refer to Dr. McGeachy's phrasing of the main question: "How do we get from breakfast to bedtime?"

Developing the Lesson

I. Considering Ecclesiastes 3:1-9

A. Times and seasons

If you have a recording of "Turn, Turn, Turn," play a portion of it for the class. Then read aloud Ecclesiastes 3:1-9. For special effect, you might have the class read responsively. As teacher, you read the first verse. Then have half the class read the first couplet in the succeeding verses, and the other half the second couplet. For example, one group will read, "a time to be born, and a time to die," and the other group, "a time to plant, and a time to pluck up what is planted." You then would conclude by reading verse 9 yourself. Be sure everyone reads from the same version of the Bible.

Ask the class, What does this passage say to you? Note Dr. McGeachy's comment that this passage is *not* a statement in favor of moderation and balance, as many interpret it. Rather, it is a description of the futility of human effort. Do your class members agree? Why or why not?

B. Clock time and quality time

Refer to the distinction between "clock time" and "quality time" that Dr. McGeachy makes. He gives several examples. Can your class think of others?

Do a verse-by-verse analysis of the passage, following the comments of Dr. Winters.

II. Considering Ecclesiastes 3:10-15

Read aloud Ecclesiastes 3:10-15, and again ask the class, What does this passage say to you? Note that these verses are the response to the question in verse 9.

A. *A vision of eternity (verses 10-11)*
See especially the comments of Dr. McGeachy and Dr. Winters on verse 11. What does "eternity" mean to your class? Dr. McGeachy quotes words from the gospel song, "When the Roll Is Called Up Yonder." What other hymns and gospel songs speak of eternity? ("Face to Face," "O That Will Be Glory," "When We All Get to Heaven," and "While the Years of Eternity Roll" are some of the more familiar ones.)

B. *God's gift (verses 12-13)*
These verses recall what was said about work in the lesson for July 29. See Ecclesiastes 2:24, also 4:18-20 and 12:13-14.

C. *God's omnipotence (verses 14-15)*
How do your class members feel about the statement, "There is nothing we can do to change what God has done or is doing or will do"? Is everything predetermined?

III. Considering Ecclesiastes 3:16-22
If time allows, discuss the concluding verses of Ecclesiastes 3. Note Dr. McGeachy's comparison of this passage with Job 14 and 19. Does your class affirm the belief that in the end God's goodness and justice will prevail?

Helping Class Members Act

Distribute pencils and copies of the following "Self-Analysis Form":

1. How do I usually deal with a problem at home with a family member? *(Check all that apply.)*
——Avoid it, hoping it will pass.
——Talk it over with the person involved.
——Talk it over with a friend.
——Pray about it, asking God's guidance.
——Make arbitrary or unilateral decisions about it.
——Other (explain).

2. How do I usually deal with a problem at work or at church? *(Check all that apply.)*
——Avoid it, hoping it will pass.
——Talk it over with a friend.
——Pray about it, asking God's guidance.
——Make arbitrary or unilateral decisions about it.
——Other (explain).

3. When I'm bothered by a personal problem, the thing that helps me most is: ————————————————————————————

Give the members time to respond to the questions silently, then ask if any would be willing to share their responses aloud. Discuss item 3 in particular, noting the different ways of coping with problems that have proven helpful to your members.
Distribute index cards to the class and ask each person to write down one new approach he or she is willing to try the next time a problem looms. Close the session with the members sharing their responses together.

Planning for Next Sunday

The scripture for next week, Matthew 7:13-29, contains Jesus' prescription for a satisfying life. How would your class members summarize it in one or two sentences?

UNIT IV: WISDOM IN THE NEW TESTAMENT
Horace R. Weaver

THREE LESSONS **AUGUST 12–26**

"Wisdom in the New Testament" presents wisdom literature of the New Testament. One lesson, from the Gospel of Matthew, depicts Jesus as an authoritative teacher of wisdom. Two lessons from James suggest that God is the source of all true wisdom and that the proof of wisdom is in one's life and works. The three lessons are as follows: "Choosing the Way of Life," August 12, asks, Where will I turn to find the secret of life? "Searching for Wisdom," August 19, asks, simply, Where shall wisdom be found? "Hear and Do," August 26, states the problem: Given that we know what is wise, how can we find the strength to do it?

LESSON 11 AUGUST 12

Choosing the Way of Life

Background Scripture: Matthew 7

The Main Question—Pat McGeachy

At long last comes the dawn that Job, Psalms, Proverbs, and Ecclesiastes have been longing for and hinting at, the coming of One who taught as one who had authority, and not as a scribe. What do you suppose that meant? In a strong clear voice? With a ring of conviction? I suspect that it means simply that he spoke as one who knew what he was talking about, rather than quoting from dusty, obscure, irrelevant manuscripts. In the Sermon on the Mount, Jesus is not simply stringing together a series of quotes. It seems a little that way to us because so much of the sermon itself has found its way into our everyday language. But Jesus is quoting himself!

Truly, he was one of the wisdom school. He, too, took illustrations from nature and spoke of the common things of life. And from these observations and a deep familiarity with the Scriptures of his ancestors, Jesus drew a philosophy of life that the common people heard with gladness. It came to them as grace; those who would hear heard it joyfully.

It is too bad we do not have time to look at the whole sermon, or indeed all of Jesus' teachings, for they are rich with wisdom. But there is enough here for our purpose. Jesus will help us answer for ourselves this very day the question that confronts us all: What shall I do with my life?

This is not merely the question high school students ask guidance counselors. It is the daily question of all of us: Where will I turn to find the secret of life, that I may follow it joyfully for all my days? That way is not easy to find; it is narrow and hard. But find it we will if we follow the One who points the way. Let us look at this one chapter from his wisdom teachings, and see what sort of map we can discover for our journey.

As You Read the Scripture—Mike Winters

In Matthew there are five major collections of Jesus' teachings. The first is the Sermon on the Mount in chapters 5–7. The others are found in 9:35–11:1; 13:1-58; 18:1–19:1; and 24:1–26:2.

Matthew 7. This is the conclusion of the first major section of Jesus' teachings, which begins with the Beatitudes (5:3-12). It contrasts the old, traditional understanding of the law with Jesus' new understanding (5:17-48); includes the Lord's Prayer, with teachings about the new piety (6:1-34); and contains certain warnings (7:13-27).

Verses 13-14. The way of unrighteousness is marked with beckoning, attractive, but ultimately deceptive roadsigns. The way of righteousness is the way of discipline and restraint (compare Luke 13:23-24 and Psalm 1).

Verse 13. The Greek word translated in the Revised Standard Version as "narrow" was translated as "straight" in the King James, but it also can mean "restrained." The Greek word for "easy" also means "wide."

Verse 14. In the Greek, the word translated as "hard" can also mean "compressed." Compare John 14:6.

Verses 15-20. See Luke 6:43-45. Though Matthew was written during a time when this kind of teaching would be a corrective for Gnostic teachings (see I John 4:1-6), Jesus' warnings in this context are strictly ethical.

Verse 15. The false prophets are the scribes, who were experts in the religious and civil law and whose decisions were the basis for the oral tradition so important in Jewish life (see Matthew 24:11, 24; John 10:12; and I John 4:1 for other treatments of the false prophet). Jesus taught a higher law than the scribes prescribed (see Matthew 5:20).

The church was characterized as sheep (Luke 12:32). Jewish leaders were characterized as wolves, because they led the people astray (Ezekiel 22:27-28).

Verse 16. This verse is repeated at verse 20. Compare Matthew 3:8.

Verse 17. See Matthew 12:33-37.

Verse 18. See James 3:12.

Verse 19. See Matthew 3:10.

Verses 21-23. More is required than the affirmation of Jesus' sovereignty. More is required than works that befit repentance. It is not stated here, but Jesus said it twice in Matthew: "I desire mercy, and not sacrifice" (9:13; 12:7; compare Hosea 6:6).

Verse 22. "That day" is the day of judgment. Compare James 2:14-17.

Verse 23. The Greek word translated as "evildoers," ("ye that work iniquity" in the King James Version) literally means "lawlessness." There

is a new, higher law. The scribes who would teach the old law teach lawlessness.

Verses 24-27. This story also appears in Luke 6:47-49.

Verse 24. Those who live by the new law are wise.

Verse 25. The new law is a firm foundation (compare this with the indelibility of the new covenant in Jeremiah 31:33).

Verse 26. Compare James 1:22-25. The fool is the one who relies on the teachings of the false prophets (scribes).

Verse 28. This is a formula Matthew uses at the end of each of the five sections of Jesus' teachings. Compare the astonishment of Jesus' audience in Luke 4:22.

Verse 29. Unlike the scribes, who appealed to the traditional authorities of law and Scripture, Jesus was his own authority (see Mark 1:22). The basis of the scribes' alienation from Jesus is rooted in this. Their hostility toward Jesus emerges for the first time in Matthew 13:57.

Selected Scripture

King James Version

Matthew 7:13-29

13 Enter ye in at the strait gate: for wide *is* the gate, and broad *is* the way, that leadeth to destruction, and many there be which go in thereat:

14 Because strait *is* the gate, and narrow *is* the way, which leadeth unto life, and few there be that find it.

15 Beware of false prophets, which come to you in sheep's clothing, but inwardly they are ravening wolves.

16 Ye shall know them by their fruits. Do men gather grapes of thorns, or figs of thistles?

17 Even so every good tree bringeth forth good fruit; but a corrupt tree bringeth forth evil fruit.

18 A good tree cannot bring forth evil fruit, neither *can* a corrupt tree bring forth good fruit.

19 Every tree that bringeth not forth good fruit is hewn down, and cast into the fire.

20 Wherefore by their fruits ye shall know them.

21 Not every one that saith unto me, Lord, Lord, shall enter into the kingdom of heaven; but he that doeth the will of my Father which is in heaven.

Revised Standard Version

Matthew 7:13-29

13 "Enter by the narrow gate; for the gate is wide and the way is easy, that leads to destruction, and those who enter by it are many. 14 For the gate is narrow and the way is hard, that leads to life, and those who find it are few.

15 "Beware of false prophets, who come to you in sheep's clothing but inwardly are ravenous wolves. 16 You will know them by their fruits. Are grapes gathered from thorns, or figs from thistles? 17 So, every sound tree bears good fruit, but the bad tree bears evil fruit. 18 A sound tree cannot bear evil fruit, nor can a bad tree bear good fruit. 19 Every tree that does not bear good fruit is cut down and thrown into the fire. 20 Thus you will know them by their fruits.

21 "Not every one who says to me, 'Lord, Lord,' shall enter the kingdom of heaven, but he who does the will of my Father who is in heaven. 22 On that day many will

22 Many will say to me in that day, Lord, Lord, have we not prophesied in thy name? and in thy name have cast out devils? and in thy name done many wonderful works?

23 And then will I profess unto them, I never knew you: depart from me, ye that work iniquity.

24 Therefore whosoever heareth these sayings of mine, and doeth them, I will liken him unto a wise man, which built his house upon a rock:

25 And the rain descended, and the floods came, and the winds blew, and beat upon that house; and it fell not: for it was founded upon a rock.

26 And every one that heareth these sayings of mine, and doeth them not, shall be likened unto a foolish man, which built his house upon the sand:

27 And the rain descended, and the floods came, and the winds blew, and beat upon that house; and it fell: and great was the fall of it.

28 And it came to pass, when Jesus had ended these sayings, the people were astonished at his doctrine:

29 For he taught them as *one* having authority, and not as the scribes.

say to me, 'Lord, Lord, did we not prophesy in your name, and cast out demons in your name, and do many mighty works in your name?' 23 And then will I declare to them, 'I never knew you; depart from me, you evildoers.'

24 "Every one then who hears these words of mine and does them will be like a wise man who built his house upon the rock; 25 and the rain fell, and the floods came, and the winds blew and beat upon that house, but it did not fall, because it had been founded on the rock. 26 And every one who hears these words of mine and does not do them will be like a foolish man who built his house upon the sand; 27 and the rain fell, and the floods came, and the winds blew and beat against that house, and it fell; and great was the fall of it."

28 And when Jesus finished these sayings, the crowds were astonished at his teaching, 29 for he taught them as one who had authority, and not as their scribes.

Key Verse: **The people were astonished at his doctrine, for he taught them as one having authority, and not as the scribes. (Matthew 7:28-29)**

Key Verse: **The crowds were astonished at his teaching, for he taught them as one who had authority, and not as their scribes. (Matthew 7:28-29)**

The Scripture and the Main Question—Pat McGeachy

Do Not Judge (7:1-5)

I suspect this commandment of having been broken more often than any other. Not everyone murders or commits adultery, but we all stand in judgment on each other. And the holier we get, the better we get at being judgmental. (Indeed, I am violating the thing at this moment by accusing everyone else of being judgmental.) Of course, we should all have good judgment, in the sense that that word has come to mean: making thoughtful decisions. But Jesus' prohibition is against judgment in the judicial sense:

trying and convicting another. The shortest and most common form that this judgment takes is "Go to hell." But only God has the right to give such orders.

We do it when we refuse to take communion with another Christian because we do not agree exactly with their way of doing or saying things. We do it when we look down our noses at others who are not as well dressed, or as sophisticated, or (God forbid) as attractive as we think we are. We do it when we find fault with our neighbor, picking at the splinter in the other's eye and failing to notice the two-by-four in our own. We do it all the time, and so does everybody else; it's too bad you are so much worse at it than I am!

Keep the Holy Things Safe (7:6)

Now Jesus seems to be saying the opposite of what the last verses intended. We are to withhold from others holy things. The word? The sacraments? Must we then judge others as unworthy? No, they must take that judgment upon themselves. We are to say, "Whosoever will, let them come," and then they are to come or not. What we must not do is indiscriminately scatter the Eucharist like birdseed before the world, or waste our wind on street corners. (Does this have something to say to the electronic church?)

The first-century teachings of the church contained this admonition: "Let no one eat or drink of your Eucharist, except those who have been baptized in the name of the Lord, for it is concerning this that the Lord hath said, 'Give not that which is holy unto the dogs'" (The Didache). Thus we wait patiently for the Spirit to move the people with a desire for religion, and then we respond to them with open arms.

God Loves Better Than We Love (7:7-12)

"Everyone who asks receives." Perhaps no Bible promise has been so disturbing or so discussed or doubted. It helps me to turn the example around. Jesus has said, "If you, mean as you are, know how to treat your children, don't you think God can do better?" Then he says, "If your child asks for bread, will you give him a stone? Or if for a fish, will you give him a snake?" But turn it around, using the same illustration. If your child asks for a stone to eat, would you not give him bread instead? If the child asks for a snake, would you not give a fish instead? If you, mean as you are, know that sometimes children's requests must be answered in the negative in order that they may receive a positive, don't you think God can do better than that with you? No wonder sometimes our prayers seem to go unanswered.

But the main point of this paragraph is worked into the Golden Rule at last. It is not original with Jesus, at least not in its positive form. Confucius had said it long before: "Don't do anything to another that you wouldn't want done to you." And Immanuel Kant was to say something like it later on: "So live that you could freely will what you do to become a universal law." But what is unique about Jesus' form of the Golden Rule is not merely its positive statement but the fact that it is worked here into the relationship between us and God. The Law and the Prophets, Moses and Elijah, the Ten Commandments and the Preaching, are all rolled up into this one proverb (verse 12).

The Narrow Gate (7:13-14)

This seems like a hard saying, but it is really one of grace. Jesus is not claiming that the way to heaven is as hard as a steep hill would be to a crippled person. He is saying that it is hard because it means giving up pride, and most people don't want to do that. They would say with Milton's Satan, "I'd rather reign in hell than serve in heaven." But Jesus calls us to say with the psalmist, "I would rather be a lowly doorkeeper in God's house than a big shot in the tents of wickedness." Most people don't understand that and so have a hard time finding the narrow gate.

False Prophets (7:15-21)

It seems to be even harder these days to distinguish false prophets from real. Let me suggest one pretty sure method: How much do they charge? If they do not have a gospel that is free for the asking, then they are really not sheep but wolves; their teeth are knives or swords (Proverbs 30:14), and they are there to devour, not to save. You will know them by their fruits: Do they walk the walk of their talk?

Belief Means Commitment (7:21-23)

There are always some who worry about those who might not be Christians. Is there any hope for their salvation? Yes, Jesus is saying. What matters is not so much whether they call me Lord as that they do God's will. Even the Roman Catholic church, since Vatican II, has made a clear pronouncement that it is possible for those who truly are seeking after God to find salvation apart from the church of Jesus Christ, if through no fault of their own they have not heard the gospel.

The Two Houses (7:24-27)

We all know this story; perhaps we know it so well that we miss some of its points. For instance, what is the rock on which the fortunate house is built? Some may quickly answer, "Christ," perhaps because of the familiar gospel song with the chorus, "On Christ the solid rock I stand; all other ground is sinking sand." But not so! The rock, as a careful reading will remind you, is your own actions! To hear the Word and not act on it is to build on sand. To hear and act is to build on a firm foundation. Is this a denial of grace? No, it is a reformulation of the proverb that says you ought to put your money where your mouth is: Put your actions where your ears are. In other words, when you hear Jesus invite you to get in the wheelbarrow for the journey over the Jordan gorge, get in. There is no other way to cross it.

Conclusion (7:28-29)

We have come then, at last, to the feet of the master wisdom teacher. And there we have heard him say to us clearly, "Choose the course for your own life! Don't fall for the false prophets and astrologers. Don't get involved with petty judgments, or cast your pearls before swine. Ask God for help and you'll get it; follow me and do what I tell you, and you will find the narrow way that most people cannot find."

Jesus is saying to us, in effect, "You are grown-up, now. You don't need the petty morality of Proverbs or the cynicism of Ecclesiastes. All you need is to drive a stake into the truth I have brought to you, and then journey where you please."

In a way, Jesus calls us to reject him; to leave him and go forth into the world, where he will provide us with the strength and vision to find our way. He did not come to glorify himself but to give his life as a ransom for many. He promised us that we could do mightier things than he. And he offers us here his confidence in our ability to make discernments of the right sort. We are not to judge, but we are to have good judgment. That is what wisdom is all about.

Helping Adults Become Involved—Ronald E. Schlosser

Preparing to Teach

Many years ago there was a boy in England who had a dream. Though his school grades were not particularly impressive, the lad had a great desire to follow in the footsteps of his father, who had a rather high position in English public life. The boy admired his father. He often said, "The thing I want to be is to be as honest and fearless as my father." The boy's wish came true. His name was Winston Churchill.

When it comes to looking for an ideal, there is no better person to choose than Jesus Christ. The wisdom of the Old Testament is helpful in providing guidelines for life, but the teachings of Jesus and the example of his life offer the best model for wise and successful living.

In today's lesson you will be leading your class toward two learning goals: (1) to identify in the teachings of Jesus in Matthew 7 the secret for achieving a satisfying life, and (2) to write out their own personal prescriptions for living a successful or satisfying life.

Carefully read the sections "As You Read the Scripture" and "The Scripture and the Main Question." These form the heart of the lesson. The ideas, insights, and suggestions in these sections should be employed throughout your lesson plan.

Prior to the session, write out on individual slips of paper the following Scripture passages:

Luke 13:23-24	Matthew 12:33-37
Psalm 1:1-2	James 3:12
John 14:6	Matthew 3:10
Luke 6:43-45	Matthew 9:13; 12:7
I John 4:1-6	Hosea 6:6
Matthew 24:11,24	James 2:14-17
John 10:12	Luke 6:47-49
I John 4:1	Jeremiah 31:33
Matthew 5:20	James 1:22-25
Luke 12:32	Luke 4:22, 28
Ezekiel 22:27-28	Mark 1:22
Matthew 3:8	Matthew 13:57

These are the passages Dr. Winters refers to in his exposition. During the session, as you note Dr. Winters's comments you will be asking class members to read these passages aloud.

Also have available pencils and paper for the class to do an opening writing activity. After this, the rest of the lesson can be outlined as follows:

 I. Examining Jesus' teachings about judging and giving
 A. Judging (verses 1-5)
 B. Giving (verses 6-12)
 II. Exploring contracts in Christian living
 A. Two gates (verses 13-14)
 B. Two trees (verses 15-20)
 C. Two followers (verses 21-23)
 D. Two foundations (verses 24-27)
 E. Two authorities (verses 28-29)

Introducing the Main Question

Basic and helpful ideas are presented in the section "The Main Question." These ideas are essential in helping to identify the purpose of the lesson.

Begin by distributing pencils and paper and asking the class members to write down a prescription for a successful or satisfying life. They might think of themselves as doctors prescribing for patients what is needed to live a good and happy life.

Allow a few minutes for the members to do their thinking and writing, then ask them to share their prescriptions aloud. Refer to Dr. McGeachy's comments about the main question in today's lesson.

Developing the Lesson

I. Examining Jesus' teachings about judging and giving
Although the main scripture for study begins with Matthew 7:13, you may wish to examine briefly verses 1-12.
A. Judging (verses 1-5)
Ask the class members if they believe these verses prohibit judging people entirely. Is there no place for proper evaluation of people's motives and deeds? Refer to Dr. McGeachy's comments on this.
B. Giving (verses 6-12)
Verse 6 is particularly difficult. How does your class interpret it? As you consider verses 7-11, note Dr. McGeachy's suggestion of turning the requests around—that is, asking for something harmful and receiving something good. Can the class members give examples of praying for something and not getting it, yet receiving a better result? The familiar Golden Rule in verse 12 has a complementary rendering in what some have described as the Diamond Rule: "Do unto others as God would do unto you." What does your class think of this?

II. Exploring contracts in Christian living
The heart of the lesson is found in verses 13-29 of Matthew 7. As you consider each section, refer to the comments on the verses by the lesson commentators. Dr. Winters's exegesis contains numerous references to parallel Scripture passages. Distribute to the class the slips of paper you have prepared listing these passages. Have individual members read the passages as they are referred to by Dr. Winters.

A. *Two gates (verses 13-14)*

The image of walking "the straight and narrow path" has its source in this passage.

B. *Two trees (verses 15-20)*

A tree may look sound but be barren. Likewise, a gnarled old apple tree with twisted limbs and scarred bark can bear the sweetest apples. The quantity and quality of its fruit is the measure of a tree.

C. *Two followers (verses 21-23)*

Not everyone who claims to follow Christ is a true disciple—only those who do the will of God. Dr. McGeachy raises an interesting issue that your class might discuss: Is it possible for those who truly are seeking after God to find salvation apart from the church of Jesus Christ? Can one be saved without hearing the gospel?

D. *Two foundations (verses 24-27)*

As you deal with these verses, ask the class members to think about storms they have faced in their lives. What was the primary source of strength that helped them live through each storm? On the chalkboard or newsprint write this question for the members to think about and discuss: "What are the strong foundation points in my life that will help me withstand life's storms?"

Dr. McGeachy points out that the parable really talks about two builders, who choose foundations for their separate houses. To hear and act on the words of Christ is to build on rock. To not act is to build on sand. Even as a tree is known by its fruits, so too is a wise builder known by the foundation on which he or she builds.

E. *Two authorities (verses 28-29)*

Jesus had no rabbinical credentials. He did not appeal to traditional authorities as did the scribes. His authority was directly from God and was reflected in his love and compassion for all people. It is no wonder that the common people heard him gladly!

Helping Class Members Act

At the beginning of the session, the class members wrote out prescriptions for living a successful or satisfying life. Ask them now to look at their statements and determine if they would like to revise them, in light of what has been discussed in the lesson. How might they summarize Jesus' teachings in Matthew 7? If it is appropriate, after some have shared their statements read Dr. McGeachy's summary.

Planning for Next Sunday

The background scriptures the members should read in preparation for next week's lesson are James 1:1-8 and 3:1–4:12. Ask the members to think about the place of doubt in a Christian's life. Should true Christians ever have doubts?

Searching for Wisdom

Background Scripture: James 1:1-8; 3:1–4:12

The Main Question—Pat McGeachy

"Where's it at?" as some people say nowadays. We've been talking together for more than ten weeks about wisdom, and we can surely agree by now that it is greatly to be desired—yea, more than fine gold, or honey from the honeycomb. But if you don't have it, how do you get it? It is not easy to find. See what Job has to say about this question (Job 28). After struggling with the mystery of its hiding place, he concludes (verses 23-28) that God alone knows where it is, and that to fear God is to begin the search for it. How *do* you go about looking for it?

The strain of wisdom literature runs throughout Hebrew history, from Solomon to the author of Proverbs (about 200 B.C.). And we find it in the New Testament, too! Jesus was a great wisdom teacher, and so was James. If, as tradition has it, this James was the brother of Jesus, we should not be too surprised to find him using the same sorts of references to nature, and expressions similar to those of his brother.

In the opening verses of James 1 and the portions of chapters 3 and 4 that we have been given for our study, it is clear that James is engaged in the same search as we: How do you get wisdom? So let's have a look at this first-century disciple, a biblical writer who has often been misunderstood but is clearly down-to-earth. James is "our kind of people," a person who experiences the common drift of life and knows what he's talking about when it comes to daily living. Like Ecclesiastes, James experienced some difficulty getting into the Bible, but thank God he did! We would be the poorer without his social gospel, his commitment to responsible discipleship, and his strong marching orders to struggling Christians about how to get on getting on.

In verse 5 of chapter 1, James says, "If you lack wisdom, ask God." And with that simple beginning, let us take a look at Job's old question: Where shall wisdom be found?

As You Read the Scripture—Mike Winters

James is a pastoral letter in sermon form that treats of the ethical life of Christianity. A fair summary of James's theme is found in 2:14.

James 1:1. It is not likely that the author was the brother of Jesus. The Dispersion or Diaspora began with the ten tribes of Israel who were exiled by the Assyrians in 721 B.C. Later, the term came to be used for all Jews living outside of Palestine, including Jews from Judah. James's audience is not necessarily Jewish but inclusive of Christians of origins other than Jewish (see I Peter 1:1). The word "greeting" literally means "rejoice," in the Greek.

Verse 2. The "trials" are the tests Christians endure to strengthen their ʾh. In Jesus' temptations, the devil wanted Jesus to fail (Matthew 4:1-11).

438

Verse 3. This "testing" is a litmus test. Those who pass are truly of the faith. The Greek word for "steadfastness" means "to bear long."

Verse 4. "Full effect" is from the Greek word meaning "ended" or "complete." This testing is likened to the training to which an athlete submits—grueling, requiring discipline, but endured to increase strength and stamina.

Verse 5. The readers are exhorted to pray for wisdom. Wisdom, here and in 3:13-18, is considered a gift from God. It is evidenced in the ethical life. God answers prayers "generously" and "without reproach" (scolding).

Verse 6. The readers are asked to pray in faith without "doubting" (hesitation). The image of the tempest-tossed wave describes the plight of the wicked set forth in Isaiah 57:20.

Verses 7-8. The Revised Standard Version word "double-minded" can be literally translated from the Greek as "two-souled." Two-souled people are "unstable," unable to be disciplined. Failure to be disciplined in prayer is a characteristic of people unable to be disciplined in all matters of faith (or ethics).

James 3:13. James poses and answers a rhetorical question that is clarified in 3:14-18. The word here translated "understanding" is from the same Greek root as the word "faith." Who are the wise and understanding? The answer is found in the ethics of one's life.

Verses 14-16. These verses tell what wisdom is not.

Verse 14. Those who boast of being wise but whose characters are marked by "bitter jealousy" and "selfish ambition" live a lie. In this context, the "heart" is the seat of character rather than emotion.

Verse 15. Bitter jealousy and selfish ambition are "earthly," primordial laws (related to Paul's "elemental spirits" in Galatians 4:3 and Colossians 2:20), "unspiritual" ("animal" in the Greek) and "devilish" (since "devilish" has connotations of cuteness in our language, a better word would be "demoniacal").

Verse 16. Jealousy and selfish ambition are the sources of "disorder" (instability) and "vile practice" (read immorality).

Verses 17-18. These verses define true wisdom.

Verse 17. The Greek word translated as "pure" shares the same root in the Greek as the Greek word for "saint." "Open to reason" can also mean "easily persuaded" (for our day, an interesting reading might be "not litigious"). "Good fruits" are the same as Paul's "fruit of the Spirit" (Galatians 5:22-23). "Insincerity" would be in relationship to faith (see James 2:17).

Verse 18. True wisdom is evidenced in peace (the quality of human relationships).

Selected Scripture

King James Version	Revised Standard Version
James 1:1-8	*James 1:1-8*
1 James, a servant of God and of the Lord Jesus Christ, to the twelve tribes which are scattered abroad, greeting.	1 James, a servant of God and of the Lord Jesus Christ, To the twelve tribes in the dispersion: Greeting.

2 My brethren, count it all joy when ye fall into divers temptations;

3 Knowing *this,* that the trying of your faith worketh patience.

4 But let patience have *her* perfect work, that ye may be perfect and entire, wanting nothing.

5 If any of you lack wisdom, let him ask of God, that giveth to all *men* liberally, and upbraideth not; and it shall be given him.

6 But let him ask in faith, nothing wavering. For he that wavereth is like a wave of the sea driven with the wind and tossed.

7 For let not that man think that he shall receive any thing of the Lord.

8 A double minded man *is* unstable in all his ways.

James 3:13-18

13 Who *is* a wise man and endued with knowledge among you? let him shew out of a good conversation his works with meekness of wisdom.

14 But if ye have bitter envying and strife in your hearts, glory not, and lie not against the truth.

15 This wisdom descendeth not from above, but *is* earthly, sensual, devilish.

16 For where envying and strife *is,* there *is* confusion and every evil work.

17 But the wisdom that is from above is first pure, then peaceable, gentle, *and* easy to be intreated, full of mercy and good fruits, without partiality, and without hypocrisy.

18 And the fruit of righteousness is sown in peace of them that make peace.

Key Verse: **Who is a wise man and endued with knowledge among you? Let him shew out of a good conversation his works with meekness of wisdom. (James 3:13)**

2 Count it all joy, my brethren, when you meet various trials, 3 for you know that the testing of your faith produces steadfastness. 4 And let steadfastness have its full effect, that you may be perfect and complete, lacking in nothing.

5 If any of you lacks wisdom, let him ask God who gives to all men generously and without reproaching, and it will be given him. 6 But let him ask in faith, with no doubting, for he who doubts is like a wave of the sea that is driven and tossed by the wind. 7, 8 For that person must not suppose that a double-minded man, unstable in all his ways, will receive anything from the Lord.

James 3:13-18

13 Who is wise and understanding among you? By his good life let him show his works in the meekness of wisdom. 14 But if you have bitter jealousy and selfish ambition in your hearts, do not boast and be false to the truth. 15 This wisdom is not such as comes down from above, but is earthly, unspiritual, devilish. 16 For where jealousy and selfish ambition exist, there will be disorder and every vile practice. 17 But the wisdom from above is first pure, then peaceable, gentle, open to reason, full of mercy and good fruits, without uncertainty or insincerity. 18 And the harvest of righteousness is sown in peace by those who make peace.

Key Verse: **Who is wise and understanding among you? By his good life let him show his works in the meekness of wisdom. (James 3:13)**

The Scripture and the Main Question—Pat McGeachy

Trusting the Source of Wisdom (James 1:1-8)

James is on our side in this quest. He knows that we have plenty of trials and conflicts (verse 2), and he helps us to whistle up our courage. "If you don't have wisdom," he enjoins us in verse 5, "ask for it!" "I never thought of that," I reply. I have been just as silly about this as about asking for directions to a strange place. It never occurred to me that all I had to do was ask! Here I have been all these years, standing foolishly in a troubled world, wondering if I was smart enough to function. And all the time, there was God, standing in the shadows with a book of instructions, waiting to give me a hand whenever I asked! Why did I never ask?

Then James adds a prescription: Ask in faith, without doubting (verse 6). He almost seems to be saying, "If you're uncertain, don't ask." But that can't be. If I were certain, why would I *need* to ask? The answer must be something like this: I am uncertain about what God's answer will be, but I am sure that God will answer. There is a form of doubting that says, "I don't know all the answers," which God celebrates and approves of. This sort of doubting is really humility, and the beginning of faith (see Proverbs 30:2-4). But there is another form of doubting, born in arrogance, that says, "I'd rather handle it myself; nobody can do it like I can." This sort of doubting leaves me as lost as a stranger in a strange land who will not ask for directions. The two forms of doubt can be summed up as follows: Faithful doubting says, "I don't know the answer, but I know God can handle it." Unfaithful doubting says, "I don't see any point to life; I might as well give up."

Talking Versus Listening (3:1-12)

James has a lot to say about the tongue. His wisdom on the subject reminds us of a number of secular sayings, such as, "It is better to remain silent and be thought a fool than to speak and remove all doubt" or, "Actions speak louder than words." And I saw the following dictum on a church bulletin board just today: "How rare are those who pray silently enough to hear God speak."

It is amazing that so small a thing as the tongue can get us into so much trouble (verse 5), but it surely can, and we will do well to guard it.

James marvels (verses 6-12) at the astonishing propensity we have for being double-tongued. Out of the same mouth issue both blessings and cursings. He longs (as do we all) for the day when the speech of a person will be not that of one with a forked tongue but utterly straightforward and honest.

Wisdom and Peace (verses 13-18)

One of the ways we can test the worldly wisdoms that come along is to ask, Does it make for peace? Not too many years ago, a beggar who had made regular appearances at our church, asking for a handout, was refused by one of the elders, who said to him in as kindly a way as he knew, "We can't continue to support you any longer; you need to get a job." At this the poor man flew into an uncontrollable rage, screaming invectives at the elder who

had said no to him. "I am an angel of God!" he shouted. "You have been entertaining an angel unawares, and now you will suffer the consequences of turning away one who possesses the spirit of God." And he began to emit a stream of curses.

The elder was deeply disturbed at having unleashed such vituperation and was wondering what to say when suddenly the quiet voice of a young woman who stood beside him was heard saying, "You say you have the spirit of God, but you don't sound like it. The New Testament tells us that the fruit of the Spirit is love, joy, peace, patience, kindness, goodness, faithfulness, and self-control." As she spoke, the steam went out of the irate man, and he moved away, muttering.

In like manner, James makes it clear, we can test the wisdom we encounter. If it makes for peace, having the same fruits as the Spirit, then it may well be of God (verse 17), but if it leads to jealousy and selfish ambition, then very likely it is not the wisdom of God with which we are dealing but the very questionable wisdom of this world.

The Arrogance of Conflict (James 4:1-10)

This theme has been running throughout our whole study of the wisdom books: The cause of strife within us is our desire for self-glorification. When we magnify ourselves and our own ends, always striving to get into *The Guinness Book of World Records,* then we can expect to run afoul of our neighbor, who has the same goals and is trying just as hard as we are. We tend to trip each other on the way up the peak of excellence. But if we can remember that we are all called to rise and that, in humility, we can help one another up the slope, then we can experience a double victory: our own success and that of our neighbor as well.

It is not strange that we miss this point, for we have been raised in a culture that cries out to us from every hand that we should excel. From the crib we are taught, "Be a good child, or your stocking will be filled with sticks and stones! Better watch out! Santa Claus is checking his list." But Santa Claus is the god of a materialistic Christmas that has no part in the birth of Jesus Christ. The baby Jesus comes not to the good children who have no need of a physician, but to the publicans and sinners, the lame and the halt, the bad children. In this is the love of God, that while we were yet sinners Christ died for us (Romans 5:8), not because we measured up on Santa Claus's list.

The letter of James has the reputation of being a "works-salvation" epistle, because of what it says about faith without works (2:17). But I don't see it that way at all. James, like Paul, believes firmly that faith is the instrument of salvation (2:22-23), and Paul certainly insists that the only saving faith is a working faith (Galatians 5:6). And this section of James's letter (4:1-10) clearly calls Christians to diminish the importance of their own righteousness. Instead, we are told, "Humble yourselves before the Lord."

Judge Not (4:11-12)

If our James was not James the brother of Jesus, then we can be sure he was someone very familiar with Jesus' words, for he sounds like Jesus. Read

what the Lord had to say on judging in Matthew 7:1-5, and recall what we had to say about it in our last lesson. Once more we are confronted with the realization that James is a disciple who believes in grace, for it is grace that calls us to forgive our neighbors, just as God in Christ has forgiven us (Ephesians 4:32).

Back to the Question

In the introduction to this lesson we said that the main question it asks is, How can we find wisdom? We can now give several answers, based on these passages from James:

1. Wisdom can be found in trusting God, and not ourselves (compare Proverbs 3:5-6).
2. Wisdom can be found more by listening than by wagging our tongues.
3. Wisdom is to be found in peace, not turmoil.
4. Wisdom is to be found in humility, not arrogance.
5. Wisdom is found in a nonjudgmental approach to life.

Wisdom, in other words, can be found by drawing near to God, and the way to do this is to draw near to Jesus, who is "God with us."

Helping Adults Become Involved—Ronald E. Schlosser

Preparing to Teach

A little girl was asked by her church school teacher if she knew what a saint was. Remembering the stained-glass windows in the sanctuary picturing some of the saints of the church, the child replied: "A saint is somebody that the light shines through." In her innocent wisdom the girl accurately described the quality that should characterize all Christians: people through whom the light of Christ shines.

The apostle Paul and other New Testament writers continually referred to the early Christians as "saints." Although James does not use that specific term, certainly his description of those to whom he was writing would qualify them to be called saints. They had endured many trials and had remained steadfast (James 1:2-3). They were persons who sought wisdom in seeking and following God's will (1:5-6; 3:13).

In today's lesson you will be helping your class do two things: (1) to identify the qualities and characteristics of a wise person, and (2) to determine what would be wise decisions in several real-life problem situations.

Carefully read the sections "As You Read the Scripture" and "The Scripture and the Main Question." These form the heart of the lesson. The ideas, insights, and suggestions in these sections should be employed throughout your lesson plan.

The lesson may be outlined as follows, after you introduce the main question:

 I. Describing a wise person
 A. What do we say?
 B. What does James say?
 II. Summarizing where wisdom is found

FOURTH QUARTER

Introducing the Main Question

Begin by referring to the story of the beggar that Dr. McGeachy tells in his comments on James 3:13-18. Read the first paragraph, ending with the sentence, "And he began to emit a stream of curses." Pause and ask your class members to discuss how they would have handled the situation. Was the elder right in denying the beggar a handout? How would the members respond to the curses of the beggar?

After the members have had a chance to share their ideas, continue the story, which tells what the young woman present at the time did. What does your class think of her response? Was it effective? Why?

Indicate that today's lesson will be getting at the question, How can we find wisdom? How can we learn to say and do the wise thing when we face a problem situation? Refer to the comments of Dr. McGeachy in the section "The Main Question." He lifts up some ideas that are helpful in identifying the purpose of the lesson.

Developing the Lesson

I. Describing a wise person
 A. What do we say?

Ask the members to think for a moment about a person they know whom they would consider wise. What are the qualities and characteristics of this person? Can the members describe some wise things this person has done?

As the members identify the characteristics of wise persons they know, write them on the chalkboard or newsprint. You might get the discussion going by first sharing something about a person you yourself know whom you look upon as being wise.

 B. What does James say?

To get into the substance of today's scripture, divide the class into five groups. Ask each group to study a particular passage in the background scripture: Group 1—James 1:1-8; group 2—James 3:1-12; group 3—James 3:13-18; group 4—James 4:1-10; group 5—James 4:11-12 and Matthew 7:1-5. Each group is to discuss what its passage says about being a wise person or acting in a wise manner.

Allow about five minutes for the small groups to discuss the passage among themselves, then call the class together and share findings. As you deal with each passage, refer to the related comments by Dr. McGeachy and Dr. Winters. Deal in particular with the question of doubting (James 1:6). Is there a place for doubt in a Christian's life? Should true Christians ever have doubts?

Lord Alfred Tennyson, the nineteenth-century poet laureate of England, struggled with doubt when his close friend and colleague Arthur Henry Hallam died suddenly while still a young man. In tribute Tennyson penned his most celebrated poem, "In Memoriam," whose opening verses have become a moving hymn of faith:

> Strong Son of God, immortal Love,
> Whom we, that have not seen thy face,
> By faith, and faith alone, embrace,
> Believing where we cannot prove.

444

Later in the poem Tennyson struggles with the ambiguities of life that give rise to doubts, but he affirms in the end that "there lives more faith in honest doubt . . . than in half the creeds." When one grapples with doubts and works them through, a stronger faith emerges.

II. Summarizing where wisdom is found

Dr. McGeachy, in the last section of his comments (headed "Back to the Question"), summarizes the five passages of James just studied. We can use his summary to describe a wise person as one who trusts God (1:1-8), listens (3:1-12), is a peacemaker (3:13-18), is humble (4:1-10), and is nonjudgmental (4:11-12).

Helping Class Members Act

Use the remainder of the session to give the class an opportunity to discuss some difficult problems. Pooling their wisdom, how would the members respond to each of these situations?

1. One day, while putting away the laundry, you find a half-used container of birth control pills behind your fourteen-year-old daughter's knee socks. What would you do?

2. You know your son is bright, and he has always done well in school. But now, as a high school junior, his grades are slipping. His teachers say he is underachieving. You know that if something isn't done, he won't get into college. He says he doesn't care, but you know that in a few years he will. What do you do?

3. It is 5:00 A.M. You get a call from the police. Your seventeen-year-old daughter was picked up by police with a carload of classmates. There were several open liquor bottles and some marijuana cigarettes in the car. She is at the station house. What do you do?

4. The husband of your neighbor has been in the hospital five months following a fiery automobile accident. He received burns over two-thirds of his body, was blinded, and suffered near-total hearing loss. He has undergone extensive skin grafting and amputation of some fingers. He is in constant pain. He has stated he does not wish to undergo additional treatments but wants to go home and die. Your neighbor shares with you her dilemma. What would you say to her?

There are no right or wrong answers to these problems. They are presented to help your class members try to discover the wisest course of action to follow, based on their understanding of the guidelines in today's scripture.

Close the session with a prayer, asking for God's guidance in all the decisions—great and small—which we must make in life.

Planning for Next Sunday

The scripture for next week is James 1:22–2:26. Ask the class members to think about why they believe many Christians do not witness for Christ on a regular basis.

Hear and Do

Background Scripture: James 1:22–2:26

The Main Question—Pat McGeachy

You can lead a kid to homework, goes an old saw, but you can't make him think. (Or maybe it was about horses and water.) But the point is, you can't motivate somebody else to do something. For that matter, how do you get yourself to do anything?

When we looked last at Jesus (lesson 11), he was telling the story of two fellows who had built houses; one, built on sand, fell, and the other, built on a firm footing, withstood the elements. The first builder was a hearer only, the second a doer of the Word. Once more we have James echoing his brother Jesus and calling us to get with it.

We all know we ought to. How many proverbs do you know that call us to get to work? Never put off till tomorrow what you can do today. Early to bed, early to rise, makes a man healthy, wealthy, and wise. Go to the ant, thou sluggard . . . And so on.

But I don't need to tell you to get to work. You know you ought to. So the question is, How can we do it? I am sitting here typing this manuscript at 2:30 in the morning, hoping to get it in the mail before the publisher's deadline. Why didn't I get it done a month ago? And what keeps me up at this benighted hour, plugging away at the keyboard? Can James, the apostle of faith *with* works, help us understand our own motivations?

I believe he can, and I would like you to join me in this, our last lesson in the wisdom literature, by dealing with the question, Given that we know what is wise, how can we find the strength to do it? We could do ourselves and the rest of humankind no greater favor than to answer this one, for it is a universal question. Parents would like to be able to motivate their children, teachers would like to be able to motivate their students. And most of us wish we could motivate ourselves!

As You Read the Scripture—Mike Winters

James 1:22-27. These verses illustrate the great prophetic concern about integrity of faith. Amos 5:21-24, for example, describes God's hatred of worship unaccompanied by justice and righteousness (Amos and James would make an interesting comparative study).

Verse 22. Matthew 7:24-27 tell the story of the one who is wise, who hears the word and does it, and the one who is foolish, who hears the word and then does not do it (compare Romans 2:13).

Verse 23. Those who only hear the word are faced with looking at themselves in the mirror, where the only standard for judgment is the reflection of their external features. They are unable to see their true character, which is hidden beneath the physical features.

Verse 24. Presumably, one's self-reflection satisfies. The point is that those who only hear the word, though satisfied, are self-deceived.

Verse 25. If the law could be likened to a mirror, then when one looks into the law the reflection is not of external features but of the true character hidden in the heart. The law presents a certain standard of conduct again which one may measure one's life. They are blessed who are thus confronted with and act upon the law of God.

The "perfect law" is a description of the Old Testament law. The "law of liberty" (Galatians 5:1-26; 6:2 for the law of Christ) is a description of the law of the Gospels (see James 2:8).

Verse 26. The word "religious" here has the sense of empty worship. The worshiper says the liturgy, chants the hymns, presents the offerings, hears the word, but his or her life is without good deeds (Isaiah 1:12-17).

Verse 27. The use of the word "religion" in a good sense is a new idea. Pure, unstained, unspotted religion translates the worship experience and the Word into an ethics of love. Orphans and widows have been constantly held before the Judeo-Christian culture as the beneficiaries of compassion (Isaiah 1:17; God is described as the father of orphans and widows in Psalm 68:5).

James 2:1. In this verse is the point of the illustration that follows in verses 2-3. The kingdom (verse 5) is especially inclusive of people we do not expect to be there. Therefore, no one should act to exclude anyone from worship. The very thought of this kind of exclusiveness seems repugnant. Yet we are not too far removed from the time when people were excluded from places of worship on the basis of the color of their skin. And in some places that still occurs.

Verse 2. The picture is created. Two people come to worship, one rich, the other poor.

Verse 3. The one who is rich is given preferential treatment, while the one who is poor is directed to take a humble place.

Verse 4. In the first place, to do so is to make a tasteless decision.

Verse 5. In the second place, if preferential treatment is to be given to anyone, it is to be given to the poor (see Luke 1:48, 52, 53; 6:20; I Corinthians 1:26-28).

Verse 6. The theme of the rich repressing the poor is repeated often, especially by the prophets (see Amos 2:6-7; 4:1, 2; 6:1; 8:4-6).

Verse 7. The honorable name is Christ Jesus (Philippians 2:9-11).

Verse 8. The royal law is also found in Leviticus 19:18 and Mark 12:31.

Selected Scripture

King James Version

James 1:22-27

22 But be ye doers of the word, and not hearers only, deceiving your own selves.

23 For if any be a hearer of the word, and not a doer, he is like unto a man beholding his natural face in a glass:

24 For he beholdeth himself, and goeth his way, and straightway forgetteth what manner of man he was.

Revised Standard Version

James 1:22-27

22 But be doers of the word, and not hearers only, deceiving yourselves. 23 For if any one is a hearer of the word and not a doer, he is like a man who observes his natural face in a mirror; 24 for he observes himself and goes away and at once forgets what he was like. 25 But he who looks into the perfect law, the law of liberty, and perseveres, being

25 But whoso looketh into the perfect law of liberty, and continueth *therein,* he being not a forgetful hearer, but a doer of the work, this man shall be blessed in his deed.

26 If any man among you seem to be religious and bridleth not his tongue, but deceiveth his own heart, this man's religion *is* vain.

27 Pure religion and undefiled before God and the Father is this: To visit the fatherless and widows in their affliction, *and* to keep himself unspotted from the world.

James 2:1-8

1 My brethren, have not the faith of our Lord Jesus Christ, *the Lord* of glory, with respect of persons.

2 For if there come unto your assembly a man with a gold ring, in goodly apparel, and there come in also a poor man in vile raiment;

3 And ye have respect to him that weareth the gay clothing, and say unto him, Sit thou here in a good place; and say to the poor, Stand thou there, or sit here under my footstool:

4 Are ye not then partial in yourselves, and are become judges of evil thoughts?

5 Hearken, my beloved brethren, Hath not God chosen the poor of this world rich in faith, and heirs of the kingdom which he hath promised to them that love him?

6 But ye have despised the poor. Do not rich men oppress you, and draw you before the judgment seats?

7 Do not they blaspheme that worthy name by the which ye are called?

8 If ye fulfil the royal law according to the scripture, Thou shalt love thy neighbour as thyself, ye do well.

Key Verse: Be ye doers of the word, and not hearers only, deceiving your own selves. (James 1:22)

no hearer that forgets but a doer that acts, he shall be blessed in his doing.

26 If any one thinks he is religious, and does not bridle his tongue but deceives his heart, this man's religion is vain. 27 Religion that is pure and undefiled before God and the Father is this: to visit orphans and widows in their affliction, and to keep oneself unstained from the world.

James 2:1-8

1 My brethren, show no partiality as you hold the faith of our Lord Jesus Christ, the Lord of glory. 2 For if a man with gold rings and in fine clothing comes into your assembly, and a poor man in shabby clothing also comes in, 3 and you pay attention to the one who wears the fine clothing and say, "Have a seat here, please," while you say to the poor man, "Stand there," or, "Sit at my feet," 4 have you not made distinctions among yourselves, and become judges with evil thoughts? 5 Listen, my beloved brethren. Has not God chosen those who are poor in the world to be rich in faith and heirs of the kingdom which he has promised to those who love him? 6 But you have dishonored the poor man. Is it not the rich who oppress you, is it not they who drag you into court? 7 Is it not they who blaspheme that honorable name by which you are called?

8 If you really fulfil the royal law, according to the scripture, "You shall love your neighbor as yourself," you do well.

Key Verse: Be doers of the word, and not hearers only, deceiving yourselves. (James 1:22)

The Scripture and the Main Question—Pat McGeachy

The Law of Liberty (James 1:22-25)

We begin with the assurance that we have been approved. "Mirror, mirror on the wall," we ask, "have I any hope at all?" And the mirror, which is not the natural mirror (verse 23) but the perfect mirror of the law of liberty (verse 25), has answered: "Yes, my child, you have been made in the image of God; you can do all things through Christ who strengthens you."

And so we can go forth being doers that act. To look into the natural mirror is to believe that sin has the last word; it is to hang our heads in confession and say, "What can I do? It's no use; I might as well give up." But to hear the word of grace from the supernatural mirror, the law of liberty, is to realize that I am set free for service.

(By the way, this is one of the reasons people love to have their preachers fuss at them from the pulpit; if they can be led to feel rotten about themselves they can say, "Aw shucks, I'm useless," but if they once get the idea that they are good, made in God's image, they will have to get to work! And we lazy mortals aren't too keen about that.)

Breathing In and Out (1:26-27)

There is a kind of polarity about life in general and faith in particular. On the one hand you are enjoined to "work out your own salvation with fear and trembling" (Philippians 2:12), while at the same time being assured that "God is at work in you, both to will and to work for his good pleasure" (Philippians 2:13). So, who's doing it? The answer is, faith is both inhaling and exhaling. It's breathing in God through faith and breathing out good works. On the one hand it's "visiting widows and orphans in their troubles," and on the other it's "withdrawing from the world." It may be talking some of the time, but a lot of the time it had better be listening.

Impartiality (James 2:1-7)

There is an old joke about the church sexton who heard a knock at the door. "Who is it?" he asked. "A lonely person looking for counsel," was the reply. "Sorry, we aren't open." Soon another knock was heard. "Who is it?" he asked again. "A beggar." "Sorry, we aren't open." The third time he heard a knock and asked, "Who is it?" no reply was given, but a hundred dollar bill was slipped under the door. The sexton flung it wide, saying, "Come in, brother!"

I hope it isn't that bad yet, but it does seem that we Christians love to butter up to the bread. I see too many signs in my own work that people are falling for the notion that "rich = good; poor = bad." About once a week I hear somebody say, in one form or another, "If they weren't sinners, they wouldn't be broke." But that is not the way Jesus responded to people; he went out of his way to be with the poor. Of course, he loved yuppies too, but he had a hard time getting through to them. (Reread Mark 10:17-31.)

Again, in our passage we have evidence that James is intimate with the consciousness of Jesus and speaks as one who might well be the brother of our Lord.

Fulfilling the Law (2:8-13)

This passage is related to the preceding one. In showing partiality, we are just as guilty as one who violates one of the more obvious commandments, like "Don't kill." In our pride we are sinners just as much as murderers and adulterers are. So let us love our neighbors as ourselves. That does not make us better than our neighbors, but it does open up the possibility for our neighbors to begin living new lives as "mercy triumphs over judgment."

All Talk, No Walk (2:14-17)

James is really being funny in these verses, driving home his point through sarcasm. But at heart it isn't funny, and James knows it. It is tragic that we Christians can so blind ourselves to the facts as to believe that a gospel that shares the Word without sharing the bread is no gospel at all. Indeed, faith without works is dead.

A Genuine Faith (2:18-26)

Throughout history, the faith of our heroes—Abraham, Rahab, Wesley, Knox, you name one—is known to us not through their words but their deeds. I know a few quotes from Abraham, but mainly I know that he went out "not knowing where" (Hebrews 11:8). I know nothing that Rahab ever said, only what she did. Of the four I mentioned, I have read more of John Wesley's words, but I still picture him preaching, traveling, singing, exhorting, and struggling with the faith. It is nonsense to think that people without faith could exist apart from what they do. That is why Jesus said, "You shall know them by their fruits" (Matthew 7:20).

Conclusion

How are people motivated to wisdom? James has told us that wisdom calls us in the following ways: God affirms us through the law of liberty, saying, "You are free to go to work." God calls us both in our coming and our going, our breathing in and our breathing out. God calls us to treat all people, rich or poor, high or low, as though the ground at the foot of the cross were level. This too gives me the courage to go on. God's mercy sets me free, as I set others free by showing mercy. God's presence within me translates itself into loving deeds.

To sum all this up: God believes in me, so I can believe in myself, and when I believe in myself, I am set free to turn my believing into doing.

One of my children once was doing rather poorly in school. In spite of all the parent noises his mother and I made (things like, "With your genes you ought to be doing better than C minus"), he would reply, "I don't care." How could we motivate him when he didn't care? In our concern we went to a wise counselor, who said, "I don't believe he doesn't care." "Well, he says he doesn't." "Of course he says that," the counselor replied. "What would you say if *you* made bad grades? Probably something like, 'There's more to school than academics.' I never met anybody, man or woman, boy or girl, who didn't care when they didn't do their best."

So the next time he made bad grades (which was the next time he brought home a report card), we bit our tongues, and instead of saying, "You can do

better than that," his mother said, "I know you must be disappointed."
"Yeah, Mom, I am," he replied. "I can do better than that." And he did!
Now, I am not a child psychologist, and I do not say that will work with every
child every time. But this much I do know: Parent noises just add to the
burden, but getting down there with him and letting him know you
understand is a way of making it easier for him to do what he ought to do.

Much of the Bible is "parent noises"—thou shalts, thou shalt nots. But the
wisdom writers in general, and Jesus in particular, come and take us by the
hand. Job, Ecclesiastes, James, and the others know our frame and how
much we hurt. Jesus says to us, "I know you must be disappointed." And we
reply, "Yes, Lord, I am. I can do better than that." And with God's help we
do.

The grace of God, made known through the prophets that tell the truth
about life as it really is, sets us free to make the world a better place. May
God grant us the grace to do the same for all those around us.

Helping Adults Become Involved—Ronald E. Schlosser

Preparing to Teach

Halford E. Luccock, noted preacher, lecturer, and author, many years
ago observed that the highest compliment an orator or public speaker could
receive was "Well said!" To a theologian or philosopher the compliment
might be phrased, "Well thought!" But, said Luccock, fine speech and fine
thought are not in themselves sufficient to win the approval of Jesus. That
approval is reserved for those to whom he can say, "Well done!"

In today's lesson the class will be focusing on the "doing" part of the
Christian life. As much as we enjoy hearing God's Word and thinking
through its implications for our lives, the crucial test of our faith is how we
put that faith into action.

The three learning goals for the lesson are (1) to consider reasons why
many Christians are hesitant to witness for Christ both by word and deed,
(2) to recognize the relationship between faith and works, between hearing
and doing what God commands, and (3) to adopt a motto we can live by as
we live out our faith.

Carefully read the sections "As You Read the Scripture" and "The
Scripture and the Main Question." These form the heart of the lesson. The
ideas, insights, and suggestions in these sections should be employed
throughout your lesson plan.

Bring to the session a large mirror to illustrate a point Dr. Winters makes
in his comments about the law. Also have on hand a supply of
four-by-six-inch index cards and fine-tipped marking pens in various
colors. These will be used in the concluding activity.

After introducing the main question, you might use the following outline
to develop the lesson:

 I. Reflecting on our conversion experiences
 II. Identifying the nature of true religion
 A. What hinders action?
 B. Hearers and doers
 C. A definition
 III. Considering our treatment of visitors

FOURTH QUARTER

Introducing the Main Question

Begin by asking the class members to list reasons why, in their opinion, Christians hesitate to witness for Christ. Write the reasons on the chalkboard or newsprint as the members give them. Included might be such things as lack of knowledge of how to do it, fear, apathy, lack of conviction or spiritual vitality, busyness, not a high priority for them.

If we believe Christians should witness for Christ, how can we do what we know God wants? How can we be motivated? Note the comments Dr. McGeachy makes about this in the section "The Main Question." His ideas are helpful in focusing on the main theme of today's lesson.

Developing the Lesson

I. Reflecting on our conversion experiences

One way of getting at the matter of motivation is to think about how we were led to Christ. Ask class members to share their conversion experiences. After several have done so, examine the motivations that compelled people to witness to them or to guide them into the Christian life. List these on the chalkboard or newsprint. Included might be such motives as wanting to share the love of Christ with someone, concern about a person's salvation, desire to bring one into the joyful fellowship of the church, attempting to restore a broken relationship, and wishing for a more complete and satisfying life.

II. Identifying the nature of true religion
A. What hinders action?

In addition to a person's spiritual welfare, should Christians be concerned about a person's social or material welfare? What does your class think? Are we to be concerned about the poor, the hungry, the homeless, the sick, the dispossessed? If so, why do so few Christians get involved? Are the reasons the same as those given earlier for not witnessing for Christ (fear, apathy, busyness, etc.)?

B. Hearers and doers

Read aloud James 1:22-25. What does James have to say about getting involved? You might use a mirror as an object lesson, referring to the comments by the lesson commentators regarding the mirror of the law. Ask someone to read Galatians 5:13-16.

C. A definition

Read James 1:26-27. Compare this with Amos 5:21-24 and Isaiah 1:12-17. Does your class think James's definition of true religion is adequate? Why or why not? Refer also to James 2:14-17. Note Dr. McGeachy's comment: "A gospel that shares the Word without sharing the bread is no gospel at all."

III. Considering our treatment of visitors

Move next to a consideration of James 2:1-7. To do so, ask your class to speculate what might happen if a well-known sports figure or television personality visited your church next Sunday. How would the celebrity be treated? (Seated at the front or on the platform, given a special welcome from the pulpit, greeted afterward by all the members.)

Now suppose a poorly clothed, foul-smelling, unkempt individual wandered into the sanctuary from off the street. How would that person be treated? (Be seated in the rear or even be asked to leave, be ignored by most folk, be discouraged from attending again.)

Ask your class to consider if any of the following people would be welcome in your church: people of another race, ethnic group, social standing; people on welfare; people with alcohol or drug problems; people who are outspoken fundamentalists or liberal social activitists. Why would or wouldn't they be cordially greeted in your church? What is the difference between an exclusive church and an inclusive one?

Note that the royal law in James 2:8 is the real test of faith. James amplifies this in verses 9-13. Recall the lesson for August 12, which discussed knowing a tree by its fruits (Matthew 7:18-20). Galatians 5:22-25 describes the fruit of the Spirit. Write the seven on the chalkboard: love, joy, peace, patience, kindness, goodness, faithfulness. Suggest that the class members evaluate their own lives in terms of how these qualities are reflected and expressed outwardly. Are your class members "doers" of these things?

Helping Class Members Act

As you bring this lesson—and the whole study of wisdom literature—to a close, spend a few minutes reviewing the lessons of the past weeks. Remind the class of the topics covered from Psalms, Proverbs, Ecclesiastes, Matthew, and James. Ask the members to share some of the insights they acquired during the quarter's study. What do they remember that made an impression on them?

Distribute the index cards and marking pens. Encourage the members to jot down a motto, a scripture, or a statement that they will seek to live by during the coming weeks and months. It might be some thought they gained from the study, a verse that took on new meaning, or a resolution they will make for the rest of the year.

Close the session by asking those who would be willing to read aloud what they have written. Make this a time of commitment and rededication as class members express aloud the new "wisdom" that will direct their lives in the future.

Planning for Next Sunday

A new course of study begins next week, focusing on Old Testament prophets, priests, and kings. The background scriptures are I Samuel 8 and 10:17-27.